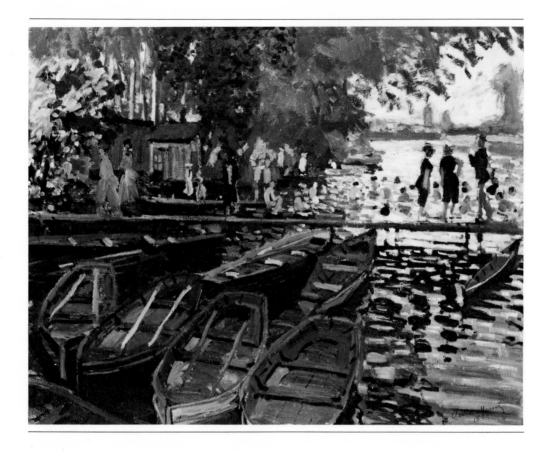

A DAY IN THE COUNTRY

Impressionism and the French Landscape

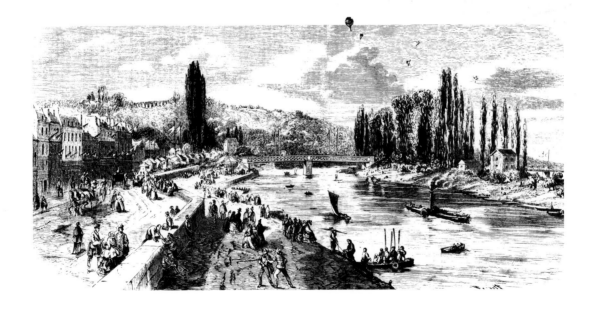

Los Angeles County Museum of Art
The Art Institute of Chicago
Réunion des Musées Nationaux

Exhibition Itinerary:
Los Angeles County Museum of Art
June 28–September 16, 1984

The Art Institute of Chicago
October 23, 1984–January 6, 1985

Galeries Nationales d'Exposition du Grand Palais, Paris
February 8–April 22, 1985

Edited by Andrea P. A. Belloli
Designed by Dana Levy

Sections III/3, III/6, III/8, and V translated from the French by
Michael Henry Heim. Except where noted, all other translations are
by the authors of the sections in which they are included.

The Checklist of the Exhibition was prepared by Paula-Teresa Wiens,
and the Bibliography by Mary-Alice Cline.

Typeset in Sabon by Continental Typographics Inc., Chatsworth, California.
Display type and initials set in Lutetia by Henry Berliner's Typefoundry, Nevada City, California.

Printed in an edition of 68,000 softcover and 7,500 hardcover on
Espel papers by Nissha Printing Co., Ltd., Japan.

Published by the Los Angeles County Museum of Art,
5905 Wilshire Boulevard, Los Angeles, California 90036.

A hardcover edition is published by Harry N. Abrams, Inc., New York.

Library of Congress Cataloging in Publication Data
Main entry under title:
A Day in the country.
 "Exhibition itinerary: Los Angeles County Museum of Art,
June 28–September 16, 1984; the Art Institute of Chicago,
October 23, 1984–January 6, 1985;
Galeries nationales d'exposition du grand palais, Paris,
February 8–April 22, 1985"–T.p. verso.
 Bibliography: p.
 Includes index.
 1. Landscape painting, French–Exhibitions.
2. Landscape painting–19th century–France–Exhibitions.
3. Impressionism (Art)–France–Exhibitions.
4. France in art–Exhibitions. I. Belloli, Andrea P. A.
II. Los Angeles County Museum of Art. III. Art Institute of Chicago.
IV. Réunion des musées nationaux (France)
ND1356.5.D39 1984 758′.1′0944074 84-3885
ISBN 0-87587-118-6 (LACMA : pbk.)
ISBN 0-8109-0827-1 (Abrams)

Front and back covers: Claude Monet, *Train in the Countryside*, c. 1870–71 (no. 48) (detail)

Contents

Lenders to the Exhibition

Albright-Knox Art Gallery, Buffalo

The Art Institute of Chicago

Birmingham City Museum and Art Gallery

The Brooklyn Museum

Cincinnati Art Museum

Ralph T. Coe

The Currier Gallery of Art, Manchester

The Detroit Institute of Arts

Armand Hammer Collection

The High Museum of Art, Atlanta

Indianapolis Museum of Art

The J. Paul Getty Museum, Malibu

The Joan Whitney Payson Gallery of Art,
 Westbrook College, Portland

John G. Johnson Collection, Philadelphia
 Museum of Art

Mrs. Lyndon Baines Johnson

Josefowitz Collection, Switzerland

Kimbell Art Museum, Fort Worth

Los Angeles County Museum of Art

The Metropolitan Museum of Art, New York

The Minneapolis Institute of Arts

The Montreal Museum of Fine Arts

Musée d'Orsay, Galerie du Jeu de Paume, Paris

Musée d'Orsay, Palais de Tokyo, Paris

Musée Marmottan, Paris

Museum of Art, Carnegie Institute, Pittsburgh

Museum of Art, Rhode Island School of Design,
 Providence

Museum of Fine Arts, Boston

The National Gallery, London

National Gallery of Art, Washington

National Gallery of Scotland, Edinburgh

Philadelphia Museum of Art

The Phillips Collection, Washington

The Phillips Family Collection

Portland Art Museum

Mr. and Mrs. A. N. Pritzker

The Santa Barbara Museum of Art

The St. Louis Art Museum

Shelburne Museum

Lucille Ellis Simon

Smith College Museum of Art, Northampton

Southampton Art Gallery

Union League Club of Chicago

Hal B. Wallis

Mrs. Arthur M. Wood

Yale University Art Gallery, New Haven

Several Anonymous Lenders

Foreword

It is with great pleasure that the Los Angeles County Museum of Art, The Art Institute of Chicago, and the Réunion des Musées Nationaux, Paris, join in presenting *A Day in the Country: Impressionism and the French Landscape*. This exhibition, which focuses on the development of a modernist vision as it can be observed in the evolution of French landscape painting, brings together a remarkable selection of artworks from all over the world. A unique loan from Paris combined with generous support from The Art Institute of Chicago forms the core of the exhibition. We are deeply indebted to these and the many other lenders for their contributions, without which this exhibition could not have been realized.

In recent years a great deal of scholarly attention has been focused on what might be termed the "geography of Impressionism." Several studies have resulted in the precise identification of the Impressionists' landscape sites and have featured photographs of the painters' motifs side by side with reproductions of their paintings. To date, however, no major international exhibition has been organized to show the range and breadth of Impressionist landscape and to place it in its broader context. *A Day in the Country*, which focuses on the iconography of Impressionism as a key to the social, economic, and ideological issues of the second half of the nineteenth century, is intended to fill this gap.

We would like to express our gratitude to Richard Brettell, Curator of European Painting and Sculpture, The Art Institute of Chicago; Scott Schaefer, Curator of European Paintings, Los Angeles County Museum of Art; Sylvie Gache-Patin, Curator, Musée d'Orsay; and Françoise Heilbrun, Curator, Musée d'Orsay, for their contributions to the catalogue and for their work on the organization of the exhibition and the selection of the paintings to be included. We would also like to thank Robert J. Fitzpatrick, Director, Olympic Arts Festival, for his ongoing support of the exhibition. *A Day in the Country: Impressionism and the French Landscape* has received major support from the IBM Corporation, for which we are extremely grateful. We also wish to thank the Los Angeles Olympic Organizing Committee; the Times Mirror Company, sponsor of the Olympic Arts Festival; the Association Française d'Action Artistique; and The Consolidated Foods Foundation, the latter for its support of the Chicago showing. Finally, we acknowledge generous support from the National Endowment for the Arts and from the Federal Council on the Arts and Humanities, which provided an indemnity to cover the foreign loans.

EARL A. POWELL III
Director
Los Angeles County Museum of Art

JAMES N. WOOD
Director
The Art Institute of Chicago

MICHEL LACLOTTE
Chief Curator
Musée d'Orsay

Preface

A *Day in the Country: Impressionism and the French Landscape* is one of the major cultural components of the 1984 Olympic Arts Festival. Of the more than 120 works on exhibit, roughly one third are on special loan from Paris and are not expected to travel again once they are installed in the new Musée d'Orsay. Thus their exhibition, organized by the Los Angeles County Museum of Art in collaboration with The Art Institute of Chicago and the Réunion des Musées Nationaux, Paris, provides an extraordinary opportunity both for the people of California and for hundreds of thousands of Olympic visitors from around the world to view outstanding masterpieces by the major Impressionist artists in a unique context.

The Los Angeles Olympic Organizing Committee wishes to express its appreciation to the three organizing museums who will host this superlative exhibition and to the Times Mirror Company as the official sponsor of the Olympic Arts Festival. We would also like particularly to thank Catherine Clément, Director, Association Française d'Action Artistique, for her assistance in the creation of *A Day in the Country*.

ROBERT J. FITZPATRICK
Director
Olympic Arts Festival

Acknowledgments

Gratitude is expressed to the following individuals and institutions whose assistance and support have been invaluable in the preparation of *A Day in the Country: Impressionism and the French Landscape:* Luce Abélès; Hugues Autexier; Andrea P. A. Belloli; Geneviève Bonté; Wallace Bradway; François Braunschweig; Peter Brenner; Terry Brown; Mary-Alice Cline; Paula Cope; Corpus Photographique XIXᵉ CNRS-BN; Merle d'Aubigné; Marie de Thezy; Anne Distel; Tom Fender; Hollis Goodall-Cristant; Gloria Groom; Alla Theodora Hall; Katherine Haskins; Michael Henry Heim; Jacqueline Henry; Françoise Jestaz; Robert W. Karrow, Jr.; David Kolch; Anna Leider; William Leisher; Timothy Lennon; Antoinette Le Normand-Romain; François Lepage; Dana Levy; Gérard Levy; Bernard Marbot; Renee Montgomery; John Passi; Sylvain Pelly; Elvire Pérégo; Jean-Jacques Poulet-Allamagny; Jim Purcell; Larry Reynolds; Christiane Roger; Anne Roquebert; Josiane Sartre; Samara Whitesides; Paula-Teresa Wiens; Gloria Williams; and Deenie Yudell.

This exhibition and its catalogue are funded by a major grant from the IBM Corporation.

Additional support has been received from the National Endowment for the Arts; the Association Française d'Action Artistique (Ministère des Relations Extérieures); the California Arts Council; and an indemnity from the Federal Council on the Arts and Humanities.

The exhibition is a part of the Olympic Arts Festival of the 1984 Olympic Games, sponsored by the Los Angeles Olympic Organizing Committee through the support of the Times Mirror Company.

Contributors to the Catalogue

RICHARD BRETTELL R.B.
Curator of European Painting and Sculpture
The Art Institute of Chicago

SYLVIE GACHE-PATIN S. G.-P.
Curator
Musée d'Orsay, Paris

FRANÇOISE HEILBRUN F.H.
Curator
Musée d'Orsay, Paris

SCOTT SCHAEFER S.S.
Curator of European Paintings
Los Angeles County Museum of Art

List of Maps

Maps 3–8, all dated 1832, are reproduced courtesy of the Newberry Library, Chicago, from *Nouvelles Cartes topographiques de la France,* which was printed in Paris between that year and 1879 for the Dépot de la Guerre.

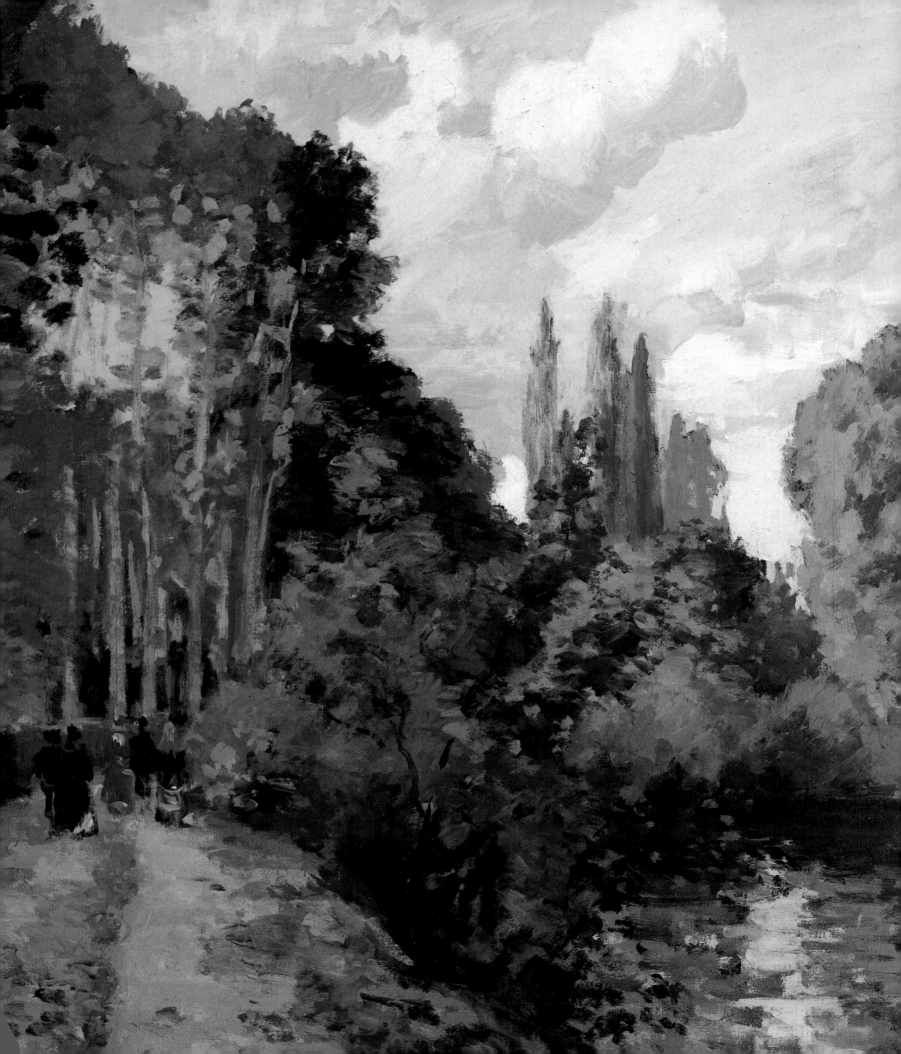

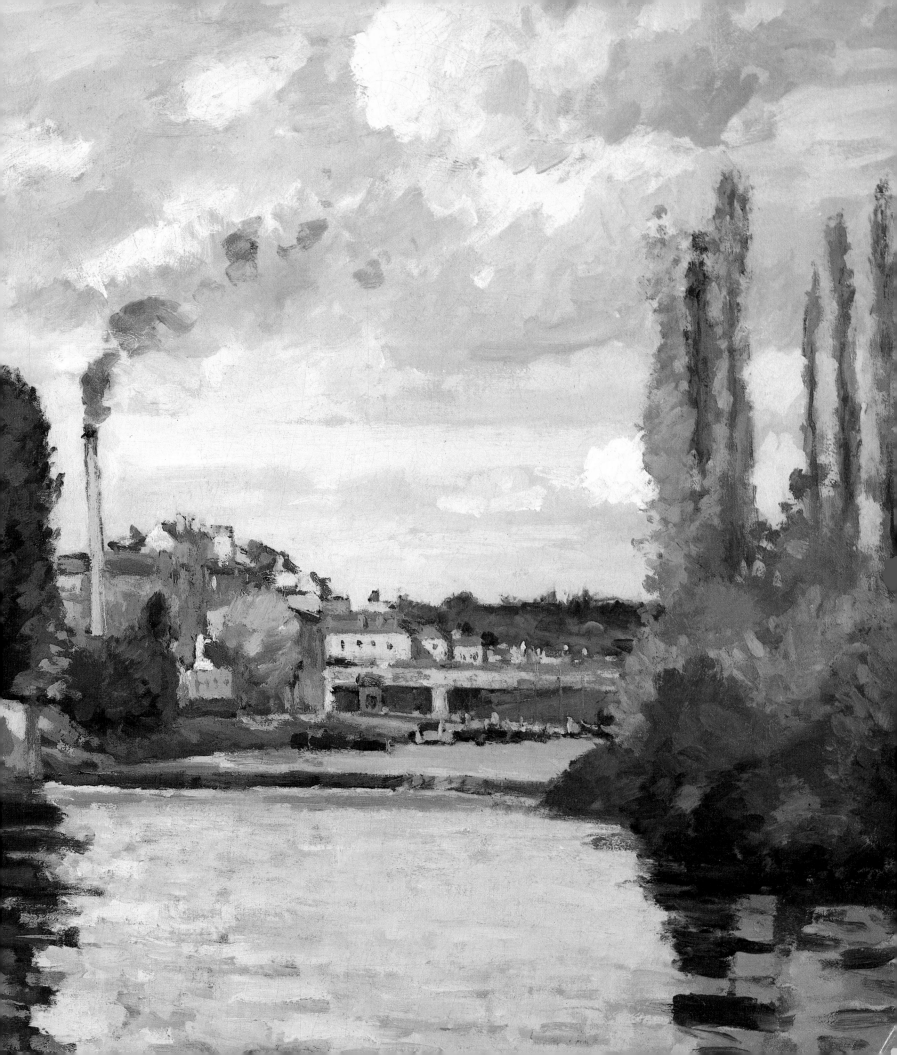

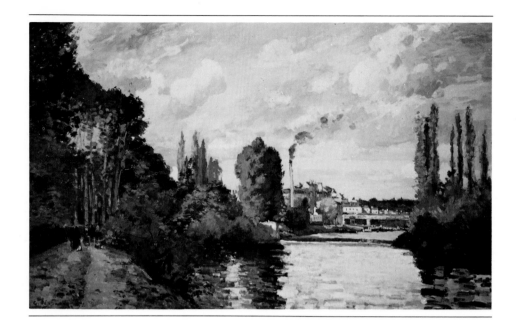

I

Impressionism in Context

THERE IS LITTLE DOUBT that Impressionist landscape paintings are the most widely known and appreciated works of art ever produced. They have become universal touchstones of popular taste, practically supplanting the work of Raphael, Leonardo da Vinci, and Michelangelo in the collective imagination of the world. From South Africa to Japan, from Lisbon to Los Angeles, virtually every educated person knows about the landscapes of Claude Monet, Alfred Sisley, Camille Pissarro, and Pierre-Auguste Renoir. Attendance in the galleries devoted to Monet in the Museum of Fine Arts, Boston, in the Impressionist galleries of The Art Institute of Chicago, in the Meyer galleries of The Metropolitan Museum of Art, New York, in the Chester Dale galleries of the National Gallery of Art, Washington, D.C., and, of course, in the French national museum of Impressionism, the Galerie du Jeu de Paume, Paris (now the Musée d'Orsay), is truly staggering, and virtually every art museum—both large and small—owns at least one Impressionist landscape painting. The world knows more about France through the eyes of the Impressionists than it does through actual experience of that nation itself. It is undoubtedly true to say that more Americans—and Japanese—know about the tiny town of Giverny, where Monet lived and worked in his later years, than they do about such economically and artistically important French regional cities as Lyon, Poitiers, or Grenoble.

What do we learn of France from the Impressionists? The question is, at first glance, an odd one. We are most often taught that one learns *nothing* from landscape paintings. Impressionist pictures, according to the common wisdom, are meant to be enjoyed, not understood, and most analysts of their meaning—like Arnold Hauser in his superb essay, "Impressionism," in *The Social History of Art*[1]—have treated them as essentially hedonistic works of art in which the world was passively accepted by artists who merely pre-

sented it to the viewer for his enjoyment. Impressionist landscapes, for Hauser and many other commentators, are remarkable for their easy accessibility, their *lack* of subject, and their highly individual style. Because this view has dominated both scholarly and popular discourse about Impressionism, few writers have attempted to discover what might be called its iconography, preferring to describe the history of its exhibitions or to chart the stylistic development of its key painters. Yet such an iconography surely must exist. The present exhibition—by grouping very well-known paintings neither chronologically nor stylistically, as is usually done, but by subject—is intended to show that there *are* identifiable Impressionist themes, the meanings of which can be analyzed and understood.

The major thesis of *A Day in the Country: Impressionism and the French Landscape* is that Impressionist landscapes are saturated with meaning and that one needs to know a great deal before one can approach them in all their richness. Like many great works of art, they appear to be simpler than they are. Although they have been explained as naive transcriptions of reality, Impressionist pictures, like the novels of Gustave Flaubert, are studied in their very naiveté. The more one reads of the vast secondary, and even vaster primary, literature about France during the period in which the Impressionists worked and lived, the clearer it becomes that their paintings were a central component of French culture, not an isolated, solely aesthetic phenomenon. Because we are so indebted to Impressionist painting for our own notions of beauty, we owe it to ourselves to understand it—and the movement which produced it—more fully. Since the subject is such an enormous one, and so many books, pamphlets, articles, exhibitions, and ephemera have been devoted to it, one might ask whether there is, in fact, anything more to be learned. We believe firmly that there is and that the line of investigation taken here is worthy of even more extensive examination than has been possible in the creation of *A Day in the Country: Impressionism and the French Landscape.*

Landscape painting is an art of selection and balance. When riding on a train, walking along a rural path, or sitting at the edge of a field, one is in the midst of nature. It unfolds in three dimensions and surrounds the viewer, who can never experience it fully. In "seeing" a landscape, one both "chooses" what to see and passively allows nature to act upon one's eyes and subconscious mind. Because of this continuous oscillation between will and passivity, one can never truly comprehend what scientists and painters alike have called the *"champ de vision,"* or "field of vision." In the end, houses are perceived as houses, trees as trees, and roads as roads, and they are not simply colored light acting upon the retina. Certain forms contain powerful meanings and associations for individual viewers, others are blander, and each participates (unequally) in a larger abstraction called "the landscape."

Painters, like all observers of nature, are attracted to certain forms and not to others. Some are moved by the chance discovery of the parallel alignment of a tree and the edge of a house viewed from a particular point on a rural path; entire landscape paintings can hinge on such a fortuitous occurrence. Others seek out intensely meaningful forms in nature and, by making these forms the "motifs" of their landscape, allow nature to conform powerfully to their will. The Impressionists followed both courses. Although many of their pictures appear to be the result of simple transcription, this is not the case. Studies of the landscapes of Pissarro and Monet have shown that each artist altered nature to suit his own requirements. Pissarro moved

buildings from one area of the actual landscape to another to achieve pictorial balance or to insert a meaningful counterbalance to a large tree or a factory. And many of the Impressionists willfully altered the shape, scale, and character of vegetation and topography to add greater variety to their landscapes as well as to intensify or diminish the importance of certain buildings, figures, or even other vegetation (no. 89). Thus, although none of these artists wandered very far from their homes in Normandy and the Ile de France, they painted landscapes with an astounding variety of moods and meanings.

Most writing about the Impressionists has stressed the *modernity* of their landscapes. This aspect of their work was very real, as this catalogue demonstrates. Yet the temporal structure of Impressionist landscapes is more complex, both seasonally and historically, than has been supposed. Many paintings represent highly stable, even traditional, worlds (see below, II and III/5), and their creators' evident fascination with rural villages and with the fields of the Ile de France is surely evidence of their concern for the enduring elements of French civilization. Such images as Monet's grainstacks (nos. 104–112) are, in a sense, landscapes of memory. While actual, they seem at the same time immutable and speak of continuity in the midst of change, of a timeless time.

The preoccupation with change that has been so persistent a theme of writers about Impressionism was certainly important to the painters. Yet time, like form, is an infinitely complex and variable abstraction, and, if one were to attempt a temporal analysis of Impressionist landscape paintings, one would confront a considerable task. In each painting, there is the time "represented" or referred to in the title. This might be a time of day (midday, afternoon, and morning are the most common) or a season. Most Impressionist landscapes also contain evidence of a "temporality" suggested by the representation of moving forms—walking figures, gliding boats, rustling leaves, or windblown clouds—each of which aids the viewer in his quest for the momentary structure of time that underlies the cyclical rhythms of days and seasons. As landscape painters the Impressionists were obsessed with history and its action upon the landscape through the works of man. Old buildings stand next to trains and newly constructed factories in their pictures (see below, III/5), and most of the man-made forms serve as referents to historical time.

The first Impressionist exhibition was held in the spring of 1874. Strong memories of the Franco-Prussian War (1870–71) and the Commune (1871) lingered in France, the national humiliation of one scarcely greater than the sense of shame generated by the other. The nation still was paying heavy reparations to the Germans, and the economy, committed to expensive modernization and industrialization, strained under their burden. Both the cityscape of the capital, Paris, and the landscape of its suburbs were filled with the scars of war next to those of modern development; buildings and bridges under construction vied with those destroyed by war for dominance in the landscape (see below, II and III/3). Change, the impetuous forward motion of history, had, in a sense, stopped in the France of early Impressionism, and the nation was busy repairing itself and its pride. The awareness of time that one might term the historical consciousness of France was confused during the decades following the Franco-Prussian War, and, as we shall see, the Impressionists' landscapes represent their artists' responses to the ambiguities inherent in the nation's recent history.

That these responses virtually exclude all evidence of this upheaval

and its resulting doubts is surely no accident. The Impressionists' France was a beautiful, a simple, and a prosperous France. Sailboats and barges—floating symbols of leisure and commerce—maneuvered its waters (nos. 5, 17). Promenaders and rural workers shared its paths (no. 65). Newly built country houses stood next to farms, and village women washed their clothes across the river from restaurants catering to suburban tourists (no. 14). Impressionist landscapes are either straightforward celebrations of the new or carefully balanced constructions in which traditional elements have been placed together with those of the new age (see below, III/5). Even their modernity is fragile.

In selecting and grouping the works of art for this exhibition, we have chosen not to be doctrinaire in our methods. It would have been easy, for example, to decide that the site represented in each painting should be the most important determinant of subject. In this way, a picture by Monet of the Seine River at the town of Vétheuil would be analyzed as an image of Vétheuil, while another painted by the same painter along the same river at nearby Vernon would fit into an "iconography" of that town. The analysis of paintings by site is certainly not futile; we have learned a great deal from Paul Tucker's extensive examination of Monet's many paintings of the suburban city of Argenteuil.[2] There are many students of local history in France, such as Rodolphe Walter, who have worked assiduously and with obvious success to identify the sites painted by the Impressionists.

It is clear, however, that the site at which a painting was made is only part of its "subject." In the search for an iconography of Impressionist landscape, it is also necessary to define certain "subjects" (in this broader sense) common to the work of all the artists. These collective subjects are not always easy to find. In many landscapes, for example, the Seine itself, more than the site at which it was painted, can be called the "subject" of the painting (see below, III/4). Yet even this observation fails to tell us just what such paintings "mean." If we know, however, that the Seine was defined by many writers as the "national" river of France and that one contemporary guidebook writer called it "the great street of a capital with Rouen and Le Havre as its suburbs, the swift passageway that begins at the Arc de Triomphe de l'Etoile and ends at the ocean,"[3] we can understand the significance of this river as *the* great national route connecting Paris and its monuments with the rest of France and, ultimately, the world. This knowledge takes us to a further realization: that rivers are like roads, boulevards, streets, and railways in that they form part of a landscape of linkages in which "place" per se is less important than movement (see below, III/4).

The same collectivity of subject can be observed in most other Impressionist paintings. When analyzing the many seascapes representing the coast along the English Channel, for example, it is often less significant to know that a picture was painted in Honfleur or Etretat than to realize that sea bathing increased in importance during the latter half of the nineteenth century in France or that trade with Great Britain was of extraordinary economic importance for France during the period of the Impressionists. The same kind of general knowledge helps in understanding the urban landscapes of the Impressionists, their faithful recording of village life, and their pictorial devotion to the controlled nature manifested in fields, parks, and gardens (see below, III/6–7).

Ultimately, the search for the "subject" of a landscape must take us beyond these crucial, but general, issues into an analysis of the paintings

themselves. Although most landscapes of the Seine have certain underlying common meanings, each embodies the particular attitudes of its painter toward actual stretches of her banks. Therefore, in order to understand an individual landscape, the dominating forms placed in central or compositionally crucial places must be named and understood in terms of French experience of the period. It is clear, for example, that a landscape dominated by a *lavoir,* or wash house, floating in a river (no. 17) has substantially different meanings than do similar river landscapes centered on sailboats, restaurants, or bridges. And, by extension, a landscape given over to a field of poppies (no. 103) has different meanings than one in which a harvested field is dominated by a massive, solitary grainstack (nos. 104–112). Such an analysis of the "motifs" of landscape painting is based essentially upon methods of naming and defining familiar to iconographers, yet it rarely has been applied systematically to landscape paintings, no doubt because forms in the landscape are not read as easily as symbols or emblems.

Although there is no Cesare Ripa for the student of landscape motifs, such sources as dictionaries, encyclopedias, guidebooks, official statistics, real-estate records, novels, and memoirs can help us in our search for the meanings of forms in French landscape paintings. For that reason, a "reading" of these misleadingly simple works of art like that outlined here requires a great deal more time in general libraries and archives than in art libraries. One can learn profitably about the real-estate transactions that doomed to development certain bucolic fields memorialized by Monet in the 1870s.[4] One must know about the physiognomy of contemporary boats to understand Renoir's *Bridge at Argenteuil* (no. 45), and a knowledge of the changes in rural dwellings of the time helps one to respond intelligently to the bright red and blue roofs which dominate the village in Pissarro's *Climbing Path in the Hermitage, Pontoise* (no. 66) or Paul Cézanne's *Auvers, Panoramic View* (no. 69). Yet neither the understanding of the broad cultural associations of certain places nor the naming and analysis of individual motifs in a landscape is sufficient to comprehend the many meanings of a landscape painting.

Such pictures, as they are interpreted in this book, are among modern man's principal attempts to make viable "patterns" of his world, to distill its essential qualities for his own generation and for posterity. For this reason, the "reader" of a landscape painting must be careful not to rely too heavily on the techniques of the traditional iconographer who selects certain forms from the entire picture for intensive analysis. Indeed, landscapes are as much about the arrangement and ordering of the many diverse forms included within them as they are about the meaning of any one—or several—among these forms, no matter how dominant. In fact, writings about landscape painting from the seventeenth through the nineteenth centuries have repeatedly made it clear that powerful motifs distract from the homogeneity necessary for a painting to achieve its status as a landscape. Students of such paintings could learn a great deal about landscape in this sense from the four generations of modern geographers, many of whom have worked in France, and most of whom have come to understand the world through a process of intensive and detailed analysis of its topography.[5] Only these investigators have looked as carefully and patiently at landscape as have its best painters.

There must be no mistake about the ultimate relativity of landscape meaning. When one knows that a thatched peasant dwelling in a picture by Cézanne or Pissarro had widespread associations with the traditional, pre-Revolutionary order of the rural world, one does *not* know the meaning of

the landscapes that contain those dwellings. Indeed, it is their *placement*—in the space of the landscape, along the surface of the picture, in juxtaposition or association with other forms—that must be understood before "meaning" can be fully comprehended. When a detached farmhouse dominates a landscape, as in Cézanne's *Farmyard at Auvers* (no. 70), the meaning of that landscape is very different than when a similar building is either juxtaposed bilaterally with what was in the nineteenth century a newly constructed country house, as in Pissarro's *Red House* (no. 62), or simply included as one of many forms in a larger view, as in Paul Gauguin's *Market Gardens at Vaugirard* (no. 74). Considered in this way, landscapes are like sentences or paragraphs in which words create different meanings as they are moved and juxtaposed with other words. A dictionary can give various definitions of a word, but it cannot tell what a specific sentence means. The same can be said for forms in a landscape painting. One could know everything about the construction of grainstacks in the north of France in the nineteenth century and yet know very little about the meanings of Monet's series of paintings with grainstacks as their motifs (nos. 104–112).

A careful reading of landscape titles as they are recorded in the catalogues of the Impressionist exhibitions tells us that many matters—time of day, season, identification of a building, or even a generic evocation of place—were signified as "subject."[6] Certain landscape paintings were exhibited with titles that make no mention of their sites, in spite of the fact that we can easily identify a great many of them today. An entire species of landscape titles tells us simply that the painting *is* a landscape or a view painted in, around, or of a certain place (no. 69). Others spell out a season or time of day, stressing that time is as important to an understanding of the pictures as place (no. 126). Still others tell us that a path, hillside, field, or river bank is the subject of the picture (no. 76). In general, Impressionist landscape titles tend to be intentionally quotidian, as if to discourage us from using them to explain the paintings.

The pictures in *A Day in the Country: Impressionism and the French Landscape* have been grouped into nine sections, seven of which (III/2–8) are proper to the subject of the exhibition: Impressionism and the French landscape. These seven catalogue sections are flanked by an introductory section (III/1) and a "coda" (III/9), each of which serves to contrast certain aspects of Impressionist landscape painting with developments in both earlier and later French landscape painting. The seven central sections are defined in various ways. One, "The Cradle of Impressionism" (III/2), is almost purely topographical and considers collectively the paintings made at the first true Impressionist site: the suburban landscape around Bougival, Louveciennes, and Marly-le-Roi just west of Paris (map 5). None of the other six "core" sections are defined by a single locale, but rather by larger subjects—the city, transportation, the sea, the village, agriculture, ornamental gardens—that link topographically diverse landscapes. In each of these sections, a short essay discusses major themes; each group of entries attempts to analyze several works of art or individual ones in relation to these themes. The "coda" (III/9) includes works by Post-Impressionist painters. This section serves to remind us that there was a change not only in the style of landscape painting in France—a change that occurred gradually during the second half of the 1880s and first half of the 1890s—but also that the landscapes painted by these younger artists were geographically as well as iconographically removed from those of Monet, Pissarro, and Sisley. Cézanne deserted the Ile de France for Provence; Gauguin and his camp followers fled to the outer

reaches of Brittany; and the Neo-Impressionists—Henri-Edmond Cross, Paul Signac (and, eventually, Henri Matisse)—developed a Mediterranean "pastorale" far from the capital on the shores of the Riviera. Some of the interpretations included in these sections remain speculative; much clearly remains to be learned about the subjects and meanings of individual Impressionist landscape paintings.

The central catalogue of nine sections itself is "framed" by two long essays, which deal with topics of central concern to the subject of the exhibition. The introductory essay, "The Impressionist Landscape and the Image of France" (II), surveys certain historical and cultural ideas of a very basic kind, a familiarity with most of which is essential to a real understanding of Impressionist landscape painting. Its aims are truly introductory, and therefore it includes very little discussion of individual works of art. The other major essay, "Impressionism and the Popular Imagination" (IV), follows logically upon the catalogue section because it concerns less the production of than the critical reception to, and marketing of, Impressionism. It treats in some detail the phenomenal rise in worldwide popularity of Impressionist landscape painting. While "The Impressionist Landscape and the Image of France" lays the groundwork for an understanding of the pictures in terms of the culture in which they were produced, "Impressionism and the Popular Imagination" examines the various reasons for their appeal beyond France and beyond the nineteenth century. Finally, an appendix, "The Landscape in French Nineteenth-Century Photography" (V), examines the development of landscape photography in France in the 1800s.

In conclusion, it is perhaps necessary to say just what is meant here by "Impressionism," in the hope of avoiding the usual pitfalls of stylistic definition in modern art history. Whether the style which Pissarro called "scientific Impressionism" and we call "Neo-Impressionism" and even "Pointillism" is *really* Impressionism is a question that can be debated ad nauseam.[7] Our subject—Impressionist landscape painting—is defined as follows: landscapes painted by artists who exhibited in one or more of the Impressionist exhibitions (that is, between 1874 and 1886) and whose art is generally considered to be central to Impressionism's aims. Although the core of *A Day in the Country: Impressionism and the French Landscape* is the paintings of Monet, Sisley, and Pissarro, the exhibition includes an important group of landscapes painted by Cézanne during the 1870s, and both Gauguin and Georges Seurat are well represented. There are also paintings by Vincent van Gogh, Cross, and Signac. While the latter artists are classified today as Post-Impressionists, most of them exhibited in one or more of the Impressionist exhibitions and developed their art in the aesthetic forum created by the Impressionist movement.

—R. B. and S. S.

NOTES

1. Hauser, 1951, vol. II, pp. 869–926.
2. See Tucker, 1982.
3. *Guide de voyageur...*, c. 1865, p. 1.
4. Tucker, 1982, pp. 35–38.
5. See Sauer, 1963.
6. Venturi, 1939, vol. II, pp. 255–271.
7. Rewald, 1980, pp. 512, 514, 518, 533; Pissarro, 1950, pp. 88–120.

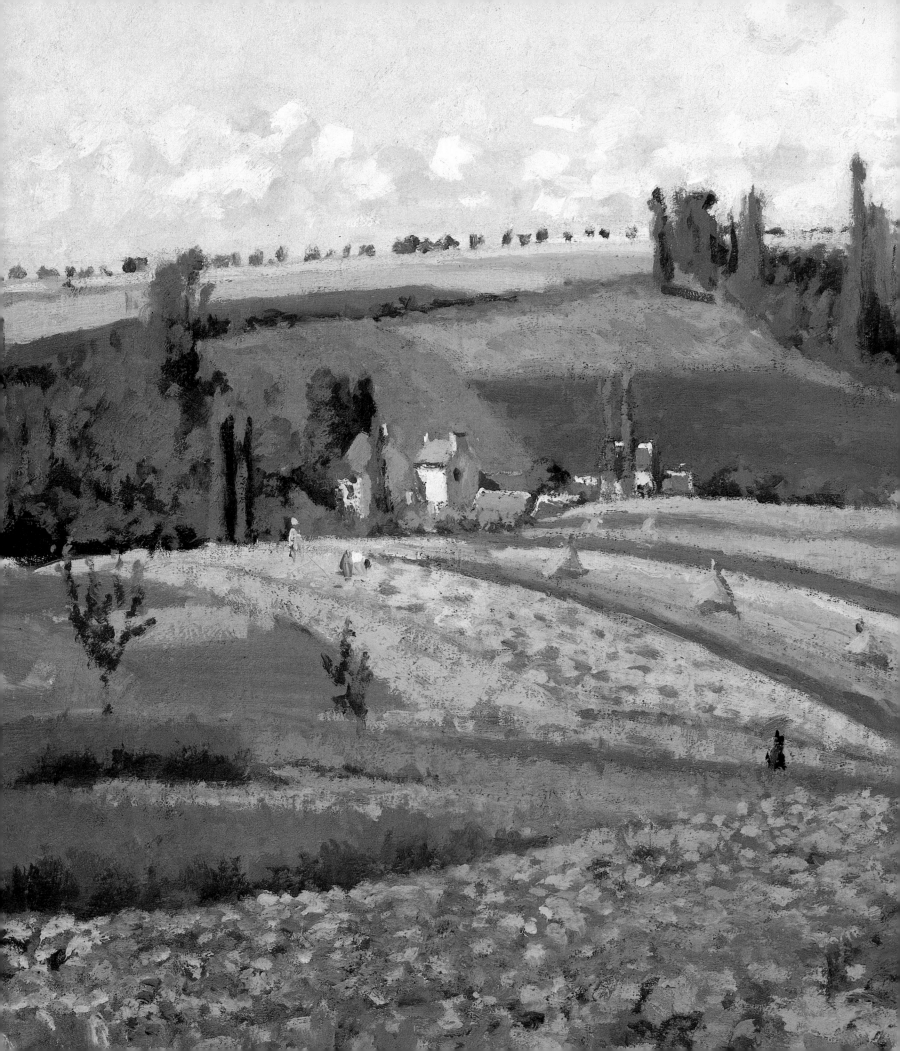

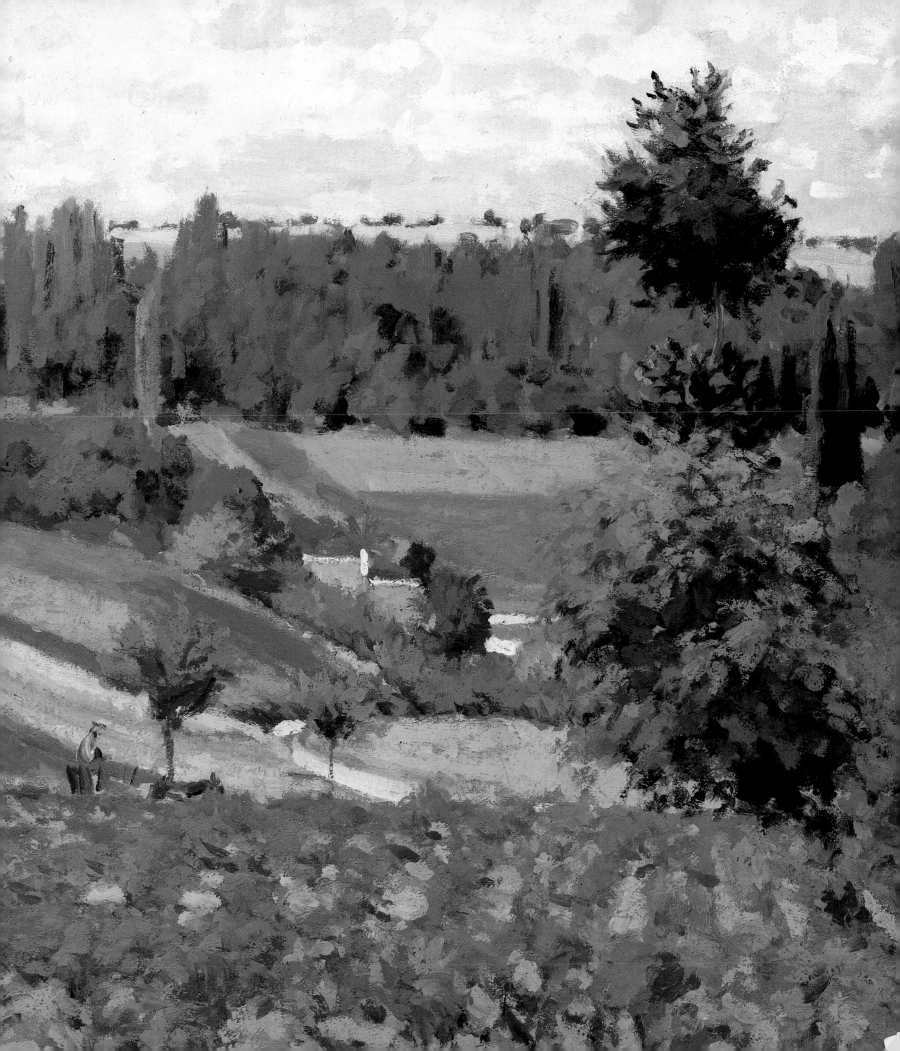

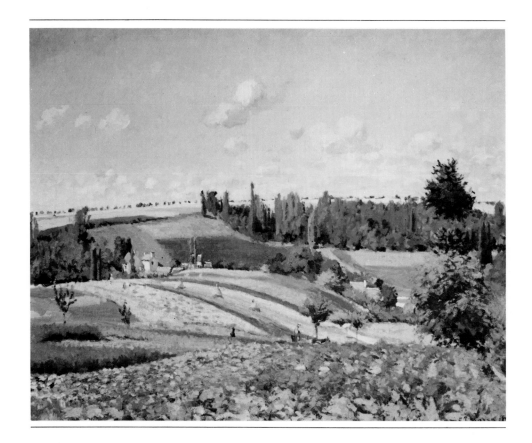

II

The Impressionist Landscape
and the Image of France

WHEN THE IMPRESSIONISTS BEGAN TO PAINT the French landscape in the 1860s, they were not alone. Several satirical writers had already counted more landscape painters than tourists or peasants in their travels through the French countryside, and the official Salon exhibitions held annually in Paris were all but dominated by French landscapes. Books and manuals about landscape painting for both professional and amateur artists abounded, and if there was a national genre in French art, it was surely landscape. The painters were joined by a legion of printmakers, draftsmen, and popular illustrators in an almost frantic collective attempt to record the national physiognomy.

It is perhaps because the landscapes produced by certain of these painters have become familiar throughout the world that the nationalism of their creators' enterprise has been neglected. We often forget that the Impressionists' French landscapes played a small, but real, role in the quest for a viable national identity that preoccupied the French people throughout the nineteenth century. More specifically, paintings by these artists represent a benign, but modern, landscape as defined for, and dominated by, urban dwellers—a countryside in the process of being conquered by a capital city.

In his analysis of the Salon of 1866, the critic Jules Castagnary wrote about what he called "the great army of landscape painters" then invading France. He divided that army into ranks and divisions less by style or imagery than by the region of France or her colonies that they painted.[1] For Castagnary, a land-based army was the most appropriate satirical metaphor for landscape painters, and he extended his metaphor to conclude that France maintained its identity and extended its domain by artistic rather than military conquest. Landscape painting, for Castagnary and many others, was intimately linked to what the slightly later writer Ernest Renan was to call "the national soul."[2]

It is customary in writing about the history of Impressionism to stress its anti-Academic tendencies and to contrast the seemingly effortless and spontaneous art of Monet and Pissarro with the labored, historicizing concoctions of Jean-Léon Gérôme, William Adolphe Bouguereau, and Jules Breton. While there is little doubt that the Impressionists detested the figural confections of their famous contemporaries, the real arena in which they fought for recognition and control was one populated by the landscape painters mentioned by Castagnary. These competitors were much more numerous—and collectively more powerful—than the presiding giants of the Ecole des Beaux-Arts with whom Edouard Manet and the others did battle.

Among the many members of Castagnary's "great army," only two painters who were to become Impressionists were included: Monet, who was a "second lieutenant," and Pissarro, who was a "captain" in what the critic called "the first corps of the Army of Paris."[3] This corps was without doubt the largest and most significant part of Castagnary's fighting force, surpassing his four other French corps—those of the west, the south, the center, and the north—in size and national importance, and it became the corps in which the Impressionists had to prove themselves and which they came to dominate by the end of the nineteenth century. In 1866 it was presided over by two artists who have no reputations today: Jean-Alexis Achard and Edme Saint-Marcel. If Castagnary had updated his metaphor a generation later in 1896, the forces would surely have been commanded by Monet with assistance from Pissarro, Sisley, and probably Henri-Joseph Harpignies. There is little doubt that the Impressionists made Castagnary's "Army of Paris" into a major force not only in French, but in world, art.

When one examines maps of France marked with the sites painted by the Impressionists (maps 1–2), the extent of their dependence upon Paris is clear. They chose to paint in places which huddle around the capital or cling to her great river, the Seine. Further, if one were to look at a railroad map of this area, there would be a startling coincidence between the landscape sites chosen by the Impressionists and the stops on the major railroad lines constructed in France during the middle of their century (see below, III/4). These artists were in many ways unadventurous in their search for landscape sites and evidently placed greater value on direct access to Paris than on the wild beauties of inaccessible natural landscapes. The rugged topography of the Massif Central, the Pyrenees, or the Haute-Savoie is essentially absent from Impressionism. The landscape of Monet and his colleagues was not an escapist one far from the haunts of man, the landscape of "silence and solitude" written about by the painter and theorist C.-L.-F. Lecarpentier and preferred by painters of the French Romantic tradition.[4] Rather, it was a "capital" landscape oriented always to Paris and its tentacular civilization.

Paris occupies a region known for the past eight centuries as the Ile de France. As a place name, "Ile de France" is ambiguous and corresponds more to an idea than to any real administrative or political area (today it comprises nine departments, the basic unit of regional administration in France). In fact, the great French historian Marc Bloch refused to define its limits exactly in a famous essay on the area, appealing instead to the French geographer Paul Vidal de la Blache, who called the Ile de France the "countryside around Paris."[5] Meaning literally "island of France," "Ile de France" suggests that the territory surrounding Paris *is* France itself, while the outlying regions are true provinces.

This notion corresponds closely with another conceit used frequently by French writers of the eighteenth and nineteenth centuries who referred to the same region as the *"campagne de Paris."* This term has even deeper roots than "Ile de France" and is associated clearly with classical antiquity: the environs of Rome have been known since ancient times as the Campagna. Hence the landscape of the Impressionists must not be considered merely to represent "the country" in a generic sense, but rather the territory controlled by a great capital city. Impressionist landscapes therefore embody in their very subjects the civilization of a city that aspired to be the greatest world capital since ancient Rome. These landscapes fed upon the myth of what was often called *"paysage classique,"* or "classical landscape,"[6] in spite of the fact that they do not conform easily to the stylistic norms of French Classical painting.

Rocked by a series of revolutions that were followed by periods of variously reactionary government, France stumbled through the 1800s unsure of herself, her survival as a nation, and her position in a capitalist and industrializing world dominated increasingly by England, Germany, and the United States. The passionate, if ideologically diverse, pleas for national unity made throughout the century in the form of speeches, books, and pamphlets filled with purple prose and verse exhorted the French people to national solidarity. This vast literature was written by intellectuals of every social and economic type, from the aristocratic Baron de Montesquieu, who espoused a connection between nationalism and republican government as early as 1748, to Renan, whose origins were in the working class and who pleaded the case of the "national soul" in a famous speech of 1882.[7] Thus in painting their landscapes, the Impressionists were linked to the most pervasive and ideologically diverse political notion of their century.[8]

The French quest for national unity became especially urgent after the humiliating defeat suffered by France at the hands of Otto von Bismarck's newly united Germany during the Franco-Prussian War. The Parisian landscapes of the Impressionists were produced precisely when French national confidence was at its lowest point since Waterloo (1815). Their representations of the *campagne de Paris* must be read in the light of what can best be described as a national identity crisis.[9] It is surely no accident that French— and specifically Parisian—landscape painting had its greatest efflorescence in the 1870s.

The story of the "conquest" of France by Paris is a long, complex, and difficult one that has been told many times and in many forms.[10] Given its most significant modern impetus by the great administrators of France during the seventeenth century, the nationalization of that country took hold slowly and with considerable difficulty. It should not be forgotten that, as late as 1864, an educator traveling in the Lozère found that the local children did not know they were French and, even more surprisingly, that a majority of Frenchmen during the nineteenth century could not speak "correct" (that is, Parisian) French, using instead one of the regional languages like Breton or Provençal.[11] Even in our century, during which French national identity has been accepted firmly both internally and externally, many writers have pleaded for a politics of decentralization, and powerful regionalist movements, particularly in Brittany, continue to exist. The struggle between region and nation that has played such a powerful rôle in modern times interrupted the smooth course of French history during the period of the Impressionists.[12]

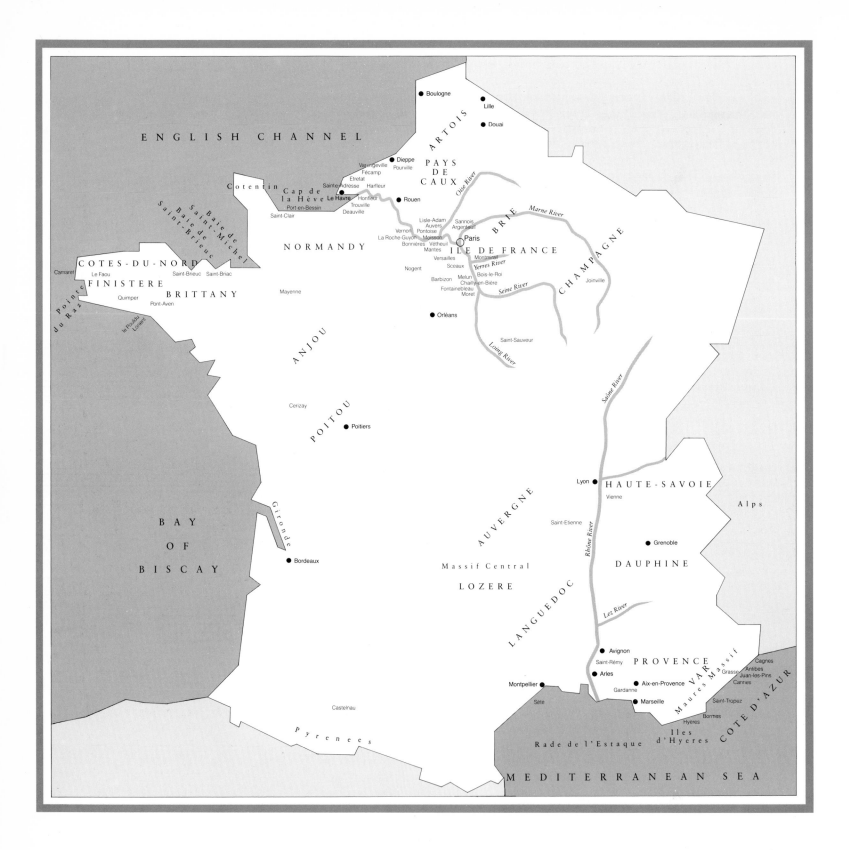

Map 1. France.

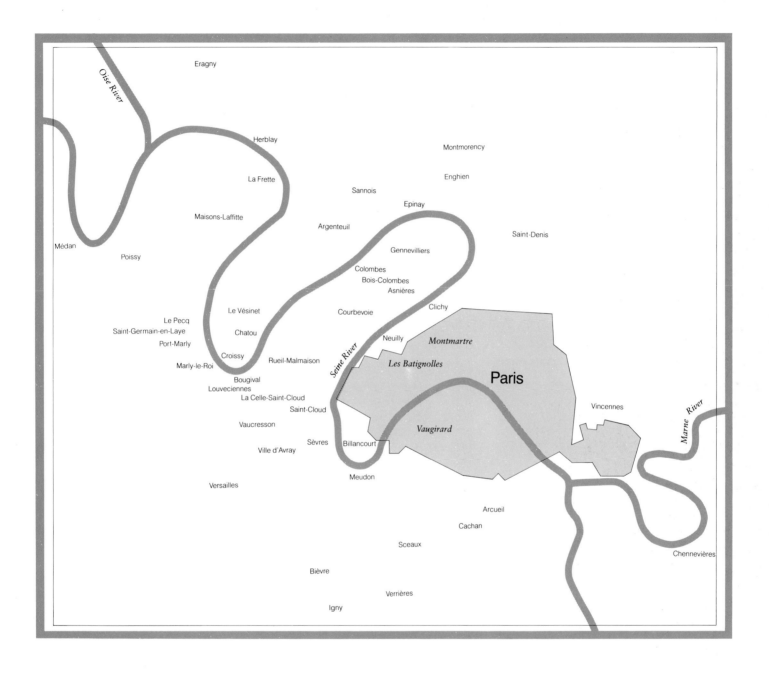

Map 2. Paris and Environs.

The national landscape inaugurated in the seventeenth century and constructed through the eighteenth and nineteenth centuries was a landscape of communication through transportation (see below, III/4). As if in support of this idea, the gardens of Versailles, begun by André Le Nôtre for Louis XIV in 1668, were designated as a metaphor for the order and control of France through the mechanism of *allées,* or roads, and canals.[13] The great parterre with fountains just outside the Hall of Mirrors was—and still is—adorned not with classical deities or military trophies, but with allegorical statues of the principal rivers of France. Although it might seem strange to say, the garden landscapes of Le Nôtre in many ways predicted the landscapes of the Impressionists. His system of straight roads and canals linked the gardens of Versailles to the actual landscape of France, and the symbolic allusions in the sculpture and plantings he arranged to man's control of land, river, and sea were part of an underlying system of nationalist values present in Impressionist landscape painting as well. The idea of landscape as "useful" nature, as nature tamed and controlled for the benefit of the nation, links the Impressionists and the ministers of Louis XIV. Although none of the painters were in any sense royalists, all of them felt themselves to be French to the core. Even Pissarro, a Danish citizen until his death in 1903, wanted to fight for the French during the Franco-Prussian War and expressed a longing to return to France during his self-imposed exile in England during that conflict.

Not surprisingly, the nationalization of France had a profound effect upon the French landscape itself. In the seventeenth century a system of national highways was inaugurated so that travel through the countryside and among provincial capitals was made easier. These roads—raised above the ground for drainage, graded, and lined with rows of trees (fig. 1)—introduced a visual unity into the diverse regional landscapes, a unity based upon an image of collective movement and transportation (see below, III/4). This arterial system was joined during the eighteenth century to a network of canals and improved natural waterways utilizing the rivers of France. Of all European nations, France is the best endowed with navigable rivers, and these—together with the canals which served to link them, thus creating an aquatic highway system—became the veins of France as the national highways were the arteries. The improvement of both networks continued into the nineteenth century.

The progress of this national system of transport and communication can be traced even in the mapping of France. Inaugurated in the seventeenth century by the Cassini family, the detailed cartographic analysis of the countryside, which clearly recorded roads, canals, rivers, châteaus, towns, and even rural paths, was not completed (by the family's descendents) until the late eighteenth century. It was then replaced by a series of maps called the *Nouvelle Carte topographique de la France,* made for the Ministère de la Défense and finished only in 1879. This was joined by increasingly detailed, specialized maps concentrating on railroad lines or regions of particular importance to travelers. The nineteenth century was the great age of mass-produced maps, and a study of them makes it clear that the Impressionists were painting a landscape that was widely accessible both in actuality and to the armchair tourist.

This process of unification through transportation was given extraordinary impetus in the nineteenth century by the invention of the railroad (see below, III/4). France, like England and the United States, gave herself over fervently to this new mode of transportation. Books and articles about rail-

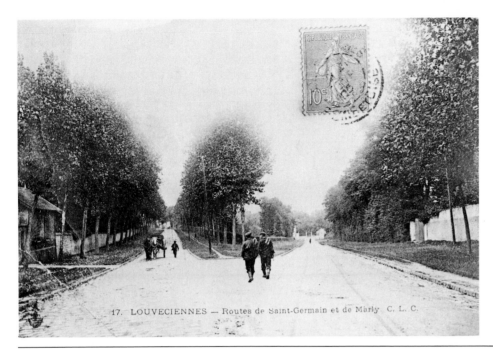

Fig. 1. *Louveciennes—The routes de Saint-Germain and de Marly,* before 1910. Postcard. Private Collection, Louveciennes.

roads appeared early in the nineteenth century, and, by the middle of the 1800s, the network of train lines was so large and complex that it had utterly transformed the nation. The first short line—between Saint-Etienne and Lyon—was inaugurated in 1828, and the first Parisian line (to Saint-Germain-en-Laye) in the mid-1830s. The government made a national commitment to the railroad in 1838 when the Chambre des Députés under François Arago voted to inaugurate separate railroad lines from Paris to Belgium, Le Havre, Bordeaux, Marseille, and Lyon. As the network of private and public train lines increased, a Frenchman could move more quickly, cheaply, and easily from one place to another than ever before. The very accessibility of the countryside made possible by the railroad utterly changed the relationship between urban man and nature. As the century progressed, an increasing percentage of the French people was able to travel, and it became possible for most provincial Frenchmen to visit the capital. Thus the railroad promoted the nationalization of France more than any law, speech, or idea and certainly more than any other mechanical invention.[14]

The landscapes painted by the Impressionists abound in emblems of national order and solidarity reflecting these changes in the landscape of France. Trains, boats, carts, and carriages move easily on roads and rivers. Newly constructed bridges traverse both natural and man-made waterways. Urbanites stroll down country lanes. Peasants carry baskets of produce to market. Factories puff smoke and steam into cloud-filled skies. Fields of wheat ripen in the sun. All this unthreatening richness and serene beauty is presented as if immediately accessible to the viewer; the paintings' titles most often affirm that we are in the presence of a "real" countryside. Paradise—or something very close to it—has been made actual in these pictures. Yet they must be seen not only in terms of the modern aspects of France's nationalism, but also in terms of what might be called the French traditional world.

Among the principal nationalist projects of the French people during the nineteenth century was the rewriting of French history. When viewed from the vantage point of the post-Revolutionary 1800s, France's history could no longer be described strictly as the dynastic chronicle of her kings

and their wars, advisors, and intrigues. Dominated by Jules Michelet, French nineteenth-century historians came increasingly to reinterpret past events as the history of "the nation" and its people.[15] Michelet's own work was a great nationalist project in which the achievements of ordinary men play an enormous role, and in which the French landscape is conceived as a vast natural theater for the actions of her people (see below, III/8).

Yet most French historians were less radical in their aims. For apologists of the old France, both royalists and religious zealots, a study of historical events served to reconnect Frenchmen with their true past, a past which many considered to have been ruptured by the Revolution rather than to have found its climactic moment in that event.[16] It was this essentially reactionary use of history that gave impetus to an extraordinary rise in the study of local chronologies and monuments in France during the nineteenth century. The number of historical societies and local museums rose astronomically during this period. Further, these institutions promoted a notion of *la France historique,* or historical France, that served very clearly as a conceptual framework for contemporary tourism. Pamphlets, guidebooks, and railroad publications were all but obsessed with the monuments of France's past greatness: her châteaus, cathedrals, ruined abbeys, important civic structures, and the like. Most nineteenth-century travel guides were illustrated with plates representing less the landscape than the architecturally—and historically—important locales which gave it significance (fig. 2).

The idea of *la France historique* fueled the fires of the national landscape movement, and countless prints and paintings produced in nineteenth-century France record pre-Revolutionary sites about which one could read easily in various contemporary publications.[17] The depth of the French national chronicle and the endurance of her people are themes alluded to in countless landscape paintings and prints made by artists varying in fame and quality from François Blin to Jean-Baptiste Corot. Indeed, French landscapes painted in the 1800s, but before the Impressionists, indicate an essentially conservative ideology: in them, France survives and continues rather than changes. Aged forests, medieval bridges, cathedrals, and thatched cottages abound in landscapes painted by artists of the Barbizon school (see below, III/1).

When painting the French landscape, the Impressionists explicitly— and persistently—avoided *la France historique*. Not until the 1890s did their landscape paintings feature architectural monuments of any age or significance, and the ecclesiastical structures which dominated so many French towns were often de-emphasized in, or even omitted from, Impressionist paintings of those places. More often than not, Monet, Pissarro, Sisley, and Renoir screened churches behind trees (nos. 13, 19), turned their backs on châteaus, and placed architectural monuments at the very edges of their compositions (nos. 59, 63–64, 69). Their landscapes—nationalist though they may be—must be read in light of these omissions. Their rejection of such subjects has often been interpreted as a reaction against the Romantic subjects of the painters who had dominated the previous generation of French art, and this view is surely correct. Yet one must also see such pictorializing behavior in ideological terms. By rejecting historically important monuments as the central motifs of their landscapes, the Impressionists promoted a self-consciously modern or anti-historical doctrine which suggested that France was a nation that should look forward into the future for her inspiration and not backward at her glorious, if confused, past. One is never reminded that

Blanche of Castille and St. Louis lived in Pontoise during the Middle Ages when one looks at a Pissarro landscape of that town (see below, III/5), although every guidebook written during the nineteenth century dwelled on that very fact. The same applies to Monet's Argenteuil landscapes (nos. 39–43) and to the many paintings made in the historically significant region around the Château de Marly by Pissarro, Sisley and Monet (see below, III/2).

If the Impressionists rejected historical France, they were not so unequivocal in their avoidance of her rural past. While châteaus of the rich—aristocratic or bourgeois—play a minor role in the iconography of Impressionist landscape painting, the modest dwellings of the rural poor are present in quantity, particularly in the work of Pissarro, Cézanne, Gauguin, Armand Guillaumin, and Sisley. (In fact, village scenes with and without figures occur in such abundance that they have been accorded a separate category here [see below, III/5]). When combined with the many hundreds of agricultural landscapes painted by the same artists and by Monet (see below, III/7), they provide evidence of a sustained investigation of the rural landscape that is as rich and significant as was that of Jean-François Millet, Corot, Charles-François Daubigny, and Théodore Rousseau, all Barbizon painters (see below, III/1).

Why did the Impressionists paint so many rural landscapes? The answer is not easy to discover. The tourists and travelers of nineteenth-century France, while not actively discouraged from visiting villages, were given few reasons to do so. In fact, most writers of the time were active in their dislike of traditional rural civilization. Honoré de Balzac, whose novel *Les Paysans* was published in 1846, treated villages and their inhabitants as unremittingly stupid and narrow, and this view persisted in much of French rural fiction of the period, culminating in the publication of Emile Zola's *La Terre* in 1890. The novelist Edmond About, who lived near Pontoise and was a friend of Pissarro, went so far as to call the French village "the last fortress of ignorance and misery."[18] If cities were sophisticated and, with all their corruptions, central to modern experience, villages were squalid and little more than tribal.

There was, of course, another view. What might be called the rural pastorale was not altogether absent from French letters. George Sand wrote many elegiac rural novels, although even she was acutely aware of the great cultural gap that existed between the peasants of France and her modern urban readers.[19] She wrote of the rural world as an antidote to urban civilization, and her view was shared by many writers. A typical popular text by an obscure physician, Dr. J.-B.-F. Descuret, entitled *La Médicine des passions, ou les passions considérées dans leur[s] rapports avec les maladies, les lois et la religion* (1842), was concerned among other subjects with the modern disease of urban ambition. Descuret's cure for this malady was country life, far removed from any city or large town. For him—indeed, for many writers throughout the nineteenth century in France—rural life was healthier and more moral than the life of the city because there were fewer pressures to progress, either financially or socially.[20]

In the midst of this dichotomous view of rural civilization, the Impressionist artists took pains to chart a middle course; their paintings of the traditional rural landscape illustrate neither Balzac nor Sand. In fact, the one major generalization which can be made about Impressionist rural images is that they are resolutely mundane. Absent, for the most part, are the grand moments of the agricultural season, the violent storms followed by delightful

Fig. 2. A. Normand (French), *New Railroad Line from Paris to Dieppe, from Pontoise to Gisors; Section between Pontoise and Gisors,* n.d. Lithograph. Bibliothèque Nationale, Série Topographique, Va95, vol. IV, no. B16871.

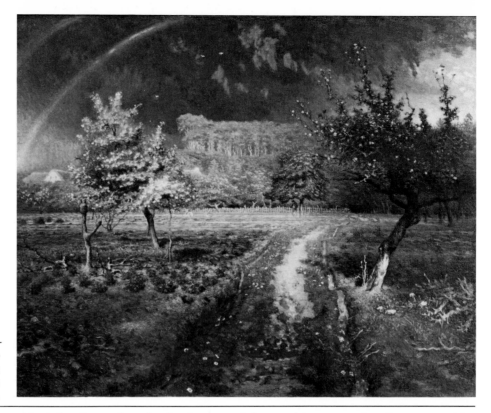

calm, that formed such a basic part of the rural iconography championed by Millet (fig. 3). Instead, the rural landscapes of Pissarro, Gauguin, Guillaumin, and Cézanne are rich in ordinary visual incidents, each patch of cabbages, each pile of faggots, each roughly textured stone wall having been carefully observed and transcribed. The message of these pictures is clear: rural life was continuing to exist even in the modern world. Pissarro's rural workers walk stoically across the railroad tracks in *Railway Crossing at Patis, near Pontoise* (no. 53); Cézanne's *Bend in the Road* (no. 72) represents a village almost outside time.

The ideological underpinnings of this admission of rural life into Impressionist iconography can be understood most easily if contrasted with the notion of *la France historique.* The Impressionists demonstrated a clear preference for what might be called humble history, a history of the people, rather than the institutions, of France. When considered collectively, these paintings suggest a belief in both the essential value of the French population and the fact that the nation's civilization stands upon a rural base. In like fashion, Michelet's *Le Peuple* (1846) is a portrayal of the French people in toto; it begins with an evocation of the peasant going to church on Sunday. Surely the strictly Republican notions of Michelet—and of the Impressionists—accord well with the spirit of revolution in France. As the great modern French geographer Daniel Faucher has said, French history is "a long, accumulated history of our soil." For him,

> France has always been a rural nation and the labors of her fields have given her both equilibrium and prosperity throughout the centuries....Her cities have been the centers of her greatest and most brilliant achievements, but they are nourished by the silent workers of her fields.[21]

Indeed, Impressionist landscapes are virtually always peopled. Whether there are figures lolling in gardens or walking down paths, houses

set confidently in the fields or at the edge of cliffs, the human presence is always felt. We know that an empty field painted by Monet was planted and will be harvested by men (no. 103), and a deserted barnyard rendered by Cézanne is like a stage set before the play has commenced (no. 70). Theirs is most often a psychologically comfortable landscape, and the viewer rarely feels lonely because he is rarely alone.

In this way as well, the Impressionists' landscape—and we might call it a social landscape—is almost everywhere at odds with the landscapes preferred by the Barbizon school. Although there are peasants and vagabonds in paintings by Corot, Narcisse Virgile Diaz de la Peña, and others, they are most often tiny and distant from the viewer, ignorant of his presence. He is—by implication—different from them. And many other landscapes—particularly those of Rousseau—are unpeopled. When in the Barbizon painters' forests, the viewer is far from civilization in a natural world of gnarled trees, rugged rock formations, and deep, hidden pools (fig. 4). Descriptions of these landscapes—particularly by the eloquent critic Théophile Thoré—stress the isolation of the viewer in a silent landscape. Moved by a small picture by Corot, Thoré wrote the following passage:

> It has at first the air of a confused sketch, but presently you feel the air gentle and almost motionless. You plunge into the diaphanous mist which floats over the river and which loses itself far far away in the greenish nuances of the sky at the horizon. You hear the nearly imperceptible noises of this quiet piece of nature, almost the shivering of the leaves or the motion of a fish on the top of the water.[22]

There are very few Impressionist landscapes that could support such a description.

Being alone in the midst of nature was often given pantheistic meanings in nineteenth-century landscape descriptions; the viewer was thought to become a better or more moral person through his contact with isolated nature. He was able to think clearly, to rid himself of petty social concerns and vanities, to restore his spirit. As if in support of this idea, landscape painters like Corot, Daubigny, or Antoine Chintreuil were described as simple, moral people by their earliest biographers, and the time spent alone with nature, far from the haunts and commerce of man, was considered to be the reason for their goodness. In this way, nature was conceived as a world apart from man, as an equivalent, in a sense, of the modern concept of wilderness or virgin nature: the place of God.

The Impressionists had a completely different concept of nature, as can be seen in their writings. They used the word frequently in their letters. To paint "before nature" for an Impressionist painter was *not* to wander for hours until one was alone in a landscape with no hint of the presence of man. Rather, it was to stand squarely in the easily accessible world and to paint it. These artists' idea of nature was the totality of the visible universe, a positivist view in which man and his works were seen as an integral part of a natural whole. Trains, boats, figures, factories, houses, fields, trees, piles of sand, machines—virtually every kind of form visible in the France of their time can be found somewhere in their landscapes. For Thoré, Sand, and many intellectuals of mid-century France, nature was the world apart from man and his corruptions. For the Impressionists, nature was everything one could see.

Thus, in pursuing their own notion of naturalism, the true Impressionists avoided the isolated parts of France. They virtually never painted mountains. They refused to travel far to seek out the "sublime," preferring an inte-

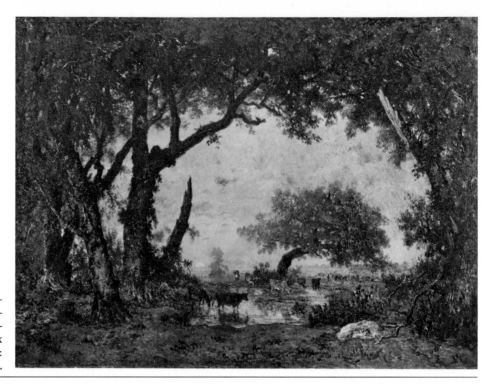

Fig. 4. Théodore Rousseau (French, 1812–1867), *Clearing in the Forest of Fontaine-bleau,* 1848–51. Oil on canvas. 142 x 197 cm. Musée du Louvre, Paris. Photo: Musées Nationaux.

grated, balanced world in which various forms complemented one another. As such, the origins—whether conscious or not—of their landscapes are classical, and again the comparison between the *campagne de Paris* and the Roman Campagna must be made. Like Nicolas Poussin and Claude Lorrain in the seventeenth century, like Pierre-Henri de Valenciennes, Corot, and Jean-Victor Bertin in the late eighteenth and early nineteenth centuries, the Impressionists conceived of the landscape as man's domain. It is no accident that the elderly Pissarro, for example, looked to Claude and the great French tradition as his major sources.[23]

Without doubt the center of modernism in France was Paris. The city not only accepted the industrial world and the future it would bring to humanity, it reveled in it. International exhibitions propagating the strength and inventiveness of French modernism took place in 1855, 1867, 1878, 1889, and 1900, and each embraced technology and its parent, science, as fervently as possible. Trains, tractors, and machines for making clothes, bread, sugar, indeed almost everything, were exhibited and published widely in the popular press, with the result that nineteenth-century Frenchmen knew—or could know—almost as much about what was then new technology as Americans can today.

The will to project into the future and thus to alter man's relationship to his past was an extraordinary feature of French nationalism in the nineteenth century. There is no greater proof of this than the rebuilding of the capital and its suburbs (see below, III/3). Based upon the urban planning projects of Napoleon I, the process of modernizing Paris was a priority of every government in the 1800s, reaching extraordinary heights during the Second Empire (1852–70), when a coherent city plan was created. Vast areas of the old city of Paris were leveled to the ground and rebuilt. People were forced out of neighborhoods which had stood for centuries, and large areas were carved out for new railroads, boulevards, and parks. It is probable that

no other city in history has so totally—and violently—transformed itself in so little time. Indeed, destruction occurred at such a level during the Second Empire that it almost seemed as if the city was at war with itself—as then happened during the Commune. When walking in Paris today, we see the results of these labors—results which seem to us to have been worth all the effort—but we can forget too easily that Paris and its environs were being simultaneously destroyed and rebuilt with immediate human consequences throughout the period of the Impressionists.

The literary work that really exemplifies the modernization of Paris and its suburbs was written by Flaubert's boyhood friend Maxime du Camp. Published in six hefty volumes between 1869 and 1876, just as the Impressionists were codifying their own pictorial attitude toward modern France, the book is entitled *Paris, ses organes, sa fonction, et sa vie dans la seconde moitié du XIX siècle*. Its analysis of the city was so different from that offered by any previous writer that its novelty can scarcely be overemphasized. Most earlier authors had treated Paris as a luxury center, the capital of world culture, of the fine arts, and of the good life. The vast majority of books about the city, whether novels, travel guides, memoirs, or histories, either waxed poetic about its monuments, restaurants, entertainments, and shops or condemned it for its profound, if luxurious, decadence. If the *campagne de Paris* was conceived of as a classical landscape, the Rome most often equated with Paris was Rome just before the advance of the barbarians. Du Camp reversed all this with a book which tells the reader how the city worked and about its systems of transport, sewage, telegraphic communication, post, canals, markets, and so on. The city for Du Camp was an enormous, quasi-organic machine which functioned because of the logic of its various organs and systems of exchange. Its history was of little interest to him—it had already been written, he thought—and its culture less something willed by its people than the direct result of the conditions of life imposed upon these inhabitants by the machine of the city itself. If Napoleon III and his minister Baron Georges-Eugène Haussmann had attempted to rebuild Paris more or less from the ground up, Du Camp was their unofficial apologist in prose. For him, a city that worked properly was worth all the pain and destruction necessary to make it function efficiently.

What is fascinating about the paintings of Paris and its local and surrounding landscapes by the Impressionists is that, while we see the positive results of Baron Haussmann's labors, we very rarely see the destruction that led to them. Manet painted vacant lots on the rue Mosnier, Pissarro a construction site near Louveciennes, and Monet a bridge in Argenteuil being reconstructed after the Franco-Prussian War. Yet these paintings are remarkable chiefly because they are so rare in oeuvres which are among the largest in the history of art. More often than not, we see the new world of trains, straight roads, boulevards, boats, parks, fields, and factories as if these forms had always been in the landscape. There are few scars on the earth, few wounds of newness to be seen. Again, the selectivity of the Impressionist vision must be remarked upon. It should be clear that Impressionism can be interpreted essentially as a healing art, an art which accepted the modern world easily and gracefully, as if rejecting, paradoxically, its very newness.

Perhaps the most important modernizing change that occurred in the nineteenth century and that affected landscape painting was the widespread increase in travel. Although an important percentage of this travel can be called tourism and related to the mapping of France and building of rail-

roads, as we have seen, as well as to a general increase in the amount of leisure time made available to working people, a great deal of the movement that took place throughout the country—especially into and out of Paris—was commercial. The extraordinary increase in barge traffic changed the character of the Seine dramatically, and large train yards were constructed in the capital and its major industrial suburbs for the loading and unloading of livestock, machine tools, food, clothing, and any other goods coming in and out of the city.

Commercial travel—the movement of goods and services—was more often pictured by the Impressionist artists and their friends than is commonly supposed, but less railroad than barge transport, particularly along the Seine. Pissarro, Cézanne, Sisley, Guillaumin, and Monet followed the leads of Johann Barthold Jongkind, Daubigny, and others who painted the industrial ports of Paris, particularly the Quai de Bercy in the eastern part of the city, as well as the port at Rouen and the immense channel ports of Le Havre and Douai. Pissarro even painted the *péniches,* or barges, that moved to and fro on the smaller Oise, which ran between the Seine and the system of canals in the industrially prosperous north of France. The motorized *guêpes à vapeur,* or tugboats, and the barges seen in many Impressionist paintings of the industrial sections of the Seine were common sights on the river. If one wanted to create an exhibition devoted to shipping and river transport in France during the second half of the nineteenth century, one could do it with paintings by the Impressionists alone.

Yet the kind of travel that is most important for an understanding of Impressionism is tourism. It is curious—and unfortunate—that a major history of tourism in France has never been written, in spite of the vast bibliography and the huge mass of archival material available to researchers. One slim book, Gilbert Sigaux's *Histoire de tourisme* (1965), makes a stab at this topic, which lies at the heart of Impressionism. The most valuable recent study of tourism, *The Tourist* by Dean MacCannell (1976), analyzes this phenomenon and its effects on human behavior as the key to an understanding of modernism and its peculiar forms of consciousness. The organization of leisure time away from home, the sightseeing of the tourist (fig. 5), has been brilliantly analyzed by MacCannell, and his identification of the tourist as the Everyman of modern culture lends even greater credence to the notion that the tourist-based landscape of Impressionism has a modernist/populist iconography.

Tourism in France had existed for centuries before the railroad, and the excellence of the French highways was noticed often by eighteenth-century English tourists, many of whom drove through France on their way to Italy as part of the Grand Tour. The first widely accessible tourist guide available to such people was written by a German named Hans Ottokar Reichard and published in French in 1793. Entitled *Guide des voyageurs en Europe,* this book was filled with practical information about inns, roads, restaurants, and routes and assumed that the tourist would see what he wanted and ask the necessary questions about local sights of the natives. It was, in fact, the peasants in their local costumes who were the principal curiosities for late-eighteenth-century travelers, and Reichard's guide was illustrated with plates of picturesque individuals in regionally varied finery.

Reichard's book was the beginning of a flood of literature, some of which was similarly narrow in focus, but a great deal more of which gave out information about local history, sights, side trips, population statistics, art

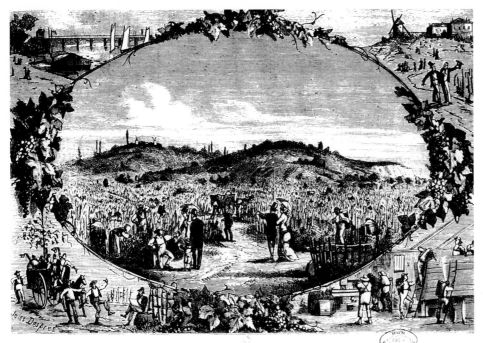

Les Vendanges d'Argenteuil
Dessin de Ch. Després — Voir l'article, page 339

Fig. 5. Jules Després (French), *Gathering the Grapes at Argenteuil*, n.d. Lithograph from *L'Illustration*, 1877, p. 337. Bibliothèque Nationale, Série Topographique, Va95, vol. I, no. B16056.

history, and the like. By the middle of the nineteenth century, tourist guides had become so bulky and so filled with densely printed prose that they resembled almanacs or encyclopedias more than the handy pocket guides envisioned by Reichard. The informed tourist, guidebook in hand, became a standard feature in France and much of the rest of Europe during this period. When we look at landscape paintings produced at the time, we must never forget that they were painted by men and women who must be thought of as tourists, armed with information about everything they saw.

The landscape the Impressionists visited and painted ran along the English Channel from Deauville to Etretat, down the Seine from Le Havre to Paris and out again along the train route into the environs of the capital (maps 1–2, 4). This landscape was a discovery of the nineteenth-century tourist; many of the small towns, villages, and hamlets on the beach, along the Seine, or in the Ile de France sported hotels, inns, and restaurants, most of which were built and opened in the 1800s especially for such visitors. In fact, the area was almost a tired one by the 1860s and '70s, when the Impressionists began to paint it in earnest.[24] Pissarro, on visiting Rouen in 1883, was struck by the number of views of this small provincial capital that had already been painted, drawn, and printed by earlier artists and was aware of the fact that his own renderings inevitably would be compared with the familiar prints by and after such artists as Richard Parkes Bonnington and J. M. W. Turner.[25]

Due to the enormous advances in mass-produced printmaking, the number of illustrated publications increased dramatically in the nineteenth century, and, for the first time in the history of Western man, a large percentage of the population was what we today call visually literate. Many mass-produced images were travel views (fig. 6), and a considerable number of French artists made their living as travel illustrators. The drawings they made

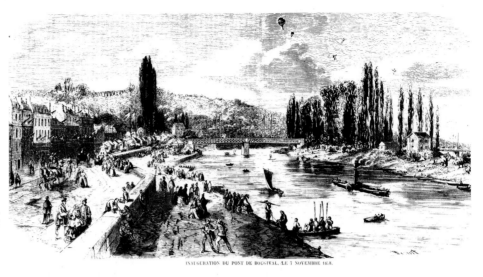

Fig. 6. Provost (French), *The Inauguration of the Bougival Bridge, November 7, 1858*, n.d. Lithograph. Bibliothèque Nationale, Série Topographique, Va78, vol. I, no. B6763.

were most often rapidly executed notations which were turned into finished views with standard buildings and figures by professional printmakers in Paris, with the result that such illustrations tended to have a suspicious sameness of appearance. Yet, in spite of their relative inaccuracies, these popular topographical prints existed in such quantity that virtually every person in France was aware of the look of the rest of the country.

If the artists who illustrated travel books were, with certain notable exceptions, untalented, the men and women who wrote the texts for such publications were considerably more gifted as a group. Writers from Stendhal, who published *Mémoires d'un touriste* in 1838, to Jules Claretie and Victorien Sardou wrote brilliant descriptive analyses of the towns, landscapes, villages, and rivers of the north of France. The landscape descriptions written by the great masters of French realist fiction during this period were not only widely accessible, but of superb quality.[26] Essays in mass-circulation journals as well as separately produced travel guides included discussions of the beauties of landscapes, the "meanings" of rivers, and the poetics of hamlets. Authors, many of incredible refinement, tested their sensibilities *en face de la motif,* directly confronting their subjects almost as if they were painters. Indeed, they wrote much better prose about actual landscapes than about landscape paintings, and the literature produced for tourists tends, in general, to be more interesting to read today than contemporary art criticism. There are countless passages in which the writer urges painters to depict a particular landscape. Hence the artist acted as an alter ego or extension of the tourist. One anonymous author of the *Guide de voyageur sur les bateaux à vapeur de Paris àu Havre* (c. 1865) exhorted the painters of France to travel the Seine, there to discover "all these delicious landscapes, all these islands, all these cliffs."[27] On occasion the coincidence between a descriptive text in a guidebook and an Impressionist painting is so close that one can scarcely believe that the painter had not read the guide. While many earlier landscape painters had considered themselves to be hermits, vagabonds, or itinerants, then, the Impressionists adopted the persona of the tourist.

The effects of tourist travel were widely debated during the Impressionist period. In 1876, for example, the year of the second Impressionist exhibition, a modest young painter named Emile Michel gave a lecture to the Académie Stanislas with the rather grand title "Du paysage et du sentiment

de la nature à notre époque." Although not particularly novel, his thesis was clearly defined: that modern, urban man, living in crowded and changing conditions far from his rural origins, needed frequent periods of rest in the country and that landscape painting could provide temporary relief for the desperate urbanite. Michel was acutely conscious of the fact that modern France—in what he called "our age"—was very different from historical France. Most of these differences he lamented; he detested technology and the resulting material progress of man, whom he called "a docile servant of machines."[28] Yet he was more willing than most conservative critics to understand that nature and country life helped to restore an equilibrium to industrial man, and he correctly interpreted the rise of both rural tourism and landscape painting as a direct result of the changes wrought on society by industrialism and urban modernism.

Michel saw the countryside painted by the Impressionists—about whom he did not know in 1876—as a hideous, modern countryside, and he wrote of Paris as a great animal devouring nature. It is certainly no accident that virtually every "ruined" landscape he mentioned was painted by the Impressionists: the coasts destroyed by beach towns, the fields scarred by train tracks, and the suburbs polluted by factories. By comparing Michel's prose and Monet's paintings, one can see instantly that where the former hated modernism and retreated to the unspoiled countryside near the forest of Fontainebleau to escape it, the latter accepted it with utter equanimity. For Michel, tourism was an element of modernism to be feared, though he acknowledged the necessity of escape from the city; for Monet, tourism was an essential way of life. A day in the country—boating, eating, walking, reading, or just sitting—was a profoundly social experience for Monet and his colleagues. We have already referred to the populated world of the Impressionists, and we can see now that it was most often populated with the tourists despised by reactionaries like Michel.

By the middle of the nineteenth century there were almost as many kinds of temporary visitors to the countryside as there were natives. The urban elite, whether aristocrats manqué or bourgeois, kept large country establishments and lived, or attempted to live, like grand seigneurs, surrounded by servants, tenants, sharecroppers, and whatever other subservient populations they could afford or control. Others, middle-class people, built small country properties, which they used on weekends and for summer vacations.[29] In fact, the huge increase in the construction of country residences during this period went hand in hand with a rise in private gardening (see below, III/6). Whether one possessed an enormous "park," as did Monet's friends and patrons the Hoschedés, or rented a small country property with an enclosed garden, as did Monet, Pissarro, and Manet, the cultivation of an ornamental flower garden was a priority. Books and magazines devoted to private gardening were produced throughout the period of the Impressionists. Some, like the *Almanach du jardinier amateur,* which commenced publication in 1870, catered to a middle-class audience, while others, like the luxurious *Albums du paysagiste pour l'arrangement des parcs et des jardins* (1875), were written for the rich. This literature served to guide the Parisian in his creation of a temporary garden landscape for enjoyment on weekends and during the summer months. Here, too, the Impressionists followed the lead of what one might call the tourist class.

Yet for the vast majority of urban petit bourgeois or working-class Frenchmen the country was accessible only for short periods of time. One

could rent a small property for a week or a month, stay in a hotel for a weekend, or, most commonly, go to the country for a single day. This latter activity, charming and easy as it might appear in the paintings of the Impressionists, was not very socially elevating. Indeed, the day trips of many of the more lowly characters in French Realist and naturalist novels figure significantly in such narratives. Rural tourism came to be considered a social equalizer.

Tourism became even easier and cheaper as the century continued and the number of train lines increased. With greater competition among the various private firms offering transport, fares were lowered, and people of very limited means could easily afford a day trip out of Paris by the middle of the Second Empire. Indeed, statistics indicate that the 1850s were the great decade of railroad construction in the environs of Paris, and conventional trains were joined by such inventions as the *omnibus américain,* or horse-drawn trolley (fig. 37), and other rail vehicles. Many of the private and semiprivate rail lines produced their own promotional material, and an entire species of travel literature arose to appeal to their newly defined clientele (see below, III/4).

Perhaps the most important item of this new genre was the series of guides called *Les Chemins de fer illustrés.* Produced for mass circulation, the guides cost as little as 25 centimes and could be purchased either singly or in sets. Each guide consisted of a four- to eight-page booklet covering a single train line (Paris to Argenteuil, Paris to Pontoise, or Paris to Fontainebleau, for example). Each included a linear rail map marked with the major roads near the stations and a text describing the railroad line itself, its history, and its construction, as well as the major sites to be seen from it. The text also alerted the tourist to the beautiful rural walks and historical sites one could see after leaving the train and mentioned restaurants and inns, where appropriate.

Les Chemins de fer illustrés appeared twice a month beginning in 1858, and many celebrated authors, including Alexandre Dumas *fils* and Claretie, wrote for it. It inaugurated a type of publication that was widely copied by private railroads and transport companies. Many promotional schemes rather like those used to lure people onto airplanes today also were widespread in the nineteenth century. Tourists could take advantage of such special arrangements as group or weekend rates, tickets with unlimited use for short periods of time, and the like, and ordinary Frenchmen came increasingly to see the world through the eyes of the writers hired by *Les Chemins de fer illustrés* and its competitors.

The first important general guidebook to the environs of Paris was written by the greatest nineteenth-century popular travel writer in French, Adolphe Joanne. His guidebook *Les Environs de Paris illustrés,* organized on the basis of the newly developed railroad lines, was first published in 1856 and appeared in numerous later editions before being substantially rewritten and enlarged in 1872. If there is one book that proposed to systematize French tourism in the period of Impressionism, it was Joanne's guide. Written in clipped, efficient prose, his book tells the tourist about everything from village fairs to local eateries. It urges the intrepid traveler to take rural walks, describing how long they will take and the major sites to be seen. It talks about ruined abbeys, beautiful views, neglected public gardens, and hidden hamlets. It includes complete schedules of train arrival and departure times and of fares. So full of information is Joanne's guide that it would require a lifetime to complete the many diverse tours it describes.

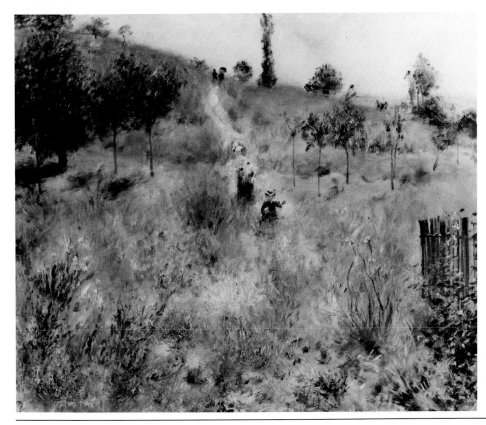

What is fascinating about this book—and many others written before and after it—is that rural tourism was presented to their readers almost as a gourmet is presented with a wonderful dinner for consideration. There were the "main courses," major sites like Versailles or the view of Paris from Le Nôtre's terraces at Saint-Germain-en-Laye. Yet a perfect day in the country required visual hors d'oeuvres and desserts as well, and Joanne provided the tourist with suggestions for delightful promenades that would take him away from the "significant" monuments. Nothing was too humble to be examined by Joanne; he led Parisians up steep hillsides in anticipation of noteworthy vistas or through narrow rural paths to catch glimpses of grand châteaus.

Joanne's landscape—and the landscape of all writers and illustrators of French tourist literature—was a quintessentially public landscape. The tourist—whether on a train or a country path—was traversing a landscape which belonged, in a sense, to *every* Frenchman. Although this does not seem remarkable to us today, one must remember that travel was not only cumbersome and difficult before the middle of the 1800s, but that it also required passports and identity papers. Absolutely free movement for people of all social classes throughout the landscape (fig. 7) was something essentially new in this period. The fact that the French conquered their own countryside as tourists and landscape painters with such determination demonstrates the extent of their pleasure in this new freedom. Additional obstacles in their way were the travel restrictions imposed upon them during the Franco-Prussian War and the Commune. These factors must be remembered when we look at the delightfully accessible landscapes of the Impressionists or read the enticing prose of the guide literature which calls us out into the country.

The freedom to go where one wanted, to wear what one wanted, to

eat out-of-doors, to be seen with whomever one wished—all these freedoms were extolled time after time in travel literature. If the idea of an entire life spent in a provincial town or county seat has been considered a form of self-imposed imprisonment by French writers since Balzac, a day or even a month in the country, spent in the company of one's dearest friends from Paris, has been treated with considerably greater enthusiasm. Flaubert celebrated the charming, if temporary, glories of the publisher Jacques Arnoux's country residence in the Parisian suburb of Saint-Cloud in *L'Education sentimentale* (1869), but disparaged the charms of the provincial hometown of his hero. If one felt confined in the tightly ordered provincial society of Nogent, one could be truly liberated in the transplanted urban society of Saint-Cloud.

These freedoms of a country tourist were not universally admired, however. Indeed, the countryside frequented by urban visitors came increasingly to be seen as a place of sexual license, immorality, and intrigue. One travel writer, Emmanuel Ducros, in a charming book called *Chemin de fer* (1884), described with great care and subtlety the processes of seduction that took place in a train compartment, quoting a delightful song about a "conversation with the eyes" that took place in a one such "padded cell." And the ever-moral Guy de Maupassant wrote scathingly in his novel *La Femme de Paul* (1880) about the goings-on, sexual and financial, at the popular restaurant in Bougival painted by virtually every one of the Impressionists, La Grenouillère (The Frogpond) (no. 14). Such literary passages were not at all rare during the second half of the nineteenth century and contrasted in every way with the notion of the countryside as a place of moral rejuvenation that was equally common during the period. The fact that Zola set the dramatic murder from his first major novel, *Thérèse Raquin* (1867), not in Paris, where the characters lived, but in the countryside, tells us a great deal about the actuality of vice imported to the suburbs. One writer of the time went so far as to say that the railroad and rural tourism had ruined the basic fabric of French society by weakening the bonds of regional and family life.[30] As we have seen, this negative view of the countryside, common enough in literature, is rare in Impressionist painting.

Although the connections between painting and the railroad are manifold and fascinating, strangely enough there is not a single major book or essay which deals clearly and specifically with these issues. Perhaps the most amusing—and, in a sense, important—discussion of trains and art in nineteenth-century France takes place in a satire by Etienne Baudry illustrated by Gustave Courbet and called *Le Camp des bourgeois* (1868). In a chapter entitled "Le Destinée de l'art" a group of fictitious characters discusses the problem of the placement of works of art in a modern, urban world. Their major contention is that the bourgeoisie cares little for its aesthetic property and that modern, urban man has less and less time to go to museums (an observation that has turned out not to be true!). The solution to this apparent conundrum is proposed by Courbet himself: to place works of art in train stations, which will become not only "temples of progress," but also "temples of art."[31] He recommends filling the huge, empty walls of waiting rooms with paintings that will instruct or educate the mass audience which comes there rather than to museums. For Baudry, the train had so utterly altered the modern world that it was necessary for artists to reconsider the relationship between their works and the new public defined by mass transit.

If Baudry wrote about the train station as the new temple of art, other writers were obsessed with the effect of rail travel upon the human body and

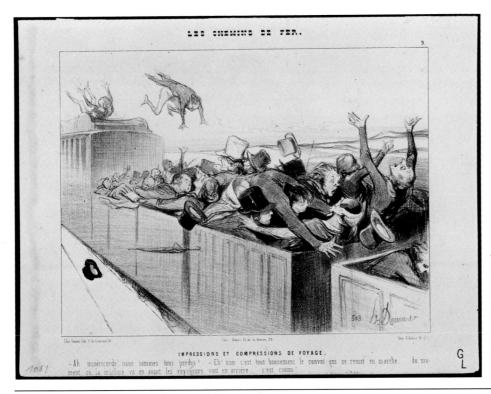

Fig. 8. Honoré Daumier (French, 1808–1879), *Impressions and Compressions of Travel* ("Ah, misericordia, we are all lost!" "Eh! It's simply the train starting up again…as soon as the machine goes forward, the passengers go backward…everyone knows that!…"). Lithograph from *The Railroads,* 1853, pl. 9 (first state). Armand Hammer Foundation. Photo: Armand Hammer Foundation.

its senses. While the volume of written evidence about the effect of speed on man is vast, two recent books, Marc Baroli's *Le Train dans la littérature française* (1969) and Wolfgang Schivelbusch's *Railway Journey* (1979), treat the subject admirably. It was clear to early railway passengers that the physical conditions of the railroad car as well as the speed and linearity of railway travel affected one's perception of the countryside and one's state of mind. The Goncourt brothers wrote in a fascinating manner of the vision of a rail passenger as a series of sensations/images/impressions perceived in rapid succession by an individual viewer who was forced into a continuum of time and space by the train itself.[32] Speed, it was thought, changed one's relationship to place and to the landscape as a world of substance through which one could move and which one could touch (fig. 8).

There are countless passages in contemporary travel guides that develop in specific contexts this idea of the dislocation of time in space produced by railway travel. Louis Barron, who traveled in the Ile de France in the 1880s and published his book *Les Environs de Paris* in 1886, made frequent mention of the contrast between one's perception of a place from a moving train and that obtained from a stationary or pedestrian viewpoint. As he crossed the Oise River on a train heading for Pissarro's town of Pontoise, for example, he made that contrast explicit: "One perceives a rapid and striking vision of a gothic, indeed almost oriental, city, and that image evaporates as the train stops at the totally modern edge of a small provincial town. What a strange contrast!"[33] The train's rapid motion allowed Barron to create in his imagination an image, which, while derived from the facts of the landscape, was not true to it. As is clear from this particular description, the town of Pontoise seen from the train was considerably more interesting than the town seen from within.

Claretie, in his book *Voyage d'un Parisien* (1865), wrote of the rela-

tionship between the way in which a landscape was perceived from the train and the way in which a landscape painter treated nature.

> Let us not disparage the straight line; it has its own particular charm. The countryside when perceived from the track of a train looks like it would if painted by an artist who proceeds, as did the great masters, to let us see only the large masses. Don't ask him for details, but for the whole ensemble in which there is life.[34]

The countryside seen from the window of a train, for Claretie and many other writers, was an artistic countryside, then, lacking the stray details that would distract from what he called the "ensemble" of a landscape. His readers, simply by taking a train outside Paris, could "see" like artists.

The fact that texts of this type were so common in this period must not be forgotten in a consideration of French landscape painting. Artists also rode the trains in and out of Paris, as we have seen, and it is highly unlikely that they were unaware of the many allusions to train travel and painting made in the popular literature. To say that this material influenced them is perhaps too strong. It is correct, however, to point out the affinities between the view of the countryside reported by train travelers and the paintings by their contemporaries, the Impressionists. The landscapes painted by these artists in which trains puff away in the distance must have had two possible meanings to contemporary train riders. First, the train acted as an emblem of, or symbol for, the modern world of tourism. Second, the viewer was reminded of the conditions of perception that occurred while riding a train.

This last point is important because it raises the issue of the train as a symbol of progress, modernity, and change. Zola, in his novel *La Bête humaine* (1890), made the train itself (the "human beast") the "hero" of his novel. Zola's human characters fed, fixed, and ran the beast, giving their lives over to its rhythms, its moods, its demands. The Impressionists, particularly Monet, were clearly susceptible to the train's iconological power. Indeed, the latter's paintings of the 1870s, culminating in the great series of paintings of 1877–78 representing the interior of the first Gare Saint-Lazare (nos. 30–32), served as a major source for Zola's later prose (see below, III/3–4).

It is interesting and not irrelevant to point out that the great anarchist-philosopher Pierre-Joseph Proudhon, in his posthumously published book *Du Principe de l'art et de sa destination sociale* (1865), realized that machines themselves must enter the realm of art and suggested that motors be represented as perfectly and completely as possible. He called for a proper representation of the railroad train with the following words:

> In the locomotive, the motor is contained in the apparatus that puts it into motion; it is that condition which gives to the machine its formidable appearance and makes it truly representative of all machines. It is itself in every sense: its gigantic proportions, its roaring and its effect of panting, the smells of its furnace, its speed....[35]

Although many photographers and illustrators worked to record the train as the symbol of the two conditions of life thought essential to modernity—speed and change—few important painters except Monet accepted such a challenge (see below, III/3–4).

The words "speed" and "change" occur over and over again in French writing, both popular and self-consciously literary, of the nineteenth century. Attitudes toward these seemingly inevitable conditions of modern life were predictably varied. The very frequency of their use together with the fact that many writers worried about the velocity of change indicates that concern

A DAY IN THE COUNTRY

over modernity and its ramifications was almost universal. Whether one embraced it, as did Monet and Zola, or looked at it with jaundiced eyes, as did Pissarro and Flaubert, the modern, urban world, the world of progress, seemed to be moving forward at a rapid and uncontrollable rate. The Impressionists painted many aspects of that world, surely knowing, as literate, if not highly educated, Frenchmen, that they lived on the cusp of time. Their paintings indicate to us that they kept one foot on each side of what seemed then to be the moment of transition between history and contemporaneity, between a world whose patterns were clearly defined and one through which one moved by instinct, unsure of the future. If their paintings project a certain air of complacency, almost an inevitability, this quality was achieved with difficulty, indeed was wrung from a landscape in transition. In fact, when Impressionist pictures are considered in the context of their time, the conceptual or philosophical confusion of nineteenth-century Frenchmen seems perhaps to be the clearest signal to us from a landscape in transition that was really not so different from our own.

<div align="right">—R. B.</div>

NOTES

1. Castagnary, 1869, pp. 3–4.
2. Snyder, 1964, p. 9.
3. See Castagnary, 1869.
4. Lecarpentier, 1817, p. 25.
5. Bloch, 1971, p. 15.
6. Bloch, 1912–13, p. 325.
7. Snyder, 1964, pp. 9–116.
8. See Gellner, 1983.
9. K. Varnedoe, work in progress.
10. Zeldin, 1977, pp. 3–85.
11. Ibid., pp. 3–21.
12. See Gravier, 1942.
13. V. Scully, work in progress.
14. See A. Joanne, 1859.
15. Kohn, 1975, pp. 46–75.
16. Brettell, 1977, pp. 28–38.
17. See Worcester Art Museum and The American Federation of Arts, 1982.
18. About, 1864, p. 155.
19. See particularly her introduction to *François le champi* (1846).
20. Zeldin, 1973, p. 91.
21. Faucher, 1962, p. 181.
22. Thomson, 1891, p. 29.
23. Pissarro, 1950, p. 500.
24. See Worcester Art Museum and The American Federation of Arts, 1982.
25. Brettell and Lloyd, 1980, pp. 33–36.
26. See Bart, 1956; Poinet, 1916.
27. *Guide de voyageur...*, c. 1865, p. 1.
28. Michel, 1876, p. 15.
29. See Daly, 1864–72.
30. Giffard, 1887, p. 314.
31. Baudry, 1868, p. 289.
32. See Baroli, 1969.
33. Barron, 1886, p. 565.
34. Claretie, 1865, p. 316.
35. See Proudhon, 1865.

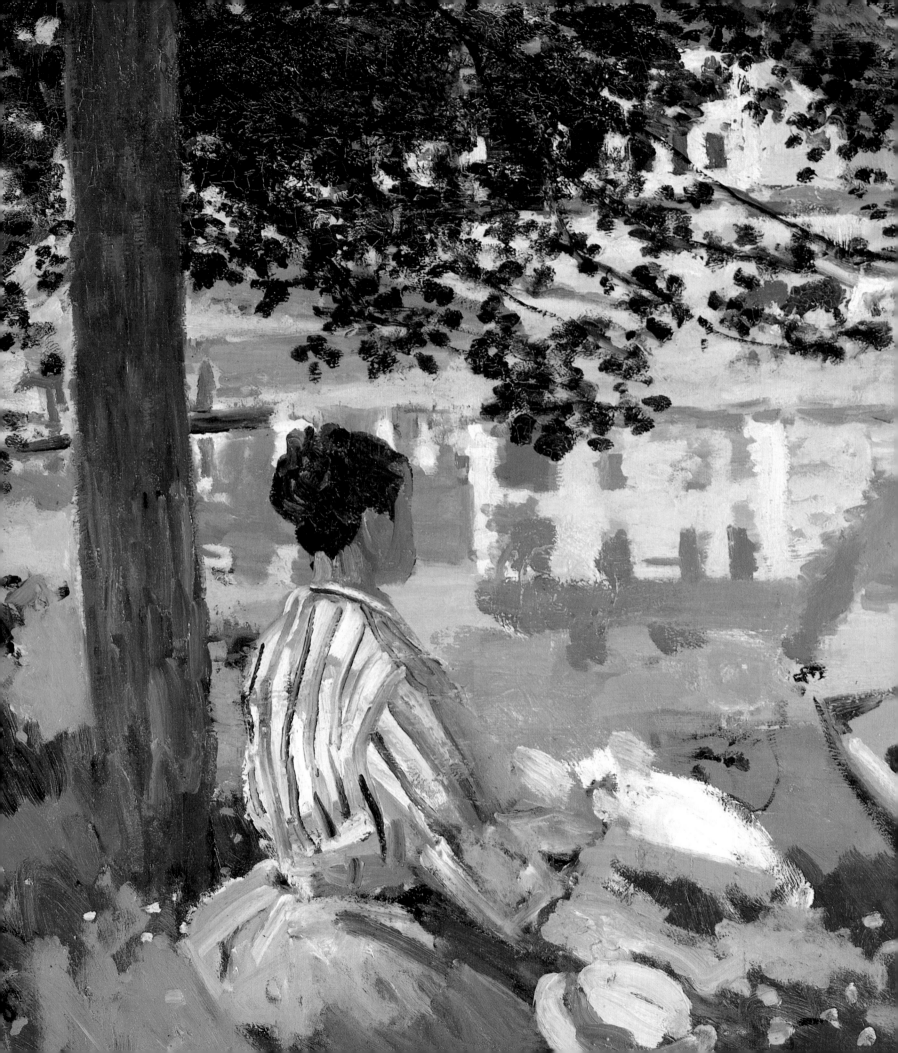

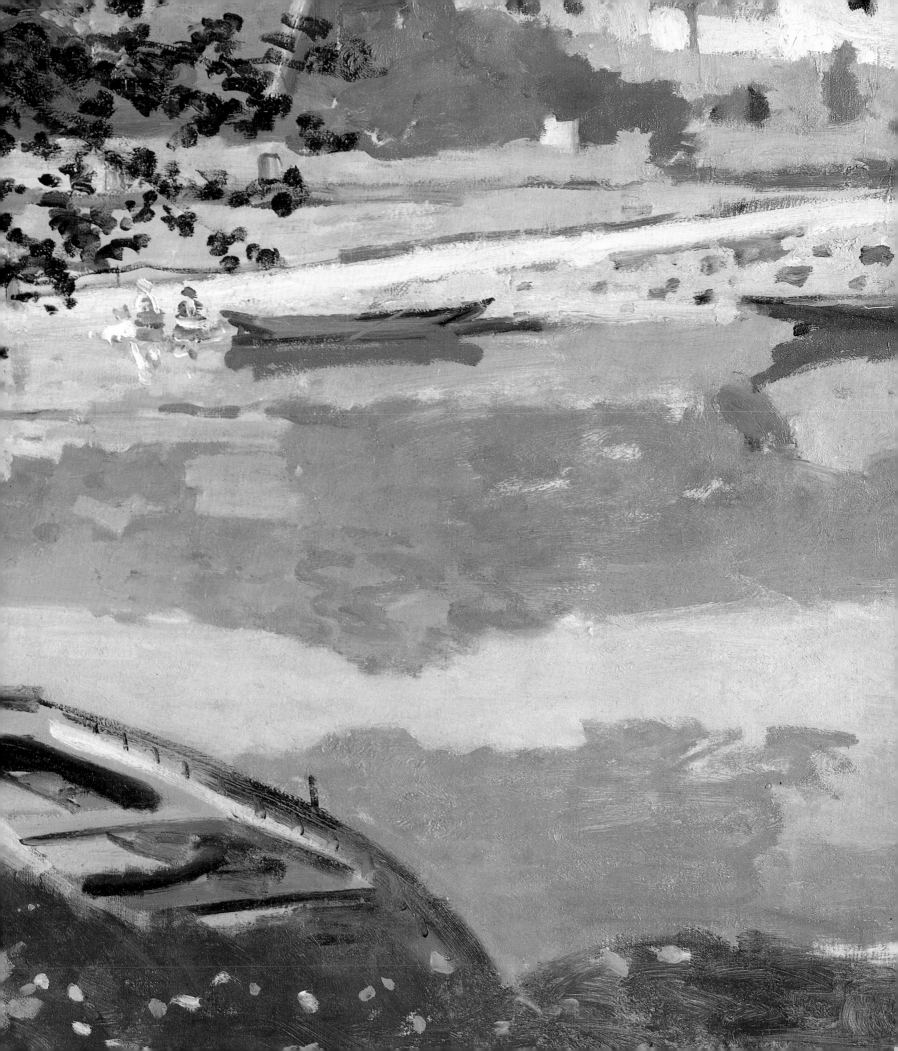

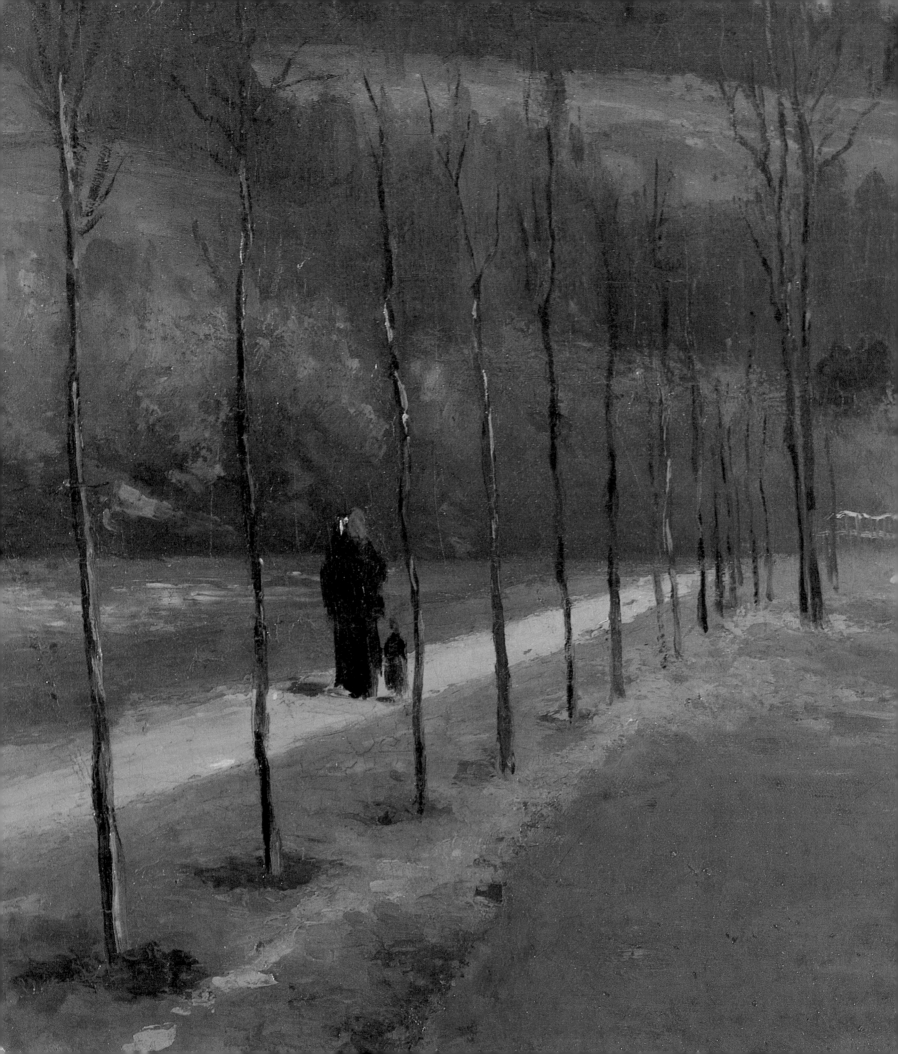

III / I

The French Landscape Sensibility

IN THE OPENING DECADES of the nineteenth century, landscape painting underwent a long, difficult, and bloodless revolution. This process eventually led to the development of Impressionism, which, as we have seen, actually had roots deep within the tradition of French landscape painting (see above, II). In 1800 and 1818, respectively, the painter Valenciennes and his student Jean-Baptiste Deperthes had written valuable theoretical and practical treatises on landscape in an attempt to raise this genre from its then rather lowly position within the artistic hierarchy of acceptable subject matter. This was not too difficult, in fact, since other types of pictures—specifically, history paintings—had become arcane and difficult to decipher. As a result, well before the Impressionists began to paint, landscape, because of its relative ease of comprehension as well as its scale and attractiveness, had become a desirable commodity. The theoretical interest in it, combined with a demand on the part of a new and ever-increasing audience for art, provided the necessary basis for its popularity.

By the mid-1830s, landscape so dominated other painting genres that the influential periodical *L'Artiste* could proclaim with confidence that "landscape is truly the painting genre of our time."[1] By the '50s, landscape painting had become the second-most-purchased type of art acquired by the State. In his review of the Salon of 1857 Castagnary cited the decline of history painting in favor of landscape with some pleasure, for he felt, along with many others, that it was *the* most important subject of art.[2] It is clear from the number of landscapes produced, exhibited, and sold that Castagnary had his finger on the pulse of his time. Although the Ecole des Beaux-Arts continued its vain attempt to resuscitate the failing body of history painting, by the 1870s the Barbizon painters had been so successful that the fledgling artists who later were to become the Impressionists could look to them to inspire hope for similar pecuniary results (see below, IV).

Fig. 9. Nicolas-Antoine Taunay (French, 1755–1830), *Landscape with an Aqueduct,* 1810. Oil on canvas. 45.7 x 53.3 cm. Los Angeles County Museum of Art. Photo: LACMA.

As early as the seventeenth century, French theorists and critics had divided landscape into two sub-categories. The more acceptable to the Académie des Beaux-Arts and to wealthy patrons of this period was the "heroic" landscape, which depicted a specific event and thus demonstrated the erudition of the artist as well as (and perhaps more importantly) that of the buyer. The other category, which had a considerably longer and stronger life span, was the "rural" landscape, which merely illustrated a scene discovered by the artist in nature, and which was intended in turn to stimulate an emotional response similar to his on the part of the viewer. In the eighteenth and early nineteenth centuries the heroic or historical landscape in the grand manner as conceived by Claude and Gaspard Dughet was raised to a position of preeminence. This does not mean, of course, that other types of landscape were not pursued. In fact, by 1850 the rural type had come to dominate the field.

The subject of a landscape, then, was of the utmost importance. It affected the place of an artist's work in the Academic hierarchy and determined the final appearance of a painting. According to Roger de Piles' *Course de peinture par principes* (1708), a forerunner of Valenciennes' and Deperthes' texts, the two different strains of landscape required by their natures different qualities of finish. The heroic, being the more important, had to be worked up to a high degree of completion, resulting in an extremely polished, smooth surface (fig. 9). The rural landscape, being of lesser importance, did not require this level of finish, but could maintain instead a sketchier, more lively appearance, rather like that of a preparatory *modèle,* or sketch. It was this lack of finish in rural landscapes as well as the conception behind them that proved attractive to later generations of painters and theorists. Interestingly enough, it was the rough surface of Impressionist paintings that most provoked the ire of contemporary critics, however (see below, IV).

Valenciennes' 1800 text, entitled *Eléments de perspective pratique,* os-

Fig. 10. J.-B.-C. Corot (French, 1796–1875), *Seine and Old Bridge at Limay,* c. 1870. Oil on canvas. 40.7 x 66 cm. Los Angeles County Museum of Art. Photo: LACMA.

sified this bifurcated response to landscape and was adopted instantly as a handbook for landscape painters throughout the nineteenth century. In fact, even Pissarro recommended the book to his son as a guide to the fundamentals of painting. Although this may not have been the only inspiration for French artists' choice of sites to paint, it is nonetheless significant that it was Valenciennes who suggested that they search river banks, in France instead of in Italy (he mentions the Seine and Oise by name), as well as the forest of Fontainebleau, for new motifs to inspire different visual effects. In such locales, he said, the artist could capture his own emotional response to virgin landscape in sketches made *en plein air,* out-of-doors at the site. It was understood, of course, that such sketches were to be thought of only as studies for use later in working up larger paintings, which were finished in the studio. Deperthes, Valenciennes' student, reiterated these ideas in his 1818 book, *Théorie du paysage.*

In the end, it was Deperthes, along with Marcel Guérin; Antoine-Chrysostome Quatremère de Quincy, Secrétaire perpetuel de l'académie; Comte de Vaublanc, Ministre de l'intérieure et de la décentralisation; and others who were influential in having the Académie institute a Prix de Rome for landscape painting in 1817. Although it was awarded only every four years and was granted exclusively in the category of heroic or historical landscape, those whose concern had been the elevation of the lowly genre of landscape painting felt that they had succeeded, and in no small measure. The very first Prix de Rome in this category was awarded to Achille-Etna Michallon for his 1817 *Democritus and the Abderitans* (Ecole des Beaux-Arts, Paris), whose title places it squarely in the category of heroic landscape. The Académie, no doubt, felt secure that this new prize assured a continuity with the moral-minded subjects of the other awards. This concern becomes more comprehensible when one sees it in the context of the contemporary historical situation. The Salon of 1817 was the first to follow the restoration

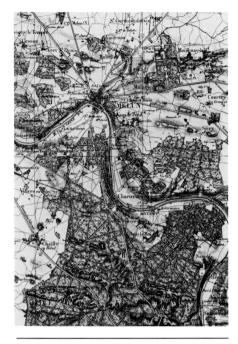

Map 3. Melun and the Forest of Fontainebleau.

of the Bourbons under Louis XVIII. More than anything else there was a conscious attempt on the part of the newly reinstalled monarchy to weave back together the great traditions of French history and art, which had been rent apart since the Revolution. Ignoring the sociological as well as the artistic changes which had occurred in the 28 years since 1789, the official artistic community sought to encourage the earlier tradition of historical landscape.

Deperthes' belief that landscape, and most particularly rural landscape, would attract those who were uneducated, who responded emotionally and not intellectually, may have made the political and artistic arbiters of the Second Empire apprehensive. In 1863 Comte de Nieuwerkerke, Supérieure des beaux-arts under Napoleon III, fearing the growing interest in this most democratic of genres, abruptly eliminated the Prix de Rome for landscape painting and proceeded to reform the entire structure of the Ecole des Beaux-Arts as well as Salon procedures. This same year saw the Salon des Refusés, the beginning of the end of the artistic hierarchy as it had been known.

The growing interest in landscape painting could not be halted, however. Indeed, in 1869, the Académie began to grant, albeit privately, a new prize in this genre. Every two years the Prix Troyon (contributed by the mother of the great animal-painter Constant Troyon) was to be awarded to a worthy artist. Now, however, there were no iconographical stipulations—neither a theme nor figural staffage of any kind was required. Pure landscape, already a success with both patrons and artists, was finally given official sanction. By 1868 Zola, in a review of the Salon of that year, could pronounce definitively that "classical landscape [was] dead, murdered by life and truth."[3]

During the nineteenth century, as has been mentioned, a great many French artists took to the out-of-doors. They chose to render unidealized views of what lay before them, in the hope of capturing, in a casual way, the genius of a specific place. In this sense they opposed themselves to the formality of their more traditionally inclined predecessors. No longer concerned with depicting scenes which took place in ancient Greece and Rome, they chose specific places in France as their sites (fig. 10).

This nationalistic interest in specific locales was developed initially by Millet, Théodore Rousseau, Corot, Daubigny, Courbet, and others. But, although these painters tramped the uncultivated woods to the southeast of Paris (map 3) and the rough rocks of the English Channel (map 4), they were urban men, seeking what they believed the cities could no longer offer. They were men who found themselves in an increasingly mechanized world—artists who grew up and lived in a period when industrialization was making its greatest advances. In effect, their retreat from the urban centers, especially Paris, to a world uncontaminated by suburbanization, railroads, and the general development of industry was in every sense an escape to what they believed to be a better world (see above, II). In the end, then, just as with history painting's artificially composed, self-contained, and intellectually self-referential views of the Roman Campagna peopled by mythological or historical figures, French landscape painting at mid-century also sought to represent a golden age on canvas, but one of the relatively recent national past (fig. 11).

As plein-air painters, the Impressionists were most like Corot and Daubigny in the way they sought to depict the landscape they discovered having stepped off a train, coach, or boat. The conciliatory nature of Corot's

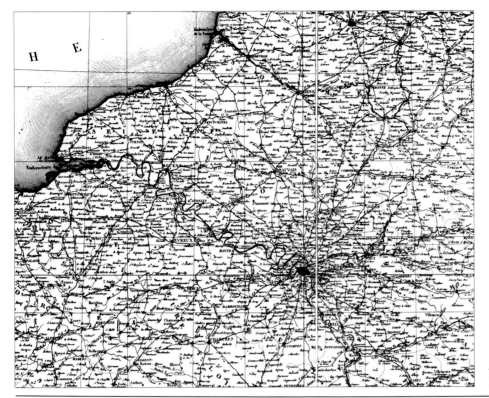

and Daubigny's paintings—unlike the more confrontative modes of Courbet and Millet—proved attractive to the Impressionists of the 1860s and '70s. Although the sense of preoccupation with the landscape was the legacy of the entire Barbizon group, in the areas of composition and overall mood only the complacent appearance and desultory atmosphere of certain paintings by that school were acceptable to, and adopted by, the new generation. On a technical level, however, Courbet's work was also of interest; his technique of thick impasto applied with a palette knife also influenced Monet, Pissarro, Cézanne, and—in a more limited way—Sisley and Renoir, most of whom Courbet met in person in the 1860s.

Corot and Daubigny contributed in other than philosophical ways to the artistic formulation of early Impressionism. Corot's early attempts to resuscitate the classical compositions of Dughet and Claude, though transformed by him by the 1850s into a peculiarly personal idiom, were admired by the Impressionist painters. Daubigny sought to aid them through his personal connections with the artistic establishment. In addition, the freedom with which his own later works were executed reveals a painter of an older generation in sympathy with younger artists.

Overlaid onto the Barbizon artists' rigid compositions, interest in directly observed nature, and heavy use of impasto and palette knife were the recent researches of Jongkind and Eugène Boudin into an even more profound pictorial literalism. Combining these elements with an intensified palette of pure color, the Impressionists consciously prepared the way for something totally new. However, the melancholy which pervades their early pictures betrays a tinge of emotionalism which they seemed able to eradicate only gradually. Their interest was in reducing the subjective interpolation of

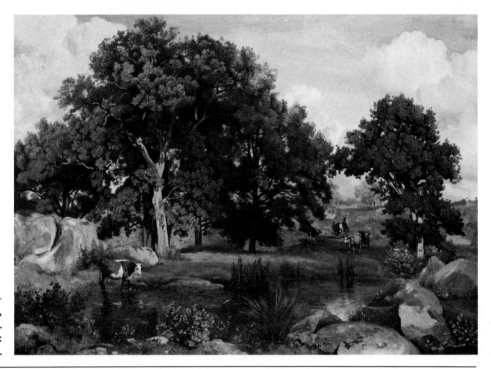

Fig. 11. Corot, *Forest at Fontainebleau,*
1847. Oil on canvas. 90.5 x 129.5 cm.
Museum of Fine Arts, Boston. Photo:
Museum of Fine Arts.

the moods of man onto his surroundings, in eliminating the reflection of
human feelings in nature seen, for example, in works by the Barbizon painter
Diaz (fig. 12). They took the Barbizon landscape, then, and cleared it of its
more overtly Romantic associations, of its subjective morality. They brought
to it a degree of objectivity that had existed before only in sketches painted
directly from nature. These are the most significant differences between the
Impressionist landscape and its predecessors.

The art of the Barbizon painters had sought to rally aesthetic forces to
protest the disappearance of untouched nature and the decline of the "noble
peasant" as a result of the industrialization and urbanization of France. The
Impressionists, on the other hand, as we have seen (see above, II), found only
beauty and wonder in those aspects of modernization that were totally alter-
ing urban and rural life. The Impressionists accepted with equanimity man
and his physical effect on the landscape. For example, although one of
Monet's first paintings, *Landscape with Factories* (1858–61; Private Collec-
tion, Paris) is a small depiction of a factory, just a few years later he was
painting the Saint-Siméon farm near Honfleur (a favorite site in Normandy
of the Barbizon painters) with the same degree of interest and a similar degree
of detachment (nos. 4–6). Because man and his works were thought of as an
integral part of nature, they were considered equally worthy of depiction.

Monet's work at Honfleur serves to remind us that, in spite of the
considerable philosophical differences between them and the Barbizon art-
ists, the Impressionists' early sites were the very same ones which the Bar-
bizon painters had begun to frequent in the 1840s and '50s. Tourists and
Parisian weekenders had discovered them as well (see above, II). By the time
Monet (fig. 13), Frédéric Bazille, Sisley, and Renoir had followed Courbet,
Daubigny, and Jongkind to the Normandy coast, Sainte-Adresse, Le Havre,
Trouville, and Etretat had been so developed for tourism that the press could
poke fun at their current state. Henry James, as Parisian correspondent to the

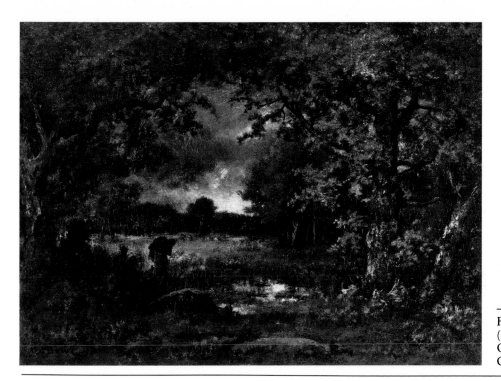

Fig. 12. Narcisse Virgile Diaz de la Peña (French, 1807–1876), *Landscape*, c. 1850. Oil on canvas. 31.7 x 41.9 cm. Los Angeles County Museum of Art. Photo: LACMA.

New York Tribune, wrote on August 26, 1876, of the crowded beaches on the coast of Normandy: "From Trouville to Boulogne is a chain of what the French call bathing stations, each with its particular claim to patronage....each weans you from the corruptions of civilization, but...lets you down gently upon the bosom of nature."[4] In this description of Etretat, James hit on the very reasons for the continuous middle-class flight from the city.

Urban dwellers also sought the virgin forest of Fontainebleau and the small towns of Barbizon, Marlotte, and Chailly-en-Bière that edged its borders. Although artists had come to the forest as a refuge from city life early in the century, by the 1860s it had become a seasonal retreat for all. Hotels and inns existed in every hamlet to absorb the myriad urban visitors. So common, in fact, had the escape to Fontainebleau become that, like the beaches, it could be mentioned in print as an instantly recognizable tourist refuge. The tourist in Fontainebleau became a common *topos* in contemporary literature. Flaubert's *L'Education sentimental* has its hero, Frédéric Moreau, take the demimondaine Rosanette to Chailly-en-Bière and Marlotte, with guidebooks in hand, to check off the trees and views described. In fact, the two tourists even espy a painter in a blue smock beneath a tree, presumably capturing his motif on canvas.

While the earlier generation of landscape artists had come to Normandy and Fontainebleau to depict the French landscape for the first time, in isolation, and as an escape from the city, the Impressionists came not to discover the new, but to record the known; not alone, but as part of a crowd. While it is true that in the 1870s and even in the '80s they sought to render specific places under specific conditions, by 1892—in the words of the critic Georges Lecomte—they had begun gradually to "[withdraw] themselves from reality and [make] compositions far from nature, in order to realize a total harmony."[5] This is not so very far from Castagnary's 1863 definition of naturalism, which embraced a group of artists who had turned almost exclu-

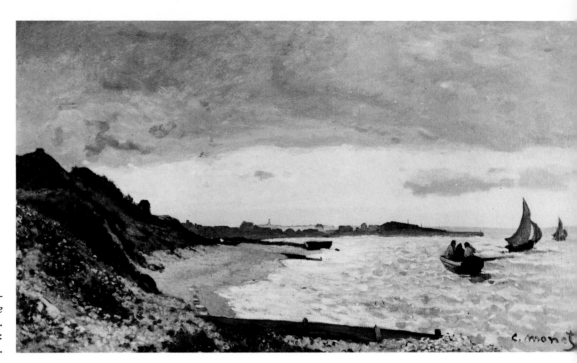

Fig. 13. Monet, *View of the Coast at Le Havre*, 1864. Oil on canvas. 40 x 66.5 cm. The Minneapolis Institute of Arts. Photo: The Minneapolis Institute of Arts.

sively to painting landscapes that dealt in no way with the social, psychological, or political problems of the day.[6] The Impressionists had absolved themselves of the responsibility to illustrate or to use representational color laid over a perspectival foundation of whatever sort (see below, III/8).

The elimination of the historical, the anecdotal, and the sentimental from Impressionist pictures of the 1870s and '80s does not mean that these artists were iconographically indifferent, however. Just as with the lack of finish, it was the effrontery to established expectations about a given genre that caused critics to be outraged and the public to be scandalized over the exhibition of their paintings (see below, IV). The Impressionists' lack of concern for the highly finished and varnished surfaces of Academic paintings, as well as their disregard for traditional subject matter, were viewed as an attack on the forms of art that the government—through the Ecole des Beaux-Arts and the Salon—condoned and, more importantly, supported. In its efforts to save traditional painting with identifiable subject matter and slick surfaces, which was created in amazing quantity (there may have been over 100,000 pictures produced during the second half of the nineteenth century), the State took a position of opposition to Impressionism, although, given the artists' fitful record of Salon acceptances, this opposition, while vocal, was not of a single mind. Even at the end of the century, there were those who still lamented the popularity of the new landscape painting. Philippe de Chennevières, Conservateur at the Musée de Luxembourg from 1863 to 1873, lived in anticipation of the passing of the plein-air school of Monet and the rest. The great landscape tradition of the past, he wrote in a letter to the landscape painter Charles-Frédéric Henriet, eventually would be revived and France would see a return to expression, invention, and composition in art—characteristics which, he felt, Impressionism lacked.[7] Plein-air painting as practiced

by Monet and the other Impressionists finally did succumb to the passage of time. But the new school of landscape painters looked back less to the past of Henriet and de Chennevières than forward in the spirit of the avant-garde.

—S. S.

NOTES

1. *L'Artiste,* 1836, p. 25.
2. Castagnary, 1892, vol. I, pp. 2–48.
3. Zola, 1959, p. 133.
4. James, 1952, pp. 198, 200.
5. Lecomte, 1892, p. 58.
6. Castagnary, 1892, vol. I, pp. 105–106, 140.
7. Henriet, 1896, pp. xvii–xviii.

1. Claude Monet
BEACH AT HONFLEUR
(LE BORD DE LA MER À HONFLEUR), 1864–66

In the summer of 1864 Monet and Bazille set off from Paris by steamboat down the Seine for Honfleur on the Normandy coast where Monet's parents, residents of Le Havre, had a summer house at Sainte-Adresse (nos. 4–6). Soon after their arrival, Bazille wrote to his mother from the rooms they had rented in the center of Honfleur:

> It took us a whole day to get here because on the way we stopped in Rouen [to see the Cathedral and the Museum]....As soon as we got to Honfleur we looked around for landscape subjects. They were easy to find because this country is a paradise.[1]

Beach at Honfleur was begun very late in the summer after Bazille had returned reluctantly to Paris to pursue his medical studies. Monet stayed on, continuing to meet and work with Boudin and Jongkind. This painting of the Côte de Grâce with its distant view of the Hospice lighthouse and the hospital of Honfleur may actually have been painted with Jongkind in attendance—a view of this same site can be seen in two watercolors by him, one of which is dated September 6, 1864 (Mr. and Mrs. James S. Deeley, New York, and Private Collection). Of all Monet's paintings of the harbor, jetty, and town of Honfleur executed during this period, however, *Beach at Honfleur* is the only depiction of this particular view. More than 20 years later, Seurat chose the same site for a landscape (Alfred Beatty Collection, Dublin).

It is probable that Monet began his painting from nature, but there is no doubt that it was worked up later in the studio. The carefully applied, short, loaded strokes of paint that so successfully capture the flickering coastal light and enliven the entire surface of the canvas make it clear that the picture was completed in a comfortable environment. In fact, in Bazille's painting (Private Collection, France) of the studio he shared with Monet until January 1866 at 6, rue de Furstenburg in Paris, Monet's *Beach at Honfleur* may be the picture shown in the center of a wall of figure studies and landscapes; however, the cloud formations, six silhouetted sailboats, and single figure (presumably a fisherman in a blue smock or *blouse de travail*, a kind of uniform adopted by workmen at this time) of Monet's finished canvas are absent. This suggests that Monet may have brought *Beach at Honfleur* to completion some two years after he had commenced it.[2]

NOTES
1. The Art Institute of Chicago, 1978, p. 166.
2. Although D. Wildenstein (no. 41) accepts unequivocably that Monet's painting is depicted here, one cannot rule out the possibility that the work may have been by Bazille himself. That two artists could choose to depict the same motif from the same point of view is shown over and over again in paintings by the Impressionists. This would not, however, nullify the argument presented here that Monet's painting was completed later in the studio and not *en plein air.*

2–3. Edouard Manet
DEPARTURE FROM BOULOGNE HARBOR
(SORTIE DU PORT DE BOULOGNE), 1864–65
MOONLIGHT OVER BOULOGNE HARBOR
(CLAIR DE LUNE SUR LE PORT DE BOULOGNE), 1869

Boulogne on the north coast of France proved to be attractive to Manet as well as other Parisian tourists. His arrival there sometime during the summer of 1864 gave him the chance to experiment within the tradition of marine painting. Of all the pictures of this type that he completed, *Departure from Boulogne Harbor* seems the least dependent on reality. Although one could cite the strong influence of Japanese prints evident in the picture's high horizon line and flat, smooth application of paint, a comparison of this painting with Manet's other marine subjects almost leads one to believe that the painting is either a sketch or simply a canvas recording his experiences away from the actuality of the site. *Departure from Boulogne Harbor* may have been the painting exhibited at the 1865 Salon (as no. 8) or in 1867 (as no. 40, *Vue de mer, temps calme*). Its total abstraction provides little visual evidence of Manet's trip to Boulogne, however. As with *The Battle of the Kearsage and the Alabama* (Philadelphia Museum of Art), which was exhibited at the dealer Cadart's shop in Paris in July 1864, it is unclear whether Manet painted *Departure from Boulogne Harbor* from life.

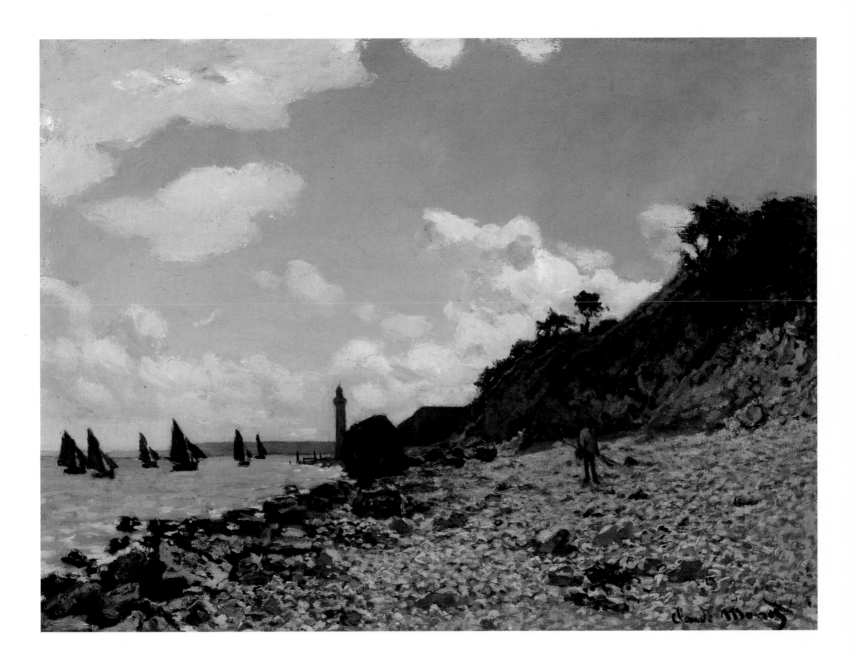

No. 1. Claude Monet
BEACH AT HONFLEUR, 1864–66

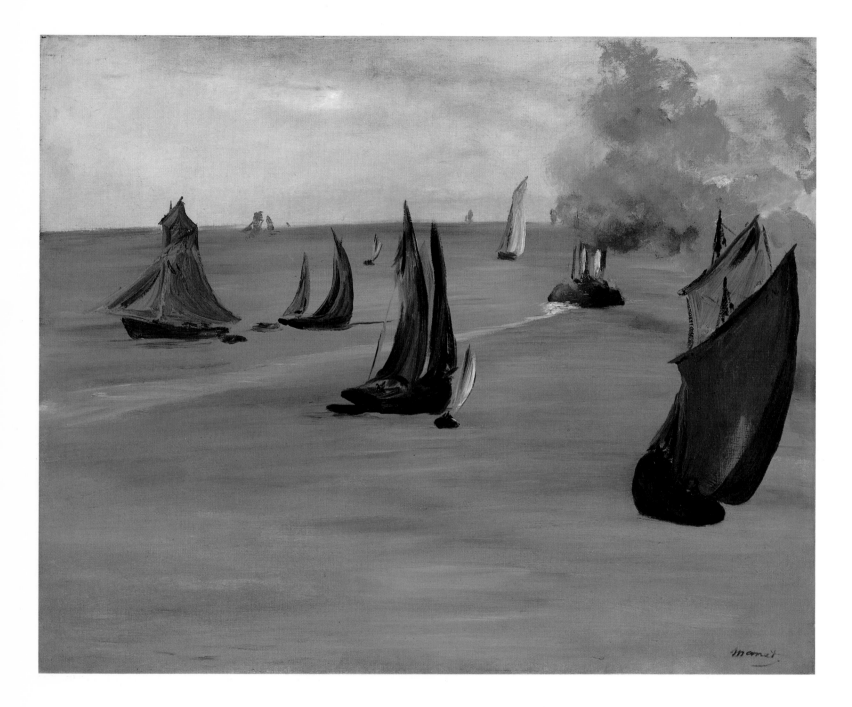

No. 2. Edouard Manet
DEPARTURE FROM BOULOGNE HARBOR, 1864–65

A DAY IN THE COUNTRY

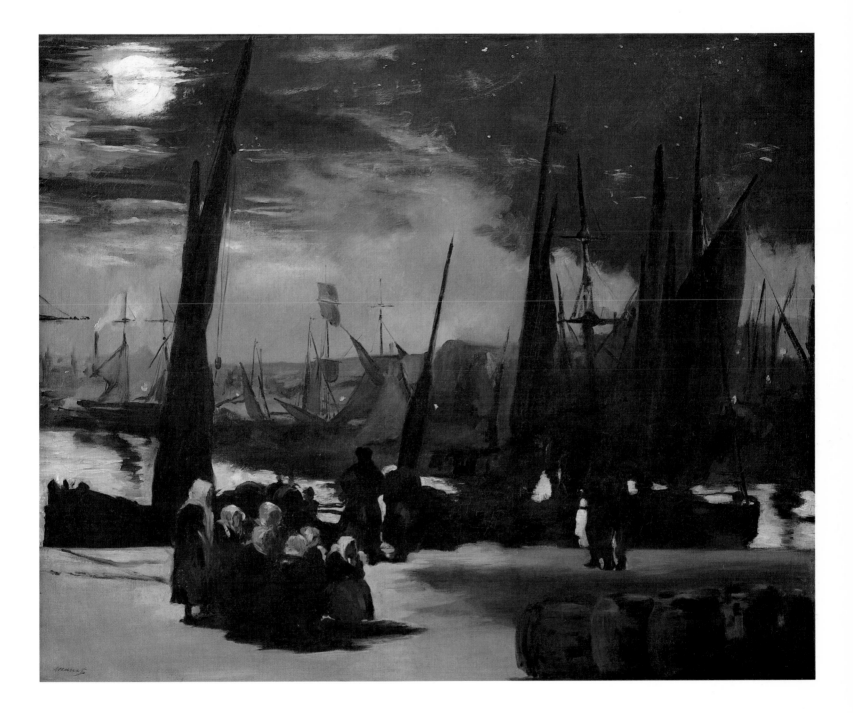

No. 3. Edouard Manet
MOONLIGHT OVER BOULOGNE HARBOR, 1869

The painting's horizontality is emphasized by the relatively unmodulated blue-green of the calm sea, which occupies three-quarters of the picture surface. The black boats with their corresponding black sails add an ominous note to the seemingly straightforward scene. Through these various sailboats, a strange, apparently ironclad vessel powered by steam chugs diagonally up across the painting's surface, leaving a whitish-green wake which creates the only sense of movement into depth on the canvas. This picture carries the artist's disregard for traditional perspective to extremes; the painting is, in fact, without time or place.

A more realistic picture, albeit a portentious and mysterious one, is *Moonlight over Boulogne Harbor* of 1869. Manet had returned to the coast in this year, staying for two to three months at the Hôtel Folkstone near the quay. From his window on the second floor of the hotel he recorded the day's activities; his subjects ranged from the *Departure of the Folkstone Boat* (Philadelphia Museum of Art) to this depiction of the local fishmongers whose white bonnets are illuminated by the moonlight as they prepare the night's catch for the morning market. The black shapes of the dock workers and fishermen are silhouetted, like the masts of the ships, against the brightly lit horizon. Although Manet was certainly inspired by the events seen out of his window, this scene was most certainly observed through a "filter": his experience of seventeenth-century Dutch paintings such as the fantastic nocturnal scenes of Aert van der Neer, a picture by whom Manet himself once owned.

4. Frédéric Bazille

BEACH AT SAINTE-ADRESSE
(*LA PLAGE À SAINTE-ADRESSE*), 1865

5–6. Claude Monet

TERRACE AT SAINTE-ADRESSE
(*TERRASSE À SAINTE-ADRESSE*), 1867
THE BEACH AT SAINTE-ADRESSE
(*LA PLAGE DE SAINTE-ADRESSE*), 1867

Bazille and Monet came to Honfleur not only because of Monet's filial devotion, but because the great Barbizon painters

had come to work at this very place: the Saint-Siméon farm outside Honfleur and its surrounding woods, coasts, and towns. Bazille's *Beach at Sainte-Adresse* was based heavily on Monet's painting of the same site (1864; The Minneapolis Institute of Arts) and was conceived, along with a landscape of Saint-Sauveur (Bazille's father's farm near Montpellier), as overdoor panels in response to a commission from the artist's uncle, M. Pomie-Layrargues, for his house in Montpellier. To render his view of Le Havre, the next town along the coast south of Sainte-Adresse, Bazille simply enlarged Monet's painting at the right and reduced its highly reflective light to a rather more sober one created by a lowering sun; the sense of scale which Monet found so difficult to capture is here brought into harmony. However, unlike Monet, Bazille did not paint *sur le motif*, that is, at the site; his painting was based on Monet's smaller picture and undoubtedly was executed in the studio. In fact, on the left over the stove niche in Bazille's painting of that studio can be seen a landscape painting by himself which may have been placed there to inspire him in creating these room decorations.

Monet returned in the summer of 1867 to Sainte-Adresse—the vacation haven of the bourgeoisie of Le Havre and of tourists from Paris—to visit his family and to paint. *Terrace at Sainte-Adresse* depicts members of his family seated on the terrace above the English Channel. Monet's father is shown seated wearing a white straw hat and looking toward the sailboats and Le Havre two kilometers away. The horizon line is populated by all manner of seagoing craft: small boats with sails furled are seen close to the harbor and town, boats with full sails trimmed can be seen further away, and steamships and large rigged ships pass the Cap de la Hève on their way into the Channel. Seen in the lowering sun of a late summer day are the kinds of subjects Monet preferred to depict—the sea, the middle class at leisure (Sainte-Adresse had been "created" by tourism), and cultivated gardens (see below, III/6 and 8). As critic and collector Théodore Duret pointed out in 1878, in Monet's pictures "you won't find any cattle or sheep...still less any peasants. The Artist feels drawn toward embellished nature...."[1]

That same summer Monet depicted the beach at Sainte-Adresse just south of this terrace. The same three-sailed boat seen above the parasol held by Monet's distant cousin, Jeanne-Marguerite Lecadre, in his painting of the terrace has here come closer into Sainte-Adresse. Other pleasure boats with and without sails are shown both moored and in use. Monet has contrasted a group of local fishermen with a man and young girl seated at the water's edge and dressed in bourgeois fashions; undoubtedly they are tourists. The man watches some of the distant boats through a spyglass. Hotels can be seen at the left on the edge of the high ground before it slopes to the beach.

No site, no activity was too mundane for Monet to set down on canvas during these visits to his family during the summer months between 1864 and 1867.

NOTE
1. Nochlin, 1966, p. 30.

7–8. Frédéric Bazille

LANDSCAPE AT CHAILLY
(*PAYSAGE À CHAILLY*), 1865
THE FOREST OF FONTAINEBLEAU
(*FÔRET DE FONTAINEBLEAU*), 1865

Bazille and Monet, while students (with Sisley and Renoir) in Charles Gleyre's Paris studio, spent the Easter holiday of 1863 in the forest of Fontainebleau in order to paint from nature. Exactly two years later, Monet returned to Chailly-en-Bière, one of the more important towns situated just at the edge of the forest, southeast of Paris, a few kilometers from the smaller town of Barbizon. Sisley and Renoir were also in the vicinity, staying in Marlotte. Monet wrote to Bazille in Paris to join him. Bazille took the 59-kilometer train journey from the Gare de Lyon and joined Monet at the Hôtel du Lion d'Or near Melun sometime at the very beginning of the summer. In the surrounding forest they painted in the open air. In fact, for Bazille it was the last time he would paint at Fontainebleau; his only plein-air paintings done after this were executed in the south of France, near his family's Montpellier estate (no. 79).

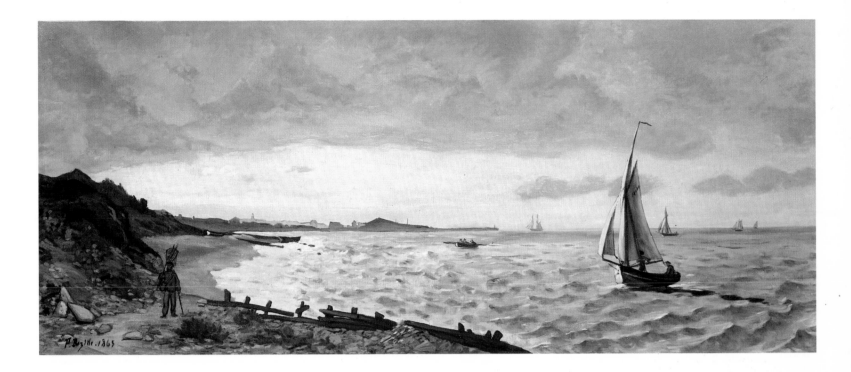

No. 4. Frédéric Bazille
BEACH AT SAINT-ADRESSE, 1865

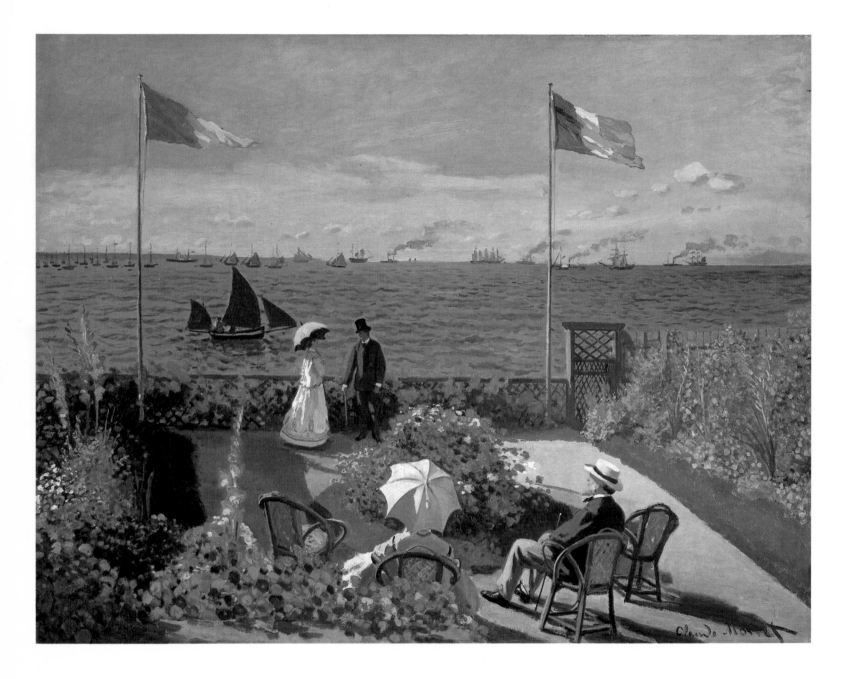

No. 5. Claude Monet
TERRACE AT SAINTE-ADRESSE, 1867

A DAY IN THE COUNTRY

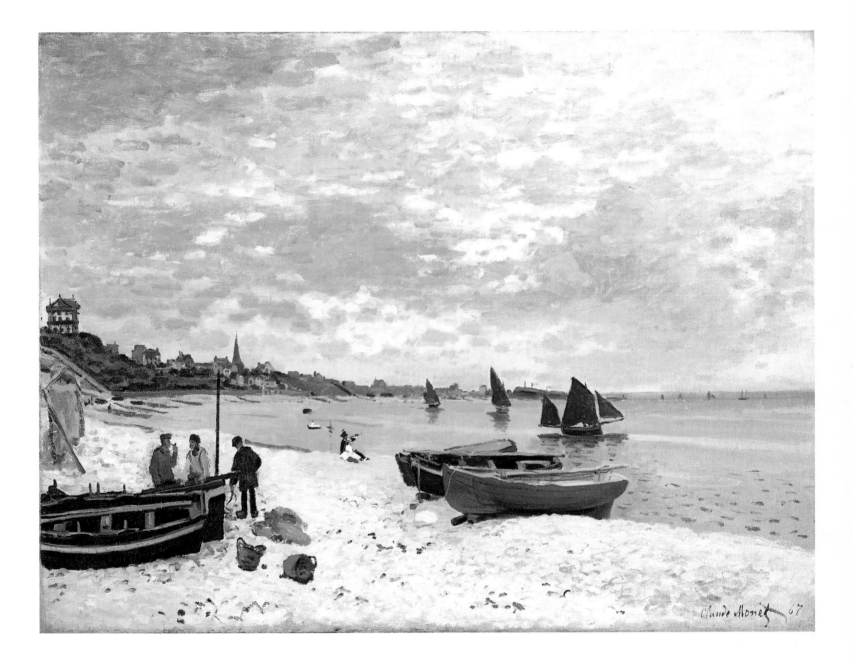

No. 6. Claude Monet
THE BEACH AT SAINTE-ADRESSE, 1867

Chailly-en-Bière and Barbizon are less than two kilometers apart on the western edge of the forest. Rousseau painted there in the late 1830s and by mid-century Charles Jacques and Millet had actually moved to the latter hamlet. Even today there are no railway lines to either town although they are both on an important post road from Paris. A visitor traveling by train to either place from the Gare de Lyon would disembark at Melun (45 kilometers from Paris) or Bois-le-Roi (51 kilometers from the city). In the immediate vicinity of both towns are two of the most popular of the sites so often recorded by landscape artists: the stand of oaks at Bas-Bréau (with its famous Bodmer Oak) and the Gorges d'Apremont. Bazille and Monet knew these sites intimately, having seen them in paintings and having had with them their guidebooks by Claude-François Denecourt and Joanne (see above, II), which provided (in handy octavo volumes) a point-by-point tour of the forest, with important landscape features indicated by blue and red markers. With these guides, and in the company of the various artists whom the two young men came to know there, Monet and Bazille saw and painted some of the major sites of the forest in the summer of 1865.

Landscape at Chailly and *The Forest of Fontainebleau*, then, represent Bazille's last artistic attempts to record the landscape of the Ile de France. And, as in his previous efforts, his debts to the great masters of the Barbizon landscape are evident. At this time Monet was working on studies for his large *Luncheon on the Grass* (Destroyed), with Bazille posing for several of the figures; the painting itself was completed in their Paris studio in 1866. Bazille's own concern was more with landscapes like those illustrated here as well as with a painting of Monet recuperating from an accident (Musée d'Orsay, Galerie du Jeu de Paume, Paris). It must have been particularly exciting for the artists to have Courbet come to watch them work as well as introduce them to Corot.

These two landscapes by Bazille rely less on the works of his acknowledged masters in the genre than on his own ability to capture the summer light as it played across the foliage and rocks of the

forest. In fact, *Landscape at Chailly* has the appearance of having been begun and completed totally *sur le motif*. It has all the informality and brilliance of a Corot sketch of 40 years earlier and reveals an artist of great confidence and ability, capable of carrying off a similar undertaking on a larger scale. The painting possesses the vibrant luminosity for which Monet had begun to strive the previous year at Honfleur. *The Forest of Fontainebleau,* on the other hand, reveals a constant awareness of a great Barbizon landscape formula which Bazille emulated. His palette here is dark, and the quality of flickering light is less insistent and certainly less dependent on reality than in *Landscape at Chailly.* Bazille's reliance on the work of Corot and Diaz is evident in *The Forest of Fontainebleau*. The two paintings together reveal an artist at a crucial moment, as he moves away with assurance in new, and as yet unexplored, directions from a dependence on his artistic ancestors.

9. Camille Pissarro

THE BANKS OF THE MARNE IN WINTER
(*BORDS DE LA MARNE EN HIVER*), 1866

Critics of the Salon of 1866, in which this early river scene was shown, were struck, as we are today, by the mundane quality of the scene Pissarro had chosen to depict. The simple field, long road, and barren farm near his home in La Varenne-Saint-Hilaire on the Marne River (across from Chennevières-sur-Marne) just southeast of Paris struck a particular aesthetic chord and prompted some favorable comment in the contemporary press. Although the painting may have been finished in the Paris studio to which the artist had had access since 1864, by January 1866 Pissarro had moved with his family to La Roche-Guyon on the Seine just north of Paris, on the way to Rouen.

In spite of the fact that the 1866 Salon was the first in which Pissarro did not state his association with his teacher Corot and the Barbizon school, the painting obstinately betrays a debt to the latter. Corot's earlier dark palette as well as his extraordinary ability to create a

palpable yet inexorable framework for his landscapes are evident here. Although one can still feel a tension between the Barbizon painters' concern for the conveying of a particular mood (here quite naturally heightened by the season depicted), and Pissarro's belief (echoed by his Impressionist colleagues) in a totally natural and objective point of view, the balance is clearly tipping here in favor of the latter aesthetic. The painting's power comes from Pissarro's ongoing experience of the work of Courbet. But while the facture reveals the former's awareness of the latter's use of the palette knife, it was combined here with the medium-reduced pigments of Daubigny in an attempt to achieve a flatness of stroke and effect combined with a sense of pure, but dull, color. To point out Pissarro's heritage, however, in no way mitigates his great originality even at this stage of his career.

10. Alfred Sisley

AVENUE OF CHESTNUT TREES AT
LA CELLE-SAINT-CLOUD
(*ALLÉE DE CHÂTAIGNIERS PRÈS DE LA
CELLE-SAINT-CLOUD*), 1867

Sisley worked in his studio in Paris until 1870. The subjects of his paintings during this period show that he traveled and worked in and around the capital and the areas near the towns of Barbizon and Fontainebleau. His *Avenue of Chestnut Trees at La Celle-Saint-Cloud* was shown in the Salon of 1868. It was painted at La Celle-Saint-Cloud, six-and-a-half kilometers from Saint-Cloud to the west of Paris in the township of Marly-le-Roi. Situated between Bougival and Vaucresson on the Paris–Saint-Germain-en-Laye railroad line, the Allée de Châtaigniers was considered the most interesting of the three woods which surrounded the tiny town of La Celle with its population of 560. When Sisley visited the area to paint in 1866–67, the Allée was owned by Napoleon III (perhaps one of the reasons why Sisley was able to show his picture at the Salon in 1868).

By the early nineteenth century Saint-Cloud had become a very popular Parisian holiday refuge, easily accessible by train and steamboat. Paul Huet, one

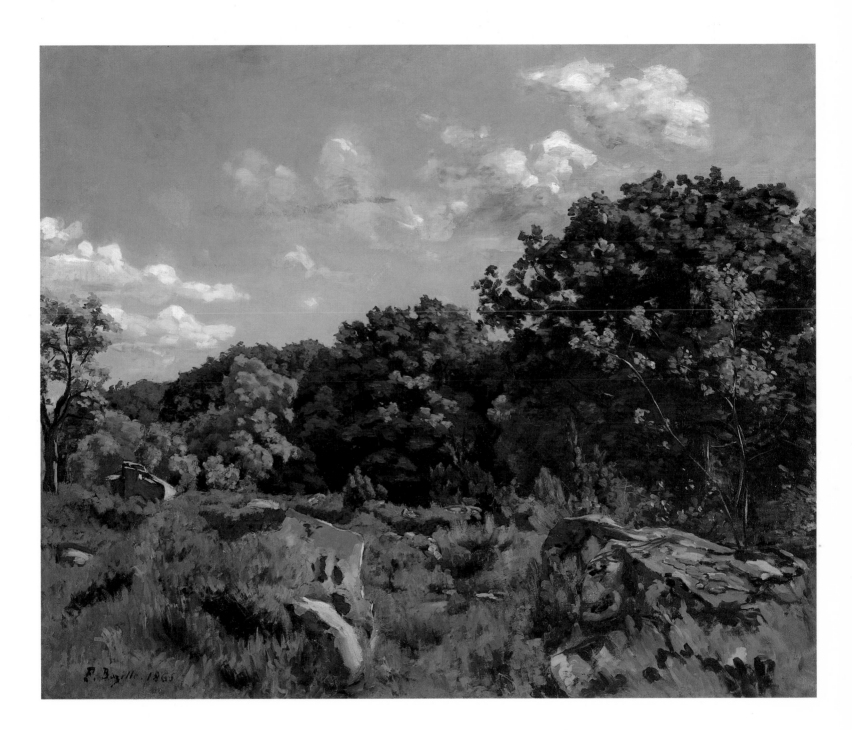

No. 7. Frédéric Bazille
LANDSCAPE AT CHAILLY, 1865

No. 8. Frédéric Bazille
THE FOREST OF FONTAINEBLEAU, 1865

No. 9. Camille Pissarro
THE BANKS OF THE MARNE IN WINTER, 1866
(detail on p. 52)

of the important artists associated with Barbizon, recalled that Saint-Cloud was "that enchanting place one talks about when in Italy."[1] The April 18, 1874, issue of *La Vie Parisienne* encouraged readers who liked long, beautiful walks in the country to visit the area as often as possible. And, according to Augustus J. C. Hare's *Days near Paris* (1888), "true Parisians of the middle class have no greater pleasure than a day spent at Saint-Cloud."[2]

This painting shows Sisley's reliance on Barbizon artists such as Rousseau, Courbet, Diaz, and Daubigny. It was Daubigny who advocated Sisley's being approved by the Salon jury. Twenty-eight years earlier Rousseau had submitted a painting entitled *Avenue of Chestnut Trees* (Musée du Louvre, Paris) to the Salon of 1839, and it had been rejected. Although Rousseau's painting depicts the Château de Souliers near Cerizay in Poitou and not Saint-Cloud, the conception of the two pictures is close enough to suggest that Sisley knew Rousseau's picture. The enclosing forest of full-leafed trees depicted by the former provides a brilliant pattern across the entire surface of his canvas. The deeply saturated colors on a dark ground reveal his dependence on Courbet's landscapes of the early to mid-1860s, such as his innumerable depictions of the Puits Noir. So, too, does the deer crossing the road at the center right—a motif which some of Courbet's new patrons demanded be included before they would purchase his pictures, in order to provide a focus or sense of relative proportions. Corot's painting of the same period as the Sisley work, *The Sèvres Road* (1864; The Baltimore Museum of Art), depicts a contiguous site and also may have been an inspiration. Sisley's work, however, is much more timid than Courbet's; the former's technique relies less on the latter's palette knife than on Corot's later, more personal, liquid application of pigment, which allowed for few hard edges: one object effortlessly blends into another. Sisley's treatment never approximated Corot's lyrical fantasies, however; his work remains impersonal and firmly wedded to the reality of the place depicted.

NOTES
1. Miquel, 1962, p. 34.
2. Hare, 1888, pp. 11–12.

11. Alfred Sisley

VILLAGE STREET OF MARLOTTE
(*RUE DU VILLAGE À MARLOTTE*), 1866

Although the training in landscape of Sisley, Monet, Bazille, and Renoir in Gleyre's Paris studio was limited and the studio closed down in March 1863 due to the master's ill health, the four men remained friends, traveling and painting together when they could find the time. In fact, in 1865 Renoir and Sisley went to Marlotte, a town of less than 100 people near Moret on the Loing River, just southeast of Fontainebleau, at the invitation of Renoir's friend Jules Le Coeur, who had a house there. Monet and Bazille went to Chailly-en-Bière at the very edge of the forest of Fontainebleau. The train from the Gare de Lyon would have taken under two-and-a-half hours to travel the sixty-five-kilometer distance. Although there was no train to Marlotte, it was a short coach ride or walk from the Bois-le-Roi station to Chailly-en-Bière.

Marlotte and Chailly were not so far apart that the four men did not occasionally see one another. For example, Renoir recorded their dining together at *mère* Anthony's inn in a large painting, *At the Inn of Mother Anthony* (1866; Nationalmuseum, Stockholm). Renoir and Sisley remained in the area, spending the fall and winter of 1865 at Marlotte, after Bazille and Monet had returned to Paris. According to Joanne's guide, Marlotte was frequented almost exclusively by landscape artists. The Goncourts described it as "the chosen birthplace of modern landscape."[1]

Village Street of Marlotte was one of Sisley's two entries for the Salon of 1866. A modest painting, it bears close relationships to works by the Barbizon painters that Sisley so admired, especially those of Jules Dupré and Corot. Dupré's emotional attachment to his subject matter, however, seems to have been eradicated in Sisley's painting, which shows the beginning of a kind of objective detachment from the scene depicted. The gray-gold light of early fall reveals the starkness of a mundane corner of the small village. Only the blue-smocked peasant chopping wood on the right breaks the stillness of the abandoned street.

NOTE
1. Goncourt and Goncourt, 1971, p. 73.

12. Eugène Boudin

ON THE BEACH AT TROUVILLE
(*SCÈNE DE PLAGE À TROUVILLE*), 1860

Although Boudin initially based his own paintings on those of the Barbizon painters, whose work he exhibited in his framing and stationery shop in Honfleur, he quickly found his own métier painting *en plein air* in and around the towns on the Normandy coast. He felt that landscape artists could achieve an honesty and "vividness of touch" only by "painting outside, by experiencing nature in all its variety, its freshness."[1] Combining this concern for the out-of-doors with a depiction of fashionable contemporary society, Boudin's beach scenes added a wondrous dimension to the expanding genre of landscape. In fact, the artist became rather sensitive, indeed defensive, about his chosen subjects:

> ...those middle class people who are strolling the jetty at the hour of sunset, have they no right to be fixed upon canvas, to be brought to our attention...these people who leave their offices and cubbyholes?[2]

Boudin's *On the Beach at Trouville* encapsulates Charles Baudelaire's concerns for painting "modern life," discussed at length in his article for *Le Figaro*, "Peintre de la vie moderne." For both the painter and the author modernity was "the ephemeral, the fugitive, the half of art whose other half is the eternal and the immutable."[3] In Boudin's paintings, all these aspects are combined with the verisimilitude in which the artist delighted. Here, chicly dressed middle-class people are enjoying a day at one of the great resorts on the Normandy coast. Boudin has enlivened the flat coastal setting, created in a facture finely filtered through the experience of paintings by Courbet, whom he had met and escorted around Le Havre the previous year. The horizontality of the beach and sky (which occupies three-quarters of the picture) is enlivened by a controlled disposition of figures across its surface and by carefully placed patches of pure color. The whites, blues, and reds of the figures provide a lively counterpoint which animates the canvas in a way totally unique to Boudin.

NOTES
1. Rewald, 1980, p. 38.
2. Ibid.
3. Baudelaire, 1970, p. 13.

A DAY IN THE COUNTRY

No. 10. Alfred Sisley
AVENUE OF CHESTNUT TREES AT LA CELLE-SAINT CLOUD, 1867

No. 11. Alfred Sisley
VILLAGE STREET OF MARLOTTE, 1866

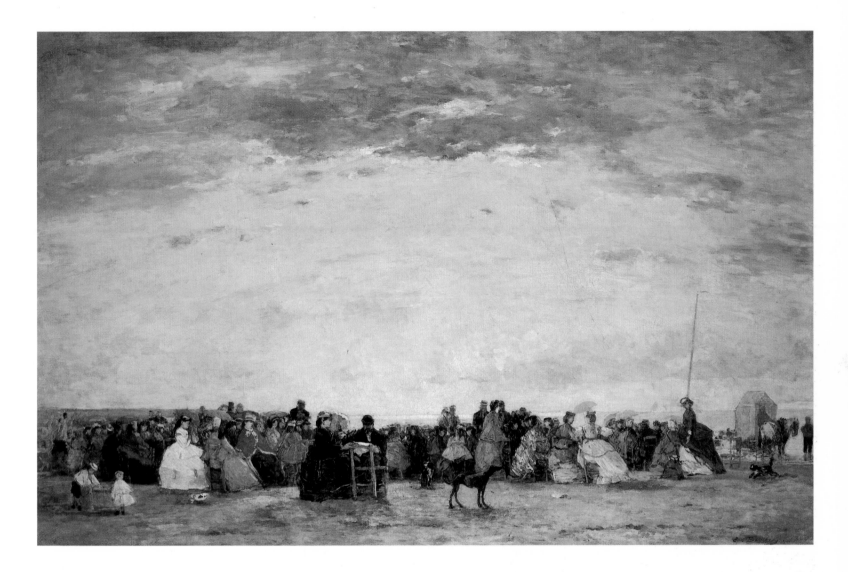

No. 12. Eugène Boudin
ON THE BEACH AT TROUVILLE, 1860

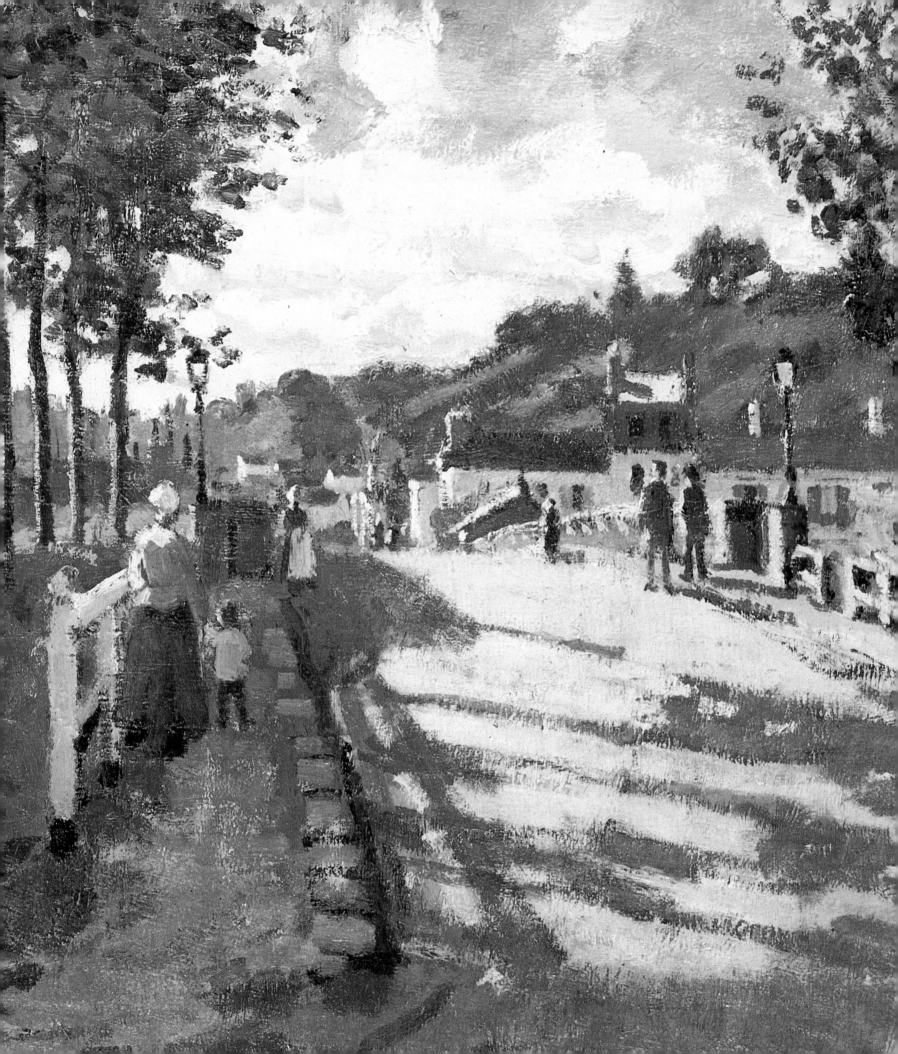

III/2

The Cradle of Impressionism

T HE SEINE WINDS IN LONG, meandering loops west of Paris, skirting the hills at Sèvres and pushing into the Parisis plains near the village of Asnières. It then swoops back to Argenteuil and runs a straight course until it arrives at Bougival, where it bends again, discouraged by the rising terrain that runs from that small town to Saint-Germain-en-Laye. Nestled in these softly contoured hills are the villages of Bougival, Louveciennes, and Marly-le-Roi (map 5).

The landscape in and around these villages was truly the cradle of Impressionism. Here, in the summer of 1869, Monet, Renoir, and Pissarro worked together for the first time at rendering the same outdoor view and began to forge the shared, informal, plein-air aesthetic of Impressionist landscape painting. If—as Arnold Hauser and many students of the movement have long maintained—Impressionism was an urban art form, born around the tables of the Café Guerbois in Paris during the second half of the 1860s, it was in the suburban countryside west of the capital that the notions of modern painting discussed in Paris were first tested. The place names of this region—Bougival, Louveciennes, Voisins, Port-Marly, Saint-Michel, and Marly-le-Roi—appear over and over in the titles of the paintings we have come to associate with the beginnings of Impressionism.

Monet moved to Bougival with his mistress, Camille Doncieux, and their son, Jean, in June 1869. Renoir spent that summer in nearby Ville-d'Avray, a favorite locale of Corot's, but came frequently to visit both Monet in Bougival and his own mother and grandmother, who owned a house at 18, route de Versailles in Louveciennes. The two painters worked together intensively during September, when their great series of landscapes of the Seine along the Ile de Croissy were painted (nos. 13–14). It is possible that Monet

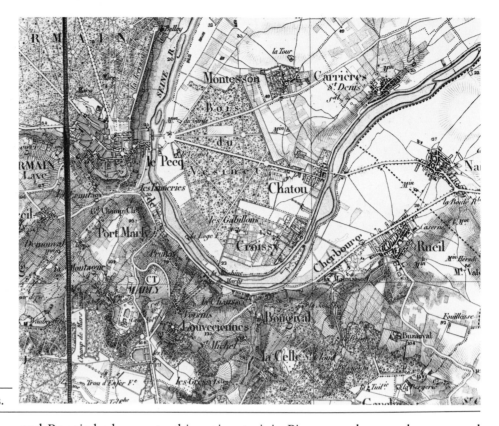

Map 5. Bougival, Port-Marly, and Environs.

and Renoir had come to this region to join Pissarro, who may have moved from Pontoise—where he had lived for several years—to Louveciennes as early as the fall of 1868, but who was definitely in residence by May 1869 (fig. 14). The Pissarro family rented part of a large house called the Maison Retrou at 22, route de Versailles, and Monet stayed with them during December 1869, when he and Pissarro worked together just as Monet and Renoir had done earlier (nos. 15–16). Sisley may have visited them that winter and definitely moved to a house on the rue de la Princesse in the hamlet of Louveciennes called Voisins in the summer or early fall of 1870. In the end, of all the painters Sisley was the most faithful to this area. Renoir was there scarcely more than a month, and Monet left after less than six months. Pissarro lived in Louveciennes for nearly a year and a half, but Sisley returned again and again from 1870 until at least 1878. For this reason, the majority of the paintings in this section are by him.

Why did the Impressionists come to this particular area? The villages southwest of Paris near the forest of Fontainebleau had been claimed long before by the Barbizon school. Chintreuil and a group of his friends had colonized the charming, hilly region near Igny and Bièvre, southwest of Paris. Daubigny had moved to Auvers, northwest of the capital, where he was visited by Daumier, Corot, and many others. And Corot and his students had claimed the landscape just west of Paris near Ville-d'Avray, Sèvres, and La Celle-Saint-Cloud. Indeed, landscape painters tended more often than not to colonize the countryside in groups, as if to guard themselves from "the natives," and the Impressionists were no exception. For this reason, the landscapes painted by them around Bougival and Marly have a collectivity of both style and subject.

The Impressionists' reasons for their choice of sites were never clearly

A DAY IN THE COUNTRY

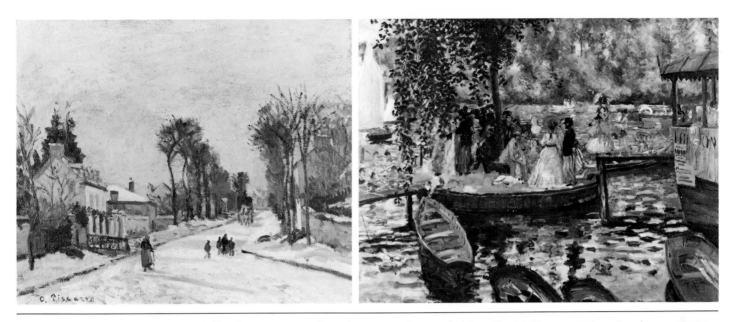

Fig. 14. Pissarro, *Winter Landscape*, 1869. Oil on canvas. 38.3 x 46.3 cm. Walters Art Gallery, Baltimore. Photo: Walters Art Gallery.

Fig. 15. Renoir, *La Grenouillère*, 1869. Oil on canvas. 66 x 81 cm. Nationalmuseum, Stockholm. Photo: Nationalmuseum.

stated, but it is not terribly difficult to guess what the attractions of this particular area would have been. First, Bougival is only 17 kilometers from the capital—indeed, one could reach it on the train within 20 minutes from the Gare Saint-Lazare. Second, it was well known enough among mid-century landscape painters—particularly Célestin François and Charles-François Nanteuil—that one could feel comfortable working there. And third, it was already famous. Gérard de Nerval had extolled its charms as early as 1855 in his *Promenades et souvenirs,* saying that, by living in nearby Saint-Germain-en-Laye, "one has the resources of the city, and one is almost completely in the country."[1] And Emile de La Bedollière, in his famous book *Histoire des environs de nouveau Paris,* published in the early 1860s with illustrations by Gustave Doré, treated the town of Bougival as an artists' colony, mentioning the hordes of artists and writers who "come together each year in Bougival."[2]

In 1867, just two years before the arrival of Monet and Renoir, the novelist Victorien Sardou was asked to contribute an essay on the environs of Paris to a vast guidebook, *Paris Guide par les principaux écrivains et artistes de la France,* which was published in connection with the "Exposition Universelle" in Paris during 1867. His offering, entitled "Paris en Promenade—Louveciennes, Marly," commenced with this resounding paragraph:

> Are you an intrepid hiker?...Does the bright sunshine invite you into the fields? And do you want to get to know the most picturesque and the richest region in all the environs of Paris, one [that is] justly praised? If so, get up early in the morning and go to Bougival, and, after a big lunch on the banks of the river, proceed to Marly-le-Roi by the road through Louveciennes, the route of schoolboys.[3]

There are countless ways in which Sardou's delightful text leads us directly "into" the Impressionist paintings we know so well today. Certain phrases, sentences, and even entire paragraphs evoke the landscapes of Sisley, Pissarro, and Monet, almost as if Sardou's prose was written after—rather than before—the pictures were made. Particular roads—the rue de la Princesse on which Sisley lived and from which he painted so many landscapes, for example—are mentioned lovingly by Sardou. The painters almost seem to have been illustrating his observations of the river's banks, of the

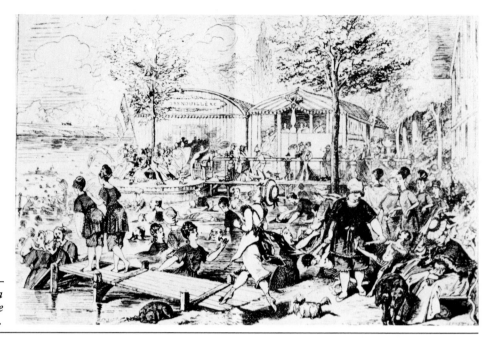

play of light and shade along a hillside, and of the houses on the slope near Louveciennes. Pissarro's *View of Louveciennes* (1869; The National Gallery, London) could be coupled with the following passage from Sardou's text:

> On one side, grape arbors; on the other, a hollow abounding in greenery; in front, houses lost in the foliage…and, crowning it all, the beautiful arcades of the aqueduct, which give the landscape a grand, Italian air. In sum, the most wonderful arrival in the country that one can find! Wherever you turn your eyes, the lines of the terrain fold in harmonious undulations with the most beautiful contrasts of light and foliage. Everywhere there are space, fresh air, country smells, and the great silence made up—I don't know how—of a thousand sounds that result from the freedom of the sky, the vigor of the wind, the calls of the birds,…all of which tell you clearly: "Here is a true village! You can enter…take off your clothes if you are hot…sing if you are happy…you will offend no one in this place!"[4]

This very freedom and the ease of living in such places as Bougival, Louveciennes, and Marly clearly appealed not only to the Impressionists who spent time in these places, but also, as we have seen, to their countrymen who came from Paris for the summer, a weekend, or the day (see above, II). In fact, these charming villages were not simple rural settlements, but rather suburban communities in which many Parisians owned country residences and from which others commuted to work on the train and omnibus. Their inhabitants were not—strictly speaking—villagers; they were not traditional peasants, small shopkeepers, or farmers. Indeed, much of the real estate in this region was owned by absentee landlords who had little expectation of economic gain from this ownership and who possessed either large country residences with considerable grounds or small houses perched precariously on small parcels of land. Statistics indicate clearly that such people swelled the villages during the summers and on weekends while the population of permanent residents of Bougival, for instance, actually declined from 2,316 in 1868 to 2,086 in 1878.[5] The "weekenders" hired local people as servants and companions, and some of them owned small restaurants or commercial

Figs. 17–19. Henri Bevan (French, b. 1825),
*The Machine de Marly; Aqueduct at
Louveciennes; Pool at Marly,* all 1870.
Albumen prints from glass negatives. Each
12.5 x 16.5 cm. Private Collection, Paris.
Photos: Musée d'Orsay, Paris.

businesses. There was also a considerable population of truck gardeners who provided fruit and vegetables on a small scale to the Parisian gentry as well as to the central markets in Paris, Les Halles. In the very diversity of their economies and their dependence upon urban civilization, these suburban villages were quite different from the "peasant" villages around the forest of Fontainebleau or in the Vexin plains near Auvers painted by members of the school of Pontoise (see below, III/5).

The two most important—and most often represented—sites in the landscape around Bougival in the mid-nineteenth century were the Seine around the restaurant called La Grenouillère near Bougival (no. 14) and the park of the ruined Château de Marly at Marly-le-Roi (see above, II). Each of these sites was a powerful symbol for Frenchmen—the first, of the possibility of unrestrained "rural" leisure made accessible by train travel (fig. 15), and the second, of the greatness of the French past. La Grenouillère was mentioned in every Second Empire and early Third Republic (1870–1940) guide to the environs of Paris as a delightfully noisy—and more than occasionally rowdy—place to eat, swim, boat, and drink that was both inexpensive and easily accessible from Paris. La Grenouillère literally floated on the Seine, and one could rent boats and small bathing houses in which to change clothing and enjoy oneself. Popular prints roughly contemporary with the period of the Impressionists illustrate the charms of the place. For example, one from the mass-circulation periodical *Le Monde illustré* of 1868 (fig. 16) shows a group of rather vulgar—and probably somewhat drunk—people cavorting in the water near the restaurant. Another, from the *Illustrated London News* of 1875, is somewhat less satirical and indicates clearly that the fame of this small place had already spread to England. La Grenouillère was among a handful of places around Paris that were known to practically everyone who lived there; it was the Moulin de la Galette of the suburbs.

The most notable aspect of La Grenouillère during the nineteenth century was its immorality. It was a place in which people from various social classes could meet in utter anonymity, unafraid of the prying eyes of friends or neighbors. For that reason, and because of the quantities of alcohol consumed and the rounds of dressing and undressing before and after swimming, La Grenouillère came to be associated with prostitution and loose morality, as the print from *Le Monde illustré* makes clear. The lengthiest and most fascinating proof of this association is a vivid, if somewhat prim, passage from Maupassant's novel *La Femme de Paul:*

> One senses there, even through one's nostrils, all the scum of the world, all the most distinguished riffraff, all the moldiness of Parisian society: a mélange of pretenders, ham actors, lowly journalists, gentlemen guardians, worm-eaten speculators, debauchers, decayed bon vivants; thronged among all the most suspect of people, partly known, partly lost, partly acknowledged, and partly dishonored, crooks, petty thieves, purchasers of women, captains of industry with distinguished airs, who seem to say: "Anyone who treats me like a rascal will get busted!"

The park of the Château de Marly, the favored country retreat of Louis XIV, was the opposite of La Grenouillère in every way, at once grander and quieter. Praised most fervently in the nineteenth century by Sardou, the park had been designed by Le Nôtre in the late seventeenth century as part of the great aquatic system that brought water from the Seine up the hills by way of the *machine de Marly,* a series of huge water wheels only just rebuilt

Figs. 20–21. Bevan, *Residence of Horace Mallet; The Ile de Croissy: La Grenouillère,* both 1870. Albumen prints from glass negatives. Each 12.5 x 16.5 cm. Private Collection, Paris. Photos: Musée d'Orsay, Paris.

by Napoleon III (fig. 17), through the aqueduct also designed by Le Nôtre at Louveciennes (fig. 18) to the great storage pools at the Château de Marly (fig. 19). These eventually fed the fountains of Versailles. The château and its numerous outbuildings had been destroyed during the Revolution, and nineteenth-century visitors to the park walked through a silent, deserted landscape which spoke as poetically of the failure of the aristocracy as of its brilliance. The massive Baroque garden scheme lent a distinctly aristocratic character to the landscape around Port-Marly, Louveciennes, and Marly-le-Roi. The route de Versailles, on which both Pissarro and Renoir lived, for example, had been designed as a royal road for the carriages which took the court from Saint-Germain-en-Laye to the Château de Marly and on to Versailles. Its straight, tree-lined character was at odds with the crooked paths and huddled roofs of the village of Louveciennes, which it passed. The aqueduct, painted by Pissarro and Sisley (*The Aqueduct of Marly* [1874; The Toledo Museum of Art]), dominated the landscape from Bougival to Saint-Germain-en-Laye. Thus the paintings by Pissarro and Monet of the route de Versailles (no. 15) and by Sisley of the *machine de Marly,* the aqueduct, and the pools at Marly-le-Roi (no. 21) are unimaginable without Louis XIV and his planners (see above, II).

The album of an important amateur photographer, Henry Bevan, who lived in Louveciennes in the 1860s and '70s, casts an interesting light on the subject matter of paintings made at precisely the same moment by the Impressionists (see below, V). Called *Photographies, Louveciennes et Bougival par Henry Bevan,* the album, made in 1870 and still in the collection of Bevan's family in France, was a private attempt to record all aspects of the landscape in and around which another family, the Mallets—to which Bevan was related by marriage—and their friends maintained large country properties. In many ways Bevan was an archetypal "new" inhabitant of the Louveciennes region. He was wealthy, having recently married one of the heiresses to a banking fortune; he lived in a large compound owned by his wife's family in the newly built-up region near the Place de l'Europe in Paris; and he commuted on weekends back and forth to Louveciennes. He had learned to photograph in the 1850s and was already an excellent technician when he began his series of photographs of the "cradle of Impressionism." He certainly knew the great photographic critic Francis Wey, who also kept a

Figs. 22–23. Bevan, *Port-Marly; Banks of the Seine,* both 1870. Albumen prints from glass negatives. Each 12.5 x 16.5 cm. Private Collection, Paris. Photos: Musée d'Orsay, Paris.

house in Louveciennes and had written perceptively about landscape photography in the 1850s.[6] It is unlikely that Bevan knew any of the Impressionist painters personally—he was wealthy enough that his circle would most probably not have overlapped with theirs. Yet he surely saw them as he prowled through the landscape they were painting in search of photographic motifs. What is surprising, therefore, is the extent to which "his" Louveciennes and "theirs" differed.

Bevan's photographic album begins with—and had its social roots in—the country residence of his father-in-law, the great banker Horace Mallet (fig. 20). Dominating its immense, exotic gardens on a slight rise, the massive, commanding dwelling of three floors had a large, recently built addition. Later plates in the book show its gardens, beautifully clipped and maintained, and the country residence of Bevan's sister-in-law, Mlle. Mallet, who owned a slightly less imposing dwelling with its own garden and a wonderful orangery. Then come two photographs of the superb garden of a M. de Bourrevilles. Fully eight of the twenty-eight landscape photographs in this book represent the private properties of wealthy landowners from Paris.

Clearly, this is *not* the kind of landscape subject painted by the Impressionists. Indeed, Sisley, the only painter who did include several of the large country properties of Louveciennes in his painted landscapes, usually showed them as they could be seen from public roadways, sitting comfortably in the middle grounds of their landscapes.[7] In the end, one must conclude that there was a social and economic gulf between the photographer Bevan and the Impressionist painters, his exact contemporaries, and that this gulf *in itself* caused their differing responses to the same landscape. The walled gardens of the *haute bourgeoisie* were not open to the Impressionists in those years.

Bevan did wander outside the carefully maintained compounds of his family and friends, however, and, on these wanderings, made landscape photographs of sites that could equally have been—or that were—painted by the Impressionists. For example, he photographed La Grenouillère, perhaps the only site depicted by the photographer, Monet, Renoir, Pissarro, *and* Sisley. But Bevan's carefully labeled view (fig. 21) shows us the restaurant from the Bougival side of the river, and we see it as merely one element in a spacious river landscape. It was the *river* that was important to Bevan, not La

Grenouillère, and he made a number of other photographs of the Seine that demonstrate this interest (figs. 22–23). These photographs come closer to the paintings of the Impressionists than any others by Bevan and provide evidence of the deep affection for the national river that was shared by them all (see above, II, and below, III/4).

In spite of this particular rapprochement, the photographer's and the painters' landscapes of the Seine are different in every way. Bevan, like many good tourists of his day, traveled with guidebook in hand and was interested in significant historical monuments. He lovingly photographed the churches at Louveciennes and Bougival (fig. 24), both of which were virtually never portrayed by the Impressionists (see above, II), and carefully documented the remains of the great park of the Château de Marly. This latter landscape, historically the most important in the region, was practically ignored by the Impressionists. In the end, the vast majority of Bevan's photographs have an "important" subject which embodies his own values—wealth, religion, and commerce. The Impressionists persistently avoided such motifs, implicit or explicit, preferring to follow the lead of painters like Corot and Daubigny and to search out beauty where one would least expect to find it. Their early landscapes painted in the "cradle of Impressionism," diverse as they seem, are almost aggressively ordinary, and they are as important for what they omitted as for what they contain. More often than not, the painters denied the motifs photographed by Bevan in their early paintings, turning their own backs to them (no. 21), screening them behind trees (nos. 13, 19, 72), or simply organizing compositions so that they are just to the left or right of the view included in the frame (nos. 59, 63–64, 69)—a view that is intentionally mundane.

—R. B.

Fig. 24. Bevan, *Church in Bougival,* 1870. Albumen print from glass negative. 12.5 x 16.5 cm. Private Collection, Paris. Photo: Musée d'Orsay, Paris.

Notes

1. See de Nerval, 1855.
2. de La Bedollière, early 1860s, p. 85.
3. La Croix (ed.), 1867, vol. II, p. 1455.
4. Ibid., pp. 1456–1457.
5. A. Joanne, 1881, p. 167.
6. In the *Bulletin* of the Société Française de Photographie and in *La Lumière.*
7. There is only one case of correspondence between the country-house photographs of Bevan and the landscape paintings of the Impressionists, and that involves a photograph by Bevan called *Luciennes, Property of M. de Bourrevilles* and a painting by Sisley entitled *The Duck Pond at Louveciennes* (1873; Private Collection). Although their compositions are different, their subjects and points of view are the same. Perhaps Sisley was given permission to enter the park of M. de Bourrevilles to paint a landscape that is otherwise unique in his oeuvre. We can feel secure in saying that Bevan knew M. de Bourrevilles and that his photograph was made as a record of their social connections.

13. Claude Monet

THE BRIDGE AT BOUGIVAL
(LE PONT DE BOUGIVAL), 1869

Monet seems already to have been painting in Bougival by June 1869. The first of his Bougival canvases to be sold, *The Bridge at Bougival* is among the largest, most traditionally composed landscapes he painted during 1869–70. For his motif, Monet chose the small bridge from the Ile de Croissy in the river to the town of Bougival that had been inaugurated on November 7, 1858 (fig. 6). He concentrated his attention less on the architecture of the bridge itself than on the spatial relationship between the unpaved road across the bridge to the town beyond and the road leading down to the river. One would have seen such a landscape at the end of a day at La Grenouillère, just as one was returning to Bougival to catch the train to Paris.

The composition of this painting was conceived along strictly geometric lines and relates, in this way, to such earlier paintings as the *Terrace at Sainte-Adresse* (no. 5). The painting is divided in half both vertically and horizontally, and the horizon line was placed exactly one third of the distance from the bottom of the painting. The trees, fences, and figures were each carefully positioned to make the space of the landscape totally legible. This composition has its most important antecedents in the paintings Corot made at nearby Ville-d'Avray,[1] and one can point to any of a number of examples known to Monet. Perhaps the closest is the famous *Ville d'Avray, The House of Cabassud* (1865–70; Musée du Louvre, Paris), but even this comparison reveals the extent to which Monet was more insistent in his application of rigid structural principles.

Like many landscapes which record the humble sites of the Ile de France, this one has no true subject. Monet was careful to balance the various elements of the landscape so that one would not dominate the others and did not include a single historically important form. Indeed, he positioned himself so that the spire of the church in Bougival, the only architecturally remarkable form in the landscape (fig. 24), was screened by the trees. In his de-emphasis of this church, an important local monument, Monet not only projected his own ideology onto the landscape, but also indicated clearly that he was not interested in creating a topographical picture dependent upon an architecturally unique building to give it a "sense of place" (see above, I–II).

Monet sold this picture in 1870 to the dealer *père* Martin, who supported both him and Pissarro; it was not published until 1921 nor exhibited until 1949 (see below, IV).

NOTE
1. Seitz, 1960, p. 82.

14. Claude Monet

BATHING AT LA GRENOUILLÈRE
(LES BAINS DE LA GRENOUILLÈRE), 1869

Monet worked actively with Renoir (fig. 15) on a group of paintings of La Grenouillère during August and September. Monet himself referred to the two he did as "miserable sketches,"[1] in spite of the fact that he signed them (probably later) and that one of them (The Metropolitan Museum of Art, New York) was in the collection of no less a connoisseur than Manet. This latter painting has long been an icon in the history of Impressionism and has been published innumerable times in juxtaposition with Renoir's painting of the same subject (Nationalmuseum, Stockholm). Both these compositions are centered on a circular swimming platform known as "Le Camembert" and connected both to the shore of the Ile de Croissy and to the floating restaurant.

Unlike *The Bridge at Bougival* (no. 13), the subject of *Bathing at La Grenouillère* is essentially without precedent. There are no major pictures by Corot, Daubigny, or Courbet that relate to it, and it comes closest iconographically to beach pictures painted by Monet's teacher and mentor, Boudin, on the north coast (no. 12). Both Monet and Boudin approached the subject of bathing with a fair degree of primness and from a distance.

This painting has a considerably more informal and active composition than its counterpart in New York. Painted from the restaurant platform itself, it shows a raised wooden walkway in front of which is a delightful still life of rowboats waiting to be rented and behind which are changing rooms, also for rent. Again, as was most often the case during the Bougival period, Monet divided the composition vertically and horizontally into halves and thirds, and important forms were anchored to this structure (no. 13). In this way, the world's constant flux—of reflections, moving boats, jostling figures, and rustling trees—is held in check, and there is a sense of activity arrested and controlled by the artist (see above, I).

There are many parallels between the depictions of La Grenouillère in popular prints and Monet's paintings, parallels which indicate that the prints (fig. 16) acted as a collective—if indirect—source for both his and Renoir's renderings. However, the boldness and rigor of Monet's touch as well as the strongly geometric division of the picture surface are his own, and his pictures of the floating restaurant can be contrasted in every way with those of Renoir. For the latter—as for the popular illustrators of the time—the "landscape" of La Grenouillère was essentially a "human-scape," a populated realm in which the artist gave himself over fervently to the description of moving figures. Whereas Monet's thickest, most confidently applied painted marks represent streaks of light reflected in the water or glistening on the wet sides of wooden boats, Renoir's brush lovingly caressed his figures. Anonymous as they are, they have their own actuality which transcends the landscape in which they move; none are mere staffage figures. On the other hand, Monet's figures merely participate in the spectacle of a lighted landscape, a landscape without a hierarchy of forms to be interpreted by the painter. The world of bourgeois leisure was painted by him as a unified, vibrating field, as the "field of vision" so often discussed in contemporary texts about light and human sight. In fact, one thinks less of popular illustrations when one confronts these paintings by Monet than of the lyrics of a famous popular song about Bougival quoted by de La Bedollière:

Of the sun, of the air, of the water
That God brings me
In this luminous picture
In which my view is full,
I always see
Green fields in front of a blue sky.[2]

NOTES
1. Wildenstein, 1974–79, vol. I, p. 45.
2. de La Bedollière, early 1860s, p. 87.

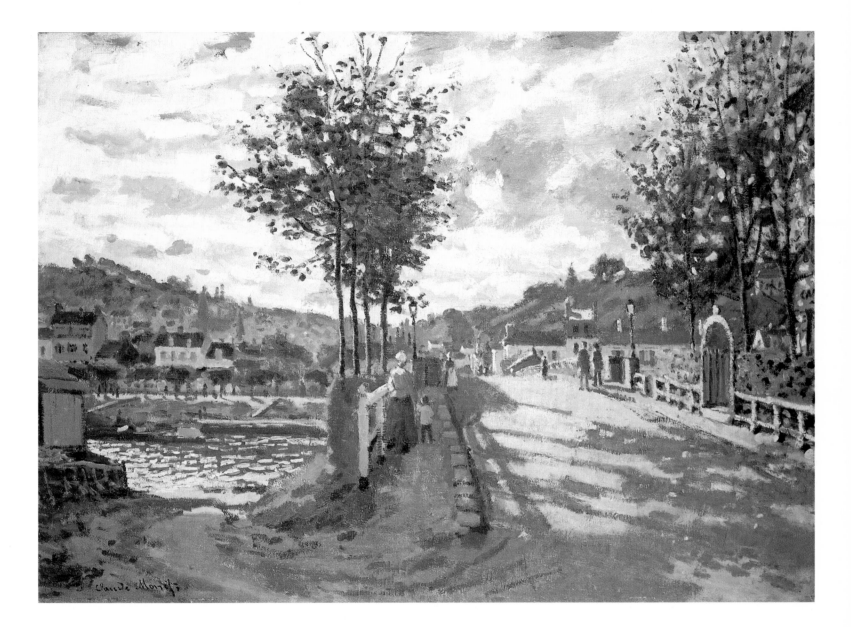

No. 13. Claude Monet
THE BRIDGE AT BOUGIVAL, 1869
(detail on p. 78)

15. Claude Monet

VERSAILLES ROAD AT LOUVECIENNES—
SNOW
(*ROUTE À LOUVECIENNES—EFFET DE
NEIGE*), 1869–70

Monet made two paintings of the route de Versailles in the winter of 1869–70 while staying with the Pissarro family. Their house is clearly visible in this, the more important of the two compositions, as the large dwelling on the left side of the street. The Pissarros rented part of this house between the autumn of 1869 and the outbreak of the Franco-Prussian War, at the beginning of which they fled from the environs of Paris to safety in Brittany. Pissarro himself worked on several paintings of the street during the same winter. One composition closely related to Monet's *Versailles Road at Louveciennes—Snow*, and with the same title (Walters Art Gallery, Baltimore), was purchased from the dealer *père* Martin by the Baltimore collector George Lucas in January 1870 (see below, IV). This suggests that Monet's painting might also date from the last months of 1869. In fact, it may record the great snowstorm of 1869 which took place in December and was written about voluminously in the newspapers. Record snowfalls and cold temperatures caused many deaths and forced closure of the Seine in certain sections. This painting, which records the effects of that winter on a "royal road" lined with large and comfortable houses, is less an image of desolation than one of comfort and domesticity in the midst of winter.

Literature about the origins of the Impressionist movement in the region of Bougival and Louveciennes customarily has stressed the importance of the relationship between Monet and Renoir at La Grenouillère in the summer of 1869 while downplaying or even dismissing the important relationship between Pissarro and Monet later in that year. This superb canvas makes it clear that both friendships were equally beneficial and significant. Pissarro's major landscapes from the years before 1869 are strongly composed village scenes painted at midday. Great as they are, they reveal the artist's debt to Corot and to the classical landscape tradition in which the careful arrangement of forms rather than

the evocation of forms in time (or weather) is of paramount importance. Monet, on the other hand, had learned from Boudin and Jongkind the secrets of a kind of landscape painting in which time—of the day, of the seasonal calendar—played across and changed the forms of nature. Here, he seized the motif of the street with a directness and simplicity that recall his earlier *Rue de la Bavolle at Honfleur* (Museum of Fine Arts, Boston). Yet in *Versailles Road at Louveciennes* he painted snow—what Renoir was later to call "the leprosy of nature"[1]—as it received and reflected the dull light of a winter day. The picture is alive with pinks, mauves, pale yellows, and manifold beiges, all of which Monet manipulated to enliven the whites and mixed off-whites of the snow itself.

While Monet was working on this canvas and the related *Road at Louveciennes, Fallen Snow, Sunset* (1874; Private Collection), Pissarro began a series of paintings of the same road—at different times of the day, in different seasons, and from different directions—that illustrates clearly the effect of his friendship with Monet. Although not conceived to be exhibited as a group, Pissarro's canvases were the first careful examination of the temporal structure of a "constant" landscape in the history of art. It is surely no accident that these landscapes about time are centered not on a building, a tree, or a hill, but on a road, along which passed the men, women, and children of Pissarro's day. This series represents a landscape seen in passing, and it might be said that it would not have been executed had it not been for Monet, who gave his older colleague the necessary push to make him a true Impressionist landscape painter.

NOTE
1. Rewald, 1980, pp. 341–351.

16. Camille Pissarro

LANDSCAPE AT LOUVECIENNES (AUTUMN)
(*LE PAYSAGE AUX ENVIRONS DE
LOUVECIENNES [AUTOMNE]*), 1869–70

This monumental landscape was probably begun in 1869, shortly after Pissarro moved to Louveciennes and established close contact with Monet.

The painting was finished in 1870, perhaps before Pissarro's departure for Brittany in July and his eventual trip to England in December. Both the composition and the patchy, rugged facture indicate that he had just seen such paintings by Monet as *The Bridge at Bougival* (no. 13) and even the pair of paintings of La Grenouillère (no. 14). When seen in contrast to the village landscapes of similar dimensions that Pissarro had painted during the previous two years at Pontoise, this picture appears both more complex and more informally structured. Gone are the rectangular areas of paint that interlock to form a rigorous geometry. Instead, walls, roofs, windows, leaves, furrows, manure, plants, figures, and paths are woven together to form a closely modulated texture of overlapping brush strokes. It is as if Pissarro had been released from an aesthetic prison by his exposure to the work being done by Monet and Renoir, and, in spite of the fact that his desire to structure his painting geometrically remained, it was mitigated in this monumental, decidedly Impressionist canvas by an abandoned recording of a "field of vision" with all its complexity and richness.

Pissarro's motif in this painting is a group of kitchen gardens behind a row of small mid-nineteenth-century houses on what was then called the rue des Creux and is today the rue du Maréchal Joffre in Louveciennes. Little more than a village path along which humble dwellings had been constructed since the seventeenth century, the rue des Creux contrasted in every way with the royal route de Versailles, which ran roughly parallel to it and on which the painter lived (no. 15). Where the latter was a wide, paved artery linking Louveciennes with Marly-le-Roi and Versailles, the former was unpaved, unimportant, and without a destination other than the fields themselves. It linked Louveciennes only with the land. Pissarro could reach the site of this landscape after a three-minute walk from his own house down the small path visible at the front of the painting, then, as now, called the rue du Parc de Marly.

Unlike Monet and Renoir, Pissarro retained a dogged affection for the tradi-

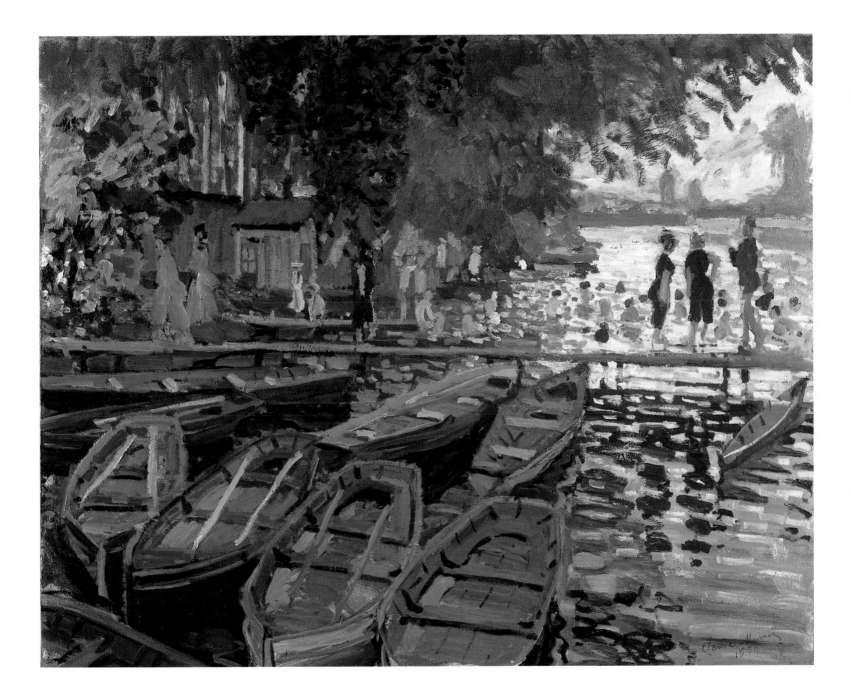

No. 14. Claude Monet
BATHING AT LA GRENOUILLÈRE, 1869
(detail on pp. 2–3)

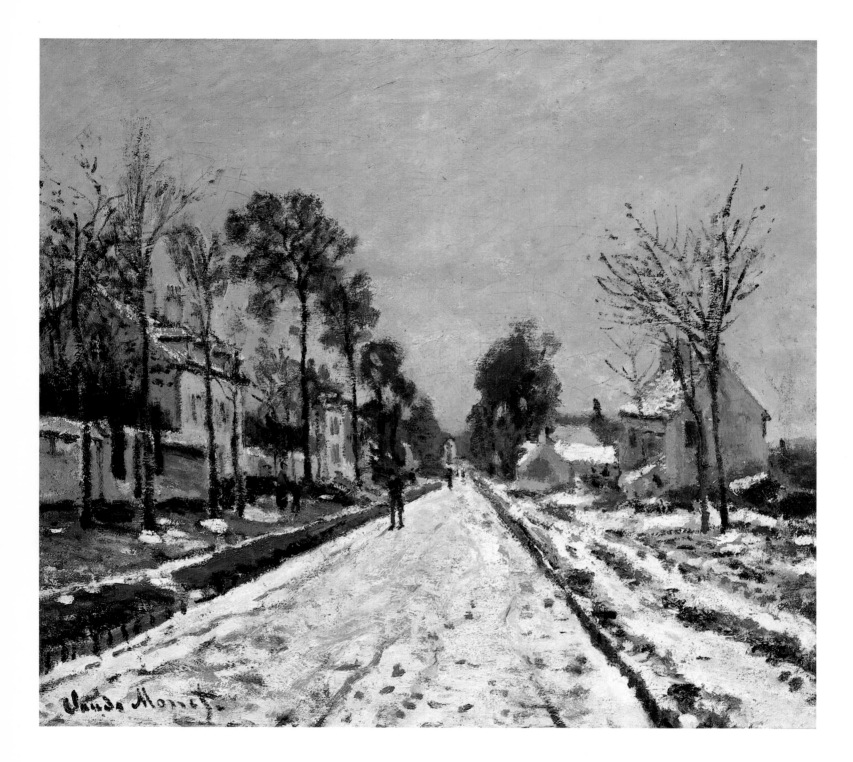

No. 15. Claude Monet
VERSAILLES ROAD AT LOUVECIENNES — SNOW, 1869–70

A DAY IN THE COUNTRY

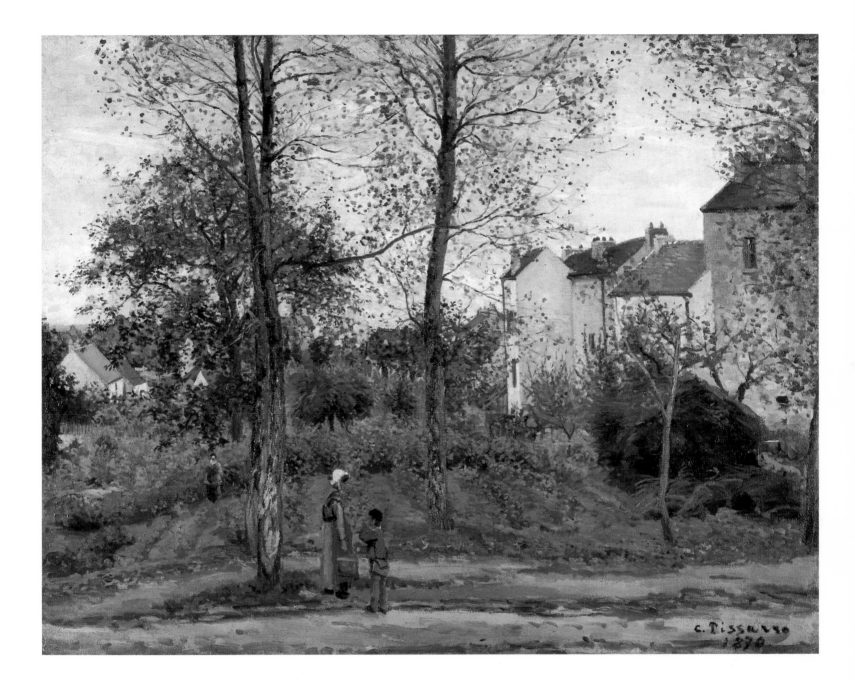

No. 16. Camille Pissarro
LANDSCAPE AT LOUVECIENNES (AUTUMN), 1869–70

tional landscape of the rural poor, the majority of Louveciennes' year-round residents. He did not depict the imposing country residences of the nouveau riche—pictured in the distance in works by Sisley[1]—nor are we given a glimpse of the palatial summer houses built by the aristocracy throughout the region during the eighteenth century, the most famous of which was the château built by Claude-Nicolas Ledoux for Mme. du Barry in the hamlet of Voisins. Here, instead, we see a simply dressed woman, if not a peasant then a housewife or agricultural worker, in the midst of an utterly mundane landscape. She is carrying a bucket and chatting with a young boy—her son?—dressed as a rural laborer, but carrying his school satchel over his shoulder. While we can easily imagine that she inhabits one of the humble dwellings in the background with her husband and family, the satchel of the boy, tiny and discreet as it is, refers to education and to the expanding literacy—and ambition—of France's rural youth. While Pissarro was celebrating rural France, Monet and Renoir were painting their glorious celebrations of urban leisure at La Grenouillère (no. 14; fig. 15). Although the difference between these two modes may appear to be immense, both were equally important components of early Impressionism. The boy's satchel is as powerful a symbol of modernity and freedom as Monet's floating restaurant.

NOTE
1. Daulte 99, 100, 144.

17. Camille Pissarro

WASH HOUSE AT BOUGIVAL
(LE LAVOIR, BOUGIVAL), 1872

This richly detailed view of the Seine at Bougival has traditionally been titled *Le Lavoir, Pontoise* and has been thought to be a representation of the smaller Oise River near the town of Pontoise, to which Pissarro moved in the late spring of 1872. In fact, comparison with firmly documented pictures by Sisley[1] as well as with contemporary photographs of the Seine at Bougival by Bevan (see above, III/2) make a correct identification of the site possible. The misidentification, trivial as it might appear, is significant

because this painting reveals the industrial aspect of modernization in this region, an aspect missing from most paintings of the area by Pissarro's colleagues. Even Sisley, who painted exactly the same landscape three years later (no. 23), omitted the smokestack from the small factory at the left, as if to de-emphasize the building's industrial nature.

Wash House at Bougival makes an explicit visual comparison between handwork and the work of machines. The composition is centered on a floating washing facility in the Seine where local women would pay a minimal sum to wash their clothes directly in the river. Presumably, the woman leaning on the tree at the left of the painting is waiting her turn, and her presence, as well as her direct gaze at the viewer, gives greater reality to the hand labor of the silhouetted women already in the washing facility. Directly behind them and further along the river is a small factory with its chimney smoking discreetly, and behind it, the village of Bougival. It is autumn or winter; the trees are bare and the barges move slowly up the river under the unmodulated light of a gray day. If this painting has a subject, it is the delicate balance between man and machine in a changing landscape, recorded with immense concentration and refinement.

The painting is startling when one considers that it does represent Bougival, but not the Bougival of Sardou, of the painter Français (see above, III/2), or of Monet and Renoir. It is difficult when looking at the picture to realize that La Grenouillère (no. 14) was no more than 100 yards from this landscape, on the right. Indeed, Pissarro, in his only painted representation of the restaurant (traditionally called *The Oise at Pontoise* [1872; Location unknown]), included it only as a flimsy building at the right of a balanced composition, the other half of which was dominated by the same factory we see at the center of *Wash House at Bougival*. Neither of these paintings shows us a landscape that conforms to any common notions of rural beauty, nor do they express clearly the modern, nationalist desires of Pissarro's France (see above, II). That they were made before and after the disastrous days of the Franco-Prussian War and the Commune,

respectively, tells us that certain of Pissarro's anxieties about the modern world played the role of social and aesthetic constants in his work during a period of rapid political change.

NOTE
1. See Daulte 159–160.

18. Camille Pissarro

LANDSCAPE NEAR LOUVECIENNES
(PAYSAGE, LOUVECIENNES), c. 1875

Although traditionally dated 1875 and called *Paysage à Pontoise*, this picture was painted near Louveciennes, probably in 1870, but possibly during Pissarro's second campaign in that region during 1871 and early 1872. Its facture and its palette, which tends toward browns and greens, bear little relationship to those of Pissarro's paintings of 1875, many of which were painted with a palette knife and have bright, high-keyed palettes. Although the group of farm buildings chosen as the central motif of *Landscape near Louveciennes* has not been identified, and the resolute flatness of the site makes it difficult to place near that town's hilly environs, three paintings securely datable to Pissarro's Louveciennes period represent the same buildings.[1] Of these, *Landscape near Louveciennes* is closest to the awkwardly titled *Path in the Field with a Garden Gate at the Right* (1871; French and Company, New York).

As we have already seen, Pissarro's representations of this region, in their frank acceptance of the traditional rural landscape, contrast with those of his colleagues. However, this painting, centered on a collection of farm buildings probably built earlier in the century, is not strictly bucolic. Indeed, Pissarro has included a construction site in the foreground of the picture where a new building, perhaps a country house, perhaps another farm building, is being built. His insertion of this image of change undercuts the viewer's easy, pleasurable response to the rural landscape as a retreat from progress and urbanism.

NOTE
1. Pissarro and Venturi 83, 126, 190.

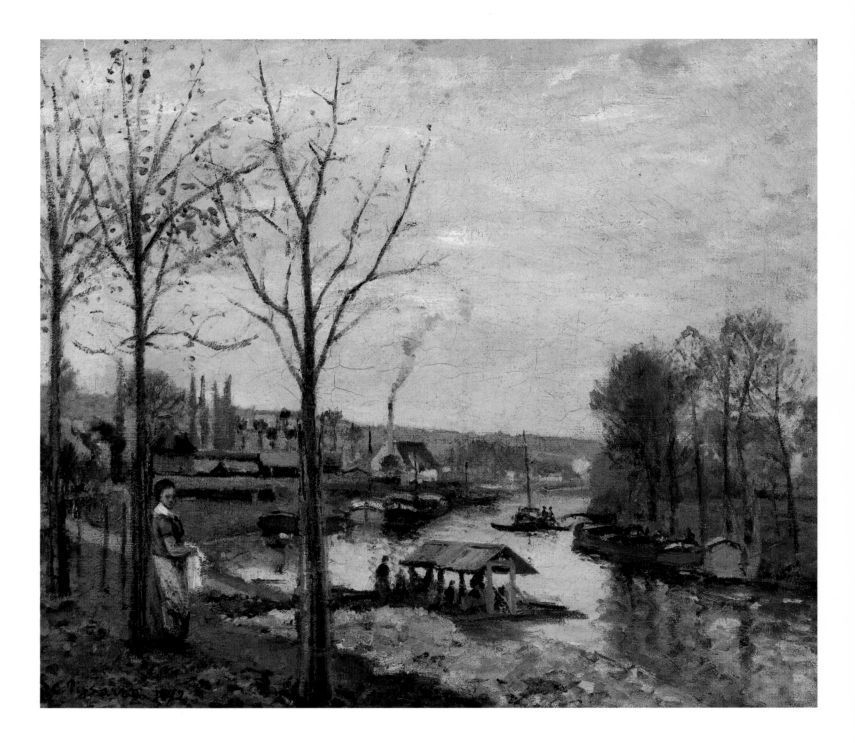

No. 17. Camille Pissarro
WASH HOUSE AT BOUGIVAL, 1872

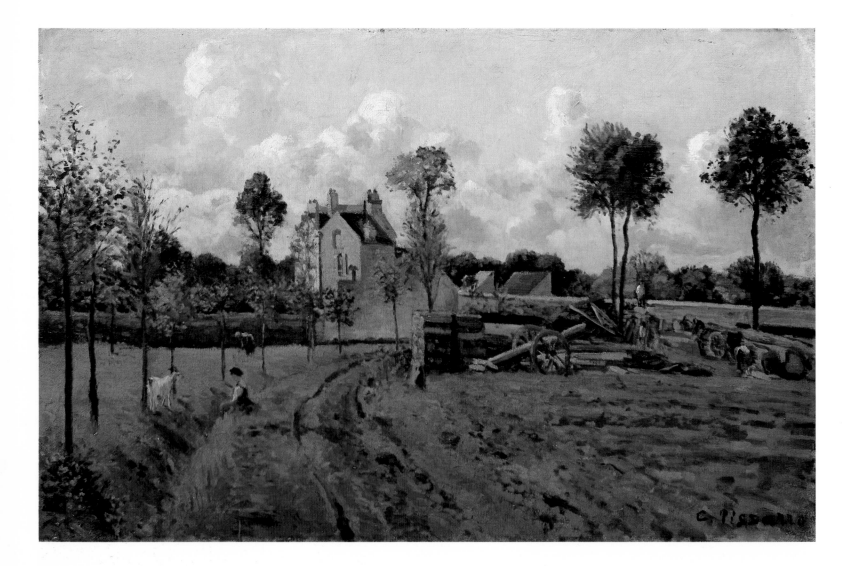

No. 18. Camille Pissarro
LANDSCAPE NEAR LOUVECIENNES, c. 1875

A DAY IN THE COUNTRY

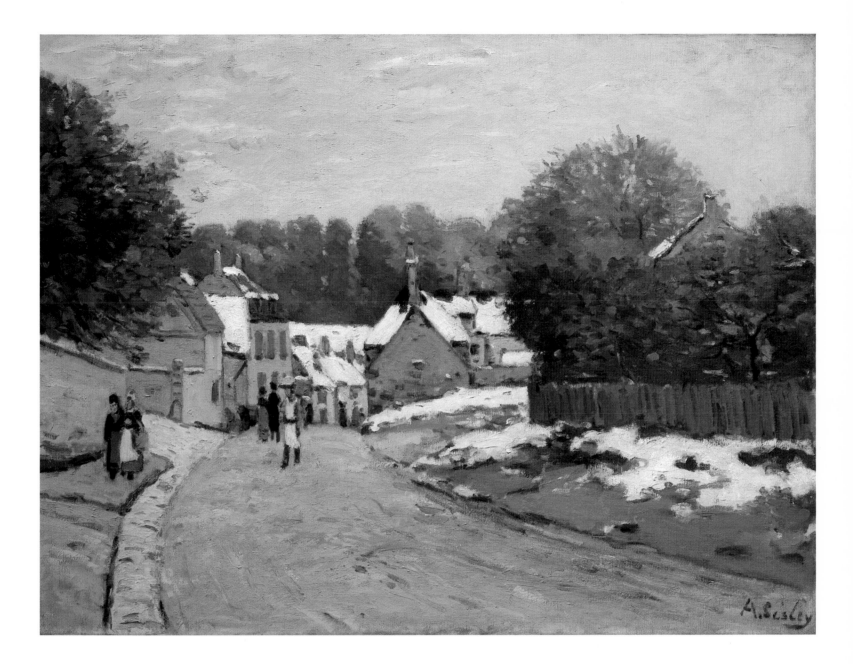

No. 19. Alfred Sisley
FIRST SNOW AT LOUVECIENNES, c. 1870–71

19. Alfred Sisley

FIRST SNOW AT LOUVECIENNES
(*PREMIÈRES NEIGES À LOUVECIENNES*),
c. 1870–71

If this picture was in fact painted during the winter of 1870 in Louveciennes, it relates closely to the famous winter landscapes of the same region by Monet and Pissarro. The earliest of these were most likely begun late in 1869 (no. 15) and finished in 1870. We know, however, that Sisley moved to Louveciennes during the Commune, and it is more likely that this painting was made in the winter of 1870–71 with Monet's and Pissarro's earlier landscapes in mind. It is even possible that Sisley saw the many paintings by Pissarro left in his house in Louveciennes when his family fled hastily to Brittany in 1870 (see above, III/2). Yet whatever its true relationship to the winter landscapes by his friends, *First Snow at Louveciennes* is among the most masterful works in this genre of the early 1870s.

For his motif Sisley chose the small road called the rue de la Paix, which led into the village of Louveciennes from the hamlet of Voisins, where he lived. There are no remarkable buildings included; indeed, the bell tower of the small church at Louveciennes is screened by the trees at the left (see above, III/2). This landscape, like those already mentioned of Monet and Pissarro, is a celebration of what was, in fact, a small road which was "enlarged" by Sisley to cover most of the picture's foreground. The humble seventeenth- and eighteenth-century stone and stucco buldings of the village huddle in a picturesque jumble at the end of the road. Only the clearly articulated plane of the house at the left gives strength to the middle ground. There is a delicate tension created by the contrast between the densely concentrated village and the spreading, spacious arcs of the road; the composition invites us to look at a small village from the perspective of the world "beyond" it.

20. Alfred Sisley

THE SEINE AT BOUGIVAL
(*LA SEINE À BOUGIVAL*), 1872–73

"Totally accessible as it is, you will leave unwillingly the banks of the river [at Bougival], so charming, so luminous, so verdant...."[1] Sardou, who wrote those delightful words in his 1867 guide to Paris and its environs (see above, III/2), surely must have been describing the part of the Seine painted early in the 1870s by Sisley. In this and another version of the composition (Nationalmuseum, Stockholm), Sisley painted the river in one of its few unspoiled reaches near Paris. Here, there is nothing but water, trees, and sky. No boats ruffle the placid waters. No newly built country houses disgorge noisy swimmers and boating parties into the water. The river is even tranquil enough that water plants grow along its banks at the left. This river-scape harks back to those of Daubigny, who worked near and far away from Paris on scenes of equivalently exquisite natural beauty.

It is difficult to imagine when looking at this painting that the Seine near Bougival was actually a busy waterway, along which hundreds of barges and steamboats passed on their way to the increasingly industrialized river ports of Argenteuil, Courbevoie, and, of course, Paris. Just behind Sisley, as he faced the Ile de Croissy looking downstream, was not only the town of Bougival with its barge-filled banks, but also the great *machine de Marly* (fig. 17). Knowing its location, a Parisian of Sisley's day would have found this intimate and bucolic painting all the more poignant because of the fragility of the landscape it depicts in contrast to the liveliness of that upon which the artist turned his back.

NOTE
1. La Croix (ed.), 1867, vol. II, p. 1455.

21. Alfred Sisley

WATERING PLACE AT MARLY
(*L'ABREUVOIR DE MARLY*), 1875

The tiny town of Marly-le-Roi was Sisley's territory. Avoided by Monet, Renoir, and even Pissarro, it clustered around the edges of the great Parc de Marly (see above, III/2). Although Pissarro lived no more than a ten-minute walk away from Marly-le-Roi, if he went there, he failed to paint it. On the other hand, there are at least 30 paintings of the town recorded in the Sisley literature, and others will undoubtedly come to light.

Marly-le-Roi was important less for its appearance in the last half of the nineteenth century than for its history. The many guidebooks to the environs of Paris written in the second half of the nineteenth century make it clear that one visited Marly-le-Roi not simply because it was charming, but because it was the site of the Château de Marly. Both Sardou and Joanne expatiated in elegant prose upon the life of the court there during the seventeenth and early eighteenth centuries and contrasted that world with the charming, but humble, village which managed to survive after the court left. Sardou, after describing Le Nôtre's brilliant gardens at the height of their glory, made this contrast perfectly clear by stating: "One single pool from the side of the second parterre remains: the women from Louveciennes and Marly come there to wash their clothes".[1]

It is just that pool that Sisley painted in *Watering Place at Marly*. His painting is not a royal landscape, nor is it a nostalgic look at a great architectural ruin in the midst of its decadence. Rather, it is a celebration of the ordinary beauties of the Ile de France on a fresh, cool summer day. Surrounded by an unpaved road which swoops into the foreground, the pool dominates the left half of this and another landscape of 1875 by Sisley (*The Pool at Marly, Snow* [Private Collection]). It is most emphatically *not* the central motif of the landscape. Indeed, Sisley was just as captivated by the clouds, the light playing on the white plaster houses, and the shadows that dappled the road as he was by the remains of the great pool itself. Because of its historical importance, most visitors to Marly would have preferred to view the pool from the town, looking into the forest of the Parc de Marly, as Sisley himself did while painting in the dead of winter in 1875.[2] More frequently, however, he turned his back on that charming and verdant landscape, choosing instead a view which exuded a maximum amount of nervous energy as light played actively across many diverse forms.

NOTES
1. La Croix (ed.), 1867, vol. II, p. 1464.
2. Daulte 152, 154.

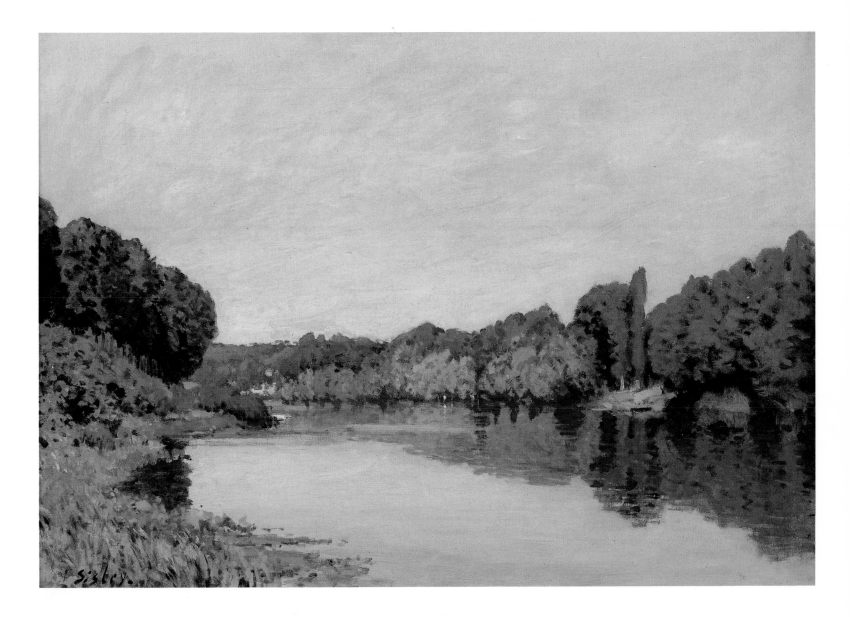

No. 20. Alfred Sisley
THE SEINE AT BOUGIVAL, 1872–73

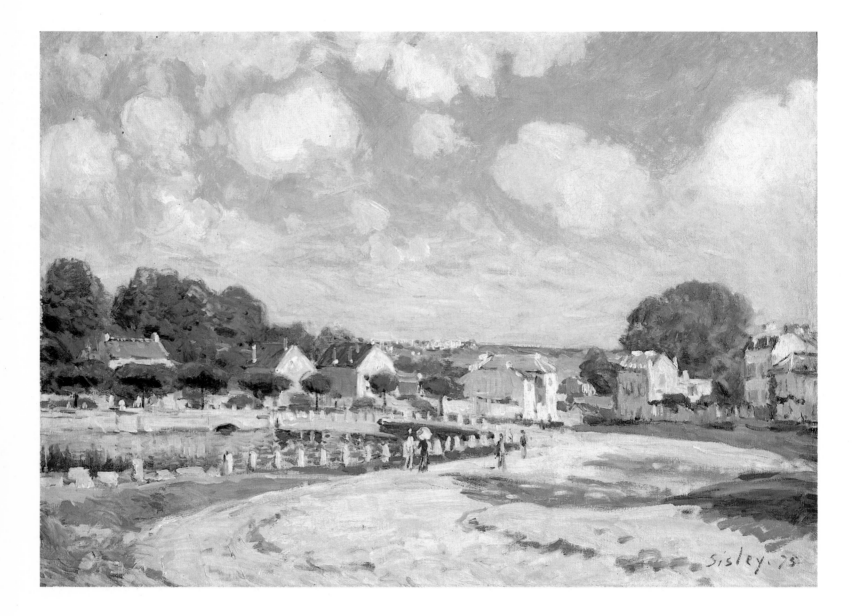

No. 21. Alfred Sisley
WATERING PLACE AT MARLY, 1875

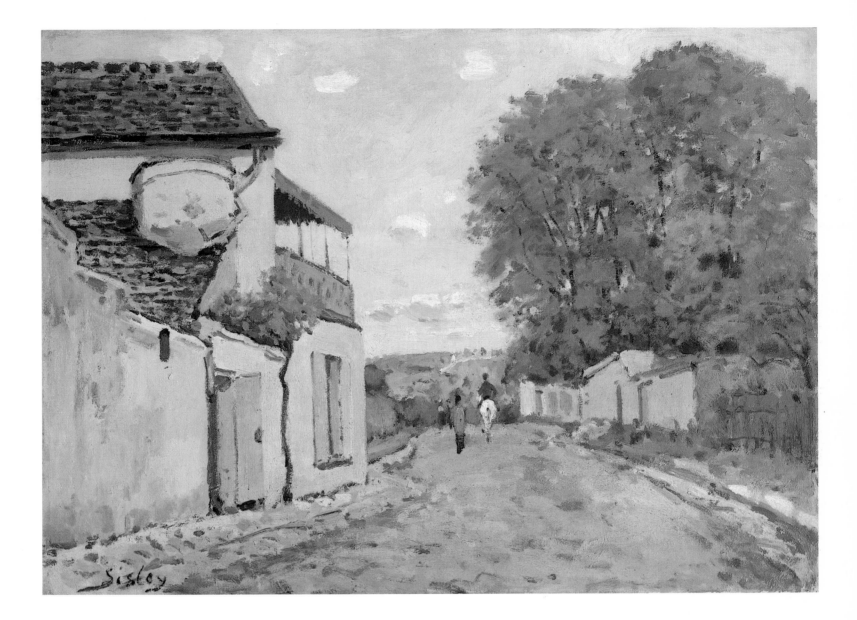

No. 22. Alfred Sisley
STREET IN LOUVECIENNES, 1872–73

22. Alfred Sisley

STREET IN LOUVECIENNES
(LA ROUTE À LOUVECIENNES), 1872–83

Sisley either retained for a long period the house he rented in Voisins in 1871 or rented it repeatedly for several years after that. (Because he rented the property, his name was never registered in the official cadastral records, and it is therefore impossible to trace his movements exactly.) It is difficult to fix his undated paintings of the area in time because he, like Pissarro, returned to his motifs through the years. *Street in Louveciennes* has traditionally been dated to 1875 because of its relationship to another landscape, *A Street in Louveciennes at Evening Time* (Private Collection, Paris), depicting the same motif that was signed and dated in that year by Sisley himself. However, the carefully controlled facture and tightly ordered composition suggest a date earlier in the decade, perhaps nearer to the time when Sisley first moved to the Louveciennes region.

One of the artist's favorite motifs in the 1870s was the rural café or restaurant. This picture represents the Café Mite in Voisins very near the painter's house. Sisley painted this restaurant from the other direction in 1874 (*A Road in Louveciennes* [Private Collection, Paris]) and it has been identified by Daulte as the painter's home for several months of that year.[1] His decision to paint such buildings repeatedly has clear precedents in seventeenth-century Dutch art, in which rural inns and taverns were frequently chosen as the locus for landscape compositions. Numerous passages in both rural guidebooks and publications about landscape painting by writers from Alfred Sensier to Henriet celebrated the food and conviviality of rural inns. Landscape painters lived, ate, and drank in such places, often decorating the walls as payment to a generous owner. A day in the country was not complete unless one dined well at an inn, generally for a price significantly lower than at a comparable restaurant in Paris.

NOTE
1. Daulte 149.

23. Alfred Sisley

THE SEINE AT PORT-MARLY, PILES OF SAND
(LA SEINE À PORT-MARLY—TAS DE SABLE), 1875

This commanding landscape was painted at nearly the same place on the river where Pissarro had stood to paint *Wash House at Bougival* three years earlier (no. 17). The building to the far left of this composition is the factory—with its smokestack omitted—on which Pissarro had centered his composition. Sisley painted two other landscapes from the same spot in 1875,[1] one of which includes the smokestack.

The Seine at Port-Marly, Piles of Sand is rare among Sisley's landscapes—indeed, among Impressionist landscapes in general—in its attention to the dredging of the Seine. More than any other Impressionist, Sisley was fascinated by the complexity of river life. Less interested in pleasure craft and their passengers than his friend Monet (nos. 39–43), Sisley preferred to render the economically important boat life of the Seine—from ferries to flat barges and motor tugs. In this painting the shipping lanes in the middle of the river are being dredged by men in small boats; the piles of sand at the side of the river were intended for sale to building contractors and gardeners. The poles in the river were used to tie the boats as they arrived from the dredging area, and the men working in the boats in the middle ground of Sisley's painting are lowering buckets into the river. Interestingly, these boats are not markedly different from the rowboats available to be rented for pleasure in the foreground of Monet's *Bathing at La Grenouillère* (no. 14); this may indicate that such craft had varying seasonal uses. A contemporary landscape photograph by Bevan (see above, III/2) also includes the piles of sand (fig. 23).

As if to mitigate against our "reading" this painting as a simple document of river life, Sisley chose a brilliant and unusual palette. In fact, it may have been the bright, almost turquoise color of the water as it contrasted with the yellow-beige of the sand that attracted Sisley to

the subject initially. Yet, for all its beauty, this is a difficult landscape, in which we can observe a pre-industrial working population struggling to control the river and keep it navigable. The painting proves very clearly that pictures of this region, the cradle of Impressionism, must be understood as pictorial meditations upon the modernization of France (no. 16).

NOTE
1. Daulte 177–178.

24. Alfred Sisley

THE SEINE AT PORT-MARLY
(BORDS DE LA SEINE À PORT-MARLY), 1875

Sisley painted this unproblematically rural landscape on the banks of the Seine near Port-Marly, where he went many times in 1875 and 1876. The small boat in the foreground of this picture is filled with sand dredged from the Seine in order to keep its channel open for the extensive commercial barge traffic between Le Havre and Paris. On the basis of this motif the picture could almost be paired with the identically sized *Seine at Port-Marly, Piles of Sand* (no. 23), where similar boats negotiate the river. In fact, it is likely that *The Seine at Port-Marly* was painted from a spot very near that at which Sisley stood to paint the other picture. Instead of directing his attention down the river here, to render it as a spacious highway of water, Sisley adopted a planar compositional strategy, representing a group of farm buildings on the island running down the center of the Seine between Bougival and Port-Marly. The viewer seems almost to be floating, and the painting can be interpreted as a stable view perceived from a watery vantage point. Thus it has precedents in Daubigny's *Boat Trip* (1862) and in many paintings by Monet made from his floating studio at Argenteuil (nos. 39–43).

This composition calls to mind the opening pages of Flaubert's *L'Education sentimentale,* in which the young hero pursues the alluring Mme. Arnoux on a boat to Paris, observing all the while the inaccessible beauties of the traditional

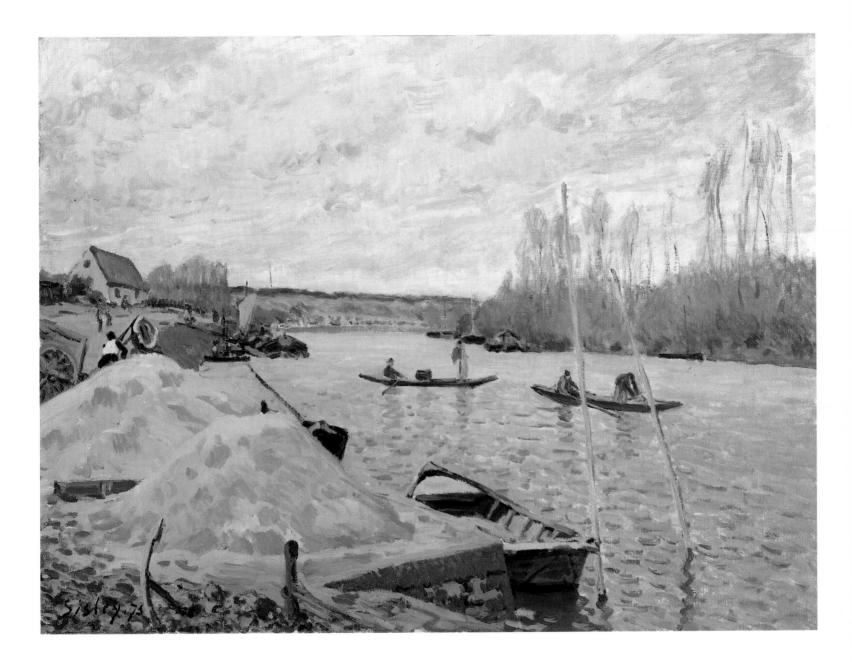

No. 23. Alfred Sisley
THE SEINE AT PORT-MARLY, PILES OF SAND, 1875

landscape. Like Flaubert, who preferred bourgeois subjects, even in the provinces, Sisley rarely painted such a completely rural subject as this detached farm, gravitating instead toward suburban landscapes with country houses, rural paths, orchards, and outdoor restaurants.

Interestingly, *The Seine at Port-Marly* was signed and dated twice by Sisley. When he finished the painting he signed it at the lower left corner. Afterwards its first owner, Comte Doria, had it placed in a smaller frame, probably to pair it with another painting of slightly narrower dimensions. At this point Sisley re-signed the painting so that his signature would appear clearly to the viewer.

25. Alfred Sisley
The Versailles Road, Louveciennes
(La Route de Versailles), 1875

As we have seen, the route de Versailles, a popular motif of Impressionist paintings, was constructed as part of Le Nôtre's vast scheme for transporting water from the Seine to the gardens of the Château de Marly and, eventually, Versailles (see above, III/2). By 1700 the road had become the major route connecting the town of Port-Marly with Versailles. It was heavily traveled throughout the nineteenth century, and both Pissarro and Renoir lived on it for short periods of time. There are Impressionist representations of virtually all aspects of the road: houses, trees, rural inns, and travelers seen from every imaginable viewpoint in every season and at many times of day. Indeed, the route de Versailles is to the Impressionist iconography of roads what the Seine is to its iconography of rivers (see above, II and below, III/4).

In this gentle summer landscape Sisley chose to emphasize the enormous chestnut trees which bordered the route de Versailles at irregular intervals. Originally lined on both sides with trees, the road was heavily built up in the 1800s, and many of them were cut down to be replaced by dwellings. In the painting two majestic trees tower over the tiny inhabitants and the informal group of houses in the middle ground. Their foliage, pruned to prevent lateral growth which would impair the view of the road, seems almost to tremble in the breeze of a hazy day.

26. Alfred Sisley
Flood at Port-Marly
(L'Inondation à Port-Marly), 1876

Flood at Port-Marly is the largest—and finest—of three identically composed versions of this subject, the first of which, identically titled (Private Collection, Paris) was painted in 1871–72. The chance to make architecture appear to dissolve by surrounding it on all sides with atmosphere and water was clearly irresistible to Sisley, and, after experiencing the flooding of the Seine in 1872, he returned to Port-Marly for a protracted period in 1876. In that year, not only did he paint six landscapes representing the flooded river, but he also painted the landscape *before* the flooding commenced (as if to form a narrative sequence).

What is fascinating about these paintings is that they are so peaceful. The viewer feels none of the danger or despair of a real flood and is, instead, captivated by the play of light in the sky and water that surround the Restaurant à Saint-Nicolas. The flood seems almost a usual occurrence, as if it were taking place in Venice rather than suburban Paris.

Both the calm and the clarity of Sisley's flood landscapes can be contrasted in every way with paintings of the same subject by French artists of the previous generation. The most famous example, Huet's *Flood at Saint-Cloud* (1855; Musée de Louvre, Paris), was purchased by Napoleon III for the Musée de Luxembourg and was therefore widely available for study. Sisley's mundane, but poetic, flood paintings, like those by Pissarro (for example, *The Inundation, Saint-Ouen-l'Aumone* [1873; Museum of Fine Arts, Boston]) lack the dramatic intensity of their iconographical prototypes in Romantic art.

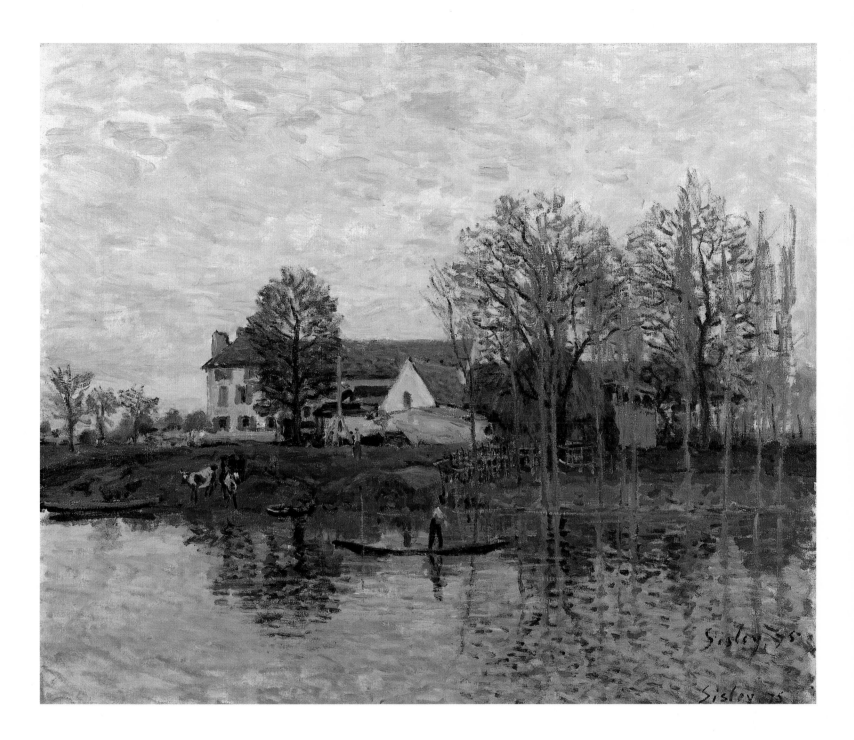

No. 24. Alfred Sisley
THE SEINE AT PORT-MARLY, 1875

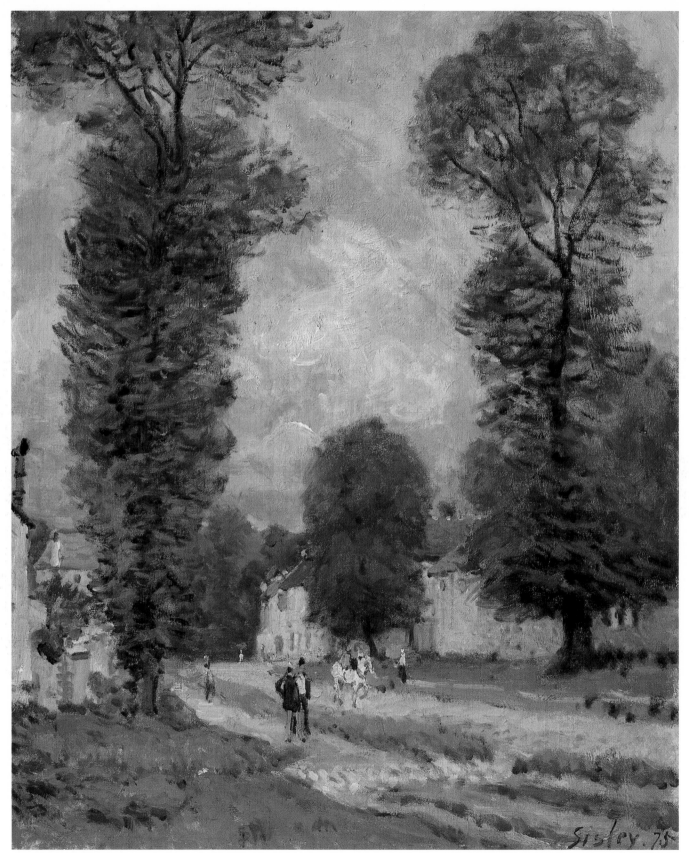

No. 25. Alfred Sisley
THE VERSAILLES ROAD, LOUVECIENNES, 1875

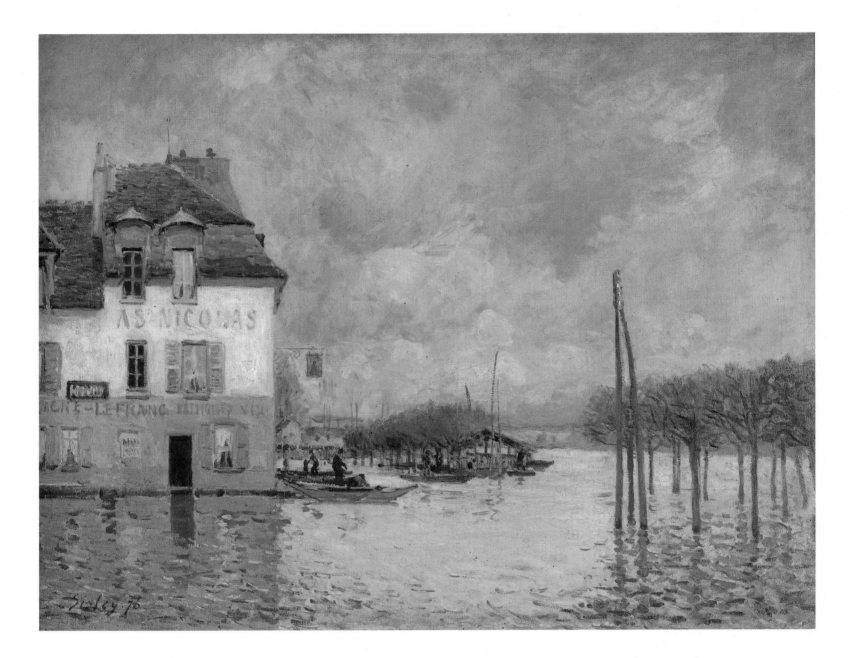

No. 26. Alfred Sisley
FLOOD AT PORT-MARLY, 1876

III/3

The Urban Landscape

L*A VIE PARISIENNE,* an operetta by Jacques Offenbach, opened to re-sounding popular success at the Palais Royal on the eve of the "Exposition Universelle" of 1867 (see above, II). Both operetta and exhibition celebrated what was then known as the "new Paris." The libretto of *La Vie Parisienne,* by Henri Meilhac and Ludovic Halévy, was an inspired inventory of the city's charms, extolling in verse her boulevards, parks, cafés, theaters, monuments, and, of course, her river, the Seine. One of the operetta's characters, a former servant, takes advantage of the "Exposition Universelle" to become a guide to Paris. "It is my business," he announces, "to take foreigners 'round the city and show them all the beauties of the capital."[1]

In fact, all Paris was "on show" in the second half of the nineteenth century. The series of well-timed industrial exhibitions (fig. 25) was designed to reveal "new Paris" to the world at large. Writers Victor Hugo, Sand, Du Camp, and Michelet, among others, sang the city's praises in the *Paris Guide* of 1867; Manet, the arch-modernist, devoted a special canvas to that year's exposition (fig. 25). During this period the Impressionists investigated the physiognomy of "new Paris" in a sweeping series of canvases.

What was "new Paris?" As we have seen, the ancient capital of France was essentially rebuilt during the 1800s under the direction of Baron Haussmann (see above, II and below, III/3). Its population swelled with a stream of provincial and international immigrants, more than tripling between 1800 and 1870. The near suburbs were annexed to Paris in 1860.[2] Sanitary services were improved, and a comprehensive urban plan was created during the Second Empire. Hundreds of thousands of buildings were sys-

tematically demolished to make way for the tree-lined boulevards which formed a transportation network resembling the neat *allées* in classical French gardens (see above, II). The major monuments of Parisian civilization—the Hôtel de Ville, Notre-Dame, the Tour Saint-Jacques, and even the Louvre (no. 84)—were detached from the fabric of the city, redesigned and rebuilt to serve as symbolic links between the glories of the French past and her modern destiny. Indeed, Offenbach's *La Vie Parisienne* was set in a shifting city. Both photographs (see below, V) and popular illustrations of the period reveal the extent of the destruction necessitated by the sweeping transformation which led to the creation of "new Paris."

In the midst of this supremely transitory city, the Impressionists seized upon those aspects that were utterly novel. Their Paris was truly an urban landscape, a mechanical and impersonal world in which the background predominated over the figures. Ignoring the narrow and tortuous streets of the old city, the traditional Paris celebrated in prose by Hugo and Balzac and in images by Corot, Honoré Daumier, and Charles Meryon, the Impressionists set their easels in the windows of newly constructed *hôtels,* or apartments, and made paintings of railroad stations (nos. 30–32), boulevards (nos. 33, 35), and parks (no. 84). Their city was grand and enormous, less a set of intersecting neighborhoods than a sweeping landscape inhabited by multitudes of people. The changing seasons in this landscape were indicated by the trees which lined the boulevards and filled the parks.

The urban landscape of the Impressionists, like their suburban landscape, had its own peculiar geography. The painters were obsessed with certain areas and ignored others. They painted the streets and boulevards around the Gare Saint-Lazare, combed the banks of the Seine, and moved around the Louvre and its garden, the Tuileries. They climbed the hills of Montmartre and the Trocadéro (no. 27) to gaze on the city as it stretched along the vast plain created by the Seine. Their landscape therefore had recognizable centers, and, for all its scale and grandeur, the Paris they depicted was only a small portion of the actual city. It was confined almost exclusively to the Right Bank and especially to the city's northwest quadrant. While the greatest small parks—the Tuileries and the Parc Monceau—were lovingly painted by Manet, Monet, and Pissarro, the sublime Parc aux Buttes Chaumont, landscaped by Adolphe Alphand and set in a large working-class area, was ignored by the Impressionists. While the Louvre was painted countless times, Notre-Dame, the Arc de Triomphe, and the Place de la Concorde were avoided. Indeed, as was the case with the Impressionists' renderings of other locales in France, the tourist sites, the places marked prominently in each guidebook, are conspicuous for their absence in the Paris the artists painted (see above, II and III/2).

The great river of Paris—its banks and its bridges spanning the heart of the capital—was especially inviting to French nineteenth-century artists, and the Impressionists were no exception. Even minor artists like Stanislas Lépine and Guillaumin executed paintings of the Seine and its surroundings in the 1860s. Berthe Morisot gained admittance to the Salon of 1867 with an 1866 view entitled *The Seine under the Iéna Bridge* (Location unknown). One of the first landscapes done by Gauguin was of *The Seine at the Iéna Bridge under Snow* (fig. 26); one of the last by Pissarro was *The River Seine and the Louvre* (fig. 27).

In his novel *La Curée* (1872) Zola opposed the traditional Ile Saint-Louis neighborhood on the Left Bank (as painted, for example, by Lépine) to

Fig. 25. Manet, *The "Exposition Universelle," Paris, 1867*, 1867. Oil on canvas. 108 x 196.5 cm. Nasjonalgalleriet, Oslo. Photo: Nasjonalgalleriet.

Haussmann's "new Paris." In his *L'Oeuvre* (1886) the Seine reappears, luring the painter-hero, Claude Lantier, to its banks again and again. Lantier becomes obsessed with the water and with the city, which he identifies with the female principle, an association which recurs often in literature and whose destructive overtones Zola wished to maximize. Yet, if such mysteries of the Seine appealed to many writers, the Impressionists seemed sensitive only to her grandeur, her beauty, and her charm. Rarely, if ever, does one imagine that the river could symbolize fate, change, or death when looking at paintings by Monet, Pissarro, Renoir, or Sisley. Indeed, it simply exists in such works as a vast visual diversion, a focus of movement, commerce, and exchange (see above, III/2, and below, III/4).

Since the experience of living in Paris was thought to be essential to the training of an artist during the nineteenth century, young provincials flocked to the city: Zola and Cézanne from Aix-en-Provence (see below, III/9), Bazille from Montpellier, and Monet from Le Havre. The attraction Paris held for artists was due in no small part to the presence of the Louvre—at the very heart of the "new Paris"—and its expanding collections. The museum—actually a palace complex containing a series of museums and government offices—was faithfully frequented by such Paris residents as Manet and I.-H.-J.-T. Fantin-Latour. In 1859 Manet made the acquaintance of Edgar Degas at the Louvre; in 1868 Fantin-Latour introduced Manet to Berthe Morisot there. Yet it was not only the museum's interior and its treasures that fascinated these young artists, but the landscape around it.

It was from the Louvre itself that Monet did his first urban views in the spring of 1867 (*Saint-Germain-l'Auxerrois* [Nationalgalerie, Berlin]; *The Garden of l'Infante* [Allen Memorial Art Museum, Oberlin]; and *Quay by*

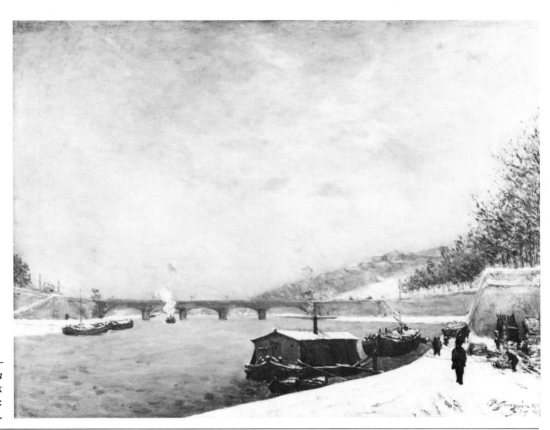

Fig. 26. Gauguin, *The Seine at the Iéna Bridge under Snow,* 1875. Oil on canvas. 65 x 92 cm. Musée d'Orsay, Paris. Photo: Musées Nationaux.

the Louvre [Haags Gemeentemuseum, The Hague]). On April 27 he requested permission from the Surintendant des beaux-arts to set up his easel, not as a copyist in the museum, but as a landscape painter in its colonnade. On May 20 he wrote to Bazille, "Renoir and I are still at work on our views of Paris."[3] Once more, in 1872, Renoir and Monet painted the same subject, the Pont-Neuf, adjacent to the Louvre (National Gallery of Art, Washington, D.C., and Wendy and Emery Reeves Foundation), but this time they chose to paint it in different seasons (see above, III/2). Interested in the same vista, Pissarro wrote to his son three years before his death, "I've found a flat on the hill overlooking the Pont-Neuf with a beautiful view. I shall move there in July...I don't want to miss the chance to show another picturesque side of Paris."[4] Indeed, the elderly Pissarro made the landscape of the Louvre utterly his own, picturing the building and its surroundings in several series of canvases.

The American viewer of these paintings of the Louvre and its landscape must remember two things. First, the palace complex as we know it was only completed during the Second Empire after a vast program of architectural unification presided over by Ludovico Visconti. It was therefore at once new and old. Second, the portion of the complex called the Palais des Tuileries, built for Marie de Medici and subsequently the urban royal palace until the era of Napoleon III, was sacked and all but totally destroyed during the Commune. Thus, when Pissarro painted this building and its garden in the last decade of his life,[5] he was portraying an incomplete monument with ambiguous political overtones.

Other parts of Paris attracted the Impressionists as well. The "urban village" of Montmartre interested them early on—Pissarro and Cézanne in

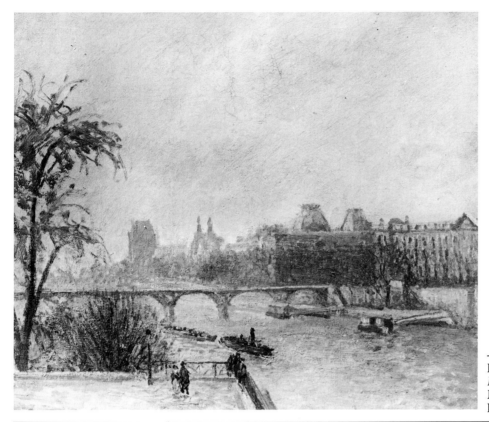

Fig. 27. Pissarro, *The River Seine and the Louvre*, 1903. Oil on canvas. 45 x 54 cm. Musée d'Orsay, Galerie du Jeu de Paume, Paris. Photo: Musées Nationaux.

the 1860s—because of its picturesque, rustic qualities and apparent separateness from Paris itself. Sisley's *View of Montmartre from the Cité des Fleurs* (1869; Musée de Peinture et de Sculpture, Grenoble) shows that the area had only just been wrested from the surrounding countryside. Renoir had his studio there, on the rue Cortot, and enjoyed painting in one of the local open-air cafés, the Moulin de la Galette (see his pictures of the same title [1876; Musée d'Orsay, Galerie du Jeu de Paume, Paris]). Van Gogh settled there in 1886 fresh from Holland and did several canvases of the view he had from his rue Lépic apartment. And it was the panoramic view of the city from the heights of Montmartre that first made the hero of Zola's *La Curée*, Aristide Rougon-Saccard, aware of the possibilities Paris had to offer.

The nearby Batignolles quarter was another neighborhood familiar to the Impressionists, who loved to wile away the hours at the Café Guerbois there. In that area they would find Manet (who lived at 34, boulevard des Batignolles from 1864 to 1867 and, later, on the rue de Saint-Pétersbourg); there, Cézanne, Pissarro, and Guillaumin met with their critics Edmond Duranty, Philippe Burty, Armand Silvestre, and, of course, Zola. In 1870 Fantin-Latour surrounded Manet with his friends Renoir, Bazille, Monet, Zola, Zacharie Astruc, Edmond Maître, and Otto Schölderer for the group portrait *The Studio in the rue des Batignolles* (Musée d'Orsay, Galerie du Jeu de Paume, Paris). And in the same year Bazille gathered the group again to paint his *Atelier* (Musée d'Orsay, Galerie du Jeu de Paume, Paris) on the rue de la Condamine. Later the Café de la Nouvelle-Athènes (on the Place Pigalle) took over as their meeting place.

The Paris of transport and industry was of key importance to the Impressionists. In this they showed, once again, their kinship with

Offenbach. The first couplet of *La Vie Parisienne* begins, "We are employees of the Western Line." In the Act One finale the chorus sings, in part: "Brought here by steam we mean to invade the sovereign city, the seat of pleasure."[6] The setting is the Gare Saint-Lazare. Like Balzac's hero Eugène de Rastignac in *Le Père Goriot* (1831), the citizens of the world outside Paris arrived at its gates with the intention of rooting out all it had to offer.[7] Most often they arrived by train. The railway station in the nineteenth century, like the airport in the twentieth, came to epitomize the bustle of modern life (see above, II, and below, III/4). In addition, the appearance of its glass and metal architecture in a city was taken as a sign that that particular urban center had entered the age of industrialization.

The industrial side of Paris was depicted by writers (such as Joris-Karl Huysmans in *Les Soeurs Vatard* [1879] and Zola in *La Bête humaine*) and painters. The Pont de l'Europe (fig. 28), "one of the most recent achievements of modern Paris,"[8] proved an inspiration first to Gustave Caillebotte, then to Monet (nos. 29–30). The 1867 *Paris Guide* directed the tourist's attention to the bridge's curious metal skeleton, "so astonishing in its bizarre form and immense proportions."[9] Inspired by such sights, in 1879 Manet proposed the following totally modern project to the Préfet de la Seine for the decoration of the new Hôtel de Ville:

> ...a series of compositions representing—to use an expression by now well established and one that serves well to illustrate what I have in mind—the guts of Paris with its various professions, each in its proper milieu, the public and commercial life of our times. I shall include Paris-Halles, Paris-Railways, Paris-Port, Paris-Underground, Paris-Races and Gardens.[10]

The then-Préfet's predecessor, the famous Baron Haussmann, had attached great importance to the construction of railway stations, as is clear in his memoirs. The arteries he created within Paris were meant to continue or extend the rail routes outside their rectilinear pattern, thus serving as a model for his plan to speed traffic within the city as well as into and out of it (see above, II, and below III/4). The Parnassan poet Théophile Gautier saw train stations as "palaces of modern industry exhibiting the religion of the age: the railways. These cathedrals of the new mankind are the points where nations meet, the center where all converges, the nucleus of gigantic iron-rayed stars that stretch to the ends of the earth."[11]

The district of Paris presided over by the Gare Saint-Lazare and known as the Quartier de l'Europe (fig. 29) was the home of Manet (4, rue de Saint-Pétersbourg, later changed to rue de Léningrad); his friend Stéphane Mallarmé, who held his "literary afternoons" there (29, rue de Moscou, then 87, rue de Rome); Caillebotte (77, rue de Miromesnil); and Monet (17, rue Moncey, then 26, rue d'Edimbourg). Since his youth Manet had been familiar with the area surrounding the Gare Saint-Lazare, from which trains left for Normandy and Argenteuil. In 1871 he gave Pissarro the following address for his Paris studio: "8 rue d'Isly, near the Gare Saint-Lazare."[12]

Following Manet and Caillebotte, who painted the region of the Gare Saint-Lazare in the early and mid-1870s, Monet decided to try his hand at painting the station in 1877 and 1878 (nos. 30–32). Instead of observing the trains from the Pont de l'Europe like Manet or Caillebotte, Monet went down to the level of the tracks. While his colleagues gave predominance to the human figure, Monet concentrated on the trains. Manet and Caillebotte merely implied their presence by rendering smoke rising from the station below; Monet, more audacious in his representation of modern life, had no

Fig. 28. Caillebotte, *The Pont de l'Europe,*
1876. Oil on canvas. 131 x 181 cm. Musée
du Petit-Palais, Geneva.

qualms about showing the locomotives themselves. His interest was shared
by others. The authors of an 1888 study devoted to the railways, entitled
simply *Chemins de fer* and, incidentally, a gold mine of source material for
Zola when he set to work on his novel *La Bête humaine*, had the following to
say about the aesthetics of the machinery involved:

> The artistic side of locomotive construction has attracted many partisans here, and
> there is no denying that it is absolutely rational: it is the experience of reality.
> Industrial objects have their own special beauty about them, and we have reached
> the point where we call a locomotive beautiful or ugly.[13]

In fact, ever since Turner's *Rain, Steam, Speed* (1844; The National Gallery,
London), the train motif had earned a certain favor with both painters and
naturalist writers. Thomas Couture recommended it as a "noble" subject,
and Champfleury, in an analysis of Courbet dating from 1861, wrote:

> Murals done for railway stations have resulted in some...curious pictures. An en-
> gine pulling out, a train pulling in, passengers alighting on the platform, a new line
> being blessed by the Church, a cornucopia overflowing with the produce intro-
> duced to Europe by the wonders of steam locomotion—all these were to provide a
> cycle of diversified motifs. What could be more fantastic than a large machine, its
> fire-breathing belly and large red eyes flying like the wind through the countryside
> at night, driven by gnome-like creatures all black with coal and coke? Is not the
> engine and the role it plays in the countryside sufficient material for a fine
> picture...[Courbet] has yet to paint the iron mastodon running along the rails
> through trees and rocks, past tiny hillside towns, across a bridge and over a vil-
> lage—intrepid, snorting, hissing, sweating—and the coming and going of the
> crowds—full of life, tumultuous, gaping, weeping, embracing.[14]

According to the memoirs of Jean Renoir, the son of the painter, Mo-
net procured permission from the director of the Chemins de fer de l'Ouest to
paint the interior of the Gare Saint-Lazare.[15] He began work in January
1877. Even if the proximity of his rue Moncey studio to the station expedited
matters somewhat, he still had to paint rapidly to complete the seven views of

Fig. 29. *Paris—The Rebuilding of the Gare Saint-Lazare—The Old Station* (1. View from the Pont de l'Europe.—2. Main station entrance.—3. Entrance to the main lines, rue d'Amsterdam.—4. The exit yard and the wooden bridge of the rue de Rome.—5. The Cour Bony.), 1885. Photo: La Vie du Rail, Paris.

the Gare Saint-Lazare (three of which are brought together here [nos. 30–32]) in time for the third Impressionist exhibition that April. There, they earned Zola's high praise:

> M. Claude Monet is the most marked personality of the group. This year he is exhibiting some superb station interiors. One can hear the rumble of the trains surging forward, see the torrents of smoke winding through vast engine sheds. This is the painting of today: modern settings beautiful in their scope. Our artists must find the poetry of railway stations as our fathers found the poetry of forests and rivers.[16]

While living alongside the railway line in Médan, Zola himself became an habitué of the Gare Saint-Lazare and conceived the idea for a novel with a railway setting:

> ...a novel, my most original yet, which will take place along a railway network. There will be a large station where ten lines cross, each line with its own story and all of them coming together at the main station; the novel will be imbued with the flavor of the place, and life's furious pace will resound through it like a musical accompaniment.[17]

The novel in question was, of course, *La Bête humaine,* part of the author's *Rougon-Macquart* series. Several passages are clearly dependent on Monet's canvases; for example, "The Pont de l'Europe signal box announced...the Havre express as it emerged from Batignolles tunnel....The train entered the station with a brief whistle, grating on its brakes, breathing smoke...."[18] Later Zola stressed the beauty of the locomotive called "La Lison":

> It was one of the express engines, the kind with two coupled axles, and it was elegant on both a grand and small scale, with its large, light wheels joined by arms of steel, its broad chest, its long and mighty loins, with all the logic and certainty that go into the sovereign beauty of metal beings, with precision in strength.[19]

With its train stations, neighborhoods, and bridges, the Paris of the Impressionists was chiefly remarkable as an out-of-door city, a city of light, atmosphere, and space. Its life was what the French writer Jean Schopfer called "life in the open air,"[20] a truly public and urban life. If the *real* city of Paris was filled with social tensions, class conflict, and urban alienation played out in small apartments and garrets and obsessively recorded by contemporary Realist writers, its inhabitants could escape from such pressures into the boulevards, parks, and quays of the "new Paris." The very grandeur and healthiness of this new city—that pictured by Monet, Pissarro, and the rest—is set into relief when compared to the patterned apartments of Pierre Bonnard and Edouard Vuillard and the claustrophobic brothels and dance halls of Théophile Steinlen and Henri Toulouse-Lautrec. In Impressionist Paris passersby, carriages, carts, and omnibuses seem trapped temporarily on canvas, caught perpetually between destinations. This Paris, the capital of the world's affairs, extended into the countryside; the promenaders of its parks and boulevards are the same transitory figures who walk through the Impressionists' poppy fields outside Paris (see below, III/7) or gather along the Seine to watch the boat races at Argenteuil (nos. 39–46). These personages are the same quintessentially up-to-date, uniformed figures—with each hat and walking stick carefully observed and recorded—who crowded the docks in Rouen or maneuvered the quays in Le Havre. Their very smallness—indeed, their insignificance in the context of the Impressionist vision—gives them a modern, and utterly urban, universality.

—S. G.-P.

NOTES

1. See Offenbach, 1869.
2. Pinkney, 1958, p. 151.
3. Wildenstein, 1974–79, vol. I, p. 423; see also Isaacson, 1966.
4. Pissarro, 1950, p. 474.
5. Pissarro and Venturi 1123–1136.
6. See Offenbach, 1869.
7. Schivelbusch, 1979, pp. 161–169; see also Centre National d'Art et de Culture Georges Pompidou, 1978, p. 62.
8. Berhaut, 1978, p. 29.
9. Museum of Fine Arts, Houston, 1976, p. 106, n. 5; National Gallery of Art, Washington, D.C., 1982, pp. 53 ff.
10. Réunion des Musées Nationaux, 1983, p. 516.
11. Centre National d'Art et de Culture Georges Pompidou, 1978, p. 8.
12. Wildenstein, 1974–79, vol. I, p. 428.
13. Walter, 1979, pp. 51–53.
14. Champfleury, 1973, p. 185.
15. Renoir, 1962, pp. 168–169; reprinted in part in Evers, 1972, pp. 20–21.
16. Zola, 1970, p. 282.
17. Zola, 1960–68, vol. IV, p. 1710; Walter, 1979, p. 51.
18. Zola, 1960–68, vol. IV, p. 1105; Walter, 1979, p. 51.
19. Zola, 1960–68, vol. IV, pp. 1127–1128; Walter, 1979, p. 51.
20. Schopfer, 1903, p. 157 ff.

27. Berthe Morisot

VIEW OF PARIS FROM THE TROCADÉRO
(VUE DE PARIS DES HAUTEURS DU
TROCADÉRO), 1872

Berthe Morisot, as we have seen, exhibited her first Parisian cityscape (*The Seine under the Iéna Bridge* [1866; Location unknown]) at the 1867 Salon.[1] This work has sometimes been confused with the now-quite-famous *View of Paris from the Trocadéro,* which by common agreement dates from 1872.[2] This silvery, diaphanous view of the city shows the artist to have been under the influence of Corot, with whom she had in fact studied during the 1860s. Morisot's own personality found expression nonetheless in her particular affinity for light, an affinity which grew throughout her career.[3]

To create this composition, Morisot set up her easel at the top of the Chaillot hill, where the rue Franklin runs into the Place du Trocadéro. The Palais du Trocadéro (1878) had not yet been built, nor, of course, had the Eiffel Tower, and the artist therefore had an unobstructed view of the old Trocadéro gardens and the far side of the Seine spanned by the Pont d'Iéna and, further east, the Pont de l'Alma at the Champ-de-Mars. Outlined in the distance, from left to right, are the two towers of Sainte-Clotilde, those of Notre-Dame in the background, those of Saint-Sulpice to the left of Les Invalides, and, to its right, a blur representing the cupola of the Pantheon. The figures in the foreground have been identified as the artist's two sisters, Edma Pontillon and Yves Gobillard, the latter accompanied by her daughter Paule.[4]

The site was a natural one for Morisot to choose: her family lived nearby, on the rue des Moulins (now rue Scheffer) on the corner of the rues Franklin and Vineuse, and her father had a studio built in the garden for his daughters. In a watercolor sketch (The Art Institute of Chicago) for a painting of the same year, *Woman and Child on a Balcony* (Henry Ittleson Collection, New York), Morisot showed Edma Pontillon and Paule on the balcony of the family house overlooking a view quite similar to the one shown here. The few differences are due to a slight shift in vantage point to the southwest.[5]

Morisot also may have chosen to observe Paris from the end of the rue Franklin because Manet had painted a canvas depicting the "Exposition Universelle" of 1867 (fig. 25) from a spot several feet lower (see above, III/3). (Morisot had married Eugène Manet, the painter's brother, in December 1874). Further, guides recommended the spot to sightseers for the panorama it offered both in conjunction with the "Exposition Universelle" and independently of it.

This painting was acquired in 1876 by Dr. Georges de Bellio, one of the Impressionists' early supporters, and subsequently became part of the Jacques Doucet Collection (see below, IV).[6] The fact that Morisot is buried in the nearby Cimetière de Passy in the tomb of Edouard Manet lends the picture an especially moving character.

NOTES
1. Bataille and Wildenstein 11.
2. Jamot, 1927, pp. 3–4; Mainardi, 1980, pp. 110; 115, nos. 31–33.
3. Fourreau, 1925, p. 280.
4. National Gallery of Art, Washington, D.C., 1982, no. 3.
5. Ibid.
6. Niculescu, 1964, pp. 213, 234; 235, no. 970.

28. Claude Monet

MONTORGUEIL STREET, CELEBRATION OF
30 JUNE 1878
(LA RUE MONTORGUEIL, FÊTE DU 30 JUIN
1878), 1878

Having left Argenteuil in the early months of 1878, Monet spent some time in Paris near the Place de l'Europe at 26, rue d'Edimbourg. The city, decked with flags for the national holiday of June 30, inspired Monet to paint two canvases: this one and *Rue Saint-Denis* (Musée des Beaux-Arts et de la Céramique, Rouen). The titles of these works, both of which were shown at the fourth Impressionist exhibition in 1879, are occasionally reversed and the painting in Rouen mistakenly entitled *July 14 in Paris.*[1]

The great street celebrations for the national holiday of June 30, 1878, were

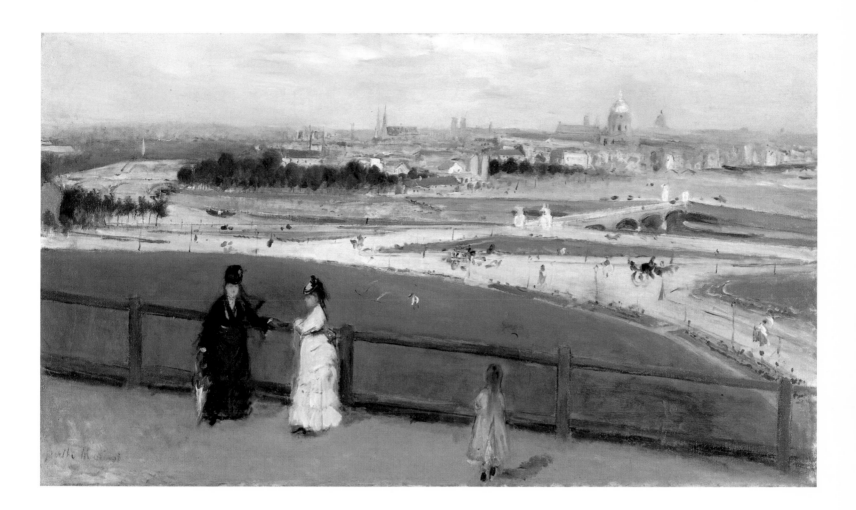

No. 27. Berthe Morisot
VIEW OF PARIS FROM THE TROCADÉRO, 1872

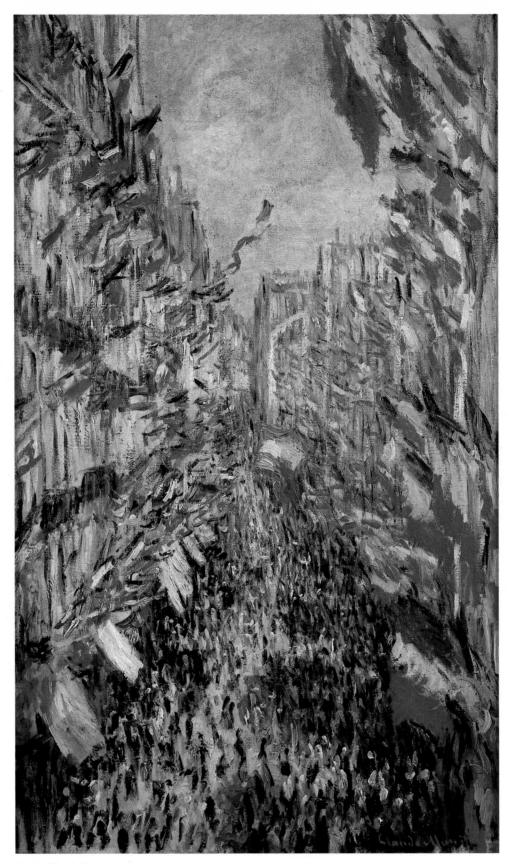

No. 28. Claude Monet
MONTORGUEIL STREET, CELEBRATION OF 30 JUNE 1878, 1878

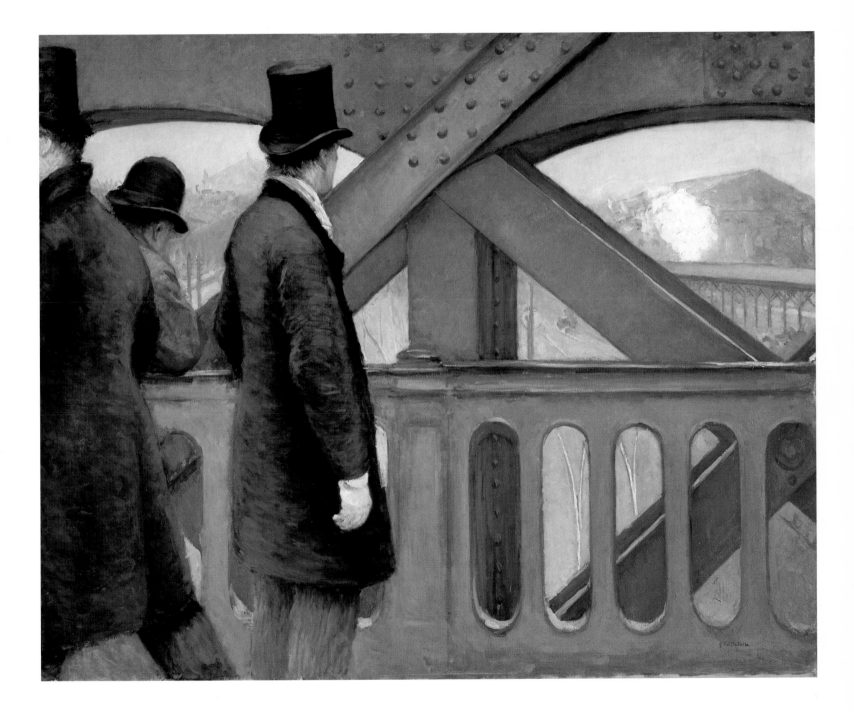

No. 29. Gustave Caillebotte
ON THE EUROPE BRIDGE, 1876–77

the first such festivities held in Paris since the Commune. In 1871 the national government had banned any form of collective assemblage in the streets to guard against riots and anti-government demonstrations. The 1878 holiday was therefore of special importance, and preparations for it were lavish. The riot of republican flags especially fascinated Monet, whose political sympathies normally were not expressed overtly in his pictures. In this case, however, the painting is as much a celebration of the republic as of the festivities themselves. Both it and *Rue Saint-Denis* were painted as seen from above. According to Daniel Wildenstein,[2] Monet observed the scene which inspired *Rue Saint-Denis* from the balcony of what is now 141, rue Saint-Denis (where it crosses the rue de Turbigo) looking north; he observed *Montorgueil Street, Celebration of 30 June 1878*, the perspective of which is considerably intensified by intersecting diagonals, from that street's intersection with the rues Mandar and Greneta, likewise looking north.

In this painting, executed several years after *The Boulevard des Capucines* (1874; Pushkin Museum, Moscow), Monet again transferred the animation of the capital's streets to canvas. To suggest the crowd, he used a large number of dark and rapid strokes (no. 32). The motif of the flags in the sun recurs several times in his work (no. 5).

The same holiday in the same year prompted Manet to paint his two canvases entitled *The Rue Mosnier Decked with Flags* (Paul Mellon Collection, Upperville, and Bührle Collection, Zurich). Unlike Monet, who went to Les Halles to show the working people celebrating, Manet remained in his studio at 4, rue Saint-Pétersbourg (later, rue de Léningrad), which gave him a good view of the rue Mosnier (now the rue de Berne).[3]

NOTES

1. July 14 did not become France's national holiday until 1880 (National Gallery of Art, Washington, D.C., 1982, p. 246; Niculescu 1964, pp. 245, n. 42; 258, 264).
2. Wildenstein 470.
3. National Gallery of Art, Washington, D.C., 1982, no. 90.

29. Gustave Caillebotte

ON THE EUROPE BRIDGE
(*LE PONT DE L'EUROPE*), 1876–77

After Manet—whose *Railroad* (National Gallery of Art, Washington, D.C.), done in the Quartier de l'Europe in 1872–73, was accepted by the Salon of 1874—and the year before Monet (no. 30), Caillebotte demonstrated his interest in this modern Parisian landmark by painting *The Pont de l'Europe* (Petit-Palais, Musée d'Art Moderne, Geneva) in 1876, of which the picture illustrated here is a variant.

The Place de l'Europe stood at the center of the district of the same name in which the streets are named after major European capitals. The Place consisted primarily of the roadway of a large iron bridge (built between 1865 and 1868 and completely rebuilt in 1930[1]) which overlooks the tracks of the Gare Saint-Lazare, giving passersby an unusual view of the station's activities.

In the spring of 1877, at the third Impressionist exhibition, Caillebotte showed *The Pont de l'Europe* together with other paintings, while Monet dispayed his seven *Gare Saint-Lazare* canvases. Caillebotte immediately acquired three of these (including one [no. 31] later accepted by the French government [Musée d'Orsay, Galerie du Jeu de Paume, Paris]), thereby demonstrating his interest in the subject matter and his insight into the value of his Impressionist friend's work.[2]

Although so grand a work as *The Pont de l'Europe* called for numerous preparatory studies,[3] this variant, done several months later, was preceded by only a single oil sketch (Richard M. Cohen Collection, Los Angeles).[4] Marie Berhaut has stressed the originality of this version, pointing out that

> ...the composition is totally different from the earlier canvas, the framing of the subject more unusual. The spot depicted here is part of the Place de l'Europe itself, the very center of the bridge, its highest point. Hence the flattened, surbased effect created by the tops of the iron crosspieces with respect to the figures. To the right we see the large glass arrival hall, which appears in several of Monet's *Gare Saint-Lazare* series....[5]

More than the canvas exhibited in 1877, this version highlights the bridge's metallic structures; their geometry demands to be noticed. They are arranged according to a plan which parallels that of the painted surface, and by shutting out the sky they reduce any sense of depth, thus creating the rising perspective sought by the artist. The figures have been relegated to the extreme left of the composition to leave the framework of the bridge relatively unobstructed. The severity and industrial, resolutely modern character of the subject are thereby greatly enhanced. At the time of the Impressionist exhibition of 1877 Zola made a point of praising the talent of "M. Caillebotte, a young painter who shows the greatest of courage and does not shrink from tackling modern subjects life-size."[6]

As in *Traffic Island on Boulevard Haussmann* (no. 33), we find the elegant silhouette of the artist himself in top hat, his light scarf and white gloves standing out against the background. In both pictures the figures are arbitrarily broken off at the edge of the canvas, a device that

> ...results from a desire to paint reality, express an instant of contemporary life, a desire that has led the Impressionists to seek out uncommon points of view.[7]

The painting also exemplifies the influence of the compositions of Japanese prints (where bridges appear frequently) and of photography on the painters of the time (see below, V).

The fact that Caillebotte repeated the Pont de l'Europe motif and even had a glassed-in "omnibus" made to enable him to observe the bridge in all kinds of weather suggests that his interests paralleled those manifested in the famous series of his friend Monet (see below, III/7).

NOTES

1. Varnedoe, 1974, pp. 28–29, 41, 58–59.
2. Berhaut, 1978, p. 18.
3. Museum of Fine Arts, Houston, 1976, nos. 16–23.
4. National Gallery of Art, Washington, D.C., 1982, no. 13.
5. Berhaut 46.
6. Zola, 1970, p. 283.
7. Berhaut, 1978, p. 34.

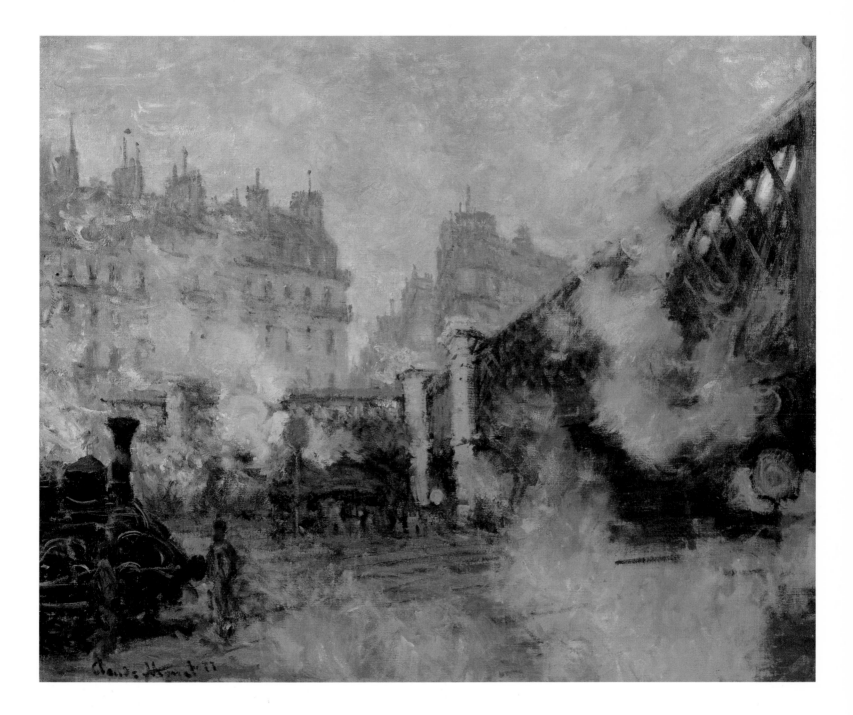

No. 30. Claude Monet
THE EUROPE BRIDGE AT SAINT-LAZARE TRAIN STATION, 1877

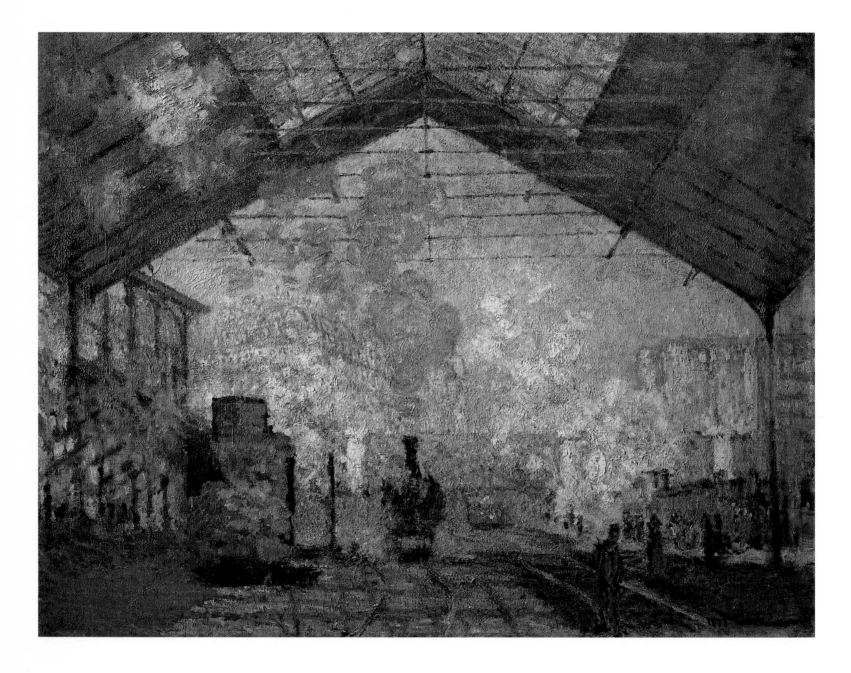

No. 31. Claude Monet
Saint-Lazare Train Station, 1877
(detail on p. 108)

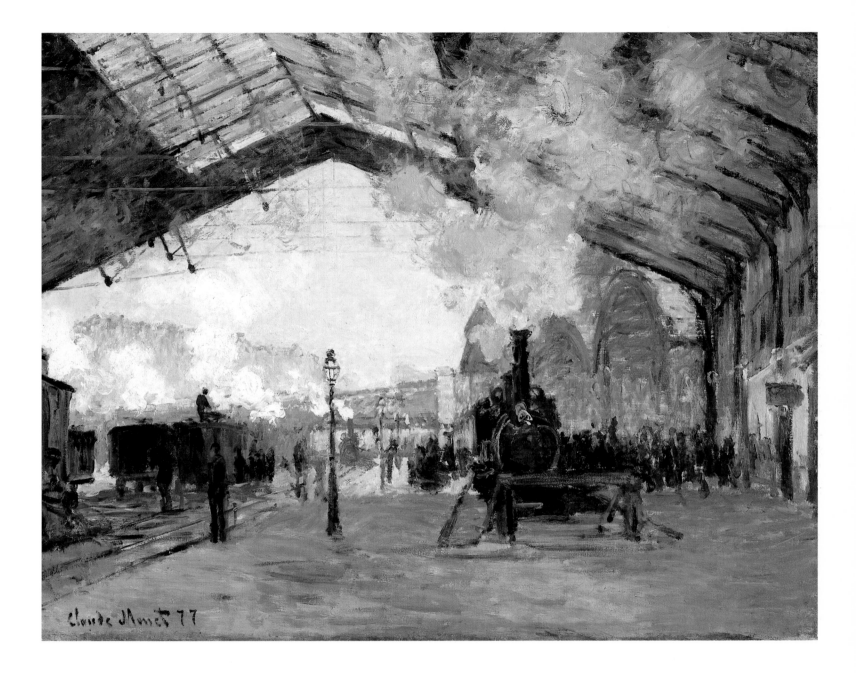

No. 32. Claude Monet
SAINT-LAZARE TRAIN STATION, THE NORMANDY TRAIN, 1877

30. Claude Monet

THE EUROPE BRIDGE AT SAINT-LAZARE
TRAIN STATION
(*LE PONT DE L'EUROPE, GARE SAINT-
LAZARE*), 1877

In creating this composition Monet positioned himself just outside the Gare Saint-Lazare, where the tracks are spanned by the Pont de l'Europe. The metal railing of the bridge, concealed in part by the smoke of the trains, can be seen on the right. Monet stood facing the backs of the buildings along the rue de Rome. The glass roof of the station, not visible in the painting, began several feet to his left.

Dr. de Bellio (no. 27) acquired this work in March 1877 and immediately lent it to the third Impressionist exhibition, which opened the following month (it was exhibited as no. 98, *Le Pont de Rome, Gare Saint-Lazare*). The place represented here is that described by Zola just over ten years later in *La Bête humaine*:

> [Séverine] turned and walked down the rue d'Edimbourg as far as the Pont de l'Europe....Unsure of where to go or what to do and quite distraught, she leaned motionless against one of the railings, looking down through the iron framework upon the vast expanse of the station, where trains were in constant motion. She followed them with anxious eyes....Then, in a paroxysm of despair, she felt a tormenting desire...to fling herself under a train. One was just emerging from the canopy of the main lines. She watched it advance and pass beneath her, puffing a tepid swirl of white steam in her face.[1]

NOTE
1. Zola, 1960–68, vol. IV, pp. 1108–1109.

31. Claude Monet

SAINT-LAZARE TRAIN STATION
(*LA GARE SAINT-LAZARE*), 1877

To paint this canvas, as Daniel Wildenstein has pointed out,[1] Monet stood inside the part of the Gare Saint-Lazare reserved for the suburban lines. The glass canopy roof creates a symmet-rical composition centered on the locomotive in motion. A skillful rendering of the effects of sunlight enabled the artist to play with variations of light on the profuse smoke clouds and background buildings. The apparent dissolution of the stone surface under the sunlight anticipates his investigations in the *Rouen Cathedral* series some 20 years later.

This work, part of Caillebotte's collection (no. 29), was shown at the third Impressionist exhibition in 1877, where the critic Georges Rivière had the following to say about it:

> This picture represents a train pulling in....The sun, passing through the panes of glass, highlights the engines and the sand along the tracks in gold.[2]

In preparation for this composition Monet did a drawing in a sketch pad (Musée Marmottan, Paris) which contains a number of sketches relevant to the *Gare Saint-Lazare* series.

NOTES
1. Wildenstein 438.
2. Ibid.

32. Claude Monet

SAINT-LAZARE TRAIN STATION,
THE NORMANDY TRAIN
(*LA GARE SAINT-LAZARE, LE TRAIN DE
NORMANDIE*), 1877

Still inside the Gare Saint-Lazare, though this time in the east, or main-line, section of the building, Monet concentrated in this painting on the train from Normandy. He demonstrated his sense of space and skill at conveying various atmospheric effects. As Rodolphe Walter has noted, "Whereas in the other canvas [*Saint-Lazare Train Station* (no. 31)] the gas lamps hung from the iron framework, in this one they stand along the platform as they do along city streets."[1] The glass lets in a diffuse light, and the smoke from the engines intrudes somewhat on the perspective. And, as in *The Boulevard des Capucines* (1874; Pushkin Museum, Moscow), the figures have been reduced to small, simple silhouettes evoked by a few dark strokes (no. 28); their profusion creates the bustle associated with railway stations.

Ernest Hoschedé, the collector who was at this time the husband of Monet's second wife, Alice (see below, III/8), acquired this canvas in March 1877 and lent it to the third Impressionist exhibition the next month, in which it was exhibited as no. 97, *Arrivée du train de Normandie, gare Saint-Lazare*. Monet's sketch pad in the Musée Marmottan (no. 31) contains a study which is related to this painting.

NOTE
1. Walter, 1979, p. 53.

33. Gustave Caillebotte

TRAFFIC ISLAND ON BOULEVARD
HAUSSMANN
(*UN REFUGE BOULEVARD
HAUSSMANN*), 1880

After his mother's death in 1878, Caillebotte moved with his brothers into a suite of apartments behind the Opéra at 31, boulevard Haussmann on the corner of the rue Gluck.[1] These apartments occupied an upper story with balconies, thus enabling Caillebotte to repeat Monet's *Boulevard des Capucines* (1874; Pushkin Museum, Moscow) experiment.

Caillebotte was particularly concerned to explore the use of rising perspective, which Pissarro employed later to such advantage in *The Place du Théâtre Français, Paris* (no. 36). In this view from above, from the very end of the building where Caillebotte lived, we are shown a traffic island at the intersection of the boulevard with the rues Gluck and Scribe. The space is flat; the sky does not appear at all. The choice of such an odd perspective reflects the influence of Japanese prints[2] and contemporary photography[3] (see below, V).

As in many of Caillebotte's paintings (no. 29), a figure is cut off at the edge of the canvas. J. Kirk T. Varnedoe has called attention to the three men in

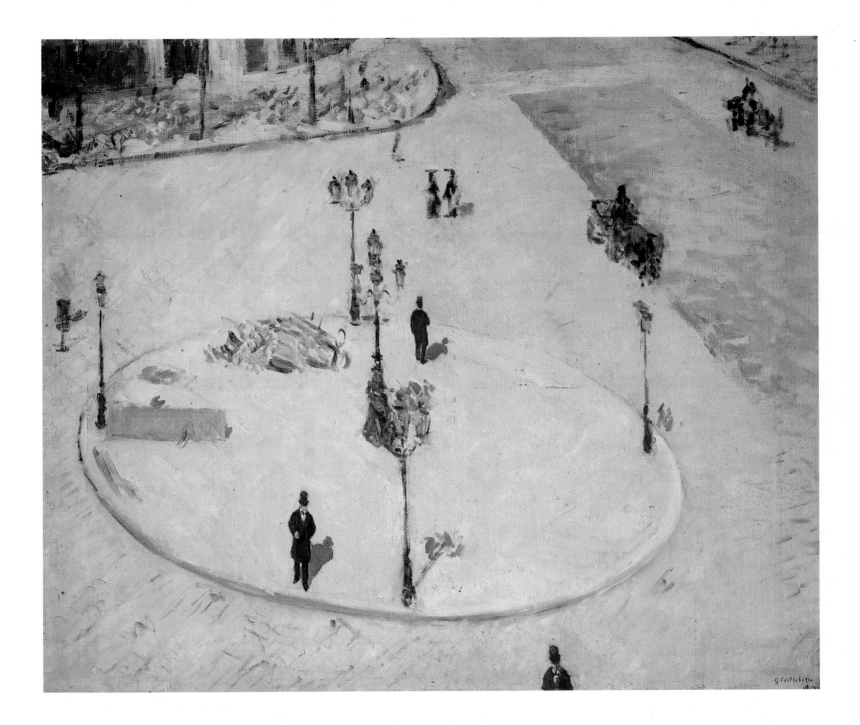

No. 33. Gustave Caillebotte
TRAFFIC ISLAND ON BOULEVARD HAUSSMANN, 1880

top hats, whose dark, isolated silhouettes contrast clearly with the light space around them. By rendering the shadows which they and a few street lamps cast on the ground, Caillebotte indicated the direction his light was coming from. Because the men are all dressed alike, Varnedoe has hypothesized that they are in fact a single walking man captured during three separate phases of a movement. He has pointed out that the artist used the same device in *The Floor-Planers* (1875; Musée d'Orsay, Galerie du Jeu de Paume, Paris) and has interpreted the recurring spectator figure in Caillebotte's work as a symbolic self-portrait.[4]

Degas must have known this canvas since in 1880 he wrote to Pissarro, "Caillebotte is doing traffic islands along the boulevard Haussmann from his windows."[5] The painting figured in the "Exposition retrospective d'oeuvres de G. Caillebotte" organized in June 1894, several months after the painter's death, by his brother Martial.

NOTES

1. Varnedoe, 1976, pp. 37; 147, fig. 1; no. 53.
2. Berhaut, 1978, p. 44.
3. Ibid., pp. 46, 48, n. 17; Scharf, 1968, p. 133; figs. 115–116.
4. Varnedoe, 1976, p. 54.
5. Berhaut 141.

34. Camille Pissarro

THE PLACE DU HAVRE, PARIS (*PLACE DU HAVRE, PARIS*), 1893

In February 1893 Pissarro moved temporarily into the Hôtel Garnier, 111, rue Saint-Lazare, in a part of Paris he had come to know well: the trains from Eragny (where he had bought a house the year before) came into the Gare Saint-Lazare, so it was always the point of departure for his explorations of the capital. Working from the window of his hotel room (a practice he later repeated in Rouen and other parts of Paris),

Pissarro painted a series of four works, which—if we exclude *The Boulevard Rochechouart* (1878) and the unusual snow effect in *The Peripheral Boulevards* (1879; both Musée Marmottan, Paris)—comprise his first pictorial impressions of the capital. All four canvases—of which *The Place du Havre, Paris* is one—were painted from a high vantage point, in the manner of Monet's *Boulevard des Capucines* (1874; Pushkin Museum, Moscow). *The Place du Havre, Paris* gives a fine view of the site, its sunny facades and roadway jammed with vehicles and pedestrians. It was first shown to the Parisian public in March 1893 at an exhibit Durand-Ruel devoted to the artist's recent works (see below, IV).

Already a master of urban scenes, Pissarro proved highly sensitive to the special light and atmosphere of Paris. In 1897 he returned to the rue Saint-Lazare and the Place du Havre, doing lithographs of both subjects[1] in the rain before turning his attention to the boulevard Montmartre (no. 35).

NOTE

1. Réunion des Musées Nationaux, 1981, pp. 196–197.

35. Camille Pissarro

BOULEVARD MONTMARTRE, MARDI GRAS (*BOULEVARD MONTMARTRE, MARDI GRAS*), 1897

On February 8, 1897, after his stay at the Hôtel Garnier (no. 34) the month before, Pissarro wrote to his son:

I'm leaving again on the tenth of the month, going back to Paris, this time to do a series of the boulevard des Italiens.... Durand-Ruel finds the boulevard series a good idea, and he's looking forward to overcoming the difficulties involved. I've decided on a spacious room at the Grand Hôtel de Russie, 1, rue Drouot, which gives me a view of the entire network of boulevards almost as far as the Porte Saint-Denis or in any case as far as the boulevard Bonne-Nouvelle.[1]

Ralph T. Coe has published a photograph of the Grand Hôtel de Russie taken before it was destroyed in 1927 so that the boulevard Haussmann could be widened.[2] By February 13 Pissarro was at work:

Here I am, settled in and covering my large canvases. I'm going to try to have one or two ready to do the Mardi Gras crowd. I can't tell yet what the results will be like; I'm very much afraid the streamers will give me trouble.[3]

A month later, however, he could write to his son,

I've got a number of irons in the fire. During Mardi Gras I did the boulevards with the crowd and the march of the Boeuf Gras, with the sun playing on the streamers and the trees, and the crowd in the shade....[4]

Pissarro depicted the boulevards in some 15 paintings. Of the three devoted to the Carnival procession, the one illustrated here is perhaps the most effective.[5] The scene is bathed in the soft, golden light characteristic of the artist's late period, and the multiplicity of small strokes to suggest the density of the crowd might as easily be considered a reference to Monet's *Boulevard des Capucines* (1874; Pushkin Museum, Moscow) as attributed to Pissarro's own Pointillist experiments of the 1880s. Suffering from an eye ailment, Pissarro was forced to give up plein-air painting. To observe the activity going on along the grand boulevards, he adopted Monet's raised hotel window vantage point.

In 1899 Pissarro did a lithograph, most likely from memory, after *Boulevard Montmartre, Mardi Gras*.[6]

NOTES

1. Pissarro, 1950, p. 431.
2. Coe, 1954, p. 93, fig. 1.
3. Pissarro, 1950, p. 431.
4. Ibid., p. 433.
5. National Gallery of Art, 1982, no. 97.
6. Réunion des Musées Nationaux, 1981, nos. 78, 199.

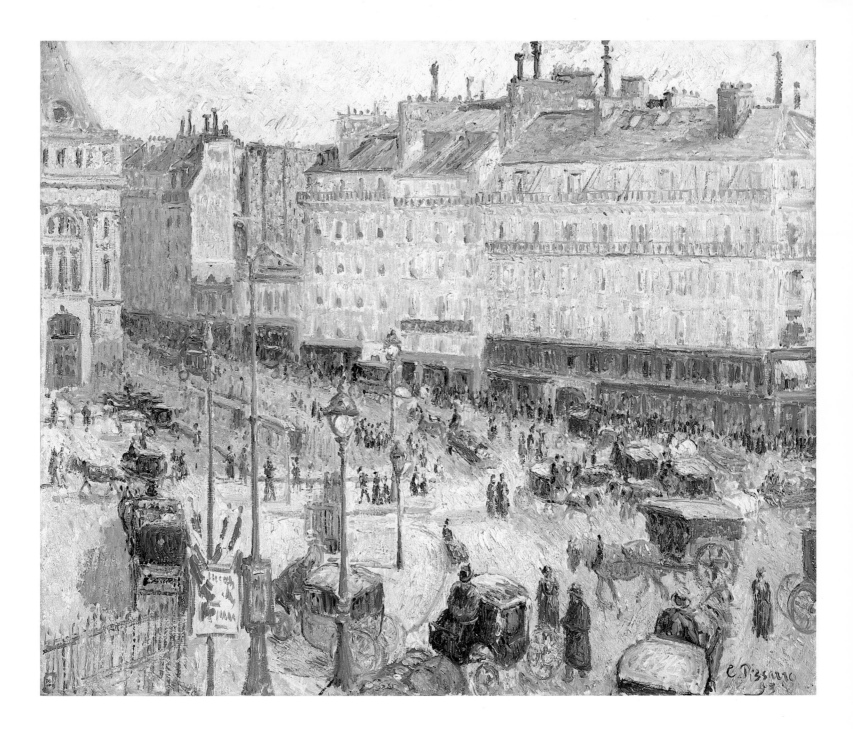

No. 34. Camille Pissarro
THE PLACE DU HAVRE, PARIS, 1893

36. Camille Pissarro

THE PLACE DU THÉÂTRE FRANÇAIS, PARIS
(*LA PLACE DU THÉÂTRE FRANÇAIS, PARIS*)
1898

On December 15, 1897, Pissarro informed his son Lucien that he had discovered a new Parisian motif:

> I almost forgot to tell you: I've found a room at the Grand Hôtel du Louvre with a superb view of the avenue de l'Opéra and the corner of the Place du Palais-Royal! It makes a beautiful subject! It may not be very aesthetic, but I'm delighted at the chance to see what I can do with these Parisian streets, which people usually call ugly but which are so silvery, so luminous, so alive. They are altogether different from the boulevards. Totally modern![1]

Six days later he added a few details:

> I hope to be back by about January 5 and take up residence at the Grand Hôtel du Louvre, where I shall start work for the [June 1898] exhibition [at Durand-Ruel's]. The expense will be considerable, but Durand-Ruel seems encouraging. I'm in the mood to work, and after a good look at the subject matter I feel on top of things.[2]

On January 6, having given his son the address of the hotel (172, rue de Rivoli),[3] Pissarro described his suite there:

> I've been settled in since yesterday. I have two large rooms and some good large windows that give me a view of the avenue de l'Opéra. The motif is very beautiful, very painterly. I've already begun work on two canvases.[4]

In a letter dated January 23 Pissarro spoke again of how smoothly his work was going: "I'm doing the avenue de l'Opéra and a bit of the Place du Théâtre Français. The motif is superb, and things are moving along quite well."[5]

Pissarro stayed in Paris until late April. From the windows of the Hôtel du Louvre he did approximately 15 paintings showing the rue Saint-Honoré, the avenue de l'Opéra, and the Place du Théâtre Français—of which this is one—from different perspectives. Most of them were shown at the "Exposition d'oeuvres récentes de Camille Pissarro" organized by Durand-Ruel in June 1898. It is this exhibition the artist alluded to in another letter to his son:

> My *Avenues de l'Opéra* are on display at Durand-Ruel's. I have a large room all to myself. There are twelve *Avenues*, seven or eight *Avenues* and *Boulevards,* and some studies of Eragny I'm quite satisfied withIt [the room] has a nice look about it. The rooms nearby have a series of fine Renoirs, superb Monets,...some Puvis de Chavannes....My *Avenues* are so bright they would go very well with the Puvis.[6]

Pissarro was right to stress the differences between his paintings of avenues and those of boulevards.[7] The long sweep of the boulevard Montmartre in *Boulevard Montmartre, Mardi-Gras* (no. 35) contrasts sharply with the wide-open space of the Place du Théâtre Français, depicted here where it becomes the avenue de l'Opéra (the beginnings of which are almost invisible); in fact, this composition is closed off completely at the right by the theater facade. The total absence of sky and horizon and a perspective which makes the background seem to rise before our eyes have suggested parallels—as with other works already discussed—with the compositions of Japanese prints.[8] Several scholars (John Rewald, Leopold Reidemeister, Charles Kunstler) also have compared the works of Pissarro painted from the windows of the Hôtel du Louvre to contemporary photographs[9] (see below, V).

NOTES
1. Pissarro, 1950, pp. 441–442.
2. Ibid., p. 443.
3. Ibid., p. 444.
4. Ibid.
5. Ibid., p. 447.
6. Ibid., p. 454.
7. Coe, 1954, p. 109.
8. Réunion des Musées Nationaux, 1981, nos. 79–80.
9. Pissarro, 1950, figs. 53–54; Reidemeister, 1963, p. 169; Kunstler, 1974, p. 65.

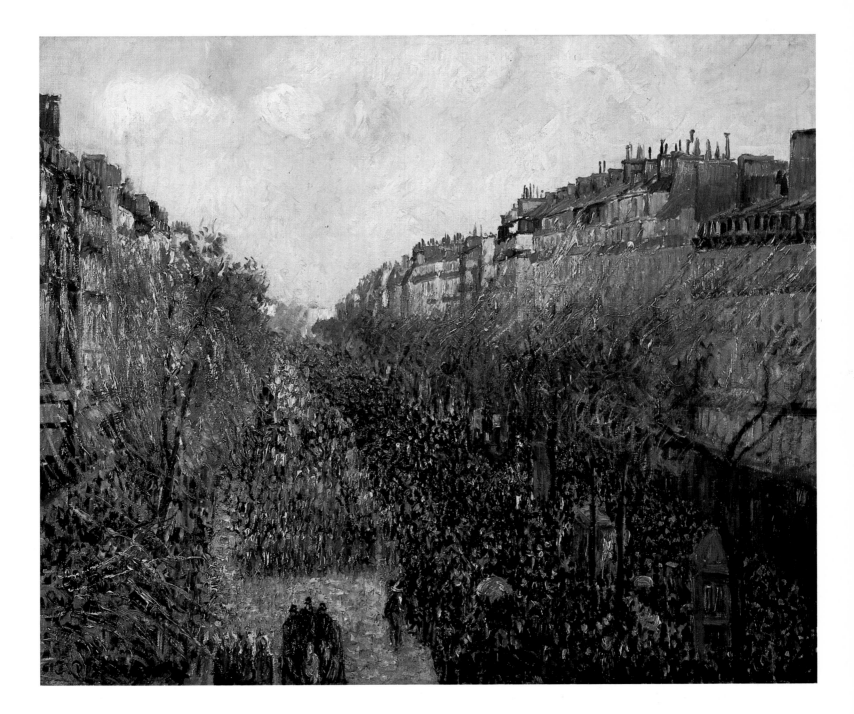

No. 35. Camille Pissarro
Boulevard Montmartre, Mardi Gras, 1897

37–38. Camille Pissarro

BRIDGE AT ROUEN,
(*LE GRAND PONT, ROUEN*), 1896

ROUEN HARBOR, SAINT-SEVER
(*PORT DE ROUEN, SAINT-SEVER*), 1896

Pissarro first worked at Rouen during the autumn of 1883. He returned for two long stays thirteen years later. From January to March 1896 he lived at the Hôtel de Paris (51, quai de Paris) on the Seine. "I've been to see the Hôtel d'Angleterre," he wrote to his son on January 23.

> It has a fine location, on the embankment, but it's very expensive: eight francs for a room on the fourth floor. I may not be so well off here, but I pay only five francs for a nice room on the second floor and another on the third, above the mezzanine. The view is beautiful.[1]

The Hôtel d'Angleterre is where Monet had stayed while painting his *Cathedral* series between 1892 and 1893.

When Pissarro returned to Rouen for two months in the autumn of 1896, he began his first letter to his son as follows:

> Rouen, September 8, 1896. Hôtel d'Angleterre, Cours Boëldieu....I am in Rouen. From my hotel window I've a view of the port at an angle different from the one offered by the Hôtel du Paris. I'm in the process of familiarizing myself with the way the scenery looks from here.[2]

Pissarro's idea of painting the Pont Boeldieu, or Grand Pont, dated as far back as the preceding February, when he had written to his son,

> What particularly interests me is the motif of the iron bridge in wet weather with all the vehicles, pedestrians, workers on the embankments, boats, smoke, haze in the distance; it's so spirited, so alive. I've tried to catch the hive of activity that is Rouen of the embankments.[3]

(The work Pissarro had in mind at that point hangs today in the Art Gallery of Toronto.[4]) The *Bridge at Rouen* shows the other side of the bridge as it appeared to the painter from the Hôtel d'Angleterre:

> I have a motif to do...from my window: the new Saint-Sever district directly opposite, with the hideous Gare d'Orléans, all shiny and new, and any number of chimneys, large and small, spouting plumes of smoke. In the foreground, boats and water; to the left of the station, the working class district that runs along the embankment to the iron bridge, the Pont Boieldieu; a hazy morning sun....It's beautiful, Venice-like,...extraordinary....It's art, art filtered through my own perceptions. And that's not the only subject; there are wonders left and right....[5]

The glass roof next to the high chimney visible in this painting belongs to the Gare d'Orléans.

Rouen Harbor, Saint-Sever represents yet another attempt on Pissarro's part to reconstruct the lively atmosphere of the port of Rouen as he saw it from his window. In the foreground he has shown several cranes unloading boats; next, some small craft on the Seine; and finally, on the left bank, the factories and warehouses of Saint-Sever.

NOTES
1. Pissarro, 1950, p. 397.
2. Ibid., p. 416.
3. Ibid., pp. 400–401.
4. Réunion des Musées Nationaux, 1981, nos. 75–76.
5. Pissarro, 1950, p. 419.

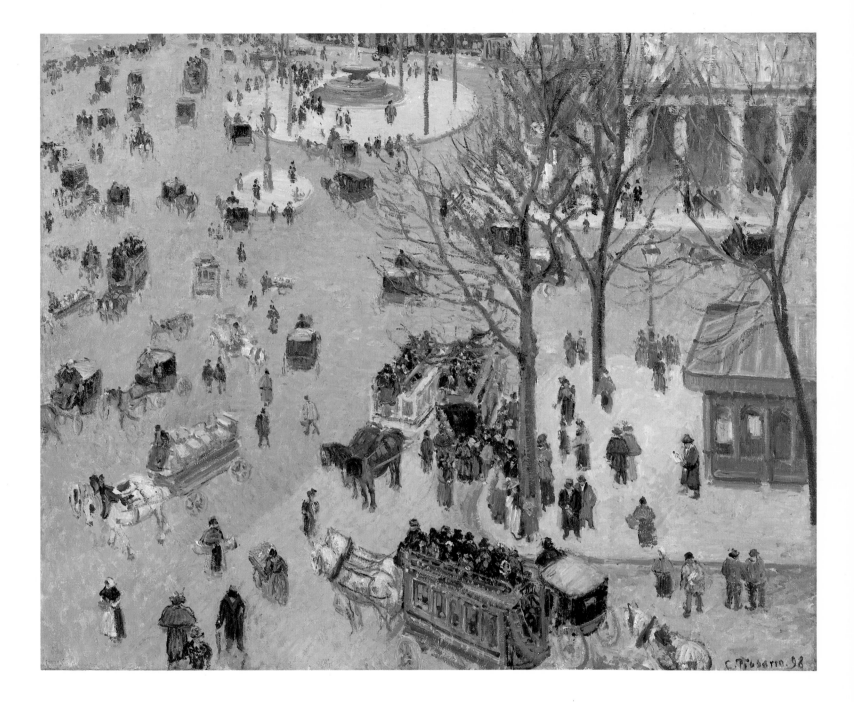

No. 36. Camille Pissarro
THE PLACE DU THÉÂTRE FRANÇAIS, PARIS, 1898

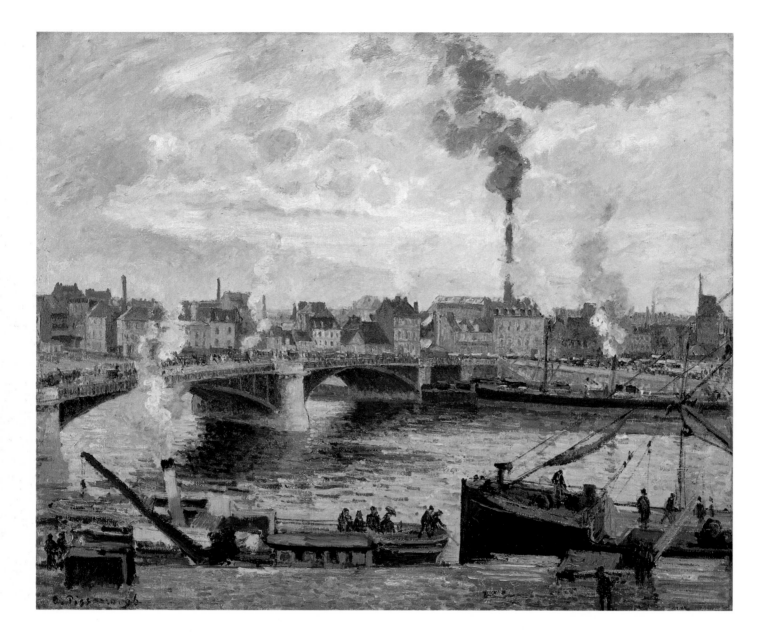

No. 37. Camille Pissarro
BRIDGE AT ROUEN, 1896

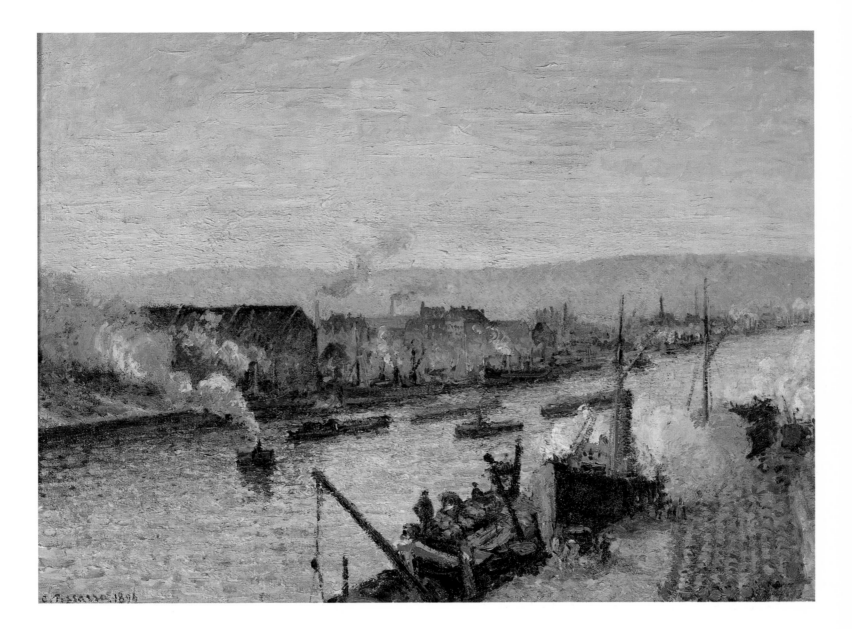

No. 38. Camille Pissarro
ROUEN HARBOR, SAINT-SEVER, 1896

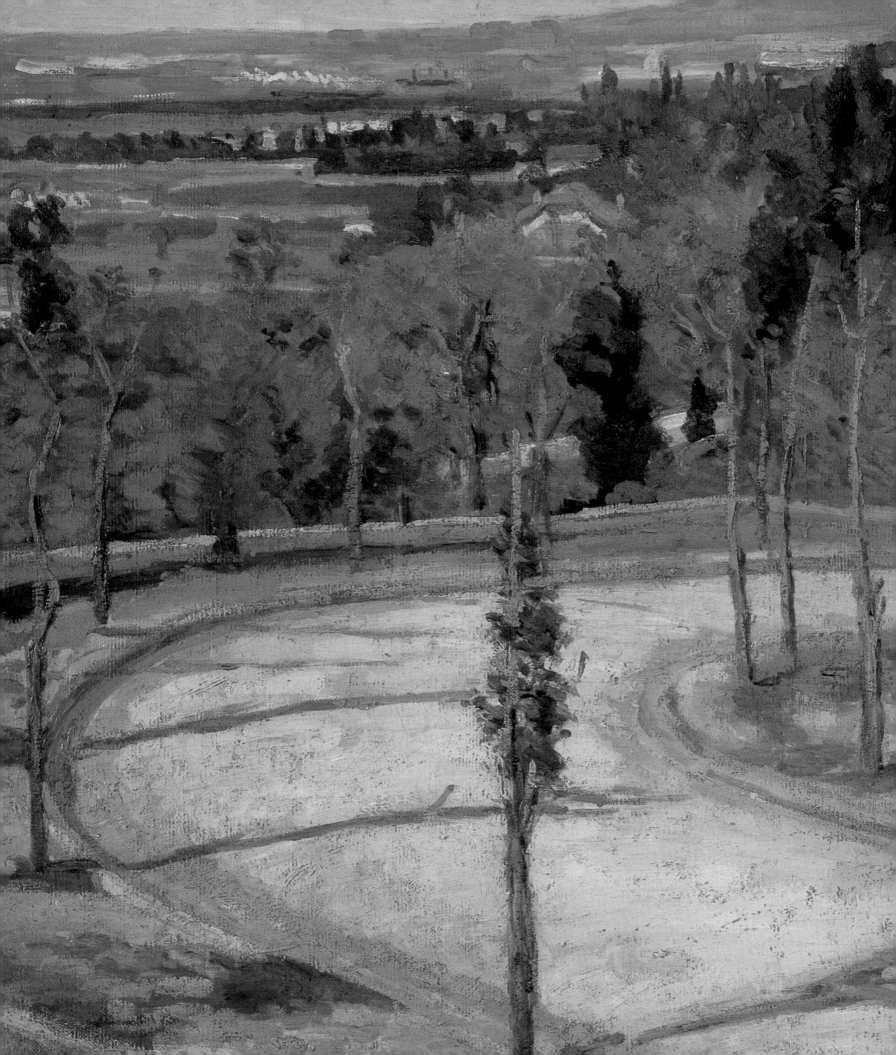

III/4

Rivers, Roads, and Trains

THE WEB OF ROADS, RAILROADS, AND RIVERS that ran throughout France during the nineteenth century was without doubt the most formidable system of transport and communication in the world. Partially nationalized and partially private, this system was organized into primary, secondary, and tertiary networks. The first was a nationwide system of communication between Paris and the major commercial and administrative cities of France; it had been operative since the 1600s as a series of national roads to which canals and railroads gradually had been added. The secondary system insured communication between provincial centers and the towns and major villages in the territories they governed; this was almost exclusively a network of roads, and less of it was nationalized than of the primary system. The tertiary system was the oldest and the least well maintained, consisting of small roads and—for the most part—paths linking small towns and villages to each other and to the countryside around them. Few of these paths were maintained by any governmental authority, and most were intended for use by animals or as access to agricultural areas.

The Impressionists painted all aspects of this system of transport and communication, from the rivers and canals to the national highways and local roads and, finally, to the tiny paths up hills and into the fields. The prototypes for this interest in representing human movement through the landscape are numerous. Most assiduous in their pictorial analysis of transit were the Dutch painters of the seventeenth century (no. 50). It is probably no accident that the paintings of the Ruisdaels, Meindert Hobbema, and others—like those of the Impressionists—record a system of roads and canals which had, in part, only recently been begun. Unlike seventeenth- and eighteenth-century French and Italian landscape painters, however, who used roads and rivers as compositional devices to move the viewer's eye slowly back through

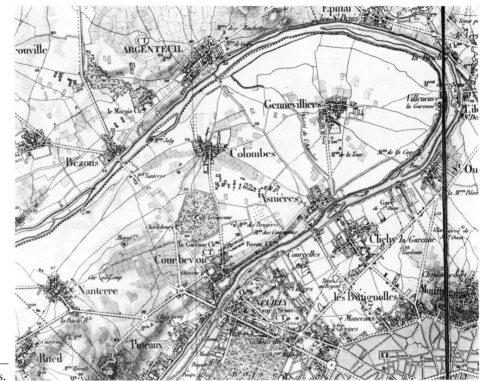

Map 6. Argenteuil, Neuilly, and Environs.

the picture plane and into the distance, Dutch artists were preoccupied with such motifs *as motifs*. Rarely in French painting before the Impressionists had this been the case. Thus the relationship between their compositions and those of the earlier Dutch masters—whose work they knew well—was crucial to the development of the Impressionists' compositions depicting movement through the landscape.

The enlargement of the basic communication system as well as new forms of transport—the train (see above, II and III/3) and steamboat—in early-nineteenth-century France made it possible, and therefore desirable, for those who lived in large urban centers to travel, if only occasionally and for short periods. Newspaper columnist Benjamin Gastineau believed that by 1860 travel had become essential as well as liberating: "Traveling is to live; it is to feel disengaged from all social restraint and prejudice." According to Gastineau, any city, especially Paris, was "huge, deceptive and chaotic, [a] vast market[place] where both the foot and the heart slide into the mire."[1] Travel provided the means to escape the pressures and ugliness of urban existence. A few years earlier Baudelaire had expressed the same sentiment in *Les Fleurs du mal* (1855), where he called for the train to carry him away from the city and his problems.

It was, above all else, the speed with which one could now travel that allowed for the vast ebb and flow of population from the city to the country. The inauguration of the railroad to Saint-Germain-en-Laye as the first major line from Paris in the mid-1830s eventually led to the construction of over 15,000 miles of track. By the end of the century construction of the six *grandes lignes,* or major systems, serving all of France (and Europe) had been finished. In addition, new canals were planned and inaugurated, and the *omnibus américain* (fig. 37) improved in quality and quantity to keep up with

.70 — Argenteuil (S.-et-O.)
Bords de la Seine
Un coin du nouveau Pont

B. F., PARIS

Fig. 30. *Argenteuil (Seine-et-Oise)/Banks of the Seine/A Portion of the New Bridge*, n.d. Postcard. Centre Documentation Sceaux. Photo: Gloria Groom.

the increased demand. Because of these developments, the social as well as the physical geography of France was altered drastically; tourism as a social phenomenon had begun in earnest. The Impressionists sought to provide images of the rapidly expanding horizon of the French population. Rivers, roads, and rails, with their appropriate modes of transport, became the major "modern" motifs in landscape painting in the second half of the century (see above, I–II).

The periodic mass exodus into the country made possible by the train and other inexpensive forms of transportation such as the tram not only allowed the urban dweller to reaffirm his humanity away from the hubbub of the city; the countryside and its inhabitants were also affected by increased building and commercial development (see above, II, and below, III/8). The periodical *La Vie Parisienne* for July 3, 1875, described the Parisians' invasion of France as one that took "possession of the countryside as though it were...a *café concert* larger than those of the Champs-Elysées." For those rich enough to avoid cafés, hotels, and the like, life was simpler and more pleasant. The French bourgeoisie bought country houses (see above, III/2), the convenience of which allowed them to spend frequent periods of time in the countryside:

> The bourgeois villas are going up in all the beautiful locations which surround the capital; entire districts have been built up, some of them of modest construction, some of them luxurious, all of them much to the taste of the Parisian populace which loves the countryside on the condition that it can be quickly transported there.[2]

In the *Paris Guide* of 1867 Léon Say pointed out in his essay "Les chemins de fer" that Parisians poured out of the city in the summer into an area between four and fifty kilometers from the city "determined by time and by the fare."[3] As we have seen, it was the sites within precisely these parameters that the Impressionists, for the most part, chose to depict in the early years (see above, III/2). Some of them focused on signs of industrial interference in the landscape and on factories (no. 38), bridges (nos. 45 – 46), and train tracks. In these paintings the man-made improvements of the industrial

Un sympathique souvenir de PARIS
que je quitte.

B. F., PARIS

Fig. 31. *A Fond Memory of PARIS, Which I'm Leaving*, c. 1900. Postcard. Private Collection, Louveciennes.

age are embraced by the natural landscape just as the rocks and fallen logs are in works of Courbet and Rousseau.

For Monet and the painters who followed him closely, then, the means of getting from one place to another was as much an artistic preoccupation as the towns outside Paris themselves. In Argenteuil, for example, where Monet lived and was visited by his painter friends, virtually every aspect of the Seine, upstream and downstream, was treated in his work (fig. 30; map 6). The paths by the river, the small inlets, the roads, and the railroad tracks and bridges of this small resort town a few kilometers from Paris were examined and re-examined in hundreds of his paintings from 1871 to 1878 (nos. 39– 43).

While it is true that the rivers, some of the roads, and the railroad lines of France were essentially public and that therefore a pictorialization of them was a celebration of property held in common by all the people of the nation (see above, II), it is difficult to know without corroboration from the painters themselves whether they believed their depictions of such subjects to be in any way a political statement. In a sense, a depiction of any of the innumerable construction projects—of viaducts, sewers, railways, roads, and canals—begun and carried out under the Second Empire was such a statement (fig. 31). And yet a comparison of Monet's depictions of the Seine and the bridges around Gennevilliers, Colombes, and Argenteuil with Pissarro's contemporaneous depictions of Pontoise and the Oise (see below, III/5) reveals the differences with which the same motif might be imbued. Monet's river is the site of bourgeois leisure; the pleasures of boating, promenading, and relaxing are celebrated. Pissarro's paintings of Pontoise, on the other hand, reveal the mundane activities of daily existence: factories and farms, peasants and workmen making use of their proximity to the river for practical ends. Pontoise, of course, was a small commercial town on the Oise River; Argenteuil, a weekend resort minutes from Paris. Thus their selection of places to live was as much an indication of the philosophical (or political) differences between these two artists as were their visions of the landscapes around them.

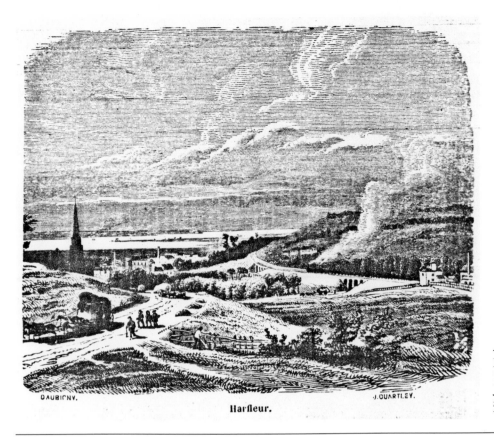

Harfleur.

Fig. 32. Charles-François Daubigny (French, 1817–1878), *Harfleur*. Illustration from Jules Janin, *Guide de voyageur de Paris à la mer*, 1862. Bibliothèque Historique de la Ville de Paris. Photo: Gloria Groom.

Their individual concerns—Pissarro's for Pontoise and Monet's for Argenteuil—also seem to have affected the method by which they realized their landscapes. Monet's paintings participate in the scenes he depicts—his odd perspectives are evidence of his use of a studio boat. This interest in the river shore seen from the water itself was inspired by Daubigny's use of a similar floating studio. In fact, Daubigny's *Boat Trip* series (1862) and his earlier vignettes entitled *Guide for the Traveler from Paris to the Sea* (1847) (figs. 32, 34–35) provided Monet with sources of inspiration, although he removed all traces of the presence of the boat itself while Daubigny delighted in revealing his very unusual way of life. Pissarro, in contrast, depicted his views as if firmly rooted on the land. He remained a spectator viewing the landscape as a thing quite apart from himself, but something which he should and must record.

This difference in point of view and artistic means employed to convey a particular ideological stance is sometimes subtle, but always crucial to an examination of these artists' paintings. Monet's work speaks to us as consummately Parisian, in spite of the fact that Paris was his adopted city. Zola remarked that

> ...as a true Parisian [sic] he brings Paris to the country; he cannot paint a landscape without including well-dressed men and women. Nature seems to lose its interest for him as soon as it does not bear the stamp of our customs....He is pleased to discover man's trace everywhere....He loves with particular affection nature that man makes modern.[4]

Monet was an excited visitor to the landscape he chose to paint, but we are constantly aware that he had purchased a return ticket and that he would leave by whatever means he had selected to come out into the country in the first place. Pissarro, on the other hand, painted in the guise of a timeless

Fig. 33. Edouard Baldus (French, 1820–c. 1881), *Land-scape near the Chantilly Viaduct*. Albumen print from glass negative. 32 x 43 cm. From *Album des chemins de fer du Nord*, 1855. Bibliothèque Nationale. Photo: Studio Harcourt.

inhabitant, viewing with suspicion any intrusion into the rural society which he set down on canvas. Although he maintained his distance, he examined subjectively the features of the essentially provincial, considerably more sober landscape about him. These two contrasting concepts characterize for the most part the different subjective points of view presented in the landscape paintings of the Impressionist artists. Although they are diametrically opposed, however, they both recognize and capture a sense of movement or transitoriness, both physical and temporal. Monet's is as quick and fleeting as the train travel he so readily embraced; Pissarro's, as slow and torpid as the barges he so often painted.

It may have been the newly found opportunities of the Parisian middle classes to travel outside the city, as well as the Impressionists' assumption that such people would desire paintings of scenes they observed on their travels, that—more than anything else—encouraged these artists to depict the landscape of transit. In any event, in response to the increased mobility allowed by the railroads, portable visitors' guides such as those by Joanne (see above, II and III/2) were created for all the major regions of France. The monuments and scenery illustrated in the folio volume *Voyages pittoresques et romantiques dans l'ancienne France* by Baron Isadore Taylor and Charles Nodier (1820–78) or in *Album des chemins de fer du Nord* (fig. 33) could now be visited firsthand by the interested traveler. Increased speed and accessibility inspired Eugène-Emmanuel Viollet-le-Duc to state that "the railroad has allowed us to see more monuments within a week than it could previously have been possible to visit in a month."[5] By 1876 tourists with guidebooks in hand had become the butt of jokes. Charles-Albert Bertall, in his *La Vie hors de chez soi (comédie de notre temps)* (1876), described

> ...tourists, limited to those verifications of a thing's permanent identity, and unable to provide the nourishment of diversifying by study and by comparison...if he does not have the Joanne guidebook in his pocket, he does not even know where he is.[6]

"If this is Tuesday, it must be Belgium" was obviously not a concept invented in the twentieth century.

The decades of the 1860s and '70s were decisive in the formation of a new language of landscape painting for the French Impressionists. This post-

A DAY IN THE COUNTRY

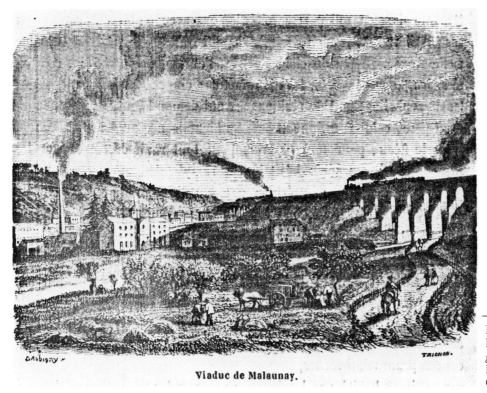

Viaduc de Malaunay.

Fig. 34. Daubigny, *Viaduct of Malaunay.*
Illustration from Jules Janin, *Guide de voya-
geur de Paris à la mer,* 1862. Bibliotheque
Historique de la Ville de Paris. Photo: Gloria
Groom.

Barbizon visual vocabulary incorporated within itself the jargon of middle-
class travel and the experiences which resulted therefrom. Although this lan-
guage remained in its nascent stages with some of the artists (for example,
Sisley and Guillaumin), with others (Monet, for instance) it provided the
basic structure out of which a larger vocabulary could grow and change. We
have become accustomed to the Impressionist vision created during these
formative years—a genial landscape iconography of meandering roads,
flowing waterways, and the more modern severity of railroad tracks piercing
the natural terrain. This iconography evoked for these artists, as it does for us
today, a sense of movement, of adventure, of visual and intellectual expan-
sion. As Henry James wrote in a column for the *New York Tribune* in which
he described a trip from Paris to Le Havre by way of Rouen, "my enjoyment
has not been of my goal but of my journey."[7]

The compositional and iconographical origins of the Impressionist
pictorial language of the 1870s do not lie altogether within the realm of the
fine art of the past. Although their work was based squarely in the traditional
landscape methods of the Académie, distilled and reinterpreted by the artists
of Barbizon, as well as in Dutch seventeenth-century painting, the Impres-
sionists turned to conceptually different artistic sources as well. These were
the popular illustrations—prints produced for French newspapers, journals,
guidebooks, and general literature—which began to appear in such extraor-
dinary profusion after the 1840s (figs. 34–37). Rather than relying on single
prints or illustrations in the creation of specific paintings, however, the
Impressionists simply absorbed this explosion of visual data and turned it to
their own uses (nos. 39–46). It was precisely this interest in what was tradi-
tionally considered to be "low art" that provoked reactions from critics both
favorable and hostile to the newly formed movement (see below, IV). Baude-
laire and Castagnary, for example, complained of the surfeit of the common-

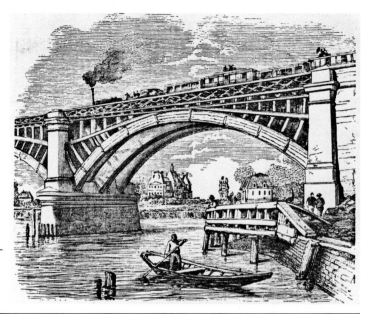

Fig. 35. Daubigny, *Maisons-Laffitte*. Illustration from Jules Janin, *Guide de voyageur de Paris à la mer,* 1862. Bibliothèque Historique de la Ville de Paris. Photo: Gloria Groom.

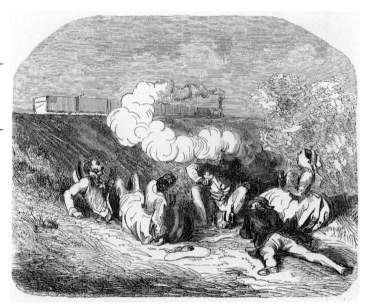

Fig. 36. Emile de La Bedollière (French), *The Rustic Pleasures of the Parc du Vésinet*. Illustration from *Histoire des environs du nouveau Paris,* early 1860s, p. 109. Photo: LACMA.

Fig. 37. Victor Geruzez [Crafty] (c. 1840–1906), *The Departure of the Last Omnibus américain*. Illustration from *Souvenirs de la fête de Bougival.* Private Collection, Louveciennes.

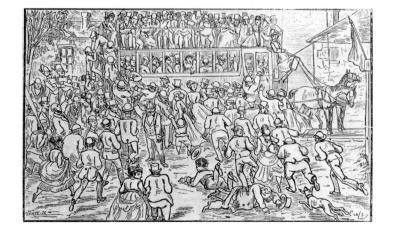

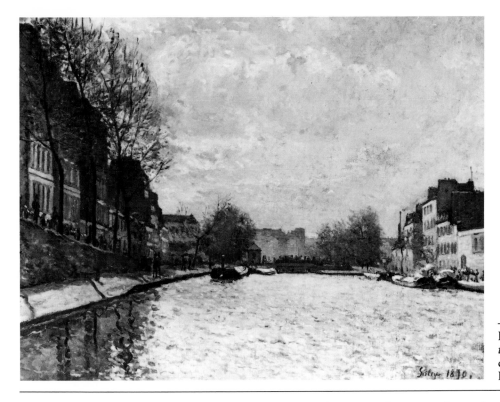

Fig. 38. Sisley, *View of the Canal Saint-Martin*, 1870. Oil on canvas. 50 x 65 cm. Musée d'Orsay, Galerie du Jeu de Paume, Paris. Photo: ACRACI.

place in landscape painting, as well as the lack of distance between the real and the pictorial worlds. They had hoped contemporary landscape painting would somehow rise above the merely descriptive. Other critics, though, could discern that these artists were capable of overcoming the banality of a subject to make something quite exceptional of it. Zola and Jean Rousseau both saw Pissarro, for example, as moving beyond the picturesque to reveal in the landscape a kind of robust and eloquent veracity which had not been examined previously.

In the end, the Impressionists created landscapes of transit that were riddled with ambiguities and contradictions. They simply exchanged the idyllic landscape fiction of the past for one of their own making. The earlier French interest in painting exotic places was supplanted by a desire for the familiar (fig. 38), a concern to see those sites which were—or which could be—known through personal experience. The Impressionists, in many cases, sought to accommodate the contemporary concern for the familiar in their art. In addition to capturing on canvas, in a specifically modern way, the popular vacation sites and pleasurable outdoor activities made possible by leisure time, they focused on the specific means by which such pastimes and places were being made accessible to an ever-growing public even as they painted.

—S. S.

NOTES

1. Gastineau, 1861, p. 2.
2. Martin, 1890, Preface.
3. La Croix (ed.), 1867, vol. II, pp. 1658–1659.
4. Zola, 1959, pp. 131–132.
5. Viollet-le-Duc, 1862, p. 254.
6. Bertall, 1876, p. 11.
7. James, 1952, p. 192.

39–43. Claude Monet

ARGENTEUIL BASIN
(*LE BASSIN D'ARGENTEUIL*), 1872

THE SEINE AT ARGENTEUIL
(*LA SEINE À ARGENTEUIL*), 1873

ARGENTEUIL BASIN
(*LE BASSIN D'ARGENTEUIL*), 1874

SAILBOAT AT PETIT-GENNEVILLIERS
(*VOLIER AU PETIT-GENNEVILLIERS*), 1874

THE RAILROAD BRIDGE, ARGENTEUIL
(*LE PONT DU CHEMIN DE FER,
ARGENTEUIL*), 1874

44–45. Pierre-Auguste Renoir

THE SEINE AT ARGENTEUIL
(*LA SEINE À ARGENTEUIL*), c. 1873

THE BRIDGE AT ARGENTEUIL
(*LE PONT D'ARGENTEUIL*), 1882

46. Gustave Caillebotte

THE BRIDGE OVER THE SEINE
AT ARGENTEUIL
(*LE PONT D'ARGENTEUIL ET LA SEINE*),
1885

In the second half of the nineteenth century Argenteuil was a small, self-sufficient town 27 kilometers by boat from Paris, although it could be reached even more quickly by the railroad, which first had begun its service there in 1851. Because of the railroad Argenteuil very quickly became one of the most important resort towns in the immediate vicinity of Paris. To get there one boarded the Paris–Saint-Germain-en-Laye train at the Gare Saint-Lazare; it departed every hour between 7:50 a.m. and 9:50 p.m. with an additional return train in the summer leaving at 11:30 p.m. The ten-kilometer trip took twenty-two minutes with stops at Asnières, Bois-Colombes, and Colombes, before proceeding across the Seine on the railroad bridge into Argenteuil. On board the more leisurely steamboat, the tourist went through Billancourt, Saint-Cloud, Asnières, Clichy, Saint-Denis, Epinay, Gennevilliers, and then into Argenteuil.

Both means of getting to the town were used by the multitude of Parisians who wanted to escape the city for a day or two of strolling in the fresh air, boating, and sailing (a new recreational sport at the time). Because of the width and depth of the Seine there, Argenteuil quickly became the most popular sailing locale near Paris. Although rapidly becoming a mere suburb of the capital

when Monet moved there in December 1871 from Holland (where he had lived for a short time during the Franco-Prussian War), Argenteuil was still considered to be in the countryside. Like many other nascent suburbs, however, its attractions were apparent not only to the tourists who visited, but also to developers and industrialists. An increase in population was to alter the town significantly as it did many other places depicted by the Impressionist painters in the 1870s.

Argenteuil's approximately 5,000 inhabitants must have become preoccupied with the activities of tourism very soon after 1851, the year the Asnières–Argenteuil stretch of the Paris–Saint-Germain-en-Laye railway opened. Contrary to the opinion of Albert Rhodes, a would-be student of the French national psyche, that Frenchmen preferred to live poorly in an urban center rather than to move to the suburbs ("an hour or two of Vincennes or Bougival from time to time suffices for them...."),[1] by the end of the century Argenteuil's inhabitants had increased and it had become part of the vast array of bland, anonymous suburbs surrounding Paris.

Monet's presence in Argenteuil, as well as the life of the place, proved to be attractions for his artist friends, many of whom came from Paris and its environs to visit, to discuss mutual interests, and, of course, to paint the town and surrounding countryside. Sisley came in 1872, Renoir in 1873 and again in 1874, and Manet in 1874. The boat basin, crowded with middle-class tourists enjoying themselves at boating, promenading, and picnicking on the banks of the Seine, proved to be an irresistible motif.

Argenteuil promoted itself as one of the most attractive points along the Seine near Paris for just such activities. As early as August 25, 1850, the town fathers sponsored a regatta in order to attract Parisian boating enthusiasts to the area. Eight years later, the town succeeded in luring the prestigious sailing club of the Société des Régates Parisiennes, the Cercle de la Voile, to relocate in Argenteuil. This resulted in the town's being selected as the site for the International Sailing Competition of

1867. By the time Monet had moved there, mooring space for sailboats, rowboats, and steamboats was at a premium. Combined with the normal commercial barge traffic, these craft made for rather crowded waters at this point in the Seine's course. Some artists, such as Pissarro, reveled in the bustle. Others, including Monet, eliminated all evidence of commercial traffic from their paintings. These choices are particularly revealing of the artists' interests at the time.

The most panoramic of the views of the boat basin at Argenteuil are Monet's *Argenteuil Basin* of 1872 (no. 39) and Renoir's *Bridge at Argenteuil* (no. 45) of a decade later. These paintings, in fact, are a veritable catalogue of what the town had to offer the tourist at this time. Top-hatted gentlemen and ladies with parasols stroll along the Promenade, a tree-lined walk on the Argenteuil side of the Seine; other tourists are seated on the bank watching the rowboats, sailboats, and a large steamboat (and three *guèpes à vapeur* in Renoir's painting) in the basin. In the distance is the highway bridge, which had been destroyed in the Franco-Prussian War and quickly rebuilt thereafter, and across the river can be seen the township of Gennevilliers. Monet's painting—showing Argenteuil seen on any beautiful Sunday afternoon in the summer—encompasses an enormous amount of the area, even though more than half of the canvas is a study in cloud formations.

Renoir's *Bridge at Argenteuil* (no. 45) embraces less of the same view, which is here separated from the viewer by a screen of trees, a common motif in Impressionist paintings of this period (nos. 13, 19). In both pictures, however, it is the boat basin and its various activities which are the true subject. Caillebotte, on the other hand, pulled his 1885 view of the bridge at Argenteuil and the Seine (no. 46) extremely close to the highway bridge, seen from Petit-Gennevilliers on the opposite side of the Seine. Framed by the curve of the arch is the town of Argenteuil itself. With Caillebotte, however, it was the uniqueness of the viewpoint that was the artist's real concern rather than the particular panorama. This use of dramatic perspective,

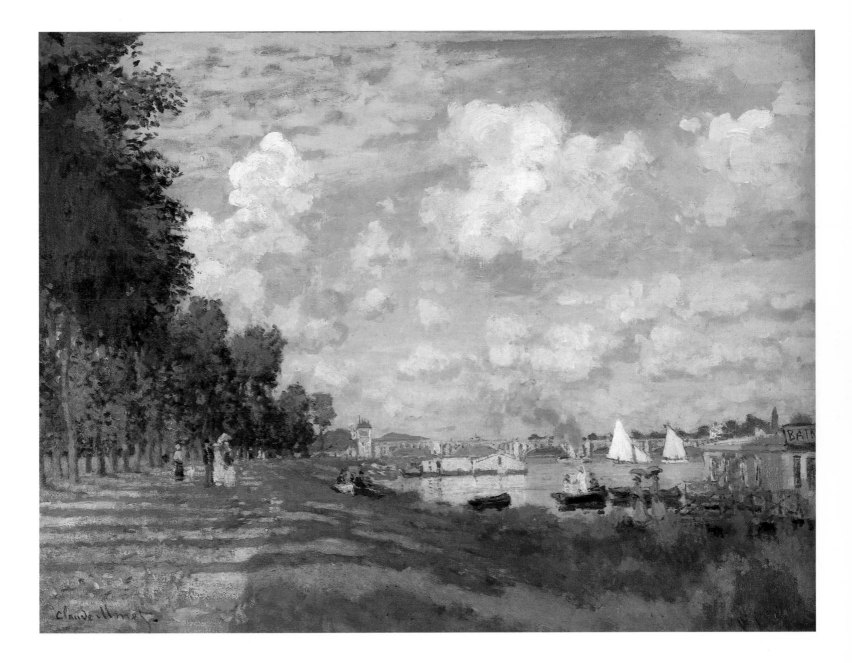

No. 39. Claude Monet
ARGENTEUIL BASIN, 1872
(detail on pp. 322–323)

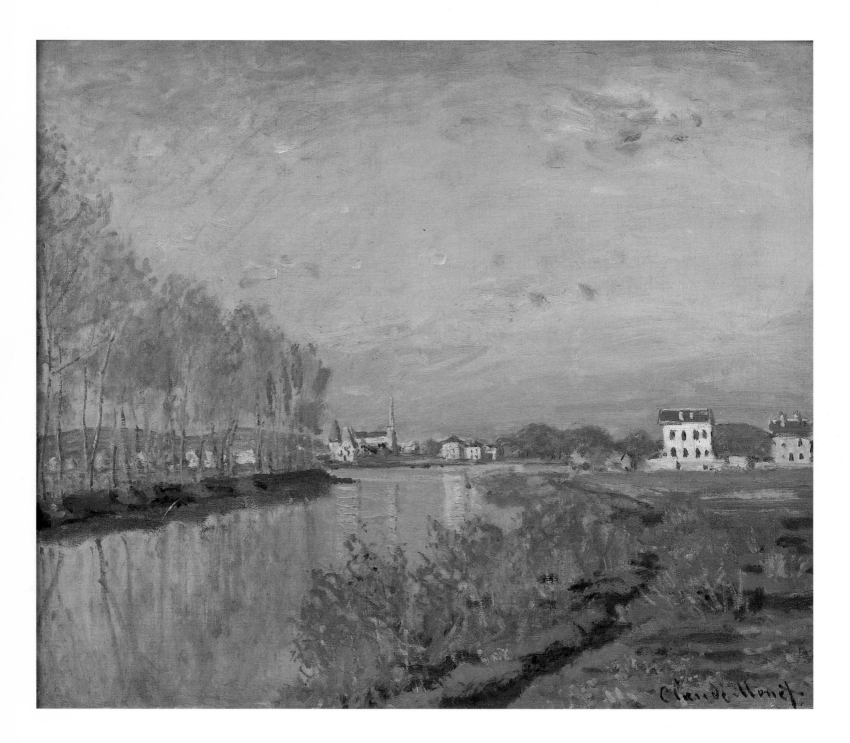

No. 40. Claude Monet
THE SEINE AT ARGENTEUIL, 1873

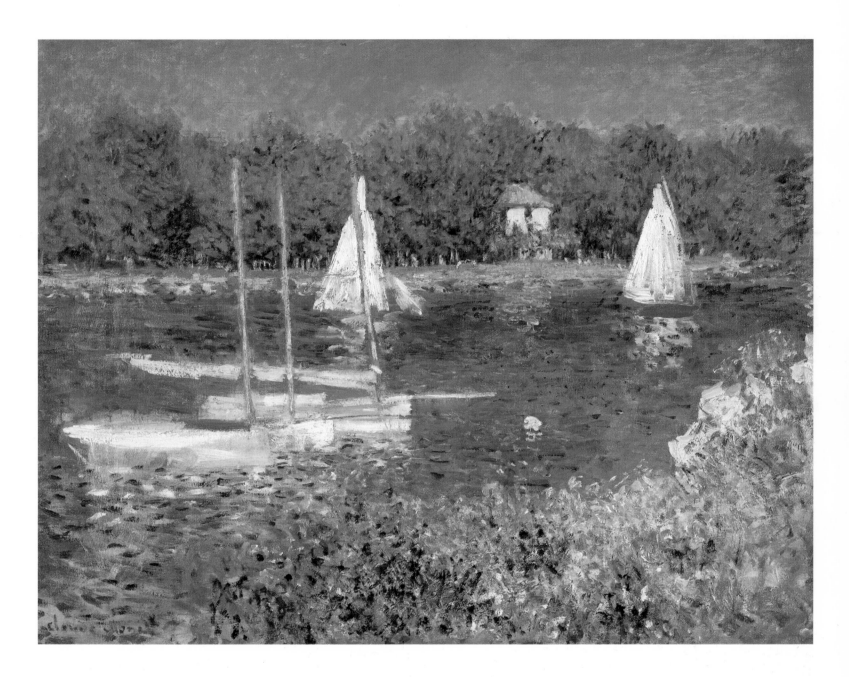

No. 41. Claude Monet
ARGENTEUIL BASIN, 1874

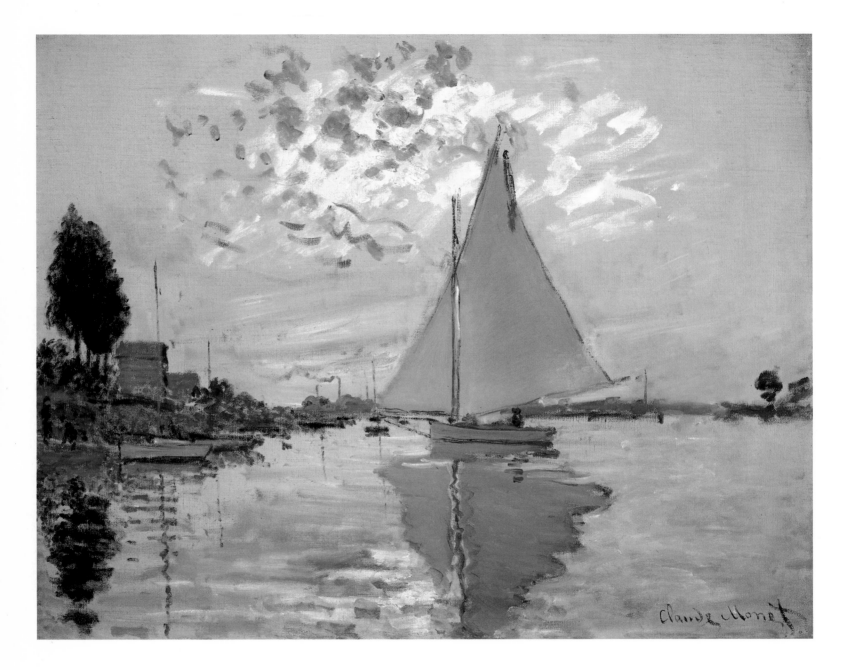

No. 42. Claude Monet
SAILBOAT AT PETIT-GENNEVILLIERS, 1874

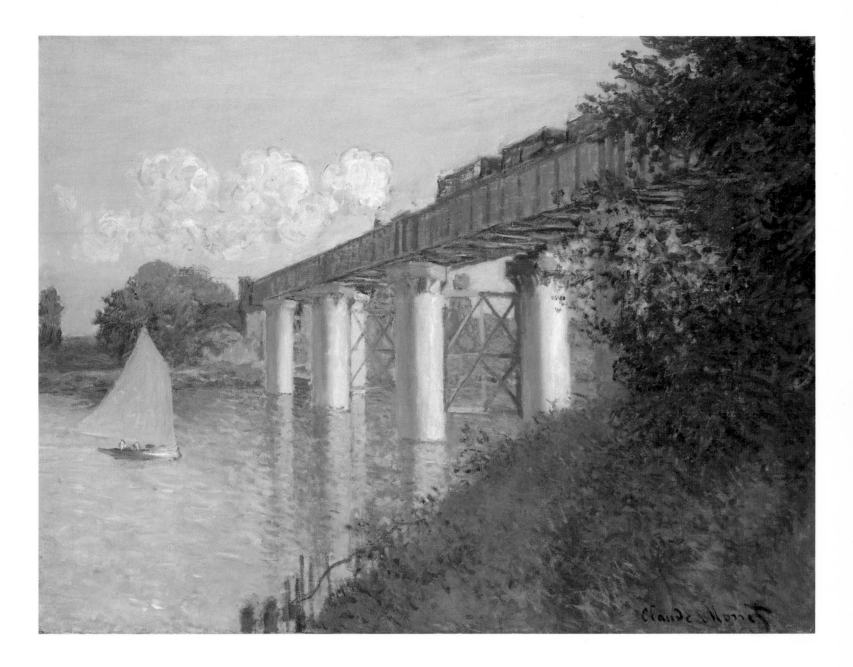

No. 43. Claude Monet
THE RAILROAD BRIDGE, ARGENTEUIL, 1874

something which preoccupied Caillebotte throughout his career, was probably dependent on popular illustrations, in which similar eye-catching experiments were constantly used to attract attention. It should be noted that Caillebotte's interest in Argenteuil was more than just for motifs to paint. He and his family owned many pleasure boats and yachts. In fact, five years before he painted this view, Texier *fils* of Argenteuil had built for Caillebotte and his brothers the first boat in France to make use of silk sails, which was successful in its various competitions and was sold a year later.

Monet chose the basin as his subject in two paintings of 1874. *Argenteuil Basin* (no. 41) depicts the Promenade near the Champ de Mars as seen across the boat rental area from Petit-Gennevilliers (the planting on the banks acts as a *repoussoir* element to thrust the viewer even further into space). To the immediate right would have been the highway bridge. *Sailboat at Petit-Gennevilliers* (no. 42) was undoubtedly painted from Monet's specially built, floating atelier modeled on Daubigny's (see above, III/ 4). Here, it must have been moored in front of the boat rental house. (Caillebotte's *Bridge over the Seine at Argenteuil* depicts the area exactly 90 degrees to the right.) Another view by Monet, *Sailboats in the Boat Rental Area* (1872; Fine Arts Museums of San Francisco), depicts this same view from a slightly closer vantage point. In both paintings by Monet, two active smokestacks, one on either side of a gabled house, reveal the area's involvement in something less capricious than the tourist trade.

From slightly further upstream Monet and Renoir also depicted Argenteuil from the Colombes shore of the Petit-Bras of the Seine. In Renoir's *Seine at Argenteuil* (no. 44) the Ile Marante can just be seen on the left. In the distance are the Château du Marais and the factory sheds. Renoir has pulled back slightly and cut off the two buildings seen on the right in Monet's *Seine at Argenteuil* of the same time and, unlike Monet, has shown the Seine in use; two men in a rowboat glide past and what appears to be a barge disappears around the bend in the river, emphasized by the cleared towpath. In contrast, Monet's painting

shows the scene undisturbed by movement. Sisley, probably during the same painting campaign, depicted the identical view seen here (*The Seine at Argenteuil* [1872; Private Collection]).

Perhaps the most startling, dramatic, and truly modern view of Argenteuil Monet painted is *The Railroad Bridge, Argenteuil* (no. 43) (another version of the subject, without the sailboat, is in the Musée d'Orsay, Paris). In addition, the painting is, in a way, the quintessential image of Monet's interest in the landscape during this period. The peaceful summer day of *Argenteuil Basin*, painted during the same year, is here further animated by the introduction of the train streaking across the railroad bridge further down the Seine from the highway bridge as well as by the compositional format Monet chose to use. The gentle sounds of city people at play are here overruled by the implied shrill whistle and mechanical sounds of a train carrying goods and passengers from one point to another. The concrete and iron bridge and the train passing over it plunge the viewer deep into the pictorial space in a manner similar to that utilized by illustrators of similar scenes from Daubigny to the innumerable anonymous artists whose work peppered the contemporary press.[2] Juxtaposed with the bridge is a single sailboat. Monet painted this picture standing on the Epinay–Argenteuil side of the bridge looking toward Gennevilliers; the boat rental area was within view on the other side of the highway bridge. From contemporary descriptions of this particular point it is possible to determine that Monet chose to enhance the physical beauty of the area. The industrialization of Argenteuil, indeed of all France, as well as the means utilized by her citizens to enjoy the leisure time created by that industrialization, are nowhere more definitively presented than in this painting.

This iconography of modern riverscapes owes its inspiration and syntax to contemporary illustrations and popular prints. There is no question that these crude graphics lack the eloquence and physical beauty of Monet's paintings, for example. In their own way, however, they exhibit a masterly ability to capture the panorama of modern life quickly and

without pretense. Today they strike us as insignificant and banal in the same way, in fact, that Impressionist painting must have appeared to some members of its contemporary audience. To peruse the ephemera of the 1860s and the '70s is to rediscover the foundations upon which the Impressionists presented to an affronted public the familiar landscape of their world, but in a radically new style.

NOTES
1. Rhodes, c. 1875, p. 80.
2. Tucker, 1982, pp. 70–75.

47. Claude Monet

ON THE SEINE AT BENNECOURT
(*AU BORD DE L'EAU, BENNECOURT*), 1868

Bennecourt is a small village situated in the elbow of the Seine about three miles southeast of Giverny. Myriad small and large islands dot the Seine between Bennecourt and Gloton on the right bank, and Bonnières and Jeufosse on the left. In the mid-nineteenth century Bennecourt's economy was essentially based on agriculture, particularly the cultivation of fruit and the making of wine. Two years before Monet painted *On the Seine at Bennecourt*, Cézanne had visited the town, which he may have known through the paintings and etchings of Daubigny and his son from the previous decade. He certainly would have known of it through several of his friends, including Zola, who lived there on and off between 1866 and 1871 and who wrote several of his novels and stories there, including *La Rivière*, *Thérèse Raquin*, and *L'Oeuvre*.

Because Monet's work of the late 1860s was, in a sense, experimental (like that of his compatriots Sisley, Renoir, and Bazille), he reworked and reused his canvases at later dates. As a result, this painting is the only picture of Bennecourt that survives from the early period. However, Monet returned to this site 15 years later in a number of winter landscapes showing the town veiled by frosty mists, his house at Giverny (nos. 91–93) being only a very short distance away.

In this painting, Monet depicted his mistress (later, his first wife), Camille Doncieux, seated beneath a tree on the largest island in the Seine at this point; the rowboat in which they traveled to get

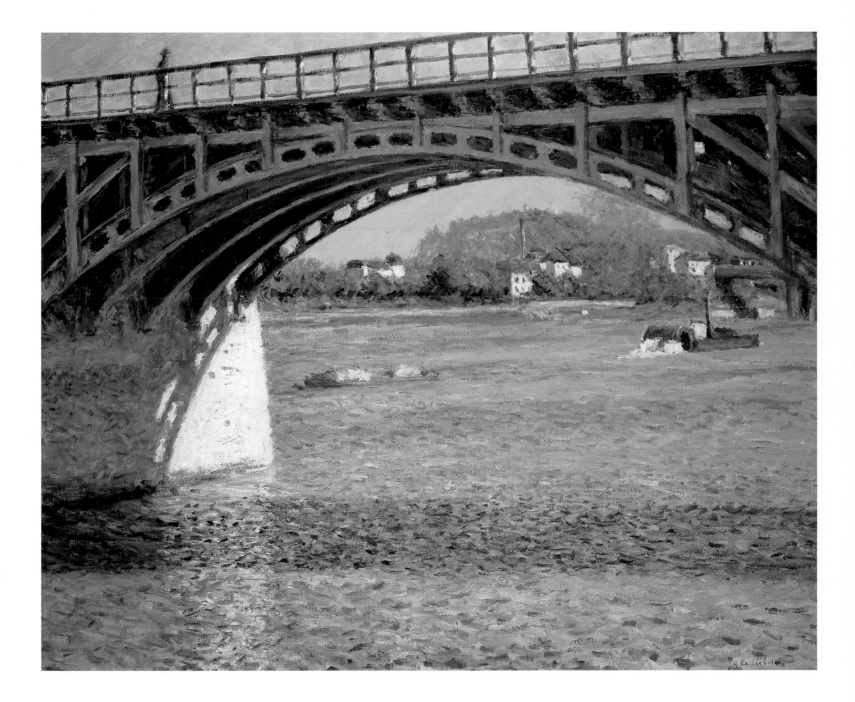

No. 46. Gustave Caillebotte
THE BRIDGE OVER THE SEINE AT ARGENTEUIL, 1885

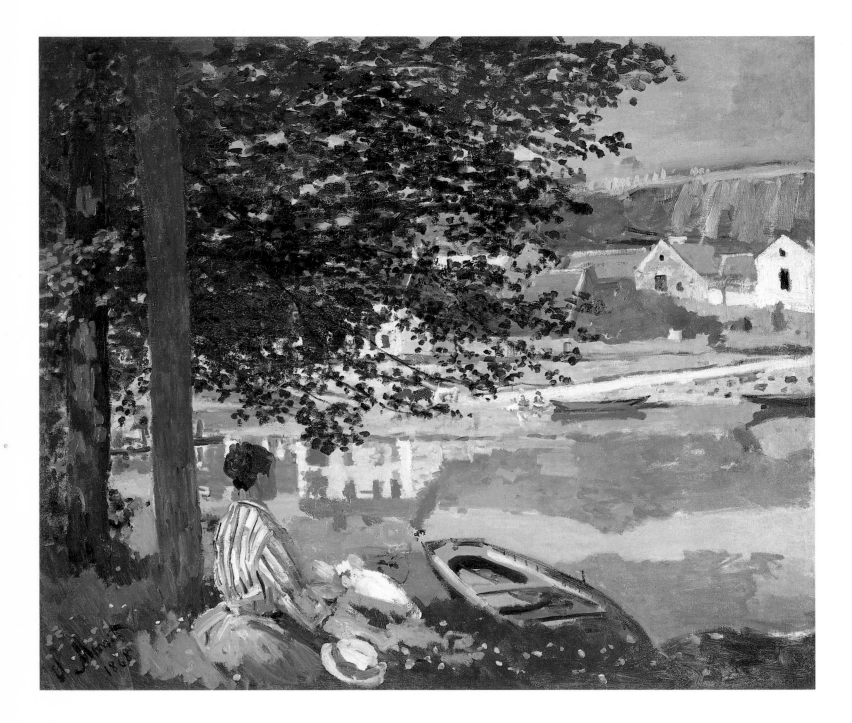

No. 47. Claude Monet
On the Seine at Bennecourt, 1868
(detail on pp. 50–51)

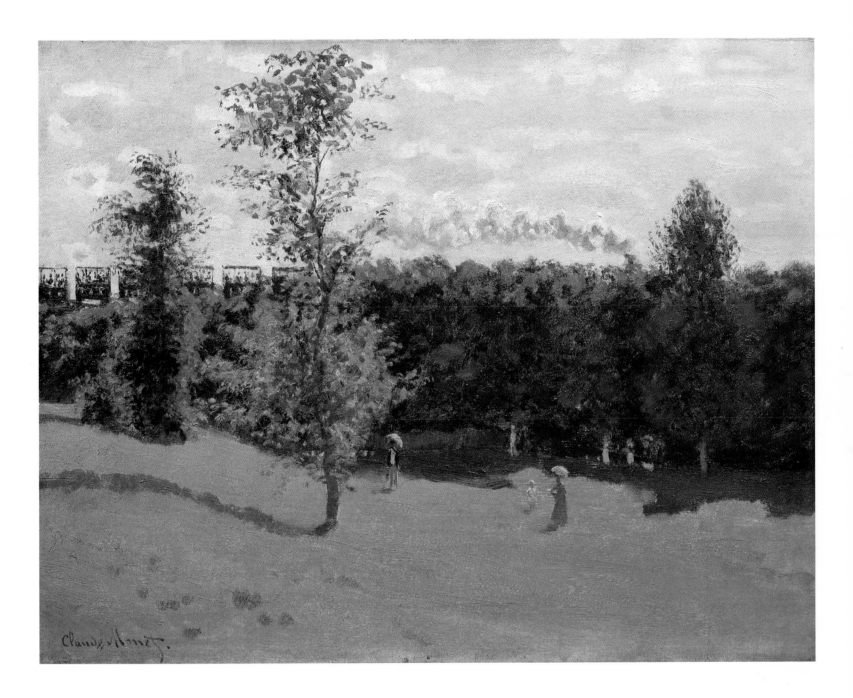

No. 48. Claude Monet
TRAIN IN THE COUNTRYSIDE, c. 1870–71

there is moored nearby. In the grand tradition of early nineteenth-century Romantic painting, she looks, with *profile perdu* (a pose which allows us only to glimpse her face) at the houses of Gloton. The lofty associations conjured by Romantic artists are here suppressed, however, by Monet's obvious delight in color and light and by the beautiful surface qualities of the whole. His clarity of vision and composition, perhaps reliant on similar effects in contemporary photography (see below, V), imbued the painting—whose focus is the river itself—with an objectivity which completely liberates the scene from its possibly sentimental constraints.

48. Claude Monet

TRAIN IN THE COUNTRYSIDE
(*TRAIN DANS LA CAMPAGNE*), c. 1870–71

49. Pierre-Auguste Renoir

OARSMEN AT CHATOU
(*LES CANOTIERS À CHATOU*), 1879

Few paintings reveal so perfectly and succinctly the "improved" landscape of nineteenth-century France. Monet's small picture depicts ladies with parasols and small children engaging in promenades in the country. Passing on an embankment is the train, that mechanical invention which allowed Parisians of various classes to participate in the pleasures to be found in the countryside. Hidden by the trees, the locomotive's presence is suggested by the puffs of steam that indicate the direction in which the train is moving. Insouciantly integrated into the landscape, much like a temple in a painting by Claude, the train provides the viewer with a focus as his eye moves slowly into the distance in order to appreciate the whole landscape.

Monet's picture shows the Saint-Germain branch of the Paris–Saint-Germain-en-Laye railroad line, the earliest to be inaugurated in France (see above, III/4). The height of the embankment suggests that the site of the painting must lie between Rueil and Chatou. The *wagons à l'imperiale,* or double-decker cars, crowded with holiday-seekers charmingly, even disarmingly, silhouetted against the sky, were a feature unique to this particular line. By 1864 the train

ran every hour (with additional departures scheduled during the summer) at a very low cost, although there was a surcharge on weekends. As early as 1848, only two years after this branch had opened, the anonymous author of an article in *L'Illustration* criticized this policy of increasing fees on the only days when people could shake off "the heavy chain" that bound them to "the merchant's bank, the office of the man of affairs, the painter's atelier, or the employee's desk."[1] Even artists, then, seem to have discovered the beauty of this site very early on in the century.

Renoir's *Oarsmen at Chatou* reveals the summer pleasures awaiting those who got off the train depicted in Monet's painting. (The line continued to Le Vésinet, Le Pecq, and, finally, to Saint-German-en-Laye.) Located on the right bank of the Seine across from Rueil and just south of Argenteuil, Bezons, and Carrières-Saint-Denis, Chatou was becoming a popular place for the rich to build country houses and for the members of other classes to visit on weekends. In fact, it was one of the oldest suburbs of Paris. By this time it had become a rival of Asnières as a place to go for pleasure-boating. Joanne's guide of 1881 describes the town as a paradise for anglers as well as *canotiers*.[2]

Unlike other paintings by Renoir of this site in which the figures become mere staffage (as, for example, in *Seine at Chatou* [1880; Museum of Fine Arts, Boston]), here the subject of the picture is the figures—the boaters and well-wishers, including the artist's own well-dressed friends Caillebotte and Aline Charigot, Renoir's future wife. The Seine is depicted here in its role as provider of enjoyment and relaxation. Renoir's great *Luncheon of the Boating Party* (1881; The Phillips Collection, Washington, D.C.) illustrates the lunch-time activities of these weekend sailors at the Restaurant Fournaise in Chatou. In the latter picture, as in *Oarsmen at Chatou*, Renoir has captured the quality of a day in the country in liquid strokes of pure color.

NOTES

1. *L'Illustration*, Oct. 7, 1848, p. 93.
2. A. Joanne, 1881, pp. 144–145.

50. Eugène Boudin

LANDSCAPE WITH WASHERWOMEN/
LE FAOU, THE HARBOR AT LOW TIDE
(*PAYSAGE AUX LAVANDIÈRES*/
LE FAOU, LE PORT À MARÈE BASSE), 1873

Boudin devoted a large part of his career to painting the far reaches of the northern and western French coastline, from the chic resort towns of Le Havre and Trouville to the quiet backwaters of the Finistère. Le Faou, a tiny village 561 kilometers from Paris, is 19 kilometers from Quimper. It is described by Paul Joanne in his *Dictionnaire géographique et administratif de la France* (1872) as being at the bottom of the estuary of the Brest basin. Although trains coming from Paris (one could board them at the Gare d'Orléans) ran very near Quimper at Lorient, its size, distance, and sociological make-up were unattractive to the Impressionists. Although Boudin painted here, his major interest seems to have been in reducing the site to a formula like those used in paintings by such seventeenth-century Dutch artists as the Ruisdaels or Jan van Goyen. The picture's surface of crusty impasto evenly applied and the objective examination of detail reveal Boudin's contribution to French painting of the period.

51. Armand Guillaumin

THE ARCUEIL AQUEDUCT AT SCEAUX
RAILROAD CROSSING
(*L'AQUEDUC À ARCUEIL, LIGNE DE SCEAUX*), c. 1874

Guillaumin's painting, possibly dating to the summer of 1874, when the architectural decoration of the newly completed Aqueduc de la Vanne was finished, depicts the point where the aqueduct—which separates Arcueil from Cachan—leaps the Paris–Sceaux railway line immediately south of Paris. People can be seen waiting at a small, covered station in the distance. To the left, a graded road alive with human traffic provides yet another link between Arcueil and Cachan. The Paris–Sceaux line had been inaugurated 30 years earlier; from the Gare de Luxembourg in Paris it took only a matter of minutes to reach Arcueil, a few kilometers away. Thus in one

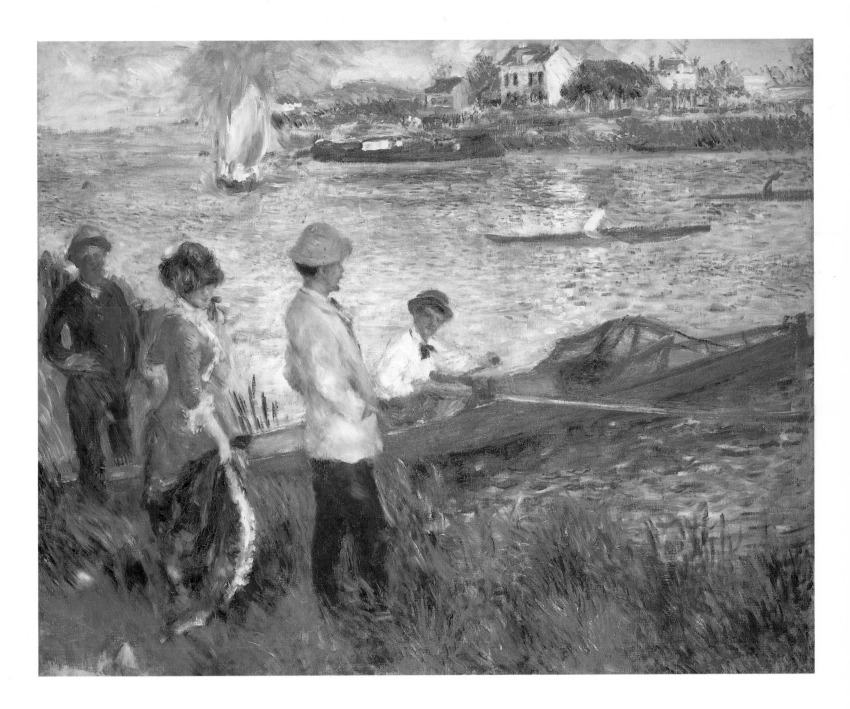

No. 49. Pierre-Auguste Renoir
OARSMEN AT CHATOU, 1879

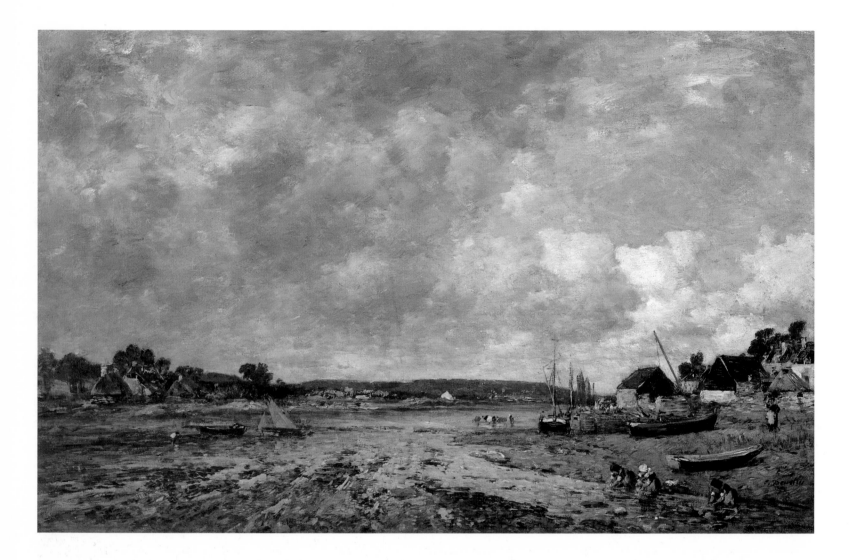

No. 50. Eugène Boudin
Landscape with Washerwomen, 1873

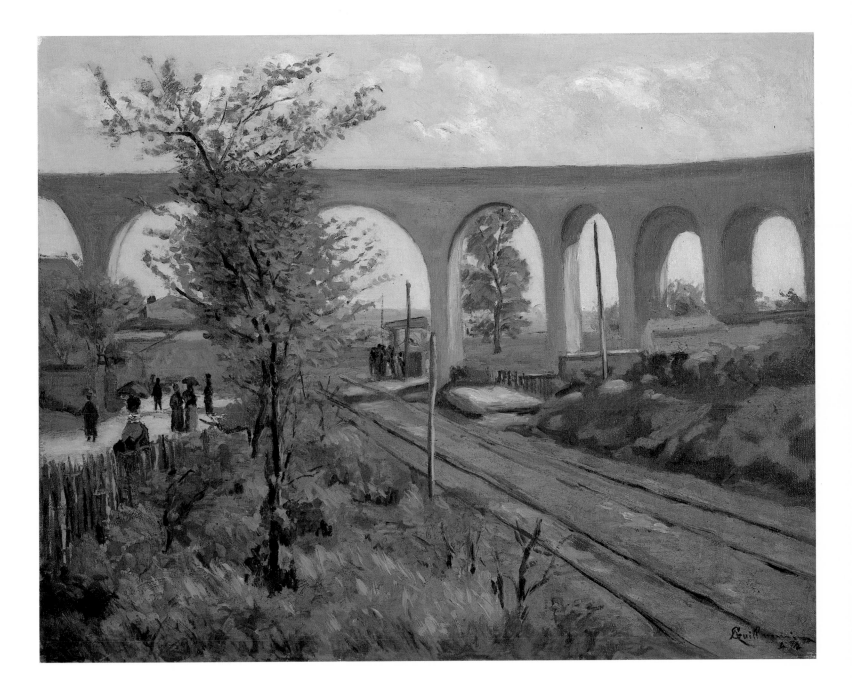

No. 51. Armand Guillaumin
THE ARCUEIL AQUEDUCT AT SCEAUX RAILROAD CROSSING, c. 1874

No. 52. Armand Guillaumin
ENVIRONS OF PARIS, c. 1874
(detail on p. 136)

A DAY IN THE COUNTRY

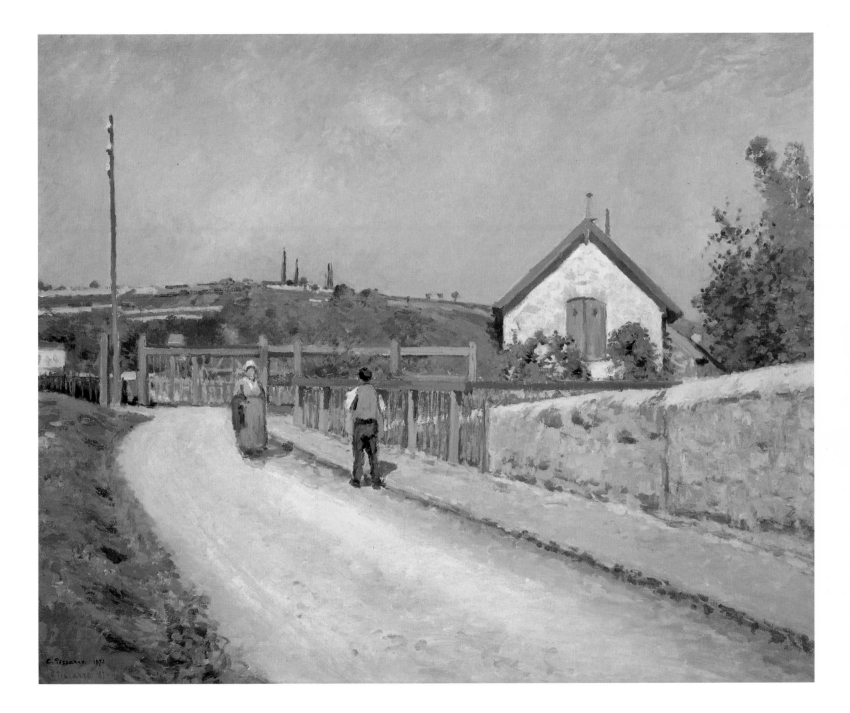

No. 53. Camille Pissarro
RAILWAY CROSSING AT PATIS, NEAR PONTOISE, 1873–74

painting Guillaumin has revealed three of the most important aspects of the mechanically improved French landscape of the nineteenth century: the road, the railroad, and the aqueduct.

The Aqueduc de la Vanne was listed in all the contemporary guidebooks as one of the major sites of this region because of its historical, aesthetic, and technological importance. It linked the Roman aqueduct of Arcueil, celebrated by Pierre de Ronsard in the sixteenth century, with the structure commissioned in 1613 by Marie de Medici and designed by Salomon de Brosse to provide water for her new Palais de Luxembourg. In 1867 the system was further enlarged and reinforced with Portland cement by Eugène Belgrand; by the time its architectural embellishments had been completed, it already had been in operation for some time.

In the nineteenth century Arcueil, with a population of about 5,300, was a small town which could be reached by train from Paris or by stagecoach by way of the post road from the Porte d'Orléans. Because it was situated in a valley which possessed both natural beauty and historical importance (Etienne Jodelle, like Ronsard a member of the Pléiade, and the Marquis de Sade had châteaus there), many bourgeois built country houses in the area.

52. Armand Guillaumin
ENVIRONS OF PARIS
(ENVIRONS DE PARIS), c. 1874

The subject of Guillaumin's painting, the road which snakes through the foreground, is a carefully constructed and newly graded one with recently planted trees placed at regular intervals—a public highway, in short, created for the general good. Its presence in the landscape outside Paris in no way interferes with nature. In fact, quite the opposite is true. The "improved" landscape, because of man's activities, has been made more effectual, more commodious, and more attractive. It is now a landscape of convenience that allows travelers and their goods to move from one place to another more efficaciously than before. Nothing could be more mundane or more modern (see above, II).

The identification of the site of

Guillaumin's painting has proved elusive. However, it has been suggested that a comparison with Sisley's *Road to Verrières* (1872; Private Collection) might be helpful in this regard.[1] The compositions are similar and the landscapes depicted have a great deal in common. Verrières-le-Buisson, near Igny, is thirteen kilometers southwest of Paris and four kilometers southwest of Sceaux in the forest of Verrières. However, as Sisley's painting depicts only a road to that town, it could be anywhere in the region in which he painted—at Versailles, Sèvres, Meudon, or Ville-d'Avray.

NOTE
1. R. Brettell, oral communication.

53. Camille Pissarro
RAILWAY CROSSING AT PATIS, NEAR PONTOISE
(LA BARRIÈRE DU CHEMIN DE FER, AU PATIS PRÈS PONTOISE), 1873–74

Pissarro lived in and around Pontoise for the better part of two decades, beginning in 1863 and ending with his departure for nearby Osny 20 years later (see above, III/2, and below, III/5). Les Patis was adjacent to l'Ermitage, between Eragny and Pontoise, 30 kilometers north of Paris. The houses of the farmers and factory workers in the area form an amphitheater around the Oise River and the Nesles plateau in the Viosne valley. This area proved to be attractive to Daubigny and other earlier artists who enjoyed its peaceful, remarkably undifferentiated river views of slowly moving water and still foliage. Pissarro, on the other hand, though surrounded by the same motifs, chose very different aspects of the area to record on canvas.

Railway Crossing at Patis, near Pontoise is a subject of almost shocking banality. A road races into the distance while a railroad barrier abruptly closes off the space. (Such barriers were much higher in Pissarro's time than they are today and were kept lowered until they had to be raised, rather than vice versa.) Two peasants walk toward each other on a broad, graded road. A wall and gate house on the right and a severely abbreviated, grassy shoulder on the left close off our vision and force it directly to the barrier and beyond to the hills of Eragny.

The telegraph pole and wood barrier indicate the presence of the tracks of the railway line, built the decade before, to connect Saint-Ouen-l'Aumône (and ultimately Paris) with Pontoise. There is no hint of the picturesque in Pissarro's painting, nor of the sentimental or romantic. The view is utterly devoid of emotional or historical reference. In this sense it is unrelentingly and insistently modern (see above, II).

54. Claude Monet
SPRINGTIME, THROUGH THE BRANCHES
(LE PRINTEMPS, À TRAVERS LES BRANCHES), 1878

In the spring of 1878 Monet did a number of paintings on the southern tip of the Ile de la Grande Jatte on the northwest outskirts of Paris, between Neuilly and Courbevoie. In this work Monet painted the few houses on the shore of the Seine at Courbevoie as seen through the branches of willow trees growing on the banks of the island. Because the site lacks particularization, it must be assumed that Monet's main concern was with the composition. The painting is conceived with a strong *repoussoir* pattern of trees that almost obliterates any view into the distance. The Seine, which is revealed in other works by Monet as having been a great playground for the Parisians at Argenteuil (nos. 39–43), is here reduced to little more than one of a series of barriers discouraging the viewer from analyzing anything except, to a limited degree, several nondescript houses seen across it. Monet's ability to reduce the branches and leaves to a surface pattern cut off at both top and bottom is particularly to be noted.

55. Claude Monet
FLOATING ICE ON THE SEINE
(DÉBÂCLE SUR LA SEINE), 1880

The winter of 1879–80 was particularly severe in France. Newspaper accounts could only compare it to the winter of the Franco-Prussian War, exactly a decade before.[1] The snow paralyzed Paris and its environs, and the transportation system of the Ile de France came to a halt. The Seine was completely frozen over. In January a thaw came, but was in-

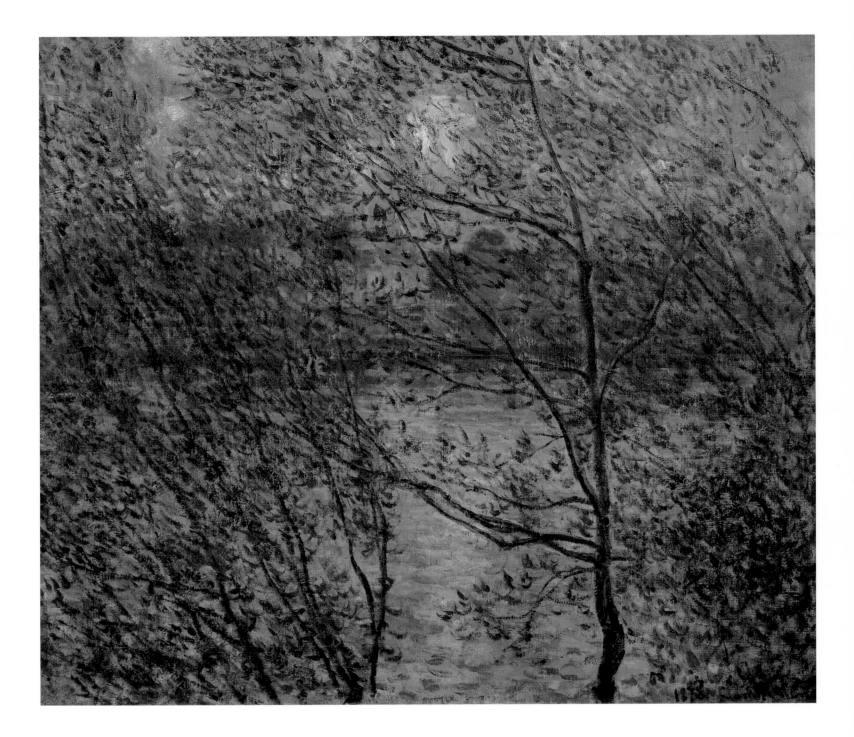

No. 54. Claude Monet
SPRINGTIME, THROUGH THE BRANCHES, 1878

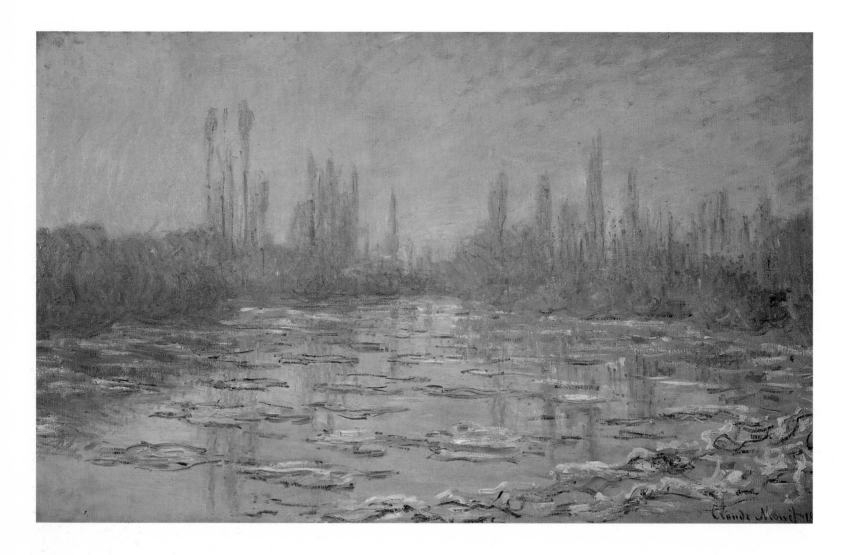

No. 55. Claude Monet
FLOATING ICE ON THE SEINE, 1880

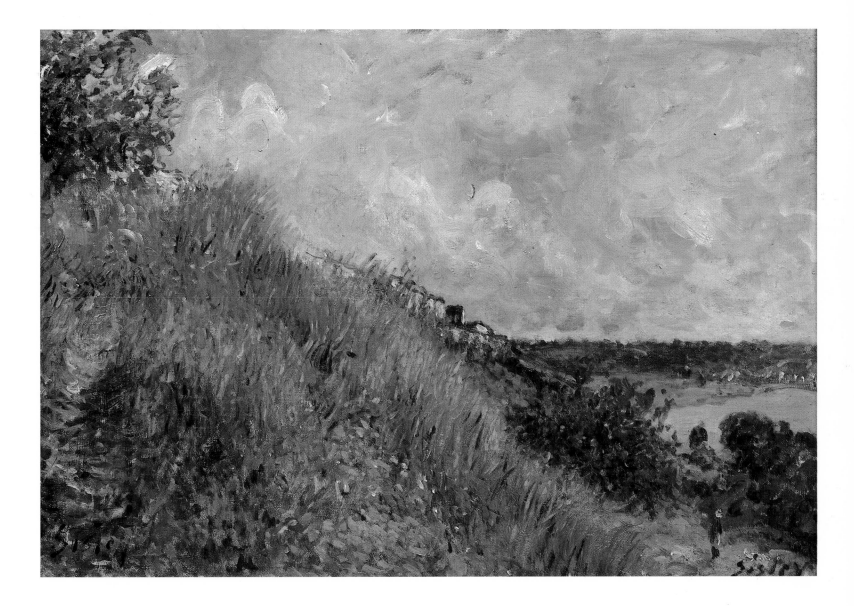

No. 56. Alfred Sisley
THE SEINE NEAR BY, 1881

terrupted by an immediate drop in temperature. At this moment Monet, in a great burst of activity, began to depict the landscape in and around Vétheuil, where he lived beginning in 1878 (having left Argenteuil in 1876). Vétheuil was a small, charming village on the river midway between Mantes and Vernon, just northwest of Paris. The resulting paintings were Monet's earliest works following the death of his first wife, Camille, at the end of the previous summer. Although the pathetic fallacy is invoked most often with disastrous results, somehow it is consoling to know that these desolate, but extraordinary, winter landscapes were painted at this most poignant moment in Monet's life.

Floating Ice on the Seine was one of 18 paintings done in the first few months of 1880 following the breakup of the ice on the river. This picture seems to have served as a sketch or as an experimental version for a larger painting (Shelburne Museum) which Monet submitted for inclusion in the Salon of 1880. In spite of the fact that he felt that this larger composition was "a more prudent, more bourgeois thing" than his other paintings, as he wrote in a contemporary letter to Théodore Duret,[2] it was rejected. What Monet meant by this comment can only be inferred. The utterly symmetrical and classical composition of *Floating Ice on the Seine*'s mirror-imaged sky and water, which almost meet at the golden mean of the canvas; its total lack of specificity; and its avoidance of anything modern in its subject matter—in spite of its technical freedom—may have been what Monet was referring to. Both in spite of, and because of, the surface pattern, the pictorial space is almost negated.

In the end, however, Monet depicted nature at its most grand and its most artificial. Although *Floating Ice on the Seine* is a picture within the early-nineteenth-century landscape tradition, its facture reveals its extraordinary modernity despite its traditional subject.

NOTES
1. See *Le Petit Journal*, Dec. 7, 1879.
2. Wildenstein, 1974–79, vol. II, p. 438.

56–57. Alfred Sisley

THE SEINE NEAR BY
(*LA SEINE VUE DES COTEAUX DE BY*), 1881

THE BRIDGE AT MORET
(*PONT DE MORET*), 1893

In competition with his Impressionist colleagues Sisley sought desperately to provide pictures of old-fashioned landscapes in a traditional format for bourgeois Parisian collectors. Although—or perhaps because—he utilized picturesque motifs found in places popular with an earlier generation, however, Sisley's work proved to be totally unsuccessful. His search for a format which would find buyers eluded him throughout his career.

By 1880 Sisley had established himself in the small village of Veneux-Nadon in the forest of Fontainebleau, a short walk from Moret-sur-Loing, the town at the junction of the Loing and the Seine rivers that was a two-hour train ride from the Gare de Lyon in Paris. In 1882 he moved to Moret itself. The area, as he wrote to Monet in an attempt to lure him there, had very picturesque views.[1] Sisley remained there, with the exception of short trips, until his death in 1899, recording on canvas views of the town and its surrounding villages and landscape.

Just two kilometers north of Veneux-Nadon is the hamlet of By, where Rosa Bonheur lived and where Sisley painted *The Seine near By*. Here, Sisley has reduced the presence of man to a few small buildings; the town of Champagne on the other side of the river is hardly alluded to. The hills slope gently down to the river. Dividing the canvas diagonally into halves, one devoted to earth, the other to sky, with a view into extreme depth, Sisley's composition is dependent on Monet's views of Vétheuil (such as *View of Vétheuil* [1880; Los Angeles County Museum of Art]) of the year before. His attempt to reinterpret Monet's work proved to be unsuccessful in terms of finding the buyers he so desperately sought, however.

Sisley must have known Moret from his earlier stay at Marlotte (no. 11), as Moret was just less than 10 kilometers southwest of that hamlet. His *Bridge at Moret* was painted when he lived near

Notre-Dame-de-Grace at the corner of the rues Montmartre and Donjon. Although the picture appears to record those features of the town mentioned by all the contemporary guidebooks, that is, the bridge, the mills, and the church, upon closer examination it becomes clear that Sisley's main interest here was in the bridge as an active and vital conductor of traffic across the Loing. Looking southwest into the town, the bridge is telescoped; the large central mills, the Moulin de Graciot on the right, and the Moulin de Provencher on the opposite side, have been emphasized at the expense of the church and the Medieval town gate in the center of the bridge whose steep, squared-off roof can be seen rising above the gabled mill to the right. In fact, Sisley took the most picturesque aspects of Moret and willfully obliterated them by using a selective point of view.

NOTE
1. Daulte, 1959, p. 31.

58. Paul Signac

THE SEINE AT HERBLAY
(*BORDS DE RIVIÈRE, LA SEINE À HERBLAY*), 1889

Four railroad stops beyond Argenteuil on the right bank of the Seine (as one goes toward the sea), twenty-one kilometers northwest of Paris, is the small town of Herblay. The village is a few kilometers past La Frette, which was popular with Parisian weekend tourists who came by boat to spend a day in the country. In 1889, when Signac came to Herblay and his artist friend Maximilien Luce joined him a few months later, Herblay was beginning to institute a major sewage and water transport system. In spite of this activity, however, the town decreased in population during this time.

This painting belongs to a series of four pictures Signac executed at this site, inspired by John Ruskin's *Elements of Drawing* (1852), parts of which he and Henri-Edmond Cross translated for the Brussels publication *L'Art moderne* in 1889. The picture almost appears to have been painted from a floating atelier like that used by Daubigny and, later, Monet (no. 41). The town of Herblay is

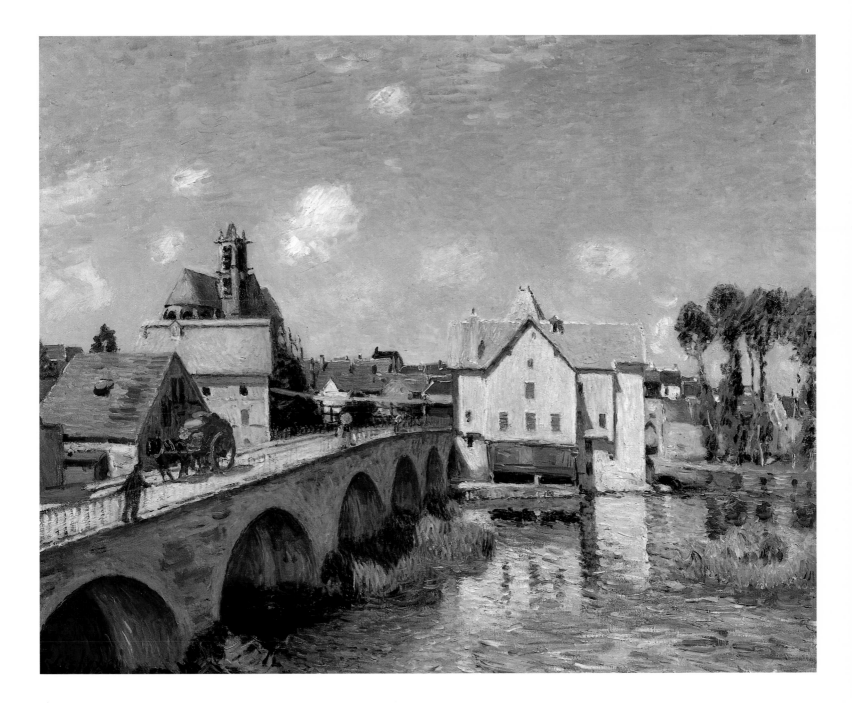

No. 57. Alfred Sisley
THE BRIDGE AT MORET, 1893

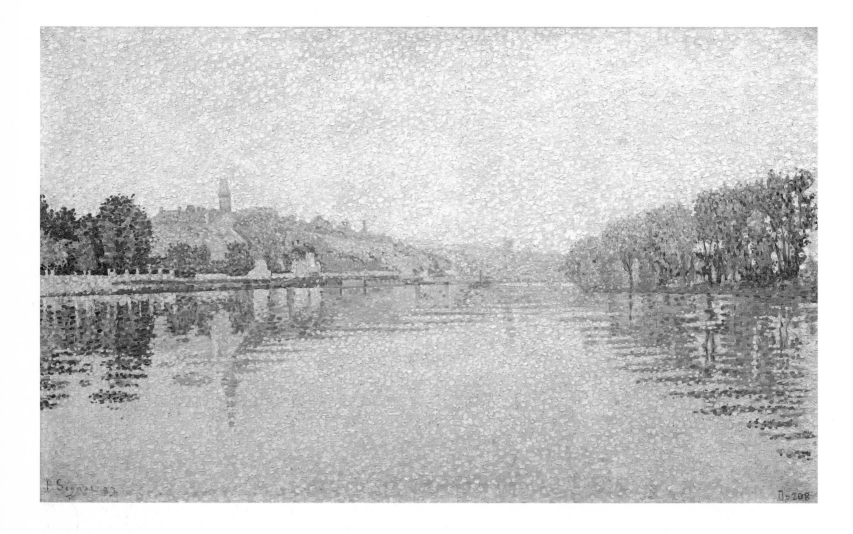

No. 58. Paul Signac
THE SEINE AT HERBLAY, 1889

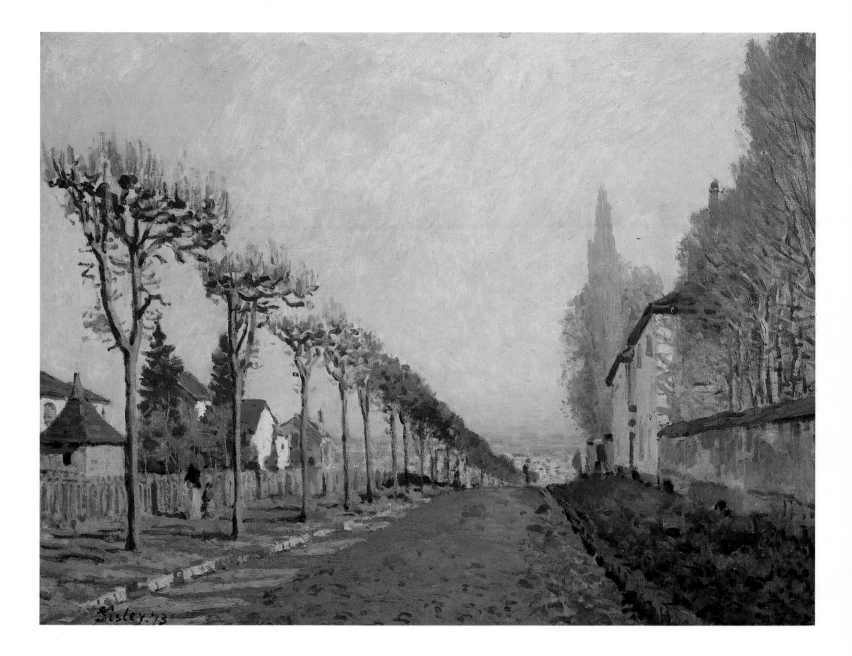

No. 59. Alfred Sisley
THE ROAD, VIEW OF SÈVRES PATH, LOUVECIENNES, 1873

reflected in the still water. The twelfth-century church tower without its spire dominates the small hamlet; the poplars on the other shore of the river balance the composition. Man is set to one side, nature to the other. The calm, watery divider between the two is broken by a small boat sailing toward Paris, its wake providing a mirrored image of the sky above. The small dots of color placed evenly across the surface of the painting quiver against the strain of Signac's attempt to provide a deep, central recession into depth. The dichotomy between the artist's pointillist technique and the type of subject—and composition—he chose to depict is particularly strong.

59. Alfred Sisley
THE ROAD, VIEW OF SÈVRES PATH, LOUVECIENNES
(*LA ROUTE, VUE DU CHEMIN DE SÈVRES*), 1873

This painting is among the most boldly conceived of Sisley's landscapes and took its composition almost directly from the series of road landscapes painted by Monet and Pissarro on the route de Versailles, also in Louveciennes, between 1869 and 1872 (see above, III/2). Although its title has traditionally been accepted, it is incorrect. The painting actually represents the *route départementale,* or main county road, from Bougival to Louveciennes. On the right are the gate buildings leading to Mme. du Barry's famous country residence.[1] Rather than having made this topographically and historically interesting structure the motif of his landscape, however, Sisley simply included it as the anchor for the right half of his carefully balanced composition.

The true subject of the painting is the road and its series of trees planted by the State. Indeed, the equidistant placement of the trees and the fact that they were carefully pruned so as to form a band of foliage in the spring and summer make it clear that this is an "official" road, designed with the *allées* that cut through the forests and parks of the French aristocracy in mind. Here, Sisley has painted the road in what one might call the "off season"; the laughter from

La Grenouillère (no. 14), just minutes on foot from this spot, is far from our minds.
—R. B.

NOTE
1. Sisley painted this motif another time in 1874; see Daulte 145.

60. Alfred Sisley
AUTUMN: BANKS OF THE SEINE NEAR BOUGIVAL/AUTUMN: BANKS OF THE OISE
(*L'AUTOMNE SUR LES BORDS DE L'OISE*), 1873

Traditionally titled *Autumn: Banks of the Oise,* this superb landscape was undoubtedly painted along the Seine near Bougival. The sharp bend of the river and the configuration of the hillsides suggest that Sisley set his easel on the path along the river near the suburban town of Malmaison and painted looking downriver toward Bougival. He had depicted the town from the other direction earlier in the same year (*The Bridge at Bougival* [Private Collection, New York]) and made at least 20 other paintings of the Seine between Bougival and Port-Marly during the 1870s. The large structure that peeks through the foliage at the right is probably the end of the aqueduct at Louveciennes, which Sisley painted in 1874 (*The Aqueduct at Marly* [The Toledo Museum of Art]).

Executed on a fresh, clear autumn day, this picture is a celebration of the most fleeting aspect of that transitional season. The brilliant yellow of the foliage and the bright blue of the sky mingle in the tranquil waters of the Seine. Sisley's inclusion of a small ferry at its ornamented dock suggests that this perfect reflection soon will be broken. A well-dressed woman with a little girl walks toward the boat, and, in front of them, a little boy runs to hold its departure. Thus the landscape is in two senses transitory; Sisley has investigated here a shift in seasons just as he has a departure which will spoil the reflected glories of autumn.

Compositionally, this picture has its roots in the river landscapes painted by Daubigny throughout the 1860s and '70s along the Oise River. It is perhaps for this reason that the picture acquired its mistaken title.
—R. B.

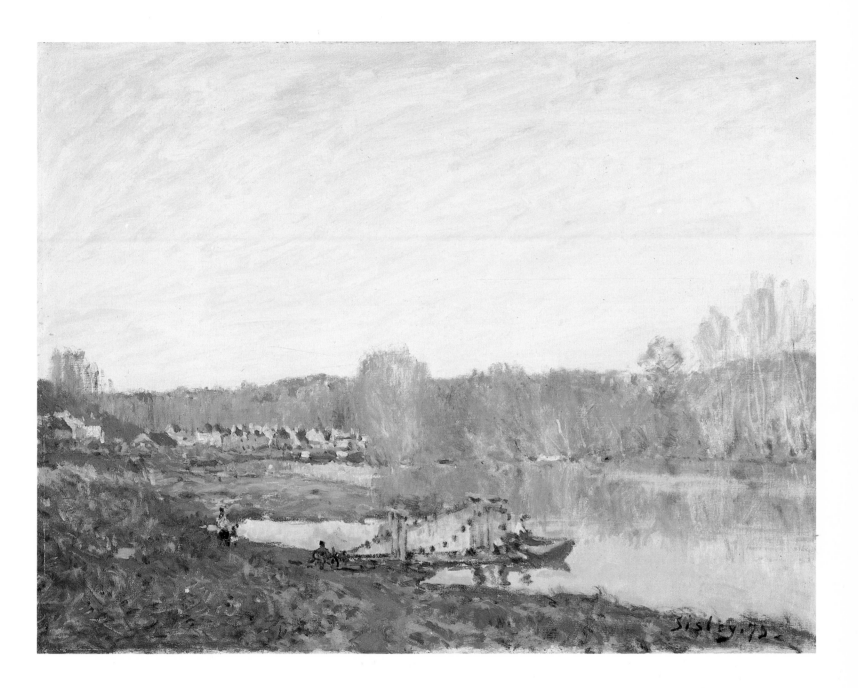

No. 60. Alfred Sisley
Autumn: Banks of the Seine near Bougival, 1873

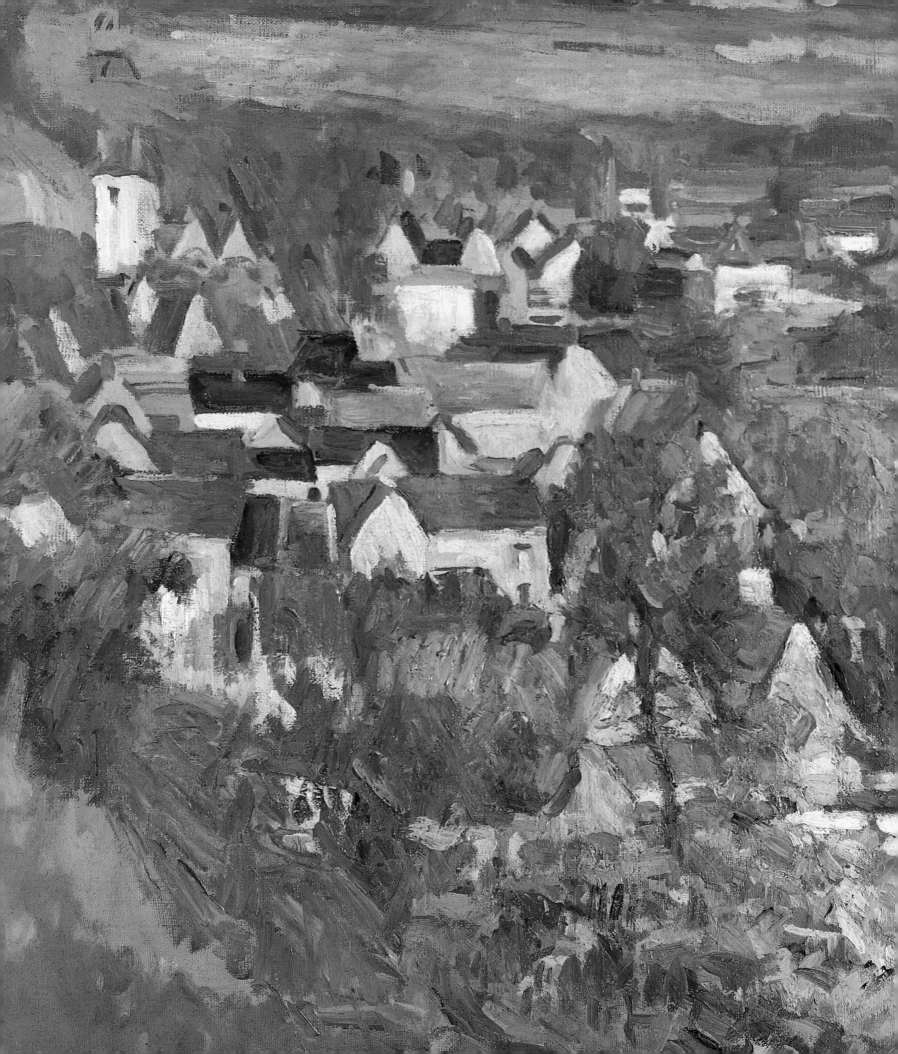

III/5

Pissarro, Cézanne, and the School of Pontoise

IF THE REGION AROUND BOUGIVAL, Louveciennes, and Marly-le-Roi provided the Impressionists with their first opportunities to paint a truly modern, suburban landscape (see above, III/2), the environs of Pontoise became the center for rural landscape painting (map 7). Dominated by the presence of Camille Pissarro, a group of painters who came to be known as the school of Pontoise worked intensely in the landscape between that town and Auvers during the 1870s and early 1880s, when the other major center of Impressionist painting was the Seine at the large suburban town of Argenteuil (see above, III/4). It is fascinating to observe that—in spite of the close pictorial relationships among works done by Monet, Pissarro, Renoir, and Sisley around Bougival—these artists split into apparently separate groups after the Commune. Monet centered himself in Argenteuil, rarely moving from that region; Sisley remained in the near western suburbs around Bougival; and Pissarro repaired to Pontoise. There is no evidence that they visited each other frequently at these sites; they tended to meet in Paris and to paint in isolation. For that reason the different locales they chose were an important component of their increasingly separate landscape aesthetics.

The school of Pontoise created an Impressionism which emphasized the work of the fields and the continuing life of hamlets and villages, a mode which must be read as a counterbalance to the Impressionism of leisure of Monet, Renoir, Caillebotte, and, to a lesser extent, Sisley. Paintings by the school of Pontoise were criticized in reviews of early Impressionist exhibitions for the vulgarity of their subjects—cabbage patches, rural paths, and farmyards. The style of these paintings was thought to be as crude as their subjects. Indeed, the Impressionists of the school of Pontoise created a rural brand of pictorial naturalism that departed dramatically from what seems by comparison to have been the poetic realism of the Barbizon school. As such,

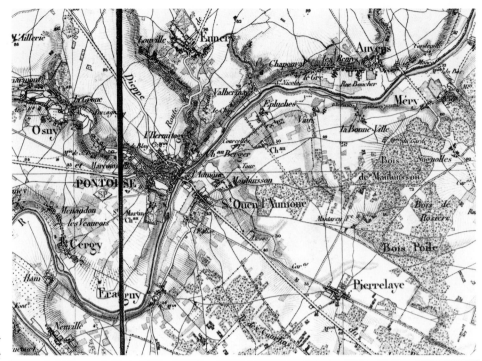

Map 7. Pontoise and Environs.

their pastoral mode was as aggressively new as the Impressionism of leisure of the school of Argenteuil.

In order to fully understand the school of Pontoise, one must know something of the nature of the town in which its members lived and painted.[1] Possessor of a distinguished history which stretched back into the Middle Ages, the town of Pontoise had been the fortified border capital of a proud, self-conscious region called the Vexin. Situated on a well-protected hillside above the Oise River, Pontoise cast a wary eye on the plains of Montmorency that stretched from the Oise uninterrupted into Paris (fig. 39). Its ecclesiastical institutions—monastic and otherwise—were wealthy and powerful, and its population in the fourteenth century was considerably larger than it was during the nineteenth century. Meaning literally "bridge over the Oise," Pontoise was the point of contact between the entire Vexin, a region rich in wheat fields since Roman times, and the great capital city of Paris. Yet since Pontoise was a capital, it was, to a degree, independent of influence from the capital of the Seine and of France. It was a provincial town proud of a history which was decidedly anti-Parisian.

By the middle of the nineteenth century Pontoise had waned in significance. Railroads had penetrated the Vexin and the religious institutions that had given it real importance had been all but totally destroyed following the Revolution. Its links to Paris became stronger as the railroad arrived in its twin city, Saint-Ouen-l'Aumône, in 1846 and in Pontoise itself in 1864, and Pontoise came increasingly to have the character of a suburban town built on the ruins of a provincial capital. As the Oise was dredged to become the connector between the Seine and the newly built canals of the industrially rich north, more and more barges sailed the river, and, as a consequence, small factories devoted to the manufacturing of paint and of sugar from sugar beets began to spring up along its banks. Parisian businessmen, ever on the lookout for pleasant sites for their weekend and summer residences, recognized, to a

Fig. 39. *General View of the Banks of the Oise,* 1849. Postcard.

Fig. 40. *Bird's-eye View of Pontoise,* c. 1890. Postcard.

limited extent at least, the charms of the region around Pontoise, perhaps the chief of which was easy accessibility to Paris. Even the agriculture of the town and the surrounding region was modernized; as a result, the valleys and hillsides came increasingly to be used as truck gardens for the expanding fruit and vegetable markets in Paris (see below, III/7).

When Pissarro arrived in Pontoise with his mistress and their two children to set up house in January 1866, there was one small factory in the town, and the railroad station had just opened two years before. A lithographic panorama of the town published in 1864 as part of the celebration of Pontoise's railroad shows us the town not from the river, its traditional source of power and wealth, but from the station (fig. 40). In fact, it was the train that enabled Pissarro and his many friends to make the landscape surrounding this suburban capital familiar to people throughout the world.

The daily train to Pontoise left the Gare du Nord in Paris at 9:30 a.m. and arrived only 45 minutes later. Once at the station, the hamlets of Les Patis and l'Ermitage, the hillsides known as the Côte des Grouettes, the Côte des Boeufs, and the Jalais, and the paths along the Seine to such places as Valhermay and Chaponval were easily accessible on foot (fig. 41). We know the names of these sites today because they were depicted by the painters of the Pontoise school, although the archives and newspapers of the nineteenth century make no reference whatsoever to these artists, almost as if they had never lived in and around the town. Yet the landscape titles preferred by them, particularly by Pissarro, show an intense familiarity with Pontoise and its surroundings, naming not only the appropriate town or village, but also the path, street, hillside, or area depicted. The precision of these titles is not in itself unusual—landscape paintings made in the forest of Fontainebleau in the mid-1800s could be equally precise (see above, I). What is fascinating is that no one who did not live in Pontoise could have recognized such places. Unlike the names of famous rocks or trees in the forest of Fontainebleau, the paths and hillsides of Pontoise were rarely—if ever—mentioned in guidebooks and were not in the least "places to see." Their inclusion in painting titles assures us that this or that humble landscape is neither a composite nor a hypothetical landscape concocted by the painter, but the representation of a real—and verifiable—place.

Why Pontoise? The answer is perhaps not as easy as those to the related questions "Why Bougival?" and "Why Argenteuil?" The Oise was not

Figs. 41–42. *Pontoise.—View from Haut Saint-Martin; Pontoise.—l'Ermitage.—Panorama*, c. 1890. Postcards.

wide enough to make sailboating very pleasurable or easy. There were no great gardens or collections of old and imposing country residences as at Louveciennes and Marly-le-Roi (see above, III/2). Le Nôtre had worked on the gardens of the Château de Pontoise for Cardinal Richelieu, but no trace of these existed except in the town archives or in old prints. Nor were the charms of Pontoise extolled in guidebooks with the same fervency as those of the other suburban towns painted by the Impressionists. It was, in fact, the rural nature of the region around Pontoise that was its most significant characteristic (fig. 42). The major reason for a Parisian to go there was not to boat or eat, as at Bougival, but to go to a rural fair like the famous Foire de la Saint-Martin or to a regional market. There were many traditional farms near Pontoise and a large population of agricultural workers who tilled the fields and tended their animals. In fact, it is arguably true to say that the region around Pontoise was the most accessible rural landscape to Paris, and Pontoisians were known in the capital on the Seine not as suburbanites, but as provincial boobs, as a drawing by Doré makes abundantly clear (fig. 43).

Perhaps the most important reason that so many important artists painted in this small area was the sheer variety of its landscape. Any of the members of the school of Pontoise—Pissarro, Cézanne, Guillaumin, Gauguin, or the other, minor figures—could paint rolling wheat fields, gently sloping hills, cliffs, rivulets, gardens, river-scapes (figs. 44–45), factories, traditional villages, country houses (fig. 46), markets, barnyards, and forests—all without walking more than 15 minutes from their various homes. Although not as famous as other Impressionist sites, Pontoise was simply richer and, as a result, more—and more varied—landscapes representing it were painted during the 1870s than of any other major site. Artists of widely diverse sensibilities could sustain themselves as landscape painters in and around the town.

It was perhaps Dr. Paul Gachet, the homeopathic physician for, and friend of, Pissarro's mother, who suggested that the painter and his family come to Pontoise. He certainly helped to find them a house—the first of several rented dwellings occupied by Pissarro and his family during the next decade—at 1, rue du Fond de l'Ermitage in the hamlet of l'Ermitage in 1866, and Pissarro visited the doctor frequently in his own large house in nearby Auvers (figs. 47–48). One might wonder, in fact, why Pissarro decided to move to Pontoise and not Auvers. The smaller town further up the Oise River

was at once more beautiful and more famous than Pontoise, and it was the site preferred by Daubigny, who visited there frequently beginning in 1860 and built a house for himself in nearby Villiers-de-Lisle-Adam in 1864. Corot, Daumier, Henriet, and many other landscape painters visited Daubigny, and Corot painted decorations for his house. Daubigny was even mentioned as *the* painter of Auvers in the 1862 edition of *Les Chemins de fer illustrés: Les Environs de Paris.*

It was probably to escape those associations with an already-famous landscape painter that the young Pissarro chose Pontoise. It was significantly un-pictured when he arrived there in 1866. In fact, his own presence—and the brilliance of his earliest landscapes painted in l'Ermitage—brought Daubigny to that site, which the older artist painted several times and which was the subject of his entry to the Salon of 1874, the year of the first Impressionist exhibition, in which Pissarro himself exhibited several landscapes painted near Pontoise. In any case, Pissarro seems to have worried continuously about the presence of Daubigny, for, in all the years he painted in Pontoise—and in spite of the fact that he visited Gachet and Cézanne in Auvers—Pissarro never painted a landscape there.

If Daubigny surrounded himself with his friends in Auvers, Pissarro did the same thing in Pontoise. Indeed, the fatherly painter who played such an active role in the formation of the Impressionist movement was the great teacher of his generation. Like Corot, who had so many students that he himself joked about their number, Pissarro was happiest when he worked with other, preferably young artists. It was undoubtedly easier to tolerate what must have been the tedious society of Pontoise in the supportive company of friends and fellow artists, and the Pissarro household not only produced a second generation of painters of its own, but fed and sustained a whole group of young artists from the difficult Cézanne through the relative unknowns Edouard Béliard and Victor Vignon to the brilliant, egomaniacal Gauguin. Although there is not a wealth of documentary material describing the life of the school of Pontoise, Henriet's books about landscape painters, published through the last third of the nineteenth century, give us a clear idea of the social and intellectual world of painters who lived in isolation from their "host" society, depicting the landscape without interacting with its inhabitants.[2]

The landscapes painted around Pontoise by members of its school are, for the most part (no. 61), self-consciously rural. Sailboats, factories, or bourgeois gardens rarely appear; thatched cottages, orchards, fields, village paths, farmyards, and kitchen gardens are common. Although Pissarro himself had managed to "ruralize" even the suburban landscape of Louveciennes (see above, III/2), he had ampler material in Pontoise for a sustained investigation of the texture of a village landscape. And it was the vernacular architecture of the hamlets surrounding the town and the anonymous, mundane rhythms of life in them that appealed to the artist and his friends. Their landscapes, Impressionist though they might be in style and in their exploration of the temporal aspects of nature, represent ordinary hamlets and villages, many of which were little touched by the upheavals of industrial modernism that created the landscape painted by the Pontoise painters' colleagues in nearby Argenteuil. When they were, the Pontoise school chose to use carefully selected evidence of "improvement" as a foil for a celebration of traditional ruralism (nos. 62, 65).

« J'ARRIVE DE PONTOISE!... »
D'après un dessin de M. Gustave Doré

Fig. 43. After Gustave Doré (French, 1832–1888), *I Arrive from Pontoise!…."* Postcard. Bibliothèque Nationale, Série Topographique.

Figs. 44–45. Pontoise.—The Oise at Ile Saint-Martin; Banks of the Oise at Pontoise, c. 1890. Postcards.

The great critic Duret was the first to recognize the rural character of Pissarro's sensibility and to encourage him (in a letter of December 6, 1873) to paint in a manner appropriate to his imagery.[3] For Duret, the proper subject matter for Pissarro was "rustic agrarian nature with animals" and not the sailboats, railroad bridges, and flower gardens upon which Monet exercised what Duret called his "fantastic eye." Duret advised Pissarro to stress in his painting "a power of the brush" that the critic considered to be the essential characteristic of Pissarro's aesthetic.[4] Duret's remarks make particular sense when we confront a series of rural landscapes painted by Pissarro and his friends in and around Pontoise. These pictures tend more often than not to be strongly painted with thickly applied, separate strokes of the brush or palette knife. It is precisely their *power* that accords with the ordinary rural subjects of the Pontoise school and is therefore the stylistic hallmark of these pictures.

To whom were these village landscapes designed to appeal? Stylistically, the rural imagery of the school of Pontoise derived loosely from the aesthetic of the Barbizon school and particularly that of Millet (see above, II and III/1). Any study of the market for Barbizon paintings during the 1860s and '70s, when the school of Pontoise was at its height, reveals clearly that they appealed strongly to the urban bourgeoisie not only of France, but, perhaps more importantly, of Britain and the United States. The number of rich businessmen who made their fortunes during the great age of industrial capitalism and who surrounded themselves with paintings of villages and villagers is truly staggering. From Paris and Liverpool to Boston, New York, Chicago, and Minneapolis, the galleries of such men had more Barbizon paintings than Old Masters or even Salon nudes, and patrons of their type formed a market to which any aspiring young landscape painter might want quite naturally to appeal (see below, IV). The simple landscapes of Barbizon—filled with peasant figures, always obedient to the cycle of the seasons and the work of the fields—suited the atavistic tastes of many men whose fortunes were founded on railroads and industry.

Yet, in spite of their evident interest in the marketing of their pictures (see below, IV), members of the school of Pontoise painted rural landscapes which have only superficial similarities to those of the Barbizon school that sold so well. Not only are the Pontoise paintings' surfaces more labored and difficult even than those of Millet's late pictures, but their subjects rarely have

the easy charm so evident in works by their predecessors. Comparisons between contemporary paintings by Pissarro and Daubigny of similar sites make this point clearly. Pissarro's rural landscapes simply exist—strongly painted, confidently composed, and absolutely actual. His houses, for example, are powerful, not beautiful; one returns to Duret and his "power of the brush."

Figs. 46–47. *Pontoise.—Château de Saint-Martin; Pontoise.—Panorama of l'Ermitage,* c. 1890. Postcards.

It was the strength and the physicality of rural nature that Pissarro understood and communicated so strongly to his friends, the other members of the school of Pontoise. They strove to paint rustic scenes with a directness and formal honesty unprecedented in the history of art. It is perhaps for this reason that their paintings, based upon the prevailing aesthetic of naturalism being practiced by so many writers following the lead of Zola, failed to appeal to the audience for Barbizon pictures which they also sought as theirs. It was, in the end, easier for a bourgeois to buy and read one of Zola's novels—crude as it might be—than to own and look repeatedly at a painting with so little finesse or charm. The novel could be fumed over and put aside; the painting could not.

One last point must be made before discussing specific landscape paintings by the school of Pontoise. The works of art created by these men are not alike in every way. The two greatest painters of the group, the painters who really developed their art in the Pontoisian landscape, were Pissarro and Cézanne. Cézanne the Provençal spent less time in the landscape around Pontoise than did Pissarro. Indeed, while the older artist worked there with only a single interruption between 1866 and 1883, the younger one was there between 1873 and 1875 and again between 1879 and 1882. Yet the site played an equally important role in their developments. Cézanne began his career in Pontoise by copying a Louveciennes landscape by Pissarro.[5] He rapidly moved out-of-doors, however, disciplining his own impetuous and erotic sensibility by a rigorous study of rural nature. Even after comparing the landscapes by Pissarro and Cézanne in this exhibition, one can tell that their sensibilities were utterly different—as different as those of Corot and Rousseau, for example. Cézanne submitted the landscape to rigorous structural and pictorial analysis, taking Duret's advice to Pissarro further than the critic intended it to be taken. Pissarro, the great socialist and humanist, perceived Pontoise and its environs not merely as a landscape qua landscape, but as a human environment, populated by humble rural workers, many of whom the

PONTOISE. - Vue prise de la Sente d'Auvers

Pontoise, A. Seyes, Imp.-édit.

Fig. 48. *Pontoise.— View from the Auvers Path*, c. 1890. Postcard.

painter knew and used as models. The village, for Pissarro, was at one with its inhabitants. For Cézanne, it was simply a group of buildings surrounded by hills and vegetation. Yet for each it was a pre-modern landscape, and for each it sustained repeated investigation and analysis.

In fact, it was less Cézanne than Gauguin who derived not just his style, but a good deal of his iconography from the village landscapes of Pontoise and its environs. Gauguin painted extensively with Pissarro during the late 1870s and early '80s, particularly in 1883, when the latter moved to the village of Osny. Here, the two men painted fields, rural roads, cottages, and barnyards in manners so similar that—were it not for the presence of signatures and dates—many of their landscapes would be virtually indistinguishable from one another. And, as if in homage to his master, Gauguin depicted village landscapes very much like those by Pissarro of Osny and Valhermay when he painted his own neighborhood in Paris in 1870 (no. 74) and even when he made his first, famous trip to Pont-Aven in Brittany in 1886—in spite of the rugged wildness of that site and the constant presence of the sea (nos. 75–76). This fact alone shows the extent to which the rural Impressionism of the school of Pontoise made its impact upon the subsequent history of landscape painting in France.

—R. B.

Notes

1. Brettell, 1977, pp. 22–69.
2. See Henriet, 1891. Other books by this author are *L'Eté du paysagiste* (1866) and *Le Paysagiste aux champs* (1876).
3. Pissarro and Venturi, 1939, p. 26.
4. See also Zola, 1959, pp. 128–129. In his 1868 review of the Salon Zola wrote of Pissarro's landscapes: "Nothing could have been more banal and nothing was more powerful. From ordinary truth, the temperament of this painter has fashioned a rare poem of life and of strength."
5. Compare Venturi 153 and Pissarro and Venturi 123.

61. Camille Pissarro
The Banks of the Oise, Pontoise
(Bords de l'eau à Pontoise), 1872

Pissarro painted this superb river landscape within months of his arrival in Pontoise from Louveciennes, and—without secure knowledge of the geography and architecture of Pontoise—one would almost think that it had been painted in Bougival. Both the composition and the facture of the painting have direct antecedents in the river landscapes Pissarro had painted just months earlier in that modernizing and suburban landscape on the Seine. In fact, as if in homage to *Wash House at Bougival*, his landscape with a small factory on the Seine (no. 17), Pissarro chose to center the composition of *The Banks of the Oise, Pontoise* on the smokestack of the *usine à gaz*, or gasworks, in the town; the bridge crossing the river in the distance is the railroad bridge, which was less than a decade old in 1872. The path from which Pissarro painted this picture, the so-called chemin de la Pelouse, passed in front of the grounds of several recently built country residences, one of which, immediately to the left of Pissarro's composition, was the property of the owner of the great Parisian department store Le Printemps. This was in every way a modernized, suburban landscape.

What is unusual about this painting in Pissarro's Pontoisian oeuvre is its very modernity. When he had painted the town and its environs in the late 1860s, his large landscapes, several of which were made for the Salon, were utterly rural in character. This tendency characterized most of the more than 300 landscapes Pissarro painted in and around Pontoise during the 1870s and early 1880s. However, during the years 1872 and 1873, just after his period in Louveciennes, Pissarro tended to paint the modernizing and suburban landscape of Pontoise itself rather than the traditional, rural landscape that surrounded it. In this context, *The Banks of the Oise, Pontoise* is a suburban, rather than a village, landscape. Its composition and the unusual length of the canvas connect the picture to the river landscapes of Daubigny (see above, III/5). However, Pissarro's frank acceptance of modern and industrial forms would not have been sanctioned by the older artist, who allowed such intrusions into his prints, but rarely into his paintings.

62. Camille Pissarro
The Red House
(La Maison rouge), 1873

This delicate, subtle painting was acquired, shortly after it was painted, by the great opera singer and collector of Impressionism Jean-Baptiste Faure (see below, IV). It is a study in balances—between old and new, earth and sky, man and nature. The red house of its title anchors the right half of the composition, its newly built facade strictly parallel to the picture plane and crying out for attention. This utterly modern dwelling is balanced by a considerably older farmhouse of a type common on the flat planes of the Vexin. The contrast of color, placement, and style is apparent, and the houses—representing two "ages" of man—vie for pictorial dominance on either side of a marvelous specimen fruit tree.

The picture was painted from a path in the fields that ran alongside the route de Gisors, an old trading road from the fields of the Vexin into the market town of Pontoise. Pissarro could walk to the spot within ten minutes from his house in l'Ermitage. Undoubtedly he returned time after time to perfect this delicate painting. So carefully observed are the nuances of color in the fields and the sky, so perfectly detailed is its facture, that a short period *en plein air* would not have sufficed to complete it. Pissarro, like his friend Sisley, was struggling through the medium of paint to understand the difficult transitions into modernity being experienced even in rural places.

63–64. Camille Pissarro
Hillside in the Hermitage, Pontoise
(Coteau de l'hermitage, Pontoise), 1873
Snow at the Hermitage, Pontoise
(Effet de neige à l'hermitage, Pontoise), 1874

These two landscapes, painted in successive years in l'Ermitage, are studies of the effect of the seasons and weather upon a single landscape composition. Such "pairings" are common in the oeuvres of both Pissarro and Sisley, who of-

ten returned to a landscape one or two years after they first had painted it. In such cases they chose to retain a particularly effective view or composition so that their attention could be directed completely to the accurate entrapment of color and atmosphere. There is no evidence that these pairs were ever exhibited together, and many of them are different enough to suggest that they were conceived as independent easel pictures rather than as part of an ongoing series or group of landscapes. None of them were ever sold together. This pair, exhibited together for the first time, gives the viewer the opportunity to analyze the many shifts that Pissarro made in the landscape to suit the demands of each picture.

These landscapes represent a group of small seventeenth- or eighteenth-century rural dwellings huddled alongside a hill, the Côte des Grouettes, in l'Ermitage (fig. 42). When he painted these landscapes, Pissarro lived in a newly constructed house on the rue de l'Ermitage, a modern, paved street in the same hamlet (see above, III/5). This street ran almost parallel to an older, curved path called the fond de l'Ermitage, along which the houses depicted in these paintings were located. It is interesting that Pissarro painted these older dwellings many more times during the 1860s and '70s than he did buildings on the larger, newer street, thereby indicating a pictorial preference for what one might call a traditional village landscape. The old man in the earlier *Hillside in the Hermitage, Pontoise,* his back bent from years of work, is a figure who transcends time as he works in his kitchen garden. Only the large beige facade of the Château des Mathurins, then owned by Pissarro's friend the radical feminist author Marie Desraimes, peeks into the landscapes from the upper right corner and gives the barest hint of modernity to these rural views (see above, II).

65. Camille Pissarro
THE ENNERY ROAD NEAR PONTOISE
(*ROUTE D'ENNERY PRÈS PONTOISE*), 1874

The rue de l'Ermitage ran from the Oise until it merged with the road to Ennery, a small village about eight kilometers from Pontoise. This road was particularly

beautiful and tranquil because it was a secondary route without much traffic and because it wound through a picturesque and forested valley before climbing the hill to the plains of the Vexin on which Ennery was situated. Pissarro's other paintings made on the same road in the early and mid-1870s all represent the section of the road closest to l'Ermitage before the more beautiful, forested area began.[1]

The Ennery Road near Pontoise is almost strictly geometrical in conception, each angled line balanced by another, each plane of color neatly delineated. Unlike all of Pissarro's other views of this road, the parallel construction of the painting allows the viewer no entrance, and it possesses a quality of transitoriness. Yet in spite of Pissarro's evident fascination with the transitory—and hence modern—quality of this landscape, it is strictly traditional in subject. The horse cart is a simple rural wagon of a type used in France for several centuries before this painting was made, and the pedestrians are not vacationing promenaders, but peasants or rural workers coming from and going to the fields. The "time" of the painting is slow and continuous and has little of the disconnected, random, and nervous quality of urban time as expressed in contemporary paintings by Monet, Degas, and Manet (see above, III/3). It is interesting to note, however, that this road had recently been rebuilt and improved, undoubtedly to the design of a government engineer from Paris, when Pissarro chose to paint it.

NOTE
1. Pissarro and Venturi 212, 304, 307, 351, 385, 397, 402, 411.

66. Camille Pissarro
CLIMBING PATH IN THE HERMITAGE, PONTOISE
(*LE CHEMIN MONTANT L'HERMITAGE, PONTOISE*), 1875

Climbing in the Hermitage, Pontoise is among the most original and accomplished landscapes by Pissarro. Painted from a point midway up a steep footpath on the Côte des Boeufs (no. 67), it represents the brightly tiled rooftops of the rural dwellings in l'Ermitage. Again, as was so often the case with Pissarro, the painting was executed less than five min-

utes away from his home, so that he could transport it back and forth with ease whenever his mood or the conditions of light and weather permitted. Pissarro derived the style and point of view of this painting from the slightly earlier Auvers landscapes by Cézanne (for example, *Auvers, Panoramic View* [no. 69], and seems, in turn, to have had a profound influence on Cézanne, who turned countless times in his later career to the interaction of planes of foliage and distant groups of vernacular buildings.

Traditional dwellings in this region of France were made of rough stones and roofed with wood or, more frequently, thatch. These dwellings, called *"chaumières,"* were painted many times by Pissarro and Cézanne; the most famous example is the *House of the Hanged Man* (1873–74 Musée du Louvre, Paris) by Cézanne. These dwellings, the norm for the region even in the early nineteenth century, either were being replaced or improved in the mid- and later 1800s, and in Pissarro's day it was becoming increasingly difficult to find a concentrated group of authentic, traditional rural dwellings. The newer houses were covered with smooth white or cream-colored stucco, had regularly hung doors and windows, and were roofed with brightly colored tile. In this way they were the opposite of the earth-toned and irregular dwellings of the past, houses which tended to merge with the landscape. The new dwellings dominated their surroundings both in color and shape; their geometric regularity and brilliance appealed to three generations of French landscape painters. Here, Pissarro, as had Cézanne before him, chose a viewpoint looking down on the strident, seemingly floating planes of the tiled roofs, described as "playing cards" in a letter Cézanne was to write to the older artist from Provence in 1876.[1]

NOTE
1. Cézanne, 1941, p. 102, no. 34.

67. Camille Pissarro
RED ROOFS, A CORNER OF THE VILLAGE IN WINTER
(*LES TOITS ROUGES, COIN DE VILLAGE, EFFET D'HIVER*), 1877

Painted late in the winter of 1876–77, this picture represents a group of eigh-

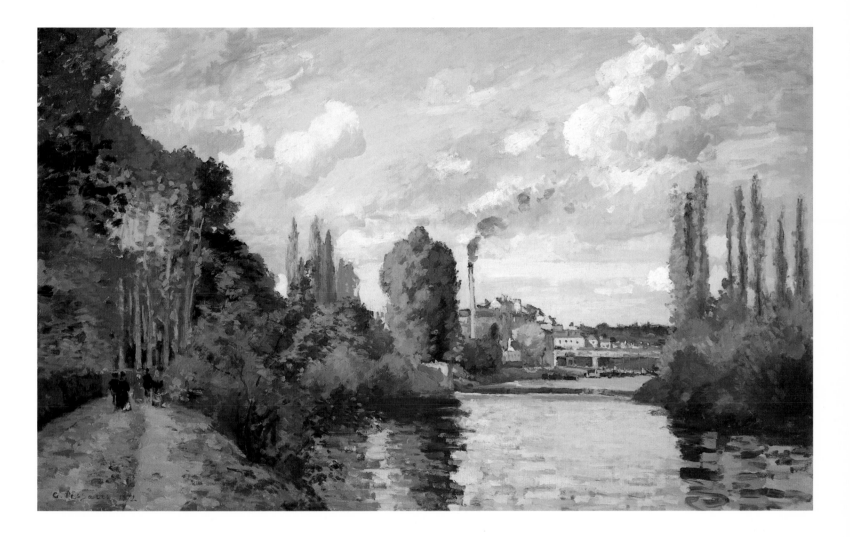

No. 61. Camille Pissarro
The Banks of the Oise, Pontoise, 1872
(detail on pp. 14-15)

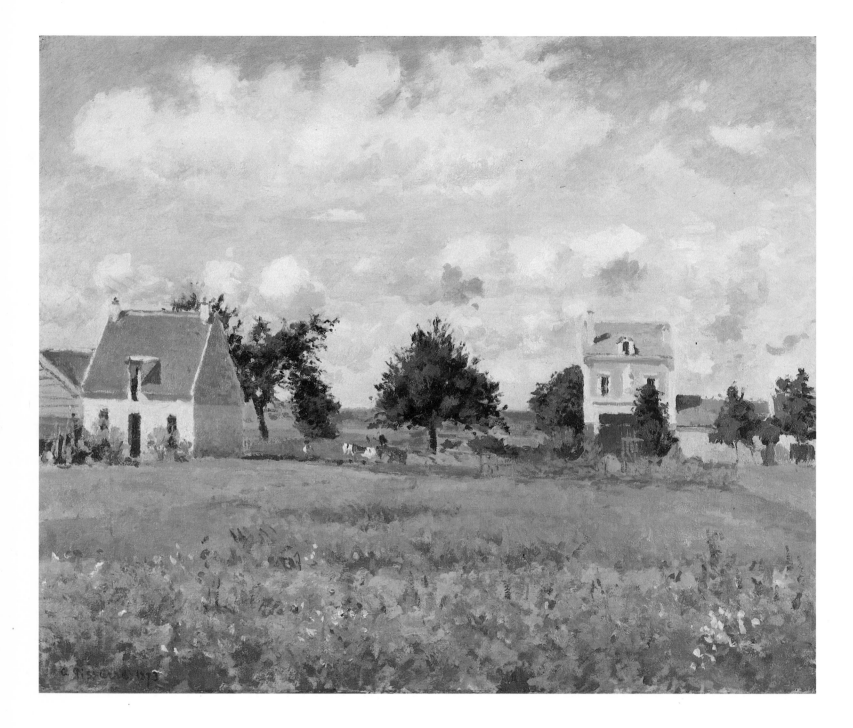

No. 62. Camille Pissarro
THE RED HOUSE, 1873

A DAY IN THE COUNTRY

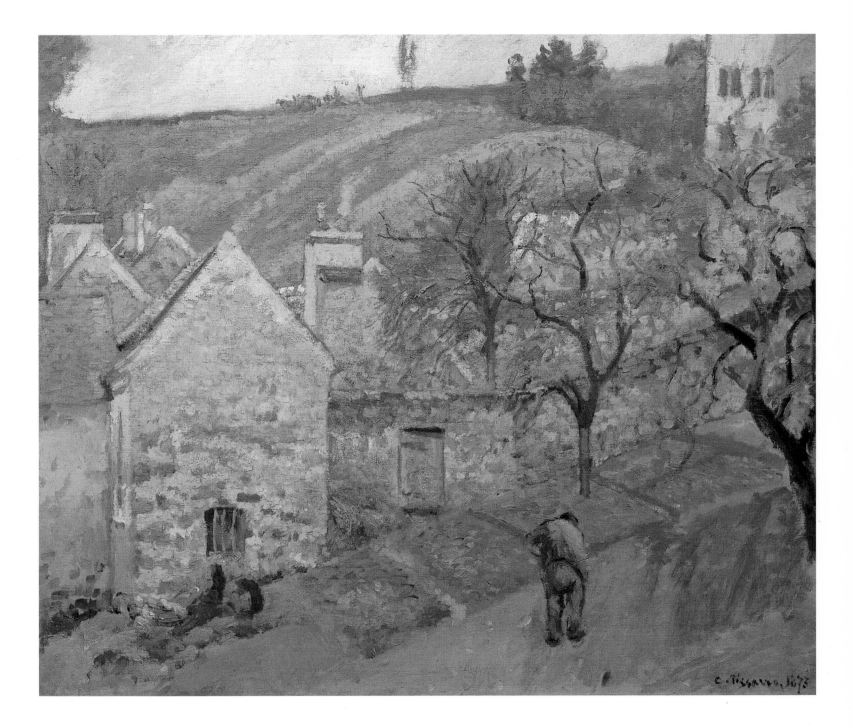

No. 63. Camille Pissarro
HILLSIDE IN THE HERMITAGE, PONTOISE, 1873

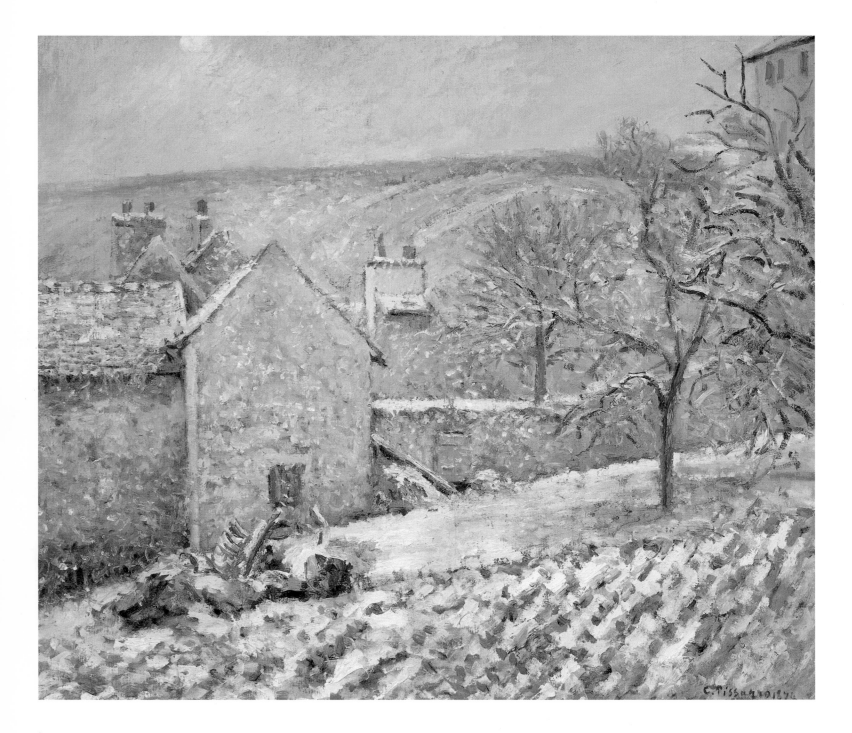

No. 64. Camille Pissarro
Snow at the Hermitage, Pontoise, 1874

A DAY IN THE COUNTRY

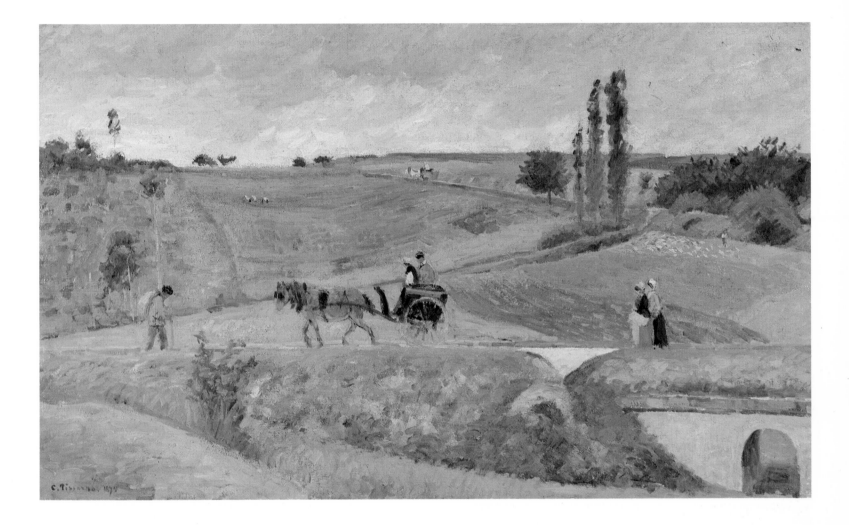

No. 65. Camille Pissarro
THE ENNERY ROAD NEAR PONTOISE, 1874
(detail on pp. 14–15)

teenth-century dwellings at the base of the Côte des Boeufs (no. 66) very near Pissarro's house. The season is late winter, almost early spring. The fields are bright with winter wheat, traditionally planted in December and green in February and March, and the fruit trees are about to burst into flower. Although old, the houses that anchor the center of this composition recently had been re-roofed in bright tile, the red and red-orange of which activates the greens of the composition.

Although the painting is close in palette and subject to many contemporary landscapes painted by Cézanne, it is significantly more complex in its facture. Pissarro built up the rugged impasto of the painting on top of an earlier portrait, the presence of which has been revealed by X rays, and created complex scumbled passages which seem almost to anticipate the paintings of 1877 and 1878 made by Monet at the Gare Saint-Lazare in Paris (nos. 30–32).

The title of the painting is fascinating—and probably original (see above, I and III/5). It indicates that the redness of the roofs is the principal motif of the picture, alerting us immediately to *color* as a *subject*. It then informs us that the painting represents a corner of an unnamed village. This latter point is significant because certain Impressionist titles, particularly those including the words "corner of," "environs of," and "near," tell us that the motif as such was less important to the artist than the site in general. This particular title ends with a temporal indicator—a seasonal one—thus explaining that the principal interest of the artist was color, his secondary interest site, and his tertiary interest the effect of time upon form.

68. Camille Pissarro

RABBIT WARREN AT PONTOISE, SNOW
(*LA GARENNE À PONTOISE, EFFET DE NEIGE*), 1879

During the particularly severe winter of 1879 (no. 55) Pissarro painted some of his most powerful—and original—landscapes. This one, probably painted from the window of a house on a small path now called the chemin du Général Belger, is doggedly complex and difficult. There

is nothing pleasant about the subject; its pictorial structure is highly idiosyncratic and even unclear; its facture is almost messy. Pissarro seems to have reveled in the ugliness of winter, and neither space nor sunshine gives us relief from what is little more than a tangle of vegetation in the dirty snow. None of this is made any pleasanter by the fact that the painting depicts a rabbit warren; the viewer is therefore called upon to imagine a group of shivering rabbits living together in the cold.

Yet, for all this, the painting is strangely beautiful because it is so richly observed. It rewards lengthy examination, less because of its theme—one would never find such a subject in a rural guidebook—than because Pissarro was so patient and careful in recording the bend of each tree trunk, the precise rises and falls of the terrain, and the familiar activities of a lone man out gathering wood to keep his house warm. The roofs and walls of l'Ermitage are visible on the right.

69. Paul Cézanne

AUVERS, PANORAMIC VIEW
(*AUVERS, VUE PANORAMIQUE*), 1873–75

Auvers, Panoramic View was painted from a small path, the sente de Pontoise, which climbs the hillside east of Auvers. The path, barely visible in the lower left corner of the painting, was used by agricultural workers on their way to the wheat fields of the Vexin plateau. When mounting this path, a number of beautiful views of the Oise River, its islands, the rich alluvial plain along its bank, and the monuments of the village itself could be enjoyed, and several of these were mentioned in the early guide literature. Cézanne seems consciously to have chosen a bland view. Absent are the Oise itself, which stretched and divided just to the right of his framed view, and the important church at Auvers, painted later by Van Gogh and admired in every guide to the charming town. This beautifully preserved building, as well as the amusing Second-Empire Mairie, or Town Hall, were omitted from all of Cézanne's landscapes of Auvers and, because of this, his views of that famous small town give it the air of a simple vil-

lage with no history and no evidence of "high" civilization. The only building which asserts itself within the interlocking geometries of walls and roofs in *Auvers, Panoramic View* is the large house of Cézanne's friend and patron Gachet, the first owner of this picture (see above, III/5). It rises, a great white rectangle, at the left edge of the composition, as it does in other of Cézanne's many paintings of Auvers. Its placement is not dissimilar to that of the house of Pissarro's friend Marie Desraimes in his village landscapes (nos. 63–64).

Neither signed nor dated, *Auvers, Panoramic View* is clearly unfinished. Certain portions of the foreground, particularly the lower left quadrant of the picture, are worked in a manner that is completely consistent with other paintings of the period by Cézanne. The remainder of the surface was thinly—and sometimes softly—painted in a way that has led several recent scholars of Cézanne's oeuvre to doubt the painting's attribution.[1] There is no doubt, however, that the picture is by him. Its early provenance, although occasionally problematic, rules out the possibility of a forgery. It was certainly owned by Gachet and may have passed through the distinguished collection of Georges Viau before being acquired by Alfred Strolin and the great dealer Durand-Ruel, who sold it to the Chicago collector Mr. Lewis Larned Coburn (see below, IV). Further, the painting is too original in conception and its finished portions too close to autograph works by Cézanne to be assigned to Vignon, Guillaumin, or Pissarro. It can be analyzed as a product of the young Cézanne's working methods precisely because it is variously "finished." It is close to Pissarro's paintings of 1875, particularly *Climbing Path in the Hermitage, Pontoise* (no. 66) and *Flowering Garden, Pontoise* (Private Collection, Paris), thus indicating the importance of the relationship between Pissarro and his most brilliant student during the first half of the 1870s.

The highly organized, geometrical facture of *Auvers, Panoramic View* is a prelude to the systematic, diagonal, "constructive" stroke used by Cézanne later in the same decade and more or less "invented" during the period when he worked on this and the superb *Auvers,*

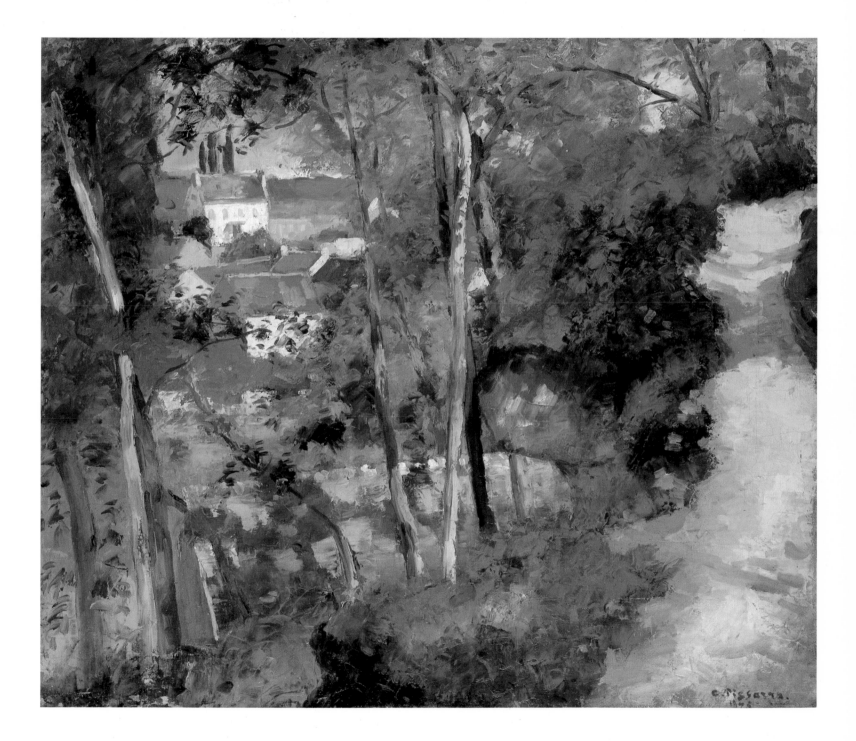

No. 66. Camille Pissarro
CLIMBING PATH IN THE HERMITAGE, PONTOISE, 1875

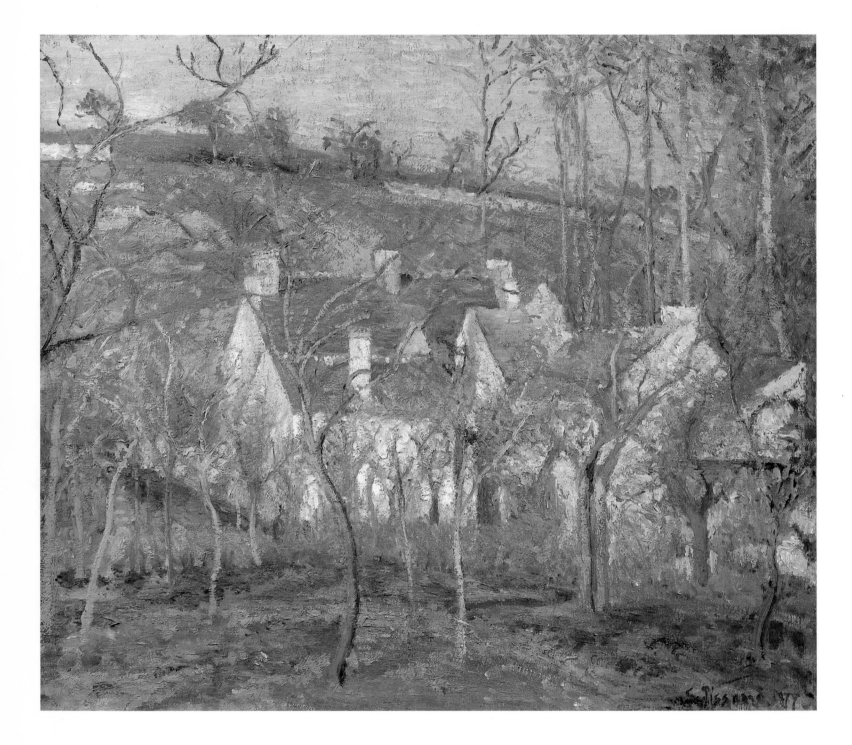

No. 67. Camille Pissarro
RED ROOFS, A CORNER OF THE VILLAGE IN WINTER, 1877

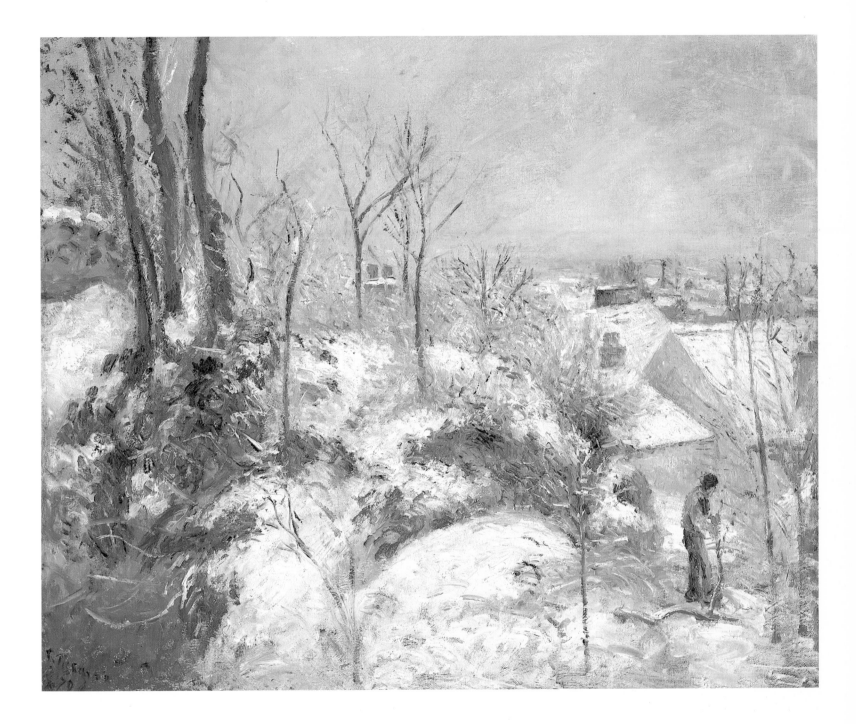

No. 68. Camille Pissarro
RABBIT WARREN AT PONTOISE, SNOW, 1879

Small Houses (1873–74; Fogg Art Museum, Cambridge).[2]

NOTES
1. Oral communications.
2. Reff, 1962, pp. 215–217.

70. Paul Cézanne
FARMYARD AT AUVERS
(COUR DE FERME À AUVERS), c. 1879–80

Farmyard at Auvers is among the group of superb village and field landscapes painted during Cézanne's second campaign in Auvers and Pontoise between 1879 and early 1882 (his first having been between 1874 and 1877). It represents a farmyard, probably not in Auvers despite its title, but in Pontoise, where Cézanne then lived. Pissarro painted several similar farmyards in the middle 1870s; *Farmyard at Montfoucault* and *Farmyard at Pontoise* (both locations unknown) are perhaps the closest in subject. However, the contrast between Cézanne's farmyard and those painted by Pissarro is extreme. Where the older artist was fascinated with the "life" of these outdoor spaces and populated them with peasants and their chickens, geese, and goats, Cézanne studied the relationship between architecture and vegetation as if the farm was abandoned, and his paintings have an abstract, formal gravity almost at odds with their subject as it had been painted traditionally.

Farmyard at Auvers is a landscape abounding in walls and barriers. A wall at the right functions as a dramatic *repoussoir*, almost becoming a stripe of creamy plaster on the picture surface. One proceeds back—step by step, plane by plane—until one reaches the ultimate barrier, a simple farm building, its door and window shut and shuttered, respectively. In front of it is a defoliated tree, whose contours are lovingly sculpted in paint and whose shadow plays across the facade and roof of the building. A thatched structure, perhaps the entrance to the farmyard, is wedged into the remaining space, completely blocking the viewer's path into the landscape beyond. The gentle, wooded hillside, painted with a series of disconnected, hatched lines, seems to shift and tremble behind the terrible solidity of the farmyard.

The painting has an atmosphere of death, desertion, and even suspicion. One feels almost afraid of what or who will emerge from behind the walls in the foreground; every exit from the barnyard is closed. How grateful we would be for one of Pissarro's lively chickens or a child playing on the packed earth of the farmyard floor! How far we have come from the most famous barnyards painted by a Frenchman, those by François Boucher. In fact, it is instructive to contrast Cézanne's desolate barnyard with a description—hypothetical though it is—of Boucher's barnyards written by Cézanne's contemporaries the Goncourt brothers:

> And to increase further the CONFUSION of his [Boucher's] landscapes, to give them more life, more disorder, more bewildering animation, flocks of birds were flung into the skies, while below the hens were squabbling, the dogs barking, the children running around the yard where their feet slip on the grain; and on the roads, he launches convoys of animals into the dust....[1]

NOTE
1. Goncourt and Goncourt, 1971, p. 69.

71. Paul Cézanne
THE POPLARS
(LES PEUPLIERS), c. 1879–82

The Poplars was probably painted just outside the park of the Château des Marcouvilles in the hamlet of Les Patis. Pissarro had worked in the region in the early and middle 1870s (no. 53), painting one landscape in the park itself, and Cézanne made several important landscapes there during his second campaign in that region.[1] Here, he concentrated on a large group of trees which ran along the Viosne River. His "problem" was to make this completely vegetative landscape formally legible, and he chose to contrast the strictly linear, even martial rhythms of the poplars with the informal clumping of the other trees. He allowed himself few, if any, distractions from the foliage. The field is uninteresting, the wall, scarcely distinguished, and the landscape at the left, summary. There are no figures working in the fields or peering at us from the park. Clearly Cézanne was intent on solving a particularly difficult pictorial problem for the landscape painter—the rendering of a view whose only subject is foliage.

The precedents for this painting lie in works by Pissarro, and there are several landscapes by the older master, mostly from the late 1860s and early 1870s, that must have been familiar to Cézanne. Perhaps the chief characteristic of the landscape that links it to Pissarro is the distance between the painter and the plane of foliage. Cézanne preferred to immerse himself in a forested landscape and to let the trunks of the trees play an important sculptural role in the composition. When viewed from a distance, however, foliage must be treated in other ways. Cézanne turned to a specific painting by Pissarro, painted at least five years earlier from roughly the same spot, as his model in this case. The difference between these foliated landscapes and the then-famous wooded landscapes by the Barbizon school should be mentioned here (fig. 12). Pissarro's and Cézanne's focus was planted trees—rather than "natural" ones—which formed part of compositions in which the intentions of man, rather than the wild will of nature, organized the landscape.

NOTE
1. Venturi 319, 323–324.

72. Paul Cézanne
BEND IN THE ROAD
(LA ROUTE TOURNANTE), 1879–82

Bend in the Road is among the very greatest landscapes from Cézanne's second period in Pontoise and Auvers. Its first owner was no less a connoisseur than Monet, and the painting was a star in the great private collection of John T. Spaulding in Boston. The site chosen by Cézanne has always eluded identification, but there is little doubt that *Bend in the Road* was painted in the village of Valhermay, situated in the hills along the Oise nearly halfway between Pontoise and Auvers. Pissarro painted many landscapes in this and the neighboring village of Chaponval during the same years,[1] and the picturesque assembly of traditional rural dwellings along a naturally curved, unpaved path appealed to the sensibilities of both artists. Indeed, in the

A DAY IN THE COUNTRY

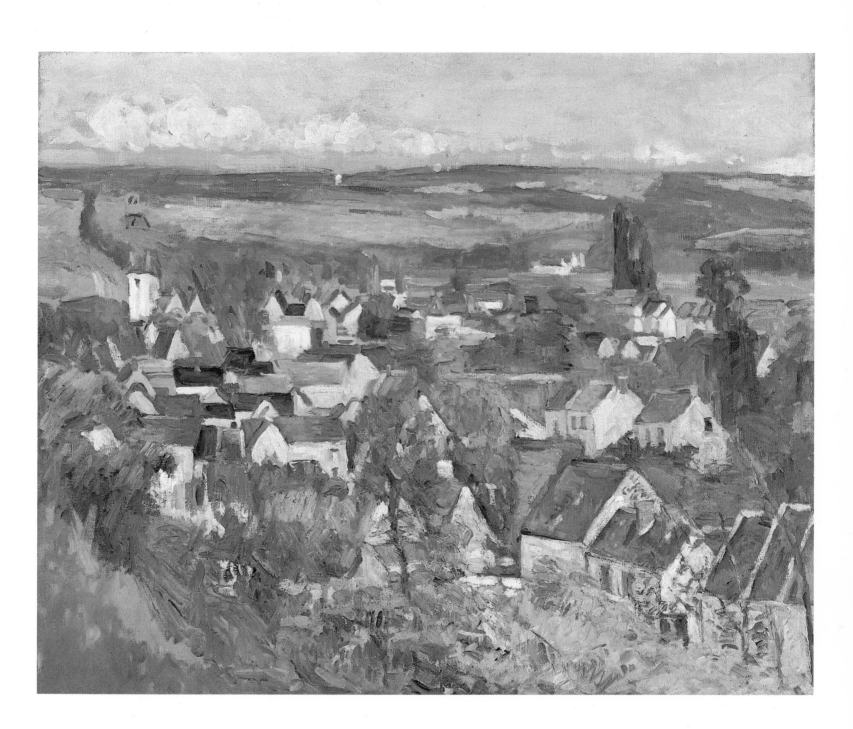

No. 69. Paul Cézanne
Auvers, Panoramic View, 1873–75
(detail on p. 174)

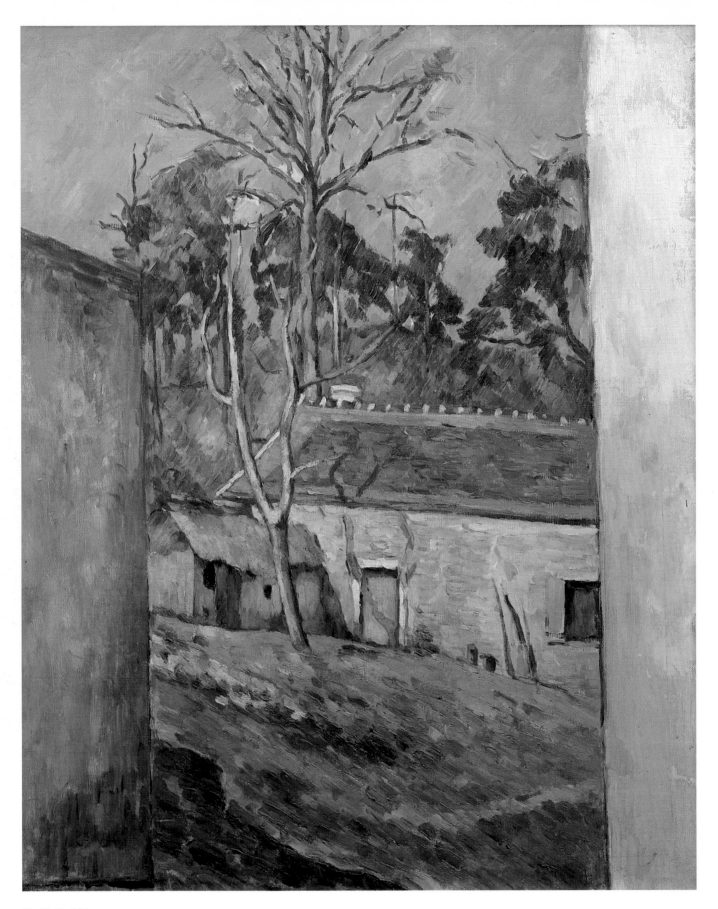

No. 70. Paul Cézanne
FARMYARD AT AUVERS, c. 1879–80

No. 71. Paul Cézanne
THE POPLARS, c. 1879–82

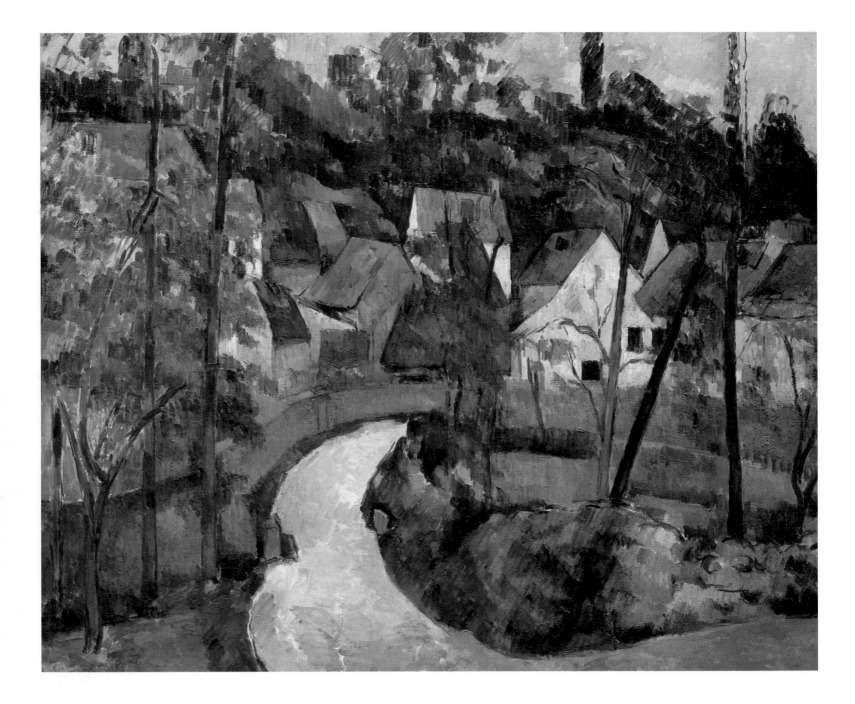

No. 72. Paul Cézanne
BEND IN THE ROAD, 1879–82

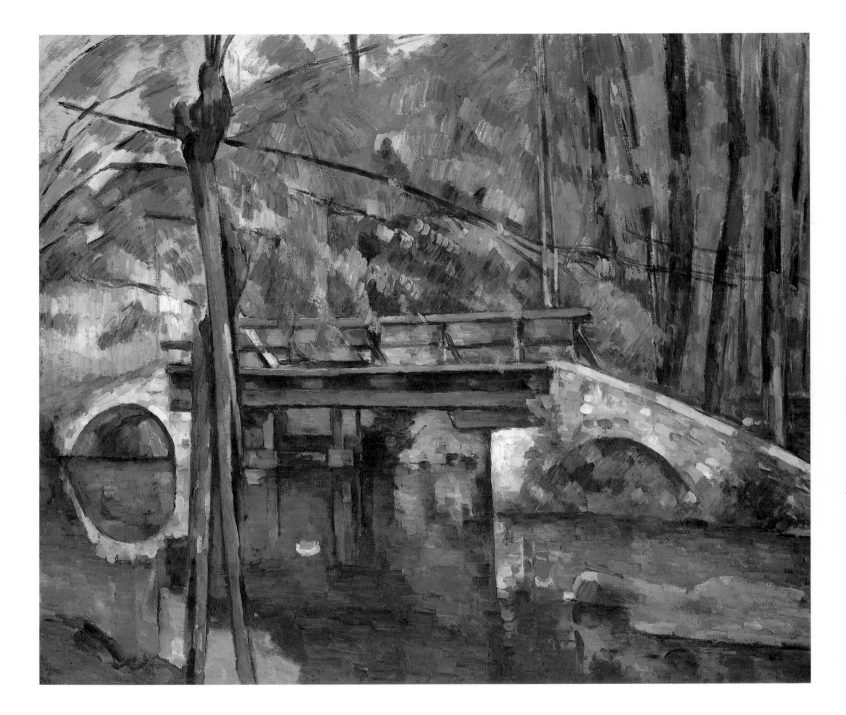

No. 73. Paul Cézanne
THE BRIDGE AT MAINCY, NEAR MELUN, c. 1879–80

early 1880s their preference for sites was distinctly anti-modern, and neither artist painted factories, river-scapes, the railroad, or newly constructed country residences during those years (see above, III/5).

No matter how much Cézanne learned from Pissarro, it was not from the Pissarro of the late 1870s and early 1880s, but from the Pissarro of 1866–68. When the latter painted in Valhermay and Chaponval, he treated the villages as part of what might be called a social or, at the very least, an inhabited landscape. Figures move back and forth on its paths and roads; young women tend cattle in the fields or weed in the kitchen gardens next to their small houses. None of this is true of Cézanne's landscapes made at the same time in the same villages. One never sees an inhabitant; smoke never comes from a chimney; animals never rustle in the barnyards. One thinks of the earlier deserted villages painted by Daubigny and Sisley.

Bend in the Road, like so many of Cézanne's landscapes, at first entices the viewer into its cool depths and then denies him access to the landscape. The road swoops generously into the painting, but bends behind a tree and seemingly disappears. The houses have virtually no windows or doors, and those openings that are present are—as always—closed, featureless rectangles. The viewer stands outside the village, which refuses him admission, and he can imagine no intercourse with its inhabitants. Indeed, the social—and psychological—detachment of this landscape is its most important characteristic—and its greatest paradox. The viewer is asked to marvel at a beautiful, forgotten, anonymous place, which huddles like a Japanese village behind a delicate screen of trees (see above, II). Yet he is completely isolated from its inhabitants, a human viewer of a village with no humans.

It may not be irrelevant to mention that the villages of Chaponval and Valhermay were ravaged by arson-caused fire in 1879, and that news of the tragic conflagrations was reported even in Paris.[2] It is perhaps because of the tragedy surrounding these events that both Cézanne and Pissarro turned their attentions to those fragile and picturesque hamlets, representing not the charred ruins described eloquently in the newspaper accounts, but the beauties which had been threatened by this terrifying rural crime.

NOTES
1. See especially Pissarro and Venturi 506, 511–512, 521, 560.
2. *La Presse illustrée*, no. 62, Oct. 12, 1879.

73. Paul Cézanne

THE BRIDGE AT MAINCY, NEAR MELUN
(*LE PONT DE MAINCY*), c. 1879–80

Although it was not painted in the landscape in and around Auvers and Pontoise, this painting by Cézanne owes a great deal to his experience in that area. It can be compared in structure and palette to Pissarro's major painting of 1875, *The Little Bridge, Pontoise* (Städtische Kunsthalle Mannheim), painted in the park of the Château des Marcouvilles, where Cézanne was also to work (no. 71). There is a slightly later drawing by Pissarro[1] which also explores many of the same pictorial problems as those studied by Cézanne in this brilliantly structured landscape. His balance of mass and space, of form and reflection, is both powerful and subtle, and he used a forthright, rigorous facture of diagonal hatchings derived in part from the graphic arts and, perhaps most directly, from early drawings made by Pissarro in South America and the Virgin Islands. Comparisons with *Wooded Landscape in St. Thomas* (1853; Ashmolean Museum of Art and Archaeology, Oxford), which remained in Pissarro's possession until his death, makes it clear that the older artist had achieved an exactly comparable organization of surface marks in these early drawings.

The Bridge at Maincy, near Melun, like most landscapes by Cézanne, has a single, clearly identifiable subject. Unlike Pissarro, who preferred to paint highly complex groups of forms with titles that stress their location in a real landscape, Cézanne was less interested in topographical matters and preferred to concentrate his attention on isolated, particularly powerful subjects. Bridge, barnyard, village panorama, winding road, mill, tree—all these subjects transcend the particularities of place and seem more "philosophical" than "topographical." In fact, Cézanne's de-emphasis of site in his landscapes is clear proof that, no matter how much he painted out-of-doors, his interests lay firmly in the visual rhythms of landscape. The deep and associative power of certain generalized subjects was of great significance to him; this representation of an old bridge over a quiet river must be contrasted in every way with earlier and contemporary representations of foot- and railroad bridges by the other Impressionists (nos. 29–30). Here, the woods are deep and cool. No figures come and go, and we are alone in what seems almost to be a timeless place.

Maincy is a small village just east of Melun in Brie and directly adjacent to the great seventeenth-century gardens of Vaux-le-Vicomte designed by Le Nôtre. Cézanne, in painting Maincy, chose to represent a wood and stone bridge connecting the mills in the hamlet of Trois-Moulin with Maincy itself. The river is the Almont, which provides water for Le Nôtre's canals and fountains at Vaux-le-Vicomte and flows into the Seine at Melun. Comparison with a photograph of the bridge and mills[2] indicates that Cézanne chose to screen the mill buildings immediately to the left of the bridge and to de-emphasize the fact that the Almont flowed rapidly at that point, to make it appear more calm and cool.

NOTES
1. Brettell and Lloyd, 1980, no. 171c.
2. Reidemeister, 1963, p. 34.

74. Paul Gauguin

THE MARKET GARDENS AT VAUGIRARD
(*LES MARAÎCHERS DE VAUGIRARD*), c. 1879

This large, highly finished, and ambitious early landscape by Gauguin was first recognized by Wildenstein as *Les Maraîchers de Vaugirard*, which Gauguin had exhibited in the fifth Impressionist exhibition in 1880. Before publication of the 1964 catalogue raisonné, the painting was called simply *Parisian Suburb*. Vaugirard, then as now part of the city of Paris, lies south of the Seine and consisted, in the nineteenth

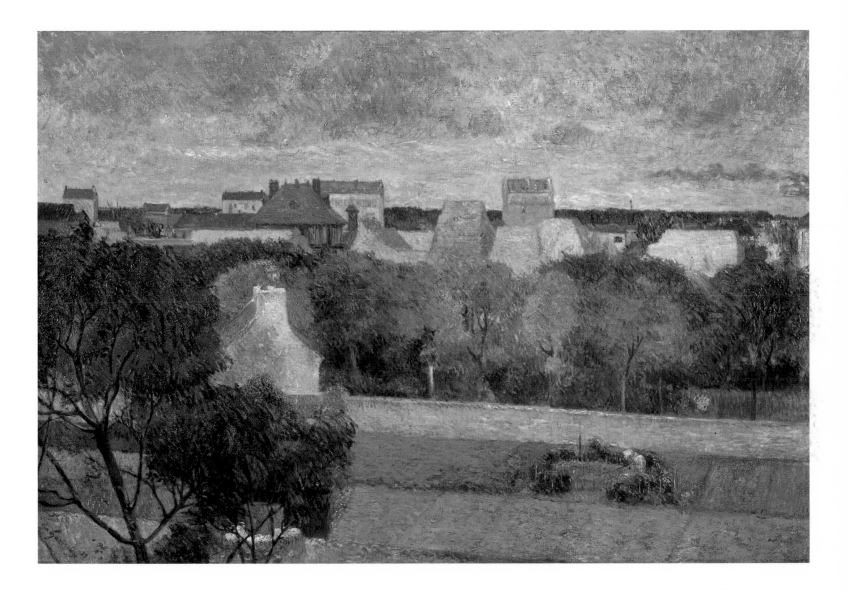

No. 74. Paul Gauguin
THE MARKET GARDENS AT VAUGIRARD, c. 1879

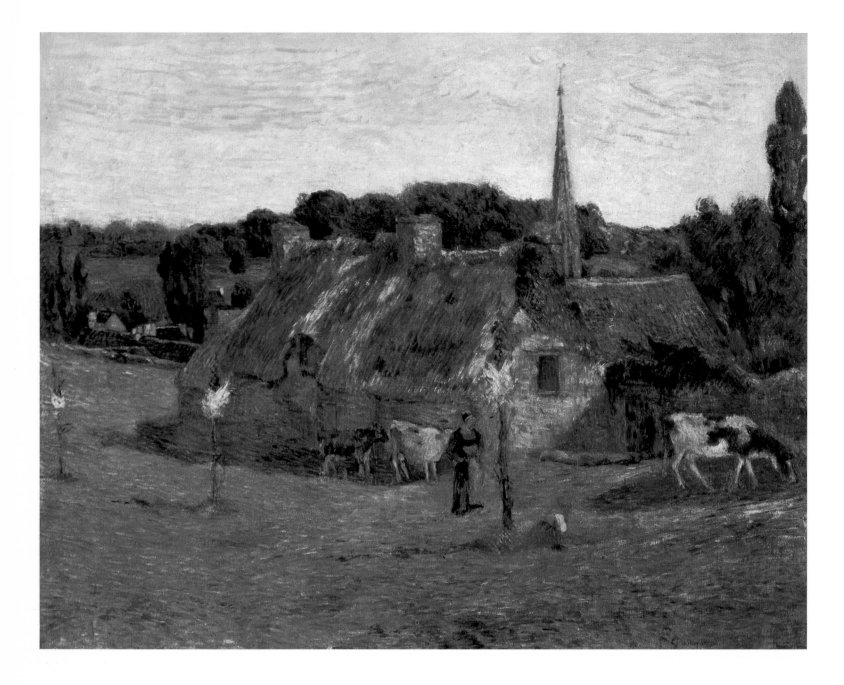

No. 75. Paul Gauguin
THE CHURCH AT PONT-AVEN, 1886

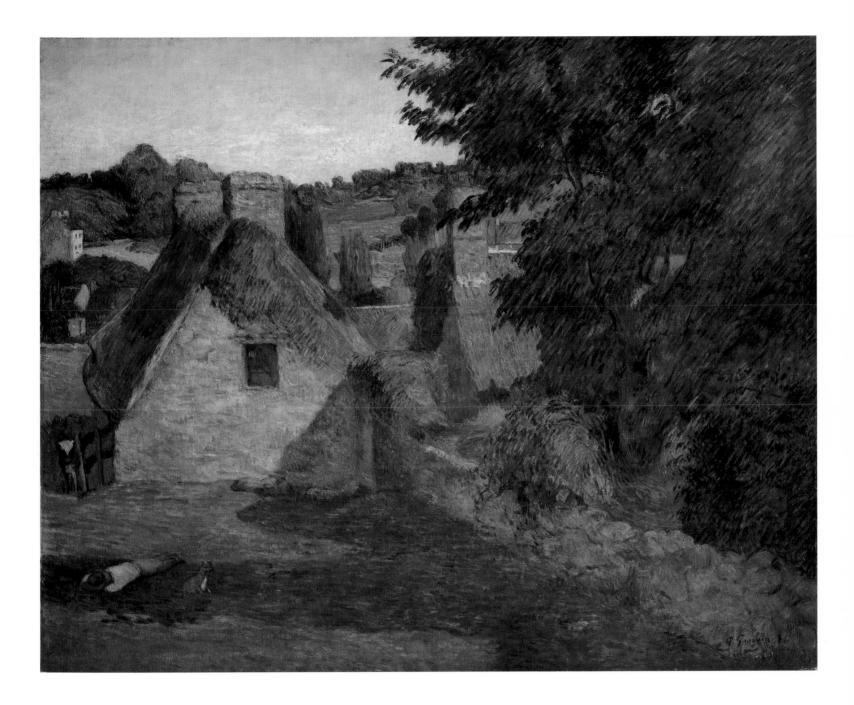

No. 76. Paul Gauguin
THE FIELD OF DEROUT-LOLLICHON, 1886

III/6
Private and Public Gardens

I F THE IMPRESSIONISTS meandered along the Seine and its tributaries, walked the roads and paths of France, and followed the tourists by means of the railroad network, they also relaxed in private gardens and public parks throughout Paris and her suburbs. Their "gardenscapes"—painted from Pontoise to Argenteuil—are so familiar to us today and so much a part of our own collective taste that we can easily forget the newness of their imagery at the time. Impressionism celebrated the conquest of the open air—indeed, of nature—by the middle classes, and the revolutions in small-scale private gardening and public parks that transformed industrializing Europe and America during the nineteenth century were central to the Impressionist aesthetic. Antoine Watteau, Jean-Honoré Fragonard, and Hubert Robert painted the French aristocratic garden during the eighteenth century. Manet, Pissarro, Berthe Morisot, Caillebotte, and Monet recorded the bourgeois garden and the public park in their first flowerings. To understand these paintings, one must consider them within the formidable context of articles, books, manuals, and magazines about horticulture published in France throughout the 1800s.

In the nineteenth century horticulture was considered to be an art as well as a science. In his *Entretiens familiers sur l'horticulture* (1860), Elie-Abel Carrière defined the term by means of the following dialogue:

Question: What is horticulture?
Answer: The art or means of making the best of any piece of land, be it from the standpoint of ornamentation or produce.

Question: What does the word horticulture mean?
Answer: It literally means "the cultivation of gardens" and comes from the Latin word *hortus,* meaning "garden," and the French word *culture*....Hence also the word horticulturist or gardener, which we give to those who exercise the profession....

Question: Apart from agriculture and silviculture, has horticulture other points of contact with the sciences, or is it independent of them?

Answer: It most certainly has. Horticulture itself, together with the sciences we have just mentioned (agriculture and silviculture), is but a part, a member of the great corpus of knowledge we designate by the name of NATURAL SCIENCES....But the science with which horticulture has the closest links is botany.

Question: What is botany?

Answer: It is that part of natural history which concentrates exclusively on the study of plants.[1]

A spate of courses and lectures on horticulture was published at this time, including: Alexandre Poiteau, *Cours d'horticulture* (1847); *Cours élémentaire d'horticulture à l'usage des écoles primaires* (edited from the notes of M. Boncenne by Sauvaget, 1859–60); Félix Boncenne, *Cours élémentaire d'horticulture* (1861); Jules Bidault, *L'Horticulture des écoles primaires* (1864); H. Billiard, *L'Horticulture des écoles primaires. Légumes, fruits et fleurs de pleine terre* (second edition, 1872); and Pierre Joigneaux, *Conférences sur le jardinage et la culture des arbres fruitiers* (1865). The "Exposition Universelle" of 1889 featured a lecture series, published the following year, on the recent development of French horticulture: *L'Horticulture française, ses progrès et ses conquêtes depuis 1789*, by Charles Baltet. Among the numerous manuals, dictionaries, treatises, and guides devoted to the subject we might mention *L'Art de cultiver les jardins, ou Nouveau manuel complet des jardiniers, par un jardinier agronome* (new edition by M. Bossin, 1852); Charles de Bussy, *Dictionnaire usuel et pratique d'agriculture et d'horticulture* (1863); H. Spruyt, *Traité élémentaire d'arboriculture, d'agriculture et d'horticulture* (1883); and Edouard Hocquart, *Guide du parfait jardinier-fleuriste, indiquant la culture de plus de sept cents espèces de plantes, arbres et arbustes d'ornement* (1873). There were also various kinds of almanacs and other periodicals, including *L'Almanach du jardinier* (in its thirty-second year in 1875); *L'Almanach du jardinier fleuriste et potager* (in its nineteenth year in 1873); and *Le Journal de vulgarisation de l'horticulture*, a monthly compendium established in 1877.

The inaugural issue (March 5, 1887) of *Le Jardin. Journal d'horticulture générale*, a journal originating in Argenteuil, the town which had seen the early blossoming of Impressionism (see above, III/4), opens with the following message:

> To Our Readers
>
> In no other era have flowers and plants been so widely appreciated: they preside at all our ceremonies, take part in all our festivities; their use has increased a hundredfold in 20 years, and their mass cultivation has become a source of revenue for many regions formerly in dire straits. Perhaps this infatuation, though perfectly natural, is merely a passing fancy....But we have resolved to encourage a love for plants as such....To give a multitude of facts, to answer all questions pertaining to our program, to conceal the difficulties of our art behind a pleasant facade, to do everything possible to help our fellow horticulturists, to guide them, urge them to keep us abreast of their discoveries, facilitate the task of presenting them to the public by giving them the full benefit of our public forum, in sum, to sacrifice our personal interest whenever the interest of our public is at stake—such are the principles of our publication.

The amateur gardening craze gave rise to the garden tour. Owners would show visitors around their properties with great pride and pleasure. Some

Fig. 49. Manet, *The House at Rueil,* 1882. Oil on canvas. 73 x 92 cm. Nationalgalerie, Staatliche Museen Preussischer Kulturbesitz, Berlin. Photo: Jörg P. Anders.

even wrote books about them, books like *Voyage autour de mon jardin, botanique amusante et usuelle* (1883) by Henri Van Looy, or *Autour de mon jardin* (1888) by Eugène de Duren. When we imagine the Impressionists standing at their easels in the vicinity of Paris, we must imagine them in this cultural context.

Gardens were considered to fall into several "families." Vegetable gardens and fruit orchards constituted the family of utility gardens and were dominated by the notions of fertility or fecundity. In the 1887 issue of *Le Jardin. Journal d'horticulture générale* already mentioned, Eugène Noel pointed to their proliferation in the region of Normandy:

> Fifty years ago nearly all farms limited their vegetable gardens to narrow plots, which were more often than not poorly cultivated, poorly kept up. Today farmers maintain gardens which are clean and properly cared for, rich in choice vegetables and strong, healthy fruit trees; moreover, the majority of their buildings and walls are covered with fruit trellises. Nor will you find these pretty little gardens, these orchards, these espaliers only among the well-to-do; you will find them among the poorest of farmers as well....The people who cultivate these gardens gain much more than a bit of extra food: they find a path to greater knowledge, to an appreciation of beauty; they find morality. A certain rich industrialist never took on a new hand for one of his workshops without asking, "Have you a garden?" The worker who answered in the negative was rarely hired....Indeed, this phenomenon will be remembered in our countryside as one of the characteristics of the nineteenth century.

Unlike these utility gardens, pleasure gardens (fig. 49) afforded views of flower bed after flower bed. For this reason they were also called "florist gardens" or "ornamental gardens." They were laid out with purely aesthetic ends in mind. Mixed gardens were sometimes planted. "To combine the useful with the agreeable is, in all things, to increase the sum of one's delights,"

Fig. 50. Monet, *Women in the Garden*, c. 1866–67. Oil on canvas. 256 x 208 cm. Musée d'Orsay, Galerie du Jeu de Paume, Paris. Photo: Musées Nationaux.

Moleri reminded readers of his *Petits jardins,*[2] therefore recommending a mixture of garden genres (as practiced today at the Château de Miromesnil near Dieppe, the putative birthplace of Maupassant). During the 1890s, however, G. Boyer took the opposite position in his "Jardin" entry for *La Grande Encyclopédie:*

> Nearly everywhere gardens are called upon to produce vegetables, ornamental plants, and fruit trees simultaneously. They are enclosed by walls lined with fruit shrubs on trellises and surrounded in turn by flower beds and paths. In the center of the garden there are one or several squares separated by paths and divided into plots for vegetables; along their perimeter run various fruit trees in the form of strings, candelabras, or distaffs....And paths all around, paths bordered with flowers, with parsley, with chervil and sorrel....Such an arrangement suits most people; they believe it makes the best use of the land. In fact, however, mixing cultures impedes success and infringes on the ornamental effect. It is thus advisable to keep different categories of garden plants separate from one another.[3]

Indoor hothouse gardens, or conservatories, were also popular. "The garden is like a fragrant entrance hall, the perfumed antichamber of the house. It is also its pantry," wrote Fulbert Dumonteil in *Le Jardin. Journal d'horticulture générale* in 1887. "Finally, the conservatory rises before us," he continued in his ornate style,

> a temple of flowers, a palace of plants. Here it is summer in winter, spring in December, the south in the north, the tropics, the equator beneath our cold European sky. Its flowers are rare, aristocratic, titled, so to speak: they come from the lands of the sun, from the scented shores of the Pacific or the Indian Ocean.

Some houses, like Baron de Rothschild's Château de Ferrières, had an orangery as well.[4] Other categories of gardens prevalent at the time included public gardens, which were numerous in Paris (see above, III/3), and botanical gardens, which were for research only.

Fig. 51. Monet, *The Turkeys*, 1876. Oil on canvas. 172 x 175 cm. Musée d'Orsay, Galerie du Jeu de Paume, Paris. Photo: Musées Nationaux.

France has had her "garden painters" like Fragonard and Robert, the latter having earned the title "Dessinateur du jardin du roi."[5] But as Louis Vauxcelles has pointed out, "in the nineteenth century we can boast no painters specializing in gardens, though nearly all of them, at a given point in their careers, painted *their* garden, the garden of a friend or teacher."[6] As a result of the influence of the Barbizon school, which had itself turned for inspiration to the English landscapists, French painters in the later nineteenth century became more sensitive to nature and the passing of the seasons. Pissarro, Monet, and Sisley, for example, all depicted the gaiety of orchards in spring blossom (nos. 98–100). However, the Impressionists were mainly attracted by pleasure gardens: Bazille on the flower-drenched terrace at Méric (no. 79); Pissarro at Pontoise (no. 85) and Eragny; Morisot at Bougival during the summers of 1881 and 1882 while Manet was at Versailles and Rueil; Renoir at the Collettes in Cagnes, and above all Caillebotte and Monet, both of whom returned often to the subject throughout their careers. Monet undertook *Women in the Garden* (fig. 50), a major composition, as early as 1866–67. The garden at Sèvres as he shows it was typical of its day. In *Flowering Garden* (1866; Musée d'Orsay, Galerie du Jeu de Paume, Paris) and *Terrace at Sainte-Adresse* (no. 5) the decorative value of the rose trees is self-evident; gardening treatises of the 1850s listed endless varieties of these.[7]

The gardens of the two houses Monet lived in at Argenteuil (nos. 80–83) belonged more to the urban world. As Paul Tucker has observed,[8] the Parisians who spent their weekends and holidays in nearby country houses recreated a disciplined landscape in keeping with their urban vision. Monet, commissioned in 1876 to decorate the grand salon of the Château de Rottembourg (at Montgeron in the south of Paris) by its owner, Ernest Hoschedé (whose wife Monet was later to marry [see below, III/8]), painted four large panels, with great virtuosity, of various views of the garden. These included a grassy expanse in *The Turkeys* (fig. 51); banks of dahlias and roses in bloom and the reflections of trees in the water in *Corner of the Garden* and *The Pond at Montgeron* (The Hermitage, Leningrad); and a luminous stretch of underbrush illustrating one of the favorite pastimes of the château in *The Hunt* (Private Collection).[9] Later, Monet would not leave Vétheuil without a picture of the place where he had lived for three years. Of the four versions of *Garden at Vétheuil*, the one in the National Gallery of Art, Washington, D.C., dated 1880 but painted in 1881, is the most monumental and fully realized. And finally, in 1883 (as we shall see) Monet discovered Giverny (nos. 91–93).

Not far from Montgeron, in Yerres, Caillebotte captured the image of his family's country residence on several canvases during the summers preceding the sale of the house: *Portraits in the Country* (1876; Musée Baron Gérard, Bayeux); *Family Reunion* (1867; Musée d'Orsay, Galerie du Jeu de Paume, Paris), executed in the manner of the young Bazille at Méric; and *Orange Trees—Zoe and Martial in the Garden at Yerres* (1878; Collection of John A. and Audrey Jones Beck, Houston). From the Yerres garden to *Roses, Garden at Petit-Gennevilliers* (no. 87), Caillebotte's art evolved in the direction of a greater freedom, a spontaneity similar to that of his friend Monet.[10]

Pleasure gardens were an important motif in the literature of the Impressionists' time just as they were in art. Zola described his childhood memories of the Gallice estate, west of Aix-en-Provence, with a fantastic twist in one of the *Rougon-Macquart* novels: "A glowing gap appeared in the black of the wall. It was like the vision of a virgin forest, a vast yet hidden stand of timber beneath a flood of sunlight."[11] The "Flower Maiden" temptresses created by Wagner for the garden of Klingsor in the second act of *Parsifal,* which had its premiere in 1882, reappeared in the title Proust gave to the second part of *A la recherche du temps perdu: A l'ombre des jeunes filles en fleurs.* (The standard English translation of the title, *Within a Budding Grove,* partly obscures the connection.) In his biography of Proust, George D. Painter paid careful attention to the role of gardens in the genesis of this novel. "Proust's Edens," he wrote, "were the gardens of Auteuil and Illiers, which later became the gardens of Combray. He saw them only at holiday times and afterwards forfeited them eternally through the original sin of asthma; but if he had never lost them, they would never have become Paradise."[12]

Indoor gardens also appear in literature, for example, in Zola's novel *La Curée,* which contains a detailed description of the conservatory in the townhouse of his hero, Aristide Rougon-Saccard:

> The conservatory, like the nave in a church, its slender iron columns rising up to support the glass arched roof, displayed a variety of lush vegetation, mighty layered leaves, luxuriant sprays of verdure. In the center, in an oval basin....the aquatic flora of the lands of the sun lived out their mysterious, blue-green lives....And floating in the sultry, stagnant, gently heated bath, water lilies opened their pink stars.[13]

In 1867 the Goncourt brothers reported in their *Journal* on the well-known salon of the Princess Mathilde. "These conservatory-salons are an entirely new luxury," they noted,

> the taste for which goes back perhaps to Mlle. de Cardoville in Sue, who astonished all of Paris at the time. The Princess, with her somewhat barbaric taste, has furnished the conservatory, which encircles the house, by mingling scattered articles of furniture of every possible country, every possible period, every possible color, and every possible shape with the most beautiful exotic plants. It creates the bizarre impression of a display of bric-a-brac in a virgin forest.

A few months later the Goncourts referred to the conservatory of La Païva as well.[14]

Indoor gardens were often associated with a feminine presence (Renée Saccard in Zola's novel, Odette de Crécy in Proust's). In fact, women wrote many of the treatises associated with indoor gardens, works like *Le Jardinier des fenêtres, des appartements et des petits jardins* (fourth edition, 1854) by Mme. Millet-Robinet, or *Le Jardinier des dames, ou l'Art de cultiver les plantes d'appartement dans les salons, sur les balcons....*(1875) by Céline

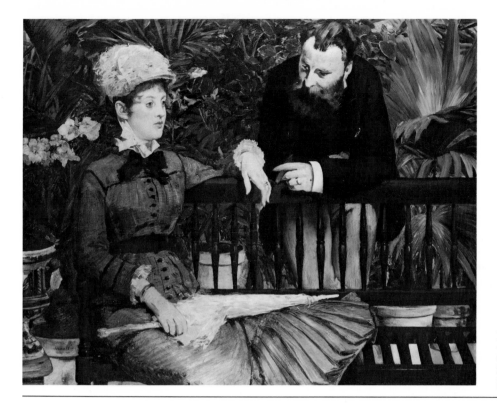

Fig. 52. Manet, *In the Greenhouse*, 1879. Oil on canvas. 115 x 150 cm. Nationalgalerie, Staatliche Museen Preussischer Kulturbesitz, Berlin. Photo: Jörg P. Anders.

Fleuriot. In these interior gardens more than elsewhere, the influence of the Orient was pervasive. In addition to orchids (about which Comte François du Buysson published a book-length appreciation entitled *L'Orchidophile, traité sur la culture des orchidées* [1878]), chrysanthemums were very much the fashion in France. "This plant," we read in a contemporary gardening manual,

> raised by the Chinese to a rare degree of perfection, has become all the rage in Europe ever since horticulturists have taken to sowing its seeds and developing varieties with a wide range of hues. No plant currently in fashion is easier to care for....Less sensitive to early cold spells than the dahlia, it will outlive it in the flower bed and disappear only with hard frost. It is advisable, therefore, to take a certain number of cuttings from them and plant them in pots, where they will serve to brighten your conservatory and fill your winter jardinieres.[15]

In *A la recherche du temps perdu* Odette de Crécy's flat contained

> ...a rectangular box in which, as in a conservatory, there bloomed a row of chrysanthemums, large for their time but not nearly the size of the ones horticulturists later succeeded in producing. Swann was annoyed by the vogue they had enjoyed for the past year, but he was glad, this once, to find the half-light in the room striped with pink, orange, and white by the fragrant rays of those fleeting stars that flare up on gray days.[16]

The motif of the indoor garden also appeared in art; at the Salon of 1879 Manet exhibited *In the Greenhouse* (fig. 52), a painting showing a couple, friends of the artist, in the winter garden of a studio Manet had sublet from a Swedish painter at 70, rue d'Amsterdam. He also painted his wife there in *Mme. Manet in the Greenhouse* (1879; Nasjonalgalleriet, Oslo).

If the pleasure gardens of Argenteuil represented the city intruding on the countryside, then the Parisian public gardens represented the opposite

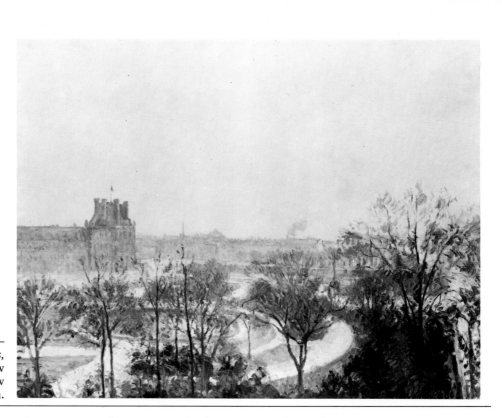

Fig. 53. Pissarro, *The Jardin des Tuileries,*
1900. Oil on canvas. 73 x 92 cm. Glasgow
Art Gallery and Museum. Photo: Glasgow
Art Gallery and Museum.

phenomenon: the countryside slipping into the capital (see above, III/3). Following in the footsteps of Napoleon I, Napoleon III (with the help of Alphand)[17] laid out a network of *promenades,* or public walks, in the working-class districts of Buttes-Chaumont and Montsouris as well as in residential areas like the Bois de Boulogne and the Parc Monceau. Zola's *La Curée* opens on "an autumn afternoon" in the Bois de Boulogne, a meeting place for elegant Parisiennes and one which Proust invoked as well. Berthe Morisot, who lived nearby on the rue de Villejust, often set up her easel there. Another promenade especially popular during the Second Empire, the Parc Monceau, the "land of illusion" designed by Louis Carmontelle between 1773 and 1778, is also described in *La Curée.* The townhouse of Aristide and Renée Saccard in the novel overlooks that "indispensable flowerbed of the new Paris."[18] Its picturesque qualities attracted Monet in 1876 and 1878, and Caillebotte did two contemporary views as well.[19]

Renoir, Monet, and Zola all depicted the public garden located in the heart of the capital and known for its important place in social rounds: the Tuileries (no. 84). Redesigned by Charles Percier and Pierre-François Fontaine in the early nineteenth century, it remained, during the Second Empire, an important center of social life (fig. 53). As a *Guide des promenades* published in 1855 has it,

The Tuileries is the promenade of Paris just as the Jardin du Luxembourg is the promenade of the Latin Quarter and the Jardin des Plantes the haven of the provincial. The Tuileries no longer attracts one particular type, one group of the population. It is a hodgepodge of childhood and maturity, merchant and artist, officer and civil servant, the Faubourg Saint-Honoré and the Chaussée-d'Antin, the Marais and the Faubourg Saint-Germain. People converse in hushed tones as at a salon; they come dressed to mix with society; they make their social calls, read their newspapers, and in general behave like members of a large and highly proper circle to which men and women are admitted only on condition that they conform to rules of the strictest decorum. One no longer sees—as one does at the Jardin du

A DAY IN THE COUNTRY

Luxembourg—the type of child whose bruised knees and tattered blue tunic betoken spirited play rather than concern for the sartorial....The Tuileries is the true garden of Paris.[20]

Like the garden of the Champs-Elysées, then, where Proust liked to meet Marie de Benardaky (the inspiration for Gilberte Swann) and her friends for a game of prisoner's base, the Tuileries differed in the elegance of those who frequented it regularly from the more common Jardin du Luxembourg (the birthplace of Marius' love for Cosette in Hugo's *Les Misérables*). A painting done there—where Watteau had also gone for inspiration—by Caillebotte around 1876 has the distinction of being "the only of his numerous views of Paris to depict a site on the Left Bank."[21] Other important sites were the Jardin des Plantes (where the former Jardin du Roi had become the Musée National d'Histoire Naturelle), which attracted both sculptors and painters, and the more recent Jardin d'Acclimatation, or Zoo, in the Bois de Boulogne, which was opened to the public in 1860. The rise of public gardens was closely correlated with the rise of the "new Paris" during the Second Empire (see above, III/3): both were created and designed not by gardeners, architects, or painters, but by town planners, and both played an active part in Parisian life of the time.

One garden of the period deserves special mention for its intimate connection with the genesis of the incomparable body of pictorial art produced by the Impressionists: Giverny. Upon his arrival there in 1883, Monet found that the house in which he was to live fronted on a large orchard, the kind for which Normandy is known (at the time the estate was called "Le Pressoir," or "The Cider Press"). Little by little, Monet transformed this utility garden into a pleasure garden (nos. 91–93), replacing the existing trees with more decorative varieties such as Japanese apple and cherry.[22] With the help of Félix Breuil, a gardener recommended by Octave Mirbeau (author of *Le Jardin des supplices*), and five assistants, the artist worked hard to make the garden beautiful, keeping his eyes open for any ephemeral flowering. Whenever he traveled, he constantly thought of his garden, worried about the temperature and its effect on his flowers, sent home instructions for the greenhouse he was having built. While working on the *Rouen Cathedral* series in 1893, he made a point of visiting that city's Jardin des Plantes, where he went into transports over the orchids and had several species sent to Giverny. Writing home two years later from Norway, he promised, ever the passionate botanist, to bring back "several specimens of plants" native to the countries of Scandinavia and, fearful of the cold back at Giverny, showered his wife with advice for the garden. "I'm heartbroken at your news of my poor rose trees," he wrote. "We seem to be in for a number of disasters. Has anyone thought of at least covering the Japanese peonies? It would be murder not to. And I'm so looking forward to seeing the greenhouse. I hope it will still be beautiful."[23]

Monet bought his supplies from Vilmorin and the firm of Truffaut. He exchanged seedlings with Caillebotte, who was a frequent guest. Mirbeau, another enthusiast, whose garden was painted by Pissarro, sometimes would join them. "I shall be very happy to entertain you," he wrote one day to Caillebotte. "What if I tell Monet to come too? Then we could spend a delightful day here chatting about painting and flowers and boats—three things all three of us dearly love."[24] Monet's addition of a new garden, the water garden, with its lilies, merely underscored the influence on him of the Orient; he was as particular about the Oriental poppies and chrysanthemums in his flowerbeds as he was about his collection of Japanese prints.[25]

If, before Giverny, Monet was merely responding to a given fashion, if he was merely one artist among many to cover his canvases with gardens, then after Giverny, in the last years of his life, he came to see the garden as more than a simple motif; he came to see it as a work of art in itself, a composition of subtle combinations of colors that he himself had imagined. Life and art became one. Jean-Pierre Hoschedé has quoted Monet as saying, "My most beautiful work of art is my garden."[26] It is for this reason that the attempt to restore Giverny to its appearance during Monet's tenure there has enriched our knowledge of his late paintings.

The creation of so distinct a universe did not go unnoticed at the time. Proust pointed to its originality as early as 1907 when he wrote,

> If...one day I can see Claude Monet's garden, I feel certain that what I shall see there in a garden of tones and colors more than of flowers is a garden less the old florist garden than a colorist garden, if I may call it that, of flowers arranged in a whole that is not entirely that of nature, since they have been planted in such a way that only those flowers blossom together whose shades match, harmonize infinitely in a blue or pink expanse, and which this powerfully revealed intention on the part of the painter has dematerialized, in a way, from all that is not color. Flowers of the soil and also flowers of the water, those tender water lilies the master has depicted in sublime canvases of which this garden (a true transposition of art rather than mere model, a picture done straight from nature, which lights up beneath the eyes of a great painter) is like a first and living sketch—or at least the palette where their harmonious hues are prepared comes already made and delightful.[27]
>
> —S. G.-P.

NOTES

1. Carrière, 1860, pp. 11–12.
2. Moleri, 1866, p. 16.
3. Boyer in *La Grande Encyclopédie*, 1886–1902, vol. 21, p. 48.
4. Robinson, 1878, pl. 257.
5. Grimal, 1954, p. 240.
6. Vauxcelles, 1934, p. 10.
7. Ysabeau, 1854, pp. 11–13.
8. Tucker, 1982, pp. 125–153, 198–199.
9. Réunion des Musées Nationaux, 1980, pp. 168–183.
10. Berhaut, 1978, pp. 9, 41, 64.
11. Zola, 1960, vol. I, pp. 1253, 1677.
12. Painter, 1966, vol. I, p. 38.
13. Zola, 1960, vol. I, p. 354.
14. Ibid., p. 1593.
15. Ysabeau, 1854, pp. 14–15.
16. Proust, 1973–74, vol. I, p. 220.
17. See Alphand, 1867–73, vols. I–II; Charageat, 1962, p. 175.
18. Walter, 1978, pp. 18–25.
19. Wildenstein 398, 466; Berhaut 58, 111.
20. *Guide des promenades*, 1855, pp. 102, 108.
21. Berhaut 37.
22. Centre Culturel du Marais, 1983, pp. 14–15.
23. Wildenstein, 1974–79, vol. III, pp. 269–271, 282, 284.
24. Berhaut, 1978, pp. 248–249.
25. Bibliothèque des Arts, 1983, pp. 12, 27.
26. Hoschedé, 1960, vol. I, pp. 57–70.
27. Proust, 1971, pp. 539–540.

78. Claude Monet

FLOWERING GARDEN
(*JARDIN EN FLEURS*), C. 1866

The private garden depicted here has been identified as part of Le Coteau, an estate in Sainte-Adresse near Le Havre belonging to some cousins of Monet, the Lecadre family. It exists to this day at the corner of the rues des Phares and Charles-Dalencourt.[1] Together with a canvas showing a more extensive view of the same garden, *Jeanne-Marguerite Lecadre in the Garden* (The Hermitage, Leningrad), it was probably done during a visit the artist made to Sainte-Adresse in 1866 (nos. 1, 4–6); however, both canvases may date from the following summer when, on June 25, Monet wrote from there to his friend Bazille,

> I am in the bosom of my family...as happy, as well as I can be....My work is cut out for me: I've a good twenty canvases under way—dazzling seascapes and figures and gardens.[2]

Much more modest in format than *Women in the Garden* (fig. 50) or *Terrace at Sainte-Adresse* (no. 5), *Flowering Garden* nonetheless bears the marks of the same plein-air investigations. In it, as in other works, Monet divided the canvas into zones of light and shade: by leaving the left-hand portion of the foreground in the shade, he heightened the intensity of the light coming from the blue summer sky. He took great care to reproduce the spontaneity of his first sun-drenched vision, which he expressed by means of color contrasts, the various reds of the roses and geraniums bursting into the green vegetation and sparkling in the light, much like the flowers he painted later scattered through the fields of Argenteuil in *Poppies* (1873; Musée d'Orsay, Galerie du Jeu de Paume, Paris). The "decorative exuberance of flowers and foliage"[3] and the unusual treatment of blooming flower beds recall works of Monet's earliest period. Even then, he used a fragmented-stroke technique, the technique that would soon epitomize Impressionism.

NOTES
1. Wildenstein 68–69.
2. Ibid., p. 423.
3. Réunion des Musées Nationaux, 1980, nos. 14–15.

79. Frédéric Bazille

ROSE TRELLIS (TERRACE AT MÉRIC)
(*LES LAURIERS-ROSES* [*TERRASSE À MÉRIC*]), 1867

Early in 1864 the young Bazille, who had been forced to study medicine by his parents, wrote to his father from Paris,

> If I pass my exam, I shall take advantage of the situation...to ask your permission to spend a fortnight at Honfleur in May with my friend Monet, the one I went to Fontainebleau with last year.[1]

The year before, Bazille had been more specific about this jaunt in a letter to his mother:

> I've just spent a week in the tiny village of Chailly near the forest of Fontainebleau. I was with my friend Monet...who has quite a flair for landscapes. The advice he gave me was very useful.[2]

It therefore comes as no surprise that Monet's investigations into the nature of painting had an influence on the early artistic career of his friend from his time at the Atelier Gleyre. Bazille's *Family Reunion* (Musée d'Orsay, Galerie du Jeu de Paume, Paris), the definitive version of which was done at Méric during the summer of 1867, owes a great deal to Monet's *Women in the Garden* (fig. 50), which Bazille bought to help his friend in need.

A native of Montpellier, Bazille rejoiced at the opportunity to visit the family seat at Méric and devote himself entirely to his painting, whiling away the hours "in the shade of the chestnut trees, on the terrace," which had an unobstructed view of Castelnau and overlooked the Lez as it flowed along the foot of the hill. As he wrote, "The cicadas chirp stridently nearby, and the sun creates infinite clouds of dust."[3] While in Paris, he often thought with nostalgia of his native region. "You must take great delight in visiting Méric from time to time," he wrote to his father.

> The greenhouse must be very pretty....Tell all the people there that I haven't forgotten them and that I sometimes envy them the wonderful sun they must be enjoying.[4]

During a trip to the coast of Normandy in 1864 he mentioned in a letter some friends who "have a charming estate at Sainte-Adresse, where the life is very much like ours at Méric."[5]

The heat of the summer afternoons

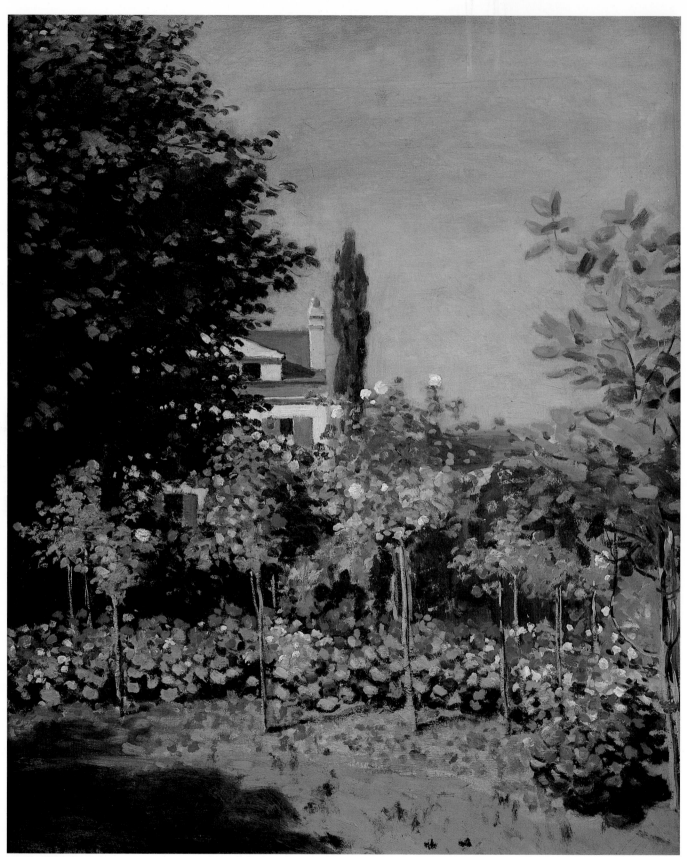

No. 78. Claude Monet
FLOWERING GARDEN, c. 1866

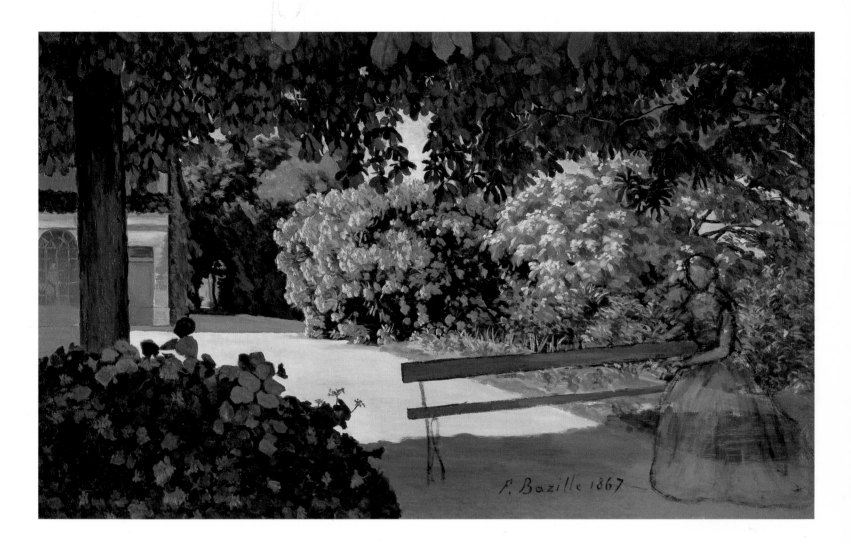

No. 79. Frédéric Bazille
ROSE TRELLIS (TERRACE AT MÉRIC), 1867
(detail on p. 206)

often sent Bazille to his terrace refuge, which appears several times in his work, in *Terrace at Méric* (1867; Petit Palais, Musée d'Art Moderne, Geneva), for example, and in *Family Reunion*, which he referred to in his correspondence as "my Méric picture." During the same summer Bazille depicted the garden there in two paintings he never completed: *The Small Jardiniere* (Museum of Fine Arts, Houston) and *Rose Trellis (Terrace at Méric)*. The latter clearly reveals Monet's lessons: the division of the canvas into zones of light and shade (as in the patch of shade cast by the tree on the ground), the interest in large clusters of flowers, and the attempt to insert figures into the landscape (the woman sketched in on the right). A comparison with *Flowering Garden* (no. 78) is instructive here. Beyond the bench, the pathway, and the marvelously tinted irises, nasturtia, and oleanders running along it, the house is just barely visible at the left. Although Bazille succeeded admirably in rendering the special, violet quality of the light of Languedoc and the sun of southern France, he was perhaps being more faithful to the letter of nascent Impressionism than to its spirit. In comparison with Monet, he has been criticized for a certain lack of spontaneity.[6]

NOTES
1. The Art Institute of Chicago, 1978, p. 197.
2. Ibid., p. 192.
3. See Poulain, 1932.
4. The Art Institute of Chicago, 1978, p. 192.
5. Ibid., p. 199.
6. Ibid., no. 20.

80. Claude Monet
MONET'S HOUSE AT ARGENTEUIL
(*LA MAISON DE L'ARTISTE À ARGENTEUIL*), 1873

Immediately after arriving at Argenteuil on December 21, 1871, Monet dashed off a note to Pissarro saying, "We are very busy settling in" and giving his new address: "Maison Aubry near the hospice. Porte Saint-Denis at Argenteuil."[1] Located more exactly at the corner of the rue Pierre-Guienne and the boulevard Saint-Denis, this was Monet's first house

at Argenteuil (it was torn down at the beginning of the twentieth century).[2] Here, we see it from the back, as it opened on the garden, a choice of setting recalling works by Manet.[3]

The years 1872–73 were far from lean for Monet thanks to the purchases of Durand-Ruel, his dealer. This temporary opulence is obvious in Monet's works of the period. The various views of the house and the luxuriant garden suggest that life was easy and might even have been happy had the artist's wife, Camille, not suffered her first bouts of illness there. The artist appears to have begun drifting away from her at the time, and several critics have remarked that the figures in the Argenteuil canvases are always separate from one another, as if unable to communicate.[4]

Here we find Jean, Monet's first-born son (he was five or six at the time), playing alone with his hoop, an object that accompanies him in a contemporary picture, *Camille in the Garden with Jean and His Nurse* (1873; Bührle Collection, Zurich). The tiny silhouette of the elegantly dressed child accentuates his isolation in the center of the composition, where he stands out against the empty, uniform surface of the ground. At the top of the stairs, framed in a doorway, a woman (Camille?) watches over him. Jean Monet is seen from behind, an unusual point of view that his father often used when inserting figures into a landscape.

Foliage and flowers, the combination of reds and greens, recall *Flowering Garden* (no. 78), and the opposition of strokes of light and shade on the path goes back to Monet's landscapes of 1867. The blue-patterned Oriental vases, commonly called Cologne ware, contribute to the decorative character of the composition. Tradition has it that Monet brought these vases back from a trip to Holland in 1871. They appear in other canvases as well. We find them in *The Garden* (1872; Private Collection, United States) and, shifted inside for the winter, in the foreground of *Corner of an Apartment* (1875; Musée d'Orsay, Galerie du Jeu de Paume, Paris), which depicts Monet's second Argenteuil house. Clearly the artist had a sentimental attachment to them, and they fol-

lowed him through many moves to Vétheuil (see *The Garden at Vetheuil* [1881; National Gallery of Art, Washington, D.C.]).

NOTES
1. Wildenstein, 1974–79, vol. I, p. 428.
2. Walter, 1966, p. 335.
3. Ibid., pp. 334–336; fig. 2.
4. Isaacson, 1978, p. 99, no. 42; Tucker, 1982, pp. 136, 139; 140, fig. 112.

81. Claude Monet
THE LUNCHEON
(*LE DÉJEUNER*), c. 1873–74

In this unusual composition, as in *Monet's House at Argenteuil* (no. 80), it is the back of Monet's first house at Argenteuil that closes off the space, but this time the artist used the large format he employed in his early works. This painting was displayed at the second Impressionist exhibition in 1876 under the designation of "decorative panel."

Once more, Jean Monet is shown lost in play, but now he has been relegated to the extreme left of the canvas, while two female figures, their bright dresses standing out against the foliage, appear in the right background. The previously noted division into highly contrasting areas of light and shade is at work here as well (no. 80), and, like *Monet's House at Argenteuil*, *The Luncheon* gives an idea of the art of country living. A feeling of genteel prosperity emanates from the picture, and every detail, however anecdotal it may appear at first,[1] works to enhance this sensation: the profusion of flowers, the beauty of the dresses, the whiteness of the linen, the arrangement of the dishes (the fruit bowl, in particular), the table settings, and the fine china (coffeepot and cups).

But, as Paul Tucker has pointed out, the fact that the meal has already been finished creates an impression of uncertainty.[2] Fruit there may be, and in abundance, but it cannot conceal the absence of the human element, the guests. The table has been abandoned, a parasol forgotten on the bench, a hat left hanging from a branch. This is the moment the artist has chosen to paint instead of a picture including family and friends sitting down to break bread together. The

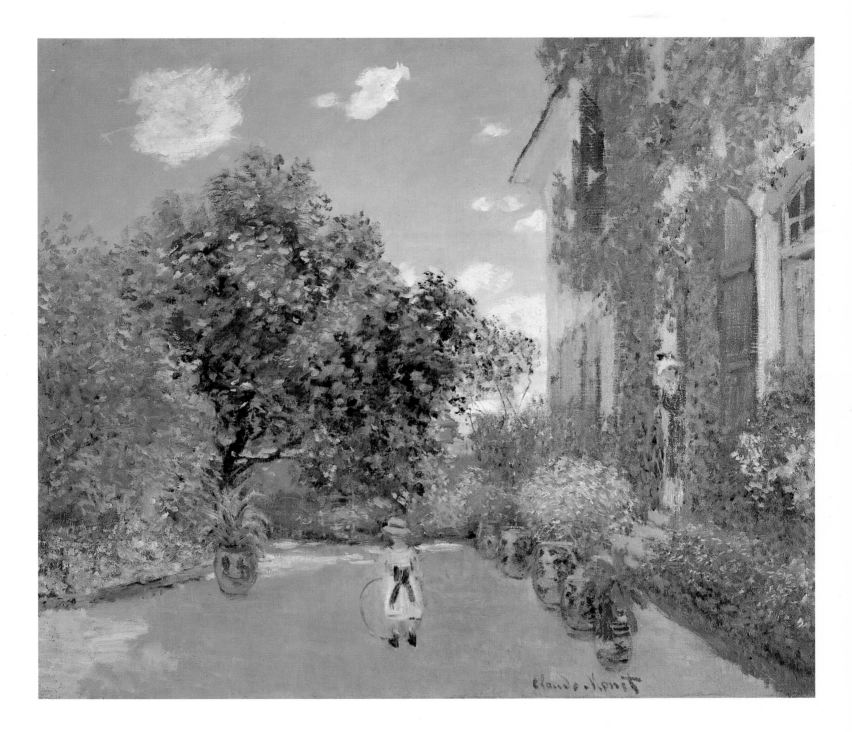

No. 80. Claude Monet
MONET'S HOUSE AT ARGENTEUIL, 1873

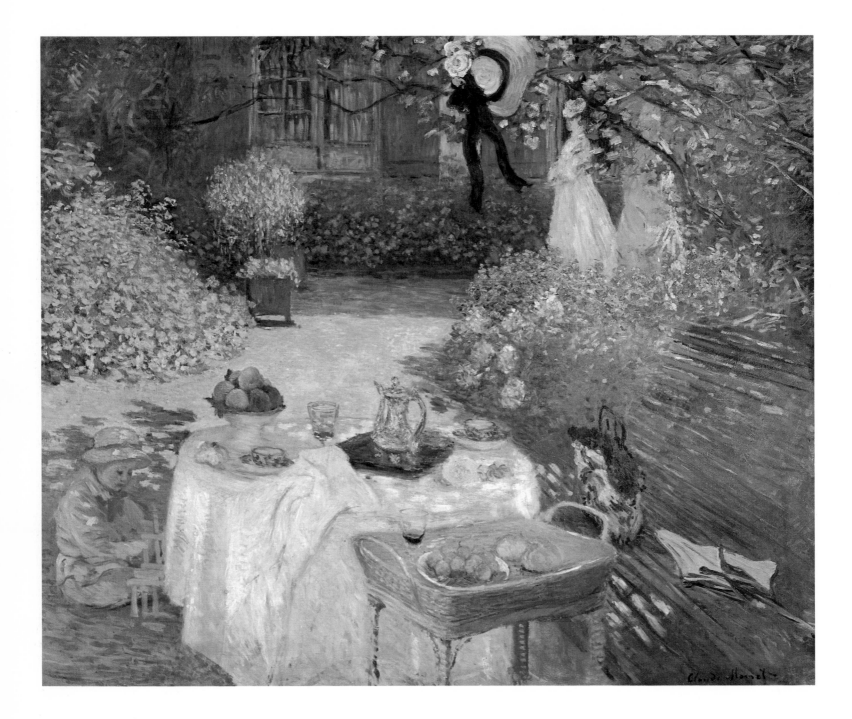

No. 81. Claude Monet
THE LUNCHEON, c. 1873–74

A DAY IN THE COUNTRY

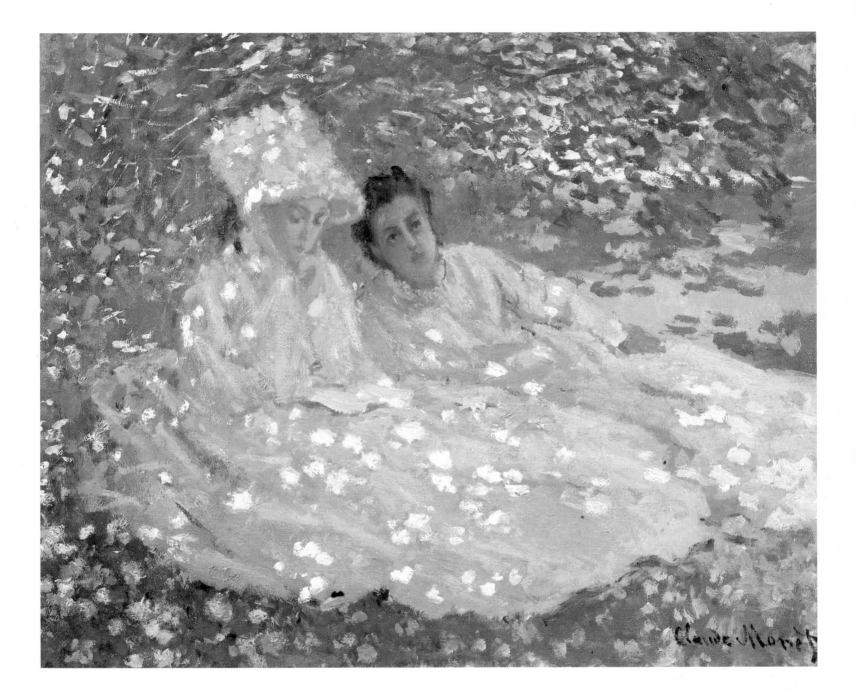

No. 82. Claude Monet
MADAME MONET IN THE GARDEN, c. 1872

choice is indicative of the absence of interchange among the members of the Argenteuil household. At the same time, however, the decorative and intimate character of the scene, its composition, and the terracing of its planes anticipate more obviously cheerful works by Bonnard and Vuillard.

The date usually assigned to this picture is 1873, but since Monet stayed in the house until the summer of 1874, he may well have done some more work on it then.[3]

NOTES
1. Isaacson, 1978, p. 99, no. 42.
2. Tucker, 1982, pp. 145–146, pl. 26.
3. Réunion des Musées Nationaux, 1980, no. 47.

82. Claude Monet
MADAME MONET IN THE GARDEN
(*MADAME MONET DANS UN JARDIN*),
c. 1872

In an article on the second Impressionist exhibition, Zola singled out Monet as being

> undoubtedly the head of the group. His brush is conspicuous for its extraordinary brilliance....His landscapes gleam in the sun....Among the many pictures deserving special attention is one of a woman in white sitting in the shade of some greenery, her dress dotted with bursts of light similar to large drops.[1]

The painting Zola was referring to is *The Reader* (Walters Art Gallery, Baltimore), which dates from 1872–74 and was bought by the American artist Mary Cassatt. Blanche Hoschedé-Monet has suggested that the model for that picture was Camille Monet, but nothing in the composition allows us to establish the sitter's identity with certitude.[2]

A painting of identical dimensions to *The Reader, Madame Monet in the Garden* shows the same figure dressed in the same white dress mentioned by Zola and with a hat fastened under her chin. But this time she is accompanied by another woman whose dress is blue by way of contrast. Here, as in *The Reader*, Monet was intent on rendering the effect of the sun filtering through the leaves. Hence the luminous strokes that made such an impression on Zola.

John House considered this work to be a variant of *The Reader*.[3] He felt that they must be a pair, like *Lilacs in the Sun* (Pushkin Museum, Moscow) and *Lilacs in the Shade* (Musée d'Orsay, Galerie du Jeu de Paume, Paris), both painted by Monet in the spring of 1872 at Argenteuil. *The Reader* also seems to have been painted in the garden there.

NOTES
1. Zola, 1970, p. 279.
2. Wildenstein 205.
3. House, 1978, p. 680, fig. 3.

83. Claude Monet
GLADIOLI
(*LES GLAÏEULS*), 1876

Monet made a point of memorializing his second, as well as his first, Argenteuil house on several canvases. The former, in which he lived for four years starting in the autumn of 1874, still stands at 5, boulevard Saint-Denis (and not 2, boulevard Saint-Denis as Monet himself indicated).[1] It was "a pink house with green shutters opposite the station" according to the description the artist gave to Victor Chocquet, a customs official and avid collector of Delacroix, Cézanne, and Renoir (see below, IV).[2]

The garden of this house, which extended back from it, is the object of a group of Monet's paintings, *Gladioli* being the most sumptuous and effective one. Long thought to have been done in 1873 (at which time Monet was still living in the first Argenteuil house), it is now dated three years later, in accordance with Wildenstein's classification.[3] It thus overlaps with three other canvases showing Camille Monet among the flowers. Here, she stands shading her face under a parasol, an object often present in Monet's works (it provided more areas of light and shade to work with), in those of other Impressionist painters (Boudin [no. 12] and Morisot, for example), and even in the stories of Maupassant: "He found her delightful, the pink young girl who, with her bright parasol and fresh dress, strolled along the broad horizon of the sea."[4]

In *Gladioli* Monet took up a line of research he had initiated some ten years before with *Luncheon on the Grass* (Destroyed) and *Women in the Garden* (fig. 51): the placement of human figures

in a landscape. He was not primarily concerned with the face of his model, preferring to let the environment predominate in order to highlight the copious growth of flowers in the foreground. These gladioli recall those of *Terrace at Sainte-Adresse* (no. 5) and are a motif which provided the artist with ample opportunity to apply the Impressionist technique whereby "stroke division accentuates the vibration of the atmosphere."[5] Monet made skillful use of the great luminosity that comes from mixing complementary colors, from exploding reds in the midst of greens. Faithful to the cheerful atmosphere of *Flowering Garden* (no. 78), this rich and sunny vision, easily synthesized by the eye from the proper distance, is characteristic of Monet's style at the height of Impressionism. It was not until much later, however, at Giverny (nos. 91–93), that he returned in his paintings to the floral extravagance he held so dear.

NOTES
1. Walter, 1966, pp. 336–338.
2. Wildenstein, 1974–79, vol. I, p. 430.
3. Ibid., p. 292, no. 414.
4. Maupassant, 1977–79, vol. I, p. 548.
5. Degand and Rouart, 1958, p. 65.

84. Claude Monet
TUILERIES GARDENS
(*VUE DES TUILERIES*), 1876

At the time he painted *Gladioli* (no. 83), Monet also showed great interest in the public gardens of Paris: the Parc Monceau and the Tuileries. He executed four views of the latter, all from a window in the apartment (at 198, rue de Rivoli) of the collector Chocquet (no. 83), whom Monet had met through the good graces of Cézanne several months before, in February 1876.[1] Yet Chocquet does not seem to have owned any of the four, all of which were done in the spring of that year shortly after the second Impressionist exhibition closed. On June 7 Monet wrote to Georges de Bellio, "I should very much like to show you my latest canvases (views of Paris)."[2] It was *Tuileries Gardens*, the most finished of the lot, that de Bellio selected; the painting is visible in a photograph of his flat

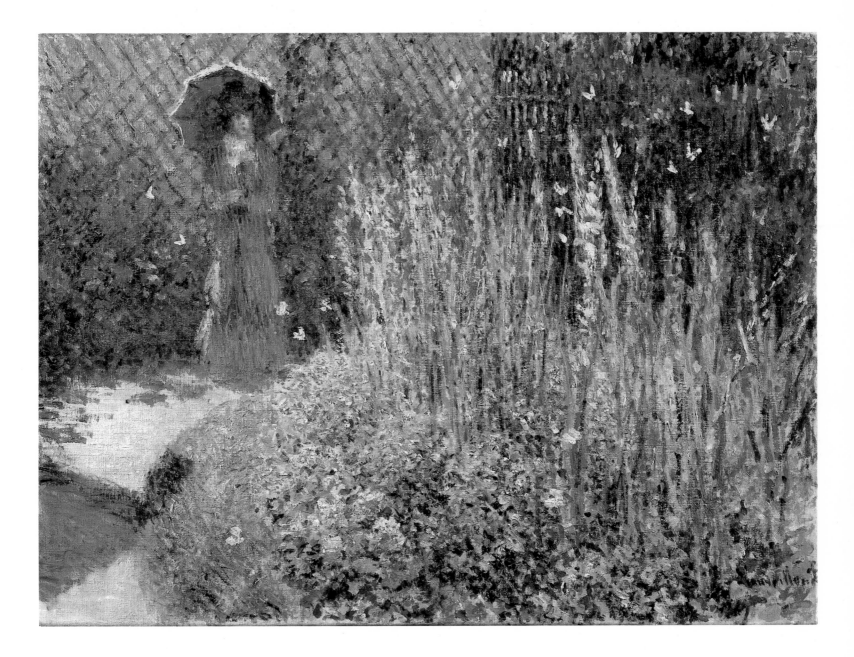

No. 83. Claude Monet
GLADIOLI, 1876

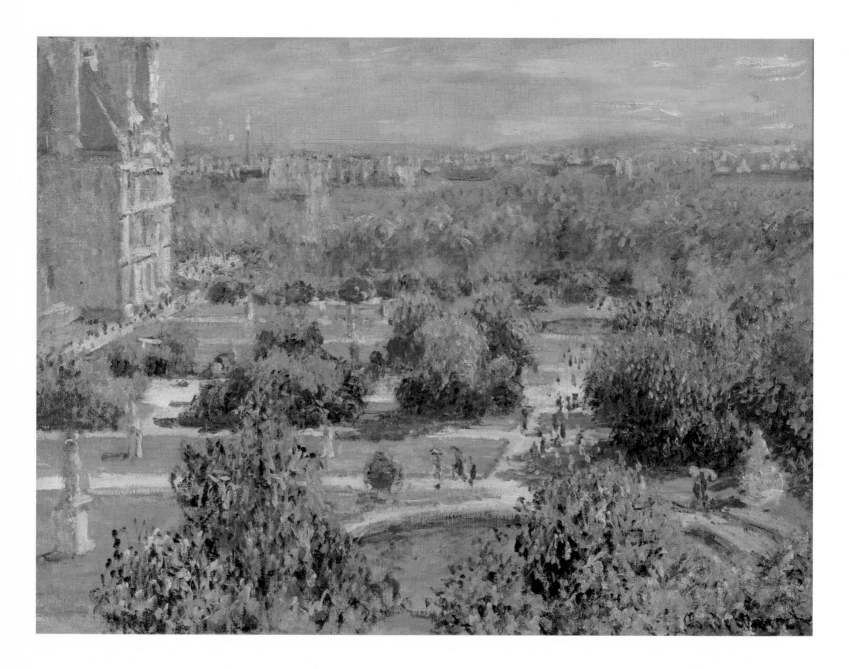

No. 84. Claude Monet
TUILERIES GARDENS, 1876

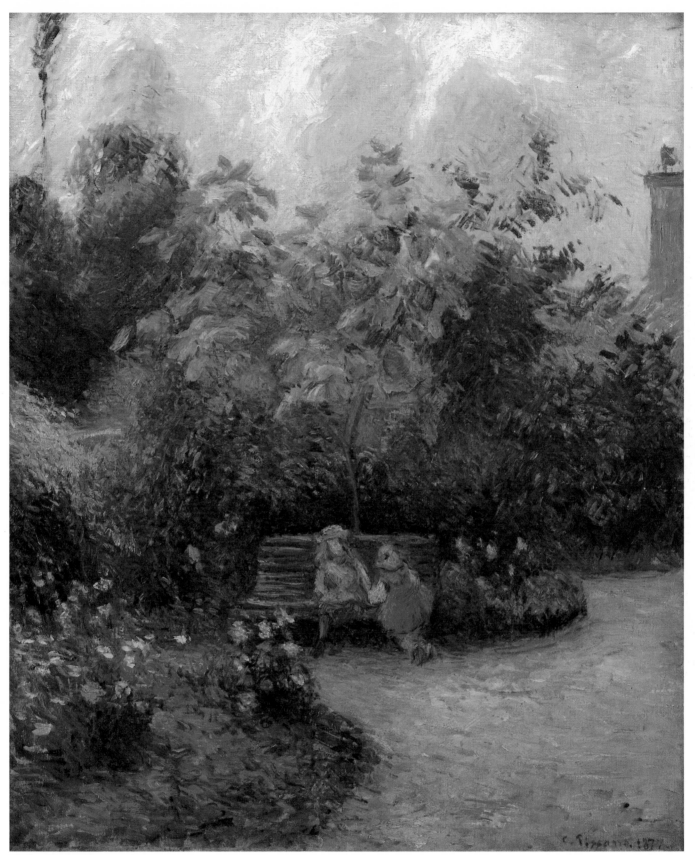

No. 85. Camille Pissarro
CORNER OF THE GARDEN AT THE HERMITAGE, 1877

taken about 1890.[3] In April of the following year he lent it, together with several other works by Monet, to the third Impressionist exhibition. Two of the other views were acquired by the collector Ernest May and by Caillebotte. (The sketch owned by Caillebotte passed to the Musée du Louvre [Musée d'Orsay, Galerie du Jeu de Paume] as part of his bequest.)

The two towers of the Eglise Sainte-Clotilde and the dome of Les Invalides on the left bank of the Seine appear in the distance in several of Monet's paintings (as here), but the present canvas is the only one that shows part of the Louvre with the Pavillion de Flore (at the left) (see above, III/3). Paul Tucker has remarked that Monet took care to exclude the Château des Tuileries, however, in ruins since the Commune.[4]

Monet concentrated here on his favorite subject: the depiction of nature as it appeared in the garden stretched out before his eyes. He had experimented with panoramic landscapes seen from above when, working side by side with Renoir from the colonnade of the Louvre in 1867, he was inspired by the coming of spring to paint *The Garden of l'Infante* (Allen Memorial Art Museum, Oberlin). In 1875 Renoir himself did a view of the Tuileries (Mrs. Grover A. Magnin Collection, San Francisco) that is quite similar to Monet's.

Zola could scarcely have been thinking of anyone but Monet when he described the revolutionary approach to painting conceived by Claude Lantier, the hero of his novel *L'Oeuvre*:

He wanted to catch the blazing sun—the Paris sun which, on certain days, turns the street white hot—in the dazzling reflection of the housefronts....what, more than anything, made his painting so dreadful was his new way of looking at light, the decomposition that resulted from extremely precise observation and ran counter to everything the eye was wont to accept by accentuating blues, yellows, reds where no one was accustomed to see them. The Tuileries, in the background, vanished in a golden shimmer, the cobblestones bled, the passersby were reduced to so many dark blotches corroded by too vivid a light.[5]

The Tuileries likewise attracted the attention of both Manet (*Music at the Tuileries* [1862; The National Gallery,

London]) and Pissarro, who wrote to his son on December 4, 1898:

We've taken a flat at 204, rue de Rivoli facing the Tuileries with a superb view of the garden: the Louvre to the left, then the buildings lining the Seine behind the trees of the garden, to the right the dome of Les Invalides and the steeples of Sainte-Clotilde emerging from clusters of chestnut trees. It's very beautiful! I shall have a beautiful series to do.[6]

In the end this series comprised close to 30 canvases, all dating from 1899 and 1900. One of the most successful is *The Jardin des Tuileries* (fig. 53).

NOTES

1. Wildenstein, 1974–79, vol. I, p. 430.
2. Ibid.
3. Tucker, 1982, p. 163; p. 173, fig. 140.
4. Ibid.
5. Zola, 1966, vol. IV, pp. 205–206.
6. Pissarro, 1950, p. 464.

85. Camille Pissarro
CORNER OF THE GARDEN AT THE HERMITAGE
(UN COIN DE JARDIN À L'HERMITAGE), 1877

In January 1866 Pissarro went to stay in Pontoise, just north of Paris, at 1, rue du Fond de l'Hermitage. He returned in 1873, residing first at 10, then at 16, rue de l'Hermitage. This district, in the northeast of Pontoise, inspired him to paint several landscapes (see above, III/ 5). In 1876 Pissarro obtained authorization from his neighbor Marie Desraimes (nos. 63–64) to work in the garden of the Château des Mathurins, of which she was proprietress. First he did a large-format (113 by 165.1 centimeters) view of the garden together with the front of the house (*Garden of the Mathurins, Pontoise* [William Rockhill Nelson Gallery of Art and Mary Atkins Museum of Fine Arts, Kansas City]). This was followed in the summer of 1877 by two others, very similar in composition and representing a corner of the same garden. One, identical in dimensions with the canvas of the previous year, showed a woman holding a parasol and sitting on a bench with a little girl at her side (formerly Baron Maurice de Rothschild Collection),

while the other (illustrated here), much more modest in format, shows two children on the bench.[1]

Pissarro's very human character comes through quite clearly in this intimate scene: we seem to be witnessing the telling of a secret. In his garden pictures the artist was highly dependent on Monet: here, he borrowed both the latter's fragmented-stroke technique and his Impressionist vision. In this picture Pissarro abandoned the rustic, countrified subjects he usually chose (see above, III/5) in favor of a landscape with a more civilized, urban feeling. This choice may have been suggested by Monet's elegant views of the Parc Monceau shown at the third Impressionist exhibition in the spring of 1877 or by the work of Renoir. Throughout this auspicious period in Pissarro's career we can also feel the influence of Cézanne in the former's sense of space and depth and in his rigorous multi-planar compositions.

NOTE

1. Coe, 1963, p. 16, fig. 14, has pinpointed the exact location of the site.

86. Gustave Caillebotte
THATCHED COTTAGE AT TROUVILLE
(LA CHAUMIÈRE, TROUVILLE), 1882

Only on rare occasions did Caillebotte leave the capital or the nearby banks of the Seine. However, the regattas of the Cercle de la Voile de Paris, in which he sailed (no. 46), and especially its annual trip to Trouville, led him to stay several times in Normandy, a region potentially significant to him because he could claim Norman ancestry on both sides of his family. But although he sailed the Norman coast regularly between 1880 and 1887, Norman landscapes—views of Villers, Trouville, or the vicinity of Etretat—disappeared from his work after 1884.

At Trouville Caillebotte painted the villas and their gardens, the Hôtel des Roches Noires, the cliffs and the road that rimmed them, and the fields near the sea (see below, III/8). That he was equally sensitive to the charm of the hin-

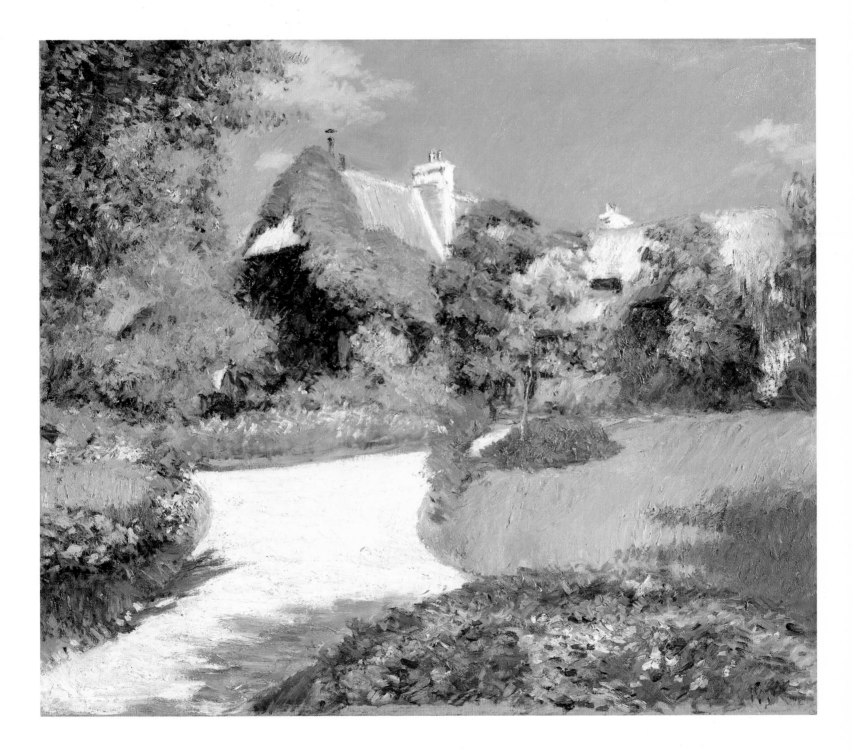

No. 86. Gustave Caillebotte
THATCHED COTTAGE AT TROUVILLE, 1882

terland, however, is clear from *Thatched Cottage at Trouville*. Both this and a contemporary canvas depicting the same thatched-roof building seen from a different point of view were signed by Renoir, who was the executor of Caillebotte's will.

This sunny garden recalls Monet's; the two artists were close friends. Caillebotte played an important part in the organization of the Impressionist exhibitions, and it was at the last one he was involved in (the seventh, and penultimate, show of the group, in 1882) that he first unveiled several of his Norman canvases to the public. They constituted a sort of transition in his career during the '80s: from urban views, portraits, and interiors he henceforth turned exclusively to the landscapes of his Petit-Gennevilliers period (no. 87).

Caillebotte's biographer gives the following analysis of his Norman paintings:

Compared with the works of the previous period, that is, of the Paris years, the Norman paintings doubtless lack a certain originality of vision; nor have they anything unusual to offer by way of composition. What they do reveal—and that quite frequently—is a spontaneity which links them with the studies of his fellow Impressionist landscapists. In these paintings Caillebotte uses a broader, freer style to convey intensity of color and the contrast between zones of light and shade in the open air.[1]

NOTE
1. Berhaut, 1978, p. 62.

87. Gustave Caillebotte
ROSES, GARDEN AT PETIT-GENNEVILLIERS
(*LES ROSES, JARDIN DU PETIT-GENNEVILLIERS*), C. 1886

Although Caillebotte seems to have bought his Petit-Gennevilliers house around 1880, it was not until 1888, the year after his brother Martial married, that he left the capital and settled there for good. In returning to the region of Argenteuil, Caillebotte was returning to one of the earliest Impressionist locales (see above, III/2 and 4). The Petit-Gennevilliers property, which ran down to the Seine, provided an inexhaustible source of motifs in the last years of his life. It was for Caillebotte what Giverny was for Monet (nos. 91–93). Caillebotte shared the latter's passion for gardening (photographs exist showing Caillebotte at work in his garden and greenhouse[1]), and he had a similar love of flowers, which are very much present in his work. Monet sent him frequent letters from Giverny, inviting him to see his own garden: "Be sure to come on Monday as agreed. All my iris will be in bloom. They'll begin to fade later."[2]

Caillebotte did numerous canvases of the Petit-Gennevilliers paths and flower beds: masses of dahlias, roses, chrysanthemums, and sunflowers, with iris and hyacinth borders. To paint the roses, as here, he adopted a freer technique than usual: drawing upon Monet's work for inspiration, he applied his colors in small, rapid strokes. Even so, both the flowers and the female silhouette in *Roses, Garden at Petit-Gennevilliers* have obvious contours which have not been absorbed by the light. Moreover, Caillebotte here rejected Monet's recurring device of juxtaposing contrasting zones of light and shade.

Caillebotte also had a different way of integrating the human figure into a landscape. Somewhat in the manner of Bazille, he refrained from completely depersonalizing his model. Here, she was Charlotte Berthier, the companion to whom he left the Petit-Gennevilliers house (which is no longer standing). Renoir, who did her portrait in 1883 (National Gallery of Art, Washington D.C.), identified her as Mme. Hagen.[3] The dog sitting in her lap in Renoir's rendering is the dog sitting on the path in Caillebotte's picture, to which it adds a note of humor and spontaneity.

In 1894 Caillebotte suffered a stroke while working on a landscape in this garden. He died several days later.

NOTES
1. Berhaut, 1978, pp. 13, 17.
2. Ibid., p. 248.
3. Daulte 432; Varnedoe and Lee, 1976, no. 70, p. 40; p. 45, n. 40.

88. Vincent van Gogh
CORNER IN VOYER-D'ARGENSON PARK AT ASNIÈRES
(*COIN DU PARC VOYER-D'ARGENSON À ASNIÈRES*), 1887

In 1886 Van Gogh left his native Holland to join his brother, Theo, who was working at the Galerie Goupil (later the firm of Boussod et Valadon) in Paris. There, he met the Impressionist painters, who initiated him into their world of light and liberated him from a palette which, until then, had been limited to somber hues. His time in Paris was one of fleeting experiences, a transitional period which enabled him to experiment with all the current styles before settling into one personal mode. As he wrote to an English painter, "I went regularly to the Atelier Cormon for three or four months, but I found it less useful than I had expected....Now I've stopped...and have been working on my own. You can imagine how much more myself I've felt since."[1]

Nonetheless, it was at Cormon's that Van Gogh discovered both Toulouse-Lautrec and an important new friend: the young Emile Bernard, whose parents lived in the suburb of Asnières, on the avenue de la Lauzière, a major artery running parallel to the railway line.[2] Bernard invited Van Gogh to spend some time there and helped to familiarize him with the countryside surrounding Paris. Like the Impressionists, Van Gogh enjoyed working on the banks of the Seine. In the course of the spring and summer of 1887 he painted several landscapes showing the Pont d'Asnières, the Restaurant de la Grève, and the factories at Asnières. This painting, which dates from May 1887, was one of several he did on the grounds of the château of Marquis René-Louis Le Voyer d'Argenson. These grounds had just been restored by Thion de La Chaume, only to be divided, approximately ten years later, to make way for the rue du Château. The importance of Asnières to Van Gogh has been emphasized by Pierre Leprochon, who has stated that it "occupies a place in Van Gogh's topography almost equal to Nuenen, Arles, or Auvers."[2]

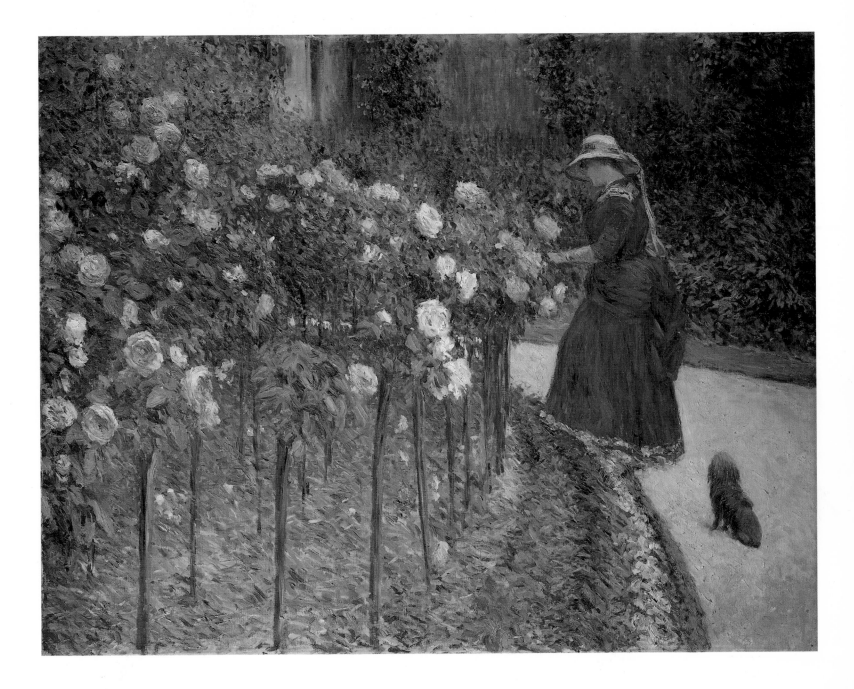

No. 87. Gustave Caillebotte
Roses, Garden at Petit-Gennevilliers, c. 1886

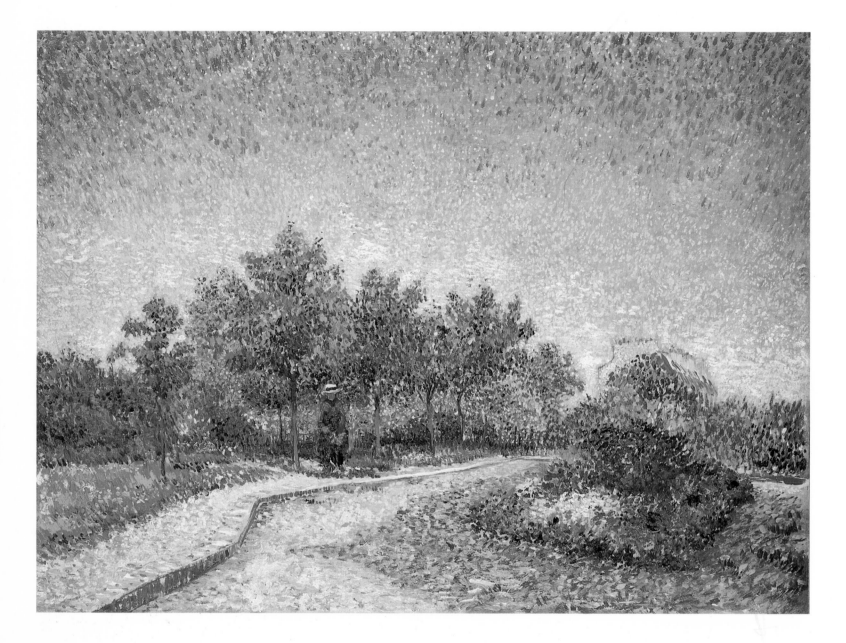

No. 88. Vincent van Gogh
CORNER IN VOYER-D'ARGENSON PARK AT ASNIÈRES, 1887

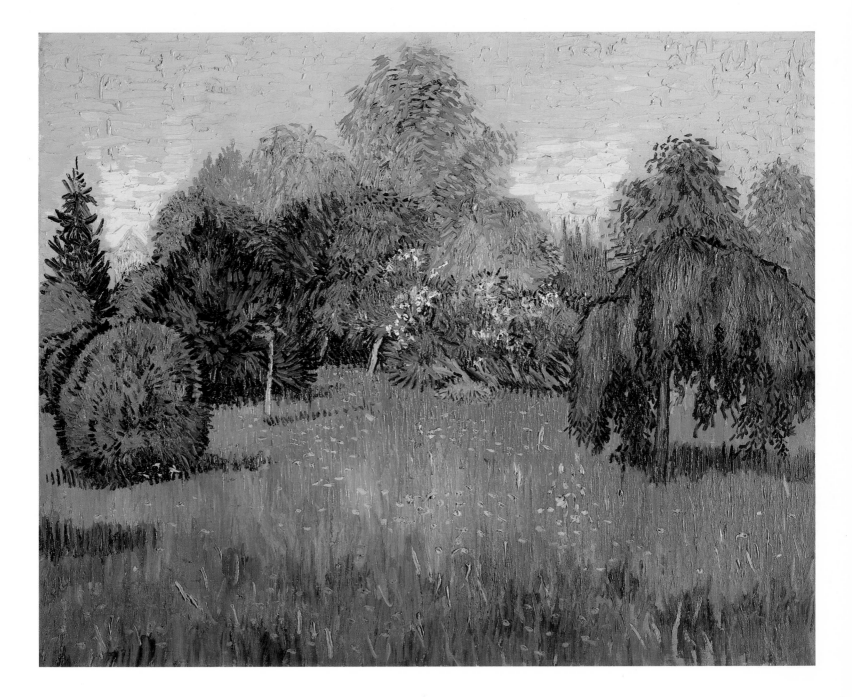

No. 89. Vincent van Gogh
THE GARDEN OF THE POETS, 1888

Both the subject and technique of this painting show the Impressionist influence on the Asnières canvases. Van Gogh was aware of the sudden change in style his work was undergoing. As he wrote to his sister, "This summer, painting landscapes at Asnières, I saw more color than before."[3]

NOTES
1. Van Gogh, 1960, letter 459a A.
2. Leprochon, 1972, pp. 353–354.
3. Van Gogh, 1960, letter W1N.

89. Vincent van Gogh

THE GARDEN OF THE POETS
(LE JARDIN DES POÈTES), 1888

On February 21, 1888, Van Gogh was at Arles, where his painting would follow the rhythm of the seasons (see below, III/9). By May he had rented the house (at 2, Place Lamartine) which became the site of several of his most famous works, of which this is one.

The first mention of this garden occurs in the artist's letters of July 1888. It was then, too, that he sent his brother, Theo, a sketch very similar to that of this canvas. "Here is a new motif," he wrote in the accompanying letter,

> a piece of the garden with ball-like bushes and a weeping tree, and some clusters of oleanders in the background. And the newly mown grass with wisps of hay drying in the sun with a small patch of blue sky above it all.[1]

In August he did several studies of gardens in bloom, but wrote to his sister:

> I have another garden without flowers, more of a pasture, actually, that has just been mown, very green, with gray hay set out in long rows. A weeping ash, several cedars and cypresses, the cedars ball-like, yellow, the cypresses tall and straight, green tinged with blue. Behind them an oleander and a small patch of blue-green sky. The shadows shed by the bushes on the grass are blue.[2]

Van Gogh worked particularly hard in his garden during the months of September and October. On September 17 he described a canvas to Theo:

> ...a piece of the garden with a weeping tree, grass, cedar bushes shaped into balls, a bush of oleander...the same piece of garden

you received a sketch of in my last letter. But much larger, with a lemony sky above it all, and the colors now have the richness and intensity of autumn.[3]

He likened the site to "the gardens of Monet."[4] In another letter he explained what he meant by "the garden of the poets":

> The garden has an odd feeling about it. You could easily picture Renaissance poets—Dante, Petrarch, Boccaccio—tripping through the bushes and succulent grass. True, I've removed some trees, but the ones I've kept in the composition are just as they are in reality. Except that it has too many out-of-character bushes. The reason I'm painting the same place for the third time is that I want to find the real, most basic character of the place. And the place is right here, in front of my house. This piece of garden is a good example of what I've been telling you about: if you want to capture the real character of things here, you've got to watch them and paint them for a long time.[5]

The Garden of the Poets is therefore part of a whole, and a letter Van Gogh wrote to Gauguin makes it clear how much it meant to him:

> For the room where you will be sleeping I've made a special decoration, the garden of a poet....The banal public garden includes plants and bushes that conjure up landscapes where you might well find Botticelli, Giotto, Petrarch, Dante and Boccaccio. I've tried to sort out in it what is essential to the fundamental character of the countryside. And I hope I've painted the garden in such a way as to make people think of both Petrarch, the old local poet (or, rather, poet of Avignon), and the new local poet—Paul Gauguin.[6]

Much can be learned about Van Gogh's artistic approach from his letters. They allow us to follow his day-to-day labor, the changes he made in his motifs (Van Gogh would have none of Monet's spontaneity), and the symbolic content he injected into the "poet's garden" pictures. John House has stressed the debt Van Gogh owed to Adolphe Monticelli in these canvases, which moved beyond his previous Impressionist phase.[7] Yet while Van Gogh continued to paint from nature, Gauguin preferred to plot the composition of *In the Garden at Arles* (1888; The Art Institute of Chicago), painted while visiting Van Gogh, in his

imagination. Thus his work was a response to his host's, but in a different vein.

NOTES
1. Van Gogh, 1960, letter 508 F.
2. Ibid., letter W5N.
3. Ibid., letter 537 F.
4. Ibid., letter 539 F.
5. Ibid., letter 541 F.
6. Ibid., letter 553a F.
7. Royal Academy of Arts, 1979, no. 100.

90. Vincent van Gogh

IRISES
(LES IRIS), 1889

After repeated personal crises and at his own request, Van Gogh entered an asylum on May 3, 1889. Northeast of Arles in the region of the Petite Crau, the asylum, Saint-Rémy-de-Provence, formed part of the thirteenth-century monastery of Saint-Paul-de-Mausole, which had maintained its Catholic church and cloister. Van Gogh spent an entire year there.

Early in May, almost immediately after his arrival, he announced to Theo, "I have two other [pictures] in progress—some purple iris and a lilac bush, two motifs I've taken from the garden."[1] At first he did not dare to leave the monastery grounds and found motifs at his window, in the corridors of the hospital, or in the garden itself. As he wrote to Theo on May 25,

> Since I've been here, the desolate garden of large pines, under which a mixture of grass and various weeds grows tall and unkempt, has provided me with enough to work at, and I have not yet strayed beyond it. But the scenery of Saint-Rémy is very beautiful, and I shall probably make my way into it by easy stages.[2]

From Paris Theo passed on to Vincent whatever he heard about the opening of the 1889 "Salon des Indépendants," where both *Irises* and *Starry Night* (1889; Museum of Modern Art, New York) were on display. "The exhibition by the Indépendants is over, and I have your *Iris* back," he wrote, singling out the canvas he particularly admired. "It's one of your good things. I find you're at your best when you do real things like that....The form is so well chosen, the whole canvas full of color."[3]

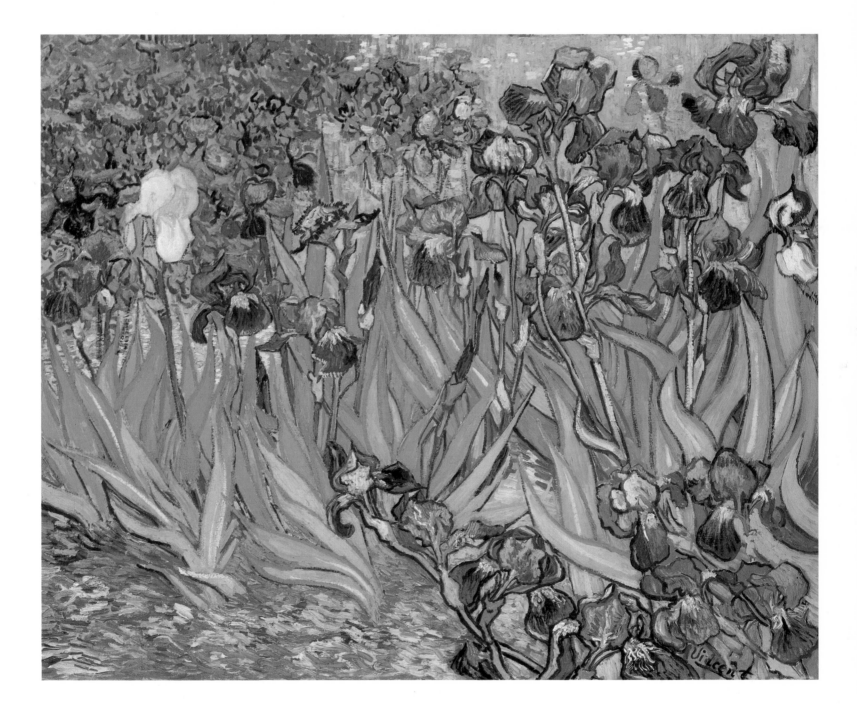

No. 90. Vincent van Gogh
IRISES, 1889

A month before entering Saint-Rémy, at the very end of his Arles period, Van Gogh had done a painting called *The Iris* (The National Gallery of Canada, Ottawa). Irises made a final appearance in his work when, shortly before leaving Saint-Rémy, he painted them lovingly in "two still lifes: large bouquets of purple iris"; one of them shows

> some against a pink background, where the effect is gentle and harmonious because of the combination of greens, pinks, and purples [The Metropolitan Museum of Art, New York], while in the other [Rijksmuseum Vincent Van Gogh, Amsterdam] the purple bouquet (a purple bordering on carmine and pure Prussian blue), which stands out against a striking lemon yellow background.... illustrates the effect of awful, ill-sorted complementarities elated by their opposition.[4]

Interestingly enough, *Irises* belonged to Octave Mirbeau, a great flower-lover, before becoming part of the famous collections of Auguste Pellerin and Jacques Doucet.

NOTES
1. Van Gogh, 1960, letter 591.
2. Ibid., letter 592 F.
3. Ibid., letter from Theo to Vincent.
4. Ibid., letter 633 F.

91–93. Claude Monet

THE GARDEN AT GIVERNY
(*LE JARDIN À GIVERNY*), 1900
MONET'S GARDEN AT GIVERNY
(*LE JARDIN DE MONET À GIVERNY*), 1900
JAPANESE BRIDGE AT GIVERNY
(*LE PONT JAPONAIS, GIVERNY*), c. 1900

> Monsieur Monet, may neither winter
> Nor summer delude his vision,
> Lives, painting, at Giverny,
> Located near Vernon in Eure.
>
> —Mallarmé

When Monet wrote to Caillebotte from Giverny inviting the latter to see his irises (no. 87), he undoubtedly had in mind the blue-mauve variety planted close together along the narrow paths leading to his green-shuttered, pink house.[1] (The nasturtia in various oranges had not yet taken over the main pathway.) A letter from Monet sent to the dealer Maurice Joyant in 1896 confirms not only the artist's taste for irises, but also the influence of the Orient, in the form of his Japanese print collection, on the garden at Giverny: "I thank you for having thought of me for the Hokusai flowers," he wrote. "But you do not mention poppies, and they are most important, since I already have irises and chrysanthemums."[2]

Monet moved to the village of Giverny, on the Ile-de-France–Normandy border, in April 1883. "I am in ecstasy," he wrote to the critic Duret a month later. "Giverny is a splendid region for me."[3] During every absence his letters showed the attachment he felt for the place. At last, in the autumn of 1890, "certain never to find comparable living arrangements or so beautiful a region" (as he wrote to Durand-Ruel on October 27[4]), Monet decided to purchase the house he formerly had rented. Immediately he redoubled his efforts to make over the garden that came with it.

Mirbeau's description of this garden, published in the March 7, 1891, issue of *L'Art dans les deux mondes,* closely corresponds to the vision offered by Monet's paintings of it:

> A house roughcast in pink mortar at the far end of a garden always dazzling with flowers. It is spring. The stock is giving off its final fragrance; the peonies—the divine peonies—have faded; gone are the hyacinths. Now the nasturtia and eschscholtzias have begun to bloom, the former displaying their young, bronze verdure, the latter their delightful, tart green linear leaves. And in the broad beds they border, against the background of a blossoming orchard, the iris lift their strange, shapely petals trimmed in white, mauve, lilac, yellow, and blue and stippled with dots and dabs of brown and crimson, their elaborate undersides conjuring up mysterious analogies, perverse, seductive dreams like the dreams hovering over provocative orchids.[5]

Fifty or so years later, another famous Giverny resident, the poet Louis Aragon, described Monet's garden from a different point of view in his autobiographical novel *Aurélien* (1944):

> When [Bérénice] reached the beautiful garden cut in two by the road, she stopped and looked to her left at the bridge, the water, the airy trees, the delicate buds, the water plants. Then she glanced toward the house belonging to the tall old man she had often seen from a distance and who was the talk of the region....She saw the blue flowers. The earth freshly turned beneath them. Blue flowers around about. The small path leading to the house. The bright lawn. And more blue flowers....The light was so lovely on the flowers....Blue flowers would give way to pink. Pink flowers to white. And each time it was as if the garden had suddenly been repainted....Bérénice began to dream. To forget her troubles. To hum a song she'd never heard. Amidst the blue flowers. The finely pebbled paths. Face to face with a house so like the houses in her dreams....But it was not a dream. Aurélien was there, in the garden of Claude Monet, looking at her, with tears in his eyes. The flowers were blue, indisputably blue.[6]

In 1893 Monet undertook to put in a second garden, a water garden, at Giverny. Within this garden was a wooden footbridge, yet another testament to the artist's interest in Japan. Its design appears to have been inspired by the prints of Hokusai and Hiroshige.

NOTES
1. Berhaut, 1978, p. 248.
2. Wildenstein, 1974–79, vol. III, p. 289.
3. Ibid., p. 259.
4. Ibid.
5. Mirbeau, 1891, pp. 183–185.
6. Aragon, 1944, chap. 63.

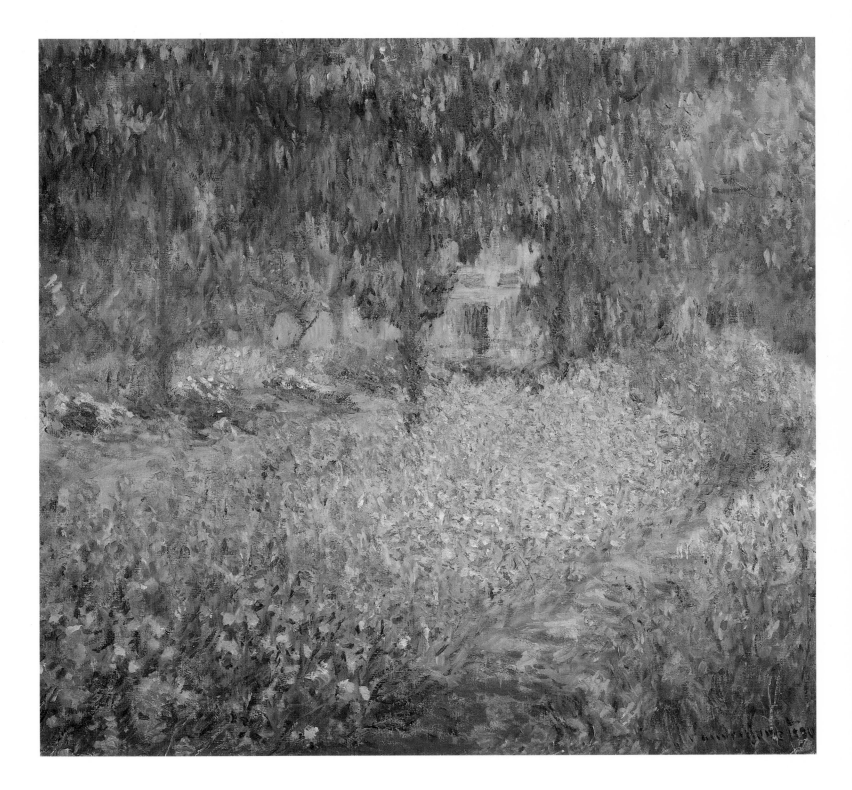

No. 91. Claude Monet
THE GARDEN AT GIVERNY, 1900

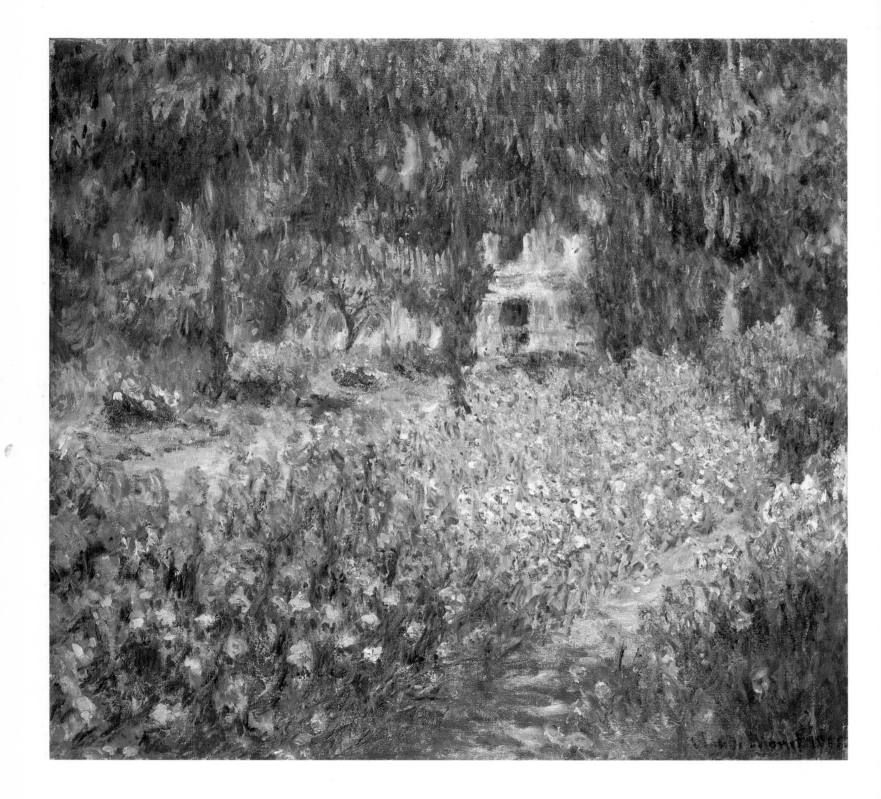

No. 92. Claude Monet
Monet's Garden at Giverny, 1900

A DAY IN THE COUNTRY

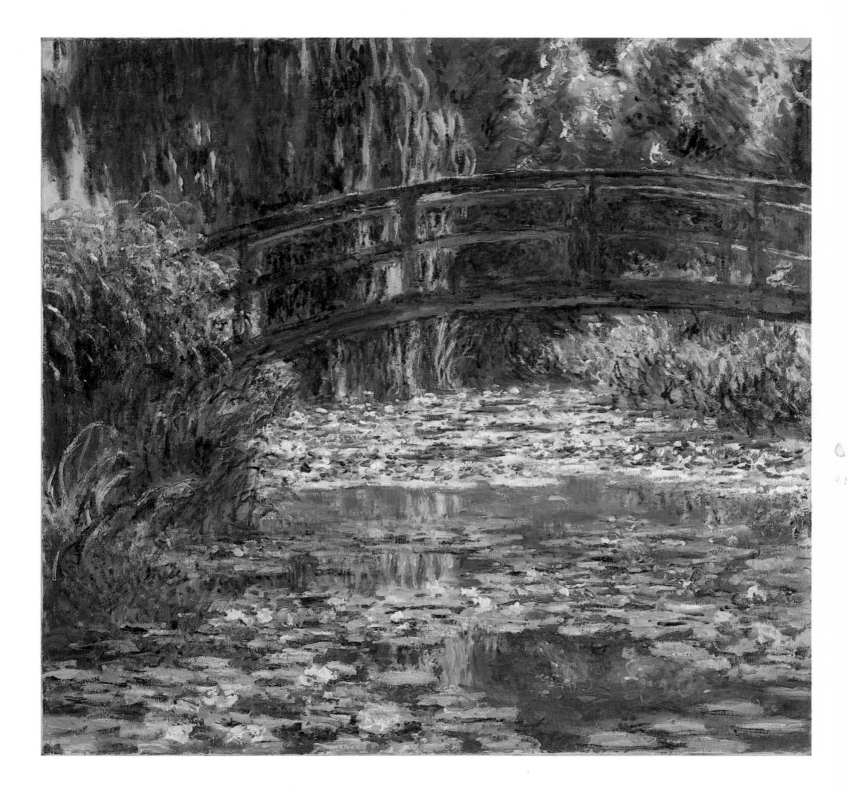

No. 93. Claude Monet
Japanese Bridge at Giverny, c. 1900

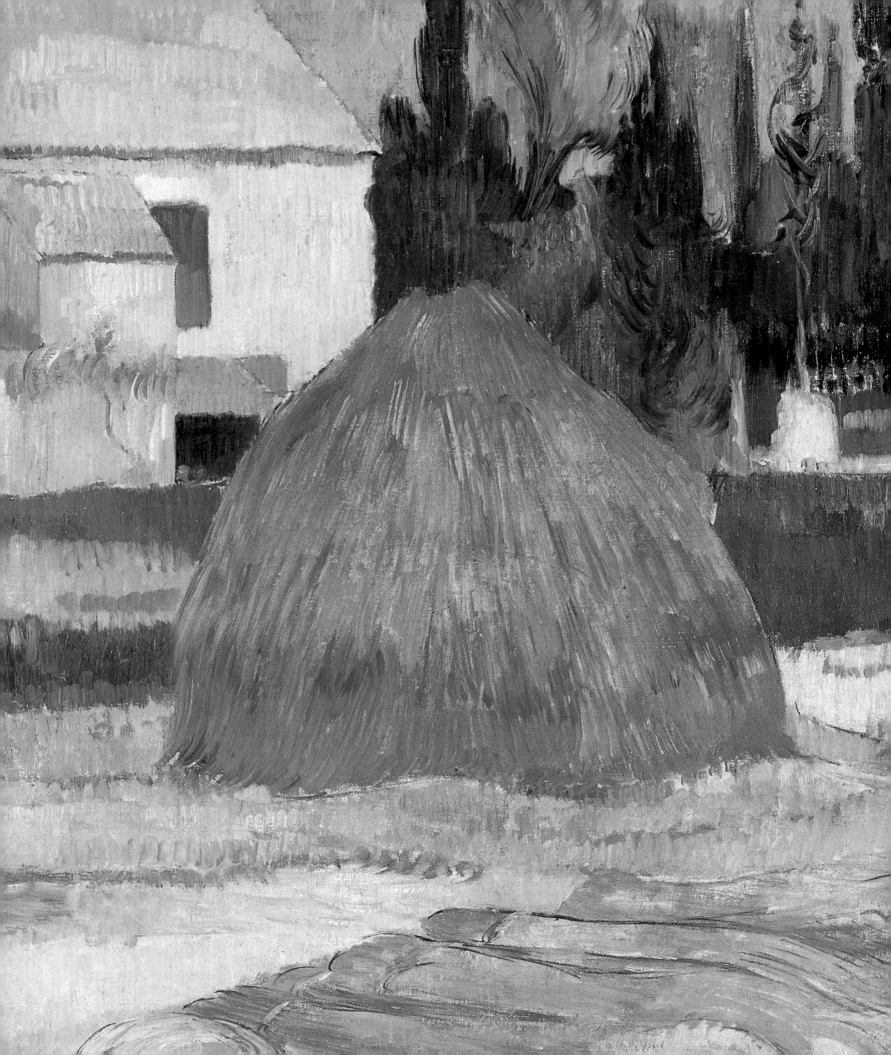

III/7

The Fields of France

I T IS SCARCELY NOVEL to say that France is—almost above all else—an agricultural nation. The fabulous extent of her fields, orchards, and cultivated forests has been celebrated in countless pages of prose and poetry, and her ability to revel in an abundance of food has often been discussed in writings about her, particularly since the famines that led to the French Revolution. The French countryside has been contrasted by French writers time after time with the smaller, more irregular, and less fertile territories of Italy, Germany, and England. It has been claimed that France is the heartland of all Europe, the largest, most diverse, and agriculturally most independent nation on the Continent. Her wines, cheeses, breads, sausages, vegetables, and fruits are fabled.

As if in silent support of such notions, the French reveled in images of their nation's fields during the nineteenth century. Agricultural abundance was celebrated in literally thousands of landscape paintings, prints, and photographs. The Impressionists were as assiduous as other artists in catering to this rich—and saleable—notion of *la belle France*. The agricultural landscapes they produced are fascinating chiefly because they are not topographical. It scarcely matters in looking at a field of grain painted by Monet, Sisley, or Pissarro to know that it was painted outside Argenteuil, Saint-Mammes, or Osny. What is important is that one enjoys the beauty of the *fields*, not the beauty of a particular field. In this way the agricultural images of the Impressionists have a greater mythic quality than do their images of villages, towns, or suburbs that are topographically titled.

The primary message of agricultural images is simple: the continuing fecundity of the earth. Landscapes with blooming fruit trees or wheat harvests speak clearly to any viewer about the habitual richness of nature as well

Fig. 54. *Modern Agriculture* ("What did you do, neighbor, to have such beautiful wheat?" "You only have to do as I do, friend: follow the advice of the *one-sou* journal, *Modern Agriculture*."). Illustration from *Supplement illustré du Petit Journal,* April 1897. Bibliothèque Nationale, Oa22 (731). Photo: Bibliothèque Nationale.

as man's civilizing influence over her. A painting of a wheat harvest celebrates the control or ordering of nature by men in no less important a way than an industrial image or a painting of suburban leisure addresses itself to man's dominance over other aspects of nature: resources, climate, space. Agriculture, like industry, was part of French nationalist rhetoric and its associated imagery throughout the 1800s, and each major world exposition—whether in London, Paris, Philadelphia, or Chicago—devoted as much space and attention to agricultural as to industrial progress. In fact, it became fashionable to refer to agriculture as "agricultural industry" during this period.[1]

The positivist concept of nature during the nineteenth century is important to understand before proceeding to an analysis of agricultural imagery in Impressionist paintings. This concept is perhaps most clearly embodied in the popular French "scientific" journal founded in 1874 by Gustav Tissandier and called simply *La Nature.* Whereas most twentieth-century Americans understand nature to be the animated world untouched by man, the nineteenth-century positivist concept of nature—a concept accepted implicitly by most Frenchmen at the time of the Impressionists—considered man and his works to be part of nature. This view included both agriculture and industry in *la nature,* rather than treating them as man's attempts to order and control the wilds of "true" nature. Reading the texts written for *La Nature* and looking at its numerous illustrations is fascinating because so much of what was included has little to do with our own notions of wild or untamed nature as expressed in the wilderness areas and lists of endangered species of flora and fauna that dominate our present-day consciousness. In *La Nature* there are both articles about and plates illustrating machines, factories, microscopes, and tools in addition to plants, animals, and landscapes.

In fact, the vast majority of books and articles written about agriculture in France during the time of the Impressionists was about the mechanization and modernization of agricultural practices (fig. 54). Impelled forward by the great advances made in the industrialization of American agriculture, the French pushed to alter the traditional practices of peasants, farmers, and large landowners in their own country. Books by hundreds of diverse authors as well as local and national periodicals gave out information about irrigation, chemical fertilizers, hybrid plants, rotating crop management, and, of course, mechanized planting and harvesting. The plates in these volumes look like illustrations in scientific texts, alternating as they do between graphs or diagrams and reproductions of new machines (fig. 55). Rarely, if ever, does one see a field, an orchard, or a garden—and almost never does one see a human being—in these illustrations, despite the fact that they describe a human activity which had been the work of the hands and bodies of men for centuries.

This "agricultural revolution" was perhaps as important to the French as the Industrial Revolution. It may have been more important. Painfully aware that France had been surpassed by England, Germany, and—even more embarrassingly—the United States as an industrial power, French officials gave a great deal of their attention not only to keeping abreast of, but to surpassing the rest of the world in, the quality and per capita quantity of their country's agricultural production. Both nineteenth- and twentieth-century readers of French novels are familiar with the satires of the "scientific farmer" to be found in the writings of Flaubert (*Bouvert et Pecouchet* [1881]) and Zola *(L'Oeuvre* and *La Terre),* and these unflattering portraits were joined by hundreds of earnest monographs written by "modern" farm-

Fig. 55. *Swinging Steam Plow by Delahaye-Bajac*. Illustration from *La Grande Encyclopédie*, Paris, 1886–1902. Bibliothèque Nationale, Md43.

ers and agricultural theorists for the edification of their less fortunate colleagues. Indeed, an illustration from the April 1897 edition of the mass-circulation *Le Petit Journal* (fig. 54) reveals the extent of the popular dichotomy between modern and traditional agriculture.

Yet the tendency toward modernization was not quite so successful in France as its promoters either hoped or claimed. In actuality French farmers had difficulty in acquiring large enough parcels of land to put mechanized agricultural practices to work, and the fact that the literacy rate for rural workers and farmers was not very high rendered the audience for much of this expensively illustrated prose too small for it to be truly effective. However—and in spite of the suspicion, ignorance, and plain stubbornness that fought against these new tendencies—French agriculture was alive with the spirit of modernism, and statistics indicate clearly that the number of mechanized harvesting and threshing machines as well as tractors and advanced plows increased steadily as the nineteenth century progressed.[2]

It is against this background of fervent modernism that one must consider the agricultural landscapes of the Impressionists. Although in 1876 Pissarro painted two rather timid farmyard scenes centered on a mechanical harvesting machine *(machine à battre)* (fig. 56) used on the large farm in Brittany owned by his friend Ludovic Piette,[3] there are few, if any, machines in the numerous Impressionist landscapes representing the fields of France. It is almost as if Monet had painted railroad stations and railroad bridges, but had omitted the trains that passed through them. This exclusion of modern agricultural equipment is evident as well in the Impressionist agricultural landscapes in which tilling or plowing is present. Never, in all the paintings with plows by Pissarro, is there a single one of recent invention, and never are they being pulled by anything other than horses or pushed by anyone other than men. This fact must be evaluated in light of the fact that more plows were invented, patented, and improved in the nineteenth century than could adequately be described in a single volume.[4] The Impressionists pictorialized agriculture in its pre-modern, or traditional, forms, and it seems from their paintings, drawings, and prints that they either ignored, or were utterly ignorant of, the considerable advances in this area evident in the popular press and official statistics of their time.[5]

Fig. 56. Hare, *Steam Harvesting Machine, Made by Ransomes and Sims, with Patented Apparatus for Cutting and Stacking Straw.* Illustration from *La Grande Encyclopédie,* Paris, 1886–1902.

Machine à battre à vapeur, système RANSOMES et SIMS, avec ses appareils brevetés pour broyer et emmeuler la paille.

This lack of interest in agricultural modernization on the part of the Impressionists is perhaps most puzzling for Pissarro. As both a painter of factories and reader of socialist texts which celebrated what came to be known as the agro-industrial revolution, Pissarro seems to have been more interested than his colleagues in an integration of the then-separate worlds of urban and agricultural modernism. Yet his paintings do not address themselves clearly to such ideas. Among the handful of truly integrated images in his oeuvre are two slight preparatory drawings, in the Ashmolean Museum of Art and Archaeology, Oxford, and the Musée du Louvre, Paris, respectively, for *The Pea Harvesters* (1887; Location unknown). In the Ashmolean sheet a group of harvesters works by hand in a field immediately in front of a factory. Pissarro has juxtaposed industry—a smokestack indicates the presence of machinery—and the hand labor of agricultural workers, as if accepting implicitly the ideology expressed in the communist villages of Robert Owen (whose work he had read), in which all inhabitants engaged in both agriculture and industry. However, the initial visual contrast must have been too sharp for him because—in the final gouache for which this drawing was made—he replaced the factory with a simple house, thereby giving the composition an unproblematically rural, even elegiac, quality. The agro-industrial landscape, advocated most passionately by the great anarchist-theorist Peter Kropotkin (with whose work Pissarro also was familiar), is implied, but never clearly expressed, in Impressionist landscape painting.[6]

A persistent dichotomy existed in nineteenth-century writings about agriculture between *agriculture* and *horticulture* (or *jardinage,* gardening). For most writers about rural life and agricultural techniques the word *agriculture* applied to large-scale field cultivation which necessitated the work of machines or large numbers of agricultural laborers. *Horticulture* applied less to ornamental gardening (see above, III/6) than to *jardins potagers,* or truck gardens, worked by one, two, or a family of laborers. This latter form of intensive polyculture grew up around the large cities of Europe and was the dominant form of agriculture in the environs of Paris (no. 74). *Horticulture* supplied the majority of produce for the Parisian market.[7] The most distinctive painter of French horticultural activity was Pissarro; his landscapes of the tiny polyculture fields around Pontoise have already been discussed (see above, III/5).

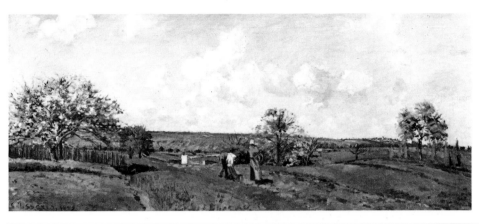

Figs. 57–60. Pissarro, *The Four Seasons: Spring, Summer, Autumn, Winter*, 1872–73. Oil on canvas. Each 55.3 x 130.2 cm. Private Collection, Spain. Photos: Robert Schmit, Paris.

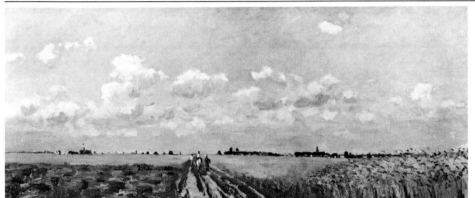

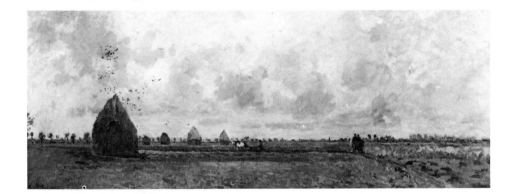

When one looks at *The Four Seasons,* painted by Pissarro in 1872–73 for the Parisian banker Achille Arosa—one confronts a truly mythic, agricultural landscape. *Spring* (fig. 57) represents a landscape of planted and fallow fields in the midst of which fruit trees bloom in profusion. The eye wanders easily through this spacious, open panorama of the richness of the earth as it begins to awaken. *Summer* and *Autumn* (figs. 58–59) are dominated by the vast wheat fields of the Vexin. In *Summer* the ripe heads of the wheat—heavy and ready for harvest—sway in the wind to the right of a roadway that moves back into a space so deep that it makes an American viewer think more of the landscape of Kansas or Nebraska than of France. *Autumn* shows us the same landscape after a rich, collective harvest. The haystacks are so numerous that they appear to go on forever, and the land is being plowed—primitively, of course—in preparation for the planting of winter wheat. Only in *Winter* (fig. 60) does one descend into a valley near Pontoise, where the houses of men huddle together against the cold.

This series of paintings—surely among the greatest produced by Pissarro during the 1870s—conveys a majesterial, nationalist belief in the richness of France, a belief which was common among the Impressionists, in fact (see above, II). Although one can explain the particularly grand nature of these paintings by suggesting that their patron may have dictated their subjects, one must remember that Pissarro had wanted to fight for France during the Franco-Prussian War and that, while living in self-imposed exile in England just one year before they were begun, he longed desperately to return to France. Although born outside that country, never a French citizen, and a frequent critic of her governments, Pissarro's belief in France was unwavering, and his paintings of her rural landscapes—whether these of 1872–73 or later paintings such as the great *Harvest* (Location unknown) painted for the Impressionist exhibition of 1880—make it clear that he celebrated her through images of wheat fields and orchards.

While Pissarro's colleagues Monet, Renoir, and Sisley joined in this pictorial festival of the fields of France, the artist who devoted his energies most fervently to their poetry was Monet. His paintings of the fields and fruit trees surrounding Argenteuil have been much discussed.[8] It was not, however, until his arrival in Giverny (nos. 91–93) that he gave himself over to the pictorialization of the grain fields bordered by trees that surrounded that village. His paintings of these fields were made in all seasons, even in the dead of winter, and culminated in his first series of interrelated paintings representing grainstacks (nos. 104–112). They are surely the most mythic agricultural images in the history of art. In them the sheltering form of the haystack has become a symbol for man's triumph over time. It stands against the frigidness of winter days, irradiating a gentle warmth as the seasons change around it.

In this connection one further point is relevant to this discussion, and that revolves around the temporal structure of the landscape. Virtually every book written about landscape painting in nineteenth-century France divides landscape "time" into eight parts: the four seasons and their "equivalents," the four times of the day: morning, afternoon, evening, and night. These formed what the great landscape theorist Valenciennes (see above, III/1) called "the varied and regular moments that form the chain of our lives."[9] For most landscape painters of the period the truest and most convenient expression of the seasonal changes in nature was agriculture, and the cycle of planting, blooming, tilling, and harvest became emblematic of natural or seasonal time. The Impressionists were well aware of this tradition—its most potent

A DAY IN THE COUNTRY

French example was Poussin's *Four Seasons* (1660–64; Musée du Louvre, Paris), which they all must have known.

Thus the Impressionists' approach to the pictorialization of the agricultural landscape had its roots in both the technological and the theoretical past. Landscapes which confronted modernity in the agricultural arena head-on, which integrated factory and field, came to be the province of the painters whom we call the Post-Impressionists as a result of their greater political consciousness. There are several compositions by Seurat, Luce, Van Gogh, and others in which a foreground of vast grain fields ends in a group of factories and working-class housing. Although they ignored them, actual landscapes of this type were common in the regions painted by the Impressionists; Pissarro could easily have painted such scenes in the region around Saint-Ouen-l'Aumône, just across the Oise from Pontoise, and Monet, who often placed factories, pleasure boats, and country houses in the same landscapes, could have painted his factories from the fields just as he painted them from the river. The important exceptions to this rule—Monet's *Path Through The Vineyard* (1872; Jack Chrysler, New York) is one—are rare. The Impressionists considered the fields most often in isolation from the modern world—whether from factories or from advanced machinery—and chose to celebrate the richness of France in generalized, but traditional, terms.

—R. B.

NOTES

1. See particularly Durand-Claye, 1880.
2. See Noilhan, 1965.
3. Pissarro and Venturi 267–268.
4. See Grandroinnet, 1854, as well as later writing by the same author in his widely read journal *Le Génie rural,* published between 1858 and 1875.
5. See Noilhan, 1965.
6. See Kropotkin, 1906.
7. See Barrau, 1883.
8. Most recently in Tucker, 1982.
9. Valenciennes, 1800, p. 427.

94. Claude Monet

LANDSCAPE, VIEW OF THE ARGENTEUIL PLAIN
(PAYSAGE, VUE DE LA PLAINE À ARGENTEUIL), 1872

This is among Monet's earliest—and most unusual—views of the suburban town of Argenteuil; generally he preferred her river-scape to her landscape (see above, III/4). As an agricultural center Argenteuil was better known for its cultivation of that most luxurious of vegetables, asparagus, than for its grain. Yet immense grain fields could be found near its borders.

Monet chose to climb a hill just north of the town on a path leading to the village of Sannois when he painted this landscape. The view that he found was wonderfully spacious. The warmth of a summer day seems to spread evenly over this picture, illuminating it with a hazy indifference. The antecedents for such scenes are numerous; one thinks immediately of the famous views of Haarlam painted in the second half of the seventeenth century by Jacob van Ruisdael and of the numerous European topographical prints and drawings from the seventeenth through the nineteenth centuries in which a city is viewed from the vantage point of a rich agricultural panorama. The notions conveyed by all these general sources is that urban civilization exists as an integral part of its landscape, and that the richness of one is dependent upon the other. Monet, who had barely become interested in exploring the poetry of the fields before doing this painting, seemed moved by the same optimism and nationalism that motivated Pissarro to paint *The Four Seasons* in the same year (see above, III/7). Like the latter he had returned only recently to France after an exile in England and Holland during the Franco-Prussian War and the Commune.

This expansive image of an almost lazy abundance is viewed from above as if to encourage our easy descent into, and participation in, its riches. Monet's treatment recalls an eloquent description by Couture of a hypothetical landscape with a great city viewed from the elevated perspective of a nearby hill. His words, published in his famous book on landscape painting (1869), are worthy of quotation:

Space allows me to embrace all without trouble....Nature, you are immense and full of variety. You show me all your treasures. Indeed, they deploy themselves in front of my eyes, strangely enough, like a gallery. That immense museum of air and space seems to contain all the works of our masters.[1]

NOTE
1. Couture, 1869, pp. 18–19.

95. Camille Pissarro

HARVEST LANDSCAPE AT PONTOISE
(PAYSAGE, LA MOISSON, PONTOISE), 1873

Like *The Red House* (no. 62), *Harvest Landscape at Pontoise* was purchased from Pissarro by Jean-Baptiste Faure and is therefore among the dozen or so major paintings from Pissarro's greatest period, the early years of the 1870s, to have been recognized early on by an important connoisseur (see below, IV). In painting it Pissarro walked from l'Ermitage to the hamlet just north of Pontoise known as Les Patis and climbed the gently sloping hillside leading to the village of Osny. When he reached a point about halfway up the hill, he turned around and looked down into the cool valley formed by the rivulet known as the Viosne. Scattered along this small tributary of the Oise River were dozens of water-powered grain mills, many of which had been in existence since the Middle Ages. Pissarro had painted this landscape from nearly the same spot in 1868, and that painting, known as *Landscape in Les Patis, Pontoise* (David Rockefeller Collection, New York), is among his great works of the late 1860s.

In returning to the spot of an earlier "conquest," Pissarro came armed with new knowledge and a new technique. Whereas the earlier painting was constructed with what seemed almost to be slabs of paint, the later one is subtler and more detailed in its recording of nature. The fields vibrate with life, and the distant landscape seems almost to shift with a delicate, uniform rhythm. Yet the major changes made by Pissarro in his conception of a landscape had to do with composition. The earlier painting shows his almost diagrammatical concern with the juxtaposition of spatial planes—foreground, middle ground, and back-ground—each of which was given a rectangular area of the picture surface. In the later painting Pissarro dispensed with a strong foreground plane and divided it by a series of gently curved, rather than straight, lines. Pissarro's landscapes had become "easier" and more visually unified under the influence of Monet and Sisley.

It is perhaps worth pointing out that, for all its traditional rural charm—its lack, that is, of any modern buildings—this landscape relates almost directly to contemporary guidebook literature. Joanne's *Les Environs de Paris illustrés*—the updated edition of which appeared in 1872, the year before this picture was painted—recommended that the visitor to Pontoise take one particularly long walk from the train station, a walk along which both versions of this landscape were painted. Although Joanne's prose has a kind of thudding, guidebook simplicity, it is perhaps worth quoting:

A visitor can also climb the valley of the Viosne up to Osny. It's a walk of about two hours (coming and going)....Osny, with a population of 467, is charmingly situated in the valley of the Viosne along which turn several water mills. From Osny, one returns to Pontoise by the right bank of the Viosne.[1]

Pissarro's painting, of course, was made from the right bank of the Viosne, looking down at all the mills along the small river. He had already painted one of these mills in 1868 (*The Patis Mill Near Pontoise* [Location unknown]).

NOTE
1. A. Joanne, 1881, pp. 232–233.

96. Camille Pissarro

HOARFROST
(GELÉE BLANCHE), 1873

Exhibited in the first Impressionist exhibition of 1874, this picture might be said to embody Pissarro's entire aesthetic. Shunning as it does any hint of modernity—there are neither promenaders on vacation nor trains nor factories to be seen—this landscape is intensely rural. There are no buildings to give us a sense of place or history. In fact, this painting depicts the old road to the village of Ennery, a road rarely painted by Pissarro, but clearly evident on nine-

A DAY IN THE COUNTRY

No. 94. Claude Monet
LANDSCAPE, VIEW OF THE ARGENTEUIL PLAIN, 1872

No. 95. Camille Pissarro
HARVEST LANDSCAPE AT PONTOISE, 1873
(detail on pp. 24-25)

A DAY IN THE COUNTRY

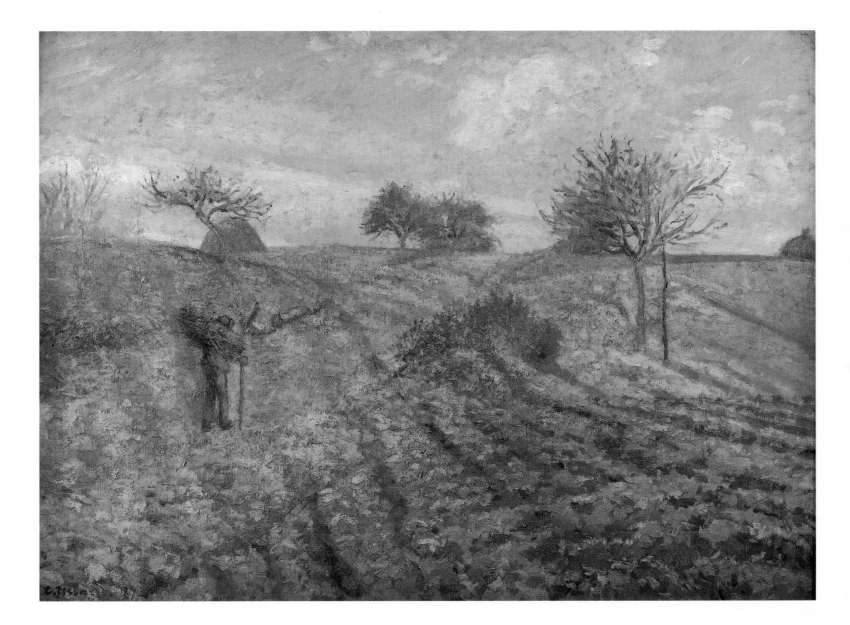

No. 96. Camille Pissarro
HOARFROST, 1873

teenth-century cadastral maps of Pontoise and its environs. The road had been supplanted by a newer route (no. 65) and had dwindled in significance until it was little more than a path when Pissarro chose to paint it in 1873. The time of year was autumn or early winter, and one can see the top of a haystack from one of the large grain fields near Ennery peeking over the hill just above the figure of a worker.

The landscape is not only carefully composed, but full of information. The fields have been carefully plowed, and the remains of the last harvest are decomposing to enrich the earth for the next planting. The worker plods along the path, a bundle of faggots on his back. How different he is from the faggot carriers in the winter landscape of Millet's *Four Seasons* (1868–74; National Museum of Wales, Cardiff) painted about the same time, how much less burdened than they and how much more a part of the landscape!

We know from Pissarro's title that it is early morning—hoarfrost disappears shortly after the first appearance of the sun—and that therefore the worker is going to the fields, over which are cast the shadows of a row of poplars just behind the painter and outside our field of vision. Pissarro was criticized for his inclusion of shadows from forms outside the picture itself, and his decision to suggest a world beyond the frame must be seen as part of the developing naturalist aesthetic of the 1870s. These poplars are a rural equivalent of the foot of the ballet dancer pushing into the frame from the right in Degas' *Dancers Rehearsing with a Violinist* (1878–79; Frick Collection, New York) or the reflections in the mirrors of Manet's and Caillebotte's café scenes. A golden light warms Pissarro's picture, lending to it an optimism at odds with its wintry subject: the hoarfrost will disappear in a moment, Pissarro suggests, and spring will come soon.

This painting, like nos. 62 and 95, was in the collection of the opera singer Faure.

97. Camille Pissarro

HARVEST AT MONTFOUCAULT
(*LA MOISSON À MONTFOUCAULT*), 1876

This is surely among Pissarro's most elemental agricultural landscapes. Painted at the farm, called Montfoucault, of his friend Piette, the picture represents an agricultural laborer, finished with her task and facing the viewer as if somehow to present us with the results of her work. Hand-formed bales of hay have been stacked neatly to create a haystack, and this generous mound has been juxtaposed with an immense green tree and a gently undulating wooded landscape. The hay is yellow, the trees are a deep, rich green, the sky is blue, and the clouds are white. Indeed, all the richness and subtlety characteristic of many Impressionist palettes was eschewed by Pissarro in this picture, in which the clarity and autonomy of each form are communicated clearly by means of appropriate local color. There are few passages of reflected light. The painting was executed not only with large brushes, but also with a palette knife, the result being that the paint generously sculpts the forms of the landscape.

Montfoucault is located near the village of Foucault, which is a few kilometers from Mayenne in eastern Brittany. Pissarro painted many of his most descriptive landscapes of rural civilization at this site, whose surrounding area of isolated farms had a quality more in keeping with the English landscapes of John Constable than with anything in the Ile de France. *Harvest at Montfoucault*, without a doubt the most confident and brilliant painting made by Pissarro in that region, was chosen by him for inclusion in the Impressionist exhibition of 1877 and, shortly thereafter, entered the distinguished collection of Caillebotte, who bequeathed it to the Musée du Louvre, Paris, in 1894 (no. 98).

98. Camille Pissarro

KITCHEN GARDEN AND FLOWERING TREES, SPRING, PONTOISE
(*POTAGER ET ARBRES EN FLEURS, PRINTEMPS, PONTOISE*), 1877

If *Harvest at Montfoucault* (no. 97) is an elemental landscape about the abundance of the earth at harvest time, the climax of the agricultural cycle, this composition carries the breath—and the optimism—of spring. Centered on an immense apple tree very much like many that still stand where it was painted, the picture was executed in an orchard at the foot of the Côte des Grouettes in l'Ermitage (see above, III/5). The same motif was also painted by Cézanne (*Path of the Ravine, View of l'Ermitage, Pontoise* [c. 1877; Galerie Neupert, Zurich]), and a comparison between his and Pissarro's landscapes is often made in the literature devoted to Impressionism. Pissarro's is magnificently confident as a composition, dominated by the great tree that rises higher than the hillside to graze the top of the picture. The landscape *is* the tree, and its flowers burst forth from the center of the painting until they utterly dominate it. How different it is from the balanced array of branches and architectural masses that make up Cézanne's slightly later treatment of the same motif.

Kitchen Garden and Flowering Trees, Spring, Pontoise was executed with hundreds of tiny, overlapping strokes, some of which consist of unmixed pigment applied directly to the picture surface, while others were carefully mixed from several pigments on the brush before being applied to the painting. Pissarro felt this work to be so successful, so completely resolved, that he chose it for inclusion in the Impressionist exhibition of 1879, in which he showed a small selection of his best work from the past decade. Like *Harvest at Montfoucault*, it was purchased by Caillebotte and bequeathed to the Musée du Louvre.

99. Alfred Sisley

SPRINGTIME NEAR PARIS—FLOWERING APPLE TREES
(*PRINTEMPS AUX ENVIRONS DE PARIS— POMMIERS EN FLEURS*), 1879

This softly painted landscape is, as its title suggests, a fervent evocation of spring and its preeminent symbol for the Frenchman, apple blossoms. The picture's site is unspecified, and it is only possible to date it by analogy with a signed and dated painting of the same landscape that represents the same season, *Spring Rain, Environs of Paris* (1879; Private Collection, Paris). Probably painted in one of the many verdant valleys near Sèvres or Saint-Cloud where Sisley was painting during 1879,

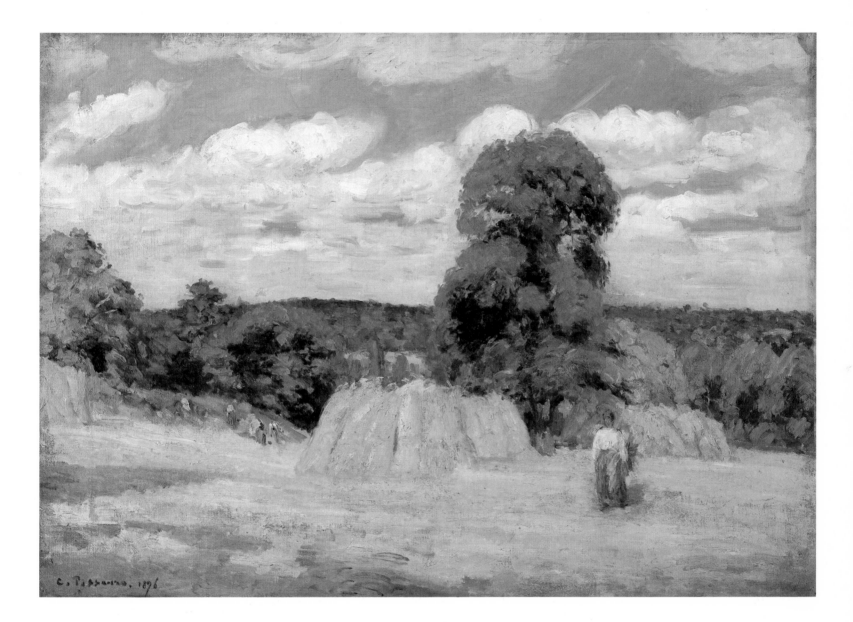

No. 97. Camille Pissarro
HARVEST AT MONTFOUCAULT, 1876

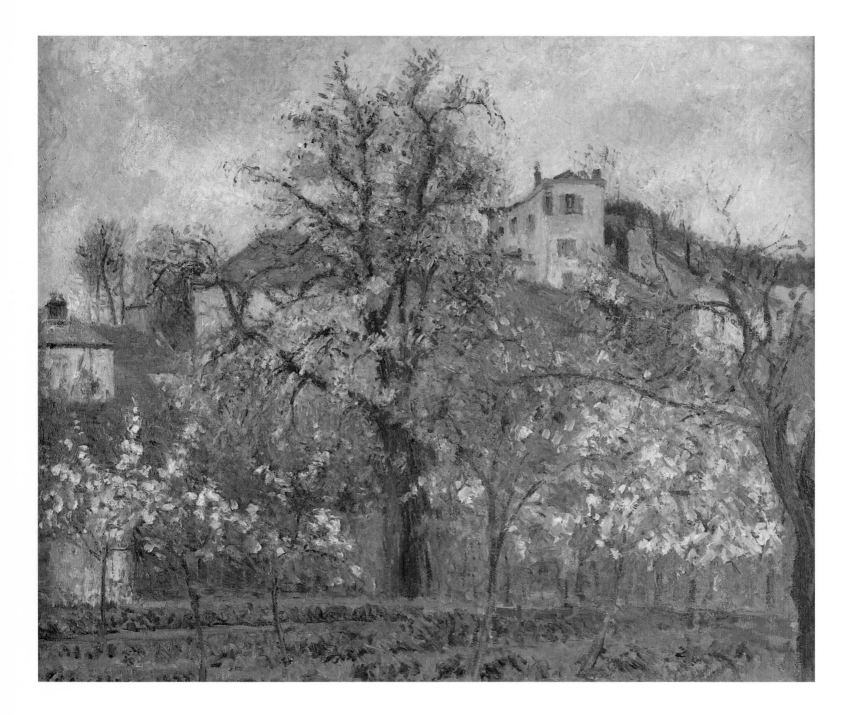

No. 98. Camille Pissarro
Kitchen Garden and Flowering Trees, Spring, Pontoise, 1877

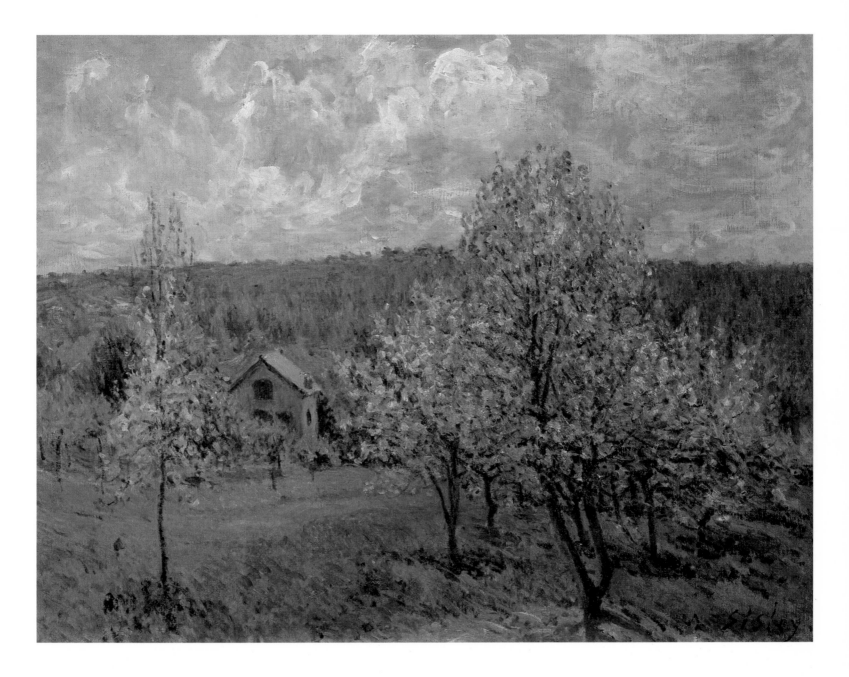

No. 99. Alfred Sisley
Springtime near Paris — Flowering Apple Trees, 1879

Springtime near Paris, Flowering Apple Trees shows little concern for topography. We are not on a path with a name. We see no important buildings. Yet the presence of a recently built country residence of three stories suggests that the landscape is, at least in a way, suburban rather than strictly rural.

Unlike Pissarro (no. 98) and Monet (no. 100), who seem to have been almost unconcerned with the sky in their spring landscapes included here, Sisley was anxious to place his orchard in a larger landscape under a changing spring sky. The small clusters of cumulus clouds animate it just as the white blossoms add life to the landscape below, and—as is so often the case with Sisley's spring and summer landscapes—one almost feels a breeze wafting through the branches and jostling the blossoms. More informally composed and hence less mythic than Pissarro's *Kitchen Garden and Flowering Trees, Spring, Pontoise* (no. 98), Sisley's painting captures the gentlest aspects of spring in the environs of Paris.

100. Claude Monet

FLOWERING APPLE TREES
(*POMMIERS EN FLEURS*), 1872

Painted in Monet's first spring in Argenteuil, *Flowering Apple Trees* is among the most unabashedly rural of his many representations of that town. Paul Tucker has discussed the extent to which Monet ranged throughout the countryside surrounding Argenteuil during his first years there.[1] Unlike a great many of his paintings made in the fields, which show the town itself or elements of it (no. 94), this picture has no intrusions of the town-scape, either modern or traditional. Its motif is a small *chemin*, or path, probably near the slopes of the Colline d'Orgemont north of Argenteuil. The path moves through several small fields used for a polyculture of fruits and vegetables and ends at the motif of the picture, blooming apple trees.

Unlike Pissarro and Sisley, who included human figures in most of their evocations of spring, Monet has allowed us to be alone in the fields. The blossoms flutter gently, and the path entices us into

a landscape that is among the most benign and beautiful painted by the artist.

NOTE
1. Tucker, 1982, pp. 9–56.

101. Georges Seurat

THE ALFALFA FIELD NEAR SAINT-DENIS
(*LA LUZERNE À SAINT DENIS*), 1885

The title of this landscape tells us clearly that it represents an alfalfa (alternatively, lucerne) field near the town of Saint-Denis just north of Paris. Although associated with the French aristocracy since the Middle Ages and the site of the great burial cathedral of the French kings, Saint-Denis was widely industrialized in the nineteenth century and also was surrounded by very large grain fields. The town and its countryside were among the least picturesque and most modern in the environs of Paris, and it is therefore no accident that Monet, Renoir, Sisley, and Pissarro never painted there. The guidebooks directed the tourist to Abbot Suger's great cathedral and to one or two restaurants, but found no charming rural walks to recommend in the bleak, flat landscape surrounding the town. In this painting Seurat has avoided both the cathedral, a considerable "event" in the landscape, and the town itself, framing instead a group of undistinguished, but geometrically clear, buildings of recent date in the deep recesses of his composition.

Seurat reveled in the very bleakness of his motif. His horizon line, fully three-quarters of the distance from the bottom of the picture, is virtually straight, and the immense field shows no paths or other means of access. Bordered by the distant houses and small factory, the field is almost a barrier to the viewer, preventing access to the "human-scape." How different it is from the grain fields with poppies painted by Monet and Renoir (no. 103)! Even the tree at the right of the composition is isolated and, ultimately, uninteresting.

In choosing to paint an alfalfa field, Seurat was undoubtedly attracted by the fact that alfalfa blooms. Its reddish-purple flowers interact powerfully with the deep green of its leaves and stems, pro-

viding a painter of Seurat's special interests with a *champ de vision* (see above, I) that would vibrate with two conflicting colors, each with its own opposite. In order to paint this field according to the optical laws he employed, Seurat needed four colors—the "local" purple and green and their opposites, yellow and red-orange. Both the composition and the complex, interlocking facture indicate that Seurat was interested in the subject as much for its color as for its associations with agricultural abundance or seasonality. Nevertheless the sheer splendor and the expanse of this field make it an agricultural image of mythic proportions.

102. Paul Gauguin

FARM AT ARLES
(*FERME À ARLES*), 1888

Gauguin painted this elemental agricultural landscape near Arles, where he worked together with Van Gogh in November and December 1888. His painting of a grainstack juxtaposed against a *mas,* or Provençal farm dwelling, is among the most fully resolved of his canvases from that two-month period spent in the south of France.

Gauguin's impetus for creating such a picture came from two sources. The first of these was Van Gogh, whose classically composed agricultural landscape with grain fields and a haystack, *Harvest at La Crau* (Rijksmuseum Vincent van Gogh, Amsterdam), was painted in June 1888 just before his powerful representation of haystacks themselves, *Haystacks in Provence* (Rijksmuseum Kröller-Muller, Otterlo).[1] Yet the example of Van Gogh cannot explain Gauguin's painting completely. Indeed, the writhing contours and bloated volumes of the former's *Haystacks in Provence* prepare us only in terms of its subject for the constrained geometries of Gauguin's *Farm at Arles*. The second source, which is surely more germane, can be found in the work of the greatest painter of Provence, Cézanne. Although there is no evidence that Gauguin visited his colleague in Aix-en-Provence, Cézanne was surely in his mind as he constructed *Farm at Arles*. The carefully

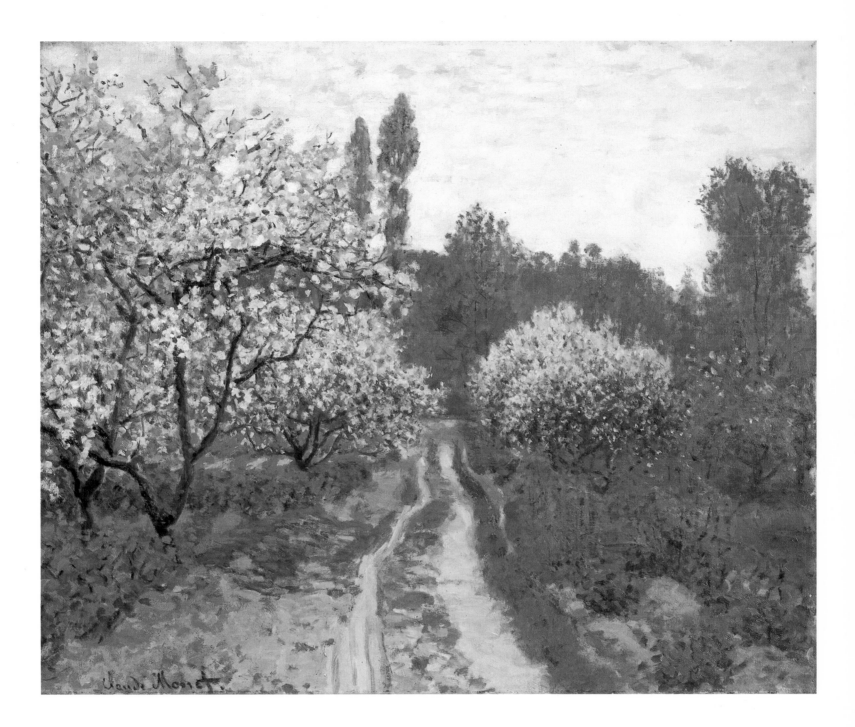

No. 100. Claude Monet
FLOWERING APPLE TREES, 1872

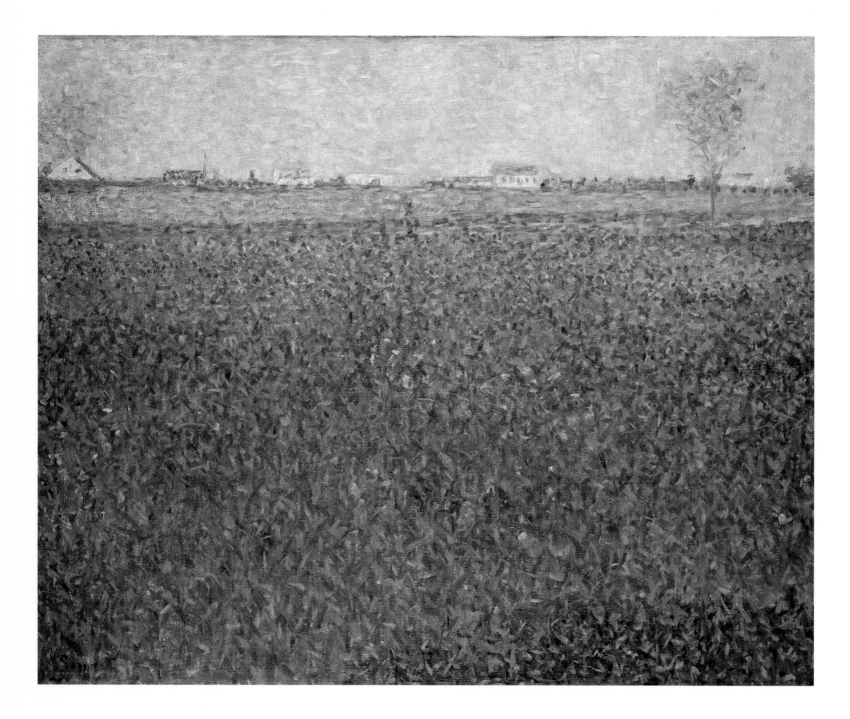

No. 101. Georges Seurat
THE ALFALFA FIELD NEAR SAINT-DENIS, 1885

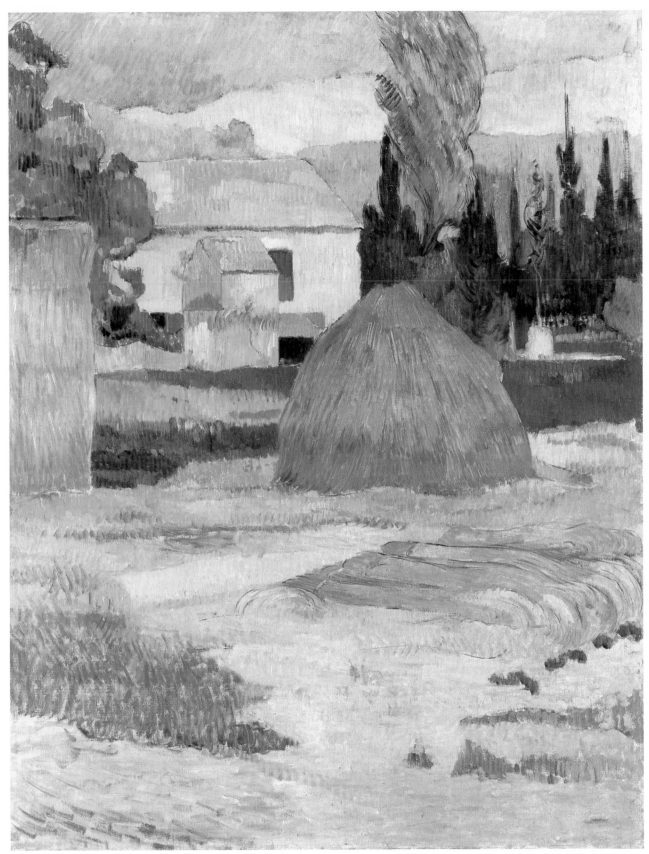

No. 102. Paul Gauguin
FARM AT ARLES, 1888
(detail on p. 240)

applied strokes of paint arranged in parallel rows, as well as the isolated, lonely character of the landscape have their origin in Cézanne's paintings of the early and mid-1880s, in spite of the fact that he rarely included so temporal a form as a haystack in his rural landscapes of that period.

Unlike Monet, whose grainstacks (nos. 104–112) were painted without knowledge of *Farm at Arles,* Gauguin was less interested in the poetics than in the architecture of his motif. In the foreground of his picture are rows of neatly stacked grain drying in the sun in preparation for a haystack. The viewer is encouraged to read the painting from foreground to background as a succession of forms that become progressively permanent and stable—from grain to grainstack to hut to house. Hence the landscape is an emblem of the continuity of life through agriculture. No figures work the fields; no smoke emerges from a chimney; no curtains blow from the window of the *mas.* Instead, the seasonal succession of the harvest is pictured as an element of continuity and endurance beyond the vicissitudes of urban time. Interestingly, Gauguin painted this picture at a moment significantly after the harvest of actual grain—and the construction of grainstacks—in Provence. This activity, as recorded *sur le motif* by Van Gogh, occurred in June. Here, Gauguin has turned to the subject of the grainstack at the end of autumn and in this sense his painting of it is less an observation than a purely pictorial construction.

NOTE
1. This picture was no doubt based on Millet's *Haystacks in Autumn* (1868–74; The Metropolitan Museum of Art, New York), which Van Gogh saw exhibited in Paris in 1887. See Herbert, 1975, pp. 298–299, no. 246.

103. Claude Monet
POPPY FIELD
(*CHAMP AUX COQUELICOTS*), 1890

Monet painted four identically sized versions of this composition in the summer of 1890,[1] and there is evidence to suggest that he conceived the group as a series and that it may have been made con-

sciously in preparation for the *Grainstack* series with which he became preoccupied later in 1890 (nos. 104–112). In any case, *Poppy Field* and its companion-pieces represent a grain field in the midst of which grow the wild poppies so common in the plains of northern France. Monet was fascinated by the interplay between brilliant daylight and the intense red-orange of the poppies, and the paintings are alive with color. The artist's analysis of light and hue evident here seems to have been a direct result of his contact with works by Seurat and his followers such as *The Alfalfa Field near Saint-Denis* (no. 101). Yet the differences between *Poppy Field* and the painting by Seurat are striking. Where the latter artist reduced the space and accessibility in his landscape, concentrating his attentions steadfastly on the interplay of hues in the flowering field, Monet was utterly mindful of the amplitude of the fields of France and placed the hills and trees within the composition in such a way as to maximize the spaciousness of his scene. One wanders effortlessly through his "field-scape" in spite of the fact that Monet, like Seurat, provided no path.

Poppies in grain fields were more a scourge than a blessing to farmers, reducing as they did the purity of the harvest. Clearly Monet saw the agricultural landscape—especially one of this type—with the eyes of an urbanite for whom even agricultural nature was a garden.

NOTE
1. Wildenstein 1251–1254.

104–112. Claude Monet
THE GRAINSTACKS
(*LES MEULES*), 1890–91

On May 4, 1891, an exhibition of recent paintings by Monet opened at the Galerie Durand-Ruel, Paris. In one small room were 15 paintings with the same motif—grainstacks—hung together as a series. Although Monet had exhibited several versions of other compositions or motifs in earlier exhibitions, never before had such pictures been hung adjacently, nor had they been considered by the artist as part of a collective ensemble. Monet himself had become interested in

painting series during the preceding year, and his letters are full of complaints about his struggles to transcribe the subtle, changing sensations of a landscape in constant variation. On October 7, 1890, he wrote a famous letter to his friend and future biographer, Gustave Geffroy:

I am working very hard: I am set on a series of different effects (grainstacks) but at this time of year, the sun goes down so quickly that I cannot follow it.... I am working at a desperately slow pace, but the farther I go, the more I realize that I have to work a great deal in order to convey what I am seeking: "instantaneity," especially the...same light spread everywhere, and, more than ever, facile things achieved all at once disgust me. Finally I become more and more frantic at the need to convey what I experience and I vow to go on living....because it seems to me that I am making progress.[1]

And indeed, he made progress. The exhibition was a critical and financial success unprecedented for an Impressionist painter (see below, IV). Pissarro, always angry about the monetary ambitions of his younger colleague, complained bitterly before he saw the show that Monet was mass-producing pictures for the American market—an opinion largely borne out by their subsequent sales. However, Pissarro's annoyance was not only modified, but completely reversed when he made the trip to Paris to see the grainstacks. He reported his amazement to his son, Lucien, in a letter written the day after Monet's opening:

That the effect is both luminous and masterly is uncontestable. The colors are at once attractive and strong. The drawing beautiful, but insubstantial, in the backgrounds as well. It is the work of a very great artist....the canvases seem to breathe contentedly.[2]

The critics were almost unanimous in their enthusiasm. The conservative critic Désiré Louis waxed the most eloquent in almost symbolist prose:

The viewer is in the presence of sensations of place and of time in the harmonious and melancholic flow of sunsets, ends of day, and gentle dawns. The violets, the roses, the sulphurs, the saffrons, and the mauves, the greens, and the topazes surround the objects with a limpidness and infinite ease. The space is generous, and the forms in the distance are magnificent with their blurred contours and their trees in allegorical profile.[3]

A DAY IN THE COUNTRY

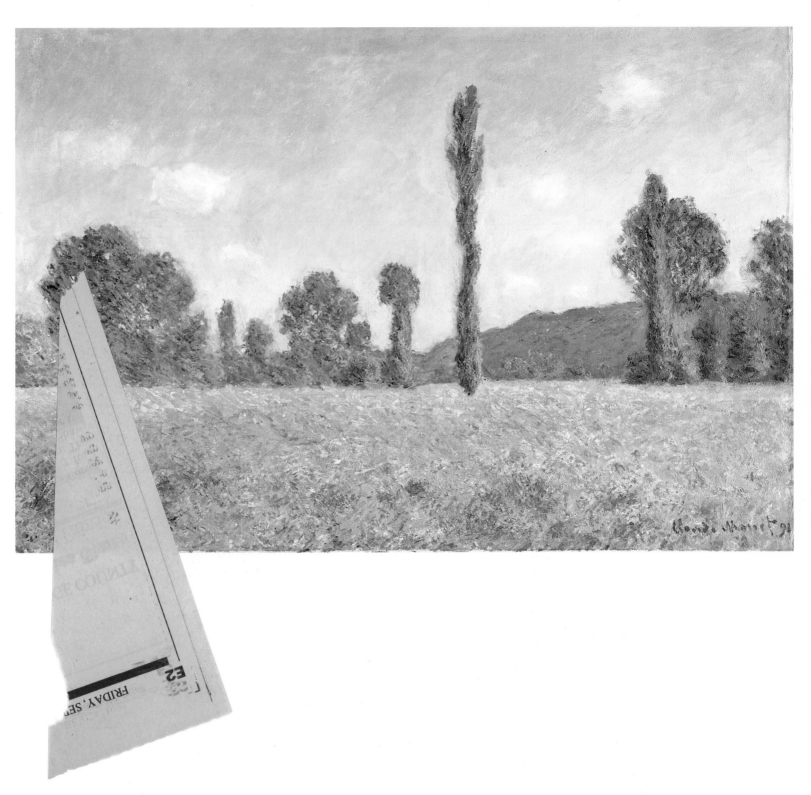

No. 103. Claude Monet
POPPY FIELD, 1890

In a brilliantly poetic review, Geffroy realized that Monet had understood "the possibility of embodying the poetry of the universe in the small space of the field."[4]

There is little doubt that the grainstacks series was made at a decisive point in Monet's development as an artist. It was painted both in the fields—where he worked simultaneously at several easels—and in the studio—where he labored to create subtle pictorial harmonies among individual pictures. The demands Monet placed upon himself as a painter became more complex as the series grew larger, because each work of art had to exist not only as a successful single entity, but as an integral partner of all the other works. Monet's success in creating both independent and interdependent paintings was virtually complete.

Until recently it has been assumed by critics and historians of Impressionism that Monet was uninterested in the motif of the grainstack, and that he used it as a foil for the "true" subjects of the paintings—weather, light, and, ultimately, time. A visitor to Monet's studio in the 1920s, the Duc de Trévise, called the series "philosophical" rather than symbolic,[5] and another writer claimed that the paintings represent not matter—with its proper shapes and colors—but form perceived by an individual who evoked what the critic called a "rapid, subjective synthesis."[6] In this way the series came to be seen as but a step in the gradual emergence of abstract art. This view was given early artistic credence by Wassily Kandinsky, who saw his first Monet grainstack painting in Russia in 1896 and another (no. 110) at the "Munich Sezession" exhibition in 1900.

The power of the grainstacks themselves for Monet must not be forgotten, however. This fact was not lost on several early viewers of the paintings, not the least of whom was Geffroy. Geffroy realized that, for Monet, the grainstack was a form rich in resonance. Its obvious associations of abundance and of man's ability to sustain himself and his animals on the richness of the harvest are obvious and compelling. Anyone familiar with the grainstacks and bales of hay in paintings and prints by Pissarro, Gauguin, Van Gogh, Bernard, and countless other important contemporary artists can instantly realize that Monet was making use of a powerful symbol with a distinguished iconological pedigree established in the decades before he began his series.

Monet himself also was attracted to many other motifs which comprise collectively a set of associations with the grainstack form. All of these were Romantic symbols. The roofed fishing boats that sit on the beach at Etretat and the deserted customs houses perched on cliffs along the north coast of France (no. 116) are each closely related in shape to the grainstacks, and there are many paintings by Monet of each of these motifs that are clear precedents for the series. All are sheltering forms with roof (or roof-like) structures; all are essentially unpeopled; and all stand against the environment. They dominate what Pissarro was right to call the "background," which interacted powerfully with the imagination of the viewer.[7] They are more than motifs—they are symbols or icons. For the most brilliant modern writer about the grainstacks, they had "become the simulacrum of man's house";[8] one is reminded in this connection of the "primitive hut" sought after by eighteenth- and nineteenth-century architectural theorists as the origin of all human architecture.

What exactly *were* Monet's grainstacks? We learn from one scholar that they were made from the hay of oats,[9] from another that they were of wheat, and that they stood in a field owned by someone who lived near Monet in Giverny.[10] Although the mythic meanings of wheat are more compelling than those of oats, the precise identification of the grain is immaterial, however. The form of these stacks tells us that they are what French writers about agriculture in the 1800s called *meules de céréale definitives,* or long-lasting stacks, highly complex structures created according to set rules, many of which were spelled out in agricultural texts. Perhaps the simplest and most accessible explanation comes from Albert Larbalétrier's entry on haystacks in *La Grande Encyclopédie,* published the year after Monet exhibited his series:

> Long-lasting haystacks are generally round, their diameter varying from four to eight meters; their substructure is solid, made with small branches or rape straw, or even with wood, because it must keep out not only moisture, but also rodents. The sheafs are placed in successive layers and tied, in a manner so that their points converge toward the center. The cover must be the object of great care; usually one uses the ends of rye straw, the inclination being pronounced so that rain water will run off it easily.[11]

Larbalétrier also explained that such haystacks were common in the north of France because of the lack of sufficient interior storage and that the chief danger to such structures was fire. In fact, he mentioned the large fines levied throughout France for the building of fires within 100 meters of a haystack and discussed ways in which they should be placed far from dwellings or other structures in which fire or heat was needed.

It is clear from Larbalétrier's text and many other similar contemporary discussions of grain storage that the grainstack represented a considerable investment in time and material and that it was, in many cases, the repository of a farmer's material wealth. Surely Monet, who lived for many years in rural settings, knew the importance of such stacks to his neighbors and, by making them the clear motif of his series, allowed their meanings to unfold in a complex succession.

NOTES

1. Geffroy, 1924, vol. I, p. 48.
2. Pissarro, 1950, p. 237.
3. See Louis, 1891.
4. Geffroy, 1891, p. 3.
5. de Trévise, 1927, pp. 125–126.
6. Aurier, 1891, p. 157.
7. Pissarro, 1950, p. 237.
8. Herbert, 1979, p. 106.
9. Wildenstein, 1974–79, vol. III, p. 13.
10. Herbert, 1979, p. 106.
11. Larbalétrier in *La Grande Encyclopédie,* 1886–1902, vol. XVII, p. 62.

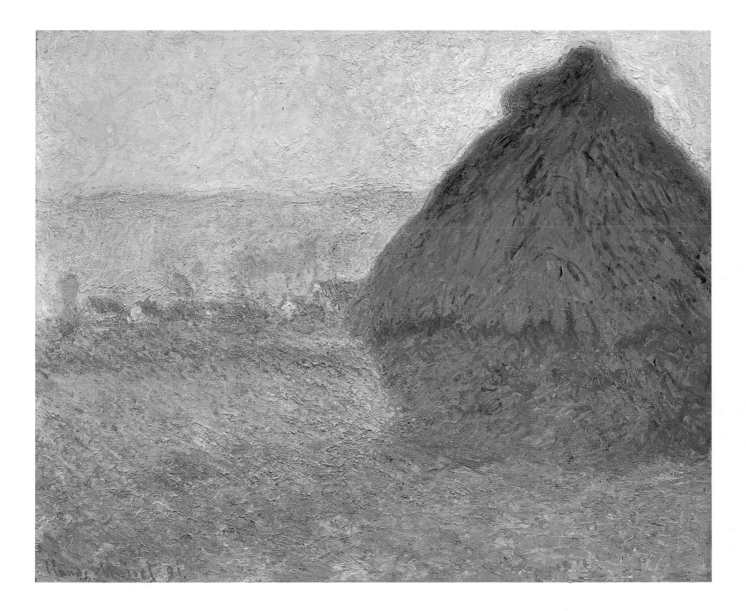

No. 104. Claude Monet
THE GRAINSTACK, SUNSET, 1891

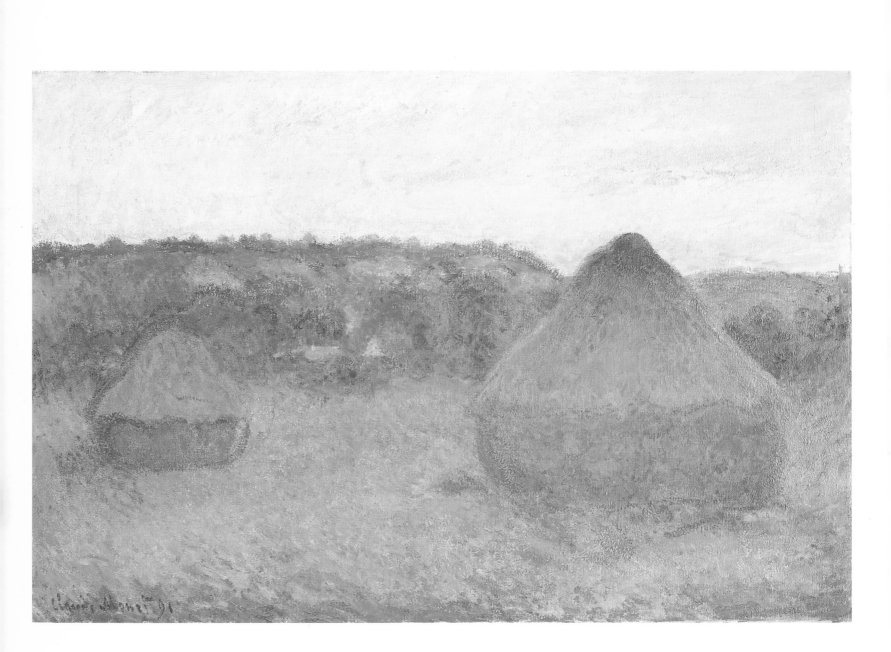

No. 105. Claude Monet
GRAINSTACKS, END OF DAY, AUTUMN, 1891

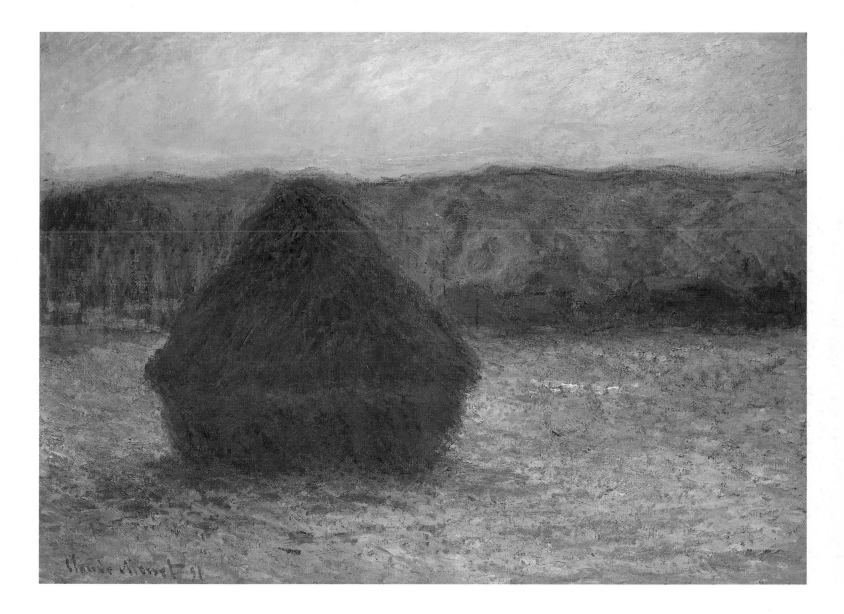

No. 110. Claude Monet
THE GRAINSTACK, THAW, SUNSET, 1891

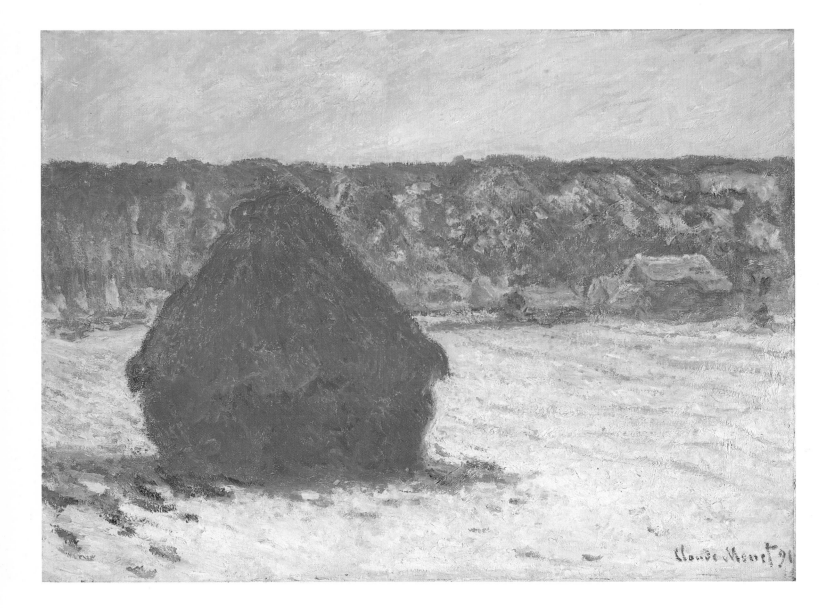

No. 111. Claude Monet
THE GRAINSTACKS IN THE SNOW, OVERCAST DAY, 1891

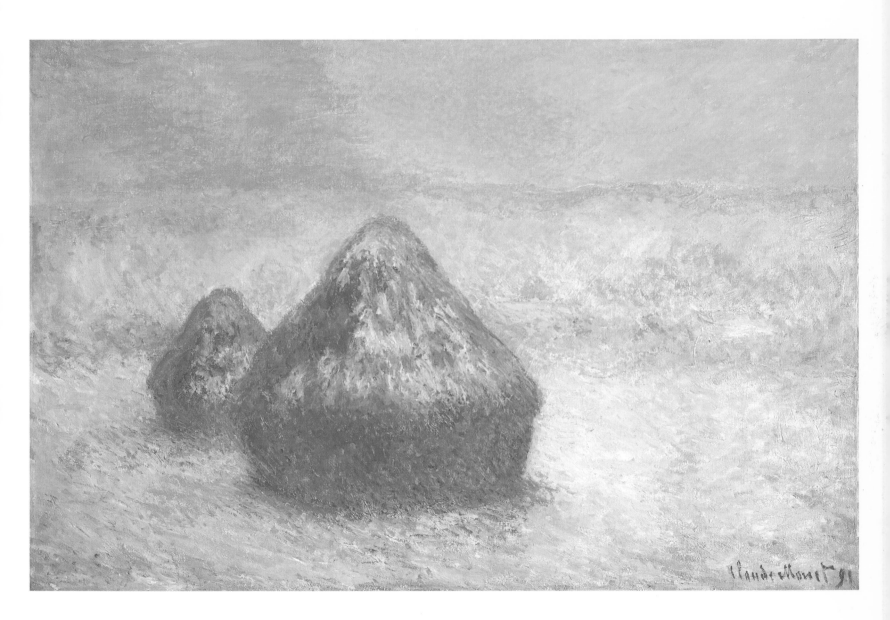

No. 112. Claude Monet
GRAINSTACKS, SNOW, SUNSET, 1891

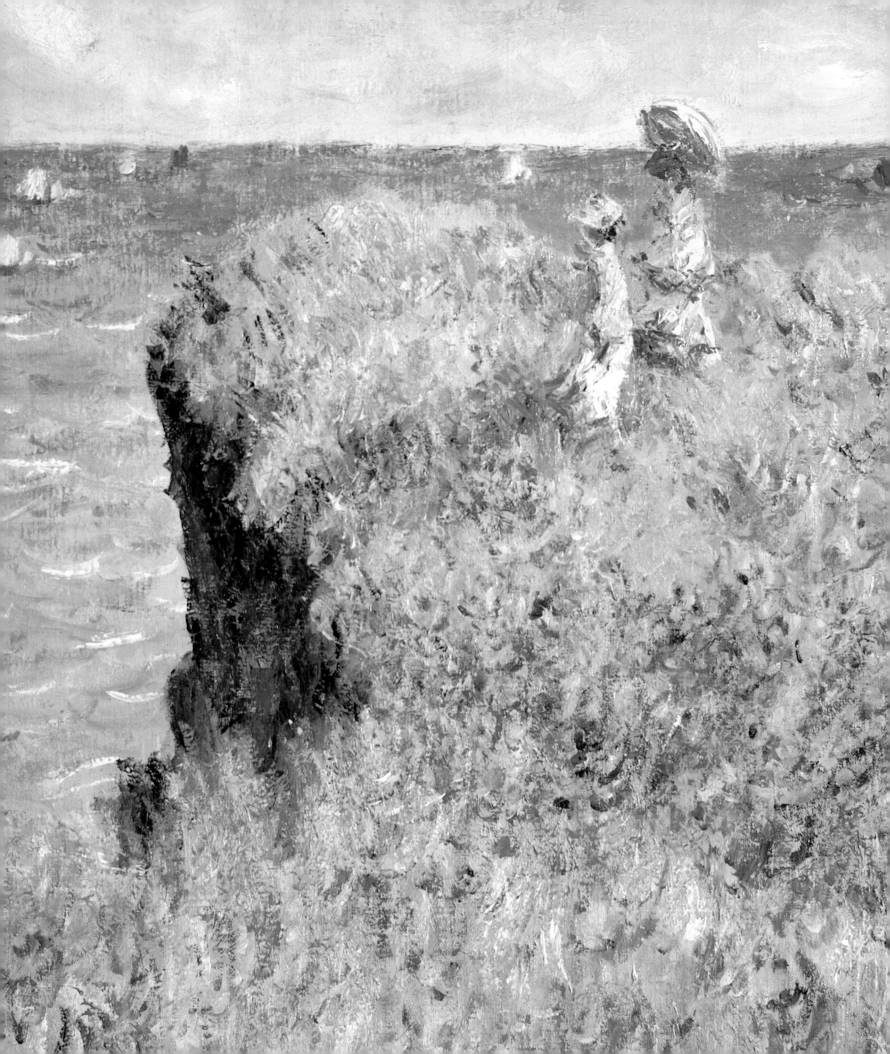

III/8

Impressionism and the Sea

SUMMER HOLIDAYS BY THE SEA were one of the novelties of early modern life. They were without a doubt facilitated by technological advances in transportation of all kinds, but most especially by train travel (see above, III/4). The *trains de plaisir,* or tourist trains, from Paris to Dieppe on the Normandy coast ran often enough that a traveler rarely had to wait long for the next one. In spite of the fact that this type of holiday allowed a large percentage of the bourgeoisie to experience the salutary effects of fresh air, sunshine, sea water, and, of course, a respite from the pressures of the cities, Jules Michelet deplored the periodic, but continuous, invasion of the Norman and Mediterranean coasts in his Romantic treatise *La Mer* (1860):

> The extreme speed of railway journeys contravenes medical sanity. To travel from Paris to the Mediterranean in twenty hours, as is now done, moving hour by hour through totally different climates, is positively foolhardy for people with nervous conditions. One arrives at Marseille agitated, giddy. When Madame de Sévigné spent a month traveling from Brittany to Provence, she overcame violent opposition of their climates little by little in stages....Then and only then did she approach the sea.[1]

Michelet disdained the fashionable appeal of resorts such as Trouville or Deauville (map 8) and was insensitive to any other charms these beaches might hold, viewing the sea solely in terms of the possible benefits of hydrotherapy, or water treatments. Only medicinal advantages might justify

> ...such open-air experiences which leave one open to the hazards of wind and sun, to a thousand accidents. Anyone who sees a poor creature emerge from the first few baths—pale, gaunt, frightful, shivering unto death—will be struck by the harshness of it all and the danger involved for certain types of constitutions. To endure all this...[people] must believe that no other remedy will help, and be willing to soak up the virtues of its waters at any cost.[2]

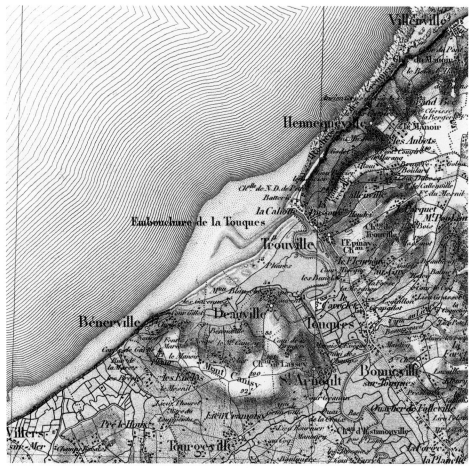

Map 8. Trouville and the Coast.

Once the Second Empire had discovered the Norman beaches, however, there was little chance of halting the Parisian advance to the sea. The popularity of the Normandy coast and the sea in French (and English) polite—and improper—society (with its vast support populations) virtually transformed the whole of the northern coast of France during the 1800s. Seaside resorts grew up to accommodate the desire to replicate the comforts of Paris in conjunction with the gaiety of a day or more at the shore (fig. 61). In addition, as gambling was essentially forbidden in Paris, seaside casinos, those splendid, airy architectural confections, provided an opportunity to wile away the evening hours. In the 1850s and '60s, building and rebuilding, amid wild financial speculation led in part by the emperor's half-brother, the Duc de Morny, pushed the permanent residents of the area further and further up and down the coast, displacing the native peasant population of fishermen, farmers, and shopkeepers.

Although Michelet began *La Mer* on a pessimistic note emphasizing the fear, the sense of struggle and capitulation, and the feeling of horror evoked by the sea, he ended his book with a hymn to man's ability to utilize the ocean for all it could offer in the way of food, medicine, knowledge of the environment, and amusement and pleasure. He could not, however, condone the irresponsible transformation of the small peasant villages of the region:

> Fishing has become unproductive. The fish have fled. Etretat is languishing, dying beside a languishing Dieppe. More and more it is being reduced to an appendix of the beaches; it earns its livelihood by renting out living quarters which—now full,

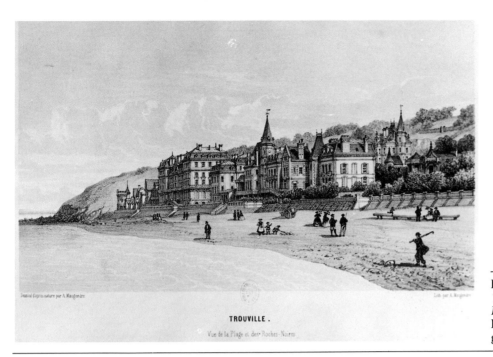

TROUVILLE.

Vue de la Plage et des Roches-Noires

Fig. 61. Adolphe Maugendre (French, 1809–1895), *Trouville. View of the Beach and the Roches-Noires*, published 1867. Lithograph. Bibliothèque Nationale, Série Topographique, Va14, vol. IX, no. H114618.

now empty—set a profit one day, a loss the next. But no matter what the material gain, the contact with Paris, worldly Paris, is the scourge of the region.[3]

But for all the destruction that man could impose upon the innocent shore and its inhabitants, Michelet remained extraordinarily sensitive to the intellectual and emotional effects of places where the earth meets the sea and the sky. With an intuition that might well be called prophetic for its willingness to explore the "scientific" nature of the sea, Michelet discussed such subjects as geography, geology, biology, oceanography, and meteorology. He believed that a "rebirth" brought about by contact with the sea could touch the heart as well as the body:

> How great, how very great is the difference between the two elements: the earth is silent; the Ocean speaks. The Ocean is a voice. It speaks to the faraway stars, responds to their course in a language grave and solemn. It speaks to the earth, to the shore, in exalted strains, converses with their echoes; now plaintive, now menacing, it scolds or sighs. But above all it addresses man. The rich crucible in which creation began and continues all-powerful, it shares creation's life-giving eloquence; life talks to life. The millions and billions of beings born therefrom—they are what constitutes its words....such is the great voice of the ocean.[4]

And it was this voice that both artists and laymen of the time sought to hear as closely as possible.

The "great voice of the ocean," however eloquent and poignant, however ably it spoke to artists, writers, and the occasional sensitive visitor, was sometimes drowned out by the din of holiday-makers who sought the seaside as a refuge. The Impressionist painters, some of whom, such as Monet and Boudin, had familial connections with the Norman coast (nos. 5, 12), and others of whom simply sought the geographical haunts of their Barbizon predecessors such as Courbet and Daubigny, followed in their wake. The early seaside pictures the Impressionists painted clearly reflect the holiday mood of the place in many cases. In this they paralleled the sentiments of such writers as the Englishman Henry Blackburn, who described Trouville as

...the gayest of the gay. It is not so much to bathe that we come here, as

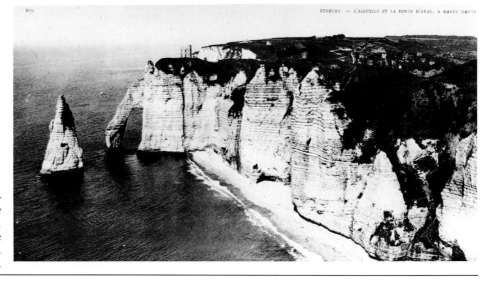

Fig. 62. *Etretat.—L'Aiguille and the Porte d'Aval, at High Tide,* 1910. Photograph. Bibliothèque Nationale, Série Topographique, Va76, vol. IIIa, no. H150719.

because...the world of fashion and delight has made its summer home; because here we can combine the refinements, pleasures and "distractions" of Paris with northern breezes, and indulge without restraint in those rampant follies that only a Frenchman or Frenchwoman understands. It is a pretty, graceful, and rational idea, no doubt, to combine the ball-room with the sanitorium, and the opera with any amount of ozone.[5]

Monet's *Roches Noires Hotel, at Trouville* (no. 115), painted 20 years after this description was written, captures its mood and feeling.

Although the Impressionists in the 1860s and '70s followed their fellow Parisians to the chic watering places of Normandy and Artois, or recorded the various small, but bustling, harbors of the faraway Finistère, by the 1880s the artists' interests had changed considerably. Monet and Renoir, for example, perhaps obeying the call of Michelet's "voice of the ocean," reduced their canvases to representations of three of the four elements and eradicated all traces of mankind (nos. 118, 120). In these paintings the viewer is confronted with the sea and the sky, the "wondrous magic of air and water," as Baudelaire described Boudin's paintings at the Salon of 1859.[6] The visual stimuli, having been reduced, allow the viewer to bring his own thoughts and associations to bear on these images of the sea—from the atavistic evocations of François-René de Chateaubriand in *Mémoire d'Outre-tombe* (1849–50)[7] to the pathetic sympathies of Hugo in *Les Rayons et les ombres* (1841) or *Les Travailleurs de la mer* (1866).

Monet, for one, continued his exploration of small coastal towns (some of which he had painted already in the 1860s in a very different manner [nos. 1, 6]), depicting isolated and carefully considered aspects of Pourville, Etretat, and Varengeville (nos. 116–119), for example. These paintings ignore the holiday aspects of the picturesque fishing villages which are their subjects and which, although not new or speculative developments like Deauville or Trouville, had become quaint, popular tourist retreats of a similar nature. Just as Sisley and Pissarro had turned their backs on the châteaus of Louveciennes and Marly (see above, III/2), Monet effaced all traces of the Etretat which Blackburn had described as a

...little fisherman's village turned into a gay parterre; its shingly beach is lined with chairs, and its shores smoothed and levelled for delicate feet. The *Casino* and *Establissement* are all that can be desired, whilst pretty chalets and villas are scat-

A DAY IN THE COUNTRY

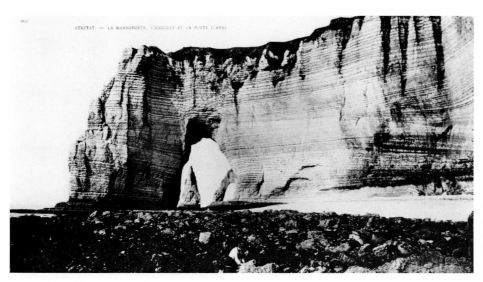

Fig. 63. *Etretat. — The Manneporte, L'Aiguille, and the Porte d'Aval,* 1910. Photograph. Bibliothèque Nationale, Série Topographique, Va76, vol. IIIa, no. H150718.

tered upon the hills that surround the town. There is scarcely any "town" to speak of; a small straggling village, with the remains of a Norman church, formerly close to the sea (built on the spot where the people once watched William the Conqueror drift eastward to St. Valery), and on the shore, old worn-out boats, thatched and turned into fishermen's huts and bathing retreats.[8]

Monet reduced man's role in the landscape to a minimum in order to examine the interrelationships of the sea and the land as well as to record specific natural monuments of the coast such as the rock formations, the Manneporte and L'Aiguille, both at Etretat (figs. 62–63). These sites preoccupied him in an enormous number of canvases produced within a very short time (no. 119). Seurat, on the other hand, chose in a number of canvases to examine in extraordinary detail the small town of Port-en-Bessin (fig. 64), reducing its picturesque charm to a geometricized aloofness (nos. 121–124). The harbor, the quay, and the buildings there have been arranged according to a preconceived idea of the port itself, reducing it to a linear pattern upon the canvas. This, however, does not preclude a certain pervasive melancholy in the series (see above, III/1), which is accentuated by the careful placement of a few figures.

In *La Mer* Michelet noted that France was "in the enviable position of having two seas," the Atlantic and the Mediterranean.[9] In contrast with the strong, turbulent waters and grayish skies of the English Channel, Michelet recommended the southern coast of France with "two things that make the Mediterranean beautiful: the harmonious setting and the keen, transparent vitality of the air and light. It is a blue sea."[10] By the 1880s the Riviera, on the southern coast, had become the new watering hole for bourgeois Parisians. In addition, the region welcomed Renoir and Monet (at Antibes and Bordighera), sheltered Cézanne (at l'Estaque), and offered its beaches to Signac (at Saint-Tropez) and Cross (also at Antibes and its environs) for artistic contemplation.

The artists sought more and more merely to render this extension of the Parisian landscape, moved from Normandy to the Riviera, in terms of its light. They also explored and experimented with landscape motifs of a very different nature from those they had used previously. Michelet's "voice of the ocean" seems to have grown fainter as the artists retreated further to the provinces and concentrated less on the sea and land and more on the light

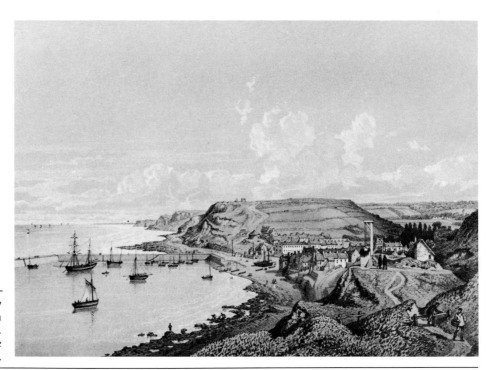

Fig. 64. Maugendre, *Port-en Bessin. View from near Signaux*, 1861. Lithograph from *Bayeux et ses environs, 1860–66.* Bibliothèque Nationale, Série Topographique, Va14, vol. VIII, no. H11435.

and air of the region. The shifting artistic concerns of the late 1880s are perhaps best exemplified by the various Impressionist depictions of the sea from that period. Although this new focus followed geographically the transplantation of the Parisian landscape, there were, nonetheless, crucial modifications in iconography as well as in the selection of landscape motifs. In their later pictures the artists concentrated less and less on the urban—and urbane—qualities of human life found on land and sea than on capturing the ephemeral: the light and color of the various regions in which they chose to paint. This new concern explicitly manifests itself in Monet's work of this decade. Almost misanthropically, he continued to move away from the depiction of urban living, human experience, and surface reality that characterized his work of the 1860s and '70s. Natural phenomena—the earth, sky, and sea—as well as the changing environment, all physically accessible but intellectually remote to the urban holiday-maker, became the paramount preoccupation of his work. As his paintings became further and further removed from quotidian experiences, they became more intensely personal. Concentrating more and more on the suffused atmosphere and subdued colors of the northern coast or on the dazzling sun and pure color of the south, Monet and the other Impressionists rejuvenated the investigative aspects of their art at the seaside and found themselves moving in new, as yet uncharted directions. Ultimately they retreated into the provinces (see below, III/9) and into their own imaginations.

—S. G.-P. and S. S.

Notes

1. Michelet, 1983, p. 287.
2. Ibid., pp. 309–310.
3. Ibid., p. 320.
4. Ibid., p. 316.
5. Blackburn, 1892, p. 53.
6. Baudelaire, 1965, p. 199.
7. Chateaubriand, 1951, vol. I, pp. 17–18, 201, 431.
8. Blackburn, 1892, p. 59.
9. Michelet, 1983, pp. 58–59, 83, 288 ff.
10. Ibid.

113. Eugène Boudin
Camaret Harbor
(Port de Camaret), 1872

Summarizing his artistic career for the journal *L'Art* in 1887, Boudin showed a keen awareness of the originality of his oeuvre:

> Using different genres, I have done all sorts of seascapes and beach scenes in which one may find if not great art, then at least a sincere attempt at reproducing the world of our time. Perhaps one will also find that my studies offer a side of great celestial Nature which was not explored more or better by my predecessors. I dare not put my small boats on the same level, though I have made a painstaking study of them. I realize they are not so perfect in detail as their Dutch counterparts—nor would today's public have them so—yet I flatter myself that a future public will view them with interest for what they show of the sails, rigging, and general state of ports in our day.[1]

Perspicacious as Boudin was in stressing the documentary interest of his painting for the future, he felt compelled by modesty to pass over the quality of his technique. Yet it is quite apparent in *Camaret Harbor*. Following the example set by the landscapes of the Dutch masters of the seventeenth century (men like Van Goyen and Ruisdael), which he had contemplated at length and duly acknowledged in the above-mentioned article, he divided his composition into two unequal zones, sea and sky, assigning the greater space to the latter. In this he was following the Dutch practice of creating so-called "four-fifths" vistas. Since he always attached such importance to the sky in his work, he tended to make numerous preparatory pastel sketches of it.

Boudin took extreme care over coloring and was able to make his clouds airy and full of light. And because the houses in the background in *Camaret Harbor* are so brilliantly lit, they contrast effectively with the shadows produced by the sails of the boats. The artist was also greatly interested in the human figure and, like Jongkind, brought his landscapes to life with tiny silhouettes like the ones puttering about on the rowboat here, back-lit against the water.

Boudin seems to have discovered Brittany in 1855.[2] Later he learned to love the region's picturesque character—its customs and festivals, its women's ethnic dress—and returned many times. His marriage in 1863 to Marie-Anne Guédès, a young Bretonne, reinforced his attachment to the area. He worked at Camaret, which is located at the tip of Brittany just north of the Pointe du Raz, every year from 1870 to 1873 and then again in 1878, 1880, and 1893. He chose two canvases from the summer of 1872 for the following year's Salon: a *Port of Camaret* (he painted several of these) and *Anchorage at Camaret* (1872; Private Collection). 1872 was also the year in which the dealer Durand-Ruel first commissioned a painting from Boudin. Durand-Ruel was to continue providing him with commissions until the end of his life (see below, IV).

Notes
1. de Knyff, 1976, p. 368.
2. Jean-Aubry, 1922, p. 32, incorrectly dated Boudin's first trip to Brittany to 1857; de Knyff, 1976, rectified the error.

114. Eugène Boudin
Bordeaux Harbor
(Port de Bordeaux), 1874

In February 1875 Boudin wrote to his friend Martin:

> ...though quite a pleasant town [Bordeaux] is beginning to wear on us. Personally, I do not care much for the embankments: there is the same jumble of vehicles, parcels, and barrels as at Le Havre or, rather, Antwerp, a hurly-burly that may be pleasing to people who count their profits by the number of bundles or barrels lowered by the cranes, but does not gladden the dreamer who prefers silence and solitude and the more monotonous, but more poetic, voices of the elements. These commercial towns are so enervating; they all smell of dust, cured leather, and especially guano—excellent items, to be sure, but not likely to make one forget the invigorating odor of seaweed or to replace the salty fresh air of our seashore. In short, dear friend, Bordeaux is as unpleasant as Le Havre along the embankments, and that is saying something![1]

Despite these plainly unfavorable impressions of the city, Boudin did some fine work there. His series of canvases devoted to Bordeaux testifies clearly to a new stage of mastery in his art. This was

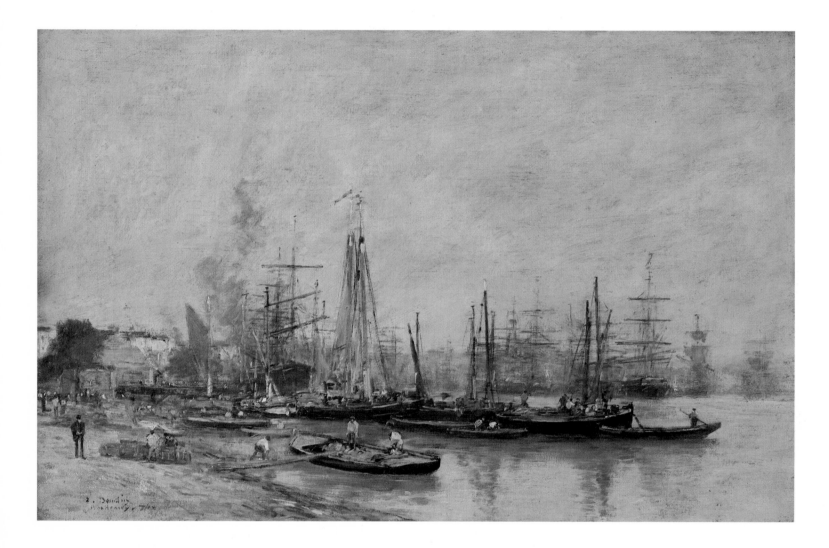

No. 114. Eugène Boudin
BORDEAUX HARBOR, 1874

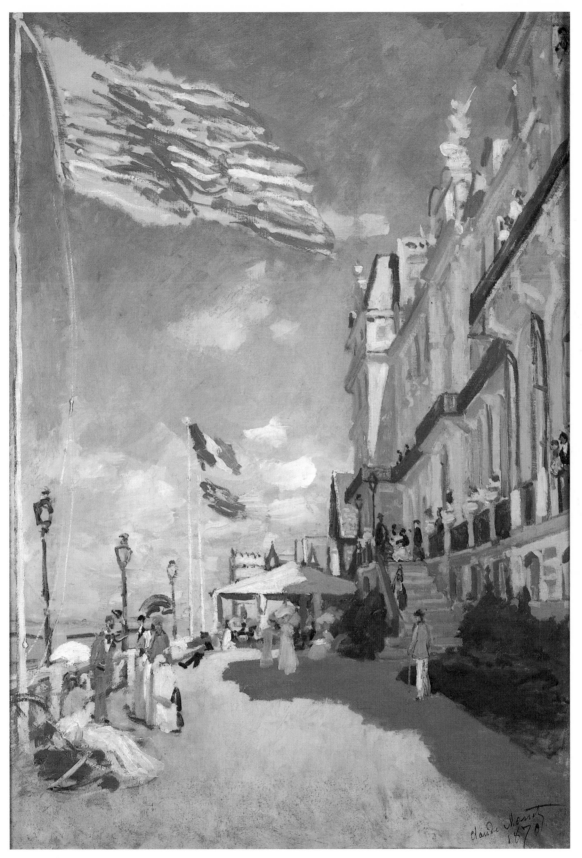

No. 115. Claude Monet
ROCHES NOIRES HOTEL, AT TROUVILLE, 1870

116. Claude Monet

CUSTOMS HOUSE AT VARENGEVILLE
(*CABANE DE DOUANIER*), 1882

Early in February 1882 Monet left Poissy, where he had lived since 1881, for the Norman coast. After passing through Dieppe, where his letters show him to have been bored and depressed, he settled in Pourville, a village several miles to the south, and stayed there from mid-February to mid-April. "It's a very beautiful region, and I only regret not having come here sooner," he wrote to his friend Alice Hoschedé on the evening of his arrival. "I couldn't possibly be closer to the sea—right at the pebbles—and the waves beat against the foot of the house."[1] During his long and fruitful stay there, Monet produced approximately 40 paintings. To the dealer Durand-Ruel he wrote, "I've been hiding out for several days in a delightful little region in the vicinity of Dieppe. I've found a number of nice things to paint, so I'm constantly at work."[2]

Monet's favorite motif in this area, one to which he devoted fourteen canvases and several sketches (Musée Marmottan, Paris), was a cabin formerly used by customs officials and located on the cliff of the Petit-Ailly about halfway between the beach at Pourville and the church at Varengeville. Daniel Wildenstein has noted that such checkpoints had been set up by Napoleon to keep watch over the Channel coast.[3] Since by the time Monet discovered it, the cabin had been taken over by local fishermen, he often referred to it in titles as *maison de pêcheur.* At other times he used a title indicating that it overlooked the gorge of Petit-Ailly.

To paint the present canvas and another very similar one, Monet positioned himself on the eastern slope of the gorge, just below the cliff.[4] The result is an unusual composition with an extremely high horizon. The image of the cliffs silhouetted against the sea is reminiscent of Japanese prints (nos. 2, 29, 33, 36, 120). (Seurat obtained the same curious effect in *Seascape at Port-en-Bessin, Normandy* [no. 124].) In fact, Monet painted the cabin from a number of angles and under various atmospheric conditions. As Steven Z. Levine has pointed out, more than ten years before

the *Grainstacks* (nos. 104–112) or *Poplars* of 1891, which are considered Monet's first true series, his paintings of the cliffs with their diverse lighting effects constituted a more or less unconscious advance in the direction of the serial treatment of motifs.[5] In fact, Monet must have begun toying with this idea while working on *Floating Ice on the Seine* (no. 55). In any case, on March 25, 1882, he wrote to Durand-Ruel, "I should rather show you the entire series of my studies at once, desirous as I am to see them all together at my studio," and on April 7 to Hoschedé, "Yesterday I worked on eight studies."[6]

On March 1, while Monet was still at work in Pourville, the "7me Exposition des Artistes Independants" opened in Paris. Among the 37 works of Monet included in the exhibition, his seascapes excited the greatest interest. Pissarro referred to these as "landscapes with something new to say [and] in a style more curious than ever."[7] In the course of the summer Monet painted several more versions of the cabin motif. All the canvases done that year at Pourville and Varengeville, including the present one, were displayed in March 1883 at Durand-Ruel's gallery in Paris.

Arriving in Pourville in July 1897 for another visit, Monet wrote to Hoschedé, who had become his wife in 1892, "Nothing has changed. The little house is intact, and I have the key."[8] Although he returned to the cabin motif, which also had appeared in several views of the gorge done in the previous year, he did not merely pick up where he had left off. As Levine has shown, Monet's work was evolving toward a greater simplicity or purity, which resulted from a decrease in detail bordering on abstraction.[9] His true subject had become light, a light that dissolved forms and modified colors.

NOTES

1. Wildenstein, 1974–79, vol. II, pp. 214–215.
2. Ibid., p. 215.
3. Ibid. 730.
4. Ibid., p. 288.
5. Levine, 1971–72, pp. 32–44.
6. Wildenstein, 1974–9, vol. II, pp. 217, 218.
7. Niculescu, 1964, pp. 253–254.
8. Wildenstein, 1974–79, vol. II, p. 292.
9. See Levine, 1971–72.

117. Claude Monet

CLIFF WALK AT POURVILLE
(*PROMENADE SUR LA FALAISE, POURVILLE*), 1882

"What fine weather," Monet wrote to Alice Hoschedé on March 17, 1882, from Pourville,

> ...and how often I dream of seeing you here, showing you the wonderful spots I've come to know! How good it would be to spend a year here with the children [his own and Hoschedé's]. How happy they would be here.

On April 4 he reiterated the thought: "How beautiful the countryside is becoming, and what joy it would be for me to show you all its delightful nooks and crannies!"[1] After an early June reconnaissance trip, during which he found a house to rent, Monet returned to Vétheuil for Hoschedé and the children. His dream had come true; for the entire summer, from June 17 to October 5, they lived together blissfully at the Villa Juliette.

Soon Monet was back at work on the cliffs of the Pays de Caux, where Alice and her girls may have modeled for the figures in this canvas. (According to Jean-Pierre Hoschedé, Alice's son, his sister Blanche first began to paint at Pourville.[2]) Another work dating from 1882 uses this setting, but without human figures,[3] as it appears in several other 1897 canvases. The location, identified with extreme precision by Daniel Wildenstein,[4] is a cliff between Pourville and Dieppe, one just upstream of the beach at Pourville. The strollers are making their way along the eastern side of the Val Saint-Nicolas, a "hanging" valley on the coast of Les Hérons.

Much has been made of how Monet succeeded in "conveying the quiver of the grass under the wind's caress with small strokes" resembling the twinkling of light.[5] William Seitz has pointed out that the composition consists of several triangles (cliffs, sails, clouds) and that the undulatory movement of the grass was differentiated from the flat surface of the sea by the artist by means of both hue and texture.[6]

By this time Monet had returned to the problem of how to insert human figures into the landscape, a problem that had concerned him during the early

284

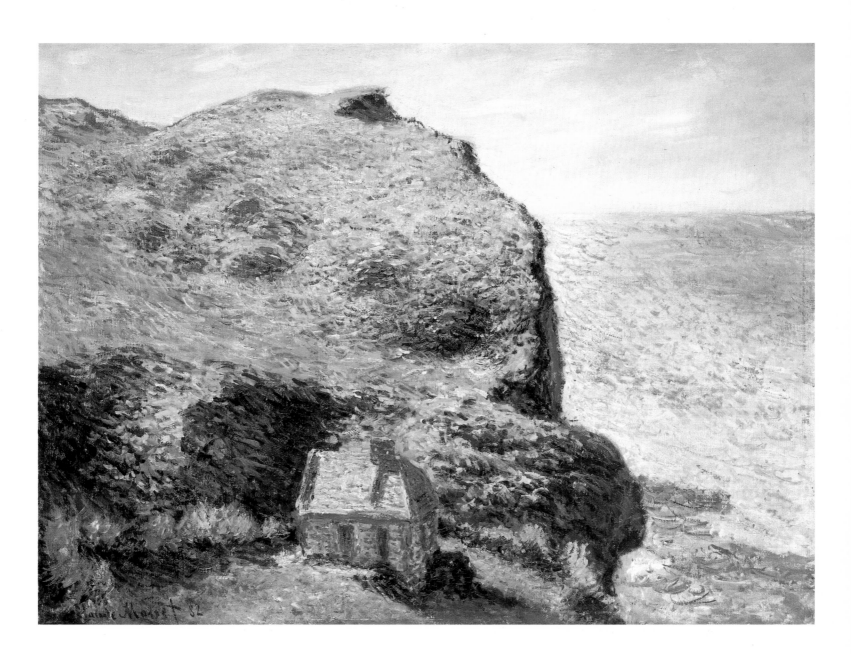

No. 116. Claude Monet
CUSTOMS HOUSE AT VARENGEVILLE, 1882

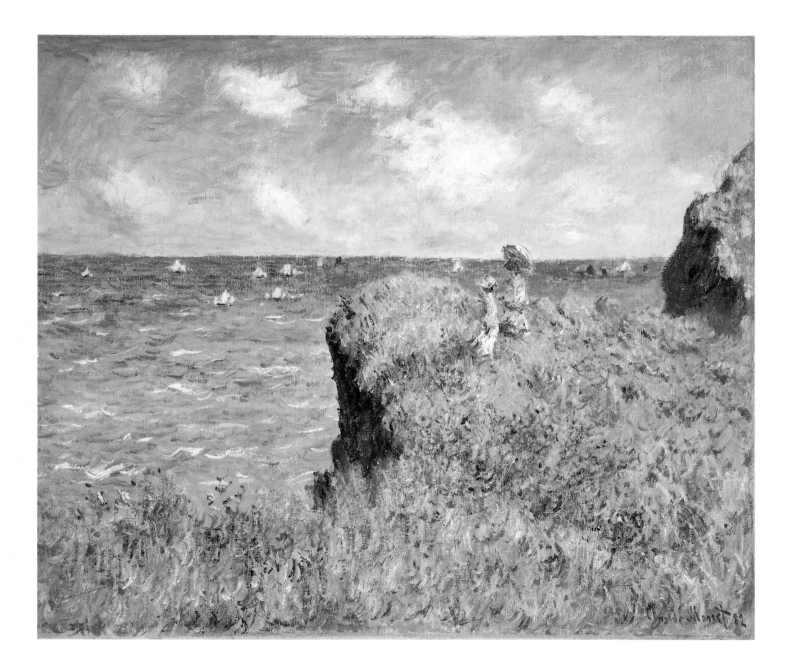

No. 117. Claude Monet
CLIFF WALK AT POURVILLE, 1882
(detail on p. 272)

286 A DAY IN THE COUNTRY

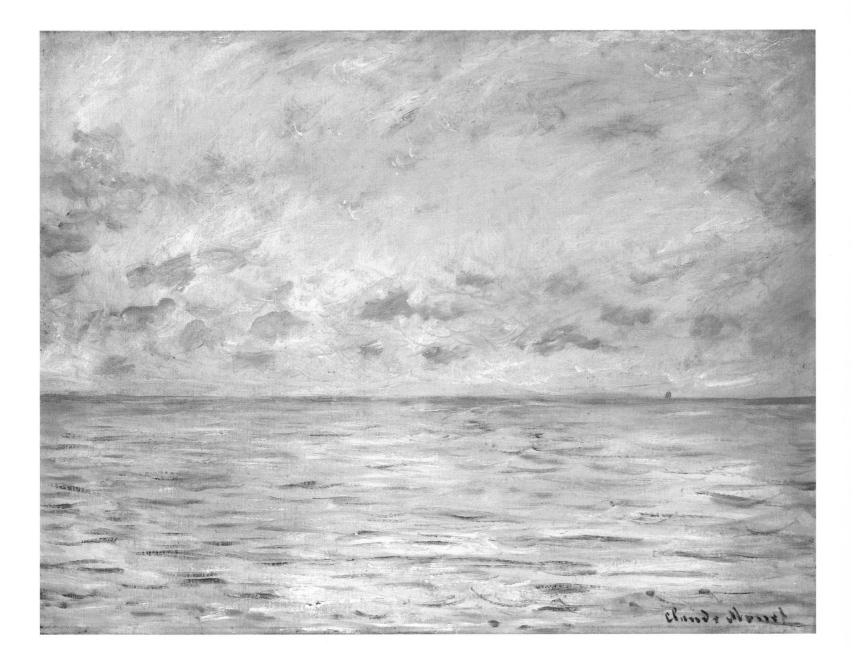

No. 118. Claude Monet
THE SEA AT POURVILLE, 1882

years of his career and at Argenteuil (nos. 40, 43, 48). He continued to show his female silhouettes from a distance, even going so far as to depersonalize them (no. 83). "I want to paint the air in which bridge, house, and boat are located, the beauty of the air around them, and that is nothing less than impossible,"[7] he stated. On the one hand, the treatment of the two figures here harks back to a work dating from 1875 and depicting Camille, Monet's first wife, walking along a cliff with her young son Jean (*The Promenade* [Paul Mellon Collection]); on the other, it looks forward to the experiments the artist later undertook at Giverny in the two *Figural Experiments in Open Air*, that is, the two large canvases painted during the summer of 1886 and based on *Woman with the Umbrella* (Musée d'Orsay, Galerie du Jeu de Paume, Paris), the protagonist of which has been identified as Suzanne Hoschedé, the third daughter of the Hoschedé family.

NOTES
1. Wildenstein, 1974–79, vol. II, pp. 216, 217.
2. Hoschedé, 1960, vol. I, p. 119.
3. Wildenstein 757.
4. Ibid. 754.
5. Rouart *et al.*, 1972, p. 26.
6. Seitz, 1960, p. 116.
7. Hoschedé, 1960, vol. II, p. 112.

118. Claude Monet

THE SEA AT POURVILLE
(*LA MER À POURVILLE*), 1882

Probably by analogy with a very similar canvas called *Sunset at Pourville, Open Sea* (1882; Private Collection, Switzerland), this work and two other seascapes were assumed by Daniel Wildenstein to have been done by Monet on the Norman coast during the summer of that year.[1] Although the artist dismissed it as a *"pochade,"* or quick sketch, a term he used often, it was bought by Durand-Ruel immediately after Monet returned from Pourville to Poissy in October.

The way sea and sky share space in these compositions evokes the manner of Monet's former teacher, Boudin, who, as we have seen, did a great number of pastel studies of the sky to give the clouds in his paintings a lightness and full range of hues. Other painters of the time were equally intrigued by the representation of waves (no. 120).

NOTE
1. Wildenstein 772–774.

119. Claude Monet

THE MANNEPORTE, HIGH SEAS
(*LA MANNEPORTE, MARÉE HAUTE*), 1885

Etretat! Monet never forgot its swaggering sailors, fragile boats, and still untamed shores. And whenever he felt the call of the sea in his peaceful Giverny [see above, III/ 6], he would head straight for Etretat and feast his eyes if not on the coastal landscape and sailors he so admired, then at least on the open sea, immutable under the cloud-filled sky and quick to roll in and exchange greetings with its painter, exhibiting the same fury and charm as in the far-off days when the artist was infatuated with the eternal youth of a sea as old as the earth itself....[1]

Monet's discovery of the Etretat cliffs dated to 1868–69, long before the Giverny period invoked here by Gustave Geffroy. The highly picturesque character of the area, located between Dieppe and Le Havre, attracted his friend Maupassant as well. An ardent devotee of the region, Maupassant used Etretat as a setting for several stories and novellas. In "The Model," for example, he described it as follows:

Crescent-shaped, the small town of Etretat with its white cliffs, white pebbles, and blue sea rested in the sun....At the two points of the crescent, two gates....[2]

The feelings he gives to the heroine of the novella *Une Vie* when she looks at Etretat might well be attributed to Monet: "It seemed to her that Creation possessed three truly beautiful things: light, space, and water."[3]

Following in the footsteps of Courbet and Boudin, Monet painted the Porte d'Amont and Porte d'Aval, sometimes with L'Aiguille and the Manneporte (figs. 62–63), which, according to Maupassant's description, was an "archway so enormous a ship could pass through it."[4] The Manneporte, located to the south of the Etretat beach, is the largest of the three gates or openings, as its name ("Manneporte" deriving from "Magna Porta") implies.[5] In this composition Monet was looking west, studying the play of light on the calm sea and the rock. He also painted the Manneporte from downstream or when the sea was choppy.

Although Monet vacationed at Etretat yearly between 1883 and 1886, he concentrated on painting the cliffs during his last two stays there. In 1886 Maupassant published an article on the artist:

Last year...I often followed Claude Monet about in his search for impressions. He was no longer a painter, actually; he was a hunter. He walked along, trailed by children carrying canvases, five or six canvases representing the same subject at various hours of the day and with varying effects. He would pick them up or drop them one by one according to how the sky changed. And face to face with his subject he would sit and wait, watching the sky and shadows, gathering up a falling ray or passing cloud in several dabs of the brush and, disdainful of everything false and conventional, setting it down on his canvas with great alacrity. I once saw him catch a sparkling shaft of light on a white cliff and fix it to a rush of yellows that gave an eerily precise rendering of the blinding ineffable effect of its radiance....[6]

NOTES
1. Geffroy, 1924, vol. I, pp. 115–116.
2. Maupassant, 1974, vol. I, p. 1103.
3. Maupassant, 1883, chap. 3.
4. Maupassant, 1974, vol. I, p. 413.
5. See Lindon, 1960, p. 180, for a map; also idem, 1963.
6. Wildenstein, 1974–79, vol. II, p. 42.

120. Auguste Renoir

THE WAVE
(*LA VAGUE*), 1879

In a large bare room a heavy-set man...was smearing slabs of white paint with a kitchen knife on a large bare canvas. From time to time he would go and press his forehead to the window, peering into the tempest. The sea came so close it seemed to beat against the house, already steeped in foam and clatter....Then Courbet...would go back to his work, a work that became his *Vague* and gained a certain notoriety.[1]

This account by Maupassant of a visit he paid to Courbet at Etretat refers to the famous painting now in the Musée du Louvre and first exhibited at the Salon of

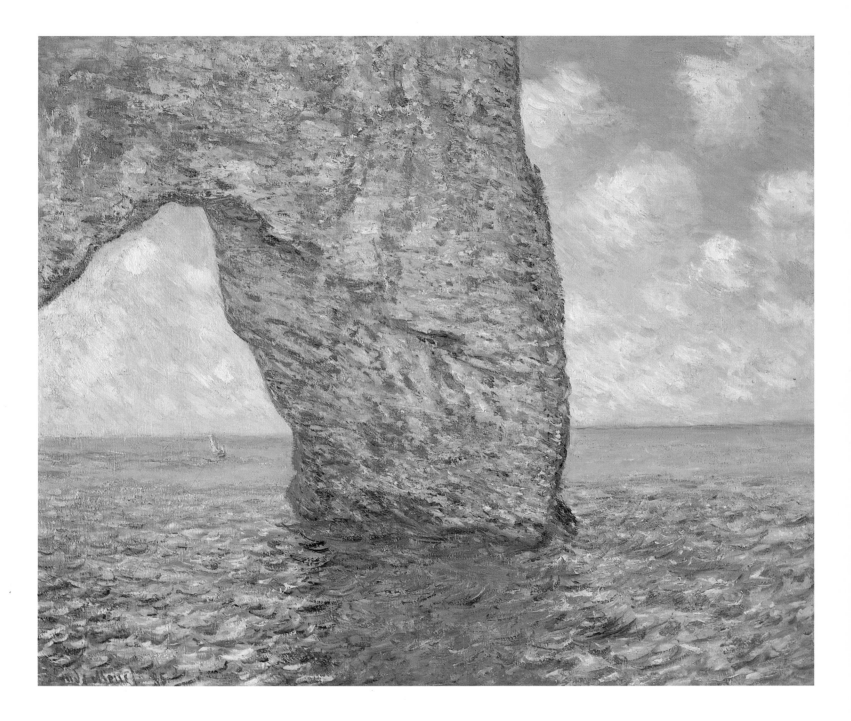

No. 119. Claude Monet
THE MANNEPORTE, HIGH SEAS, 1885

1870. Courbet returned to the subject over and over again, attracted by the Romantic character of waves in the canvases of the earlier Paul Huet. Hélène Toussaint has pointed to the possible influence on Courbet of J. A. M. Whistler's *Blue Wave* (1862; Hillstead Museum, Farmington).

Far from sharing the Romantic spirit of Courbet and Whistler, Renoir approached the same subject, a rare one for him, in the manner of Monet's pictorial investigations at Pourville and Etretat (nos. 117–119). Using the same light stroke which characterized his land- and seascapes of the period, Renoir transferred pure colors directly from palette to canvas, where they blended into a finely shaded spectrum.[2] But he was a step ahead of his friend on the road to abstraction. Predating Monet's *Water Lilies* by more than 20 years, *The Wave* seems at first to be an abstract field, a study in colors and light rather than the representation of a choppy sea and storm-swept sky.[3]

Among the numerous parallels between Impressionist paintings and eighteenth-century Japanese prints, the drawings of Hokusai, brought together in the famous Manga volumes that began making their appearance in Paris in the 1850s, deserve special mention. Led by Manet, all the Impressionists perused the mammoth collection (particularly the first of the 15 volumes), which was published between 1814 and 1879. The influence of Hokusai's subject matter on Renoir is indicated by *The Wave*.

NOTES
1. Réunion des Musées Nationaux, 1977, nos. 112, 117.
2. "Renoirs...Institute," 1925, p. 32.
3. The Art Institute of Chicago, 1973, no. 27.

121–124. Georges Seurat
PORT-EN-BESSIN, THE OUTER HARBOR AT HIGH TIDE
(*PORT-EN-BESSIN, AVANT-PORT, MARÉE HAUTE*), 1888
PORT-EN-BESSIN, THE OUTER HARBOR AT LOW TIDE
(*PORT-EN-BESSIN, L'AVANT-PORT À MARÉE BASSE*), 1888

THE BRIDGE AND QUAYS AT PORT-EN-BESSIN
(*LE PONT ET LES QUAIS À PORT-EN-BESSIN*), 1888
SEASCAPE AT PORT-EN-BESSIN, NORMANDY
(*LES GRUES ET LA PERCÉE À PORT-EN-BESSIN, NORMANDY*), 1888

Seurat painted his famous *grandes machines*, or large compositions, in winter, preferring to devote summers to smaller canvases. From his stay in Port-en-Bessin during the summer of 1888 (Signac had been there before him, in 1882 and 1883) Seurat brought back six seascapes, whose technical mastery and atmosphere of tranquility and silence made them one of the painter's most successful series. They represent an unusually harmonious combination of the devices Seurat employed in his quest for perfection.

Port-en-Bessin, which the local populace calls simply "Port," is located in a cove on the Calvados coast, just east of the Cotentin peninsula in Normandy. Its special, picturesque quality comes from a tiny harbor nestled in marlstone cliffs and from the bustle of its harbor. The outer harbor is bounded by two granite breakwaters, which provide shelter for the sailboats visible in *Port-en-Bessin, the Outer Harbor at High Tide*.

In addition to the works illustrated here, Seurat depicted Port-en-Bessin in *Entry to the Outer Harbor* (Museum of Modern Art, New York), which concentrates on the sailboats themselves, and *Sunday at Port-en-Bessin* (Rijksmuseum Kröller-Müller, Otterlo), a highly decorative composition featuring masts decked with flags.

Inspired by the writings of Delacroix, Charles Blanc, Eugène Chevreul, and the American Ogden Rood, Seurat began to paint according to "simultaneous color contrast" theories and, using separate strokes, began to produce spectacular, vibrating light effects in his pictures. His "scientific" bent led him to look into Charles Henry's research on the expressive power of lines, horizontals providing a source of calm, descending lines provoking sadness, and rising lines giving a sense of high spirits.[1] The Port-

en-Bessin seascapes are a good example of Seurat's tendency to geometrize his compositions, though John Rewald has noted the introduction of wavy lines here as well.[2] Seurat's use in these pictures of painted borders was explained in 1889 by Félix Fénéon:

This arrangement does away with the bands of shadow created by three-dimensional frames and enables the artist to color in the frame while working on the painting....[3]

Seurat showed these versions of Port-en-Bessin (minus *Seascape at Port-en-Bessin, Normandy* and plus one other painting of the site) at the sixth exhibition of Les XX in Brussels in February 1889. In the autumn of the same year *The Bridge and Quays at Port-en-Bessin* elicited the following comment from Fénéon:

We might wish the figures walking along the Port-en-Bessin embankment a bit less stiff; if the stray child has a charming, accurate look about him, the indistinct customs officer and the woman carrying firewood or dried seaweed lack veracity. We have known the customs officer for two years now; he was the leader of the *Parade*, another canvas by Monsieur Seurat.[4]

In 1890, the year before his death, Seurat was represented by several views of Port-en-Bessin at the "Salon des Indépendants," where the Parisian public first saw *Seascape at Port-en-Bessin, Normandy*.

NOTES
1. Fénéon, 1970, vol. I, p. 165.
2. Dorra and Rewald, 1959, p. lxvi.
3. Ibid., p. xvi, n. 9.
4. Fénéon, 1970, vol. I, p. 165.

125. Paul Signac
THE ANCHORAGE OF PORTRIEUX
(*LA RADE DE PORTRIEUX*), 1888

Signac spent a portion of the year 1888 in the small Breton village of Portrieux, located on the Channel coast. Situated about 11 miles from Saint-Brieuc, the capital of the Côtes-du-Nord, and with a population of approximately 957 according to Joanne in his guidebook of 1867,[1] Portrieux was notable for its harbor, as a bathing place, and for an event

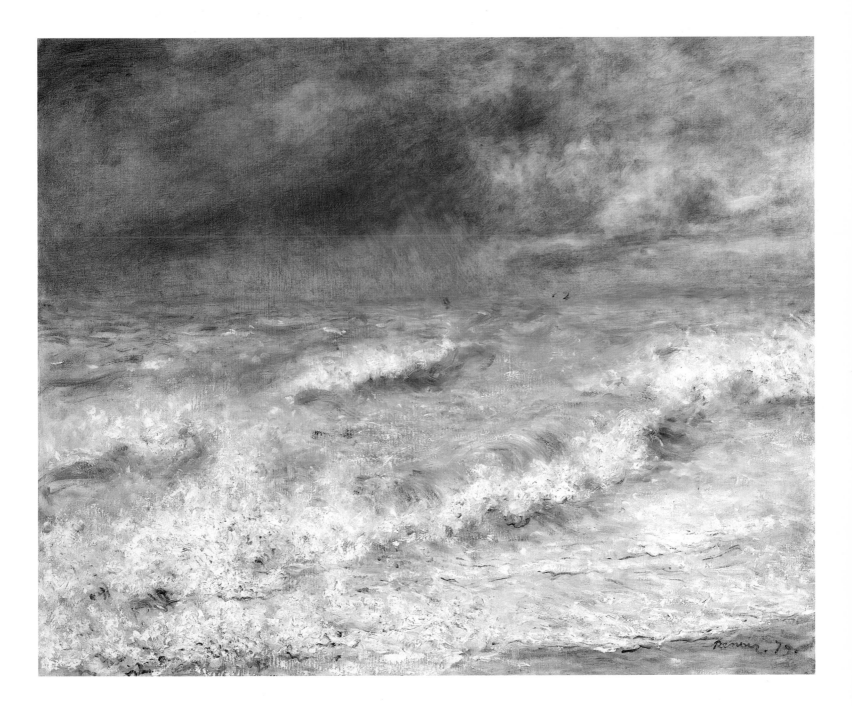

No. 120. Pierre-Auguste Renoir
THE WAVE, 1879

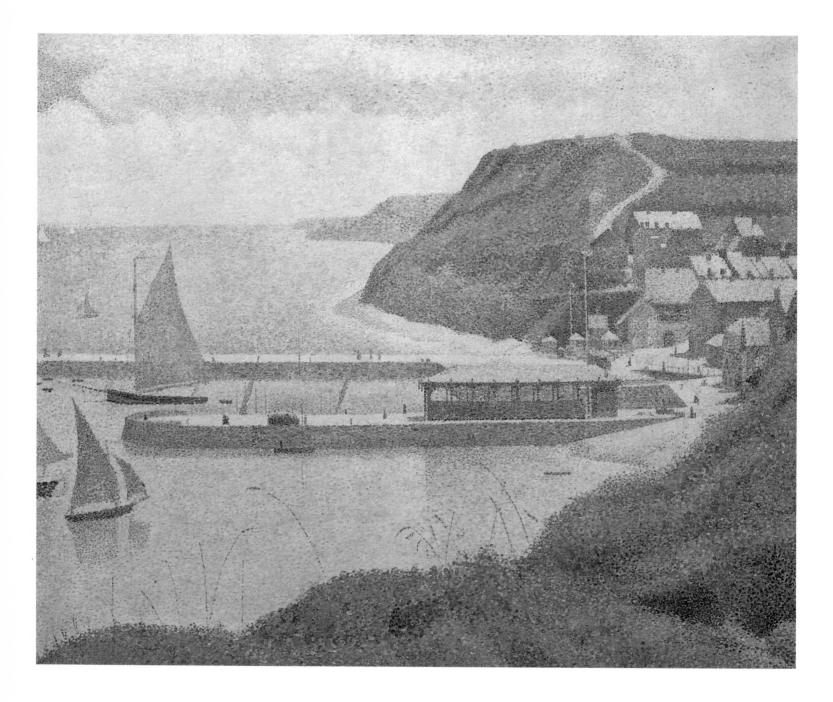

No. 121. Georges Seurat
Port-en-Bessin, the Outer Harbor at High Tide, 1888

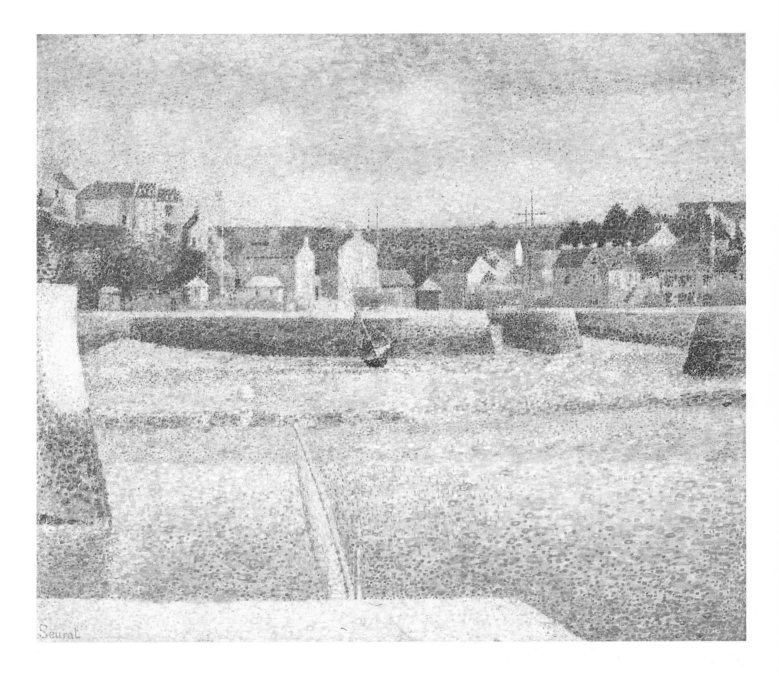

No. 122. Georges Seurat
Port-en-Bessin, the Outer Harbor at Low tide, 1888

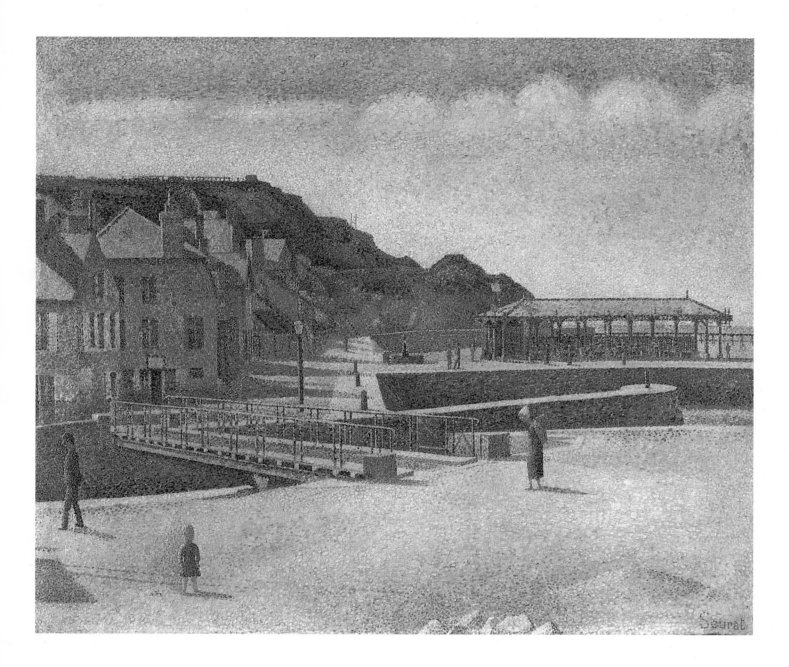

No. 123. Georges Seurat
The Bridge and quays at Port-en-Bessin, 1888

A DAY IN THE COUNTRY

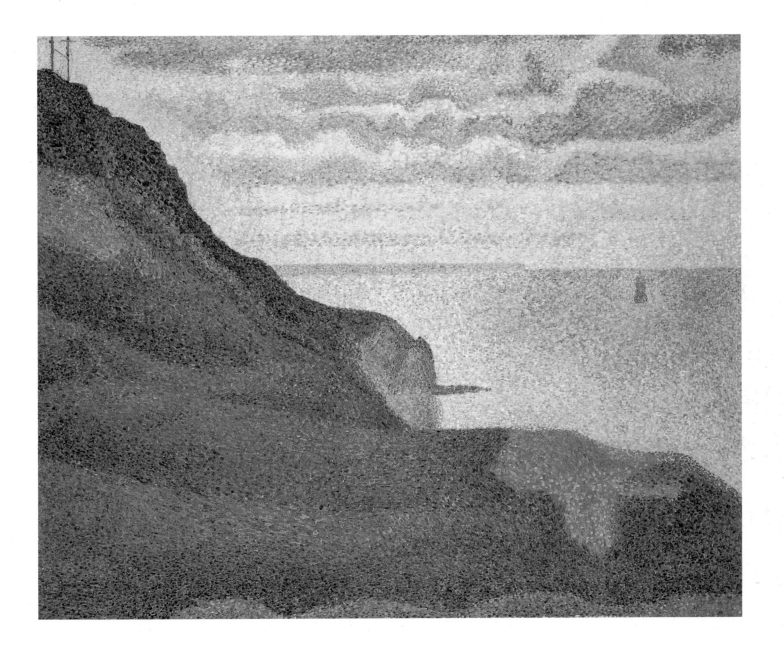

No. 124. Georges Seurat
SEASCAPE AT PORT-EN-BESSIN, NORMANDY, 1888

which took place "on the Sunday nearest the first flood-tide in May," in which "the fishing fleet of the Bay of St. Brieuc (with about 4,000 men) [set] sail hence for the Newfoundland fishing banks."[2] As an intrepid sailor, Signac was naturally drawn to the village. The light and atmospheric effects of the Breton coast offered an opportunity for him to further his exploration of the divisionist technique he had learned from Seurat. In *D'Eugène Delacroix au Néo-Impressionnisme* (1899), he attempted to define these goals:

> ...to assure the benefits of luminosity, color, and harmony: by optical mixture of uniquely pure pigments (all the colors of the prism and all their tones); by the separation of various elements (local color, light, and their interactions); by the balancing of these elements and their proportions (according to the laws of contrast, gradation, and irradiation); by the selection of a brushstroke commensurate with the size of the canvas.[3]

One of several studies of the harbor, *The Anchorage of Portrieux* was originally offered by the painter to Charles Henry, the scientist whose theories had been so important to his own research and with whom he collaborated in the publication of *Education du sens des formes* (1890) and *Cercle chromatique présentant tous les compléments et toutes les harmonies en couleurs* (1888–89). *The Anchorage at Portrieux* displays a bright palette, which is typical of Signac's northern studies, in contradistinction to that which he adopted in painting the "blond" light of the Mediterranean. The use of counterbalancing diagonals as a compositional motif, so obvious in this picture, may derive from his studies of Henry's theories concerning the psychological effects of the direction of lines upon a viewer (nos. 121–124).

—S. S.

Notes

1. A. Joanne, 1867, p. 413.
2. Baedeker, 1894, p. 205.
3. Rewald, 1978, p. 98, n. 51.

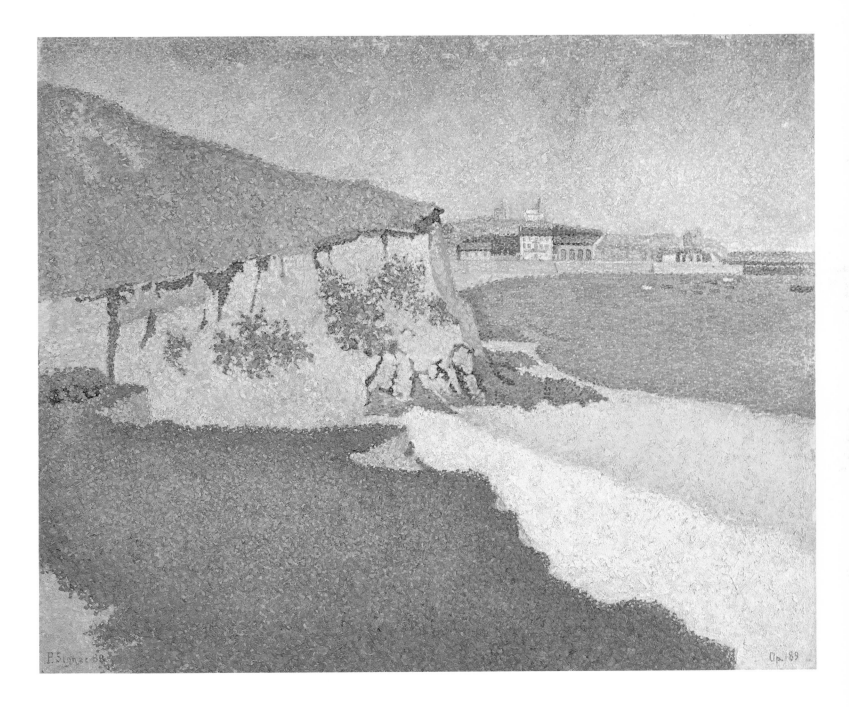

No. 125. Paul Signac
THE ANCHORAGE AT PORTRIEUX, 1888

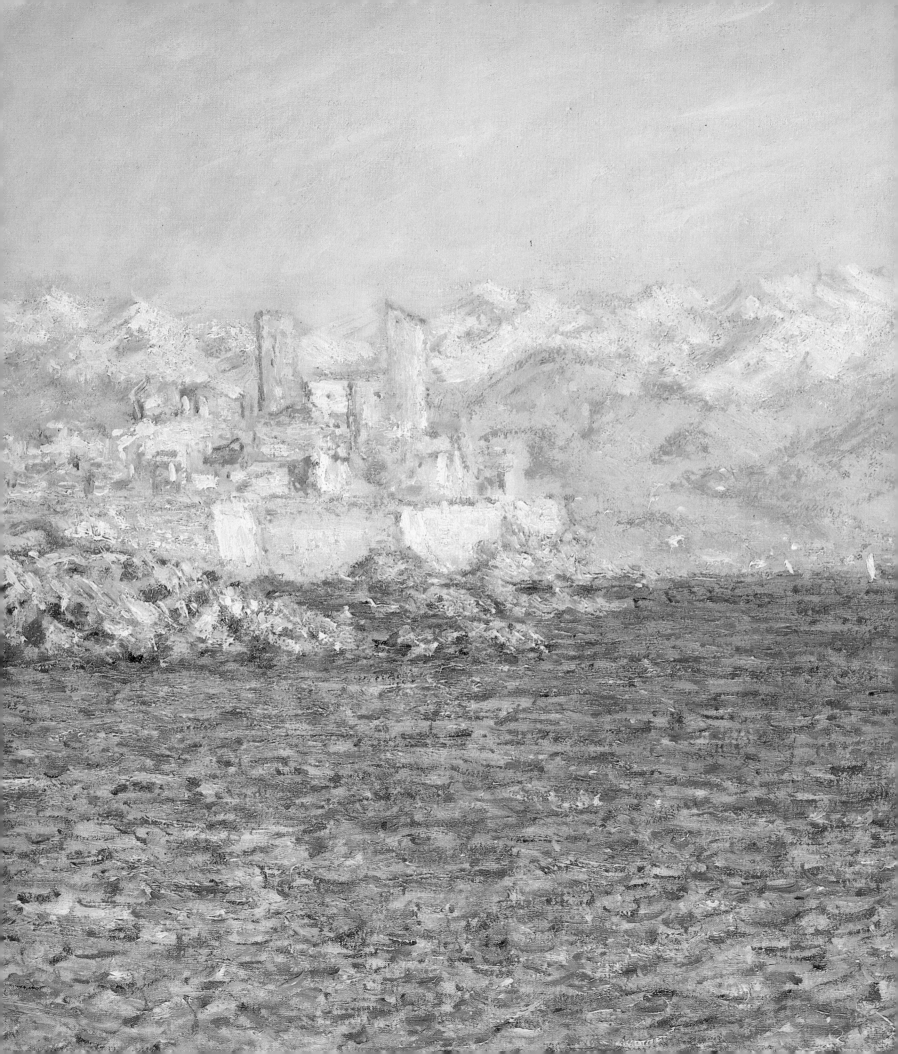

III/9

The Retreat from Paris

AS WE HAVE SEEN, France in the 1880s and '90s saw a rapid acceleration in the growth of travel and tourism. With the migration of a large portion of the population to the increasingly industrialized cities and their suburbs, an intense yearning was felt for the pure air and open spaces of country and coastal resorts. Facilitated by the swift expansion of the railway lines (essentially, by the 1890s, to their present extent [see above, III/3–4]), brief excursions, as well as seasonal sojourns for those of greater means, became ever more customary interludes in the city dweller's life. Indicative of the burgeoning significance of tourism was the formation of agencies such as the *syndicats d'initiative,* or tourist information bureaus, the first of which dates from 1885. During the period between 1874 and 1900, numerous *comités de promenade,* or walking clubs, also were established throughout the provinces; in 1890 the Touring Club de France, one of the most influential forces in the development of tourism, was created.[1]

The primary distinctions between travel in the final decades of the nineteenth century and that in the preceding years lay in the distances traversed and in the interest in exploring outlying regions. The upper class, always in possession of more leisure, had for some time frequented coastal areas such as the Côte d'Azur (see above, III/8), but with progress in the speed and ease of transportation, those of lesser means could now explore the more remote regions much as they had once gone to places such as Bougival or Louveciennes on the outskirts of Paris (see above, III/2). The appearance in 1893 of the first volume of Victor-Eugène Ardouin-Dumazet's monumental 60-volume *Voyage en France* is proof of the interest that travelers now took in the entire map of France.

Pierre Giffard's *La Vie en chemin de fer*, published six years earlier, provided the traveler with a complete guide to using the railway system in France—from which seat to occupy in a given car on a given line to which buffet service was the best. However, Giffard believed that "one could say that France, at least within a radius of 200 miles, is no more than a suburb of Paris, thanks to the railroad."[2] In his view the destruction of the barriers between city and country encouraged by the train was detrimental to maintaining the traditional geographical and social organization of France. Thus, as we have seen, the revolution in transportation and tourism that encouraged travel to the furthest corners of France was greeted with mixed emotions by contemporary writers (see above, III/8).

Parallel to this general trend in travel, artists began to find their subject matter in hitherto little-explored areas. During the 1860s and '70s the Impressionists largely had frequented Paris and its environs, the forest of Fontainebleau, and locations along the northern coastal area extending from Honfleur to Dieppe (see above, III/1–2). In subsequent decades younger Neo-Impressionist artists such as Signac, Seurat, and Cross, as well as a few of the older Impressionists such as Monet, discovered the Riviera (see above, III/8). The landscapes they painted there are, in an iconographic sense, simply geographical extensions of the Parisian landscape of early Impressionism, as we have seen. On the other hand, Cézanne, Gauguin, and Van Gogh journeyed into the more primitive regions of Brittany in the north and the Midi and Provence in the south. In their desire to maintain their independence from urban civilization and its surburban dependencies they moved further and further from Paris. Anti-urban as well as anti-nationalistic, the new generation and a few artists who had come into prominence in the previous generation selected the two provinces most aggressively opposed to Paris in particular and France in general. Brittany and Provence each had been independent at several points in their long histories, and each maintained its unique customs. Both were attempting to restore original or "lost" languages and cultures just as they were being discovered by the painters. In Provence, for example, the regionalist movement in literature was spearheaded by a contemporary of Cézanne's, the poet Frédéric Mistral, one of the earliest winners of the Nobel Prize.

The far reaches of France, now so easily accessible, provided inspiration both for the artists' work and their lifestyles. However, it is interesting that some areas seem to have remained too remote for them. The Pyrenees, for example, or the French Alps never were painted by the original Impressionists and their successors in spite of (or perhaps because of) the fact that many tourists and innumerable photographers traveled to those areas (see below, V).

By the mid-1880s the Impressionists as a group exhibited little unity, and many were deeply dissatisfied with what they saw as the superficiality of their own approaches. A growing need was felt for an art of greater profundity, of a timeless nature, and it was with this in mind that, in 1886, Gauguin set off for Pont-Aven, a village in the south of Brittany. Paul Sérusier, a friend and protégé, outlined the tenets of the aesthetic program Gauguin was to follow:

> ...the impression of nature must be wedded to the esthetic sentiment which chooses, arranges, simplifies, and synthesizes. The painter ought not rest until he has given birth to the child of his imagination...begotten by the union of his mind with reality...Gauguin insisted on a logical construction of composition, on a

harmonious apportionment of light and dark colors, the simplification of forms and proportions, so as to endow the outlines of forms with a powerful and eloquent expression....[3]

Although most often associated with the name of Gauguin and his followers, Bernard, Charles Filiger, Sérusier, Maurice Denis, Emile Schuffenecker, and Meyer de Haan (collectively known as the Pont-Aven school), Pont-Aven had for some time been established as an artists' colony. Boudin, François Bonvin, Daubigny, and Whistler had all worked in the Breton region, while in 1862 two friends of Corot, Français and Auguste Anastasi, had worked within Pont-Aven itself, soon to be followed by the Academic artist Jules Bastien-LePage. And, in the 1880s, Monet and Renoir also made working expeditions there. The French artists were soon followed by an international group including English, Belgian, Dutch, Scandinavian, and American painters.[4] The attractions of the Breton region were compelling: a landscape dominated by dolmens and menhirs (monuments of ancient Celtic origin), strong and mystical religious customs, and a distinctly picturesque mode of dress maintained by a concerted sense of individualized tradition. Nature here was savage and the lifestyle archaic and harsh, dependent entirely upon the bounty of the land and the sea.

From 1886 to 1890 Gauguin spent much time in Pont-Aven, with the exception of trips to Martinique and Arles, and, when the mass of visitors who sought the unusual and traditional became overwhelming, in the nearby coastal village of le Pouldu. Like many artists, Gauguin initially had been attracted to Brittany by financial considerations. Henry Blackburn, in his guide *Breton Folk: An Artistic Tour in Brittany* (1880), had noted that an artist could live on credit at the Pension Gloanec in Pont-Aven, and Gauguin, finding this to be true, wrote with satisfaction of his new living arrangements in a letter of June 1886, addressed to his estranged wife, Mette:

> I managed to find the money for my journey to Brittany, and am living here on credit....What a pity we did not take up our abode in Brittany formerly; at the pension we pay 65 francs a month for board and lodging, and one can soon grow fat on the food.[5]

His delight with the Breton region was, nonetheless, far more than monetary: "I love Brittany. I find wildness and primitiveness there. When my wooden shoes ring on this granite, I hear the muffled, dull, and powerful tone which I try to achieve in painting."[6]

Bernard, in an 1892 letter to Schuffenecker, offered his own poetic, if enigmatic, observations of Pont-Aven: "This is the country of atrocious dreams, of hideous nightmares, of walls garnished with larvae and sea-eagles, with owls and vampires, fit to die."[7] That the lure of the region did not work on all who visited there, however, is made clear in a letter from Signac to his fellow-artist Luce:

> Yesterday I was at Pont-Aven. It is ridiculous countryside with little nooks and cascades, as if made for female English watercolorists. What a strange cradle for pictorial Symbolism....Everywhere painters in velvet garments drunk and bawdy. The tobacco merchant has a sign in the form of a palette: "Artist's Material," the maidservants in the inns wear arty ribbons in their headdresses and probably are syphilitic.[8]

A master yachtsman, Signac found several cities along the Channel coast more suited to the demands of his temperament and his art (no. 125).

Despite his dislike for Brittany, Signac and the other Neo-Impression-

ists felt, like Gauguin (a bitter rival) and his followers, that art must achieve a deeper and more lasting significance. The contemporary critic Fénéon explained:

> The phenomenon of the sky, of water, of shrubbery, varies from second to second, according to the original impressionists. To cast one of these aspects upon the canvas—that was the goal. Hence the necessity to capture a landscape in one sitting and hence an inclination to make nature grimace in order to prove conclusively that the moment is unique and will never occur again. To synthesize landscapes in a definite aspect which will preserve the sensation implicit in them is the neo-Impressionists' endeavor. Moreover, their procedure makes haste impossible and necessitates work in the studio....Objective reality is for them a simple theme for the creation of a higher and sublimated reality into which their personalities are transfused.[9]

Thus the Neo-Impressionists sought to establish their art upon a firm scientific basis, largely drawn from Seurat's interpretation of the work of Chevreul and Henry (nos. 121–124). Paradoxically, as those within Seurat's circle penetrated further into the provinces in search of subject matter, Seurat himself proved atypical. Increasingly he turned to the city for inspiration and by the end of his life, cut short at the age of 31, he had entirely abandoned landscape for interior scenes.

It was most often the south of France, then, which captured the imagination of tourist and artist alike in the latter years of the nineteenth century. For the tourist the appeal was largely that of the beaches, mountains, and climate; artists, too, were drawn by the mountains and water, but most of all by the dazzling light. Beyond these basic common denominators, however, individual motivations for the move to the south were as diverse as the artists themselves. Cézanne, for example, the victim of harsh criticism and ridicule in the Impressionist exhibitions of 1874 and 1877, largely abandoned Paris and its environs during the 1880s for his native Aix, the old capital of Provence. Although his return to the landscape of his boyhood was a form of escape from the pressures of Paris to work in isolation and to confront his art, it must never be forgotten that he returned to the region—and to a small city—rich in historical resonance as well as separatist feeling. Colonized by the Romans at the end of the second century B.C., Aix was later the capital of Provence until its annexation in 1481 by the French crown. With a population of about 29,000 at the end of the 1800s, the city is listed in the 1914 Baedeker guide as famous for its olive oil and cakes.[10] When Cézanne returned there, Aix was the capital of the then-current Provençal revival. André Gouirand, for example, a minor Provençal intellectual, published a history of the area's modern school of painters that traced its roots to the mid-eighteenth century with François Duparc.[11] Cézanne, although not mentioned in this work, was in many ways the culminating genius of this tradition, and many of his best pictures could easily be paired with passages in Gouirand's short book. In fact, Cézanne's *Old Woman with a Rosary* (The National Gallery, London) was painted in homage to Duparc's *Woman Knitting* (Musée des Beaux-Arts, Marseille).

Brilliant in color and rich in contrast, an amalgam of blazing sun, vivid blue sky, and textured rock, this region, in spite of Gouirand's proselytizing, inspired few artists of great importance. In fact, it is almost exclusively with Cézanne's views of Mont Sainte-Victoire, which commanded the landscape to the east of Aix from a height of 3,315 feet; the Golfe de l'Estaque; and the village of Gardanne that this area of the Midi has come to be associated. Here, away from hostile criticism and sometimes well-intentioned

misunderstanding, Cézanne isolated himself in an intense and lonely struggle: "I think of art as personal apperception. I place this perception in sensation, and I require that the intelligence organize it into a work of art."[12] Clearly disillusioned with the approach that brought many of his fellow Impressionists success and renown, always dissatisfied and disappointed with his own efforts, his love of this land remained Cézanne's one certainty: "For me, what is there left to do…only to sing small; and were it not that I am deeply in love with the *configuration* of my country, I should not be here."[13]

The Midi was to attract a second artist of tragic circumstance and unique vision. In February 1888 Van Gogh set out for Arles, a Provençal city to the west of Aix-en-Provence. Arles had long been famous for its Roman ruins and the Romanesque church of Saint-Trôphîme, but its appeal for Van Gogh was different. In a letter of September 1889, written to his brother, Theo, the artist summarized his motivation in coming to the south of France:

> You know that there were thousands of reasons why I went south and threw myself into my work there. I wanted to see a different light, I thought that to observe nature under a clearer sky would give me a better idea of the way in which the Japanese feel and draw. I also wanted to see this stronger sun because I felt that without knowing it I could not understand paintings by Delacroix from the standpoint of execution and technique, and because I felt that the colors of the prism were blurred by mist in the North.[14]

That Van Gogh felt this region to be particularly conducive to artistic progress already had been made clear in a letter to Theo of June 1888: "One likes Japanese painting, one has felt its influence—all the impressionists have that in common—then why not go to Japan, that is to say the equivalent of Japan, the *midi*? Thus I think that after all the future of the new art lies in the South."[15]

Van Gogh's plan was grander and more utopian than those of the numerous artists who migrated to the south of France during the final decades of the century. He envisioned a "Studio of the South," which, with characteristic modesty, he hoped to put under the leadership of Gauguin. In sympathy with Van Gogh's ideas, but more inclined to a location in the tropics (at this point, Martinique), Gauguin, still in Pont-Aven, informed Bernard: "I am inclined to agree with Vincent: the future is to the painters of the tropics, which have not yet been painted. (Novelty is essential to stimulate the stupid buying public.)"[16] In desperate financial straits, Gauguin agreed, after much pleading on Van Gogh's part, to move to Arles, where both painters were to be supported by Theo. But in December 1888 Gauguin once again wrote to Bernard:

> I am at Arles quite out of my element, so petty and shabby do I find the scenery and the people. Vincent and I do not find ourselves in general agreement, especially in painting…. He is romantic while I am rather inclined towards a primitive state.[17]

The tragic end of the "Studio of the South" is well known: Van Gogh, overcome by madness, purportedly tried to attack Gauguin and then severed his own ear. The latter left the following day for the north, and Van Gogh, after a period of convalescence, in May 1889 entered an asylum in nearby Saint-Rémy (no. 90). For Van Gogh's art, however, this period had been of supreme importance, as he attained a new mastery of color and an ability to render a more potent expression of those life forces and cycles he discovered beneath the constant flux of nature.

Not all journeys to the south, however, were characterized by the isolation, disappointment, and disaster we have seen in the cases of Cézanne,

Gauguin, and Van Gogh. Like those who had traveled to the areas surrounding Aix and Arles, the artists of the Côte d'Azur were also drawn by the intense light, lush vegetation, and temperate climate. Combined with the shimmering waters of the Mediterranean and the sandy beaches, the terrain was ideal for those who hoped to further their inquiries into the systematic representation of the interaction of light and color. Inspired by Signac and his explorations of the region, Cross, who had wintered at Monaco for years, settled in 1891 at Cabasson (no. 136), and in the following year at Saint-Clair, both tiny villages on the Mediterranean coast near Hyères, an area of the Var. Signac himself was later to build a home on the coast at Saint-Tropez, while in 1910 Cross had as a new neighbor the Belgian Neo-Impressionist Théo van Rysselberghe, a regular visitor since the early 1890s.

Thus in the closing decades of the nineteenth century, while the residents of the increasingly industrialized cities of France made a periodic exodus in search of leisure and relaxation, artists too, found their way to the remote regions of the country. Cézanne stands alone in his attempt, within the landscape of his childhood, to wrest from elusive vision its realization upon canvas in a new and solidly ordered depiction of the visible world. In escaping Paris and the national civilization for which she stood, he and Gauguin and his group paradoxically projected their art to a wider, non-Parisian audience. This withdrawal from the capital was a deliberate physical and iconological escape from original Impressionism. In contrast, Monet and Pissarro, in spite of their later travels, remained rooted in the soil of the Ile de France and continued to propagate the landscape formulas they had invented in the 1860s and '70s. This was true even though Monet later began to traverse a more personal and cerebral landscape, turning away from the portrayal of space to the depiction of the physicality of time. Following his move to Giverny in 1883, the world outside his garden and its immediate environs essentially ceased to exist (nos. 91–93).

The revolution in landscape painting which resulted in Impressionism, begun in the early nineteenth century, was now being fought on new aesthetic fronts. Following the lead of the major Impressionists, avant-garde artists at the end of the 1800s became less interested in rendering specific sites in the new style. Seurat, Signac, and Gauguin, for example, came to believe that the raw material presented by the natural world had to be fully digested by the artist's mind; they sought the personal, the psychological, the mythic, and the symbolic in the landscape of France. No longer dependent on the faithful rendering of an individual place, the new generation of landscape painters virtually eschewed the activities or haunts of the middle class. Instead these artists chose to paint landscapes of their own invention, relying not on reality, but on their imaginations. As the terrain in which they chose to work changed, they explored alternative approaches to subject matter in new and fascinating ways.

—S. S.

NOTES

1. Sigaux, 1965, pp. 74–75.
2. Giffard, 1887, p. 314.
3. Rewald, 1978, p. 184.
4. The Tate Gallery and Arts Council of Great Britain, 1966, p. 5.
5. Gauguin, 1949, pp. 68–69.
6. Rewald, 1978, p. 189.
7. Ibid., pp. 290–291.
8. Ibid., p. 290.
9. Ibid., p. 89.
10. Baedeker, 1902, pp. 444–445.
11. See Gouirand, 1901.
12. Hamilton, 1967, p. 42.
13. Rewald, 1977, p. 83.
14. Rewald, 1978, p. 344.
15. Ibid., p. 76.
16. Gauguin, 1949, p. 102.
17. Ibid., pp. 115–116.

126. Claude Monet

AFTERNOON AT ANTIBES
(ANTIBES, EFFET D'APRÈS-MIDI), 1888

In January 1888 Monet made his second trip to the Côte d'Azur. Four years earlier he had visited Bordighera and Menton, but this time he chose as his destination the popular seaside resort of Antibes, where, at the suggestion of Maupassant, he stayed at the Château de la Pinède, an establishment with a primarily artistic clientele. Initially unhappy with these lodgings, where, he found, the Academic landscapist Harpignies and his followers held sway, and dissatisfied with the region itself, in which he had arrived during a rainstorm, Monet eventually reconciled himself to the situation. He worked at Antibes and neighboring Juan-les-Pins until the beginning of May. In a letter to Alice Hoschedé dated January 20 he wrote:

> I'm painting the town of Antibes, a small, fortified town, entirely gilded by the sun, which stands out clearly against the beautiful blue and pink mountains and the chain of the Alps eternally covered with snow.[1]

The color and atmosphere of the surrounding area proved fascinating to the artist, as indicated in his subsequent letters. "The pink and blue are so clear, so pure, that the smallest inappropriate stroke creates a blot of dirt," he wrote.[2] "What I want to bring back from here is the sweetness itself, of white, of pink, of blue, all enveloped in this magical air."[3]

Monet obtained permission from the military authorities to paint at Antibes through the intervention of Castagnary, now Directeur des beaux-arts. Daniel Wildenstein pinpointed the site depicted in *Afternoon at Antibes,* sometimes called *Old Fort at Antibes:*

> When he wishes to paint Antibes at close range, Monet goes to the east coast of the cape and sets up his easel at the Ponteil.... As we proceed along the coast in the foreground, we note the Ilet headland with the Bastion Saint-André to the left, the steeple of the cathedral in the center, and the tower of the Château des Grimaldi off to the right; in the background we see the Franco-Italian Alps.[4]

The contrast between the canvases Monet painted at Antibes and the darker, more vibrant color and heavy brushwork of the Mediterranean scenes he painted earlier is striking. His palette had become pastel, dominated by the pink and blue tones he described in his letter to Hoschedé, while the brushwork, somewhat crusty in the foreground, becomes thin and smooth in the background, allowing glimpses of unpainted canvas. Monet's intent is clear: to capture the varied effects of sunlight as it was refracted against the surfaces of water, mountain, sky, and the walls of the fort.

Although the Antibes paintings were a great commercial success, critical reception was mixed. Particularly negative were the remarks of those who supported or who had joined the ranks of the Neo-Impressionists. Fénéon, in the July 1888 issue of *La Revue indépendante,* commented:

> Monsieur Claude Monet is a spontaneous painter....Well served by an overdone bravura of style, the productivity of an improvisor, and a brilliant vulgarity, his renown is growing, but his talent does not seem to have made any strides since the Etretat series....[5]

Pissarro, having adopted a Neo-Impressionist technique himself, was inclined to agree. In a letter to his son, Lucien, dated July 8 of that same year he observed:

> I've seen the Monets. They are lovely, but Fénéon is right: good as they may be, they are not the work of a sophisticated artist. To my mind—and I've heard him [Fénéon] say the same to Degas many times—they represent the art of a decorator, highly skillful, but ephemeral....[6]

But Monet's purpose was not decorative, nor were his Antibes paintings ephemeral. In the struggle to come ever closer to nature in its constant fluctuation, the works he did there are a logical progression toward his series paintings of the 1890s (nos. 104–112).

NOTES

1. Wildenstein, 1974–79, vol. III, p. 5.
2. Ibid., p. 5.
3. Ibid.
4. Ibid., p. 7 (translated by M. H. Heim).
5. Fénéon, 1970, vol. I, p. 113 (translated by M. H. Heim).
6. Pissarro, 1950, p. 171 (translated by M. H. Heim).

becomes the drawing....The contrasts and relations of tone comprise the secret of drawing and form...the form and contour of objects are conveyed to us through the opposition and contrast resulting from their individual colours...nature, for us men, is more depth than surface, whence the necessity of introducing in our vibrations of light—represented by reds and yellows—a sufficient quantity of blue to give the feeling of air.[4]

Thus, in *Mount Sainte-Victoire* one can observe the reduction of the range of tones in Cézanne's palette. Forms are outlined in blue, and fore- and background are balanced through the juxtaposition of warm and cool tonalities. Through the use of sharp contrasts of light and dark, as in that between walls and their fenestration, the artist has rendered the effect of unrelenting sunlight.

NOTES
1. Rewald, 1959, p. 135.
2. Gasquet, 1926, p. 148.
3. Loran, 1947, p. 127.
4. Rewald, 1959, p. 172.

131. Paul Cézanne

MOUNT SAINTE-VICTOIRE FROM THE LARGE PINE TREE
(*LA MONTAGNE SAINTE-VICTOIRE AU GRAND PIN*), 1885–87

This painting, which, characteristically, was reworked by Cézanne between 1885 and 1887, belongs to a stage in his development that is sometimes referred to as his "classical" period. His pictures produced during this time are often compared to those of Poussin. The composition here is planar and stable: the strong horizontal emphasis, strengthened by the inclusion of the train trestle at the base of the mountain, is counterbalanced by the vertical thrust of the trunks of the enframing pines. The "improved" landscape, in this case evidenced by the presence of the trestle (which resembles an aqueduct), had become important to Cézanne by this time. In the end, however, he utilized the *whole* landscape for purely formal purposes. The undulating branches in the foreground echo the rise

and fall of the mountains, while at the same time they emphasize the picture plane and set up a spatial ambiguity between fore- and background. Dominated by tonalities of green and yellow, the color is thin and muted, applied with hatched brush strokes that gradually build and give solidity to the forms represented.

132. Paul Gauguin

THE SWINEHERD, BRITTANY
(*LE GARDIEN DES PORCS, BRETAGNE*), 1888

In 1888 Gauguin made his second trip to Brittany and Pont-Aven. The author of *Breton Folk: An Artistic Tour in Brittany* offered this idyllic description of the countryside to which Gauguin had returned:

> At a point where the River Aven—breaking through its narrow channel, dashing under bridges and turning numerous water-wheels—spreads out into a broad estuary, is the little port of Pont-Aven, built four miles from the sea. The majority of the houses are of granite, and sheltered under wooded hills; the water rushes past flour-mills and under bridges with perpetual noise, and a breeze stirs the poplar trees that line its banks on the calmest day....A small community of farmers, millers, fishermen and peasant women, is its native population....Pont-Aven being set in a valley between two thickly wooded hills, opening out southwards to the sea, the climate is temperate and favourable to outdoor work.[1]

The picturesque nature of this landscape might have appealed more to one of the older Impressionists, such as Berthe Morisot, who worked at Pont-Aven in 1866, than to Gauguin. In fact, he professed himself to be attracted more by the primitive and harsh nature of the region and its customs than by the low cost of living. Nonetheless, in his many landscapes and scenes of peasant life, such as *The Swineherd, Brittany*, the artist presented scenes not unlike Blackburn's descriptions.

NOTE
1. Blackburn, 1880, pp. 128–130.

133. Paul Gauguin

THE ROMAN BURIAL GROUND AT ARLES
(*LES ALYSCAMPS, ARLES*), 1888

On October 20, 1888, after numerous invitations from Van Gogh, Gauguin arrived in Arles for a two-month stay. Rich in history, this Provençal town had, under Julius Caesar, been a rival of Marseille. Growing rapidly, it became known as "the Gallic Rome" and frequently served as a residence for the Emperor Constantine. Christianity came early to the city with the proselytizing of St. Trophimus, a disciple of St. Paul. With the fall of the Roman Empire, Arles became an independent city, and by 879 it was the capital of a kingdom which in the eleventh century was to include all the territory bounded by the Rhine, the Saône, the Rhone, the Mediterranean, and the Alps. The Holy Roman Empire soon annexed the region, but in 1150 Arles proclaimed itself a republic. Not until 1481, under Charles d'Anjou, did the city become a part of France.[1]

Henry James, in his *Little Tour in France* (1884), says of Arles:

> As a city, indeed, Arles quite misses its effect in every way; and if it is a charming place, as I think it is, I can hardly tell the reason why. The straight-nosed Arlesiennes account for it in some degree; and the remainder may be charged to the ruins of the arena and the theatre.[2]

Unimpressed by the blazing sun and rich color which so enchanted Van Gogh, Gauguin would have agreed with James as to the town's assets, albeit with much less enthusiasm. Despite his own description of the scenery and the people of Arles as "petty and shabby," Gauguin characteristically manifested some interest in the female population:

> Women here with their elegant coiffure have a Greek beauty. Their shawls, falling in folds like the primitives, are, I say, like Greek friezes. The girl passing along the street is as much a lady as any born and of as virginal an appearance as Juno...there is here a fountain of beauty, *modern style*.[3]

In *The Roman Burial Ground at Arles* Gauguin combined the Arlesian motifs of ruin and woman. One of Arles' most famous landmarks, and a site also

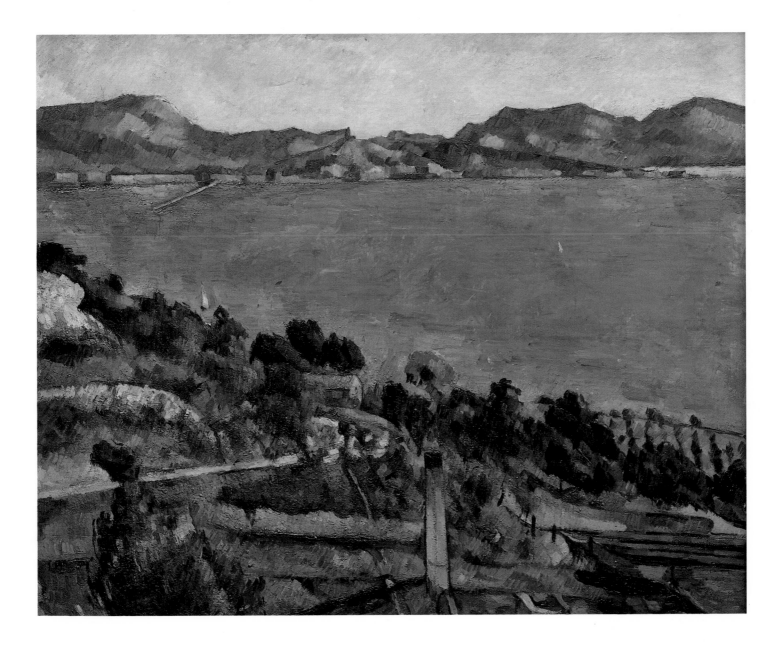

No. 127. Paul Cézanne
THE BAY OF MARSEILLE, SEEN FROM L'ESTAQUE, c. 1878–79

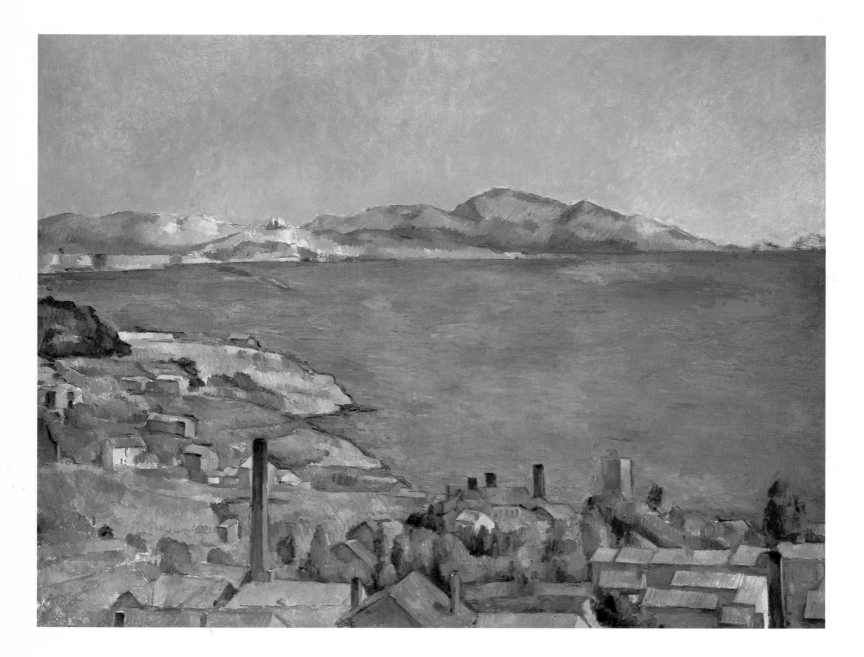

No. 128. Paul Cézanne
The Bay of Marseille, Seen from l'Estaque, 1883–85

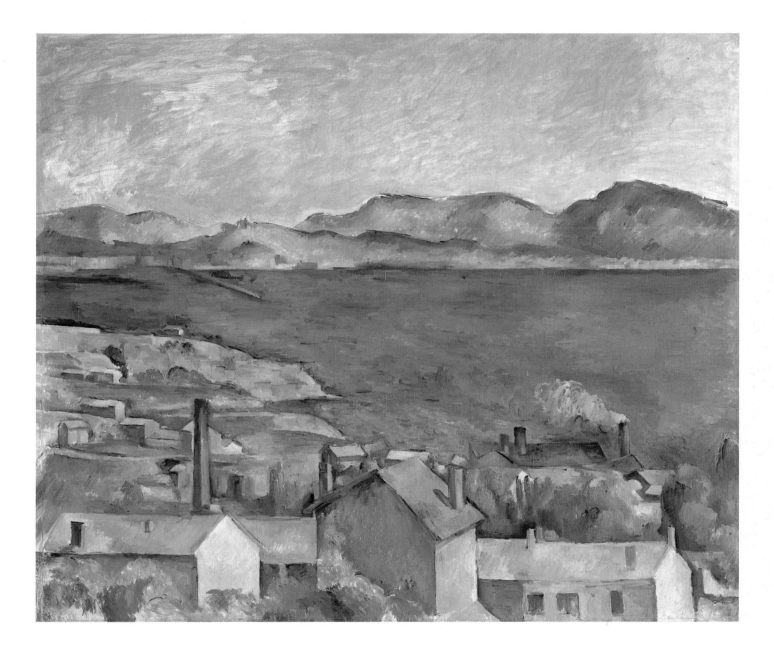

No. 129. Paul Cézanne
THE BAY OF MARSEILLE, SEEN FROM L'ESTAQUE, 1886–90

depicted by Van Gogh, the Alyscamps (or Champs-Elyseés) was a Roman burial ground which, or so legend had it, was later consecrated for Christian burial by St. Trophimus. Dante referred to this in the *Inferno*, where he spoke of "Arles where the Rhone turns to stagnant waters....The sepulchers make the land uneven."[4] The melancholia of the area continued to exert its influence into the nineteenth century, as James noted:

> I walked out of the town to the Aliscamps, the old Elysian Fields, the meagre remnant of the old pagan place of sepulture, which was afterwards used by the Christians, but has been for ages deserted, and now consists only of a melancholy avenue of cypresses, lined with a succession of ancient sarcophagi, empty, mossy, and mutilated.[5]

Maurice Barrès, in "Le Jardin de Bérénice," offered a similar observation:

> On one of those evenings at the Alyscamps, my past life appeared to me in the form of the empty sarcophagi lining that melancholy walk under the plane trees.[6]

Gauguin's *Roman Burial Ground at Arles*, executed in autumn hues set against subdued tones of blue and green, directs the viewer's gaze down the alley of trees toward a background in which stands the partially visible ruin of the Romanesque church of Sainte-Honorat. A bright splash of orange in the lower right-hand corner brings the foreground nearer and draws attention to the picture plane itself. In the middle ground stand three women in customary Arlesian dress, typified by the *chapelle*, or white fichu, and black velvet headdress. The figures are very like those in the background of *Women in a Garden* (1888; The Art Institute of Chicago), a work Gauguin had undertaken in order to instruct Van Gogh in the technique of painting from memory, as opposed to nature. Although the sepulchers of the Alyscamps are not visible in *The Roman Burial Ground at Arles,* in another painting of the same year at the site, *Avenue in the Alyscamps* (Private Collection,

Zurich), Gauguin made them the motif of the painting.

NOTES
1. Baedeker, 1902, p. 513.
2. James, 1884, p. 191.
3. Gauguin, 1949, p. 113.
4. Dante, *Inferno*, 9.112–115.
5. James, 1884, p. 199.
6. Barrès, n.d., p. 90.

134. Emile Bernard
HARVEST NEAR THE SEASIDE
(*LA MOISSON AU BORD DE LA MER*), 1891

Without the inventory of Bernard's paintings sold to dealer Ambroise Vollard in May 1905, in which the artist carefully described the exact site depicted in *Harvest near the Seaside*, only its date of 1891 could be used to pinpoint its location as somewhere in Brittany or the Côtes-du-Nord, where the artist and his family summered from 1886 on. The Vollard list describes the town at the right in the background as Saint-Briac, a small settlement between the Baie de Saint-Brieuc and the Baie de Saint-Michel, with the smaller village of La Chapelle slightly to the left of center.[1]

Although for many artists the attractions of Brittany were its savage nature and archaic lifestyle, an artist with a temperament like Bernard's was not above traveling there to paint while summering elsewhere. By the 1880s and '90s Saint-Briac, like Trouville and Sainte-Adresse (nos. 4–6, 12, 86, 115) earlier, had been discovered by Parisian holiday-makers. Henry Blackburn, in his *Artistic Travels*, written the year after Bernard painted *Harvest near the Seaside*, discussed the entire region as a tourist spot, crowded with bathers and promenaders, where

> ...the majority of the people are dressed as in Paris; the country people and the fishing and poorer class...only wearing any distinctive costume.[2]

The coastal area as an isolated bit of authentic provincial France obviously

had become a thing of the past.

In spite of Saint-Briac's seasonal urbanity, Bernard chose to depict traditional activities in the Breton landscape on the outskirts of the small coastal "summering place." All evidence of the holiday-makers has been eliminated; the format and iconography of the painting are totally conventional. Bernard's synthetic and theoretical vision has simplified and reduced the scene to a series of rhythms of basic shapes and unmodulated planes and colors. His move away from Impressionism could not have been more complete. *Harvest near the Seaside,* in fact, one of a number of Bernard's paintings depicting harvests in Brittany, reflects the spirit of Blackburn's book quite closely. Blackburn stated that the area offered

> ...opportunities for outdoor study; and...suggestive scenes for the painter. Nowhere in France are there finer peasantry; nowhere do we see more dignity of aspect in field labour, more nobility of feature amongst men and women. We...see the Breton peasants on their farms, reaping and carrying their small harvest of corn and rye, oats and buckwheat. Here we are reminded at once of the French painters of pastoral life, of Jules Breton, Millet, Troyon, and Rosa Bonheur.[3]

In works like *Harvest near the Seaside* Bernard depicted the peasant within the grand French tradition of such pictures. It was with his new aesthetic vision that this artist and others like him were able to reinterpret this tradition and renew its vigor.

NOTES
1. Royal Academy of Arts, London, 1979, p. 44.
2. Blackburn, 1892, p. 66.
3. Ibid., p. 63.

135. Emile Bernard
THE VILLAGE OF PONT-AVEN
(*LE VILLAGE DE PONT-AVEN*), 1892

Bernard painted this refined, highly ordered view of Pont-Aven in 1892, the year after his final break with Gauguin,

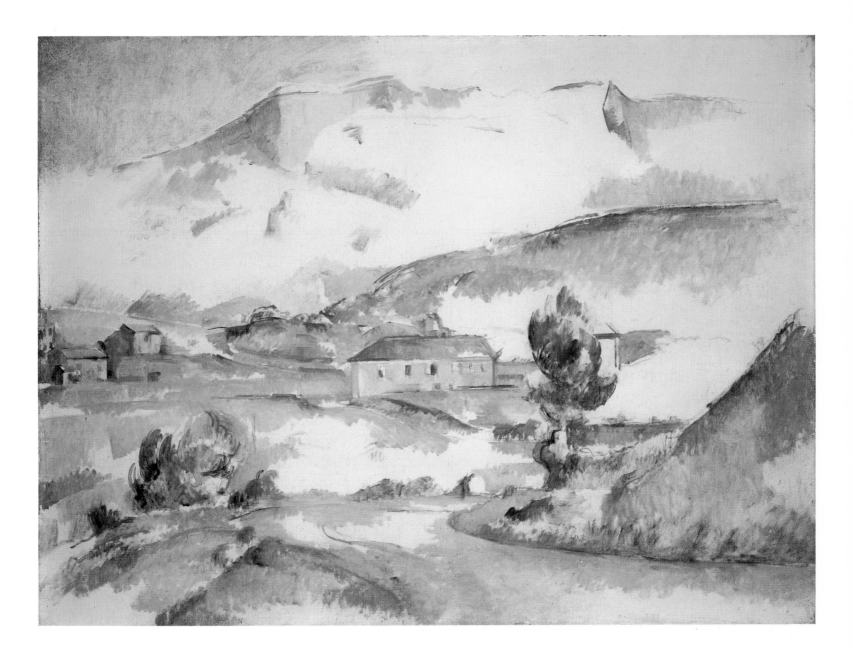

No. 130. Paul Cézanne
MOUNT SAINTE-VICTOIRE, 1886–88

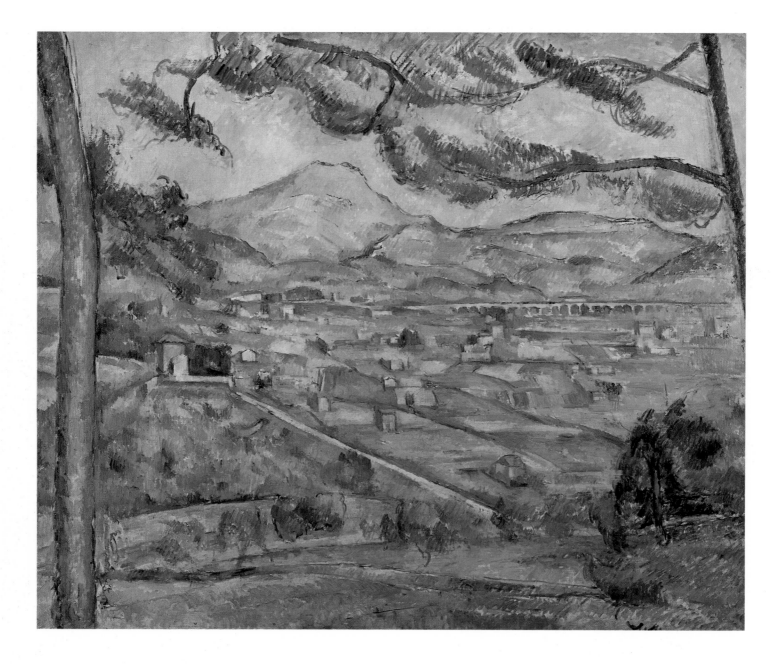

No. 131. Paul Cézanne
Mount Sainte-Victoire from the Large Pine Tree, 1885–87

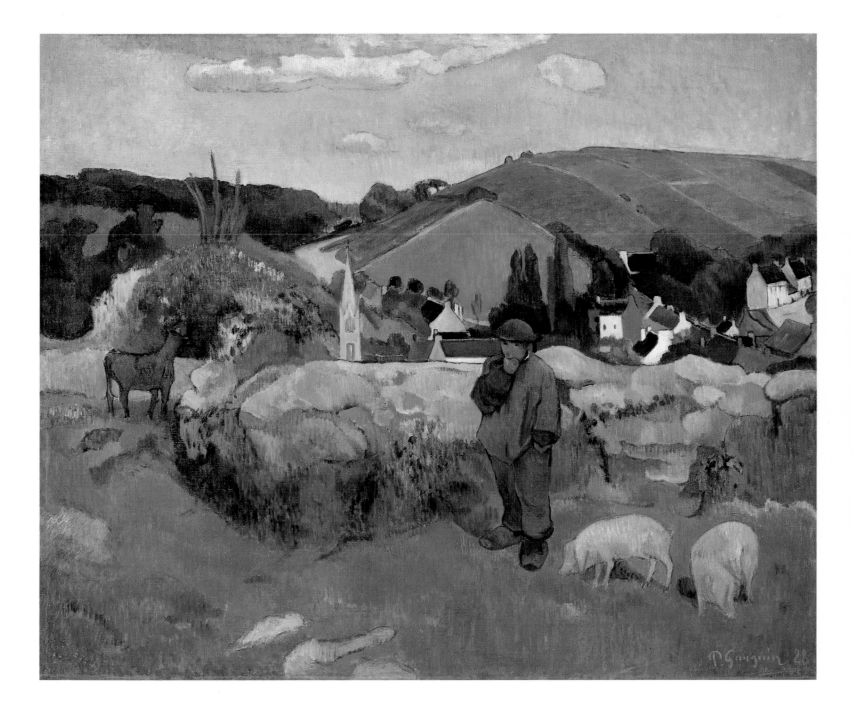

No. 132. Paul Gauguin
THE SWINEHERD, BRITTANY, 1888

the preeminent painter of that site. In style it recalls less the synthetism of the school of Pont-Aven, with whom Bernard was closely associated between 1888 and 1891, than the rigorously classical type of Impressionism developed by Cézanne in the 1880s. Although Bernard had not yet met the great Provençal painter whose career he was to champion so brilliantly in the first decade of the twentieth century, he had seen several of his paintings and had written an insightful essay on him in 1891–92 for the series *Les Hommes d'aujourd'hui. The Village of Pont-Aven* was surely made in homage to Cézanne and can be contrasted in every way with the brilliantly colorful, curvilinear representations of Pont-Aven by Bernard's first mentor, Gauguin. In this sense the painting is a conundrum, a painted representation of the "site" of one great artist painted in the manner of another.

The aridity of this picture contrasts with the brilliance of Gauguin's—and Bernard's own—earlier presentations of the site. Derivative as it might seem, however, *The Village of Pont-Aven* is a major painting, one of the earliest works to show a true understanding of the revolutionary formal principles being investigated by Cézanne, principles that were to lead to the invention of Cubism. Here again, the real landscape seems to have been a mere pretext for pictorial investigations that transcend it. It tells us less about Pont-Aven than about Bernard's problematic relationships with two painters of genius.

136–137. Henri-Edmond Cross

BEACH AT CABASSON
(PLAGE DE BAIGNE-CUL), 1891–92

COAST NEAR ANTIBES
(CALANQUE DES ANTIBOIS), 1891–92

In October 1891 Cross moved to Cabasson, a tiny village on the Côte d'Azur. Although he had frequently visited Monaco and the surrounding area, it was Signac who introduced him to the Var. Located on a small peninsula between the massif of the Maures and the Iles d'Hyères, nestled between pine woods and the sea, Cabasson provided both isolation and inspiration, as well as a climate in which Cross, a rheumatic, could live comfortably. Ardouin-Dumazet's description of Bormes, a nearby town in which Cross also painted, provides an accurate evocation of this region of the Mediterranean:

> From the outskirts of the small town there is an incomparably splendid view of the verdant plain, of lovely villages stretching as far as Cap Bénat, and of the Iles de Port-Cros and du Levant. Higher up the panorama is even more imposing. Coming out of the woods, you may climb any one of many rocks and look out over an immense expanse of sea and the festooned slopes of the Monts des Maures.[1]

The year 1891 was a particularly important one for Cross. Not only did he take up permanent residence in the Midi, but it was also in this year that he adopted the Neo-Impressionist technique. *Beach at Cabasson* and *Coast near Antibes*, both begun toward the end of 1891 and finished early the following year, demonstrate this new interest and make clear the central preoccupation of his art: the depiction of light. In the former the figures somewhat recall those in Seurat's *Bathing Scene at Asnières* (1883–84; Tate Gallery, London); a solidity and stillness were achieved by brushing in large areas of color over which Cross meticulously ordered precise rows of dotted pigment. The color is restrained and the composition simple, a succession of planes in which the beach occupies the foreground, the sea the middle ground, and the sky the background. The figures of the three boys and the heavy shadows they cast were placed very near the foreground and rendered in a smoother manner. The enframing pines and tufts of grass are characteristic of the beaches along this portion of the coast.

Despite its title, *Coast near Antibes* also represents the area around Cabasson[2] and is stylistically quite close to *Beach at Cabasson*. The colors are high in value and the shadows emphatic, with the entire scene drenched in a bleached light. Elision has replaced the details of *Beach at Cabasson*, while its planar composition has yielded to a diagonal recession into space. The strong horizontals of boats, rocks, and hills punctuate this recession at intervals. Overall, the effect is rather Japanese, as in *Point Galère* (1891–92; Location unknown), a third painting from this period.

The many exhibitions in which *Beach at Cabasson* and *Coast near Antibes* were shown attest to the importance which Cross attached to his works executed during 1891–82. (He later moved to the neighboring village of Saint-Clair). Both paintings appeared in the "Société des Artistes Indépendants" (Paris, 1892); the "Exposition des Peintres Néo-Impressionnistes" (Paris, 1892–93); "Les XX" (Brussels, 1893); the "Seconde Exposition de l'Association pour l'Art" (Auvers, 1893); and probably in the "11ᵉ Exposition des Peintres Impressionnistes et Symbolistes" (Paris, 1892).

NOTES

1. Ardouin-Dumazet, 1898, p. 255 (translated by M. H. Heim).
2. Compin, 1964, p. 37.

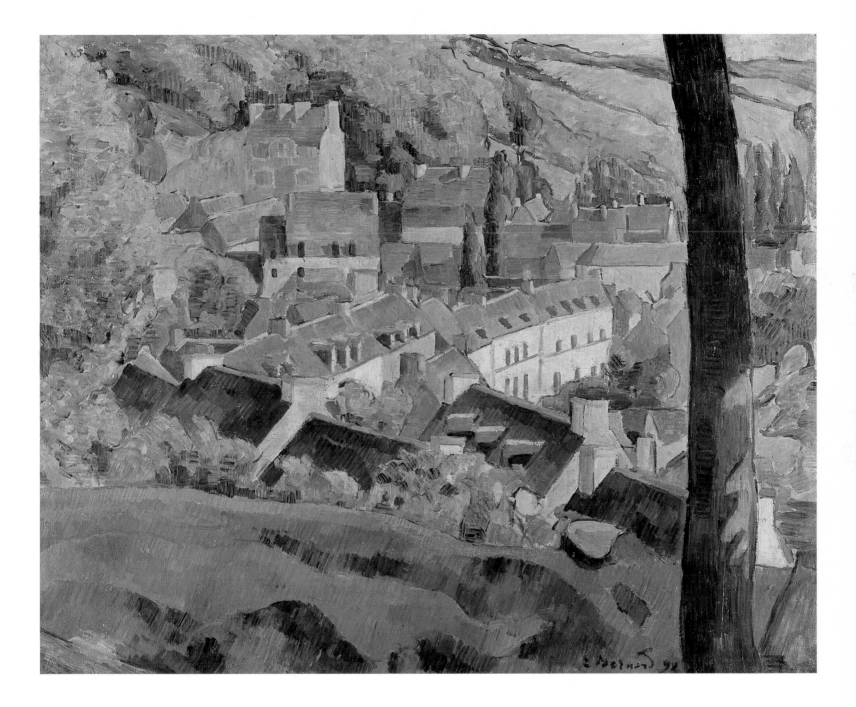

No. 135. Emile Bernard
THE VILLAGE OF PONT-AVEN, 1892

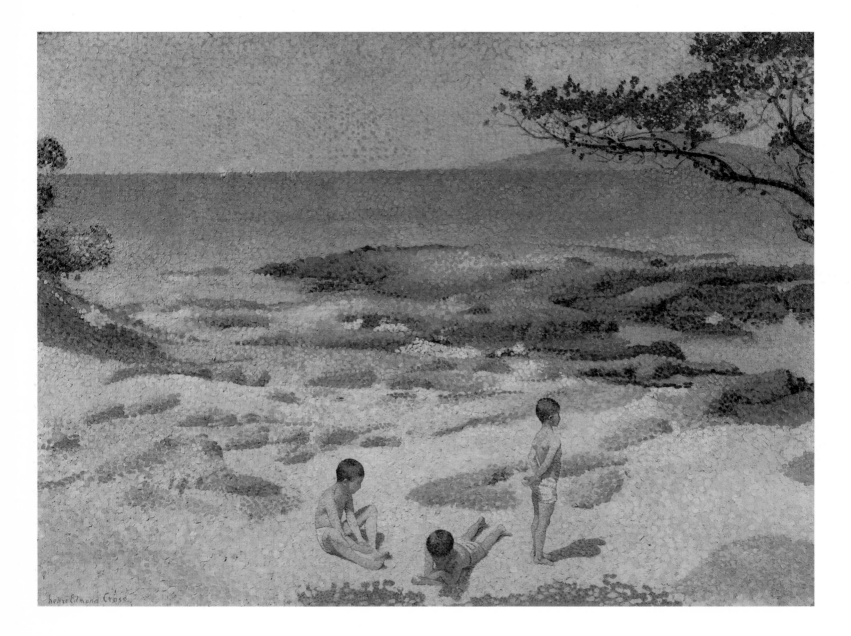

No. 136. Henri-Edmond Cross
BEACH AT CABASSON, 1891–92

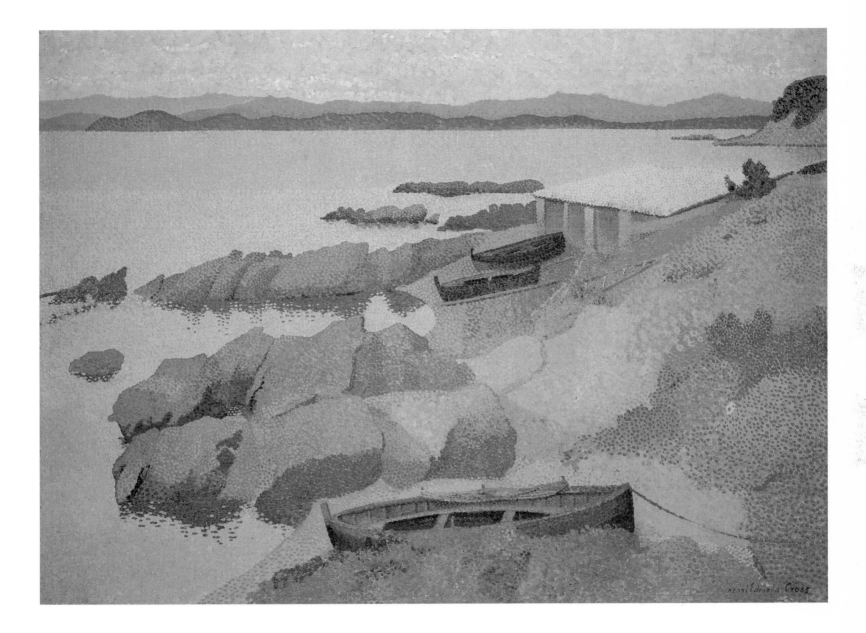

No. 137. Henri-Edmond Cross
COAST NEAR ANTIBES, 1891–92

IV

Impressionism and the Popular Imagination

THAT THE IMPRESSIONISTS initially met with abusive criticism, a lack of interest, and relatively few sales is generally accepted as a simple summation of the facts. However, given the contemporary popularity of travel and the out-of-doors in all its manifestations, as well as the ability of a great many people to enjoy them (fig. 65), it is all the stranger that the Impressionists' public "should not have recognized that these...landscape paintings were just the pictures they wanted."[1] It is this enigma which needs to be addressed if one studies the extraordinary later popularity of Impressionism. But there is another more general question to be considered as well. How deep into the popular imagination can one delve? There is obviously a great difference between knowing who Durand-Ruel's clients for Impressionist paintings were and explaining Impressionism's popularity among the general populace. After all, the smile of recognition on the smoke-smudged face of the locomotive engineer when he hears Renoir's name in *The Train* (1964), John Frankenheimer's film about the evacuation of art from Paris during the Second World War, is not inspired by love for the painter; it is caused by the fact that the engineer had once dated one of Renoir's models. Frankenheimer's clever use of this recollection is, of course, based on the assumption that the viewer will not only share in the knowledge that Renoir was a painter, but that he was a painter of a specific type of full-bodied woman. Viewers' appreciation of this vignette reveals an uninterrupted awareness of Impressionist artists, and even of their subjects, from the 1940s, the period in which the film is set, until today.

For the late-nineteenth-century bourgeois public who could afford and desired to own works of art, however, an appreciation of this style of painting came slowly. While it is true that there was a gradual secularization of the iconography of art during this period, middle-class collectors continued to be drawn to genre paintings and traditional landscapes on a modest scale. More than anything else, they sought to associate themselves with the

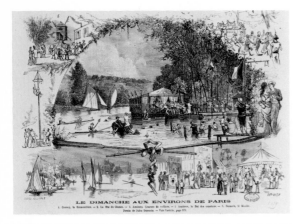

Fig. 65. Després, *Sunday in the Environs of Paris*
(1. Croissy, La Grenouillère.—2. The fair at
Chatou.—3. Asnières. Sailing expedition.—4. As-
nières, Oarsmen's Ball.—5. Sannois, the mill.)
Bibliothèque Nationale, B41039. Photo:
Bibliothèque Nationale.

aristocracy and preferred to avoid the radical or innovative, most especially in the arts. In the introduction to his review of the Salon of 1845 Baudelaire wrote, not without a hint of malice, that "the bourgeois—since he does in fact exist—is a very respectable personage; for one must please those at whose expense one means to live." Baudelaire became increasingly frustrated with a public which demanded the unusual only "to be astonished by means which are alien to art."[2] Later, Duret could write to Pissarro that "the public doesn't like, doesn't understand, good painting," and that of those who did, "very few are millionaires."[3]

Thus the Impressionists' original public sought more than anything else to maintain the status quo and could only have been shocked by their works. Such viewers wanted paintings which told stories or represented recognizable people and things with a degree of finish that would warrant the prices charged for such pictures. Impressionism simply did not fill the bill. And in spite of the fact that landscape was of major importance during this period (see above, III/1), Impressionist paintings were perhaps too cool, objective, and reliant on popular illustrations to be accepted seriously. In short, these paintings appeared to evoke little emotional response from the viewer and they were thought aggressively unattractive to boot. In the end, these factors did not encourage a desire to own such works in spite of the reasonable prices at which they could be obtained.

In fact, price was probably the least important obstacle to the acquisition of Impressionist paintings. Works by the Old Masters traditionally had fetched large sums. Further, contemporary works of art fresh from the studios of artists in favor often fetched astronomical prices. That the Impressionists' low prices worked against them is made clear by the banker Pillet-Will's explanation to Renoir about why he sought to buy art from the painter's Academic contemporaries rather than from him: "...in my position I have to have expensive pictures. That is why I must go to Bouguereau, at least until I find another painter whose prices are higher."[4]

Impressionist paintings only became generally desirable with the advent of Cubism. After all, in comparison with pre-World-War-I modernism, the earlier style was undemanding, fundamentally unaggressive, instantly recognizable, and decorative. In addition, it was evocative of a world of perfection and harmony thought to have been lost; it had become an art which Everyman could accept and embrace. In it could be found a sense of timelessness, of repose, and of beauty which, while not necessarily undisturbed by man, at least coexisted harmoniously with him and his works. As we have seen, rarely in Impressionist painting do we witness the ravages of Baron Haussmann's rebuilding of Paris and the resulting flight of her inhabitants to the suburbs; the destructive industrialization of the rural and urban landscape; or the horrors of war or revolution (see above, II and III/3). If, out of the thousands of pictures painted by these artists, there is an occasional suggestion of social commentary or overt melancholy, it is so unobtrusive as to be virtually unnoticeable. France is portrayed in its improved state, improved by man for his own benefit; natural ravages are recalled, but, by implication, the resuscitative powers of nature are as well. It was precisely these qualities which attracted later buyers of such art.

Champfleury, in an 1862 essay entitled "Du rôle important des paysagistes à nôtre époque,"[5] tried to explain the popularity of the innumerable landscapes which were being produced to attract a broader and less discriminating buying public. Simple, uncomplicated landscapes, such as those

A DAY IN THE COUNTRY

being painted by Courbet at this time, he said, appealed to the middle-class city dweller who frequently spent a day in the country. But in order for such an individual to relax in the city and take his mind off a grueling urban existence, Champfleury continued, it was crucial that he have something pleasant, unchallenging (fig. 66), evocative, and instantly recognizable to look at when he was relaxing after a long day at work. Landscape painting, of all the genres, was the perfect antidote.

This idea was not new, in fact. Two hundred years earlier Baron von Mayer had "alleviate[d] and divert[ed] his mind from very important chancery and very heavy government business detailed by His Electoral Highness by means of an interesting cabinet of the very rarest of paintings." These paintings included three landscapes by Claude and two by Jan Both.[6] Such pictures must have provided the same means of escape even earlier, but this function was often unstated and, indeed, overlooked. Landscape painting has always been intended, by and large, for a civilized urban audience.

This study of the popularity of the Impressionists is necessarily slanted toward a market reception of their *landscape* paintings. In fact, the history of the movement is replete with the antagonism felt by both the artists and their critic friends to exist between figure painting (urban subjects, exemplified by Degas and his associates) and landscape painting (promoted by Monet, Pissarro, and Sisley).[7] In the end, the "pure" Impressionism of landscape discussed so fervently by such critics as Duret, in *Les Peintres impressionnistes* (1878), and Zola triumphed over the depiction of urban life favored by Duranty in *La Nouvelle Peinture* (1876) and by Burty. Landscape became the genre most comfortably discussed in relation to Impressionism; it became the genre most associated with Impressionism in the public's imagination.

The century-long success story of the school of Impressionism probably would have astounded the writers of earlier generations, steeped as they were in the Romantic tradition of lonely, starving artists painting only to meet with public indifference and scorn. For just such an image of pathetic heroism had taken deep root during the nineteenth century, widely propagated by the public success of literary, theatrical, and operatic works which played upon this theme. It therefore should not be surprising if Romanticism influenced the many early accounts of the lives of the Impressionists. It is quite possible, in fact, that such an image continues to subvert the objectivity of those who are studying the origin and rise of the school today.

Traditionally there was only one way a painter could achieve recognition in France. He had to study technique and theory as prescribed by the national Ecole des Beaux-Arts, in the studio and under the tutelage of a Master associated with it. This would be followed by several successful showings of the artist's work in the government-sponsored and -supervised exhibitions of the Académie de l'Institut National de France, the annual or biennial Salon (fig. 67). While it is true that one did not have to be an Academician in order to see one's work hung in a specific exhibit, it is also a fact that the canvases of newcomers often failed to find favor with the Salon jury. Since this jury selected all the canvases which would hang in the Salon galleries, the new painter was likely to be hastily and brutally eliminated from the exhibition. Nor did Salon acceptance guarantee any measure of recognition, let alone popularity. With row upon row of paintings crowding the gallery walls, it was only the most famous artists, or those to whom the jurors had awarded medals, who saw their paintings well placed in the Salon. Any work which was "skyed" in one of the topmost tiers, or which hung in a dark corner or

behind a door, was bound to be overlooked by the multitudes who came to see each year's event. In the end, the artist's only hope was that one of his paintings would catch the fancy of a famous and popular critic. Favorable mention by any one of the 200-or-so columnists who wrote on art for Paris' many newspapers and periodicals was what the aspiring artist sought. A few complimentary lines in *La Presse* or *L'Opinion nationale* were sometimes worth as much as a third-class Salon prize medal when it came to making a name or selling a painting to an affluent client.

It is estimated that some 4,000 full-time professional painters were at work in or near Paris in the 1860s. This situation created formidable competition, and it is obvious that the likelihood of any newcomer making a living from the sale of paintings was small indeed. The Impressionists, then, were no more handicapped by their unorthodoxy of style or subject matter than they were by the sheer numbers of their competitors. There were many artists, ever more submissions to the Salon jury each year, and far, far too many paintings hung in the Salon exhibitions. It is clear that these problems were insoluble within the framework of the Academy's methods of recognition and distribution.

During the 1860s the artists who struggled to achieve recognition, as well as the art critics and journalists, tended to blame Academicians serving on the jury and the governmental officials who supervised them for what was perceived as the constant and apparently unjustified rejection of worthwhile paintings. Such agents of Emperor Napoleon III as the Comte de Nieuwerkerke were regularly villified by artists and their literary friends for the shortcomings of the Salon system. And yet, from today's vantage point, it would appear that the harassed jury as well as the artists whom it rejected were equally the unwitting victims of social change. As the unprecedented number of available paintings grew, and as Paris' increasing population and prosperity swelled the ranks of potential art buyers (fig. 68), the existing machinery of artistic supply and demand simply broke down. A Salon jury required to eliminate by at least one half the 5,000 works submitted for exhibition in galleries woefully insufficient to contain 2,500 was more deserving of pity than censure. The Salon's hallowed, if overcrowded, halls demanded reform.

By the 1860s the Impressionists were all immersed in the milieu of the Parisian art world. Several were less than satisfied with the instruction they received at the Ecole des Beaux-Arts or in the private ateliers in which some of them had enrolled. Even so, and though they must have been as anxious for quick recognition and success as any talented artist, they appear to have had every intention of working within the existing framework of the traditional system. In addition to availing themselves of varying types of formal training (Cézanne was the only one who had none), they submitted their paintings for consideration to each year's Salon jury. When rejected, they despaired; when accepted, they rejoiced and hoped for someone to take notice of their work. They played the game according to the rules and awaited critical success and discovery by the buying public. If they were not patient, they were at least resigned to the fact that recognition was likely to be slow in coming. Thoroughly, almost banally conventional, they only permitted innovation to surface in their paintings. In other matters they were conformists rather than rebels, a credit to their mostly bourgeois and lower bourgeois backgrounds.

The overall acceptance record to the Salon of the Impressionist paint-

ers was surprisingly good if the statistical odds against them are considered. A cursory summary of the results of Salon submissions of the artists from 1859 (when Pissarro was accepted and Manet refused) until the last Salon before the Franco-Prussian War reveals a great deal.[8] Degas and Berthe Morisot were the most successful of the group, for both saw their work accepted each of the seven times that paintings were submitted. Bazille was refused only once and accepted four times. Pissarro was successful on seven occasions, refused on three; Renoir and Sisley were each accepted one time more often than they were rejected, with five-four and three-two records, respectively. Monet was successful only half of the time, with three acceptances and three refusals. Only Cézanne, whose work seems to have been appreciated solely by his artist friends during his first decade as a painter, met with consistent rejection; he was refused for five consecutive Salons. With this exception the Impressionists' overall record was a positive one. On the negative side, however, it should be noted that often only one painting was accepted of two or more submitted, and many paintings were so poorly hung as to be virtually invisible.

At the "Salon des Refusés" of 1863 open to all those who had been refused by that year's Salon jury, Manet was criticized for the vulgarity of *Déjeuner sur l'herbe* (1863; Musée d'Orsay, Galerie du Jeu de Paume, Paris). On the other hand, Pissarro's two landscapes were singled out for special praise from some 3,000 paintings on display. He received a few complimentary lines from Castagnary, supporter of Courbet and other Realists; the critic ended his review by warning the "young" artist (Pissarro was 33, considerably older than all but Manet and Degas) against imitating Corot.

The 1865 Salon saw Monet exhibiting for the first time, and two marine paintings he had executed at Honfleur met with real success.[9] They were popular with both the gallery crowds and the critics. Even the reviewer for the conservative *Gazette des beaux-arts,* Paul Mantz, wrote of the artist in glowing terms:

> ...the striking point of view of the whole, a bold manner of seeing things and of forcing the attention of the spectator, these are qualities which M. Monet already possesses in high degree. His *Mouth of the Seine* abruptly stopped us in passing and we shall not forget it.[10]

After this first exposure of Monet's painting to the public, Bazille wrote to his parents, "Monet had a much greater success than he expected. Several talented painters with whom he was not acquainted have written him complimentary letters...."[11]

Zola, then a young journalist and novelist, wrote a series of articles prompted by the 1866 Salon that were panegyrics for some of the avant-garde artists, including Manet, who had not been accepted by the jury. When Zola reviewed the paintings of those whose work actually had been in the exhibitions, he singled out a landscape of Monet, *Road in the Forest of Fontainebleau* ("Ah yes! There is character, there is a man in that crowd of eunuchs....") and one by Pissarro, *The Banks of the Marne in Winter* (no. 9; "What a great unskilled person you are, Sir—you are an artist that I love!") as being by two newcomers who should be watched very carefully.[12]

Zola was not alone in mentioning Monet, however, for of the entire group he was the most successful with the critics of 1866. Thoré [Burger] praised both of Monet's paintings in extravagant terms and called *Road in the Forest of Fontainebleau* the work of a born painter.[13] Castagnary wrote a second complimentary piece welcoming Monet to the ranks of "the natural-

Fig. 66. Daumier, *More Venuses this year...always Venuses!...as if there were women built like that!...,* 1864. Lithograph from *Salon Sketches,* 1865, pl. 1. Armand Hammer Foundation. Photo: Armand Hammer Foundation.

Fig. 67. *The Salon of 1861*. Photograph. Musée d'Orsay, Paris. Photo: Musée d'Orsay.

ists," which the critic defined as "the whole idealistic and realistic younger generation."[14] Martial [Potément] included Monet among those painters whose work he found "above eulogy."[15]

The many good reviews received during the 1868 Salon were evidence of the power which the Café Guerbois set, the artists and critics of a naturalist bent who orbited around Manet, wielded in the liberal periodicals. Castagnary protested the unfavorable treatment that works by Monet, Renoir, Bazille, and Pissarro received from the Salon hanging committee, which, he complained, had deliberately hung Pissarro's landscapes high among the rafters "but not high enough to prevent art-lovers from seeing the solid qualities which distinguish them."[16] The artist-critic Odilon Redon believed that "the best things are still to be found among the works of artists who are seeking revitalization at the fecund sources of nature...it has given us some true painters chiefly among the landscapists." He noted especially Pissarro's *Côte de Jalais* (1867; Private Collection, New York) and Monet's seascape of Le Havre (1866; Location unknown), which, Redon believed, showed a "rare audacity" although it suffered on account of its scale.[17]

Zola undertook his 1868 Salon review with the specific aim of drawing attention to his friends. On this occasion the novelist followed yet another article on Manet with one on Pissarro's views of Pontoise. Zola also described Manet, Monet, Pissarro, Bazille, Degas, and the Morisot sisters as a "group" for whom he admitted feeling the greatest sympathy.[18] Not all the 1868 reviews were favorable, of course. Some were sarcastic and negative. The caricaturist Bertall chose a Monet seascape as his particular target, lampooning it in a cartoon just as he had done with *Camille; Woman in a Green Dress* (1866; Kunsthalle Bremen) two years earlier.

The Salon of 1870 also received mixed reviews. Duret, also an early collector of the Guerbois group's paintings, wrote excellent reviews of the works of Manet, Pissarro, and Degas in the exhibition. This was also a highly successful Salon for Bazille, who wrote his parents that his painting was much discussed by the spectators and press, adding, "at least I am in the swim and whatever I show from now on will be noticed."[19] It was also in 1870 that Arsène Houssaye, whose once conservative views on art had developed into an ardent admiration for the work of Monet and Renoir, publicly announced his partisanship in a letter to the Salon reviewer of *L'Artiste*, a magazine for which he wrote and of which he was director for many years. His letter concluded:

> Remember well, then, the names of M. Renoir and M. Monet. I have in my collection the *Woman in a Green Dress* by M. Monet and an early *Bather* by M. Renoir which, one day, I will give to the Luxembourg when that Museum will open its doors to all the opinions of the brush. In the meantime they arouse admiration....[20]

In the period following the Franco-Prussian War, France suffered a severe recession, a direct result of the war's destruction and the heavy burden of reparations imposed upon the nation by Germany. Many artists, the Impressionists not least of all, found themselves without funds. Since most of them were disenchanted with the Salon system (fig. 69), the holding of independent communal exhibitions was actively discussed. Such thoughts had been in the air for some years, and various groups had toyed with them. In 1867 Monet and Bazille had gone as far as attempting to raise enough money to stage an exhibit which would be independent of the Salon. They failed to do so, but the concept remained an attractive one. Plans were formulated

again at various meetings in the late months of 1873; this time they proved to be fruitful.

On April 15, 1874, the "Première Exposition," an exhibition of 165 works of art, opened to the Paris public. Held in the commercial heart of the city at the corner of the boulevard des Capucines and the rue Danou, it occupied an upstairs suite of connecting rooms formerly home to the photographer Nadar. The exhibition had been organized and financed as a joint-stock corporation composed solely of artists who wished to present a series of annual exhibits of their work. The corporation bylaws, which the artists had written, stated its purpose:

> (1) The organization of independent exhibitions, with neither juries nor a system of awards, where each of the associates may exhibit his works; (2) The sale of these selfsame works; (3) The publication, as soon as possible, of a journal exclusively devoted to the arts.[21]

For the first of these "independent exhibitions," each artist contributed an equal amount to a fund to cover expenses. Each was then a shareholder, entitled to exhibit his works and subsequently to partake equally in any profit which might be realized. Of thirty participants in this unusual undertaking, nine were artists who would soon be known as "The Impressionists."

Among the founders of the corporation, Monet and Pissarro were two of the seven artists appointed to be "Provisional Administrators" with Henri Rouart, a wealthy collector and lover of the fine arts. Renoir was appointed as one of three members of the official "Committee of Surveillance."[22] Degas, Sisley, Berthe Morisot, and Guillaumin were also members of the initial group; Cézanne and Boudin were invited later to participate, as were Astruc, the art critic and artist, and Louis Latouche, an artist and shop proprietor who sometimes dealt in paintings. Some painters in the Academic style, many of them friends of Degas who were represented regularly in the Salon, were added to the roster.

It was the Impressionists, however, who were the guiding force. Through diplomacy and hard work, they managed to pull together a disparate group of artists into a cohesive unit which functioned effectively and accomplished much of what it originally had set out to do. This was no mean feat. Each painter had his own idea of what should be done and how. Even the matter of deciding upon an official title for the new organization was debated with considerable passion—"Société anonyme des artistes peintres, sculpteurs, graveurs, etc. à Paris" was the descriptive name finally agreed upon. It evidently was intended to include everything and offend no one, while sounding as entrepreneurial as possible.

John Rewald's exemplary description of the details of the "Première Exposition" makes it easy to envision the give and take of the artists as they put their show together.[23] What motivated these hardworking painters, most of them beset by financial problems and family responsibilities, to devote so much time and effort to the organization of the corporation and the implementation of its precedent-shattering exhibition? Were they bent on a defiance of art officialdom, as has been assumed? Or were they simply seeking an effective way to circumvent the Salon system and get their paintings before the public under favorable circumstances, in as direct a way as possible, and—not a small matter—to sell more of them?

The long-range effect of this exhibition and of the ones which succeeded it from 1876 to 1886 was extremely important. The artists attained their goals in at least one respect, that of exhibiting their paintings without

the sanction of the Salon. Having more than one or two paintings before the public in a given exhibition was a novel experience for most of them, although the nucleus of the group had enjoyed that experience when Durand-Ruel exhibited their paintings in his gallery. Further, attendance at the "Première Exposition" was not unimpressive for a first-time endeavor. Some thirty-five hundred visitors in four weeks (an average of one hundred-seventeen persons per day) saw the exhibit.[24] These figures appear small indeed when compared to the staggering statistics of Salon attendance. Zola wrote that in 1875 some 400,000 Parisians thronged the galleries of the Palais d'Industrie at the rate of 10,000 per day.[25] Yet those who attended the "Première Exposition," where there was space actually to *see* the paintings, had a definite advantage over Salon visitors. In addition, the manner in which works were hung was incomparably better in the smaller exhibition. The majority of paintings was hung on one level, with only a few larger ones placed in the higher second register. Care was taken to preserve ample space between them. What Castagnary called "the wise disposition of the paintings which guarantees to each exactly the same sum of advantage" allowed the canvases breathing space and showed them off effectively.[26] He wrote that the determination of which name would come first was made by lottery, so anxious were the artists that each receive fair treatment. Great care was taken by Renoir, head of the hanging committee, to position each painting in a satisfactory visual context so that it could be seen without interference from neighboring canvases. It would seem, then, that the audience had every opportunity to examine all the paintings in the best of circumstances. Did the public like what it saw?

The "Première Exposition" was widely covered in the press, with about 15 articles written about it. Of ten important reviews, six were very favorable to the concept and execution of the show itself, although somewhat mixed in their opinions of the individual paintings. Four reviews were thoroughly negative. Burty, Léon de Lora, and Ernest d'Hervilly, three of the six favorable critics, were unstinting in their praise of the artists and their works. Marc de Montifaud, Armand Silvestre, and Castagnary, the other three, described some of the paintings in complimentary terms, others in a less positive fashion. It was Castagnary who wrote the most carefully reasoned review, emphasizing the exhibition's superiority to the Salon, endorsing the group's defiance of the jury's "egotism" and "imbecility." He identified Pissarro, Monet, Sisley, Renoir, Degas, Guillaumin, and Berthe Morisot as the "new school—if it is a school," discussed the work of each, and stated: "If one wants to characterize them with a single word which explains their efforts, one would have to create the new term 'Impressionists.' They are impressionists in the sense that they render not a landscape, but the sensation produced by a landscape"[27] (fig. 70). In the end, Castagnary felt that the novelty of the exhibition neither constituted a revolution nor indicated the emergence of a new school. Impressionism was "a fashion, nothing more," he wrote, predicting (correctly) that within a few years the artists would split up.

> The strongest among them...will have recognized that while some subjects lend themselves to the impressionist manner, some are content with a sketched outline, others...cry out for clear expression, for precise execution....Those who have succeeded in perfecting their drawing will leave impressionism behind, as something that has become really too superficial for them.[28]

Castagnary ended his review by pointing to Cézanne's *Modern Olympia* (1872–73; Musée d'Orsay, Galerie du Jeu de Paume, Paris), which was in the

exhibition, as an example of the undesirable end which awaited those who "neglect[ed] reflection and learning" and persisted in "pursuing the impression to the death." The imaginations of such artists would become "powerless to formulate anything more than subjective personal fantasies, with no echo in the general consciousness," the critic believed, "and with no verification in reality."

In contrast to Castagnary and those others who wholeheartedly endorsed the exhibition in spite of reservations about individual works or the Impressionist style, Sylvestre and Ernest Chesneau felt that the corporation should have been more exclusively Impressionist, or at least should have confined its exhibition to those who represented "the plein-air school." The figure painters included simply diverted the group's focus and reduced the effectiveness of its purpose.

By far the most negative review was the over-long article in *Le Charivari* written by Louis Leroy. It is this article which is most often quoted by historians. The critical tradition of venomous satire was a staple in the competitive journalistic world of mid-nineteenth-century Paris, and the Impressionists simply provided new prey for the hunt. Leroy's article purported to be a running conversation between the writer and a shocked Academic painter as they wandered through the "Première Exposition." It was a tour de force of the brand of wit that Parisian critics employed with telling effect: tongue-in-cheek "objectivity" combined with thinly veiled hostility.[29]

Fig. 68. Daumier, *A Day When Entrance is Free.—20° Centigrade.* Lithograph from *The Salon Public,* 1852, pl. 10 (second state). Armand Hammer Foundation. Photo: Armand Hammer Foundation.

Because of Leroy's preoccupation with *"l'Impression"* and the fact that his piece was the first to be published of those which used this term, he is generally credited with contributing the terms "Impressionist" and "Impressionism" to posterity. However, the word "impressionism," inspired by the Monet painting of Le Havre which the artist called *Impression, Soleil levant* (fig. 71), was used by at least five other reviewers. In any case, it was the general opinion that the artists of the "Première Exposition," whether they liked it or not, now constituted a recognized movement with a future.

One of the purposes of the Impressionists' direct appeal to the public was to sell more of their paintings. According to the financial report of their corporation, sales of paintings from the "Première Exposition" amounted to 3,500 francs, not a significant profit. Of this amount 1,510 francs came from the sale of paintings by Impressionist artists. Monet evidently received 200 francs; Renoir, 180 francs; Pissarro, 100 francs; and Sisley, 130 francs. Neither Degas nor Berthe Morisot sold a painting, although Cézanne found one buyer. Comte Doria, a banker who visited the exhibition, bought his landscape *House of the Hanged Man* (1873–74; Musée d'Orsay, Galerie du Jeu de Paume, Paris) for 300 francs and later bought paintings by Renoir and Sisley. John Rewald has noted that Renoir was unable to obtain the 500 francs he asked for his *Loge* (1874; The Courtauld Institute Galleries, London), but the artist eventually persuaded the dealer *père* Martin to part with 425 francs for it—the exact amount Renoir needed to pay his rent.[30] In terms of sales, landscapes seem to have fared better than figure paintings.

Since the exhibition failed to bring in a large profit from admission fees, catalogue sales, and commissions, the corporation was dissolved at the end of the year. It had, however, inspired the addition of a few new recruits to the thin rank of collectors, some wealthy and some of limited means, who became ardent partisans of the Impressionists. Although the corporation's original plan for a continuing series of independent exhibitions was carried

out during the decade between 1876 and 1886, the course of events surrounding these later exhibitions was by no means a smooth one.[31] The critical reviews and publicity which they received may have inspired a popular image of the Impressionists as a closely knit, homogeneous group in which all the members employed the same painting style and believed in the same theories. But this was not the case. Disagreements over various issues weakened the foundations of the group although, interestingly, lack of stylistic unity proved to be less consequential than debate over appropriate genres. Although new artists joined in the later exhibitions—Caillebotte showed with the group from 1876; Cassatt and Gauguin asked to participate in 1879—Renoir, Cézanne, and Sisley chose to return to the Salon. The last exhibition in 1886 (which included Signac, Seurat, and Camille Pissarro's son, Lucien) was more a debut of the painters of the next generation than it was a confirmation of the series of exhibitions that had begun in 1874.

The Salons and the independent exhibitions, of course, were not the only means to market paintings. The Impressionists were quick to realize that there were many avenues open for them to sell their pictures, and they chose to explore them all. Collectors—both artist friends and colleagues such as Bazille and Zola and a few independent spirits such as Chocquet (no. 73) and Faure (nos. 62, 95–96)—acquired the Impressionists' paintings and helped in a small way to make their work known to a slightly larger audience. Public auctions set by the artists out of self-interest, such as the Hôtel Drouot sale of 1875, as well as those generated out of financial necessity, such as the Hoschedé sale of 1874, were another means of tapping into the market. More to the point, of course, were the dealers, such as *père* Martin and Durand-Ruel, who promoted the artists' work through exhibitions and publications. All of these strategies enlarged the artists' audience and, with luck, generated the sale of paintings.

As has been discussed, the Impressionists managed to catch the imagination of at least a few friendly journalists during their first decade of public exhibition. Zola, almost more of a first-rate publicist than an interpreter of stylistic innovation, purchased Impressionist paintings by Monet and Pissarro,[32] among others, as soon as the income from his successful novels enabled him to do so. The collection of Houssaye, critic, author, and amateur artist, was considerably smaller. Of Monet, for example, he owned only the rather traditional portrait of the artist's first wife already mentioned, *Camille; Woman in a Green Dress*. In the spring of 1868, after Monet made this sale, he wrote to Bazille:

> I've had one sale which, if not financially advantageous, is perhaps so for the future, although I don't believe in that any more. I have sold the *Woman in Green* to Arsène Houssaye...who has come to Le Havre, who is enthusiastic, and wants to get me launched, so he says.[33]

Although he never bought another picture from the artist, Houssaye tried his best to help Monet, whose launching turned out to be a long, slow process, however.

Duret, the intellectual son of a rich Bordeaux wine merchant, befriended Monet in 1865 and met the other artists at the Café Guerbois. Duret assembled, beginning in 1870, a large collection of important figure paintings by Manet, Degas, Cézanne, and Renoir. The core of his collection, however, consisted of early landscapes by Monet, Sisley, and, to a lesser extent, Pissarro. Of the dozen or so early Sisleys he owned, most depicted the roads, rivers, and bridges of Louveciennes and Marly. The Monets were fewer in

number and were mostly sea or river views. Duret's early support of the Impressionists was most important. In addition, his collection revealed that he was not only interested in their avant-garde style, but in their more innovative iconography as well.

Among the Impressionists' artist patrons was Daubigny, who purchased Monet's *Zaan at Zaandam* (1871; Acquavella Galleries) in 1871. The engineer Henri Rouart, who bought the work of Degas and Manet as early as 1870, was a well-to-do amateur. Bazille, helped financially by his wealthy parents, was upon occasion a patron as well as a hardworking member of the group. He was particularly close to Monet, and bought *Women in the Garden* (fig. 50) for 2,500 francs, considerably more than the artist was used to getting for a canvas. This generous price was paid in monthly installments from Bazille's allowance. Caillebotte, Monet's neighbor in Argenteuil and a specialist in boat-building (see above, III/4), was a man of wealth and soon became one of the most important collectors of Impressionism. The encouragement he gave to Monet during the late 1870s was especially important to that artist in a difficult period of his career. Caillebotte's collection formed the basis of the present-day Impressionist holdings of the Musée d'Orsay (nos. 67, 70, 81, 97–98).

Renoir acquired much-needed patronage during this early period from the Le Coeur family of architects and artists. They welcomed him into their home, and he became one of the family while he did portraits of several of them. At least one substantial commission was also obtained for the artist as part of a Le Coeur architectural project. This was for a ceiling in the townhouse which Prince Georges Bibesco was building for himself. It is known that Renoir was at work on this project in 1868; Bibesco continued to take a personal interest in the artist, and other commissions came his way. The Le Coeurs' support ended abruptly in 1874, however, when the family learned that Renoir was courting one of its young members.[34]

Another supporter of all the Impressionists was Julian Tanguy, a traveling paint merchant who met Pissarro, Renoir, Monet, and the others in Fontainebleau in the 1860s. He liked the brightness of the Impressionist palette and acquired paintings outright or in exchange. An American who visited Tanguy before 1892 described his shop:

> It was very difficult to find as he is constantly shifting his quarters, from inability to pay his rent. No one knows what or where he eats; he sleeps in the closet among his oils and varnishes and gives up all the room he can to his beloved paintings. There they are, piled up in stacks: violent or thrilling Van Goghs; dusky heavy Cézannes...all lovingly preserved and lovingly brought out by the old man....[35]

Several of the artists sold or traded their paintings to a restaurateur named Eugène Mürer (né Meunier), a classmate of Guillaumin. Mürer commissioned Renoir and Pissarro to decorate his restaurant and often accepted their paintings, as well as those of Monet, Sisley, and Cézanne, in lieu of payment for meals. The artists were frequently forced by circumstances to accept whatever he offered, and Mürer and his sister gradually accumulated a sizable collection. When he later moved to Rouen to become the proprietor of the Hôtel du Dauphin et d'Espagne, he publicized his "magnificent collection of Impressionist paintings which can be seen any day without charge between ten and six" as a cultural inducement to his clients. Though there is no evidence that this helped the hotel business, it could hardly have hurt the artists' reputations.

By the early 1870s there had been an increase in the number of

Fig. 69. Daumier, *The Last Day for the Acceptance of Paintings* (—"Rats! Here we've already arrived, and my painting isn't done...What a pity I hired my carrier by the trip and not by the hour!..."). Lithograph from *Current Events*, 1846 (first state). Armand Hammer Foundation. Photo: Armand Hammer Foundation.

Fig. 70. Daumier, *But of course, my dear, I assure you that Monsieur is drawing a landscape…Isn't it true, Monsieur, that you're drawing a landscape?…* Lithograph from *The Good Bourgeois*, 1846, pl. 23 (second state). Armand Hammer Foundation. Photo: Armand Hammer Foundation.

supporters who gathered around the artists in order to buy their work and espouse their cause. One of the most significant was the operatic baritone Faure. In 1871, on one of his singing tours, Faure met Durand-Ruel in London. With the dealer's assistance, he transformed his collection of Barbizon landscapes into one of the largest and most important early collections of Impressionist paintings (nos. 62, 95–96). Faure, however, remained true to his earlier predilections in that the works by Sisley, Monet, and Pissarro that he acquired were, almost without exception, their landscape paintings. More specifically, the singer seems to have been preoccupied with water; his Monets, for example, were predominantly seascapes of the Normandy coast and Holland, and the majority of his Sisleys were views of rivers both in the Ile de France and in England. Perhaps Faure wanted to surround himself in his home with travel mementos of his concert tours. In any case, his paintings by Pissarro, an artist whose work he collected in even greater quantity than anyone else's, were almost exclusively of the various byways and fields in and around Pontoise.

Another independent collector, although one less wealthy than Faure, was Chocquet, who had his first taste of Impressionism at the 1875 sale organized by the artists at the Hôtel Drouot.[36] Chocquet had been devoted to the work of Delacroix for years, but his head was turned by the canvases he saw at the 1875 sale, especially those of Renoir. He asked the artist to do a portrait of Mme. Chocquet, and Renoir later took him to *père* Tanguy to see the latter's Cézanne paintings. As a result, Chocquet became the first major collector of Cézanne's work. Cézanne, in turn, took him to Argenteuil to meet Monet, and Chocquet bought a landscape on his first visit. A man with total confidence in his own judgment, he preferred to collect the work of artists who were somewhat neglected and did not command high prices. Chocquet resigned from his civil service position just before the 1876 group exhibition and, according to Duret, became a kind of apostle in his advocacy of Impressionism.

Dr. Gachet, the homeopathic physician and amateur printmaker who was a friend of the families of both Cézanne and Pissarro (see above, III/5), became a collector as he grew to know the artists, and after he moved to Auvers in 1872 he played host to several of them. He collected works by Pissarro, Monet, Sisley, Renoir, Guillaumin, Gauguin, and Van Gogh and was one of the earliest buyers of Cézanne's work when he purchased *A Modern Olympia* in 1872. It was also Gachet who took care of Van Gogh in the last few months of the artist's life.

Several bourgeois collectors became important to the Impressionists at this time as well. Two financiers, Gustave and Achille Arosa, both became interested in the new style before 1872, when Achille commissioned Pissarro to paint four decorations of the seasons for his home (see above, III/5). The banker Albert Hecht purchased the work of several members of the group, as did Ernst Hoschedé (no. 61), the director of the Paris department store Le Gagne-Petit. Hoschedé owned predominantly landscape paintings by Sisley, Monet, and Pissarro. In 1876 he commissioned a series of large-scale landscape decorations for his country home at Montgeron. Thus the Impressionists' early Parisian middle-class patrons not only collected their pictures; they even went so far as to seek out the artists to execute paintings for their residences. By and large these decorations, like earlier ones by Bazille (no. 4), were landscapes.

The general economic recession in 1873 in France forced Hoschedé to

auction part of his collection at the Hôtel Drouot on January 13, 1874. Eighty-four paintings were sold, of which thirteen were by the Impressionists. Of these, eleven were landscapes by Monet (three), Pissarro (five), and Sisley (three).[37] After a Degas racetrack painting, two landscapes by Pissarro fetched the highest prices; one of these was probably *Banks of the Oise, Pontoise* (no. 61). Interestingly enough, this most modern of "improved landscape" paintings was acquired by M. Hagerman, a painting dealer who also bought six other landscapes.

Propelled by the high prices fetched for the Hoschedé pictures, sometimes as much as four or five times what they were used to getting, the artists decided to organize an auction on their own. On March 24, 1875, works by Berthe Morisot, Renoir, Sisley, and Monet went on sale.[38] Three-quarters of the seventy-two pictures were landscapes. It was an unmitigated disaster. The average price was but half that paid for the Pissarro in the Hoschedé sale of the year before. Given their earlier success, the artists were at a loss to explain the public humiliation of such pathetically low prices. An Impressionist sale on May 28, 1877, was similarly disappointing.

These two sales and the second Impressionist exhibition of 1876 provoked extraordinarily hostile reactions, and not only in print. During the first sale at the Hôtel Drouot the police had to be called in. The Parisian public had been told by many of their hostile critics that the Impressionists were a strange group of radical, revolutionary artists, even *communards,* who painted very odd pictures. It is not surprising, then, that many who came to the second and third sales or exhibitions were motivated by curiosity rather than by the love of art. The Parisian public was similar to the press in its tendency to ridicule that which it did not understand. Duret described the third (1877) exhibition this way:

> Numbers of people went to see it. They were not attracted by any sort of artistic interest; they simply went in order to give themselves that unpleasant thrill which is produced by the sight of anything eccentric or extravagant. Hence there was much laughter and gesticulation on the part of the visitors. They went in a mood of hilarity; they began to laugh while they were still in the street; they laughed as they were going up the stairs; they were convulsed with laughter the first moment they cast their eyes upon the pictures.[39]

This antipathy was surely provoked at least in part by critics who were more concerned with displaying their agility at ekphrasis than with explaining the iconographic and stylistic characteristics of the new art.

Although the Impressionists were never totally ignored by conventional art dealers, such merchants were not significant in the early selling of their works. Latouche, whose art supply shop was a favorite rendezvous for his peers, occasionally bought or borrowed a painting for his display window. He purchased a Parisian scene by Monet (*The Quai du Louvre* [1867; Gemeentemuseum, The Hague]) in 1867 for that purpose, and showed another Monet of Sainte-Adresse in 1869. According to Boudin this work constantly attracted crowds, although no one was moved enough to buy it. *Père* Martin paid Sisley and Pissarro from 20 to 40 francs per canvas and retailed the paintings at prices ranging from 60 to 80 francs. For a Monet he asked 100 francs, but thought himself lucky to get 50 for a painting by Cézanne.

In 1871 all this changed. The Franco-Prussian War found Monet and Pissarro in London, where they were introduced to the man who would become their greatest patron: Durand-Ruel, owner of successful private gal-

leries in France, England, Germany, and Holland. By 1861 Durand-Ruel had become one of over 100 art dealers operating in Paris although his gallery had commenced business earlier in the century. Its customers were the solid new bourgeoisie of Paris: bankers, merchants, engineers, physicians, professionals of all kinds. By the time Paul had succeeded his father, J.-M.-F. Durand, as head of the business, there were branches on the Continent. At this time the gallery specialized in the paintings of Théodore Géricault, Delacroix, Millet, Corot, and the Barbizon school of landscapists.

It was to the London shop at 1 Bond Street that Daubigny brought Monet in January 1871. Durand-Ruel later wrote of Monet in his memoirs:

> His entries in the last few Salons had greatly impressed me, but we had never met, as he was so rarely in Paris....I immediately bought the paintings he had just done in London. Monet, in turn, introduced me to Pissarro....I paid Monet 300 francs a painting and Pissarro 200 francs, prices which remained unchanged for many years. No one else would have been as generous as became painfully obvious when, unable to continue my purchases, both artists were forced to sell their works for 100 francs, then 50, and finally even less.[40]

Upon their return to Paris Monet and Pissarro introduced the dealer to other members of the Impressionist group. Soon Durand-Ruel not only bought paintings by these two, but by Renoir, Sisley, and others as well, and on a regular basis, for 200 to 300 francs each. Manet and Degas also received his support. Soon pictures by all the artists were a familiar sight at Durand-Ruel. "Most visitors glanced at them with neither interest nor hostility," the dealer wrote. "...a small number of unprejudiced collectors was impressed to the point where I succeeded in selling a few...."[41] Such a paucity of sales was not as disappointing to the artists as might be assumed, for the dealer's payments, buyers or not, provided a steady income for months at a time.

In 1873 Galerie Durand-Ruel brought out a deluxe, leather-bound, three-volume catalogue of the paintings it was then offering. Carefully arranged, with engravings, the catalogue contained work by French artists from Jacques-Louis David to Léon-Augustin Lhermitte, from Salon pictures to watercolors, with a heavy concentration on the art of the Barbizon artists. The twenty-one illustrations of Impressionist painting were scattered throughout the three volumes. With the exception of those by Degas and Manet, all these pictures were landscapes conservatively chosen to be discreetly integrated with pictures by the earlier generation. Durand-Ruel's stock was extensive, and the buyer was made to feel by reviewing this catalogue that the history of art had not only unfolded without complication, but that it was without a true development or progression of any kind. The leveling effect of the black-and-white illustrations suited Durand-Ruel's purpose perfectly. In Silvestre's introduction, prospective bourgeois purchasers were assured that the "new" painters, by their intimate association with the established generation whose works were included between the same covers, would eventually acquire similar reputations and that their pictures would incur a resultant rise in value. Durand-Ruel's desire to make the Impressionists, especially their landscapes, more acceptable to his bourgeois clientele kept his publisher busy indeed.[42]

In a conversation some 30 years later, Monet recalled the trauma of looking for a substitute dealer when Durand-Ruel was unavailable:

> I went to the big dealers of the 1830 [i.e., Barbizon] school, such as Arnold and Tripp, with some canvases under my arm. I was not admitted to the shop but left standing in the vestibule while the two partners and their staff examined my work.

They laughed out loud. "These are by Monet, the Impressionist," they said, "isn't he absurd?" They lifted the curtains to look at me and made fun of me to my face. Would you believe it?[43]

It is no wonder that several of the Impressionists later looked back upon Durand-Ruel's purchase program as their salvation. An idea of the esteem in which the artists held their patron can be gained from Monet's recollection of what the help of "this incomparable man who used his life to break ground for us" meant to all of them:

Without Durand we would have been dead of hunger, all of us Impressionists. We owe everything to him. He was tenacious, he risked failure 20 times in order to sustain us. One [observer] wrote: "These people are crazy, but there is one who is even crazier, a dealer who buys them!"[44]

Although such a small number of French collectors could not support the Impressionist artists alone, their paintings were becoming known outside France. American art students and tourists, for example, wrote home about the new style, and it was discussed within the context of the artistic life of Paris. Henry James' report on the 1877 Impressionist exhibition for the *New York Tribune* is a good example:

An exhibition for which I may at least claim that it can give rise…to no dangerous perversities of taste is that of the little group of the Irreconcilables—otherwise known as the "Impressionists" in painting.…I have found it decidedly interesting. But the effect of it was to make me think better than ever of all the good old rules which decree that beauty is beauty and ugliness ugliness, and warn us off from the sophistications of satiety. The young contributors to the exhibition of which I speak are partisans of unadorned reality and absolute foes to arrangement, embellishment, selection, to the artist's allowing himself…to be preoccupied with the idea of the beautiful.[45]

In addition, Impressionism was being mentioned—not necessarily favorably—in American art books, such as Henry Bacon's *Parisian Year* (1882). Bacon, a Boston artist and author, wrote that the new painters

…have at last formed themselves into a society under the title of "Impressionnistes" which, as well as we can learn, intends to explain that they wish to present to the public their impression of nature. We have no reason to consider them dishonest, so we must conclude that they are afflicted with some hitherto unknown disease of the eye; for they neither see form nor color as other painters have given them to us, or as nature appears to all who do not belong to this association. Their models must be a regiment of monstrosities with green or violet flesh, the skies of their landscapes green, the trees purple and the ground blue.[46]

Given the French critics' initial response to Impressionism, Bacon's comments certainly come as no surprise. James, on the other hand, although decidedly uninteresting as a reporter, was more liberal in his views than one might expect. However, only firsthand experience with Impressionism would allow the American public to be able to judge their art for itself.

In 1883 Americans were given this opportunity. The "International Exhibition for Art and Industry" opened in Boston under the auspices of the French government. Its participation assured that all French paintings could be exhibited duty-free unless they were sold in America, in which case a tax was to be levied. Durand-Ruel, still desperately searching for a market for his artists' work and finding none in France, had sent a good representation of their paintings; pictures by Manet, Monet, Pissarro, Renoir, and Sisley were

included. Although their canvases were somewhat eclipsed by the larger Academic paintings and decorative objects which surrounded them, they did not escape notice. The *Art Amateur* mentioned them, saying that the men who created them were "not without talent, although their conceit of themselves is certainly excessive...."[47] The *Boston Advertiser* critic noted "a queer genius called Pissarro; and a marvelous realist-impressionist called Renoir who is the boldest bad man of the lot." The critic disliked the "disturbing tone" of the exhibit, however, which came from those "eccentric products of the *Salon des Refusés*."[48] Unfortunately Durand-Ruel does not mention the 1883 Boston exhibition in his memoirs, and it is not known if he sold any paintings there.

Residents of Boston were not unsophisticated in their knowledge of French painting. Since artist William Morris Hunt had returned to his native city from Paris in 1862, wealthy Bostonians had shown great interest in Millet, Corot, and all the Barbizon landscapists. S. H. Vose, a dealer in Boston and Providence, began importing great numbers of these paintings in the 1870s, and few Boston collectors were without at least one Millet or Corot and several representative landscapes by their cohorts. The ascendancy of nineteenth-century French landscape painting in Boston after 1870 was unique among major American urban centers.

Also during 1883 New Yorkers had their first opportunity to view Impressionism at the "Pedestal Exhibition," a benefit show organized by artists William Merritt Chase and Carroll Beckwith in order to raise funds for a base for the Statue of Liberty. As the sculpture had been presented to the United States by France, the occasion was a perfect one for an exhibit of French paintings. The two American organizers ignored the monumental Academic canvases by such Salon favorites as Ernest Meissonier and Edouard Detaille, in which New York dealers had invested heavily, and centered their exhibition around Géricault, Millet, Courbet, Corot, the Barbizon painters, and what few Impressionist works could be found in New York collections. Among the latter were four Manets, at least two of which artist J. Alden Weir had purchased in Paris in 1881 for collector Erwin Davis, and a Degas canvas from the same collection. Few landscapes were to be seen. The New York critics complained about the preferential treatment given France's most avant-garde contemporary art, but the ground had been broken in New York for French Impressionism.

Meanwhile, in France Durand-Ruel's financial situation was rapidly deteriorating. He therefore could now pay very little to the Impressionist painters, and this only on an irregular, "handout" basis. The dealer wrote many years later, "I do not know how I would have been able to surmount my innumerable difficulties without a fortuitous circumstance which, at the end of 1885, put me in touch with the American Art Association of New York."[49] The brainchild of James F. Sutton and Thomas Kirby, this association was founded ostensibly to bring the paintings of younger American artists to the fore. Such artists were much neglected by New York dealers, who, reflecting the tastes of their wealthiest customers, were far more interested in selling the costly canvases of well-established painters such as Albert Bierstadt, Emanuel Leutze, or Frederic Edwin Church. Apparently Sutton was intent on selling foreign art and cloaked his organization in the garb of a non-profit educational enterprise. Since the customs office therefore regarded his idea of importing contemporary French paintings as educational—an opportunity for young American artists to view at first hand the best of mod-

ern European art—Durand-Ruel was allowed to send paintings to him duty-free, with the understanding that anything sold in the United States would be taxed after the fact.

The American Art Association exhibition, entitled "Works in Oil and Pastel by the Impressionists of Paris," opened on April 10, 1886. Some 250 of the 300 Durand-Ruel paintings were by the Impressionists or by artists close to them in style. Scheduled to run for one month, the show was so well attended that Durand-Ruel was invited to move his paintings to the National Academy of Design, New York, for a second, four-week-long showing. Exhibiting under the auspices of the National Academy was tantamount to official sanction by the American art establishment, an accolade which had yet to be granted by France. The exhibition was supplemented by privately owned Impressionist paintings lent by A. J. Cassatt, brother of the artist and a Pennsylvania Railroad magnate; Davis, who had made his fortune in silver and would present two Manets to The Metropolitan Museum of Art, New York; and the H. O. Havemeyers, whose collection was rapidly becoming one of the finest in the United States and which would, in the twentieth century, form the foundation of the Metropolitan Museum's nineteenth-century French holdings.

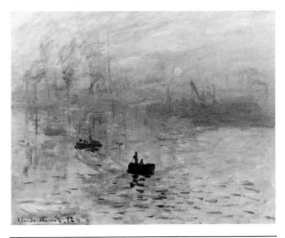

Fig. 71. Monet, *Impression, Sunrise*, 1872. Oil on canvas. 48 × 63 cm. Musée Marmottan, Paris. Photo: Routhier.

Although it is known that the Impressionists' dealer sold some $18,000 worth of the paintings he had shipped from France, information is scanty as to who the American buyers were and which paintings were sold. Aside from Havemeyer and Davis, few New Yorkers preferred the work of the Impressionists to the approximately 50 conservative paintings also in the exhibition. One buyer, Albert Spencer, sold his collection of Academic paintings in order to concentrate on Impressionism. William H. Fuller probably bought a Monet; it was he who arranged the first Monet exhibit in America, held at New York's Union League Club in 1891, and wrote a newspaper article on Monet that same year. Cyrus J. Lawrence's interest in Impressionism began with his 1886 purchases, believed to have included two Boudin seascapes and one of Pissarro's Pontoise landscapes. Sutton himself bought several paintings, which he kept for the rest of his life.

The moderate sales from this exhibition showed that the American public was at least curious and open-minded about Durand-Ruel's first major venture in the New World. Referring to this event years later the dealer wrote, "The general public, as well as every amateur, came not to laugh, but to learn about these notorious paintings which had caused such a stir in Paris." Although there is no reason to disagree with his assessment of those who visited the galleries, his memory was faulty when he wrote in his memoirs that "the press proved unanimously favorable, and a number of laudatory reviews appeared in the New York papers and those of other large cities."[50] Laudatory reviews there were, but the press' response was not unanimous.

Less sophisticated in their understanding of works of art than their French and English counterparts, nineteenth-century American art critics rarely reached the standards of analysis and interpretation maintained by the best of the European writers. A review of an exhibition in an American journal or daily paper was more likely to take the form of "News Notes" than that of formal criticism, and such phrases as "felicity of brush stroke" and "manly and virile representation" tended to predominate. For most of the century the longer articles and books on art that appeared tended to be appreciative rather than critical in tone. Henry Tuckerman's volumes *Book of the Artists* (1867) and *Artist-Life* (1847) were typical American publica-

tions in that they were biographical and anecdotal, and a strong stream of patriotism permeated the descriptions of the paintings, especially those of the American landscape. Although genre subjects may have been the most popular with the nineteenth-century American public-at-large, landscapes received the greatest critical support. This was true whether they were painted by members of the Hudson River school or by later painters trained abroad. America's vast, unspoiled natural wilderness, free and open to all, was an area in relation to which the unacknowledged cultural superiority of Europe seemed insignificant; its depiction could only be political in nature. It is not surprising that Americans liked the Barbizon landscape painters best of contemporary European artists (see above, III/1). This was the basis for Durand-Ruel's hope that Americans would be capable of the next ideological leap: to embrace the landscapes of the Impressionist painters.

In general the tone of the New York press was one of curiosity and amazement—in a few cases, as we have seen, even enthusiasm—as opposed to hostility. The critic for the *New York Times* believed that:

> The first feeling about such works as these is, what extraordinary impertinence on the part of the artists! It is like turning the wrong side of the stage flies to the audience, it is offering the public work which has been prepared up to a certain point only. No wonder that artists who are not in sympathy with the undaunted band of Impressionists affirm, sometimes not without a round expletive, that they can turn out several such canvases every day in the week.[51]

Although this was not a favorable review, it was far from the vitriolic comments made by some of the critics in Paris. In *Cosmopolitan* magazine Luther Hamilton described the exhibition as "one of the most important artistic events that ever took place in this country...." In his view Impressionism was "a glorious protest against the everlasting commonplace, which is another way of saying that its pictures were that rarest thing, a record of the artists' own impressions, not, as usual, their reminiscences of other pictures."[52] And one *New York Tribune* review sounds as if it could have been written by one of the avant-garde Parisian critics: "We are disposed to blame the gentlemen who purvey pictures for the New York market for leaving the public in ignorance of the artists represented at the exhibition in the American Art Galleries."[53]

Although the collecting base in Boston was far broader, that city's taste within the avant-garde context was much narrower. Monet's landscapes found an immediate market, but the Bostonians' lack of interest in figure painting meant that Manet and Degas were admitted into collections more reluctantly. In fact, that city's love of landscape kept many of its collectors loyal to the Barbizon school long after the turn of the century.[54]

Boston painter Lilla Cabot Perry had much to do with Monet's success in her native city. She worked in Giverny near the French master's home in 1889 and brought one of his views of Etretat back to Boston that year. During the next decade she became a source of introductions for Americans who wished to visit Monet, acted as his interpreter much as Mary Cassatt did in Paris for other Impressionists, wrote about him, and gave talks in Boston and elsewhere explaining his painting methods.

Interestingly, very few of the Bostonians who were early purchasers of Impressionism were from the old collecting families; mostly they were newcomers to the city. An unusual number of these collectors were women: Mrs. David P. Kimball, Annette Roger, Hannah Marcy Edwards and her sister Grace. Because of collectors like these, the Museum of Fine Arts, Boston, has

more paintings by Monet than any museum outside Paris, with the possible exception of The Art Institute of Chicago. Much of the credit for the fact that the latter city, far removed from the Atlantic coast, could boast of its early collectors of Impressionism was due to Berthe Honoré Palmer, the wife of wealthy real estate magnate Potter Palmer and leader of society in her Midwestern city. She collected with verve and originality and during her lifetime owned literally thousands of pictures. Like Havemeyer, she was advised by Mary Cassatt and opened a Paris account with Durand-Ruel in 1880, some years before the dealer came to America. 1891 and 1892 were her biggest buying years, possibly because she had been appointed chair of the Board of Lady Managers of Chicago's "Columbian Exposition" of 1893. In 1890 Mrs. Palmer visited Monet, at Giverny, for the first time. By the time she stopped collecting she had owned over 90 of his paintings alone, in addition to works by Pissarro, Renoir, and Degas (nos. 2, 34, 47, 112, 120). The works by Monet were almost exclusively landscapes, which allowed Mrs. Palmer to recreate visually her journeys through France. These "travel illustrations" formed a frieze which encircled the upper level of a gallery designed in part for her Chicago mansion by no other than Paul Durand-Ruel. Mrs. Palmer was the first to introduce Impressionism to Midwestern America and, because of her constant buying and selling, placed many paintings by Monet and others in American collections. Her collection formed the foundation of The Art Institute of Chicago's Impressionist holdings.

The 1893 "Columbian Exposition" devoted its Fine Arts Palace to the so-called "Loan Exhibition of Foreign Masterpieces Owned by Americans." Although visitors to these galleries saw many different styles of painting, Impressionism was particularly well represented. The primary lenders were the Havemeyers, A. J. Cassatt of Philadelphia, and the Palmers. This loan exhibition, which also included paintings by Barbizon artists, stood in marked contrast to the official gallery of France, located in the same building. The French Académie had sent history pictures, Biblical scenes, and female nudes reclining, kneeling, and sitting, "and all of a stultifying sameness."[55] There were no pictures at all by the Impressionists in the official French gallery, for official acceptance had not succeeded in France even at this late date.

If America proved to be a natural place for Impressionism, it was not unique in this regard. Durand-Ruel also found markets in Germany and England. Although sales of Impressionist paintings in England were practically nonexistent before 1905, the work of Degas was acquired very early on. In 1874 Louis Huth, a collector, bought a Degas, and Henry Hill, a tailor from Brighton, bought seven paintings in the late 1870s. The British painter Walter Sickert bought his first Degas in 1889, and Constantine Ionides did the same in 1891. Four Pissarros were purchased in the 1870s or '80s by Samuel Barlow, and a disciple of Whistler, Arthur Studd, bought a Monet grainstack painting in 1892. The publisher Fisher Unwin also acquired some Impressionist pictures in the 1890s, including a Van Gogh. Interestingly enough, however, Alexander Reid, the Glasgow picture dealer, was unable to sell the stock of French pictures he had purchased in the 1880s until long after 1900.[56]

Most of the paintings which were seen early in England—the Impressionist works in Durand-Ruel's London gallery from 1871 to 1875 or those included in his later exhibitions of 1883 and 1893—eventually returned to the Continent. For whatever reasons Impressionism seems to have left England singularly unimpressed at the time. It was only in the early twentieth century that Hugh Lane assembled his collection, which was eventually

divided between The National Gallery, London, and the National Gallery of Ireland, Dublin. Samuel Courtauld collected and later left his Impressionist collection to the Courtauld Institute Galleries, London, and the Davis sisters amassed the largest collection of such paintings, which is housed in the National Museum of Wales, Cardiff, today.

The Germans also came late to Impressionism, in spite of the fact that the German painter Max Liebermann saw paintings by these artists in Paris immediately after the Franco-Prussian War. Although he could not afford to buy any for himself until much later, his enthusiasm converted Hugo von Tschudi, the wealthy director of the Nationalgalerie, Berlin. Tschudi began purchasing works by Monet, Manet, and Renoir after 1896; they were hung in the museum's galleries until the Kaiser dismissed the director for exhibiting such work without his permission.[57] When Tschudi was made director of Munich's Neue Pinakothek, his Impressionist paintings provided inspiration for local Bavarian collectors. Although the Germans proved to be more interested in the new style than their English counterparts, they acquired few Impressionist paintings.

When Durand-Ruel came to America in 1886, then, the Impressionist artists' hardest days were almost over. Most of them, at least, were making a decent living by dealing with other private galleries and were selling more paintings without an exclusive arrangement with Durand-Ruel. Monet was beginning to receive excellent prices for his pictures, many of which he sold directly to customers. Pissarro was still struggling financially, but selling enough to provide an adequate income. Renoir was a highly paid society portraitist, discontent with his painting, but pleased with the financial security it provided. Only Sisley, whose work rarely sold as well as that of the others, and Cézanne, working in solitude in Provence (see above, III/9), still lacked an adequate measure of popular success.

Official recognition was slower in coming. When Caillebotte died in 1894 and left his entire collection of Impressionism to the State, there was an uproar. It was years before France finally accepted his bequest to the then-Musée de Luxembourg, the museum designated by the government as the repository for the work of living artists, and even then the conservative Academicians insisted that only a portion of the paintings be accepted.

By the end of the century almost all of those who had participated in the "Première Exposition" of 1874 had achieved some measure of financial and critical success. Monet and Renoir were wealthy and famous; Pissarro was financially successful, though failing physically. Sisley, on the other hand, was dead and never realized the increased prices his paintings fetched shortly after his demise. It was different with Cézanne. Although he died long before the prices of his work equaled those received by the others, his paintings became popular with the young artists who visited Tanguy's shop to see his collection. What the Impressionists of the 1870s had hoped so long to obtain was finally within their grasp, though in some cases too late. In 1900 Monet could say, correctly: "Today nearly everyone appreciates us to some degree."[58] Thus began an era of renown which none of the artists could possibly have foreseen.

Eighty-four years later, Impressionist landscapes are the most popular paintings in the world, for precisely the reasons which Champfleury and, earlier, Joachim van Sandrart had suggested. For twentieth-century humanity, living in a world of extraordinary pressures, basic self-doubts, gross intolerance, and the prospect of total annihilation, Impressionist paintings possess

those qualities which many believe to have been lost in the subsequent development of art: imagination, humanitarian and conservational concerns, as well as a basic empathy with their audience. Paradoxically, these are precisely the qualities which the public of its time believed to have been lacking in Impressionism. To a modern public, however, Impressionist paintings are instantly recognizable. They are obviously pretty and soothing. They take us back to what we believe, however incorrectly, to have been a golden age in a pre-industrial world of bright, clear colors, vaguely defined but nonetheless recognizable forms, and strong evidence of the artist's hand, all of which appeal to both our aesthetic and moral sensibilities. In short, Impressionist paintings appear to be exactly what they are—although, as we have seen, they are rich in many kinds of meaning and remain the subject of investigation and discovery even today.

—S. S.

Notes

1. Clark, 1979, p. 168.
2. Baudelaire, 1924, vol. II, pp. 121–124.
3. Venturi and Pissarro, 1939, vol. I, p. 34.
4. Vollard, 1938, p. 180.
5. See Champfleury, 1862.
6. Van Sandrart, 1925, pp. 331 ff.
7. University of Michigan Museum of Art, 1980, pp. xii–xiii.
8. White and White, 1965, pp. 142–143, Table 12.
9. Wildenstein 51–52.
10. Mantz, 1865, p. 26.
11. Poulain, 1932, p. 49.
12. Zola, 1959, pp. 71, 78.
13. Sloane, 1951, p. 24.
14. Castagnary, 1892, vol. I, pp. 224, 240.
15. Sloane, 1951, p. 31, n. 39.
16. Rewald, 1973, p. 186. Rewald's indispensable history provides a comprehensive picture of public reaction to Impressionism during the nineteenth century.
17. Ibid., p. 188.
18. Zola, 1959, pp. 126–128.
19. Daulte, 1952, p. 80.
20. Venturi, 1939, vol. II, pp. 283–284.
21. Adhémar and Gache, 1974, p. 223.
22. Ibid.
23. Rewald, 1973, pp. 309–318.
24. Adhémar and Gache, 1974, p. 224.
25. Zola, 1959, p. 148.
26. Adhémar and Gache, 1974, p. 264; for major reviews of the exhibition of 1874, see pp. 256–270.
27. Ibid., p. 265.
28. Ibid.
29. Ibid., pp. 259–261.
30. Rewald, 1973, p. 334; for the account sheets of the corporation and the document drawn up when it was terminated, see Rewald, 1955, Appendix.
31. University of Michigan Museum of Art, 1980, pp. 2–42.
32. Wildenstein 393; Pissarro and Venturi 160.
33. Poulain, 1932, p. 149.
34. Cooper, 1954, pp. 322 ff.
35. Waern, 1892, p. 541.
36. See Rewald, 1969.
37. Bodelsen, 1968, pp. 335–336.
38. Ibid., pp. 333–336.
39. Duret, 1906, p. 26.
40. Venturi, 1939, vol. II, pp. 179–180.
41. Ibid., p. 197.
42. *Galerie Durand-Ruel*, 1873, vols. I–III.
43. Gimpel, 1927, p. 173.
44. Elder, 1924, p. 25.
45. Rewald, 1973, p. 370.
46. Morgan, 1973, p. 119.
47. Huth, 1946, p. 231. Huth's essay is an invaluable source on Impressionism's first appearances in the United States.
48. Morgan, 1978, pp. 120–121.
49. Venturi, 1939, vol. II, p. 214.
50. Ibid.
51. Morgan, 1978, p. 123.
52. Ibid., p. 124.
53. Ibid., p. 125, n. 26.
54. Murphy, 1979, p. xliii. Murphy's essay is the source of most of the information on Boston collectors presented here.
55. Saarinen, 1958, p. 16.
56. Cooper, 1954, pp. 60–76. Cooper's introductory essay is the definitive work on early Impressionism in England.
57. Cooper, 1974, p. vii–xx.
58. Monet, 1957, p. 199.

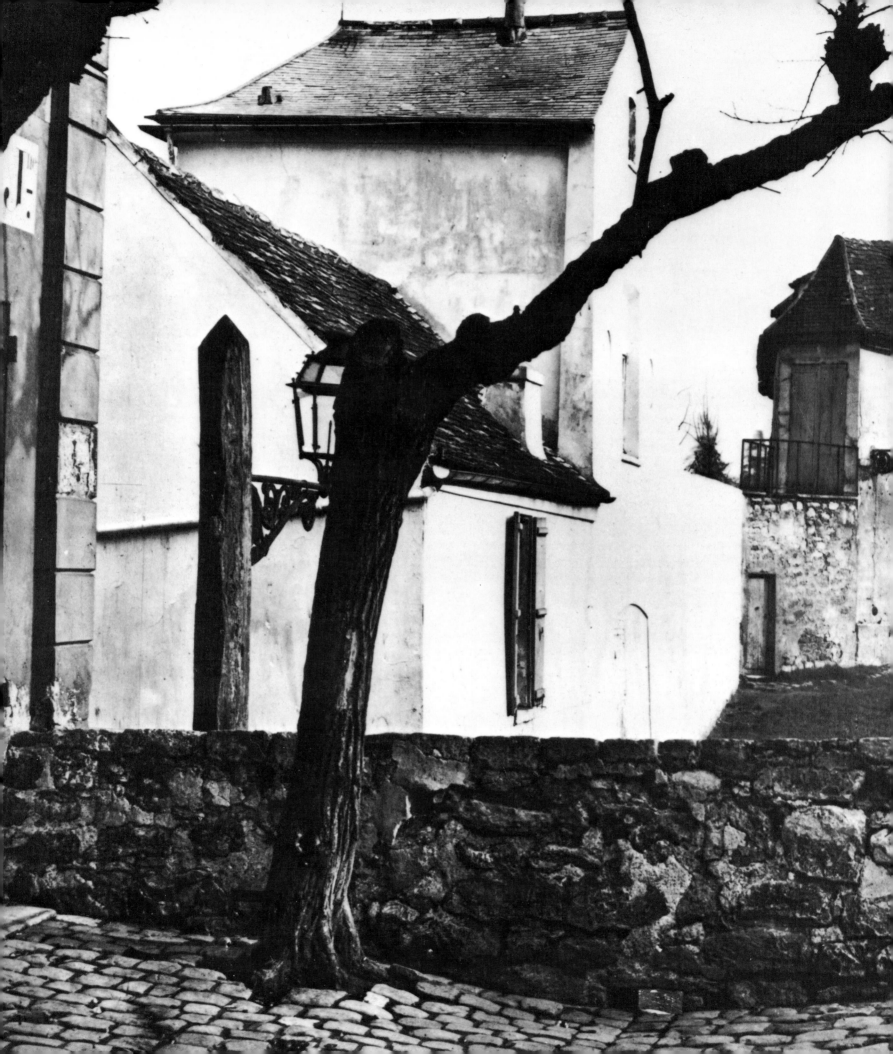

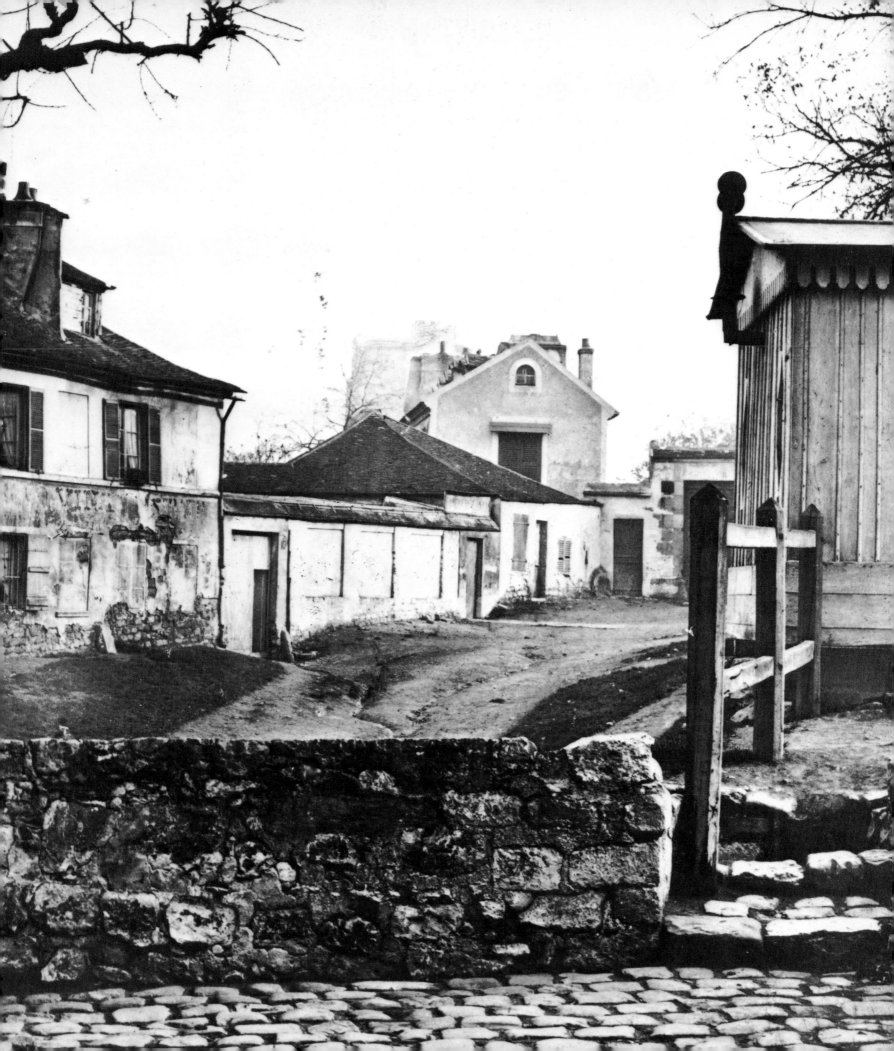

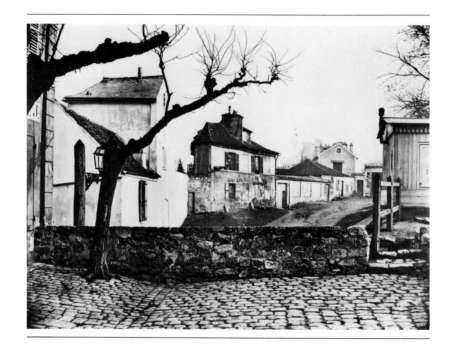

V

Appendix: The Landscape in French Nineteenth-Century Photography

THE ARTISTIC CLIMATE in which photography was born was that of the Realists' return to nature. The first known French photograph is a landscape, a view of Gras taken by Joseph-Nicéphore Niépce from his window in 1826. This image neatly illustrates the fact that landscape photography—like landscape painting—must never be regarded as a literal transcription of reality. Even the most elementary decision in the compositional process, that is, where to place the camera, imposes an interpretation on the real. No matter how spontaneous and original it may appear, the point of view adopted by Niépce has been shown to have had a representational past going back to the second two decades of the nineteenth century.[1] His view exaggerates—and therefore emphasizes—such characteristics as the flattening of space and the extreme simplification of tones into stark black and white.

Less popular among photographers than portraits, landscapes have always been more conducive to formal experimentation in photography. The development of stereoscopy, beginning in 1852, also contributed to the development of a certain landscape aesthetic or, rather, of certain landscape clichés. Thus landscape subjects offer an ideal control group for the study of the interrelationship between photography and painting in France at just the time when Impressionism began to develop.

Historians of nineteenth-century French photography have barely skimmed the surface of their field, but even now they can state without hesitation that its richest period belonged to the 1850s and '60s, i.e., precisely the early years of Impressionism (see above, III/1–2). In landscape photography these two decades were especially crucial: with great technical mastery and seemingly inexhaustible inspiration, landscape photographers all but invented the genre from scratch, and—apart from a few outstanding personal-

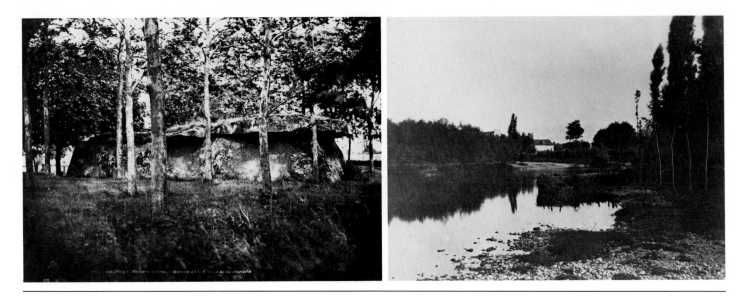

ities like Eugène Atget—the next two generations merely rehashed their inventions with less talent. If the terms "Realism" and "Impressionism" have any meaning at all when applied to photography, it is in this brief moment, when we can trace clearly the evolution from one to the other. The quarter of a century between 1850 and 1875 therefore will form the basis for our investigation of the interrelationship between painting and photography.

The development and spread of landscape photography in France from the end of the 1840s on owed a great deal to the Lille publisher L.-D.-J. Blanquart-Evrard. His illustrated voyages (the first of which was the work of Maxime du Camp [see above, II] in 1852) and, even more, his albums for professional and amateur artists offered incentives to starving photographers to work and a means of recognition to fortunate amateurs. They also assured an entrée for the medium into the realm of high art. Roughly speaking, we may distinguish two types of landscapes in Blanquart-Evrard's publications: the architectural or topographical landscape, the main purpose of which was to depict what was usually already a well-known site, and the nature study. These two types of landscape were felt to be the most likely to attract a broader public to the medium and thus increase demand.

France's rediscovery of her native architectural heritage (see above, II) was greatly assisted by the Romantic school of literature, which, together with the Realist artists' concern with nature and the rapid growth of long-distance rail travel (see above, II and III/2–4), prompted a strong surge of interest in the rediscovery of the landscape itself. The *Mission hélio-graphique,* representing the first major official undertaking involving photography, originated with the Commission des Monuments Historiques and has been shown to bear a close relation to the *Voyages pittoresques et romantiques dans l'ancienne France* of Taylor and Nodier (see above, III/4). Despite its purely scientific aims, the *Mission héliographique* represents an important stage in the development of French photography in general and in the area of landscape photography in particular. A mission participant like Gustave Le Gray, for example, patently uninspired by buildings as motifs, transformed every architectural view he could—at Chauvigny in Vienne or Bagneux in Anjou, for example (fig. 72)—into a landscape. So even though the *Mission*'s goal was to document historical monuments in need of or in the

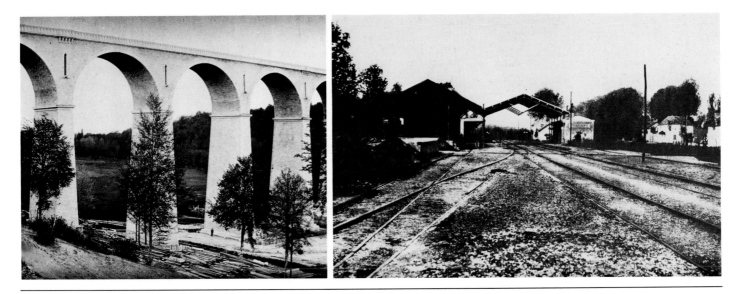

Figs. 74–75. Baldus, *Commelle, Close-up of the Viaduct; The Gare de Picquigny.* Albumen prints from glass negatives. Each 32 x 43 cm. From *Album des chemins de fer du Nord*, 1855. Bibliothèque Nationale, Cabinet des Estampes, Paris. Photo: Studio Harcourt.

course of restoration, critics who wrote about it for the various photography journals (men like Francis Wey or Henri de Lacretelle) gave it a good deal of publicity, ignoring its documentary aspect and using the pictures as a basis for the first theories in the aesthetics of photography.

The dual example of the *Mission héliographique* and the publications of Blanquart-Evrard encouraged photographers to undertake photographic journeys of their own and to publish their work in albums or journals. The results include Charles Nègre's *Midi de la France* (1852), published by Gide et Baudry, a melange of architectural views and landscapes; and Joseph Vigier's *Voyage dans les Pyrénées* (1853), published by La Chevardière and consisting exclusively of landscapes. A project on the Anglo-Norman islands envisioned by Charles Hugo and Auguste Vacquerie, with accompanying poems by Victor Hugo, and Edouard-Denis Baldus' series *Villes de France photographiées* (the latter a rather vaguely conceived project dating from 1852) led Baldus to re-explore France—not only the Midi, which he had covered for the *Mission héliographique,* but the Dauphiné and the Auvergne, where in 1854 he and Fortuné-Joseph Petiot-Groffier essentially devoted all their time to landscapes.

After 1855, works initiated by individuals gave way to ambitious official or semi-official commissions. Most important were the two albums done by Baldus himself to illustrate the landscapes crossed by the northern railway line from Paris to Boulogne (c. 1855) and the lines from Paris to Lyon and to the Mediterranean (1859). The album *Haute Savoie. Le Mont Blanc et ses glaciers. Souveniers du voyage de LL. MM. l'Empereur et l'Impératrice (1860 à 1862)* by the Bisson brothers does not appear to have resulted from an official commission, its title notwithstanding; it was more likely a high-quality commercial publication, with royal patronage added after the fact for purposes of publicity.

To these major topographical reports, each of which marked the celebration of a significant event—the completion of a railway line, the amalgamation of two companies, or the establishment of a new mountaineering record—must be added commissions more strictly historical in scope. These included the coverage by Baldus of the Rhone overflowing its banks at Avignon and Lyon (1856), and by Colonel Jean-Charles Langlois, assisted by

Fig. 76. Henri Le Secq (French, 1818–1882), *Paris under Snow (with Les Invalides and the Ecole Militaire in the Background)*, c. 1853. Calotype. 24 x 34.9 cm. Bibliothèque des Arts Décoratifs, Paris. Photo: Musée d'Orsay, Paris.

Léon-Eugène Mehedin and Frédéric Martens, of the Crimean War (1855). In fact, these assignments provided each of the photographers with opportunities to do landscape work as well. Though imbued with the heroic poetry that characterized the greatest history paintings, these landscapes constituted a new genre, since their sites, while perfectly real, were treated in a monumental style which deliberately turned its back on Realism. To some extent these landscapes belong to the tradition of engraved or lithographed topographical views (fig. 2), but they lack any anecdotal quality. In the end, the basic properties of the photographic technique or medium led to results that are formally unique. For example, Baldus' constant use of *repoussoir* elements, which borders on the comic, contradicts Realist aesthetics by creating a feeling of both artifice and distance. This is particularly striking in his magnificent view of the waterfall at Sassenage in the Dauphiné, a landscape which cannot by any means be called abstract, yet which does not seem quite real either; it lies somewhere between the two, more intellectual than sensual.

The Bisson brothers' album devoted to the ascent of Mont Blanc is a splendid example of the formal innovations in photography at the time. Amid the glaciers the glass negative process found its ideal subject, a material as cold, inhuman, and transparent as itself. The Bissons' most spectacular results can be seen not in their classical compositions of peaks, but in their purely "photographic" long shots. One of these, which was clearly meant to enable its audience to follow the mountain climbers' progress, achieves precisely the opposite effect: a totally dehumanized landscape, which lacks all reference to the familiar mountain that minimizes the pitiful silhouettes of the climbers. These pictures enjoyed great success in their day; they were doubtless admired as proof of the technical skills of both the mountaineers and their photographers. To what extent the French public of the time was sensitive to the hyperrealism involved is difficult to say, however. During the same period in England this mode attracted men like John Ruskin and his protégés John Brett and William Dyce (none of whom was averse to using photographs); in France it went unnoticed except perhaps by the architect Viollet-le-Duc, who expressed his fascination for it in numerous sketches of the Pyrenees during the 1830s and—30 years later—on Mont Blanc itself.

Visionary interpretations of natural landscapes were very often deliberate on the part of photographers. Whether recording the rocks of Guernsey or the mountains of the Auvergne and Midi, and despite basic differences in goals and format, Victor Hugo and Baldus showed a similar talent for bringing out what was dramatic in a scene and a similar understanding of the expressive possibilities inherent in dark, almost anthropomorphic silhouettes, which seem to be embedded in pure white backgrounds rather than to stand out against them. Hugo was fascinated by the resultant ambiguity, because it closely paralleled his personal poetic vision. As for Baldus, he experimented with inking in skies to set off rocks in profile, a process which paradoxically obliged him to re-draw the outlines of the rocks whenever his ink ate into them. This tendency to re-make landscapes (with techniques more or less purely photographic) in the direction of the abstract was also noticeable in the views Nègre took of the beaches in the vicinity of Cannes in 1852. Nègre achieved a supernatural effect that is, however, more poetic than fantastic.

Of the endless topographical series stimulated by mountain vistas, Vigier's *Voyage dans les Pyrénées,* one of the first and most accomplished photographic studies of a locale particularly popular during the Second Em-

A DAY IN THE COUNTRY

pire (see above, III/9), exhibits the most meticulous interest in the new naturalism. Vigier took great pains to define the proper atmosphere for each type of landscape he undertook: rustic countryside, arid hollow, woodland, or rushing water. In this he was ably assisted by the rich and flexible medium of the calotype, which he had mastered to perfection (fig. 73).

Thus, while even the most remarkable topographical photographs reflect a basically traditional concept of landscape (apart from certain views of Mont Blanc by the Bissons), it is a concept of landscape lacking a contemporary equivalent in other media. Yet, interestingly enough, it does have parallels with German Romantic painting (although there was no historic link between the two), with American landscape painting of the time, and, even more importantly, with the landscape photography of the American West that blossomed independently of French influence ten years later.

Where French photographers created a totally new genre was in their pictures of railways, railway stations, and railway viaducts (see above, III/3–4) for the sumptuous albums commissioned either by large business concerns or the Administration des Ponts, the government bureau in charge of civil engineering projects. Of course, working with such subject matter as part of a commission was quite different from working, as the Impressionists did, within the context of the Academic painting tradition (see above, IV).

Civil engineering made its entry into the art of landscape with the photographs of Baldus (figs. 33, 74) and the Bissons. Their monumental images stood head and shoulders above the vignettes intended for the press or guidebooks, even when they came from the pen of a Daubigny (figs. 32, 34–35). Between 1860 and 1880, a time when creativity in French photography was at a low ebb, these photographers did some of their most interesting and vital work. Best known among those employed by the Ecole Nationale des Ponts, where their prints are now preserved, was A. Collard, who did most of his work in and around Paris from 1850 to 1880. Others, who have not yet received their due, include Duclos, who called himself a "landscape photographer" and had studios at Quimper and Lorient, where he worked during the 1860s and '70s for the railway companies of both Brittany and Orléans; Sée, who did a fine album in 1863 on the navigation of the Seine and its dams; Lafon, a Parisian, who did photographic reports in the 1870s on the viaduct of Lessart spanning the Rance and on the Pont de Bayonne; and others. As we have seen (see above, III/4), these were all themes of vital interest to the Impressionists and, indeed, were hallmarks of their "modernity."

Already skilled in photographing public monuments, men like Baldus and the Bissons displayed a remarkable intuition for the aesthetic of industry as it would be formulated early in the twentieth century by painters and photographers like Fernand Léger, Charles Sheeler, Paul Strand, and Edward Steichen. Part of their success is due to the complementarity of subject and medium (apart from Baldus' series on the northern railways, they were all done with glass negatives), although that does not in the least detract from their worth. At that time, to be a "Precisionist" meant—in painterly terms—to sacrifice one's stroke to an extent unacceptable to the Impressionists (except for someone like Caillebotte, who tended toward a certain dryness in any case [no. 29]). Detailed and rigorous as the photographs of Baldus and the Bissons may be, however, they transcend their objective. A prime example of this is the supple, inventive way in which Baldus showed how contact between machine and nature could bring about a new kind of landscape (fig. 74). Such works as *Landscape near the Chantilly Viaduct,* depicting a loco-

Fig. 77. Charles Marville (French, 1816–1878/9), *Rue de l'Essai, View of the Horse Market,* c. 1865. Albumen print from glass negative. 25.5. x 37 cm. Bibliothèque Historique de la Ville de Paris. Photo: Musée d'Orsay, Paris *(detail on pp. 346–347).*

Fig. 78. Victor Regnault (French, 1810–1878), *Nature Study—Sèvres,* c. 1853. Calotype. 26 x 20 cm. Texbraun Collection, Paris. Photo: Musée d'Orsay, Paris.

motive in a context in which severity of line contrasts with lush nature; the less known, but delicately poetic view of the same viaduct which, when seen from a distance, seems as fragile as the trees surrounding it; the *Gare de Clermont* or the *Gare de Picquigny* (fig. 75), so expressive in their laconic compositions, which have been· reduced to the lines of a track disappearing into the distance and framed by several shanties—all these represent a ten-year advance on the Impressionists' lyrical vision of the modern industrial world.

To what extent were these photographs, which, after all, were intended for a narrow, specialized audience, accessible to painters? Given the reticence on the part of the latter to divulge their iconographic sources, we cannot know for certain. But in the last analysis the question is of minor concern. Apart from precisionist tendencies, which did not interest the Impressionists at all, the formal inventiveness displayed by the photographers—especially by Baldus—gave the painters nothing they could not have come up with on their own. What is highly probable is that in its most popular, most banal form, that is, in the form of magazine illustrations,[2] photography encouraged the Impressionists to accept the admonitions of avant-garde critics and writers (see above, IV) and tackle modern subject matter (factories, trains, and so on) in their canvases.

Commercial landscapes in the form of stereoscopic views offered a fertile field for innovation and were widely disseminated in photography journals of the day. While landscape photographers showed a clear preference for Normandy, the north, the Midi, the Pyrenees, the Alps, and the countryside near Paris, stereoscope photographers traveled everywhere including Brittany. As a result, beginning in 1858 they offered the public a highly diversified repertoire: monuments, pure landscapes, pleasant country scenes, railway stations, and trains. From 1880 on, however, both charm and invention tended to diminish. By the time such images reappeared, at the turn of the century, it was in the form of picture postcards (though not necessarily postcards of landscapes). Introduced officially in France during the 1870s, the picture postcard (figs. 1, 30–31, 39–42, 44–48) did not take on commercial importance until after 1900. Soon the card album, an intermediary between stereoscopic views and large-scale books of landscape plates, popularized what remains to this day the most banal mode of topographical photography.

Topographical views based on photographers' personal experiences quite naturally exhibited a high degree of independence (fig. 76). Hippolyte Bayard, for example, photographed mundane motifs such as a colonnade of La Madeleine at an interesting angle, or the carriage entrance of a private house, while Nègre showed a special interest in the markets of the neighborhood near the Hôtel de Ville in which he lived. Like the Impressionist painters (nos. 34–35, 74), quite a few photographers created pictures of the Paris rooftops from their windows.

The conventions regulating topographical views of Paris were quite clear-cut, and the genre has come down to us virtually untouched in the form of picture postcards. The original clientele for this type of photographic view, however, was more or less official in nature: libraries, art schools, and individual artists and (especially) architects. Hence the monumental format, the high quality of prints, and the great attention paid to detail (in lighting and composition). Rigid as it was, this type of *veduta* seems to have attracted all the finest photographers from Le Gray and Marville to the Bisson brothers. It consisted essentially of frontal views of monuments, taken either at street

level or from above, and of panoramic views of the banks of the Seine. Para-doxically, then, this type of photography gave rise to the most severe form of architectural or urban landscape, lacking as it was in any of the picturesque hustle and bustle that painters, draftsmen, or engravers invariably added to their compositions. Even so, architectural views of this type must have been valued as a genre since they survived in the work of photographers at the turn of the century, that is, years after the perfection of stereoscopic views and their candid street scenes. Indeed, even today's postcard photographers do their best to create voids around the monuments they depict, quite in keeping with this nineteenth-century topographical aesthetic born of necessity.

During the crucial period of urban renewal in Paris under Baron Haussmann (see above, III/3), certain commissions from official bodies gave photographers a chance to re-introduce an element of the picturesque into their cityscapes. Henri Le Secq did an album on the destruction of the Hôtel de Ville (1849–52) for Préfet Berger; Delmaet and Edward(?) Durandelle covered the construction of the avenue de l'Opera; Collard and Marville that of the Parc des Buttes Chaumont. Marville was also inspired by the Paris quarries to do some pure landscapes, such as a view of the Carrière d'Amérique (located in the nineteenth arrondissement). But it was the report he prepared around 1860 for the city of Paris on the neighborhoods sched-uled for demolition that led this exceptional artist to create a completely new genre, one of the most original, perhaps, of the nineteenth century.

Fig. 79. Eugène Cuvelier (French, d. 1900), *Raging Sky, Fontainebleau,* c. 1860. Albumen print from paper nega-tive. 20 x 26 cm. Musée d'Orsay, Paris, Photo: Musée d'Orsay.

Adjusting his style to the documentary requirements of his commis-sion, Marville tended to photograph streets lengthwise and thereby point up how deserted they were.[3] At times, however, he created stupefying spatial effects. In the well-known *Rue de l'Essai, View of the Horse Market,* for example, the street opens before our eyes like a stage (fig. 77). But what gives Marville's photographs their great, suggestive aura is the emotional power conveyed by the way he constructed his images and, even more, by the way he used light. His empty streets have nothing monotonous about them; they seem imbued with their own peculiar charm. When, at the turn of the cen-tury, Atget returned to the theme of the deserted city, not only did he work under different conditions (as a freelancer with a more diversified clientele in mind), but he had a different personality and most definitely a different visual imagination. All the same, he shared Marville's knack of transforming docu-mentary duress into a sort of secret necessity, of identifying with the city to such an extent that he could evoke a human presence with disturbing power by showing nothing more than an architectural framework, the "scene of the crime," as it were.

The first examples of a truly "instantaneous" vision date from the introduction of stereoscopic views in 1858. Shot from a high angle, they show crowds ambling down the boulevards of Paris. Although for purely technical reasons[4] the snapshot was long limited to stereoscopic photog-raphy, painters were not slow in reaping its benefits. Degas was especially intrigued; indeed, he based his own style on the study of familiar poses never before isolated by the eye, on arbitrary, mechanically imposed divisions evocative of the feeling of real life. His famous *Place de la Concorde* (1875; Location unknown)—much like Caillebotte's *On the Europe Bridge* (no. 29)—originated in serious thought about the photographic vision.

But the gap between paintings and the photographs that might have inspired them was still quite great. Only the series by Monet (1873) and Pissarro (1898) showing the Paris boulevards from above (nos. 34–36) bear

Fig. 80. Louis Robert (French, 1810–1882), *The Parc de Saint-Cloud*, c. 1853. Calotype. 23 x 19 cm. Texbraun Collection, Paris. Photo: Musée d'Orsay, Paris.

a clear resemblance to stereoscopic scenes in their purely photographic point of view and composition. In fact, however, their interpretations are quite free in that they do not indicate any attempt to convey perspective with real rigor. Not until the 1890s and the appearance of the box camera did the Pictorialist photographers, who were descended directly from the Impressionists, produce candid street scenes. In their highly stylish work they seized the instant in its most expressive and harmonious form.

Since it was only in the area of pure—that is, uncommissioned—landscape that photographers were left to their own devices, it is there, naturally enough, that a relationship with painting made itself felt with the greatest clarity. Generally speaking, in fact, the photographic nature study developed along the same lines as its analogy in painting. During the 1850s this type of photograph was basically land-oriented, an evocation of solid, massive, eternal earth. Then came the advent of the Realist painters, with whom certain photographers worked in close proximity at Fontainebleau (see above, III/1),[5] which remained an important center for both throughout the 1860s and '70s. Starting in the '60s, landscape photographers worked more and more along the river banks near Paris, trying to evoke a new, fleeting, evanescent nature (a task to which the glass negative was quite well suited). Tempting as it is to imagine these individuals to have been swept away by the same "pre-Impressionism" as their painter colleagues, the fact is that their approach to nature was more superficial or in any case more distant. That they came closer to nature than they had been in the previous decade was a result not only of better artistic training and greater interaction with painters (at a time when there was no clear definition of what it meant to be a photographer), but also of the exceptionally rich, responsive, inviting medium of the calotype, ideal both for suggesting the warmth of a subject and capturing the play of light upon it.

Many calotype landscapes are reminiscent of canvases by the Barbizon school; many look compellingly ahead, by ten years, to those of the Impressionists. As we have seen, the latter were remarkably reticent on the subject of photography. In fact, there is little evidence that the landscapes of Le Gray or Marville had the slightest influence on their way of looking at nature. On the other hand, certain general characteristics of the photographic vision which were obvious in even the most anonymous of prints— the tendency toward simplification, the flattening of space—may well have served to influence the Impressionists' approach to composition, especially in conjunction with such indisputable influences as the Japanese print.

In photography, even pure landscape photography, naturalism was an important trend, but only one of many. Another strong tendency, the movement toward abstraction, began to come into its own once the glass negative process, the process best suited to abstraction, gained widespread acceptance. If one leafs through the albums published by Blanquart-Evrard between 1851 and 1853, one is struck by the simplicity of the motifs that make up the major part of the landscape illustrations. The titles themselves are indicative: *Tree Studies; Coppice; Open Gate; Rocks and Rivers; Ladder* (in the remote part of a garden); and so forth. These pictures were meant as models for artists, professional and amateur alike, and competed as such with a type of sketch, done from nature in oil or watercolors, which since the late eighteenth century had played a significant role in the training of painters in general and landscape artists in particular. In principle, at least, such sketches represented

A DAY IN THE COUNTRY

a stage preceding the final composition. Since photography by its very nature afforded a direct and readily localized approach, the very essence of the sketch, photographers understandably conceived their early landscapes in sketch-like terms. As Peter Galassi has pointed out, there was nothing innovative about photography's contribution in this domain, but neither could its contribution be surpassed.[6] The most skillful photographers managed to give even the most unpretentious subjects an extraordinary opulence. Whether they focused their attention on a rake amid the hollyhocks in an out-of-the-way spot in a garden or on an espalier in the sun, both Le Gray and Bayard went beyond the anecdotal. And if variations on the theme of the tumbledown thatch-roofed cottage—by Humbert de Molard, a country squire who did some attractive rustic studies in Normandy, or by Loydreau, Louis Robert, and many others—begin to seem a bit too pretty and conventional, Loydreau's shots of quarries or simple, snow-covered hills are quite modern in conception.

Fig. 81. Baldus, *Chalet at Enghien*. Albumen print from paper negative. 28 x 44 cm. From *Album des chemins de fer du Nord*, 1855. Private Collection. Photo: Musée d'Orsay, Paris.

No one was able to express the aesthetic of the fragmentary better than Le Secq, whose studies have a dramatic monumentality about them. The fine calotype series he did at Montmirail, northeast of Paris, in 1852 and had published by Goupil, Vibert et Lerebours for the use of artists and amateur painters is among the most gripping examples of nineteenth-century photographic landscape. It comprises a group of close-ups of deeply pockmarked rocks. The composition is extremely free, the chiaroscuro violent. The unusual size of the prints (approximately 52 by 34.9 centimeters) and their extremely rich texture reinforce the mixture of realism and poetic mystery that makes Le Secq's works so appealing.

The same qualities are evident in Victor Regnault's remarkable study of brush in a garden (fig. 78), but in this instance the work is entirely atypical of the artist. The rock studies Marville did at Fontainebleau around 1851 are similar in spirit to those of Le Secq, but on the whole Marville was the type of landscapist who, like Le Gray, composed principally with light and air. Le Gray, in *his* well-known Fontainebleau forest scenes of 1851, did several rock studies of an extraordinary density deriving from the absence of sky and the rich, precise texture of the calotype process. In these works, the most "Realist" he ever did, Le Gray showed how greatly his sensibilities differed from Le Secq's. The strictly head-on composition favored by Le Gray introduced a certain distance into his landscapes and gave them their characteristic classicism. On occasion, however, he opted in favor of a highly unexpected point of view. His *In the Back of the Garden* and well-known close-up shot centered on the roots of a tree are striking examples of inventive composition.

In these restricted studies photographers were able to skirt one of the principal problems posed by the medium: what to do with the sky. In 1858, however, when Alexandre-Edmond Becquerel began publishing his research on the colors of the spectrum, scientists realized that the way silver salts rendered natural color relationships in black and white wreaked havoc with what the retina actually perceived. The salts were highly sensitive to blue and violet (of the sky or any brightly lit object), less sensitive to green, and even less to red and yellow. What this meant in practice was that different exposure times were needed to render the play of light on different objects: objects in shade, objects in the sun, and the sky itself. This remained a difficult issue until about 1885, when a professor named Vogel discovered the means to impart orthochromatic sensitivity to negative plates with an emulsion fast enough for instantaneous exposure.

Fig. 82. Marville, *The Bois de Boulogne*, 1858. Albumen print from glass negative. 36 x 49 cm. Bibliothèque Nationale, Cabinet des Estampes, Paris. Photo: Studio Harcourt.

An 1851 treatise by Blanquart-Evrard on how to make the best use of natural light in architectural photography gives a good idea of what went on "behind the scenes" to make natural lighting look natural. If between two short exposures in bright light, which brought out the parts of the picture in direct sun, the negative received a longer exposure in overcast conditions (and if the photographer remembered to close the shutter whenever the clouds began to move), the shadows in the final print would exhibit a certain transparency. As for the sky, it could not be rendered in any but the most approximate fashion until the development of such rapid exposure techniques as the collodion process. Calotypes tended to make skies look stormy, which may have been effective when atmospheric illusion was called for, but was otherwise quite problematic. The superb "raging sky" threatening the bare hill in a print by Eugène Cuvelier, a late calotypist, illustrates remarkable skill in exploiting the simplest of devices and a frequently deficient medium to create a poignant atmosphere worthy of Rousseau (fig. 79).

Technical handicaps notwithstanding, the calotypists succeeded in imbuing their studies, especially those published by Blanquart-Evrard, with a feeling for nature in all its diversity. This impression is accentuated by the originality of their ever-changing compositions, but it was in large part due to the experimentation they undertook to capture the quality of light appropriate to the season and even to the moment of the day: the crisp, cold light of winter in Loydreau's *Frost Impressions,* the light mist hovering over the snow in Marville's Ecole des Beaux-Arts garden, or the hot sun beating down on Regnault's Sèvres factory courtyards. Since light rarely figures in the titles of these works, the attention it received seems to have been more spontaneous than premeditated.

Two studies of the Parc de Saint-Cloud by Robert—one a calotype (fig. 80), the other (c. 1855) from a glass negative—catch the mysterious depths of a forest all but impervious to light, which, when it does emerge, lends a supernatural cast to the statues. But the theme of the deep forest, already dear to Rousseau and Diaz (figs. 4, 12), came into its own in photography with Le Gray's study *Forest of the Bas-Bréau* (1851), which has often—and correctly—been likened to Monet's *Street in Chailly* (1865; Musée d'Orsay, Galerie du Jeu de Paume, Paris) or *Avenue of Chestnut Trees at La Celle-Saint-Cloud* (no. 10) and which conjures up a light and airy world far from that of the Realists. In Marville's study *Man Sitting at the Foot of an Oak* (c. 1852), which might be termed a poem of leisure bathed in golden light, or in Le Gray's *Covered Pathway at Bagneux in Anjou* (fig. 72), the foliage, schematized into pools of light, looks inexorably forward to the forest of Monet's *Luncheon on the Grass* (1865; Destroyed).[7] Further analogies with Impressionism can be found in photographic river scenes. In Olympe Aguado's *Ravager Island* (c. 1855) and Baldus' *Chalet at Enghien* (fig. 81)[8] and his series of a group of figures in a park (c. 1855), the all but audible rustle of the trees, the random details—a rowboat, a parasol—connoting leisure, and, most important, the lack of depth highlighted by the mirror image in the water below all make for a true Impressionism in the spirit of Monet's *On the Seine at Bennecourt* (no. 47).

But it is not in such analogies of style and atmosphere—rather superficial ones, when all is said and done—that these French calotypes may be compared to the work of the Impressionists. The real bond stems from their common attitude toward nature, which was both punctilious and inventive.

Just as painters of the time came closest to nature in their sketches, so photographers came closest in their studies. And with the notable exception of Le Gray's Fontainebleau forests, the photographer's compound landscapes demonstrate either a classicism (which makes their prints similar to paintings) or a completely original taste for abstraction.

Just as they were interested in the landscape, French photographers of the 1800s also were captivated by the ocean. Considering that most of the finest nineteenth-century photographers of the sea completely dodged the problem of representing the motion of the waves, they must have considered it insurmountable. In the very fine seascapes done by Le Secq at Dieppe around 1852 and by Baldus at Boulogne in 1855, the sky is empty and the sea calm, with only an occasional glint of light clinging to it. In other words, the sea plays only a modest role in the composition. When E. Nicolas photographed Etretat, he was so much more interested in the cliffs than the sea that he resolutely turned his back on it. And although around 1850, Norman photographers like Macaire and Bacot gained a reputation for having taken the first photographs of the sea ever to convey wave motion, the achievement was purely technical in character: their small views had no formal pretensions whatever. (Bacot's seascape, which includes figures, is nevertheless one of the rare beach scenes to recreate the feeling of immediacy present in the contemporary canvases of Boudin.)

The widely praised series of approximately 20 seascapes done by Le Gray in 1856–57 at Sète and Dieppe is therefore unique in its genre. In these compositions, as in their titles, Le Gray made a point of avoiding all reference to topography; here, sea and sky are the true subjects (no. 120). *Large Wave* and *Broken Wave,* two particularly well-known pictures, communicate more than motion; they show the compact consistency of rough water. Le Gray alone was able to coax such riches from the glass negative. Yet the true grandeur of his seascapes lies not so much in their technical virtuosity as in their eloquently expressed cosmic message. Le Gray's seascapes derive from studies executed in situ. They were composed of two negatives taken independently of one another—one for the sea, the other for the sky—and lay no claim to represent a specific moment in time. Despite the distinction he made between day and night scenes, Le Gray's main concern was with the serene contemplation of nature as an eternal entity (see above, III/8).

The practice of bringing together more than one negative to make a print reopened an old debate among critics and photographers. How far should a photographer go in creating the final image by other than chemical means? This debate resurfaced at the turn of the century on an even larger scale and again during the 1930s among American photographers. Apart from combining negatives, however, Le Gray hardly touched up his works.

During the 1860s and '70s many of the major photographers abandoned their attempt to convey a sense of the sky in their landscapes. Marville and the Bisson brothers, in their albums on the Bois de Boulogne, Bagatelle, and Bois de Vincennes; Charles Famin; and Achille Quinet all cultivated the precise vision and graphic style appropriate to the glass negative. Perhaps Marville's superb views of the Bois de Boulogne, those infinite variations on the theme of trees and foliage intermixed with light and reflected in water (fig. 82), constitute his equivalent, pictorially wanting though it may be, of the series later so dear to the Impressionists (nos. 104–112).

Figs. 83–84. Ildefonse Rousset (French), *The Ile des Vignerons at Chenevières; Sunset.* Albumen prints from glass negative. Each 12 x 16 cm. From *Le Tour de Marne,* 1865. Bibliothèque Nationale, Cabinet des Estampes, Paris. Photos: Studio Harcourt.

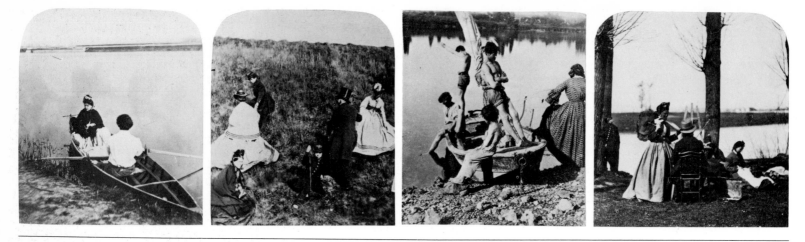

Figs. 85–86. J. Raudnitz (French), *Couple in a Boat; In the Country*, 1865, 1863. Stereoscopic views: albumen prints from glass negatives. Each 5 x 5 cm. Bibliothèque Nationale, Cabinet des Estampes, Paris. Photos: Bibliothèque Nationale.

Fig. 87. Verneuil (French), *Picnic on the Water*, 1868. Stereoscopic view: albumen print from glass negative. 5 x 5 cm. Bibliothèque Nationale, Cabinet des Estampes, Paris. Photo: Bibliothèque Nationale.

Fig. 88. Raudnitz, *A Sunday Painter*, 1863. Stereoscopic view: albumen print from glass negative. 5 x 5 cm. Bibliothèque Nationale, Cabinet des Estampes, Paris. Photo: Bibliothèque Nationale.

A look through the Société Française de Photographie exhibition catalogues of 1857–59 reveals a sharp rise in the number of photographs devoted to river banks in the region around Paris and a clear interest in capturing the feeling of specific times of day. In looking at such photographs, however, we must not allow ourselves to be fooled by the fact that their titles are often identical to those of Impressionist paintings. The spirit of the works the titles refer to may be quite different. Fortier's photograph entitled *The Banks of the Seine at Bas-Meudon* (1857), for example, represents a rather dry view of the subject and shows no attempt to transmit the surrounding atmosphere. Contemporary work by Bevan (see above, III/2) lacks any deep sense of nature or light, and his technique was that of the true amateur. His Louveciennes album, though photographed in the "cradle of Impressionism," records the first appearance in photography of a new landscape theme, the comfortable, bourgeois house and garden (fig. 20), which has no precedent whatever in the albums of Blanquart-Evrard and which was of minimal interest to Pissarro and his colleagues, as we have seen. Like Bevan, Idelfonse Rousset photographed certain sites dear to the Impressionists, and at the same time. But in Bevan's case the desire to return to nature was more clearly affirmed.

Le Tour de Marne (1865), with photographs by Rousset and text by Emile de La Bedollière (see above, III/2), is not only a delightful book; it is, in its way, a miniature return-to-nature manifesto, as was the first collaborative effort by these men, *Le Bois de Vincennes* (1865). In *Le Tour de Marne* de La Bedollière explains that the river, spared normal traffic by the canal linking the towns of Joinville and Gravelle, had become a paradise for holiday-makers with their boats and for artists with their palettes, and that it was one of them—he fails to specify whether boater or painter—who advised him and Rousset to undertake an exploration of the area. During the year Rousset spent along the river, photographing the same landscapes in full bloom and under snow, at dawn and at dusk (figs. 83–84), Pissarro was painting there. Looking through Rousset's charming, if somewhat repetitive, photographs, however, one cannot help but notice that what for the Impressionists was a veritable passion, a passion they had the means to consummate, was for their photographer contemporaries, as sincere as they may have been, a matter of mere fashion. Hampered by meager inspiration as well as by imperfect technique, they produced limited results.

A similar call for working in situ and for accurately evoking the atmosphere of a particular place manifested itself in the realm of the stereoscopic view. Topographical series focusing on the environs of Paris took on a delightfully picturesque aspect around 1857. In the same period genre scenes mimicking bourgeois life were most often done out-of-doors, rather than being "reconstructed" in the studio. New themes appeared: the country house and, above all, the boating picnic on the banks of the Seine, conceived in what was already a cinemagraphic spirit (figs. 85–88). The family garden remained a preferred spot for genre scenes, however. Less spontaneous than those presented in Impressionist paintings, such scenes derive their greatest charm from effects of lighting. At the turn of the century the painter Bonnard tried his hand at these themes, not only in paintings, but also in photographs, creating the most intimate and radiant visions (fig. 89).

If in the 1860s and '70s such landscapists as Quinet and Rousset, or even Marville, appear to have been inspired by the same current of feelings as the Impressionists, they were less dependent upon them and did not try to imitate painting. On the contrary, Quinet, for example, furnished motifs for painters (most often for Academic artists) rather than vice versa. Around 1900, however, references to paintings by Monet, Renoir, and Sisley became conscious and explicit in the landscapes of amateur photographers, particularly among the Pictorialists. For Robert Demachy, the most influential member of this group, in particular, the Impressionists were important models. He shared their predilection for "modern" subjects: the banks of the Seine where barges were moored, hillsides "planted" with factories. He allowed himself to create, in his astonishing *Speed*, an almost abstract landscape, by adding an automobile to it. And he made the Impressionists' research on light and atmospheric vibration his own, translating it into gum bichromate prints. Certain of his landscapes provide an interpretation of Impressionism which—if not novel—is never ponderous, thanks to the happy equilibrium maintained between naturalism and abstraction, while others (fig. 90) begin to show the influence of Art Nouveau. Constant Puyo seems also to have had a true propensity for landscape. But in populating his luminous meadows with mannered nymphs, he irrevocably diluted its essence. It is in the small snapshots he took repeatedly and which served him as a type of sketch—a practice dear to the Pictorialists—that we must look for the freshness of spontaneous impressions.

The influence of Impressionist painting can be seen even in the work of amateurs on the fringes of Pictorialism. This is the case with Frégniot-Arnal (fig. 91) and, above all, with Antonin Personnaz. For the latter, a friend of Pissarro and Guillaumin and a celebrated collector of Impressionist paintings, there could have been nothing more natural. Personnaz was one of the first to use the autochrome process, which was patented by the Lumière brothers and commercialized in 1907, and was surely one of the foremost practitioners in this area. Often his landscapes are to be admired for their masterly technique, harmonious composition, and refined color. However, they are lacking, like all French photographs inspired by Impressionism, in the vigor of completely original works and thus point up the delicate, sometimes tenuous, relationship between painting and photography in the 1800s.

—F. H.

Fig. 89. Pierre Bonnard (French, 1867–1947), *Martha in the Garden*, c. 1900. Modern print from original negative. Private Collection. Photo: Musée d'Orsay, Paris.

Fig. 90. Robert Demachy (French, 1859–1937), *Landscape*, c. 1904. Gum bichromate print. 21.2 x 15.8 cm. Musée d'Orsay, Paris. Photo: Musée d'Orsay.

Fig. 91. Fregniot-Arnal (French), *Mist on the Oise*, 1905. Artigue carbon print by Fresson. 12.5 x 16.5 cm. Gérard Levy Collection, Paris. Photo: Musée d'Orsay, Paris.

NOTES

1. See The Museum of Modern Art, 1981.
2. Newspaper illustrators themselves often used commercial photographs as the basis for their drawings and engravings.
3. During the 1860s, the years when Marville began his reportage, it would have been necessary for him, given the dimensions of his negative plates (35 by 23 centimeters), to use posed models to provide figuration. Not only did he not do this, but it is probable that such a process would not have interested him.
4. The use of a lens with a very short focal length in effect allowed the clear registration of an image located very far away in an exposure period brief enough to capture movement, but on an extremely reduced surface. The possibility of interfering with the photograph during this procedure was nil.
5. It is impossible to review here the question of rapports among the Realist painters and contemporary photographers and critics. See Scharf, 1968, pp. 65–67, 95–108, 263, 269–270; Jammes and Parry, 1983, pp. 4, 82, 207, 231; and Heilbrun, 1980, pp. 18–19, 348–349.
6. See The Museum of Modern Art, 1981.
7. The same characteristic can be found in the treatment of foliage by many other photographers of this period, including Colliau, Delondre, Pettiot-Groffier, and Nègre.
8. This print, if not the entire album of which it is a part, was derived from a stereoscopic view of the time (Sirot-Angel Collection).

Checklist of the Exhibition

Unless otherwise noted, all artists were of French nationality.
All works are oil on canvas. Each entry in Section III of this volume was authored by the contributor whose initials appear on the essay immediately preceding it. Exceptions are initialed individually.

Frédéric Bazille
1841–1870

BEACH AT SAINTE-ADRESSE
LA PLAGE À SAINTE-ADRESSE, 1865
57 × 139.7 cm.
The High Museum of Art, Atlanta, Gift of the Forward
Arts Foundation in Honor of Frances Floyd Cocke
Daulte 15/1
No. 4

THE FOREST OF FONTAINEBLEAU
FORÊT DE FONTAINEBLEAU, 1865
60 × 73 cm.
Musée d'Orsay, Galerie du Jeu de Paume, Paris
Daulte 11
No. 8

LANDSCAPE AT CHAILLY
PAYSAGE À CHAILLY, 1865
82 × 105 cm.
The Art Institute of Chicago, Charles H. and
Mary F. S. Worcester Collection
Daulte 12
No. 7

ROSE TRELLIS (TERRACE AT MÉRIC)
LES LAURIERS-ROSES (TERRASSE À MÉRIC), 1867
55.5 × 91.5 cm.
Cincinnati Art Museum, Gift of Mark P. Herschede
Daulte 26
No. 79

Emile Bernard
1868–1941

HARVEST NEAR THE SEASIDE
LA MOISSON AU BORD DE LA MER, 1891
70 × 92 cm.
Musée d'Orsay, Palais de Tokyo, Paris
No. 134

THE VILLAGE OF PONT-AVEN
LE VILLAGE DE PONT-AVEN, 1892
72 × 92 cm.
Josefowitz Collection, Switzerland
No. 135

Eugène Boudin
1824–1898

BORDEAUX HARBOR
PORT DE BORDEAUX, 1874
41 × 65 cm.
Musée d'Orsay, Galerie du Jeu de Paume, Paris
Schmit 976
No. 114

CAMARET HARBOR
PORT DE CAMARET, 1872
55.5 × 89.5 cm.
Musée d'Orsay, Galerie du Jeu de Paume, Paris
Schmit 803
No. 113

LANDSCAPE WITH WASHERWOMEN (LE FAOU,
THE HARBOR AT LOW TIDE)
*PAYSAGE AUX LAVANDIÈRES (LE FAOU, LE
PORT À MARÉE BASSE), 1873*
37 × 58 cm.
Musée d'Orsay, Galerie du Jeu de Paume, Paris
Schmit 873
No. 50

ON THE BEACH AT TROUVILLE
SCÈNE DE PLAGE À TROUVILLE, 1860
67.3 × 104.2 cm.
The Minneapolis Institute of Arts, The William
Hood Dunwoody Fund
Schmit 254
No. 12

Gustave Caillebotte
1848–1894

THE BRIDGE OVER THE SEINE AT ARGENTEUIL
LE PONT D'ARGENTEUIL ET LA SEINE, 1885
65 × 82 cm.
Josefowitz Collection, Switzerland
Berhaut 310
No. 46

ON THE EUROPE BRIDGE
LE PONT DE L'EUROPE, 1876–77
105 × 130 cm.
Kimbell Art Museum, Fort Worth
Berhaut 46
No. 29

ROSES, GARDEN AT PETIT-GENNEVILLIERS
*LES ROSES, JARDIN DU PETIT-GENNEVILLIERS, c.
1886 89 × 116 cm.*
Private Collection
Berhaut 312
No. 87

THATCHED COTTAGE AT TROUVILLE
LA CHAUMIÈRE, TROUVILLE, 1882
54 × 65 cm.
The Art Institute of Chicago, Gift of Frank H. and
Louise B. Woods
Berhaut 196
No. 86

TRAFFIC ISLAND ON BOULEVARD HAUSSMANN
UN REFUGE BOULEVARD HAUSSMANN, 1880
81 × 101 cm.
Private Collection
Berhaut 141
No. 33

Paul Cézanne
1839–1906

AUVERS, PANORAMIC VIEW
AUVERS, VUE PANORAMIQUE, 1873–75
65 × 81.3 cm.
The Art Institute of Chicago, Mr. and Mrs. Lewis
Larned Coburn Memorial Collection
Venturi 150
No. 69

THE BAY OF MARSEILLE, SEEN FROM L'ESTAQUE
*LE GOLFE DE MARSEILLE, VU DE L'ESTAQUE,
c. 1878–79 59.5 × 73 cm.*
Musée d'Orsay, Galerie du Jeu de Paume, Paris
Venturi 428
No. 127

THE BAY OF MARSEILLE, SEEN FROM L'ESTAQUE
*LE GOLFE DE MARSEILLE, VU DE L'ESTAQUE,
1883–85 73 × 100 cm.*
The Metropolitan Museum of Art, New York,
Bequest of Mrs. H. O. Havemeyer, 1929, The H. O.
Havemeyer Collection
Venturi 429
No. 128

THE BAY OF MARSEILLE, SEEN FROM L'ESTAQUE
*LE GOLFE DE MARSEILLE, VU DE L'ESTAQUE,
1886–90*
76 × 97 cm.
The Art Institute of Chicago, Mr. and Mrs.
Martin A. Ryerson Collection
Venturi 493
No. 129

BEND IN THE ROAD
LA ROUTE TOURNANTE, 1879–82
60.5 × 73.5 cm.
Museum of Fine Arts, Boston, Bequest of John T.
Spaulding, 1948
Venturi 329
No. 72

THE BRIDGE AT MAINCY, NEAR MELUN
LE PONT DE MAINCY, c. 1879–80
58.5 × 72.5 cm.
Musée d'Orsay, Galerie du Jeu de Paume, Paris
Venturi 396
No. 73

FARMYARD AT AUVERS
COUR DE FERME À AUVERS, c. 1879–80
65 × 54 cm.
Musée d'Orsay, Galerie du Jeu de Paume, Paris
Venturi 326
No. 70

MOUNT SAINTE-VICTOIRE
MONT SAINTE-VICTOIRE, 1886–88
67.3 × 91.5 cm.
National Gallery of Art, Washington, D.C., Gift
of the W. Averell Harriman Foundation in Memory
of Marie N. Harriman, 1972
Venturi 437
No. 130

MOUNT SAINTE-VICTOIRE FROM THE LARGE PINE
TREE
*LA MONTAGNE SAINTE-VICTOIRE AU GRAND
PIN, 1885–87 60 × 73 cm.*
The Phillips Collection, Washington, D.C.
Venturi 455
No. 131

THE POPLARS
LES PEUPLIERS c. 1879–82
65 × 81 cm.
Musée d'Orsay, Galerie du Jeu de Paume, Paris
Venturi 335
No. 71

Henri-Edmond Cross
1856–1910

BEACH AT CABASSON
PLAGE DE BAIGNE-CUL, 1891–92
65.7 × 92.1 cm.
The Art Institute of Chicago, 1983
Compin 31
Los Angeles and Chicago only
No. 136

COAST NEAR ANTIBES
CALANQUE DES ANTIBOIS, 1891–92
65 × 94 cm.
National Gallery of Art, Washington, D.C., The John
Hay Whitney Collection, 1982
Compin 33
No. 137

Paul Gauguin
1848–1903

THE CHURCH AT PONT-AVEN
LE CHAMP DEROUT-LOLLICHON [I], 1886
73×92 cm.
Private Collection, Switzerland
Wildenstein 199
No. 75

FARM AT ARLES
FERME À ARLES, 1888
91.5×72.5 cm.
Indianapolis Museum of Art, Gift in Memory of
 William Ray Adams
Wildenstein 308
No. 102

THE FIELD OF DEROUT-LOLLICHON
LE CHAMP DEROUT-LOLLICHON [II], 1886
73×92 cm.
Hal B. Wallis
Wildenstein 200
Los Angeles only
No. 76

THE MARKET GARDENS AT VAUGIRARD
LES MARAÎCHERS DE VAUGIRARD, c. 1879
65×100 cm.
Smith College Museum of Art, Northampton,
 Purchased 1953
Wildenstein 36
No. 74

THE ROMAN BURIAL GROUND AT ARLES
LES ALYSCAMPS, ARLES, 1888
91.5×72.5 cm.
Musée d'Orsay, Galerie du Jeu de Paume, Paris
Wildenstein 307
No. 133

THE SWINEHERD, BRITTANY
LE GARDIEN DES PORCS, BRETAGNE, 1888
73×93 cm.
Lucille Ellis Simon
Wildenstein 255
No. 132

Armand Guillaumin
1841–1927

THE ARCUEIL AQUEDUCT AT SCEAUX RAILROAD
 CROSSING
L'AQUEDUC À ARCUEIL, LIGNE DE SCEAUX, c. 1874
50×63 cm.
The Art Institute of Chicago, Mrs. Clive Runnells,
 Restricted Gift
Serret and Fabiani 34
No. 51

ENVIRONS OF PARIS
ENVIRONS DE PARIS, c. 1874
60×81 cm.
Birmingham City Museum and Art Gallery
Serret and Fabiani 32
No. 52

ENVIRONS OF PARIS
ENVIRONS DE PARIS, c. 1890
74×93 cm.
Mrs. Lyndon Baines Johnson
Serret and Fabiani 210
No. 77

Edouard Manet
1832–1883

DEPARTURE FROM BOULOGNE HARBOR
SORTIE DU PORT DE BOULOGNE, 1864–65
74×93 cm.
The Art Institute of Chicago, Potter Palmer Collection
Rouart and Wildenstein 78
No. 2

MOONLIGHT OVER BOULOGNE HARBOR
CLAIR DE LUNE SUR LE PORT DE BOULOGNE,
 1869
82×101 cm.
Musée d'Orsay, Galerie du Jeu de Paume, Paris
Rouart and Wildenstein 143
No. 3

Claude Monet
1840–1926

AFTERNOON AT ANTIBES
ANTIBES, EFFET D'APRÈS-MIDI, 1888
66×82.5 cm.
Museum of Fine Arts, Boston, Gift of Samuel
 Dacre Bush, 1927
Wildenstein 1158
No. 126

ARGENTEUIL BASIN
LE BASSIN D'ARGENTEUIL, 1872
60×80.5 cm.
Musée d'Orsay, Galerie du Jeu de Paume, Paris
Wildenstein 225
No. 39

ARGENTEUIL BASIN
LE BASSIN D'ARGENTEUIL, 1874
55.2×74.2 cm.
Museum of Art, Rhode Island School of Design,
 Providence, Gift of Mrs. Murray S. Danforth
Wildenstein 325
No. 41

BATHING AT LA GRENOUILLÈRE
LES BAINS DE LA GRENOUILLÈRE, 1869
73×92 cm.
The Trustees of The National Gallery, London
Wildenstein 135
No. 14

BEACH AT HONFLEUR
LE BORD DE LA MER À HONFLEUR, 1864–66
60×81 cm.
Los Angeles County Museum of Art, Gift of Mrs.
 Reese Hale Taylor, 1964
Wildenstein 41
No. 1

THE BEACH AT SAINTE-ADRESSE
LA PLAGE DE SAINTE-ADRESSE, 1867
75.8×102.5 cm.
The Art Institute of Chicago, Mr. and Mrs. Lewis
 Larned Coburn Memorial Collection
Wildenstein 92
No. 6

THE BRIDGE AT BOUGIVAL
LE PONT DE BOUGIVAL, 1869
65.5×92.5 cm.
The Currier Gallery of Art, Manchester
Wildenstein 152
No. 13

CLIFF WALK AT POURVILLE
PROMENADE SUR LA FALAISE, POURVILLE, 1882
65×81 cm.
The Art Institute of Chicago, Mr. and Mrs. Lewis
 Larned Coburn Memorial Collection
Wildenstein 758
No. 117

CUSTOMS HOUSE AT VARENGEVILLE
CABANE DE DOUANIER, 1882
60×81 cm.
Philadelphia Museum of Art, William L. Elkins Collection
Wildenstein 743
No. 116

THE EUROPE BRIDGE AT SAINT-LAZARE TRAIN
 STATION
LE PONT DE L'EUROPE, GARE SAINT-LAZARE, 1877
64×80 cm.
Musée Marmottan, Paris
Wildenstein 442
No. 30

FLOATING ICE ON THE SEINE
DÉBÂCLE SUR LA SEINE, 1880
60×100 cm.
Musée d'Orsay, Galerie du Jeu de Paume, Paris
Wildenstein 567
No. 55

FLOWERING APPLE TREES
POMMIERS EN FLEURS, 1872
57.5×69.5 cm.
Collection of Union League Club of Chicago
Wildenstein 201
No. 100

FLOWERING GARDEN
JARDIN EN FLEURS, c. 1866
65×54 cm.
Musée d'Orsay, Galerie du Jeu de Paume, Paris
Wildenstein 69
No. 78

THE GARDEN AT GIVERNY
LE JARDIN À GIVERNY, 1900
81.9×91.5 cm.
Musée d'Orsay, Galerie du Jeu de Paume, Paris
Paris only
No. 91

GLADIOLI
LES GLAÏEULS, 1876
55.9×82.6 cm.
The Detroit Institute of Arts, City of Detroit Purchase
Wildenstein 414
No. 83

THE GRAINSTACK
LA MEULE, 1891
65.6×92 cm.
The Art Institute of Chicago, Major Acquisition Fund
 and Mr. and Mrs. Daniel C. Searle Restricted Gift
Wildenstein 1283
No. 106

GRAINSTACKS, END OF DAY, AUTUMN
DEUX MEULES, DÉCLIN DU JOUR, AUTOMNE, 1891
65×100 cm.
The Art Institute of Chicago, Mr. and Mrs. Lewis
 Larned Coburn Memorial Collection
Wildenstein 1270
No. 105

GRAINSTACKS, END OF SUMMER, EVENING
MEULES, FIN DE L'ÉTÉ, EFFET DU SOIR, 1891
60×100 cm.
Mrs. Arthur M. Wood
Wildenstein 1269
No. 108

GRAINSTACKS, END OF SUMMER, MORNING
MEULES, FIN DE L'ÉTÉ, EFFET DU MATIN, 1891
60.5 × 100 cm.
Musée d'Orsay, Galerie du Jeu de Paume, Paris
Wildenstein 1266
Paris only
No. 107

THE GRAINSTACKS IN THE SNOW, OVERCAST DAY
MEULES, EFFET DE NEIGE, TEMPS COUVERT, 1891
66 × 93 cm.
The Art Institute of Chicago, Mr. and Mrs. Martin
A. Ryerson Collection
Wildenstein 1281
No. 111

GRAINSTACKS, SNOW
MEULES, EFFET DE NEIGE, 1891
60 × 100 cm.
Shelburne Museum of Art
Wildenstein 1274
Los Angeles and Chicago only
No. 109

GRAINSTACKS, SNOW, SUNSET
*MEULES, EFFET DE NEIGE, SOLEIL COUCHANT,
1891*
65.3 × 100.4 cm.
The Art Institute of Chicago, Potter Palmer
Collection
Wildenstein 1278
No. 112

THE GRAINSTACK, SUNSET
MEULE, SOLEIL COUCHANT, 1891
73.3 × 92.6 cm.
Museum of Fine Arts, Boston, Juliana Cheney
Edwards Collection, Bequest of Robert J.
Edwards in Memory of his Mother, 1925
Wildenstein 1289
No. 104

THE GRAINSTACK, THAW, SUNSET
MEULE, DÉGEL, SOLEIL COUCHANT, 1891
65 × 92 cm.
Private Collection, U.S.A.
Wildenstein 1284
No. 110

JAPANESE BRIDGE AT GIVERNY
LE PONT JAPONAIS, GIVERNY, c. 1900
89.8 × 101 cm.
The Art Institute of Chicago, Mr. and Mrs. Lewis
Larned Coburn Memorial Collection
No. 93

LANDSCAPE, VIEW OF THE ARGENTEUIL PLAIN
PAYSAGE, VUE DE LA PLAINE À ARGENTEUIL, 1872
53 × 72 cm.
Musée d'Orsay, Galerie du Jeu de Paume, Paris
Wildenstein 220
No. 94

THE LUNCHEON
LE DÉJEUNER, 1873–74
160 × 201 cm.
Musée d'Orsay, Galerie du Jeu de Paume, Paris
Wildenstein 285
Paris only
No. 81

MADAME MONET IN THE GARDEN
MADAME MONET DANS UN JARDIN, c. 1872
51.5 × 66 cm.
Anonymous Loan
No. 82

THE MANNEPORTE, HIGH SEAS
LA MANNEPORTE, MARÉE HAUTE, 1885
65 × 81.3 cm.
Mr. and Mrs. A. N. Pritzker
Wildenstein 1035
No. 119

MONET'S GARDEN AT GIVERNY
LE JARDIN DE MONET À GIVERNY, 1900
80.6 × 90.8 cm.
Ralph T. Coe
Los Angeles and Chicago only
No. 92

MONET'S HOUSE AT ARGENTEUIL
LA MAISON DE L'ARTISTE À ARGENTEUIL, 1873
60.5 × 74 cm.
The Art Institute of Chicago, Mr. and Mrs. Martin
A. Ryerson Collection
Wildenstein 284
No. 80

MONTORGUEIL STREET, CELEBRATION OF 30
JUNE 1878
*LA RUE MONTORGUEIL, FÊTE DU 30 JUIN
1878, 1878*
80 × 50 cm.
Musée d'Orsay, Galerie du Jeu de Paume, Paris
Wildenstein 469
No. 28

ON THE SEINE AT BENNECOURT
AU BORD DE L'EAU, BENNECOURT, 1868
81.5 × 100.7 cm.
The Art Institute of Chicago, Potter Palmer
Collection
Wildenstein 110
No. 47

POPPY FIELD
CHAMP AUX COQUELICOTS, 1890
61 × 96.5 cm.
The Art Institute of Chicago, Mr. and Mrs. W. W.
Kimball Collection
Wildenstein 1253
No. 103

THE RAILROAD BRIDGE, ARGENTEUIL
LE PONT DU CHEMIN DE FER, ARGENTEUIL, 1874
54.3 × 73 cm.
John G. Johnson Collection, Philadelphia Museum
of Art
Wildenstein 318
No. 43

ROCHES NOIRES HOTEL, AT TROUVILLE
HÔTEL DES ROCHES NOIRES, TROUVILLE, 1870
81 × 58.3 cm.
Musée d'Orsay, Galerie du Jeu de Paume, Paris
Wildenstein 155
No. 115

SAILBOAT AT PETIT-GENNEVILLIERS
VOILIER AU PETIT-GENNEVILLIERS, 1874
56 × 74 cm.
Lucille Ellis Simon
Wildenstein 336
No. 42

SAINT-LAZARE TRAIN STATION
LA GARE SAINT-LAZARE, 1877
75.5 × 104 cm.
Musée d'Orsay, Galerie du Jeu de Paume, Paris
Wildenstein 438
No. 31

SAINT-LAZARE TRAIN STATION, THE NOR-
MANDY TRAIN
*LA GARE SAINT-LAZARE, LE TRAIN DE NORMANDIE,
1877*
59.6 × 80.2 cm.
The Art Institute of Chicago, Mr. and Mrs. Martin
A. Ryerson Collection
Wildenstein 440
No. 32

THE SEA AT POURVILLE
LA MER À POURVILLE, 1882
54 × 73 cm.
Philadelphia Museum of Art, Bequest of Mrs.
Frank Graham Thomson
Wildenstein 772
No. 118

THE SEINE AT ARGENTEUIL
LA SEINE À ARGENTEUIL, 1873
50.3 × 61 cm.
Musée d'Orsay, Galerie du Jeu de Paume, Paris
Wildenstein 198
No. 40

SPRINGTIME, THROUGH THE BRANCHES
LE PRINTEMPS, À TRAVERS LES BRANCHES, 1878
52 × 63 cm.
Musée Marmottan, Paris
Wildenstein 455
No. 54

TERRACE AT SAINTE-ADRESSE
TERRASSE À SAINTE-ADRESSE, 1867
98 × 130 cm.
The Metropolitan Museum of Art, New York,
Purchased with Special Contributions and
Purchase Funds Given or Bequeathed by
Friends of the Museum, 1967
Wildenstein 95
Los Angeles only
No. 5

TRAIN IN THE COUNTRYSIDE
TRAIN DANS LA CAMPAGNE, c. 1870–71
50 × 65 cm.
Musée d'Orsay, Galerie du Jeu de Paume, Paris
Wildenstein 153
No. 48

TUILERIES GARDENS
VUE DES TUILERIES, 1876
53 × 72 cm.
Musée Marmottan, Paris
Wildenstein 401
No. 84

VERSAILLES ROAD AT LOUVECIENNES—SNOW
*ROUTE À LOUVECIENNES—EFFET DE NEIGE,
1869–70*
56 × 65.5 cm.
Private Collection, Chicago
Wildenstein 147
Chicago and Paris only
No. 15

Berthe Morisot
1841–1895

VIEW OF PARIS FROM THE TROCADÉRO
*VUE DE PARIS DES HAUTEURS DU TROCADÉRO,
1872*
46.1 × 81.5 cm.
Santa Barbara Museum of Art, Gift of Mrs. Hugh
N. Kirkland
Bataille and Wildenstein 23
No. 27

Camille Pissarro
Danish, 1830–1903

THE BANKS OF THE MARNE IN WINTER
BORDS DE LA MARNE EN HIVER, 1866
91.8 × 150.2 cm.
The Art Institute of Chicago, Mr. and Mrs. Lewis
 Larned Coburn Memorial Fund
Pissarro and Venturi 47
No. 9

BANKS OF THE OISE, PONTOISE
BORDS DE L'EAU À PONTOISE, 1872
55 × 91 cm.
Lucille Ellis Simon
Pissarro and Venturi 158
No. 61

BOULEVARD MONTMARTRE, MARDI GRAS
BOULEVARD MONTMARTRE, MARDI GRAS, 1897
63.5 × 80 cm.
Armand Hammer Collection
Pissarro and Venturi 995
No. 35

BRIDGE AT ROUEN
LE GRAND PONT, ROUEN, 1896
73 × 92 cm.
Museum of Art, Carnegie Institute, Pittsburgh,
 Museum Purchase, 1900
Pissarro and Venturi 956
No. 37

CLIMBING PATH IN THE HERMITAGE, PONTOISE
*LE CHEMIN MONTANT L'HERMITAGE, PONTOISE,
 1875*
54 × 65 cm.
The Brooklyn Museum, Gift of Dikran G. Kelekian
Pissarro and Venturi 308
Los Angeles only
No. 66

CORNER OF THE GARDEN AT THE HERMITAGE
UN COIN DE JARDIN À L'HERMITAGE, 1877
55 × 46 cm.
Musée d'Orsay, Galerie du Jeu de Paume, Paris
Pissarro and Venturi 396
No. 85

THE ENNERY ROAD NEAR PONTOISE
ROUTE D'ENNERY PRÈS PONTOISE, 1874
55 × 92 cm.
Musée d'Orsay, Galerie du Jeu de Paume, Paris
Pissarro and Venturi 254
No. 65

HARVEST AT MONTFOUCAULT
LA MOISSON À MONTFOUCAULT, 1876
65 × 92.5 cm.
Musée d'Orsay, Galerie du Jeu de Paume, Paris
Pissarro and Venturi 365
No. 97

HARVEST LANDSCAPE AT PONTOISE
PAYSAGE, LA MOISSON, PONTOISE, 1873
65 × 81 cm.
Private Collection, Chicago
Pissarro and Venturi 235
Chicago and Paris only
No. 95

HILLSIDE IN THE HERMITAGE, PONTOISE
COTEAU DE L'HERMITAGE, PONTOISE, 1873
61 × 73 cm.
Musée d'Orsay, Galerie du Jeu de Paume, Paris
Pissarro and Venturi 209
No. 63

HOARFROST
GELÉE BLANCHE, 1873
65 × 93 cm.
Musée d'Orsay, Galerie du Jeu de Paume, Paris
Pissarro and Venturi 203
No. 96

KITCHEN GARDEN AND FLOWERING TREES,
 SPRING, PONTOISE
*POTAGER ET ARBRES EN FLEURS, PRINTEMPS,
 PONTOISE, 1877*
65 × 81 cm.
Musée d'Orsay, Galerie du Jeu de Paume, Paris
Pissarro and Venturi 387
Paris only
No. 98

LANDSCAPE AT LOUVECIENNES (AUTUMN)
*LE PAYSAGE AUX ENVIRONS DE LOUVECIENNES
 (AUTOMNE), 1869–70*
89 × 116 cm.
The J. Paul Getty Museum, Malibu
Pissarro and Venturi 87
Chicago and Paris only
No. 16

LANDSCAPE NEAR LOUVECIENNES
PAYSAGE, LOUVECIENNES, c. 1875
51.5 × 81 cm.
Musée d'Orsay, Galerie du Jeu de Paume, Paris
Pissarro and Venturi 309
No. 18

THE PLACE DU HAVRE, PARIS
PLACE DU HAVRE, PARIS, 1893
60.1 × 73.5 cm.
The Art Institute of Chicago, Potter Palmer Collection
Pissarro and Venturi 838
No. 34

THE PLACE DU THÉÂTRE FRANÇAIS, PARIS
LA PLACE DU THÉÂTRE FRANÇAIS, PARIS, 1898
73 × 92 cm.
Los Angeles County Museum of Art, Mr. and Mrs.
 George Gard de Sylva Collection
Pissarro and Venturi 1031
No. 36

RABBIT WARREN AT PONTOISE, SNOW
LA GARENNE À PONTOISE, EFFET DE NEIGE, 1879
59.2 × 72.3
The Art Institute of Chicago, Gift of Marshall Field
Pissarro and Venturi 478
No. 68

RAILWAY CROSSING AT PATIS, NEAR PONTOISE
*LA BARRIÈRE DU CHEMIN DE FER, AU PATIS
 PRÈS PONTOISE, 1873–74*
65 × 81 cm.
The Phillips Family Collection
Pissarro and Venturi 266
No. 53

THE RED HOUSE
LA MAISON ROUGE, 1873
59 × 73 cm.
Portland Art Museum, Bequest of Winslow B. Ayer
Pissarro and Venturi 221
Los Angeles and Chicago only
No. 62

RED ROOFS, A CORNER OF THE VILLAGE IN WINTER
*LES TOITS ROUGES, COIN DE VILLAGE, EFFET
 D'HIVER, 1877*
54.5 × 65.6 cm.
Musée d'Orsay, Galerie du Jeu de Paume, Paris
Pissarro and Venturi 384
Paris only
No. 67

ROUEN HARBOR, SAINT-SEVER
PORT DE ROUEN, SAINT-SEVER, 1896
65.5 × 92 cm.
Musée d'Orsay, Galerie du Jeu de Paume, Paris
Pissarro and Venturi 957
No. 38

SNOW AT THE HERMITAGE, PONTOISE
EFFET DE NEIGE À L'HERMITAGE, PONTOISE, 1874
54.5 × 65.5 cm.
Anonymous Loan
Pissarro and Venturi 238
No. 64

WASH HOUSE AT BOUGIVAL
LE LAVOIR, BOUGIVAL, 1872
46.5 × 56 cm.
Musée d'Orsay, Galerie du Jeu de Paume, Paris
Pissarro and Venturi 175
No. 17

Pierre-Auguste Renoir
1841–1919

THE BRIDGE AT ARGENTEUIL
LE PONT D'ARGENTEUIL, 1882
54 × 65 cm.
Private Collection, U.S.A.
No. 45

OARSMEN AT CHATOU
LES CANOTIERS À CHATOU, 1879
81.3 × 100.3 cm.
National Gallery of Art, Washington, D.C., Gift of
 Sam A. Lewisohn, 1951
No. 49

THE SEINE AT ARGENTEUIL
LA SEINE À ARGENTEUIL, c. 1873
46.5 × 65 cm.
Musée d'Orsay, Galerie du Jeu de Paume, Paris
No. 44

THE WAVE
LA VAGUE, 1879
64.8 × 99.2 cm.
The Art Institute of Chicago, Potter Palmer Collection
No. 120

Georges Seurat
1859–1891

THE ALFALFA FIELD NEAR SAINT-DENIS
LA LUZERNE À SAINT-DENIS, 1885
65 × 81 cm.
National Gallery of Scotland, Edinburgh
de Hauke 145
No. 101

THE BRIDGE AND QUAYS AT PORT-EN-BESSIN
LE PONT ET LES QUAIS À PORT-EN-BESSIN, 1888
67 × 84.5 cm.
The Minneapolis Institute of Arts, The William
 Hood Dunwoody Fund
de Hauke 188
No. 123

PORT-EN-BESSIN, THE OUTER HARBOR AT
 HIGH TIDE
PORT-EN-BESSIN, AVANT-PORT, MARÉE HAUTE, 1888
67 × 82 cm.
Musée d'Orsay, Palais de Tokyo, Paris
de Hauke 193
No. 121

PORT-EN-BESSIN, THE OUTER HARBOR AT LOW TIDE
PORT-EN-BESSIN, L'AVANT-PORT À MARÉE BASSE, 1888
53.5 × 65.7 cm.
The St. Louis Art Museum
de Hauke 189
No. 122

SEASCAPE AT PORT-EN-BESSIN, NORMANDY
LES GRUES ET LA PERCÉE À PORT-EN-BESSIN, NORMANDY, 1888
64.7 × 81.5 cm.
National Gallery of Art, Washington, D.C., Gift of the W. Averell Harriman Foundation in Memory of Marie N. Harriman, 1972
de Hauke 190
No. 124

Paul Signac
1863–1935

THE ANCHORAGE AT PORTRIEUX
LA RADE DE PORTRIEUX, 1888
65.5 × 82 cm.
Private Collection
No. 125

THE SEINE AT HERBLAY
BORDS DE RIVIÈRE, LA SEINE À HERBLAY, 1889
33 × 55 cm.
Musée d'Orsay, Palais de Tokyo, Paris
No. 58

Alfred Sisley
1839–1899

AUTUMN: BANKS OF THE SEINE NEAR BOUGIVAL (AUTUMN: BANKS OF THE OISE)
L'AUTOMNE SUR LES BORDS DE L'OISE, 1873
46.5 × 61.6 cm.
The Montreal Museum of Fine Arts, Bequest of Miss Adaline Van Horne
Daulte 94
No. 60

AVENUE OF CHESTNUT TREES AT LA CELLE-SAINT-CLOUD
ALLÉE DE CHÂTAIGNIERS PRÈS DE LA CELLE-SAINT-CLOUD, 1867
89 × 116 cm.
Southampton Art Gallery
Daulte 9
No. 10

THE BRIDGE AT MORET
PONT DE MORET, 1893
73.5 × 92.3 cm.
Musée d'Orsay, Galerie du Jeu de Paume, Paris
Daulte 817
No. 57

FIRST SNOW AT LOUVECIENNES
PREMIÈRES NEIGES À LOUVECIENNES, c. 1870–71
54.8 × 73.8 cm.
Museum of Fine Arts, Boston, Bequest of John T. Spaulding, 1948
Daulte 18
No. 19

FLOOD AT PORT-MARLY
L'INONDATION À PORT-MARLY, 1876
60 × 81 cm.
Musée d'Orsay, Galerie du Jeu de Paume, Paris
Daulte 240
Paris only
No. 26

THE ROAD, VIEW OF SÈVRES PATH, LOUVECIENNES
LA ROUTE, VUE DU CHEMIN DE SÈVRES, 1873
54.7 × 73 cm.
Musée d'Orsay, Galerie du Jeu de Paume, Paris
Daulte 102
No. 59

THE SEINE AT BOUGIVAL
LA SEINE À BOUGIVAL, 1872–73
46 × 65.3 cm.
Musée d'Orsay, Galerie du Jeu de Paume, Paris
Daulte 87
No. 20

THE SEINE AT PORT-MARLY
BORDS DE LA SEINE À PORT-MARLY, 1875
54 × 65.5 cm.
Private Collection, Chicago
Chicago only
No. 24

THE SEINE AT PORT-MARLY, PILES OF SAND
LA SEINE À PORT-MARLY—TAS DE SABLE, 1875
54.5 × 73.7 cm.
The Art Institute of Chicago, Mr. and Mrs. Martin A. Ryerson Collection
Daulte 176
No. 23

THE SEINE NEAR BY
LA SEINE VUE DES COTEAUX DE BY, 1881
37 × 55 cm.
Musée d'Orsay, Galerie du Jeu de Paume, Paris
Daulte 443
No. 56

SPRINGTIME NEAR PARIS—FLOWERING APPLE TREES
PRINTEMPS AUX ENVIRONS DE PARIS—POMMIERS EN FLEURS, 1879
45 × 61 cm.
Musée Marmottan, Paris
Daulte 305
No. 99

STREET IN LOUVECIENNES
LA ROUTE À LOUVECIENNES, 1872–73
38 × 54 cm.
Private Collection
Daulte 167
No. 22

THE VERSAILLES ROAD, LOUVECIENNES
LA ROUTE DE VERSAILLES, 1875
47 × 38 cm.
Musée d'Orsay, Galerie du Jeu de Paume, Paris
Daulte 162
No. 25

VILLAGE STREET OF MARLOTTE
RUE DU VILLAGE À MARLOTTE, 1866
65 × 91.5 cm.
Albright-Knox Art Gallery, Buffalo, General Purchase Funds, 1956
Daulte 3
No. 11

WATERING PLACE AT MARLY
L'ABREUVOIR DE MARLY, 1875
39.5 × 56.2 cm.
The Art Institute of Chicago, Gift of Mrs. Clive Runnels
Daulte 169
No. 21

Vincent van Gogh
Dutch, 1853–1890

CORNER IN VOYER-D'ARGENSON PARK AT ASNIÈRES
COIN DU PARC VOYER-D'ARGENSON À ASNIÈRES, 1887
59 × 81 cm.
Yale University Art Gallery, New Haven, Gift of Henry R. Luce, B.A., 1920
de la Faille 276
No. 88

THE GARDEN OF THE POETS
LE JARDIN DES POÈTES, 1888
73 × 92 cm.
The Art Institute of Chicago, Mr. and Mrs. Lewis Larned Coburn Memorial Collection
de la Faille 468
No. 89

IRISES
LES IRIS, 1889
71 × 93 cm.
The Joan Whitney Payson Gallery of Art, Westbrook College, Portland
de la Faille 608
No. 90

Bibliography

EDITOR'S NOTE: Catalogues raisonnés are referred to in this volume by author's surname and painting number (i.e., "Daulte 112"). All other publications are cited by author's surname, year of publication, and appropriate reference.

Catalogues Raisonnés

Bataille, M.-L., and G. Wildenstein, *Berthe Morisot: Catalogue des peintures, pastels et aquarelles,* Paris, 1961.

Berhaut, M., *Gustave Caillebotte: Sa Vie et son oeuvre,* Paris, 1978.

Compin, I., *H. E. Cross: Premier Essai du catalogue de l'oeuvre peint,* Paris, 1964.

Daulte, F., *Alfred Sisley: Catalogue raisonné de l'oeuvre peint,* Lausanne, 1959.

———, *Frédéric Bazille et son temps,* Geneva, 1952.

de Hauke, C., *Seurat et son oeuvre,* 2 vols., Paris, 1961.

de la Faille, J., *The Works of Vincent van Gogh: His Paintings and Drawings,* Amsterdam, 1970.

Pissarro, L.-R., and L. Venturi, *Camille Pissarro: Son Art—son oeuvre,* 2 vols., Paris, 1939.

Rouart, D., and D. Wildenstein, *Edouard Manet,* 2 vols., Geneva, 1975.

Schmit, R., *Eugène Boudin, 1824–1898,* 3 vols., Paris, 1973.

Serret, G., and D. Fabiani, *Armand Guillaumin 1841–1927: Catalogue raisonné de l'oeuvre peint,* Paris, 1971.

Venturi, L., *Cézanne: Son Art—son oeuvre,* ed. P. Rosenberg, 2 vols., Paris, 1936.

Wildenstein, D., *Claude Monet: Biographie et catalogue raisonné,* 3 vols., Lausanne and Paris, 1974–79.

Wildenstein, G., *Gauguin,* Paris, 1964.

General Bibliography

About, E.-F.-K., *Le Progrès,* Paris, 1864.

Adhémar, H., and S. Gache, "L'Exposition de 1874 chez Nadar," in Réunion des Musées Nationaux, *Centenaire de l'impressionnisme,* exh. cat., Paris, 1974.

Alphand, A., *Les Promenades de Paris,* 2 vols., Paris, 1867–73.

Aragon, L., *Aurélien,* Paris, 1944.

Ardouin-Dumazet, V., *Voyage en France, 13e série: Le Provence maritime,* Paris, 1898.

The Art Institute of Chicago, *Frédéric Bazille and Early Impressionism,* exh. cat., Chicago, 1978.

———, *Renoir,* exh. cat., Chicago, 1973.

Atelier Eugène Boudin: Catalogue des tableaux, pastels, aquarelles et dessins, dont la vente après décès aura lieu..., sale cat., Paris, 1899.

Aurier, G.-A., "Le Symbolisme en peinture Paul Gauguin," *Le Mercure de France,* vol. 2, 1891, pp. 155–165.

Bachaumont, "La Vie à Paris: Le Parc Monceau," *Le Sport,* September 19, 1877, pp. 2–3.

Baedeker, K., *Northern France from Belgium and the English Channel, Excluding Paris and its Environs,* London, 1894.

———, *Southern France Including Corsica,* New York, 1902.

Bancquart, M.-C., *Images littéraires du Paris "fin de siècle" 1800–1900,* Paris, 1979.

Baroli, M., *Le Train dans la littérature française,* Paris, 1969.

Barrau, T., *Simples Notions sur l'agriculture,* Paris, 1883.

Barrès, M., *La Provence: Peintres et écrivains de Thèophile Gautier à Paul Valery, de Corot à Dufy,* ed. F. Mermod, Lausanne, n.d.

Barron, L., *Les Environs de Paris,* Paris, 1886.

Bart, B., *Flaubert's Landscape Description,* Ann Arbor, 1956.

Baudelaire, C., *Art in Paris 1845–1862,* ed. and tr. J. Mayne, Aberdeen, 1965.

———, *Oeuvres complètes,* Paris, 1961.

———, *The Painter of Modern Life and Other Essays,* ed. and tr. J. Mayne, London and New York, 1970.

———, "The Swan," in M. and J. Mathews (eds.) and F. Sturm (tr.), *The Flowers of Evil,* New York, 1958, pp. 78–82.

———, *Variétés critique,* 2 vols., Paris, 1924.

Baudry, E., *Le Camp de bourgeois,* Paris, 1868.

Bazin, G., *Trèsors de l'impressionnisme au Louvre,* Paris, 1965.

Bellony-Rewald, A., *Le Monde retrouvé des impressionnistes,* Paris, 1977.

Bertall, C.-A., *La Vie hors de chez soi (comédie de notre temps),* Paris, 1876.

Bibliothèque des Arts, *La Collection d'estampes japonaises de Claude Monet,* exh. cat., Paris, 1983.

Blackburn, H., *Artistic Travel,* London, 1892.

———, *Breton Folk: An Artistic Tour in Brittany,* London, 1880.

Bloch, M., *The Ile de France,* Ithaca, 1971.

———, "L'Ile de France," *Revue de synthèse historique,* vol. 25, no. 74, pp. 209–223; no. 75, pp. 310–339; vol. 26, nos. 76–77, pp. 131–193; no. 78, pp. 325–350.

Bodelsen, M., "Early Impressionist Sales, 1874–94, in the Light of Some Unpublished *Procès-verbaux,*" *Burlington Magazine,* vol. 110, June 1968, pp. 330–349.

Bourdin, E. (ed.), *Guide de voyageur de Paris à la mer par Rouen et Le Havre,* Paris, 1847.

Brettell, R. *Pissarro and Pontoise: The Painter in a Landscape,* unpub. Ph.D. diss., Yale University, 1977.

———, and C. Lloyd, *A Catalogue of the Drawings by Camille Pissarro in the Ashmolean,* Oxford, 1980.

Cario, L., *Eugène Boudin,* Paris, 1928.

Carrière, E.A., *Entretiens familiers sur l'horticulture,* Paris, 1860.

Castagnary, J., "Salon de 1866," *Le Nain jaune,* May 30, 1869.

———, *Salons (1857–1870),* ed. E. Spuller, 2 vols., Paris, 1892.

Centre Culturel de Marais, *Claude Monet au temps de Giverny,* exh. cat., Paris, 1983.

Centre National d'Art et de Culture Georges Pompidou, *Le Temps des gares,* exh. cat., Paris, 1978.

Cézanne, P., *Letters,* ed. J. Rewald, London, 1941.

Champfleury, J., *Champfleury: Le Réalisme,* ed. G. Lacambre and J. Lacambre, Paris, 1973.

———, "Du rôle important des paysagistes à notre époque," *Le Courrier artistique,* no. 17, February 15, 1862, pp. 1–2.

Charageat, M., *L'Art des jardins,* Paris, 1962.

Chateaubriand, F.-R. de, *Mémoire d'Outre-tombe,* 2 vols., Paris, 1951.

Claretie, J., *Voyage d'un Parisien,* Paris, 1865.

Clark, K., *Landscape into Art,* New York, 1979.

Coe, R., "Camille Pissarro in Paris: A Study of His Later Development," *Gazette des Beaux-Arts,* ser.

6, vol. 43, February 1954, pp. 93–118.

———, "Camille Pissarro's 'Jardin des Mathurins': An Inquiry into Impressionist Composition," *The Nelson Gallery and Atkins Museum Bulletin,* vol. 4, Spring 1963, pp. 1–22.

Cooper, D., "Early Collectors of Impressionist Painting," in M. Strauss (ed.), *Impressionism and Modern Art: The Season at Sotheby Parke-Bernet 1973–74,* London and New York, 1974, pp. 7–15.

———, "Introduction: VII, Modern French Painting and English Collectors," in *The Courtauld Collection: A Catalogue and Introduction,* London, 1954, pp. 60–74.

Corpechot, L., *Parcs et jardins de France,* Paris, 1936.

Couture, T., *Paysage: Entretiens d'atelier,* Paris, 1869.

Daly, C., *L'Architecture privée au XIXe siècle sous Napoléon III: Nouvelles Maisons de Paris et des environs,* 3 vols., Paris, 1864–72.

d'Arneville, M.-B., *Parcs et jardins sous le premier Empire,* Paris, 1981.

Daulte, F., *August Renoir: Catalogue raisonné de l'oeuvre peint,* Lausanne, 1971.

Degand, L., and D. Rouart, *Claude Monet,* Geneva, 1958.

de Knyff, G., *Eugène Boudin raconté par lui-même, sa vie, son atelier, son oeuvre,* Paris, 1976.

de La Bedollière, E., *Histoire des environs de nouveau Paris,* Paris, [early 1860s].

de Nerval, G., *Promenades et souvenirs,* Paris, 1855.

Deperthes, J.-B., *Théorie du paysage ou considérations générales sur les beautés de la nature que l'art peut imiter, et sur les moyens qu'il doit employer pour réussir dans cette imitation,* Paris, 1818.

de Piles, R., *Cours de peinture par principes,* Paris, 1708.

de Trévise, Duc, "Le Pèlerinage de Giverny," *La Revue* de l'art ancien et moderne, vol. I, 1927, pp. 42–50, 121–134.

Didot, F., *Guide des promenades,* Paris, 1855.

Dorival, B., *Cézanne,* tr. H. Thackthwaite, Boston, n.d.

Dorra, H., and J. Rewald, *Seurat, l'oeuvre peint, biographie et catalogue critique,* Paris, 1959.

Durand-Clay, A., *Le Matériel et les procédés des industries agricoles et forestières, Exposition universelle internationale de 1878,* Paris, 1880.

Duret, T., *Histoires des peintres impressionnistes,* Paris, 1906.

———, *Manet and the French Impressionists,* tr. J. Flitch, New York, 1971.

Elder, M. [M. Tendron], *A Giverny chez Claude Monet,* Paris, 1924.

Elvers, H., *De l'impressionnisme à l'art abstract,* Paris, 1972.

Faucher, D., "Le Fonds paysan de France," in *La Vie rurale vue par un géographe,* Toulouse, 1962.

Fénéon, F., *Oeuvres plus que complètes,* ed. J. Halperin, 2 vols., Geneva and Paris, 1970.

Forge, A., et al., *Monet at Giverny,* London, 1975.

Fourreau, A., *Berthe Morisot,* Paris, 1925.

Gachet, P., *Deux amis des impressionnistes: le docteur Gachet et Mürer,* Paris, 1956.

Galerie Charpentier, *Un Siècle de chemin de fer et d'art,* exh. cat., Paris, 1955.

Galerie Durand-Ruel, *Les Manet de la collection Faure,* sale cat., Paris, 1906.

———, *Recueil d'estampes graviés à l'eau-forte*, exh. cat., 3 vols., Paris, 1873.

Gasquet, J., *Paul Cézanne*, Paris, 1926.

Gastineau, B., *La Vie en chemin de fer*, Paris, 1861.

———, *Sottises et scandales du temps présent*, Paris, 1863.

Gauguin, P., *Letters to his Wife and Friends*, ed. M. Malingue and tr. H. Stenning, Cleveland, 1949.

Geffroy, G., *Claude Monet, sa vie, son oeuvre*, 2 vols., Paris, 1924.

———, *Exposition d'oeuvres récentes de Claude Monet dans les Galeries Durand-Ruel*, Paris, 1891.

Gellner, E., *Nations and Nationalism*, Ithaca and London, 1983.

Giffard, P., *La Vie en chemin de fer*, Paris, 1887.

Gimpel, R., "At Giverny with Claude Monet," *Art in America*, vol. 15, no. 4, June 1927, pp. 168–174.

Goncourt, E., and J. de, *Journal des Goncourts: Mémoires de la vie littéraire*, ed. R. Ricatte, 4 vols., Paris, 1959.

———, *L'Art du dix-huitième siècle*, 3 vols., Paris, 1928.

———, *Paris and the Arts, 1851–1896: From the Goncourt Journal*, ed. and tr. G. Becker and E. Phillips, Ithaca and London, 1971.

Gouirand, A., *Les Peintres provençaux*, Paris, 1901.

Grandroinnet, J., *Traité de mécanique agricole*, Paris, 1854.

——— (ed.), *Le Génie rural*, Paris, 1858–75.

Gravier, J.-F., *Régions et nation*, Paris, 1942.

Gray, C., *Armand Guillaumin*, Chester, 1972.

Grimal, P., *L'Art des jardins*, Paris, 1954.

Guide des promenades, Paris, 1855.

Guide de voyageur sur les bateaux à vapeur de Paris au Havre, n.p., [c. 1865].

Hallberg, K., "Le Port de Bordeaux vu par Manet et Boudin," *L'Oeil*, vol. 25, no. 250, May 1976, pp. 14–17.

Hamilton, G., *Painting and Sculpture in Europe 1880–1940*, New York, 1967.

Hare, A. J. G., *Days near Paris*, New York, 1888.

Haus der Kunst, *Welt Kulturen und moderne Kunst*, exh. cat., Munich, 1972.

Hauser, A., *The Social History of Art*, tr. S. Godman and A. Hauser, 2 vols., New York, 1951.

Heilbrun, F., *Charles Nègre photograph*, Paris, 1980.

Henriet, C.-F., *Les Compagnes d'un paysagiste*, Paris, 1896.

Herbert, R., "Method and Meaning in Monet," *Art in America*, vol. 67, no. 5, September 1979, pp. 90–108.

Hoschedé, J.-P., *Claude Monet, ce mal connu*, 2 vols., Geneva, 1960.

House, J., "The New Monet Catalogue," *The Burlington Magazine*, vol. 120, no. 907, October 1978, pp. 678–682.

Hugo, V., *Les Travailleurs de la mer*, in *Oeuvres complètes*, 18 vols., Paris, 1967–70, vol. 12 (1969).

Huth, H., "Impressionism comes to America," *Gazette des Beaux-Arts*, ser. 6, vol. 29, April 1946, pp. 225–257.

Isaacson, J., *Claude Monet, Observation and Reflection*, Oxford and New York, 1978.

———, "Monet's Views of Paris," *Allen Memorial Art Museum Bulletin*, vol. 24, Fall 1966, pp. 5–22.

James, H., *A Little Tour in France*, Boston, 1884.

———, *Parisian Sketches*, ed. L. Edel and I.D. Lind, New York, 1952.

Jammes, A., and E. Parry, *The Art of French Calotype*, Princeton, 1983.

Jamot, P., "Etudes sur Manet," *Gazette des Beaux-Arts*, ser. 5, vol. 15, January 1927, pp. 27–50.

Jean-Aubry, G., *Eugène Boudin d'après des documents inédits: L'Homme et l'oeuvre*, Paris, 1922.

Joanne, A., *Atlas historique et statistique des chemins de fer français*, Paris, 1859.

———, *Itinéraire général de la France: Bretagne*, Paris, 1867.

———, *Les Environs de Paris illustrés*, Paris, 1878.

———, *Les Environs de Paris illustrés*, Paris, 1881.

Joanne, P., *Dictionnaire géographique et administratif de la France*, Paris, 1872.

Kohn, H., *Prophets and Peoples: Studies in 19th Century Nationalism*, New York, 1975.

Kropotkin, P., *The Conquest of Bread*, London, 1906.

La Croix, A. (ed.), *Paris Guide par les principaux écrivains et artistes de la France*, 2 vols., Paris, 1867.

Lecarpentier, C., *Essai sur le paysage, dans lequel on traite des diverses méthodes pour se conduire dans l'étude du paysage*, Paris, 1817.

La Grande Encyclopédie, 31 vols., Paris, 1886–1902.

Lecomte, G., "Des Tendences de la peinture moderne," *L'Art Moderne: Revue critique des arts et de la littérature*, February 21, 1892.

Le Petit Journal, December 7, 1879.

Leprochon, P., *Vincent van Gogh*, Corymbe, 1972.

Les Chemins de fer illustrés, Paris, c. 1860–80.

Levine, S., "Monet's Cabane du Douanier," *Fogg Art Museum Annual Report (1971–72)*, Cambridge, Mass., 1972, pp. 32–44.

L'Illustration, October 7, 1848, p. 93.

Lindon, R., *Etretat, son histoire, ses légendes*, Paris, 1963.

———, "Falaise à Etretat par Claude Monet," *Gazette des Beaux-Arts*, ser. 6, vol. 55, March 1960, pp. 179–182.

Loran, E., *Cézanne's Composition: Analysis of his Form with Diagrams and Photographs of his Motifs*, Berkeley and Los Angeles, 1947.

Louis, Désiré, "Claude Monet," *L'Evénément*, May 19, 1891, n.p.

Mainardi, P., "Edouard Manet's "View of the Universal Exposition of 1867," *Arts Magazine*, vol. 54, no. 5, January 1980, pp. 108–115.

Mallarmé, S., *Oeuvres complètes*, ed. H. Mondor and G. Jean-Aubry, Paris, 1974.

Mantz, P., "Salon de 1865: Part 2," *Gazette des Beaux-Arts*, ser. 1, vol. 19, July 1865, pp. 5–42.

Martin, A., *Toute autour de Paris*, Paris, 1890.

Maupassant, G. de, *Contes et nouvelles*, ed. L. Forestier, 2 vols., Paris, 1977–79.

———, *Une Vie (l'humble vérité)*, Paris, 1883.

Michel, E., *Du paysage et du sentiment de la nature à notre époque*, Paris, 1876.

Michelet, J., *La Mer*, Paris, 1861.

———, *La Mer*, Paris, 1983.

Miquel, P., *Paul Huet: De l'aube romantique à l'aube impressioniste*, Sceaux, 1962.

Mirbeau, O., "Claude Monet," *L'Art dans les deux mondes*, no. 16, March 7, 1891, pp. 183–185.

Moleri, *Les Petits Jardins*, Paris, 1866.

Monet, C., "Claude Monet: The Artist as a Young Man," *Art News Annual*, vol. 26, 1957, pp. 127–138, 196–199.

Morgan. H., *New Muses: Art in American Culture 1865–1920*, Norman, 1973.

Murphy, A., "French Paintings in Boston: 1800–1900," in Museum of Fine Arts, Boston, *Corot to Braque: French Paintings from the Museum of Fine Arts*, exh. cat., 1979, pp. 17–46.

Musée Carnavalet, *Paris vu par les maîtres de Corot à Utrillo*, exh. cat., Paris, 1961.

Musée Jacquemart-André, *Marcel Proust et son temps*, exh. cat., Paris, 1971.

Museum of Fine Arts, Houston, *Gustave Caillebotte: A Retrospective Exhibition*, exh. cat., Houston, 1976.

National Gallery of Art, Washington, D.C., *Manet and Modern Paris*, exh. cat., Washington, D.C., 1982.

Niculescu, R., "Georges de Bellio, l'ami des impressionnistes," *Revue roumaine d'histoire de l'art*, vol. 1, no. 2, 1964, pp. 209–278.

Nochlin, L., *Realism and Tradition in Art 1848–1900*, Englewood Cliffs, 1966.

Nodier, C., et al., *Voyages pittoresques et romantiques dans l'ancienne France*, 20 vols., Paris, 1820–78.

Noilhan, H., *Histoire de l'agriculture à l'ère industrielle*, Paris, 1965.

Offenbach, J., *La Vie Parisienne*, New York, 1869.

Painter, G., *Marcel Proust*, tr. G. Catteau and R. P. Vial, 2 vols., Paris, 1966.

———, *Marcel Proust: A Biography*, 2 vols., London, 1959.

Pinkney, D., *Napoleon III and the Rebuilding of Paris*, Princeton, 1958.

Pissarro, C., *Letters to his son Lucien*, ed. J. Rewald, New York, 1943.

———, *Lettres à son fils Lucien*, ed. J. Rewald, Paris, 1950.

Poulain, G., *Bazille et ses amis*, Paris, 1932.

Proudhon, P.-J., *Du Principe de l'art et de sa destination sociale*, Paris, 1865.

Proust, M., *A la recherche du temps perdu*, ed. H. David, 2 vols., Paris, 1973–74.

———, *Essais et articles*, in P. Clarac (ed.), *Contre Sainte-Beuve*, Paris, 1971.

Reff, T., "Cézanne's Constructive Stroke," *Art Quarterly*, vol. 25, no. 3, Autumn 1962, pp. 214–226.

Reidemeister, L., *Auf den Spuren der Maler der Ile de France*, Berlin, 1963.

Renoir, J., *Renoir par Renoir*, Paris, 1962.

"Renoirs in the Institute," *Bulletin of The Art Institute of Chicago*, vol. 19, no. 4, April 1925, pp. 47–49.

Réunion des Musées Nationaux, *Gustave Courbet*, exh. cat., Paris, 1977.

———, *Hommage à Claude Monet*, exh. cat., Paris, 1980.

———, *Jean François Millet*, exh. cat., Paris, 1975.

———, *Manet 1832–1883*, exh. cat., Paris, 1983.

———, *Pissarro*, exh. cat., Paris, 1981.

Rewald, J., "Chocquet and Cézanne," *Gazette des Beaux-Arts*, ser. 6, vol. 74, July–August 1969, pp. 33–96.

———, *Histoire de l'impressionnisme*, Paris, 1955.

———, *The History of Impressionism*, New York and Tokyo, 1980.

———, "The Last Motifs at Aix," in The Museum of Modern Art and Réunion des Musées Nationaux, *Cézanne: The Late Work*, exh. cat., New York, 1977, pp. 83–106.

———, *Paul Cézanne*, tr. M. Liebman, London, 1959.

———, "Paysages de Paris de Corot à Utrillo," *La Renaissance*, vol. 20, January–February 1937, pp. 5–52.

———, *Post-Impressionism from Van Gogh to Gauguin*, New York, 1978.

Rey, J.-D., *Berthe Morisot*, Paris, 1982.

Rhodes, A., *The Frenchman at Home*, New York, [c. 1875].

Robinson, W., *The Parks and Gardens of Paris*, London, 1878.

Roger-Marx, C., *Le Paysage français de Corot à nos jours (ou) Le Dialogue de l'homme et du ciel*, Paris, 1952.

Rouart, D., J.-D. Rey, and R. Maillard, *Monet, Nymphéas*, Paris, 1972.

Royal Academy of Arts, *Post-Impressionism: Cross Currents in European Painting*, exh. cat., London, 1979.

Saarinen, A., *The Proud Possessors*, New York, 1958.

Sauer, C., *The Morphology of Landscape*, in J. Leighly (ed.), *Land and Life: A Selection from the Writings of Carl Ortwin Sauer*, Berkeley and Los Angeles, 1963.

Scharf, A., *Art and Photography*, London, 1968.

Schivelbusch, W., *The Railway Journey: Trains and Travel in the Nineteenth Century*, tr. A. Hollo, New York, 1979.

Schopfer, J., "Open-Air Life in a Great City," *Architectural Record*, vol. 14, no. 12, 1903, pp. 157–168.

Seitz, W., *Claude Monet*, New York, 1960.

Sigaux, G., *Histoire de tourisme*, Lausanne, 1965.

Sloane, J., *French Painting between the Past and the Present*, Princeton, 1951.

Snyder, L., *The Dynamics of Nationalism*, New York, 1964.

The Tate Gallery and Arts Council of Great Britain, *Gauguin and the Pont-Aven Group*, exh. cat., London, 1966.

Thomson, D., *The Barbizon School of Painters*, London, 1891.

Thoré, T. [W. Bürger, pseud.], *Salons de W. Bürger 1861 à 1868*, Paris, 1870.

Tucker, P., *Monet at Argenteuil*, New Haven, 1982.

University of California at Riverside Art Gallery and Los Angeles County Museum of Art, *The Impressionists and the Salon (1874–1886)*, exh. cat., Riverside, 1974.

University of Michigan Museum of Art, *The Crisis of Impressionism 1878–1882*, exh. cat., Ann Arbor, 1980.

Valenciennes, P.-H. de, *Eléments de perspective pratique*, Paris, 1800.

Van der Kemp, G., *Une Visite à Giverny*, Paris, 1980.

Van Gogh, V., *Correspondance complète de Vincent van Gogh*, trans. M. Beerblock and L. Roelandt, 3 vols., Paris, 1960.

———, *Lettres de Vincent van Gogh à Emile Bernard*, Paris, 1911.

Van Sandrart, J., *Der Teutschen Academie zweyter und letzter Haupt-Teil*, ed. A. Pelzer, Munich, 1925.

Varnedoe, K., "Caillebotte's Pont de l'Europe: A New Slant," *Art International*, vol. 18, no. 4, April 20, 1974, pp. 28–59.

Vauxcelles, L., "Introduction," in Galerie Stein, *Jardins d'hier et d'aujourd'hui*, exh. cat., Paris, 1934.

Venturi, L., *Les Archives de l'impressionnisme*, 2 vols., Paris and New York, 1939.

Viollet-le-Duc, E., "L'Enseignement des arts: Il y a quelque chose à faire: Part 4," *Gazette des Beaux-Arts*, vol. 13, no. 4, September 1862, pp. 249–255.

Vollard, A., *En écoutant Cézanne, Degas, Renoir*, Paris, 1938.

Waern, C., "Some Notes on French Impressionism," *Atlantic Monthly*, vol. 69, no. 414, April 1892, pp. 535–541.

Walter, R., "Le Parc de Monsieur Zola," *L'Oeil*, no. 272, March 1978, pp. 18–25.

———, "Les maisons de Claude Monet à Argenteuil," *Gazette des Beaux-Arts*, vol. 68, December 1966, pp. 334–336.

———, "Saint-Lazare l'impressionniste," *L'Oeil*, no. 292, November 1979, pp. 48–55.

White, H., and C. White, *Canvases and Careers: Institutional Change in the French Painting World*, New York, 1965.

Wildenstein and Company, *Caillebotte*, exh. cat., Paris, 1951.

———, *One Hundred Years of Impressionism: A Tribute to Paul Durand-Ruel*, exh. cat., New York, 1970.

Worcester Art Museum and The American Federation of Arts, *Visions of City and Country: Prints and Photographs of 19th Century France*, exh. cat., Worcester and New York, 1982.

Ysabeau, A., *Le Jardinage, ou l'art de créer et de bien tenir un jardin*, Paris, 1854.

Zeldin, T., *France, 1848–1945*, 3 vols., New York, 1979–80.

———, *France, 1848–1945, Vol. I: Ambition, Love and Politics*, London, 1973.

———, *France, 1848–1945, Vol. II: Intellect, Taste and Anxiety*, Oxford, 1977.

Zola, E., *Les Rougon-Marquart: Histoire naturelle et sociale d'une famille sous le second Empire*, ed. H. Mitterand, 5 vols., Paris, 1960–68.

———, *Mon Salon, Manet, écrits sur l'art*, ed. A. Ehrard, Paris, 1970.

———, *Salons*, ed. F. Hemmings and R. Niess, Geneva, 1959.

Index

Trustees and Supervisors

Photo Credits/Color Plates

All color photographs are reproduced courtesy of the lenders with the following exceptions: nos. 15, 24, 45, 64, 95 (courtesy Melville McLean, Fine Art Photography, Chicago); no. 46 (courtesy Nathan Rabin, Fine Art Photography, New York); and nos. 116 and 118 (courtesy Eric E. Mitchell).